Gothic Sculpture in France
1140–1270

WILLIBALD SAUERLÄNDER

with photographs by
MAX HIRMER

Translated by JANET SONDHEIMER

THAMES AND HUDSON · LONDON

Translated from the German *Gotische Skulptur in Frankreich 1140–1270*
© 1970 Hirmer Verlag, Munich
English translation © 1972 Thames and Hudson Ltd, London

Text filmset in Great Britain by Filmtype Services Limited, Scarborough
Printed in the Netherlands by A. W. Sijthoff N.V., Leyden
Plates printed in West Germany by Kastner & Callwey, Munich
Bound in the Netherlands by Van Rijmenam N.V., The Hague

ISBN 0 500 16017 1

CONTENTS

PREFACE

Since the days of the Romantics the great gothic cathedrals of northern France have attracted the nostalgic admiration of a world separated from the Christian Middle Ages by the Enlightenment. Adopting a religious, aesthetic, patriotically French or socio-historical approach, poets, writers, artists and historians have celebrated the cathedrals – and invoked them. Chartres in the late nineteenth and early twentieth century engendered a whole literature of its own, some of it quite embarrassing in its excesses. It is rare indeed to find the cathedrals of the Middle Ages viewed in the same free spirit as the artistic inheritance from antiquity. Attempts to be objective slide all too easily into sentimentality or declarations of faith, into an aesthetic obscurantism.

As we know, the men of the eighteenth and early nineteenth century who rediscovered Gothic, which Humanism and the Renaissance had so disparaged, were stirred initially by feelings of awed stupefaction at the interior of the gothic church, at what Franz Kugler describes as its 'light-pervaded sublimity'. By contrast, until well beyond the middle of the nineteenth century, interest in the imagery of the cathedrals, in gothic sculpture, was largely preoccupied with content or took the antiquarian approach. When Ruskin wrote in 1883 he discoursed not on the beauty of the portal sculptures but on the 'Bible of Amiens', and about Emile Mâle's *L'Art religieux en France au treizième siècle*, published in 1898, there hangs a slight air of '*renouveau catholique*'. The reason for the difference in attitude towards the architectural and sculptural manifestations of Gothic lies in the running conflict between historical thinking and the idea of a normative aesthetic, which characterizes much of the art-historical activity of the nineteenth century. While the gothic church, regarded as embracing the quintessence of Christian spirituality, very soon earned a place alongside the Greek temple, the idea that sculpture was, as Hegel put it, 'the classical art form' focused nineteenth-century attention almost exclusively on the sculptures of Greek and Roman antiquity. This explains why gothic sculptures were studied primarily for their content, since there was still no specific feeling for their form. When we read experts like Didron, or even Mâle in his early days, their exposition of cathedral sculpture strikes us as didactic and doctrinaire. Today, if we read what Viollet-le-Duc, writing *c.* 1860, had to say about thirteenth-century sculpture in his *Dictionnaire d'architecture* (under *Sculpture*), it is embarrassing to see this passionate apologist for medieval French art grasping at the sorriest commonplaces of the 'milieu' theory to defend the deviations of gothic figures from the classical canon. It is surely no coincidence that the nineteenth century first credited gothic sculpture with intrinsic aesthetic value in a field for which the classical canon laid down no rules: the field of the grotesque. It was the drolls and gargoyles which first attracted admiration, not the jamb figures.

The question whether gothic sculptures followed laws of their own was first raised in 1894 by the German scholar Wilhelm Vöge. In the preface to his book on the Chartres Royal Portal he says: 'To grasp works of art, and that includes those that are imperfect and medieval, as creatures of an artist's mind, as creations of an artist's hand, and to try to gain insight into the hidden processes by which style is formed, is to my mind the beginning and end of the matter. What gives them their peculiar beauty? Why are they so odd, so deviant/degenerate? WHY so hideous?' At the time these words were

written, European art was already ranged beneath the banner of the modern style, and a sensibility perpetually open to new stimuli had long since made any idea of a normative aesthetic a thing of the past. The gothic cathedral sculptures, too, now started to emerge from the long shadow cast by classicism. They have since been admired without reservation, even if their disciplined, noble forms have not transported twentieth-century beholders into the ecstasies induced by the seeming primitivism and expressive elusiveness of romanesque sculptures. The sensations aroused by the contemplation of the Rheims Visitation and a romanesque bestiary pillar are of a different order – if the latter is more evocative of violence and terror, the former surprises us into the realization that losing ourselves in a medieval work of art does no injury to our humanity. Since the end of the nineteenth century gothic sculpture has been subjected to a thoroughgoing process of style criticism. Armed with model classifications of the kind already evolved in the nineteenth century for several later periods, art historians started to look for schools and connections between schools, to trace masters and their careers, even to the point of distinguishing between their earlier and their later works. In their zeal for discovery and delight in the sculptures, whose beauty and vitality were only now emerging into the full light of day, the researchers perhaps at times failed to pay due consideration to specific historical circumstances: the organization of work in the masons' yards, ecclesiastical patronage, and the commitment to iconographical tradition. Yet the fact remains that it was through this work, and Vöge's pioneering researches in particular, that the vast store of monuments became not only physically accessible but also, still more important, artistically alive. The connections between the individual workshops, and the chronological ordering of the works – how they stand after, with, or opposed to one another – was again revealed. Gothic sculpture's relationship to antiquity, nature, life, and iconographic tradition also came under scrutiny. In the gothic cathedral as we conceive it today, sculpture occupies an essential place as the first memorable attempt to capture parts of the Christian cycle of images in statuary form.

In planning the present volume, the first consideration was to reduce the available material to reasonable proportions. It was decided that although the influence of French sculpture spread to neighbouring parts of Europe – triumphant proof of its pioneering role – works outside the boundaries of present-day France must be excluded. The next step was to fix a chronological limit, which in the nature of the case was bound to be somewhat arbitrary. The year of the death of St Louis was chosen, as roughly defining the period by which French cathedral sculpture had passed its peak; with one or two exceptions none of the monuments illustrated is, to the best of our belief, later than 1270. At the same time we were concerned to present, so far as possible, a broad and comprehensive picture of the development of gothic sculpture in the big masons' yards, from Saint-Denis shortly before 1140 until the third quarter of the thirteenth century. We have therefore been at pains to include, along with the well-known and much photographed monuments, some that are less accessible and in a few instances virtually neglected, even today. This decision was all the easier to adhere to because the artistic level of sculpture during this gothic heyday was almost uniformly high, with the result that the beauty of the works illustrated has rarely been in question. We hope we have succeeded in presenting a picture of cathedral sculpture between 1140 and 1270 which if not formally complete is at least full and comprehensive.

The text is divided into a general Introduction and a Documentation section, in which there are notes on the individual monuments. The Introduction deliberately refrains from any attempt at an outline history of gothic sculpture in the twelfth and thirteenth century. I have tried instead to elucidate certain elements and aspects of twelfth- and thirteenth-century sculpture which may not be self-evident to the modern spectator, but which could assist him to a better historical understanding of the monuments. The purpose of the Documentation section is different. The notes on each monument attempt to sum up, so far as this is possible within the limits of the available space, the present state of our knowledge, and to indicate, in one or two cases, problems still unresolved. We have tried to cover the existing literature and to give bibliographical references full enough to lead the reader to titles not

specifically cited; with the best of intentions, it is almost inevitable that among the modern spate of scientific literature on historical problems one or two works will have been overlooked. In a volume of this kind, designed as it is for a wider readership, it would be out of place to enter into a critical discussion of divergent opinions. In compiling the Documentation, however, we have paid careful attention to the results of scholarly research.

It is a pleasant duty to thank the friends, colleagues and pupils who assisted in the preparation of this volume, by providing us with information or with material for use as illustrations: Madame Anne Prache and Fraülein Regina Teuwen, Monsieur Alain Erlande-Brandenburg, Dr Johannes Langner, Monsieur Léon Pressouyre, Monsieur Pierre Quarré and Herr Lorenz Seelig. My especial thanks go to Fraülein Ursula Kriedte for her vigilant proofreading, and to Frau Hedwig Cromer, secretary at the Kunsthistorisches Institut, Freiburg, for the final preparation of the texts for the Documentation section.

The final version of the text is the result of a scholarly collaboration between Dr Renate Kroos, research assistant at the Kunsthistorisches Institut, Freiburg, and the author. Dr Kroos has read and corrected both the Introduction and the Documentation section, and the accuracy of the texts has profited from her many additional references and her counsel. Without her wide knowledge of medieval art and iconography, placed unstintingly at my disposal, the Documentation, in particular, would never have reached its present comprehensive state.

I must lastly thank Professor Max Hirmer for his patience and for the inexhaustible enthusiasm he brought to the difficult and often hazardous task of taking the photographs.

WILLIBALD SAUERLÄNDER

The Plates attempt to provide a comprehensive and so far as possible self-contained picture of the development of gothic sculpture in France down to the death of St Louis. By contrast with the wealth of illustrated works devoted to Greek sculpture which have appeared over the past two decades, French sculpture, surely no less eminent in artistic significance and influence, has not hitherto received such comprehensive treatment. I was therefore emboldened to make a photographic record of gothic sculpture from its beginnings shortly before 1140 down to the third quarter of the thirteenth century, and to publish it. That the photography was itself an arduous undertaking will best be appreciated by those who know what a large number of cathedral figures survive, many of them in extremely lofty and inaccessible positions.

The large amount of space devoted in the Plates to the great cathedrals and their sculpture is surely self-explanatory. The figures of the Royal Portal at Chartres and of the cathedrals of Senlis, Sens and Laon, the portals of the Chartres transept and the south transept of Strasbourg, not to mention the sculptures on the portals of Notre Dame in Paris and the cathedral of Amiens, have a universal appeal. These works are mentioned here as being among the most important of the monuments illustrated, culminating in the sculptures of Rheims.

If in its artistic significance and assertive force the sculptural *œuvre* of French Gothic in the thirteen decades covered by this volume can compare with the Greek sculpture of the classical period and the preceding and following decades, then it must be allowed that the ultimate experience, comparable with confrontation with the sculptures of the Parthenon at Athens, is provided by the sculpted decoration of Rheims, in all its brilliance and intellectual and spiritual richness.

Just as no effort was spared in securing the photographs, great care has been taken over their reproduction. It was in general decided not to make colour plates, since virtually all traces of the original glowing colouring have long since disappeared. Exceptions were, however, made for a few photographs which bring out the colouring of the stone itself: the sheen which makes the sculptures on the Chartres Royal Portal and on the jambs of the west portal at Rheims gleam in the afternoon light, and

9

creates the sonorous purple tone which mystically envelops the Death of the Virgin on the tympanum of the Strasbourg south portal.

I must thank Professor Sauerländer for his illuminating discussion of the problems of gothic sculpture in the text; it will be appreciated that for reasons of conciseness he has often deliberately refrained, especially in the Introduction, from giving precise indications of the location of the sculptures on the building in question.

For permission to take photographs I must thank: the Direction de l'Architecture du Ministère d'Etat chargé des Affaires culturelles, Paris; M. Michel André, Architecte des Bâtiments de France, Rheims; M. Pierre Pradel, Conservateur en chef du Département des Sculptures, and M. M. Gaborit, Conservateur-adjoint, Musée du Louvre, Paris; M. Francis Salet, Directeur, and M. Alain Brandenburg, of the Musée de Cluny, Paris; the Direction of the Musée National des Monuments français, Paris, of the Musée d'Archéologie, Besançon, of the Musée Départemental des Antiquités, Dijon, and of the Musée des Augustins, Toulouse. I must finally express my gratitude to M. Parruzot, Musée Municipal, Sens, for his friendly assistance.

The photographs for this volume were made in the closest collaboration with my son Albert and my daughter Irmgard. Their ready enterprise and photographic skill contributed substantially to the success of an often difficult undertaking. The task of preparing the plates for publication was left in the experienced hands of Frau Helga Maurus and Frau Helga Thomas.

MAX HIRMER

INTRODUCTION

OPUS FRANCIGENUM

'Opus Francigenum' is the name given by the German chronicler Burckhardt of Halle to the new gothic style of architecture which in the thirteenth century spread from Paris and northern France to the whole of Western Europe. The style had originated in the French royal domain during the reign of Louis VII (1137–80), and its first monument was the abbey church of Saint-Denis, which had close associations with the Capetian dynasty. The church at Saint-Denis was built under the patronage of Abbot Suger, who played an important historical role as royal counsellor and as regent of France during the Second Crusade (1147–49). The formation of the gothic style, and its extension further afield, runs parallel with the rise of the French monarchy. Until the end of the twelfth century the new style was largely confined to the dioceses of northern France. In Normandy building in the gothic style started only after Philip Augustus (1180–1222) had captured the duchy from the English. In the south of France the appearance of gothic cathedrals followed the expansion of the royal domain under Louis VIII (1223–26) and still more under Louis IX (St Louis; 1226–70). By this time Gothic had admittedly become a European style, spread in part by religious orders based in France, for example the Cistercians, and by the attraction of Paris as a place of study for clerics from all over Europe. The mendicant orders, who played such a leading role in the thirteenth century, built in the gothic style – in Regensburg or Florence as readily as in Paris or Toulouse.

From the beginning the painted and carved decoration which furnished gothic cathedrals and monastic churches took specific and unmistakable forms. The northern French Gothic of the twelfth and thirteenth centuries was the great age of medieval stained glass. The glass windows of the gothic church assumed the role played in many earlier churches by wall paintings, mosaics or tapestries. In other countries, the French lead in gothic glass painting and sculpture was as influential as it was in architecture. Without some knowledge of the work in French cathedrals, it is impossible to understand the development of sculpture in Germany, Spain, England or Italy during the thirteenth century. The initiative came from France, and the artists of other countries fell under the spell. Sculpture played a major part in the adornment of churches, as also in its liturgical furnishings. An introduction to the sculptures in their historical context cannot do better than to start with a brief review of the various categories within which gothic sculpture developed.

11

CATEGORIES AND FUNCTIONS

FIGURE-DECORATED PORTALS

Inscriptions and symbols on church doorways – the point at which the secular world is left behind – go back to the early Christian period. Their purpose was to remind the faithful who crossed the threshold of God's house of their duty to practise virtue and obey the Commandments, and of the forgiveness of sins. They were placed there in part to preach and in part to ward off evil. The same warnings and promises appear on church doorways of the early Middle Ages, no longer merely as inscriptions or symbols but in pictorial form. The medium used was painting, joined from the eleventh century by sculpture. Representations on the tympana of romanesque churches in Burgundy issued urgent warning of the End of the World, Christ's Second Coming and the Last Judgment. The doorways of portals in western France show the Calendar, the struggle of the Virtues with the Vices, the Wise and Foolish Virgins, and on the inside arch, above the threshold, the Agnus Dei: a pictorial progress leading from the war against sin to the eucharistic symbol. In northern Italy figures were placed on the doorposts and the jambs; mostly they are of prophets, displaying banderoles inscribed with texts. The romanesque sculpture of southern France, Spain and Italy was chiefly developed in the area round the doorways, and this was a tradition which the newly emerging Gothic of northern France adopted, adapted and enlarged.

On the cathedrals of the French royal domain the portal cycles attained dimensions previously unknown. Architectural members and figures entered into a more systematic relationship, the structure of the composition gained in tautness and clarity. The central themes were still carried by the tympana, which in the twelfth century were usually shaped as large lunettes dominating the doorway complex and filled, as in the romanesque period, with hieratical compositions. At this date the lintel was still quite clearly subordinate to the tympanum. In the thirteenth century the tympanum was subdivided to accommodate several scenes, and its monumental impact was thereby diminished. On the Calixtus portal at Rheims, tympanum and lintel are no longer distinguishable; the field enclosed by the pointed arch above the entrance is divided into equal bands, and the rows of figures are ranged one above another like lines on a page of writing. In place of one dominant symbol above the threshold of the church, there was a series of broadly elaborated scenes.

The gothic portal brought together motifs previously confined to buildings of particular regions, and combined them in a way which gave the structure new meaning. Erwin Panofsky has aptly described this process as an 'implosion'. On the Royal Portal at Chartres, for example, we find the tangentially disposed archivolt figures characteristic of western France framing a tympanum in the Burgundian tradition. In consequence, the adoring figures in the arches stand in a new relationship to the dominant figure at the centre. The clarity of the architectonic structure has brought new order to the content. On certain thirteenth-century portals the number of arches is significantly increased. At Amiens no less than eight ranks of archivolt figures sweep round the tympanum of the central doorway – an aureole of saints and angels. The combination of massive proportions with minutely subdivided detail came to be characteristic of the thirteenth-century portal.

5; 16; 24; 37; 42; *ill. 8*

245

5

164, 165

13

Where the lintel exceeded a certain length its centre had to be supported by a pillar, the trumeau. The earliest examples, already decorated with figures, are found in Burgundian romanesque portals dating from the first half of the twelfth century. The figure chosen for this place of honour was always one with particular significance: at Saint-Bénigne in Dijon, Saint-Loup-de-Naud and Sens it was the church's patron; at Rheims it was the Virgin; in the Judgment portals of the thirteenth century it was the triumphant Christ, in a literal illustration of the text 'Ego sum ostium' (John 10:9). On a few of the great facades – Mantes, Paris, Amiens – trumeau figures appear in all three adjacent doorways, and at Bourges in all five. Gothic's preoccupation with systematic arrangement demanded repetition and accumulation in preference to the single outstanding motif.

Carved ornament is sometimes found on the narrow sides of the trumeau. At Sens, tendrils sprout on either side of St Stephen. In Paris the sides of the trumeau of the Coronation of the Virgin portal of Notre Dame are divided into rectangular compartments containing allegorical figures. At Chartres the half-figures of censing angels are seen near the head of St Anne; at Rheims this solemn motif extends to the whole trumeau, and we see seven standing angels on either side of the Virgin. Subordinate figures and scenes may be introduced at the feet of the trumeau figure, for example the various decorations found on trumeau plinths at Chartres, Amiens and Rheims.

The lintel beam rests on the doorposts. Sometimes the doorposts were left completely bare, or they might be hidden, as at Senlis and on the transept at Chartres, by an attached column. Romanesque portals in Burgundy covered their doorposts with tendril ornament in the antique style, and in the twelfth century this same decoration is found on gothic doorways at Bourges, Mantes and Saint-Denis; after 1200 it completely disappears. The doorposts of the west portal of Saint-Denis are already decorated with figures, framed by arcades or wreathed medallions. Most later portals follow this lead and use the surfaces of the doorposts for an extension of the iconographic programme. At Sens and Amiens, and even at Auxerre, more than halfway through the thirteenth century, the doorposts faithfully reproduce the arrangement at Saint-Denis. The Coronation of the Virgin portal in Paris employs a framework of simple rectangles, and for the first time introduces figures on to the doorpost's narrow sides. Rheims followed the example of Paris, with the difference that the figures stand unframed on smooth ashlars.

In early Gothic the church entrance is shaped as a graduated doorway in which the angles of the recessed jamb are filled with attached columns; Saint-Denis and the Royal Portal at Chartres are good examples. The elements of this type of doorway already existed in romanesque architecture, above all in Normandy. Later the walls adjoining the entrance were made to run slantwise in an unbroken line, with the columns set against this plain surface. The final stage of this development is seen, for example, in the west doorways of Amiens. The problem of installing large figures on a jamb with attached columns had already been faced at Saint-Denis. For technical reasons it was not feasible to instal them as freestanding statues, nor could they take the form of reliefs, which required a smooth wall surface. The solution was to chisel both figure and column from the same block, thus producing a statue-like high relief for which there is no precedent in antique or early medieval art. In the specialist literature these figures go under the imprecise designation 'column figures' or 'statue-columns'. I prefer the more neutral 'jamb figure', which arouses no uncalled-for associations with the antique statue, and does not lead us astray into the mythicizing view that the figures emerge from the columns as though from their primal form. The gothic portal is an artificial and derivative creation which ties motifs of varying provenance into one complicated system. Its emergence can not, therefore, be compared with processes at work in primitive civilizations, which rested on animistic conceptions.

On a few twelfth-century portals the gothic jamb figure presented forms of great severity. At Chartres, despite subsequent deterioration of the figures, it is still very obvious that they were chiselled from long narrow blocks; the figures rest on a conical socle and their feet point downward. The use of projection techniques carried over from painting and relief sculpture can give the modern observer the illusion of figures suspended on the jambs. Even after 1200, when figures have increased in volume and

14

the play of limbs is freer, as on the Chartres transept, at the base there are still the sloping socle and the downturned feet. Change first sets in *c.* 1220: on the north porch of Chartres the socle slab has been fashioned into a proper pedestal, which at Amiens is then given architectural form. The figures of the Coronation of the Virgin portal in Paris are set on a socle of continuous arcading as though raised on a platform, while on the Calixtus portal at Rheims they stand on a socle covered with tendril ornament. Characteristically, the stance and movement of these figures is freer and more relaxed. There is an approach towards the statue forms of antiquity, tentative imitation of *contrapposto* motifs. At Rampillon the figures are set back into niches, thus transforming them into silhouettes. This solution found no imitators, but the combination of notched socle with polygonal or circular jamb niches, devised by Jean de Chelles and Pierre de Montereau for the Paris transept, was widely adopted. It was an arrangement which eliminated the illusion of suspension, yet matched the slender proportions of the gothic figure and the élan of its upward movement. To appreciate this one has only to look at the Virgin on the trumeau of the north transept of Notre Dame in Paris. 110, 111 97 162 152 246, 247 180, 181 267 188

The jamb figures on the Royal Portal at Chartres are surmounted by miniature arcades: arches carry gables, towers sprout at corners. Standing figures framed by arcades or arcading were familiar from painting, mosaic, or relief work, and had been since late antiquity. In a few cases the motif carried a reference to some specific place, town or building, but in romanesque painting and architectural sculpture it had by and large become a formula, used with mechanical repetition to frame individual figures and scenes, or even initials and tendril ornament. This arcading motif survived on the jambs and in the archivolts of gothic portals, but in different form. The arcade supports disappeared and the traditional plain surface was replaced by projecting sculptures. Around the mid-twelfth century the connection with the original form is still clearly recognizable. At Bourges each pair of figures support a single arch and the surmounting miniature architecture rings the shaft of the column like a hoop. Thereafter there were changes, both in the form and in the method of attachment. Examples on the Chartres transept are polygonal and culminate in a central turret, and instead of being attached here or there to the column they are combined with the capital. These miniature buildings are known to art historians as 'baldachins', a description no less misleading than the expression 'column figure'. *Baldachinus* originally meant 'oriental silk fabric', and a woven canopy (baldachin) of this material was borne aloft over a ruler or priest to set him apart from his retinue. By contrast, a chain of sculptured baldachins surmounting jamb and archivolt figures was merely a motif capable of repetition which belonged to the gothic scheme of figure presentation. It has no distinguishing significance. 12, 13, 14 166, 167 38, 39 110, 111

On the jambs of the Royal Portal of Chartres the columns rise from squat, ornamented socles; the motifs of the decoration look remotely reminiscent of antique fluting. On the Chartres transept the socles are left unadorned, modelled only by gradation and profiling. At Rheims they are hung with drapes, as though to perpetuate in stone the temporary coverings placed there for some festival. It is more usual, however, to find the socle decorated with scenes or figures. The earliest example is Senlis, with its frieze of reliefs running beneath the jamb figures. At Sens the socle decoration is richer: on the centre doorway, two rows of figures ranged one above the other; on the side-door to the north, large figures in octofoils, flanked by columns. Paris follows on from Sens. The peak is reached at Amiens, with its double row of quatrefoils running beneath the jamb figures of all three doorways. It is at Amiens, more than in any other great cathedral, that the scheme of the gothic portal is most fully, and most systematically, worked out: jamb figures, enthroned figures in the archivolts, scenes in the tympanum, statuettes on the doorposts, geometrically framed reliefs on the socle, mount up into a 'summa' of representations, graded and ordered through the logic of the arrangement and its conformity to mathematical laws. 8 77; 107 191 42; 59 58 145 161

Portals are most commonly found on the west façade. The west front of Saint-Denis has three, all with figures. Because of its size, the centre doorway dominates those on either side, which are separated from it by boldly projecting buttresses. This marks the beginning of a development whose influence 1

can still be seen in the triple doorway layouts of the thirteenth century. The Royal Portal at Chartres arose from different external circumstances. The three doorways have been compressed into the narrow space between the massive west towers, and welded into a single coherent composition. Triple

Ill. 34
144
68

doorways in the Saint-Denis tradition are found at Mantes, Sens, and Notre Dame in Paris. In Paris aedicules with figures were introduced for the first time on the intervening buttresses, with the result that the three portals were more firmly united in a single composition. The west façade at Laon, before which barrel-vaulted porches now stand, belongs to much the same date. Here aedicules crown the buttresses, and gables with groups of figures rise above the doorway arches, investing the portal with a new stateliness. This was the starting point for the great creations of the thirteenth century. Amiens

161

still has strongly projecting buttresses, terminating in tall pinnacles, between the doorways, and gables above the doorway openings. But doorways and buttresses now form a single composition, in which jamb figures and socle reliefs parade across the façade in unbroken succession. The figure decoration, whether on the portal jambs or on the front and side faces of the buttresses, is of the same type.

190

Only Rheims went further: the relationship between the sloping walls of the doorways and the straight sides of the buttresses has here been modified to make the walls dividing the entrance bays even less obtrusive. The jamb capitals have been gathered into a frieze, and wind like a ceremonial wreath across the façade. Individual baldachins above the statues have now merged to form a chain of gables. The walls of the triple portal form, as it were, a single stage for the display of figures. The archivolts of side and centre doorways meet, covering the front faces of the buttresses with figures and leafy garlands. Crowning the façade are five gables, stepped up to a peak above the centre doorway. At Rheims the gothic triple portal is seen in its final and most developed form. The façades dating from this period or

296; 292

earlier in central France – Poitiers and Bourges having no fewer than five doorways – modelled themselves on prototypes in the royal domain.

On the romanesque churches of western France sculptural ornament was not confined to the portals but spread over the entire west front. For this there was a long tradition in mural painting and mosaic. Some idea of the appearance presented by a fully ornamented façade can be gained from San Frediano in Lucca, and one could cite further extant examples from Italy and the East. In Gothic it is more usual to find the iconographic programme restricted to the zone around the doorways. But there are notable

68
144

exceptions: at Laon the window soffits of the rose window storey are decorated with figures, and in Paris a gallery with figures, stretching right across the façade, is interposed between the portals and the rose window. The influence of the Spanish *apostolado* has been suggested, but it is more likely that the idea was arrived at independently. For further examples of figures placed on the upper storey of a façade we can go to thirteenth-century Burgundy. At Vézelay the figure decoration of the portals of the Madeleine had been completed before the middle of the twelfth century, which explains why the

Ill. 106
Ill. 34; 190

elaborate gothic programme of statues had to be placed on the gables of the west front. Finally, it is known that the façades of Sens and Rheims, severely damaged in the eighteenth and twentieth centuries, were once decorated with scenes and figures on every storey. Here the tradition of the fully ornamented west front lived on, though in altered form.

As a rule it is only great cathedral churches which possess three, or even five, entrances on their west façade. To find this layout in an abbey church like Saint-Denis or a collegiate church like Notre

42

Dame in Mantes is exceptional. A small cathedral, for example Senlis, might content itself with a single figure-decorated portal, and the same is true of most monastic churches. The three figure-decorated

Ill. 65
Ill. 43; 45; 53
141

doorways of Notre Dame in Dijon are exceptional, since it is rare to find thirteenth-century parish churches with even one such portal, though Germigny-l'Exempt, Saint-Pierre in Nevers, Saint-Nicolas in Amiens, and Lemoncourt could be cited as examples. It would be wrong to suppose that the great figure-decorated portals were always on the west side. Topographical considerations, or some circumstance in the building's architectural history, might dictate a different solution. At Chartres, for example,

76, 106

the main entrances to the new cathedral built in the thirteenth century were placed in the transepts

16

rather than at the west end. At Le Mans the main entrance to the cathedral was a single doorway on 16 the south side, and similarly at Etampes, determined by one of the main axes of the medieval town. In 31 some cases figure-decorated portals were erected at nave and transept entrances because completion of the main entrance front was not expected for several decades. This may account for the side entrances at Bourges, and for the doorways in the north transept at Rheims. Carvings are also sometimes found 34, 37; 236, 244 on the lesser doorways which in a monastic church led to the cloister, and in a cathedral to the bishop's palace. The cloister doorway of Saint-Denis had a rich programme of figures, in the transept of Notre 183 Dame in Paris the north doorway, giving access to the chapter-house, is devoted to the Virgin, and the 186–188 south doorway, leading to the bishop's palace, shows scenes from the life of St Stephen. The transept of Strasbourg cathedral presents an unusual variant of the gothic figure-decorated portal, a double 130, ill. 64 doorway reflecting the internal division of the transept into two aisles. The same type was used a century earlier in large pilgrimage churches – Saint-Sernin in Toulouse, Santiago de Compostela – which had galleries running all the way round the transept.

Our knowledge of the functions assigned to the portals is still in its infancy. The urge to create an imposing entrance façade does not in every case account for the lavishness of the layout. We can probably assume that portals also had a liturgical role, in processions and blessings, and that they were used for transactions under canon law. Spacious porches, of the kind added to the portals of the Chartres 76, 106 transept, are obvious cases in point. Positive answers to these important questions will emerge, if at all, from a study of the liturgical orders in use at the time.

SCULPTURES ON THE EXTERIOR

Since Christian rites are celebrated mainly in the interior of the church, exterior decoration is placed chiefly at the doorways, its function being to address, instruct and admonish the worshipper before he crosses the threshold. Apart from this, the exterior of a great gothic cathedral is almost completely bare of imagery. Bourges, to name a striking example, has not a single figure to relieve the monotonous divisions of its vast exterior. The sculptures cluster at the doorways, proclaiming the means of grace dispensed within the church or the saints whose relics it enshrines.

This is not always the case, however. The second half of the twelfth century saw a decisive alteration in the exterior construction of the basilica, brought about by the invention of the flying buttress. Support walls springing from the side aisles carry on upward like towers, often to the height of the nave dripline, to receive the bridges of the open flying buttresses. The functional form required formal treatment, which in turn invited decoration, with the result that the tower buttresses came to be occupied by figures. At Chartres, where the buttresses are unusually massive, high-relief figures in niches had to suffice. At Rheims the buttresses culminate in open-sided aedicules capped by tall 250, 254, 255 octagonal helms. Inside the aedicules stand large figures of angels – over life-size – poised on narrow pedestals, their wings outstretched like those of a heraldic eagle: an angelic host ringing choir and nave, in fact the entire cathedral. Aedicules with huge figures also crown the buttresses of the transept façades. Rheims cathedral, where the kings of France were crowned, exceeds all others in the lavish 258, 262, 264 adornment of its buttress work with statuary. On other cathedral buildings buttress figures are few and far between. We know that one such group, now in the Musée de Cluny, Paris, originally stood on the choir of Notre Dame.

Ill. 90

In ancient buildings statues might deputize at certain points for architectual members, and so symbolize principles inherent in the construction. In the gothic cathedral, with its more complicated structure and statics, this substitution was not possible. This is not to say that the multipartite exterior

did not sometimes accommodate such figures – figures merely incorporated into the play of architectural forces, with no thought of a specific content and no intention to instruct, edify or admonish. The figure of Atlas, adapted from classical mythology, was used and interpreted in various ways throughout the Middle Ages and was not neglected by gothic sculptors. Atlantes appear as column supports of the west façade of Sens and on the statue gallery at Mailly-le-Château. At Laon small support figures crouch beneath the drip cornice of the nave roofs. The device is repeated, in much magnified form, at Rheims, where glum looking figures in the dress of the period stoop between roof and buttresses. The motif of the large head-shaped corbel to receive the window arches of the upper clerestory at Rheims was another device previously used at Laon, but filled here with a new vigour. On the Rheims exterior the sculptor's art has taken more intense possession than on any other gothic cathedral. The impression that we are close to antiquity arises not only from the style of the sculptures but also from their great number, which here brings the exterior of the building to life.

Ill. 68

254, 256

257, *ill. 99*

FIGURES IN THE INTERIOR

In the interior of gothic churches of the twelfth and thirteenth centuries the combination of sculpture in the form of figures with the architectural structure is extremely rare. Gothic did not favour the figure-decorated capitals familiar in romanesque churches. The capital of the gothic pier or shaft is decorated with foliage, either naturalistic or in the late antique style; figures, if present at all, take the form of drolleries, a play on those hybrid beings whose remote ancestry can be traced back to ancient mythology. Figures or cycles actually incorporated into the structure remain an exception, and in each case call for special explanation.

136
For example, the Last Judgment pillar inside the south transept of Strasbourg must be considered in the light of a unique situation in the history of the cathedral's construction: the arrival of a gothic
130
workshop at a time when the division of the transept façade by means of a modest double doorway was already an accomplished fact. The only place still available for an extensive programme of figures was the interior; hence the decision to encircle the central pillar of the south transept, then on the point of erection, with figures in three zones. The other great gothic cathedrals have nothing comparable. a freestanding figure-decorated pillar inside Chartres, Amiens or Rheims is quite inconceivable. There may have been other reasons, connected with the liturgical use of the transept, for the erection of the Strasbourg pillar, but if so we know nothing of them.

229–235
The desire for an extension of the figure cycles may again have contributed to the unusual decision to decorate the west wall of the nave of Rheims with large niches containing figures. The programme links up with the portals on the outer front. The draped socle motif, for example, follows on directly from the socle arrangement of the doorways. Admittedly, in planning this niched wall other considerations may also have played their part, for example the desire to enliven the vast blank spaces at the west end of the nave; this desire was not uncommon around the middle of the thirteenth century, but elsewhere led merely to the decoration of the west wall with blind tracery.

Statuary on choir and nave pillars, a familiar sight in churches of the fourteenth and fifteenth centuries, was virtually unknown in the great gothic cathedrals of northern France. In the Sainte-Chapelle
184, 185
in Paris, repository of the precious relic of the Crown of Thorns, figures of Apostles are stationed on either side of the single-aisled interior. The presence of the cycle may be explained by the chapel's particular purpose, and the row of statues may relate to the relics of the Passion. The closest French
310
parallel appears to be Saint-Nazaire in Carcassonne, where the sequence on the choir pillars is often thought to derive from the Sainte-Chapelle.

18

In the French Gothic of the twelfth and thirteenth centuries, the sculptures which decorate the interior of Angevin churches have a place apart. Western France is not rich in figure-decorated gothic portals. What is noteworthy in the twelfth-century churches of the region is the early appearance of statue sequences on the choir walls, and of narrative cycles on the decorative keystone bosses of the *Ill. 30–32* multipartite rib vaulting. In churches on Gothic's home territory, we again find bosses among the few parts of the interior to receive figure decoration. Admittedly, in some cases the bosses have merely been shaped into rings or decorated with foliage, and the figurative pieces are mostly mediocre in quality, the work of masons rather than sculptors. There are exceptions, however, notably the personification of a River of Paradise in the vault of the chevet chapel at Vézelay, whose outstanding beauty *Ill. 46* was perceived by Viollet-le-Duc.

Sculptors and carvers made a major contribution to the furnishing of a twelfth- and thirteenth-century church, of the choir in particular. Few pieces survive from this once rich store, the remainder having been swept away by changes in liturgical practice, not least those prescribed by the Council of Trent, and by the desecration of churches at the time of the Revolution. Nowadays the best idea of a thirteenth-century choir with its original sculptural decoration is conveyed by Protestant churches of northern and eastern Germany and Scandinavia, which these ravages did not touch. Thus the only thirteenth-century jubé comparable with those of the great French cathedrals and still *in situ* is to be found at Naumburg. All the French jubés were dismantled in the seventeenth and eighteenth centuries. Sketches of the jubés at Chartres and Strasbourg show how reliefs or figures were disposed on the side *Ill. 59; 104* meant for display. As artistic achievements, the fragments still preserved at Chartres and Bourges rank *126, 127; 294* with the sculpture of the portals. The scenes unfold with greater breadth and freedom, there is less compulsion to conform to a given architectural framework. Triumphal crosses dating from the thirteenth century can still be seen at Halberstadt, Wechselburg or Freiberg, but in no French cathedral. The Crucifixion group (not a stylistic unity) from Cérisiers, which later made its way to Sens, is a second- *63, ill. 38, 39* rate work which cannot be said to compete. A few thirteenth-century choir stalls have survived, but none which in richness of figure decoration can compare, for example, with the fourteenth-century stalls at Cologne cathedral. The choir furnishing might include altar curtains. These were attached to freestanding columns sometimes surmounted by angels (possibly the wooden angels of French workmanship found in several museums and smaller churches had such an origin). The exceptional quality of the two pieces in the church at Humbert reinforces the testimony of the jubé slabs from Chartres and *276* Bourges: the carving on such church furnishings could reach the highest standard, and in fineness of execution might at times surpass that of the portals. Our view of French gothic sculpture is distorted by the fact that only the architectural sculpture survives in any quantity.

So far as we can tell, the altar retables of the twelfth and thirteenth centuries were simply rectangular blocks of stone, possibly with a slight elevation at the centre. The decoration took the form of juxtaposed scenes or single figures. We cannot be sure, however, that the relief depicting the apostles, discovered in Saint-Denis in 1947, is correctly identified as a retable, and the same doubt hovers over the relief from Carrières-Saint-Denis, despite its inclusion in every standard work on the history of the altar published *20* over the last hundred years. On the other hand, the relief from the Sainte-Chapelle at Saint-Germer is *281* quite certainly a retable, and shows what distinction could be achieved, in the heyday of gothic sculpture, by fineness of execution applied to a very simple form. Altars depicted on the tympana of the north transept of Notre Dame in Paris and the Honoratus portal at Amiens show figurines standing on the *186; 279* *mensa*. There must once have been a large number of such statuettes, but virtually no French examples from the twelfth and thirteenth centuries are known. Two possible survivors of such a type are the Virgin enthroned from Saint-Martin-des-Champs, which is unusually large, and the attractive standing *19* Virgin and Child, carved in wood, from Abbeville. *275*

Today one is often struck by the chilling emptiness of a great gothic cathedral interior. From the Romantics onwards, these spacious churches, pervaded by light from their huge windows, have been

the inspiration for a great spate of scholarly and pseudo-scholarly literature. The fact is that with the removal of the furnishings we no longer recognize the great variety of functions and uses which these churches originally had to serve, and today without the furnishings our idea of gothic sculpture is inevitably the poorer.

CLOISTER SCULPTURES

In northern Spain, southern France and southern Italy cloisters with pillar reliefs and figure-decorated capitals survive from the romanesque period. In northern France most of the medieval cloisters were destroyed by the remodelling of chapter or conventual buildings in the seventeenth and eighteenth centuries. In the light of fragments discovered over the past few years we have at length come to recognize that gothic cloisters, in the twelfth century at least, were as rich in figure decoration as their romanesque predecessors.

Ill. 4 In 1729 Montfaucon illustrated three statues which then stood in the cloister of Saint-Denis. As with the gothic portal figures, statue and column shaft were chiselled from the same block and then installed in the cloister arcades. Gothic cloister figures of this type can still be seen *in situ* at Saint-Georges-de-Boscherville in Normandy and at Aix-en-Provence. Since they are considerably smaller than jamb figures, for the most part only about 90 cm high, one can presume a similar origin for the much smaller

51; ill. 29 than life-size figures preserved in the museums at Saint-Maur-des-Fossés and Sens. The researches of Léon Pressouyre have shown that the cloister of Notre-Dame-en-Vaux at Châlons-sur-Marne once

52, 53 possessed about fifty such figures, and a number of figure-decorated capitals. As this extensive cycle proves, the renovation of conventual and chapter buildings in the post-medieval period obliterated the evidence for gothic sculptural activity in a distinct and important field. With the cloister sculptures before us, our view of gothic sculpture becomes wider and more varied. The figure-decorated capital, which Gothic banished from the church interior, apparently held its own in the cloister. Examination of

53, 54 the fragments from Châlons-sur-Marne gives the impression that in cloister arcades the layout of the figures could at times be freer and more narrative than was possible in the case of the more severe statues of the portal. Influenced by what chance has preserved for our inspection, it may be that our picture of the style of the epoch is deceptively one-sided and too uniform. The form which appears to be an underlying principle was perhaps only a mode adopted for a specific purpose, that of portal sculpture. As the twelfth century gave way to the thirteenth, figure decoration in cloisters seems to have become more sparing and less common. In cloisters which survive from the thirteenth century there is often no figure sculpture at all. Large tracery windows came to replace the cloister arcading and these offered little scope for statuary or figure-decorated capitals.

65, ill. 41 From the cloister of Saint-Denis we still have a basin of its fountain. As a rule medieval fountain basins carry no figure decoration, but here the exterior of the shallow bowl is decorated with twenty-eight heads in relief. We cannot fail to be struck by their resemblance to antique models, and by the great subtlety of their execution. This item, unique in our repertory of surviving monuments, is further evidence of the wide range of tasks sculptors of the twelfth and thirteenth centuries were expected to undertake, in and about the cathedrals and in monasteries. The most challenging problems were undoubtedly posed by architectural sculpture, which is the sculpture most clearly imprinted with customary gothic forms. However, the sculpture applied to objects unconnected with the actual fabric is by no means negligible. In works of this category the presentation is at times less inhibited, the form more relaxed.

20

SEPULCHRAL AND OTHER COMMEMORATIVE MONUMENTS

The tomb figure occupies a central position in the history of gothic sculpture in the twelfth and thirteenth centuries. The advent of the gothic portal statue, and its subsequent transformation, is reflected in the changing appearance of sepulchral monuments. Developments arising from the gothic tomb figure led ultimately to the modern portrait.

Tombstones bearing an effigy of the deceased appear here and there in western Europe from the late eleventh century. In the twelfth and thirteenth centuries it became the practice to restore old burial places and provide them with retrospective effigies of the dead. By this means monasteries commemorated founders who had died centuries before and reigning dynasties converted their burial places into galleries of ancestral statues. By the thirteenth century important personages, prelates and members of the higher aristocracy were commemorated by tomb effigies as a matter of course. The less costly incised stones, of which there are examples from *c.* 1225 onward, attracted a still wider circle of patrons. These grave slabs were not invariably the work of sculptors or stonemasons. Some, even in twelfth-century France, were executed in mosaic: for example the tomb slab of Queen Fredegunde at Saint-Denis, and the sepulchral monument of Bishop Frumaud, now in the museum at Arras. Important persons might employ goldsmiths: two of the plates made in the Limoges workshops for the French royal family (mid-thirteenth century) have survived, and are still at Saint-Denis. Again, the plate might be cast in bronze, as was the case with the tomb monument for Bishop Evrard de Fouilloy in Amiens 174, *ill. 88* cathedral, which is a work of outstanding merit. As a rule, however, the slabs were of stone and the effigies were carved by sculptors, presumably by the same sculptors and in the same workshops as those engaged on the portals. That this was indeed so is borne out by study of fragments from Notre Dame de Josaphat, an abbey on the outskirts of Chartres; one, the head from the tomb monument of a bishop of Chartres (perhaps Renaud de Mouçon, who died in 1217), so closely resembles the jamb 120–122 figures of the cathedral's Confessors' portal that one feels convinced the same artists were at work. Again, the tombstone showing the figure of a young man bears a strong resemblance to the tympanum *Ill. 63*; 118, 119 and archivolts of the same portal. These resemblances confirm the evidence of the sources for later periods, to the effect that work on architectural sculptures and tomb monuments were not treated as separate tasks but were entrusted to the same atelier.

The deceased is rarely, almost never, shown as a corpse. Faithful portraits in the modern sense, as on the French royal tombs of the later fourteenth century, were not yet the aim. We are dealing principally with idealized figures: the dead man is shown in the prime of life, unblemished by age or physical 273 decay. The desire was not so much to commemorate in monumental form the achievement of a life on earth but to give hope of the life to come, and it was this which determined the tomb's programme and appearance. That is why the tomb of Adelais of Champagne takes as its subject the parable from the 295 legend of Barlaam and Josaphat in which human life, deceptively sweet, is compared with a honey-giving tree whose roots are gnawed by mice and dragons. In most cases the deceased is shown in an 159; 272; attitude of prayer. Often there are attendant angels, who arrange the pillow beneath his head or swing 295; *ill. 63* censers towards him. Angels may even be seen bearing his soul heavenwards in a shroud. 174

In the most common form of gothic sepulchral monument the slab bearing the dead man's effigy rests on a rectangular sarcophagus. Placed in the choir or transept, this *tumba* was visible from all sides, as at least is the case today with the royal tombs in Saint-Denis. Alternatively, the *tumba* might be surmounted by an open baldachin, as in the monuments for Philip and Louis of France (brother and son of 159, *ill. 82*; 273 St Louis) at Royaumont. In the type known as 'enfeu' the *tumba* was set back into a niche, which in the tomb of Ogier the Dane in Saint-Faron (Meaux) was arranged like a full-blown gothic portal, with *Ill. 16* archivolt figures in the arches and statues along the walls and entrance. Tombs often included figures

relating to the funeral procession or to the office for the dead. Figures with this function are still visible in the fragments from the tomb of an archbishop of Rheims which were used in the thirteenth century to make the Virgin's portal on the north transept of the cathedral, and the praying clerics stationed at *Ill. 33* either end of the sarcophagus of Abbot Arnoult in the abbey of Saint-Père at Chartres also fall into this category. The gothic funerary monument, through its representation of the deceased in an attitude of prayer, and through the presence of the other figures about the sarcophagus, was intended to bear witness down the years that the church in which it stood continued to offer prayers for the dead man's soul and to recite the Mass for the Dead on his anniversary days. Count Thibaut V of Champagne left orders for his body to be buried in Provins in the Franciscan church, but bequeathed his heart to the *Ill. 102; 274* Dominicans, who preserved it in a monument resembling a six-sided tower reliquary: in modern times it would have been placed in an urn. The monks seated against the walls of the monument assume attitudes of mourning, but they are also equipped with breviaries to read the prayers for the dead. By this means the deceased was present in both houses, the Franciscan and the Dominican, and in both prayers were offered for his soul. There was nothing new about such practices, which can be traced back to much earlier periods, but it was gothic sculpture which first gave visible expression to them on funerary monuments.

142, ill. 71 The tombs of the Plantagenets in the abbey church of Fontrevault should be interpreted in very much the same way, as monumental expressions of burial ceremonies. The figures do not repose on sarcophagi, nor are the hands folded in prayer. What is here represented is rather the lying-in-state, as is indicated by the stiffened limbs and lifeless gaze of the figures stretched out on ceremonial biers. If we are right in assuming that auxiliary figures, like those found elsewhere, were placed around the 'biers', the Plantagenet tombs were indeed monuments symbolic of the office for the dead.

These were not the only types of monument by which the memory of founders and other important persons was kept alive in the place of their burial. About 1140/50 seated statues of two French kings, *Ill. 15; 28* Louis d'Outremer and Lothaire, were set up in the choir of the abbey church of Saint-Rémi, which had been their burial place in the tenth century. Here there are no auxiliary figures symbolizing the office for the dead, no gestures in supplication for the souls of the dead; in type these statues are much closer to secular portrayals of rulers.

In the crypt of Saint-Médard in Soissons, statues were set into the walls close by the effigied tomb-*Ill. 80, 81* stones of Chlotar I and Sigebert I. At Saint-Denis, if we can believe antiquarian accounts dating from the seventeenth and eighteenth centuries, there were two such statues in memory of the abbey's royal *Ill. 5* founder: a statue of Dagobert enthroned with lions beneath, dating from the time of Abbot Suger, which in the eighteenth century stood in the west end of the church; and another, made over a century later, which stood in the cloister, again showing Dagobert with lions, holding the sceptre in his right hand and the orb in his left and flanked by attendants.

The figures of the Carolingian kings in Saint-Rémi (Rheims) and the statues of the two rulers in Saint-Médard (Soissons) are perhaps best described as cenotaphs to commemorate men whose bodies were buried close by. By contrast, the Dagobert statues at Saint-Denis had no known connection with their subject's place of burial and evinced no concern for the welfare of his soul. They were founder's memorials, erected to perpetuate the memory of a royal foundation; and as such these figures come close to the secular monument whose object, unlike that of the gothic tomb figure, which points forward to the life to come, was to laud fame and distinction achieved on earth. Yet in saying this we are perhaps going too far. In comparison with Greek and Roman antiquity or the early modern period, the tasks demanded of gothic sculpture in the thirteenth century can be seen to be circumscribed, not merely in 55 practice but in principle. Incursions into the secular field were restricted to the unpretentious decoration of secular buildings – one thinks of the decorated windows of certain twelfth- and thirteenth-century buildings. The monumental statue and portrait bust were completely unknown. In French gothic sculpture of the twelfth and thirteenth centuries there was no place for works designed to perpetuate the

22

fame of mortal men. The reasons for this particular limitation are complex. It is not as though cultivation of secular fame was repugnant to men of the Middle Ages – their biographical literature alone is enough to prove the contrary. More important, surely, is the attitude Christendom had inherited from St Paul and the early fathers, who associated statues – idols – with the worship of pagan deities. In gothic cathedrals of the thirteenth century, a man kneeling before an idol was still the figure chosen to represent 125 false belief.

This outlook had immense significance in determining the character and development of medieval sculpture. It also has to be borne in mind if the gothic portal figure is to be placed in its proper historical context. The medieval period experienced no revival of monumental sculpture as practised in the antique world, nor could it have done, for the reasons just advanced. Not only is the gothic portal figure different in form from the freestanding antique statue, it is not even its spiritualized counterpart, bearing as it does a quite different relation to reality. The gothic figure was not prayed to or venerated, it was not a cult object; it was never anything but a representation of a character from the Bible: *imago*, not *statua*. That was why it remained fixed halfway between free figure and high relief; even the thirteenth century, with its borrowings from nature and the antique, brought no release from this limitation.

THE SCULPTORS AND THEIR METHODS

The sculptures for gothic cathedrals were made in the masons' yards; they did not, like late gothic German altars for example, issue from established urban workshops which had entered into a fixed contract with the patron. Nor was it customary in the twelfth and thirteenth century for sculptors working in the northern French yards to sign their work. The documents record at most the name of the Magister operis, who had financial or technical responsibility for the building as a whole. In romanesque southern France and Burgundy things were different. There we find architectural sculptures signed by their authors: at Autun we read on the tympanum 'Gislebertus hoc fecit', and on a statue in the chapter house at Toulouse, 'vir non incertus me celavit Gilabertus'.

In Italy sculptures were still signed by the artist even in the thirteenth century. But in the rigidly organized masons' yards of the gothic cathedrals responsibility obviously devolved on the Magister operis, who for that reason is mentioned by name in the documents. The sculptors were only anonymous assistants, the difference between jamb figure, capital, and simple ashlar being merely one of degree. In consequence, not a single sculptor who worked in French Gothic is known to us by name. We have no contracts, inscriptions or signatures to provide clues to the 'masters'. If this situation creates complications for the researcher, it also offers him temptations. A gap in the historical records leaves the field clear for discoveries of 'masters' and grouping of works into an 'œuvre', without the corroboration of contemporary sources. Efforts in this direction have made our picture of French sculpture in the thirteenth century richer and more colourful, but no general agreement is to be expected.

In the building of a gothic cathedral the separate pieces of stone were prepared in the masons' yard; all that had to be done on site was to fit the pieces into the required positions. Tally marks, as found for example on the archivolts of the west portal of Rheims, make the procedure clear. Before it left the work bench in the yard, each ready-worked stone destined for the archivolts was given two marks: a symbol showing to which side of which doorway it belonged, and strokes indicating its exact place within the arch. At a craft level, the procedure was similar to that used for modern prefabricated buildings.

A window of Chartres cathedral depicts thirteenth-century sculptors at work: the window has two fields, each with a pair of sculptors at work on the same figure of a king, whose progress we follow from a roughed-out to a more advanced state. The block rests on a kind of workbench, and so can be worked from above and from the sides, but not, as with a freestanding statue, in the round. The relief-like construction of this gothic jamb or aedicule figure is shown in considerable detail. On the right, the man holding the mallet in his upraised hand is about to apply it to the chisel, poised in readiness. The figure has been sketched on the block in its rough outlines, but the details have yet to be worked. Unworked stone is still visible around the head and shoulders, where the pillar-shaped block projects beyond the outline of the figure. By contrast, the flanks of the figure exactly fit the outer edges of the block, and these edges, be it noted, fix the angle of the arms, the twist given to the points of the feet, and the fall of the mantle. In the compartment on the left the figure has progressed to the point where details of crown, sceptre and face are recognizable. The sculptor is now working with the pointed iron, making the folds of the mantle deeper and more precise.

24

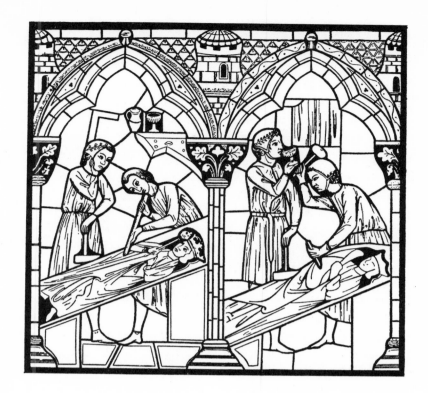

Chartres cathedral. Window in the ambulatory,
showing thirteenth-century stonemasons at work

The gothic figure, whether on the jamb, in the archivolts or in the aedicules, is always derived from 10; 171; 15;
the rectangular block. A consequence of this method of working is the angularity or constriction of the 165; 264
movements, the harsh and frequently non-organic contradiction between front and side views, which
presents such a striking contrast with antiquity. The addition of extra pieces to allow for more ex-
pansive movement, as in the Visitation group at Rheims, was a very rare occurrence. 199, 202, 203

It is interesting in the Chartres window that both scenes show two sculptors to a single block and that
both hold tools, though only one is actually at work: setting more than one sculptor to work on the same
figure was presumably quite a common practice in the gothic masons' yard. We must even be prepared
for positive specialization, the execution of particular motifs – borders, book covers, hair and suchlike –
by sculptors specifically trained for the task, who would work up a whole batch of figures at a time. The
monotony of some of the large figure cycles, for example the cycles on the central doorways of the south
portal at Chartres and of the west portal at Amiens, could be connected with this method of working. 110, 111; 162
Here it was certainly imperative to make a large number of very similar figures in the shortest possible
time, and the changes of form roughly between 1200 and 1230 also suggest a drive to simplify and
shorten the working schedule. The archivolt figures at Laon, with their finely linear folds in the antique 70, 71
style, suppose much greater care in their execution than for example the archivolts at Amiens, where the 164, 165
blocks have obviously been worked in relative haste and with scant attention to detail. Since the
sources are silent, the prevalence of divided working in the masons' yards must remain a matter for
conjecture, and it is hard to imagine that figures like the Strasbourg Ecclesia or the Rheims Joseph were 132; 192
created by more than one hand. But the attempt to distinguish masters and 'hands' in these gothic figure
cycles must at least take the possibility of 'production line' methods into account. Until the twelfth
century, in a few documented cases, the sculptors were clerics. By contrast, those who worked in the
gothic masons' yards were apparently laymen, presumably with nothing more behind them than a craft
training as stonemasons, though in view of the many figure cycles which are highly complex in content –
the archivolts of the Solomon portal at Chartres, for example, or the quatrefoils beneath the prophets at 88, 89; 173
Amiens – one wonders whether some sculptors may not have had some theological knowledge as well.

The noticeable traffic in forms between the great centres of gothic sculpture – between Laon and Chartres, Chartres and Rheims, Paris and Amiens – is presumably to be explained by the migratory character of the work force: when their work in one yard was finished, the sculptors hired themselves out to the next. When figure types and narrative cycles were handed on, there must have been sketches to act as a guide, but these should not be confused with the later cartoon, the preliminary sketch of an artist's *concetto*. There were no cartoons behind the sculpture of the thirteenth-century masons' yards, just as there were no models or *bozzetti*, all of which presuppose the free exercise of artistic talent, as it was known in the Renaissance but not in the Middle Ages. The sculptors' pattern book was more like a manual, a compendium containing figure types, formulas for movement, and cycles (schemes for illustrating biblical texts, lives of saints, legends). The manual was not meant for preservation; it acted merely as a working guide, and in consequence very few pattern books have survived. Two examples from the early thirteenth century may be mentioned, the book from the abbey of Reun, now in the Nationalbibliothek, Vienna, containing sketches of beasts, foliage and ornament, and the so-called Wolfenbüttel pattern book, with sketches of scenes, groups, and figures; neither, however, has any primary connection with the gothic masons' yard. No complete pattern book has come down to us from the twelfth- and thirteenth-century gothic cathedrals. The fragmentary manuscript of Villard de Honnecourt in the Bibliothèque Nationale is too heterogeneous in content, and contains too much that is curious and discursive, to have served as a pattern book for working craftsmen. Some of its sheets, however, may resemble the sketches of figures and scenes which the sculptors had to work from. The drawings have been done with a pen, in a way that leaves the calligraphy noticeably regular and un-emphatic. Figures are often shown in unusual positions or from unusual aspects, but this again may be due to the author's penchant for the curious and the unfamiliar. Thus our questions about the models used in gothic portal sculpture are not really capable of an answer. For most of the scenes illustrated on gothic portals there was a long-established tradition in painting, but they were new to sculpture. Precisely how, and with what practical aids, these traditional types and cycles were made available to sculptors in their workshops is still not clear.

While Hebbel was in Paris in 1843 he wrote: 'Notre Dame de Paris. A truly medieval building, black, gloomy, eccentric, very much like a crow which, having arrived late, stares with vacant eyes on the spring blossom all around.' The verdict is no doubt coloured by post-Romantic aversion to the senti-mental view of the Middle Ages, but its justice will be admitted by anyone who knew the cathedral's façade before its recent cleaning. Walls and buttresses were encrusted with black, right up to the towers. The façade of Amiens still gives a very sombre impression, its statues and reliefs smothered with soot and grime. No one already familiar with the sculptures of gothic cathedrals from illustrations can escape a feeling of disappointment on first meeting the originals. What has to be remembered, however, is that portal and jubé sculptures were originally coloured. On close examination many traces of this painting can still be seen, as for example in the archivolts of the west portal at Senlis, where in places the drapery retains its full colouring. At Notre Dame in Paris the groundwork at the apex of the Last Judgment tympanum was gilded, and (with the aid of scaffolding) a close inspection reveals evidence of extensive gilding on the Judge of the Angels' Pillar at Strasbourg. Cleaning of the Rheims west portals has brought out brightly coloured patterns on the garments. Still further examples could be cited, though as yet no systematic list has been made. In any case, since traces are still so few and the possibility of restoration at a later date so great, this is not the place for a general characterization of this vanished colouring and its role in gothic portal sculpture. It is only mentioned here as a reminder that the painted carvings must have been more telling and more lifelike in their original appearance. The same loss has been suffered by sculptures of Greek antiquity, but unpainted marble retains a greater surface charm, a more sensuous appeal, than is the case with limestone, in which the gothic sculptors chiefly worked. What is more, the handling of forms in the gothic jamb figures relied more heavily on painting; without it, gothic sculpture at times gives a bald impression, such as one never receives from antique statues.

SUBJECT MATTER

A survey of the most important themes of gothic sculpture may proceed in one of two ways. The first method, which is to classify individual themes systematically and then deal with them in turn, is the one adopted in the most important work to date on the iconography of gothic cathedrals, Emile Mâle's *L'Art religieux du XIIIe siècle en France*. Mâle classifies the themes under headings derived from the *Speculum Majus* of Vincent de Beauvais, and discusses each individual theme within its appropriate group. This arrangement makes for clarity but has the drawback that it breaks the programmatic connections which integrate the various themes when they appear on the portals. Portal programmes were not constructed along the same lines as a scholarly encyclopaedia. A single iconographic motif changes its meaning according to the context. Thus, a Virtues' cycle in the context of the Last Judgment exhorts the churchgoer to virtuous conduct; in conjunction with the Virgin enthroned it directs his thoughts to the Mother of God, vessel of all the virtues. The second course is to start with the leading programmatic ideas rather than the individual themes, a plan which keeps closer to the monuments themselves. Over the past few decades there have been efforts in many fields to steer iconographical research away from individual themes towards programmatic connections. The pioneering work on twelfth- and thirteenth-century church portals has been done by Adolf Katzenellenbogen.

For a brief survey of the kind undertaken here the obvious course is to adopt a compromise. A few leading themes from the large overall programmes will be singled out for systematic treatment; mention will also be made of the subsidiary scenes and individual motifs sometimes found in conjunction with these leading themes, but only insofar as they relate to the programmes.

APOCALYPSE AND LAST JUDGMENT

On the figure-decorated portal of the early twelfth century the most important theme referred to the end of the world and the Last Judgment. The scenes most commonly chosen to represent this set of themes on romanesque tympana were: (i) the figure of Christ in Majesty with the four beasts and the four and twenty elders from chapter 4 of the Book of Revelation; (ii) the Last Judgment, following Matthew, chapters 24 and 25; (iii) the Ascension, following Acts 1:11 – 'This same Jesus, which is taken up from you into Heaven, shall so come in like manner as ye have seen him go into Heaven.'

From *c.* 1140 this set of themes was adopted for churches in northern France, but with a change of emphasis. The Ascension linked with announcement of Christ's second coming occurs on only two portals, and by 1160, if not earlier, had been abandoned. On the Chartres west portal the Ascension takes its place within a wider programmatic context: displayed on the left doorway, it prepares the way for the main scene in the centre. At Etampes, by contrast, the Ascension portal is the only entrance. Here again the connection with Christ's second coming at the end of the world is made particularly clear. On the tympanum the Saviour is shown ascending, with Mary and the Apostles at his feet.

7

5; 31

Ranged around him in the archivolt are the four and twenty Elders from the Book of Revelation, figures commonly used to denote the second coming. This portal remains, however, an isolated case. At Etampes the influence of the Burgundian sculpture of the twelfth century determined more than just the programme. In later gothic portals the allusion to the last days never features in the treatment of the Ascension.

With the Majestas, the first of the themes mentioned above, the situation is different. The Majestas was first placed above the entrance to a church at Cluny, shortly after 1100. The influence of the Burgundian abbey was so great that in the early decades of the twelfth century the Majestas spread far and wide, ultimately reaching northern France where, on gothic portals constructed between 1140 and 1170, it occurs as the leading theme. The earliest example, artistically never surpassed, is displayed above the centre doorway of the Royal Portal at Chartres: on the tympanum the enthroned Christ, in a clearly defined mandorla, and the four beasts symbolizing the four Evangelists; in the archivolts, angels and the four and twenty elders. On many romanesque churches the representation of the apocalyptic vision was more powerful and more awesome. But at Chartres the relationship between the figures is clarified, thanks to the systematic division of the field, and though the forceful forms are energetically activated, every turn and gesture is restrained and controlled.

The motifs of the Chartres composition are found on many other portals dating from the third quarter of the twelfth century. At Angers and Bourges the Majestas tympanum, like the corresponding tympanum at Chartres, has a border of Elders of the Apocalypse. At Le Mans, and at Saint-Loup-de-Naud, the Majestas is combined with other cycles, portraying scenes from the life of Christ or legends of the saints. As we see, the construction of programmes did not always follow a logical sequence as to content. Local requirements, and the wish to assemble several sequences on the one available entrance, could lead to the juxtaposition of unconnected themes. It is a different matter when the Majestas is joined by images of Judgment, which reinforce the allusion to the second coming: for example, the angels with souls at Ivry-la-Bataille, and the scenes of Heaven and Hell in the archivolt of Saint-Ayoul at Provins. Likewise Ecclesia and Synagogue, as seen to the left and right of the enthroned figure at Saint-Bénigne, Dijon, and Saint-Pierre, Nevers, hint at election and rejection.

After 1170 the Majestas virtually disappears from gothic portals. It belongs to the first phase of medieval portal sculpture, and was a theme common to both Burgundian Romanesque and the early Gothic of the royal domain. Its disappearance may have been due to a number of factors. From c. 1170 the new themes associated with the Virgin were making their way into the centre of the programme, and Gothic was showing a preference for a scenic, more narrative style of representation as opposed to the old hieratical style of composition. An enthroned Christ makes a further appearance around 1200 on two portals in the Loire valley, but this time surrounded by the four Evangelists, writing their Gospels. The theme is familiar from manuscript illumination, where it figures in Bibles and Gospels from early in the Middle Ages, but in French portal sculpture it remains without sequel. After 1170, when the Majestas disappears from the repertory of themes used in French portal sculpture, themes from the Book of Revelation in general become almost equally uncommon. We know of only one place where the pictorial sequence of the illustrated Apocalypses was translated into portal sculpture, and that was on the west portals of Rheims, which in any case occupy a special position in the history of large-scale sculpture programmes.

Of the three eschatological themes, the gothic portal attached greatest importance to that of the Last Judgment. It was a theme which already had a long tradition in monumental painting and manuscript illustration, and was among the first subjects to be illustrated on church portals, shortly after 1100. At Mâcon and Autun in Burgundy, at Conques and Beaulieu in south-western France, church doorways present the theme in restless and disturbing terms, depicting the consequences of sin and the terrors of

5, I

32; 37
16, 18; 24

Ill. 12, 13; 22
Ill. 8
Ill. 45

66; 67

223–225, 234

I Chartres cathedral, west portal, centre doorway. Detail of tympanum: Majestas Domini. 1145–55

gothic Judgment portals, stands in a class apart. The disproportionately large figure of the Judge in the 236
apex is immediately followed by two bands of the dead in process of resurrection, after which there is
still room, on this powerful tympanum, for two further zones, with scenes of Heaven and Hell. An 238, 239
unusual architectural problem – the portal had to be set between buttresses already in place – produced
a unique solution. Later Judgment portals follow early thirteenth-century models. Bourges, Poitiers, 292; 296, 297
Bordeaux, Bazas, Dax – none has anything new to offer. The cathedrals of the royal domain had already 306; 307; 308
evolved the effective solutions, in the first thirty years of the thirteenth century.

The Apostles, now that they no longer appeared beside the Judge as assessors, were transferred as
over life-size standing figures to the jambs. This plan was first adopted at Chartres. Sequences of this 110, 111
kind were not of course unknown in the romanesque sculpture of the twelfth century: the cycle of
standing Apostles is a feature of cloister and chapter houses of southern France and northern Spain,
introduced to remind each Christian community of the example set by Christ's first disciples and
successors. There were standing figures of the Apostles against the walls of the romanesque portals of
Arles and Saint-Gilles. The novelty of the Chartres cycle lies in the attributes given to the Apostles: in
place of the Gospel book, which from the days of the early Church had been their almost invariable
attribute, they now display the instruments of their martyrdom. Thus James the Less is identifiable by
a club, Bartholomew by a knife, Andrew by a cross. The Apostles were the first martyrs; like the
Redeemer himself, they exhibit the instruments of their passion and stand triumphant over the pagan
rules who despatched them to their earthly grave.

The cycle culminates in the trumeau: Christ sets his feet on the neck of lion and dragon. In his left 109
hand he grasps the book, his right hand is raised in blessing. The image type was an old one, based on
verse 13 of Psalm 91: 'Thou shalt tread upon lion and adder: the young lion and the dragon shalt thou
trample under feet.' Descriptions such as 'Beau Dieu', which is a common designation, touch only on
externals, and the suggestion that the figure is a 'Teaching Christ' is certainly wrong. Christ treading
down lion and dragon is Christ the redeemer, victorious over death and sin. In this single figure is again
reflected the conception of Judgment underlying the portal conception as a whole. If the emphasis of
twelfth-century Judgment portals was on warnings of damnation and the terrors of Hell, the message
here is of hope and confidence: hope of deliverance through the Saviour, confidence in the intercessors
and Apostles, who in their martyrdom overcame earthly death. The cycle of martyr-apostles recurs on
Judgment portals later in the century, most notably at Amiens and Rheims, and at Bordeaux and Dax.

In Paris the Judgment takes in yet another thematic cycle. The doorposts, as at Saint-Denis, show
the Wise and Foolish Virgins. Represented on the jamb socle, however, are the Virtues which bring 145
man to eternal bliss and the Vices which lead to his damnation. Earlier Judgments had incorporated 151
personified Vices into their depiction of the punishment of Hell, and in south-western France the
Psychomachia, the warfare between the Virtues and Vices described by Prudentius, was included in
the programme. In Paris the Virtues and Vices are not directly part of the Judgment but form an asso-
ciated and separate cycle. Nor does Paris show us Virtue at war with Vice, a motif too dramatic for
Gothic. The Virtues are enthroned figures, each with a round shield displaying an emblem – a reminder
of the spread of heraldry at this period. The Vices, by contrast, are exemplified: cowardice is the knight
fleeing from an owl and a hare, inconstancy the monk who casts off his habit and turns his back on the
monastery. The pictures follow one another in systematic order, which makes their lesson easy to
grasp. The notion of monstrosity, as it appears in the hideous romanesque torments of the Vices, is
absent, though it lives on in the Hell scenes up above. The Virtues and Vices cycle was repeated else-
where. It can be seen at Amiens, and on the porch pillars in front of the Judgment portal at Chartres. 162, 165

The place for a Last Judgment, with its message of warning and hope, was first and foremost the
portal, the entrance to the church. A unique example of a Judgment on an interior pillar occurs in the
south transept at Strasbourg. What is revealing is how this transposition affected the choice and 136
grouping of the images. There is no Apostles' cycle, since there are only four places available for statues.

In the bottom tier, to introduce the Judgment, we have the four Evangelists, followed in the tier above by angels sounding trumpets to waken the dead. In the top tier there is room only for the Judge with the resurrected souls at his feet, surrounded by angels with instruments of the Passion. There is no Paradise and Hell, no separation of the Blessed from the Damned. With a gothic cycle of this kind, it is beside the point to ask whether part of the sequence has been omitted. The fact is that the traditional compositions were undergoing continual dismantling, dissection and regrouping. The conflicting demands of the old iconographical tradition and the new tasks imposed on architectural sculpture were constantly inspiring unexpected solutions, some brilliant, some absurd. Difficulties of this kind played a part even in a work as unique as the Judgment Pillar at Strasbourg.

THE VIRGIN MARY

The period which saw the beginnings and diffusion of Gothic was also a time of increasing veneration of the Virgin. The great founders of religious orders in the twelfth century, Norbert of Prémontré and above all Bernard of Clairvaux, did much to promote the cult of the Virgin, and they were followed in the thirteenth century by the Dominicans. Much of the space on gothic portals was devoted to Marian themes, which at times even deposed the Last Judgment from its position at the centre of the great programmes.

Whether the Virgin appeared on the west portals of Saint-Denis, on the left tympanum destroyed in the eighteenth century, we do not know. Chartres, as the most important centre of pilgrimage to the Virgin in France, had particular reason to assign her a place of honour on the Royal Portal. Flanked by angels, she appears on the right-hand tympanum, an enthroned Mother of God depicted in the severe manner of the Byzantine Nikopoia: note the fully frontal view and the majestically enthroned Child in his mother's lap. But note also the presence of motifs not derived from the East: for example, Mary is shown wearing a crown – here she is portrayed as Queen of Heaven, a mark of distinction accorded her only in Western, never in Byzantine art. Assembled around her in the archivolt are personifications of the Liberal Arts, the curriculum taught in medieval schools. Mary, as the throne of divine wisdom, stands at the centre of the disciplines whose function was to prepare the minds of men to grasp the revelations of the New Testament.

This Chartres programme is unique. In the twelfth century, however, the Nikopoia is frequently found as the central figure of early gothic tympana. In Paris, indeed, the enthroned figure is still framed within a ciborium-like baldachin. As at Chartres, the Mother of God is flanked by angels with censers. These figures have now been joined by others: a king, a bishop, a cleric in the act of writing. How we should interpret this picture in detail is not clear. It is probably connected with a founder's gift to the Virgin as patroness of the Paris cathedral. Tympana showing founders are extremely rare in France, and so far as we know the only other Virgin's tympanum with a comparable programme is the one at Donnemarie-en-Montois (south portal), which dates from the thirteenth century.

The Mother of God enthroned usually occurs as part of a scene. At Bourges the great figure is enthroned beneath a stately baldachin supported by slender columns. She is raised above, yet remains part of, the scenes which occupy the tympanum. From the left the Magi approach. The tradition of combining the Adoration of the Magi with a frontal portrayal of the Virgin enthroned goes back to the early Christian period. The twelfth century transferred the central composition to the tympana of church portals; examples are the church at Saint-Gilles, and the baptistery at Parma, later in date. The composition is also found in Gothic, for example on the doorway of the parish church of Germigny-l'Exempt, though here it is combined with a rather awkwardly interpolated Annunciation. More

32

impressive is Laon, where beneath a baldachin the Virgin is shown with, on either side, the adoring Magi, an angel and Joseph.

On this Laon portal, however, the traditional presentation of the Epiphany is linked with cycles which could only have applied to the Virgin as a result of the mariological exegesis carried on in the twelfth century: Mary has become the living vessel of all the virtues. It is appropriate, therefore, to gather round her in the archivolts the Virtues, victorious over the Vices. The north portal (left door) at Chartres, which is later, goes even further: here Mary is *Virgo prudentissima*. The Virgin of the Adoration is therefore surrounded not only by the Virtues but also by the Wise and Foolish Virgins. Mary unites in herself the merits of the contemplative and active life: hence the personifications of *Vita Contemplativa* and *Vita Activa* on the arch of the adjoining north porch. Hers, too, are the blessings which, according to Anselm of Canterbury, body and soul will enjoy in Paradise; this accounts for their presence at Chartres on the arch of the same porch, as crowned female figures displaying shields. 94 105

The biblical story of the conception and birth of Christ caused the exegetes to search the Old Testament, and even the writings of the ancients on natural history, for parables, parallels and prefigurations of the birth of the Saviour from a virgin's womb. Parables and prefigurations of this kind are sometimes represented on gothic Virgin's portals. The unicorn, which could be captured only by a virgin, the burning bush which blazed before Moses and remained unconsumed, and many other similar figurations appear on the outer arches of the archivolts of the Virgin's portal at Laon. Earlier Christian art knew nothing comparable. It was Western veneration of Mary, and Western Marian exegesis, both of them twelfth-century developments, which produced this wealth of metaphor for her virtues and virginity. Even so, the metaphors are very rarely reproduced on gothic portals. The Laon portal remains unmatched, and the only echoes of it are at Chartres, Amiens and Rheims. 70, 71

Tympana with the Nikopoia type in the centre belong, like those with the Majestas, to the hieratical compositions from which Gothic soon departed. Laon is the last important example, Germigny-l'Exempt and Donnemarie-en-Montois merely follow on. Chartres had already made some alterations to the composition. The Mother of God is no longer depicted frontally and enthroned beneath a baldachin, but is treated as a full participant in the action. In place of the old hieratical composition we have the narrative-scenic presentation favoured in the thirteenth century. 67 141 94

The Epiphany is not the most important theme of the gothic Virgin's portal. During the twelfth century the conception of Mary as *Regina Coeli* led in the West to the creation of a new image which enjoyed great popularity on gothic church portals of the twelfth and thirteenth centuries: the Coronation of the Virgin. The earliest example on a gothic portal is at Senlis, where for the first time the Marian theme occupies the central position on a cathedral façade. On the lintel of such a portal the death of the Virgin and the Assumption (her corporeal ascent to Heaven) are shown side by side. In one variant or another these scenes are also found at Mantes, Chartres, Amiens (the cathedral and Saint-Nicolas), Dijon and Strasbourg. The tradition of depicting the death of Mary and the raising of her soul by Christ went back a long way and was Eastern in origin, but before the twelfth century it is very rare to find a portrayal of her Assumption. This innovation is proof of the growing veneration of Mary in the West. In the tympanum of a Coronation portal the crowned Mother of God is shown enthroned at the right hand of her divine son. At Senlis she holds the book and sceptre in either hand; at Chartres the crowned head is inclined towards the Saviour, as also at Braine, where the hands are folded in prayer. On later portals an angel sets the crown on her head, or it may be Christ himself who crowns the Mother and Virgin. On these Virgin's portals the idea of Mary as *Regina Coeli* and Bride of Christ, takes visible form. A twelfth-century lectionary from Saint-Corneille in Compiègne includes the words 'Hodie coronatur' and 'Hodie collocatur in throno a dextris Dei' in the sermon for the Feast of the Assumption. The parallel between Mary and the Ark of the Covenant is drawn in Marian litanies still in use today. On the Coronation portal in Paris the Ark of the Covenant, inside the tabernacle, stands in the centre of the lintel: just as the Ark held manna (Hebrews 9:4), so the Virgin's womb brought forth the son of God. 42 43 47; 78; *ill. 52* *Ill. 65*; 131, II 42; 79 74 153; 191

33

Above the Ark we have the Assumption, which here takes place in the presence of Christ and all the apostles. This is followed in the apex by the Coronation.

On tympana with the Nikopoia type, the figure of the Virgin soon came to be joined by a cycle of scenes from the Infancy of Christ. At Chartres it fills two registers, with the Nativity in the centre of the lower field and the Presentation in the Temple in the upper. In Paris the cycle is further developed to include Herod and the Magi. At Laon the Nativity again occupies the centre of the lintel. As the portal layout increased in area, providing more space for large figures on the jambs, it was a natural step to transfer these infancy scenes from the tympanum to the walls. There were precedents in twelfth-century Burgundy, as at Vermenton, where figures of the Magi and the Virgin stood on the jamb. Of the existing portals with large-scale figures from the cycle of Christ's infancy, the first is the north portal (left door) at Chartres, which has jamb figures representing the Annunciation and the Visitation. In each case the Virgin stands on the inside, next to the doorpost, receiving from Gabriel and Elizabeth their respective salutations – 'Ave' and 'Benedicta tu inter mulieres'. On the outer side each pair is flanked by a prophet. Beneath the console of the Mary of the Annunciation we see the serpent of Genesis, and beneath the Mary of the Visitation, the burning bush. By means of these typological console figures the scenic statue groups are brought into a wider, soteriological context.

The jambs of twelfth-century Coronation portals displayed Old Testament figures. In Paris the figures beneath the Coronation of the Virgin represented saints. At Amiens and Rheims we have large figures telling the story of Christ's infancy. Amiens is the more comprehensive: on the left Herod as well as the Magi, on the right the Annunciation, Visitation, and Presentation. They appear almost as paired figures engaged in dialogue, yet their actions and gestures appear frozen and all facial expression is extinguished. Narrative illustration, of the kind found in medieval painting and relief sculpture, is here in conflict with the statue-like rigidity which clings to the gothic jamb figure from its origins. At Rheims the cycle is more concise, with only four figures to each jamb: on the right two pairs, in the Annunciation and Visitation, on the left four figures grouped together in a Presentation. The Rheims Visitation is freer and more relaxed than any of the statue pairs at Chartres or Amiens, and moreover, there is an inner connection between the two figures, arising from the play of limbs and flow of lines. Significantly, it is this group which can largely dispense with the outward signs of face-to-face dialogue, such as we find at Chartres and Amiens. In the Presentation, by contrast, the waiting figures on the far left and right make pronounced turns and gestures. The composition of the group is something of a *tour de force*, since the confinement of the gothic jamb figure within its original narrow block could only be transformed into a dialogue stance by exaggerated means.

Unlike the enthroned figure, which was current in the West before the twelfth century, the standing figure of the Virgin, the Byzantine Hodegetria, is found only after 1100. Probably the earliest example is one which occurs in a Cistercian manuscript. The first ascertainable statue figures are also Burgundian. Vermenton had a standing jamb figure of the Virgin which still showed her in the scenic context of an Epiphany cycle. At Moutiers-Saint-Jean, where the portal, no longer extant, dated from the third quarter of the twelfth century, the Virgin was already a trumeau figure. The portals of Senlis, Mantes and Laon have lost their trumeau figures, so the development of the type in the royal domain can be pursued only after 1200.

The St Anne at Chartres, usually mentioned in this connection, comes near the beginning in point of time but occupies a special position. The portrayal of the Virgin's mother, uncrowned, kept close to the Byzantine Hodegetria. The figures of Mary present a different appearance. We have only to look at the earliest ascertainable examples, from the Coronation portals at Paris and Amiens, to find special characteristics emerging in Western practice. As *Regina Coeli* the Virgin of the thirteenth century wears a crown; her feet are planted on the serpent's back and the socle below carries a representation of the Fall. Just as the trumeau Christ of the Judgment portals triumphs over lion and dragon, so here the Virgin stands victorious over the serpent which tempted Eve to sin. 'Eve put her faith in the serpent,

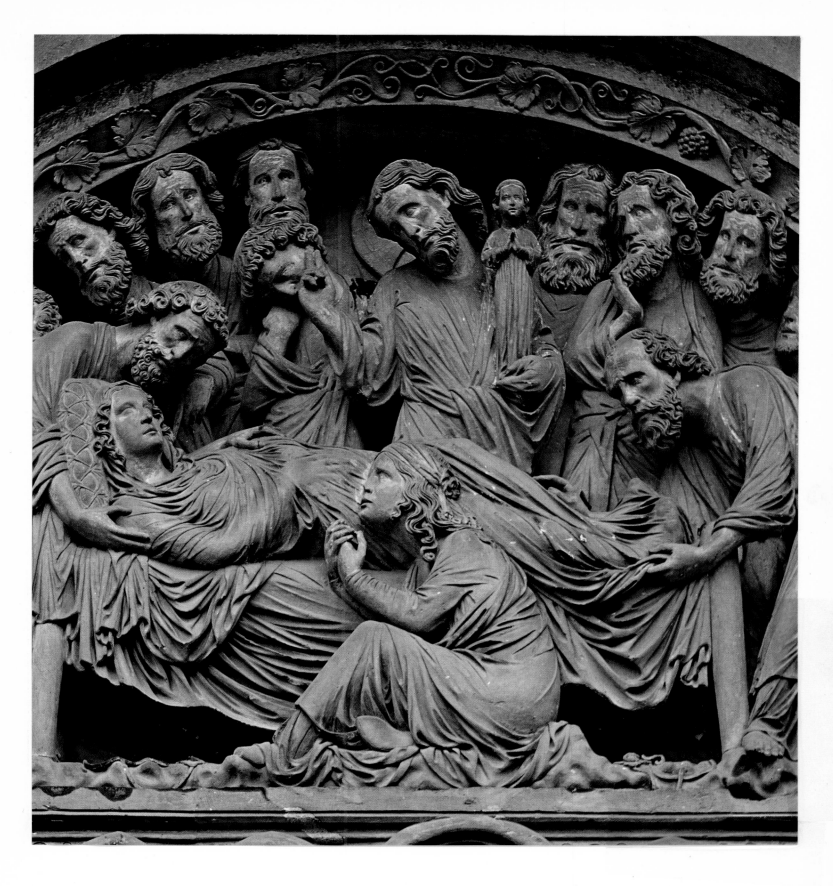

II Strasbourg cathedral, south transept portal. Detail of left-hand tympanum (cf. pl. 130, 131): Death of the Virgin. About 1230

Mary in Gabriel. The offence Eve committed in trusting, Mary in trusting made good.' (Tertullian). The substance of this remark has left its imprint on the gothic figure of the Virgin. An air of triumph manifest in expression and bearing is no trite reproduction of the joys of earthly motherhood but refers to the Virgin's part in the redemption of man.

Ill. 78
168
Paris was presumably the source of the strictly frontal type of trumeau Madonna which became prevalent in the first half of the thirteenth century. We can take Amiens as a characteristic example. The Virgin wears a girdled full-length robe. From her shoulders falls a mantle, whose free end is swathed across her right hip. The stance is upright, the head too is unbending. The Child, his hand raised in blessing, is seated in the crook of the left arm, supported against his mother's breast. There is no feeling
178
of intimacy; the character of the group is majestically regal. Villeneuve-l'Archevêque and the heavily
188
restored trumeau figure of the Virgin at Rheims follow the same type. The Virgin of the Paris north transept is a more slender figure. She also has a different stance: the right foot is set well back, the left hip curves outward and the short upper part of the body leans back, rotated in the opposite direction. In this case there were special circumstances: the figure was conceived not as a single statue but as part of a scenic group in which the three Magi approached from the left – hence the marked curvature and torsion, since the Virgin had to be shown presenting the Child to the kings for their adoration. Thus the Paris figure cannot simply be placed in a series with other trumeau figures.

277, 279
168
Nevertheless, isolated figures of the Virgin from the second half of the thirteenth century show an undeniable change of type. In dress, the 'Vierge dorée' of Amiens resembles the earlier Virgin of the Coronation portal; it is the attitude that has changed. Here too the right leg is set back, the left hip curves outward, the upper part of the body leans back; but this stance, which in the Paris figure was still connected with a particular scenic context, is here adopted solely to enliven the group of Virgin and Child, and the same applies to the smile now seen on the Mother's face. In the figure from Saint-
275
Corneille, Compiègne, these action-motifs are more pointed still, with an even clearer drawing together of Mother and Child. At Abbeville, the countenance of the animated, activated figure of the Virgin is again lit by a smile. By now these works can be said to reflect an altered conception of the Virgin. In place of the majestic *Regina Coeli* we have the 'Dame qui est la douce Mère aux doux Seigneur' of Gautier de Coincy's *Miracles de la Vierge*.

186
The legends of the Virgin, which proliferate in the pious literature of the period, scarcely ever found their way on to church portals. The Theophilus tympanum on the north transept of Notre Dame in Paris remains an exception.

OLD TESTAMENT TYPOLOGY

Old Testament cycles and figures are never at the centre of portal programmes. They refer always to representations based on the New Testament. In reading the programmes, the Old Testament themes only become comprehensible when one has tracked down the figures and images from the Gospels to which they are subordinate. In most cases the reference is typological: an event which is recorded in the Old Testament is regarded as the type, the antitype being the event recorded in the New Testament. Thus Abraham's willingness to sacrifice Isaac is a type for the Crucifixion, in which the sacrificial object was God's own son. Again, Jonah, who passed three days and nights in the belly of the whale and was then spewed up on land, is a type for Christ, who lay three days in the tomb and then rose from the dead. This particular parallel already appears in the Gospels, where it is enunciated by Christ himself (Matt. 12:40). In the centuries that followed, the Church Fathers, and even more conspicuously certain medieval theologians, built up the typological conception of the redemption of man into a system. It played an important role between the twelfth and fifteenth centuries, and exercized a strong influ-

36

ence on the iconography of Christian art. The organization of gothic portal programmes cannot be understood unless this system is first made clear.

The figures on the jambs of the Coronation portals at Senlis and Chartres are Old Testament types for the Crucifixion. At Amiens, the sixteen prophets on the buttresses of the west façade are accompanied by reliefs with scenes from their writings, which in the typology of the Church Fathers refer to the Last Days. Attention is thus directed first to prophecies, and then to the fulfilment represented by the Judgment in the tympanum of the centre portal. There is a side entrance on the north transept of Chartres, immediately to the right of the Coronation portal, which is decorated exclusively with figures and scenes from the Old Testament. All the same, the figures of Solomon and the Queen of Sheba on the left jamb stand there merely as an Old Testament type for Christ side by side with Mary as *Regina Coeli* on the tympanum of the centre doorway. The same pair, for the same reason, appear on other Coronation portals: at Amiens on the jamb next to Herod and the Magi, at Rheims on front of the buttresses flanking the centre doorway. If the figures on the opposite wall of the Chartres portal are indeed Joseph the patriarch and his wife Asenath, this pair too should be understood as a type for the union of Christ and Mary/Ecclesia. The Old Testament cycles in the archivolts of this portal also relate typologically to Christ and the Virgin: Esther, crowned by Ahasuerus, is a type for Mary who receives her crown from Christ; Judith, the slayer of Holofernes, prefigures Mary, who as the New Eve triumphs over the Serpent of Paradise. Typology played a much greater role in the portal programmes of the late twelfth and early thirteenth century than it did in the following decades. Even then, however, its influence was by no means extinct. The socle of the Baptist's portal at Auxerre tells the story of David and Bathsheba: Bathsheba bathing is a type for the Church, purified through baptism, David beholding and desiring her in her beauty stands for Christ. The typological combinations as they appear in the theological literature are as numerous as they are various. It is no longer possible in each case to find a key to the typological references within the portal programmes themselves. Written instructions of twelfth- and thirteenth-century façade programmes were presumably formulated *ad hoc* by theologians working on the spot, but none have come down to us.

Thus there are Old Testament cycles on gothic portals which to this day we are unable to read. Take the twenty-two figures of kings, queens and other Old Testament characters which adorned the west portal of Saint-Denis. Mabillon and Montfaucon, the learned Benedictines from Saint-Maur, took them to represent Merovingian rulers. Cycles of this kind were precisely those attacked with special frenzy by the Revolutionaries, who saw in them memorials to the monarchy they had overthrown. The Royal Portal at Chartres still has seventeen such figures, and there are similar though less extensive cycles at Etampes, Le Mans, Bourges and Angers. Illustrations in antiquarian publications of the eighteenth century show that such figures once existed at Dijon, at Nesle-la-Reposte, at Saint-Germain-des-Prés and Notre Dame in Paris, and at Saint-Pierre, Nevers. As early as the eighteenth century, perceptive observers realized that the identification of these figures as kings of France was wrong, since at Saint-Denis, Chartres, Angers, Bourges and Dijon the cycle includes Moses with the Tables of the Law. In addition, the jambs of Angers and Paris had David with his harp. At Le Mans it was still possible in 1856 to read the inscription SALOM(O) on the roll carried by the beardless king-figure on the right jamb. Now on the jambs of Nesle-la-Reposte and of Saint-Pierre, Nevers, we note the figure of a queen with a goose-foot. Twelfth-century texts ascribe this unusual malformation to the Queen of Sheba, so we must presume that the figure standing next to these goose-footed queens at Nesle-la-Reposte and at Nevers also represented Solomon. Indeed, one eighteenth-century scholar, the Abbé Lebeuf, concluded from these observations that twelfth-century portal jambs portrayed figures from the Old Testament. The arrangement of the sequence varies. Here and there Peter and Paul are included as representatives of the New Testament, for example at Le Mans, Saint-Loup-de-Naud, Dijon and Paris. No key to the identity of the figures has yet been discovered, and the suggestion sometimes advanced that they represent the genealogy of Christ is sufficiently refuted by the presence of Moses.

42; 82, 83
170, 171

92
79

166; 204, 205

93

88
89

283
285

Ill. 1–3

4, 8–14
31; 16; 38, 39; 32
Ill. 8–10
Ill. 25; 45

17
Ill. 9; 45

16, 17; 24, 25
Ill. 25

In the present state of our knowledge, the most that can be said is that these are Old Testament figures, and that they stood in a typological relationship to themes drawn from the New Testament.

It was at this period in the Middle Ages that the West evolved a new pictorial type for the genealogy of Christ, a type which also found its way into the portal programmes. On the basis of the passage in Isaiah (11:1), 'And there shall come forth a rod out of the stem of Jesse', Christ's genealogy was represented as a 'Stem of Jesse'. The trunk of a tree is seen growing from the loins of the sleeping Jesse, and in its branches are figures representing Christ's human ancestors. The first pictures of this type occur in book illumination. Saint-Denis, followed a little later by Chartres, introduced the Stem of Jesse into window glass. At Senlis it makes its first appearance in the archivolt of a portal. Later Coronation portals repeat the theme: Mantes in a very similar formal treatment, Laon, Braine and Chartres with slight alterations. On Coronation portals the Stem of Jesse, though not itself a typological subject, occurs in a distinctly typological overall programme.

One is struck by the important role played by Old Testament rulers and Christ's human forebears in the pictorial programmes of early gothic cathedrals and abbey churches. This was also the period when royal tombs were being renovated and statues of royal founders erected in monasteries. Scholars have naturally speculated on a possible connection between the portrayal of biblical kings and the rise of the French monarchy, whose progress in the twelfth century was so closely linked with Saint-Denis. The possibility is not to be dismissed out of hand. Old Testament cycles, as they appear on portal jambs fron Saint-Denis onwards, are unknown to the romanesque architectural sculpture of the preceding period. But we should bear in mind that before Saint-Denis, French portal sculpture is equally untouched by typology. There is no substance in the evidence so far adduced to support the thesis that the Old Testament rulers are types of the French kings. The Coronation Orders of the French kings stand in a tradition of their own, and neither they nor the allegorical portraits of classical or early modern rulers provide pointers to the significance of the statue sequences on church portals.

On thirteenth-century portals, the Stem of Jesse occurs very rarely. The west portal of Rheims (centre doorway) includes only the sleeping Jesse, with a bush growing from his loins. After 1175–80 the cycles of Old Testament figures disappear from the portal jambs. Around 1220–25 however a new statue sequence makes its appearance; precisely what it signifies is still a matter for debate. At Notre Dame in Paris a gallery of royal figures (restored) extends above the west portals. At Chartres the same cycle, on the façade of the south transept, survives in the original. The fourteen statues in the aedicules of the Rheims transept are of the same iconographic type. The question then arises: are these Christ's royal ancestors, or are they rulers of France? No conclusive argument can be advanced in support of either thesis. The predominantly theological content of the portal programmes, with their emphasis on redemption, favours a biblical identification. The royal galleries would then represent a Stem of Jesse in a different guise, that of a statue sequence. On the other hand, we know that medieval bystanders gave the figures on the Paris gallery the names of kings of France. The attributes of the figures provide no unequivocal answer to our problem.

By means of typology attempts were made in medieval times to combine events in the Old and New Testaments into a single scheme; it should be noted, however, that in medieval practice image types were coined which stressed the antithesis between the two. Personifications of Ecclesia and Synagoga (representing Christianity and Judaism) are not unknown even in the Carolingian era. On the jambs of gothic portals the contrast between them is made much sharper and more dramatic. At Strasbourg the figure of Ecclesia, the Church, wearing a crown, confronts in triumph the defeated Synagogue. The latter, with veiled eyes, turns her bowed head away; her hands let slip the Tables of the Law, across her right shoulder lies the broken shaft of the pennanted lance. Strasbourg is the most famous extant example. We know that in the twelfth century at Dijon, at Saint-Ayoul in Provins and somewhat later at Saint-Pierre in Nevers, Church and Synagogue appeared on either side of a Majestas. On the south transept of Rheims we see them next to the rose window, Synagogue in the type later taken up at

Bamberg, with the crown slipping from her head; in the archivolt, above Church and Synagogue, are respectively figures of Prophets and Apostles. 263, *ill. 94–97*

In the corresponding position on the Rheims north transept we have Adam and Eve, and above them in the archivolt a Creation cycle. The Creation, the starting point for the story of the redemption of man, is the only Old Testament cycle sometimes represented in portal programmes as a continuous narrative. Apart from Rheims, the most important example is on the north porch at Chartres. The socles beneath the statues of this porch also carry a sequence of Adam's descendants, as named in Genesis 4; amongst them we can recognize Jubal the musician and Tubalcain the smith. Sequences of this type on church portals might thus, in a few cases, run from the Creation to the End of the World. No single scene is independent – all that counts is the promise each held for a later epoch. It is this teleological conception of history which underlies the typological system. In such a circle of images, when the Old Testament makes its appearance it does so through individual scenes and figures – intended to be no more than shadows whose meaning only becomes plain in the light of the Gospel. 258, 259
100–104
Ill. 58

SAINTS

We sometimes find that figures and scenes are placed on a church portal to draw the attention of the faithful to the specific means of grace available within. The tympanum of Sainte-Foy at Conques, one of the great pilgrimage churches of the twelfth century, shows the saint interceding at the Last Judgment: in drawing up the programme, the monks saw to it that pilgrims were reminded of her power to save even before they entered the church. At the most important pilgrimage church of all, Santiago de Compostela, pilgrims were greeted on their arrival at the main entrance by an enthroned figure of St James the Greater prominently placed on the trumeau.

On some twelfth-century gothic churches the patron saint appears on the trumeau, Saint-Denis having a patron of exceptional importance. The cult of St Dionysius, which in twelfth-century France became distinctly political and nationalistic in tone, was not least among the reasons for the abbey's prestige and special status. Hence the great prominence given to the saint on Suger's west portal: he appeared on the (destroyed) trumeau of the centre doorway, and his martyrdom is seen in the right tympanum, and we know that the scene was used again on another twelfth-century portal. He was not forgotten in the next century: when the renovation of the tomb of Dagobert was undertaken in the last years of St Louis, St Dionysius, along with St Martin of Tours and St Maurice, figured in the scenes from their legends carved on the back wall of the niche, shown as the rescuers of Dagobert's soul. 48
Ill. 100

Other monastic and episcopal churches of the twelfth and thirteenth centuries were scarcely less eager to incorporate patrons and locally venerated saints into their portal programmes. At Saint-Bénigne, Dijon, the patron is displayed on the trumeau of the west portal, and he once had his own tympanum portraying his martyrdom. St Lupus stands on the trumeau of the priory church of Saint-Loup-de-Naud, and scenes from his legend fill the archivolt. At Sens it was decided to devote the entire centre portal to the cathedral's famous patron, the first Christian martyr, St Stephen: a standing figure of the saint appears on the trumeau, and his martyrdom (Acts 7:57–60), still extant, in the tympanum, surrounded by figures of angels, saints and virtues in the archivolts. *Ill. 8*
24
62, 59

In the tympanum of the left-hand doorway of the west portal of Amiens cathedral we see the translation of the relics of St Firmin. Those saints whose relics were preserved and venerated in a particular church were a favourite subject for inclusion in the portal programme. In the Amiens portal St Firmin stands on the trumeau and there are saints on the adjoining jamb; Georges Durand has sought to identify them from records of relics which belonged to the cathedral. It appears that a gift of relics influenced the programme of the Paris Coronation portal: King Philip Augustus presented Notre Dame 161
168, 169
152

with relics of Dionysius, Stephen and John the Baptist, and as we know, all three saints appeared on the portal's jamb. In 1204 the cathedral of Chartres obtained the head of St Anne from Constantinople and forthwith accorded the saint a place of honour on the trumeau of the centre doorway of the north portal. Miracles worked by relics figure quite prominently in the tympanum scenes on the portal of St Honoratus at Amiens.

But local saints were also displayed on portals when it was important to produce evidence of a see's great antiquity, or to testify at the entrance to a metropolitan church that it had a right to its special privileges. At Bourges one of the four side doorways of the west façade is devoted to St Ursinus, the first bishop. The tympanum cycle starts with Ursinus being sent forth by Peter on his mission to Bourges and ends with the baptism of the local Roman governor. Not least among the reasons for the creation of a great Saints' portal at Rheims was the desire of archbishop and chapter to testify to their cathedral's right to crown the kings of France, a privilege they had skilfully arrogated in the early Middle Ages but had constantly to defend against counterclaims from Saint-Denis or Sens. The figure on the trumeau is St Calixtus, whose body was venerated in the cathedral. On the jamb we see (on the left) St Nicasius, a martyr bishop of Rheims, and (on the right) St Remigius (Remi), who baptized Clovis, king of the Franks, and anointed him with oil sent from Heaven. Until 1914 the Miracle of the Ampulla, on which the claims of Rheims to be the coronation cathedral chiefly rested, could still be seen in the lower band of the tympanum. Even now it is possible to make out the figure of Clovis standing as a candidate for baptism before Remigius, who originally held the ampulla, brought down from Heaven by a dove. The dove is also present in the jamb statue of Remigius, swooping from the clouds to a point near the saint's head. Here one has a clearer indication than in biblical or mariological programmes of the way portal iconography was linked with ritual functions and hierarchical claims.

The St Nicasius on the left wall of the Rheims west portal holds his severed head in his hands. Angels bearing the martyr's crown hover above his decapitated body. Beside the bishop is a large figure of an angel, advancing and swinging a censer. In the legends of northern French saints the same miracle constantly recurs: having been decapitated with the sword, the martyr picks up his head, rises and walks escorted by angels to his burial place. In the thirteenth century these legends found a place on portal jambs, portrayed by full-size figures. The earliest example, which has not survived, was probably the Dionysius of the Coronation portal at Paris. He was escorted by two angels, as he is on the later Rheims west portal. At Rheims the two angels carry censers and the martyr is shown not beheaded, but with his cranium cut off. The escorting angels turn smiling toward him. There is a similar group at Amiens. Most impressive of all is the group inside the west portal of Rheims cathedral. St Nicasius, holding his head in his hands, stands on a slender column which backs on to the trumeau. Portrayed in the large niche containing the rose are Vandal warriors, allegedly responsible for beheading the saint at the entrance to the cathedral. The group is separated from the nave by two large angels, turned toward the saint and pointing forward into the church. They are escorting him on the path he trod, so the legend says, from the threshold to the high altar. Thus we have sculptures placed at the entrance to a High Gothic cathedral to demonstrate the continuing presence of a martyr bishop who had been beheaded centuries before on the threshold of this very church and had deposited his head on the *mensa* of its altar. This group of martyrs with smiling angels is found only in the northern French cathedrals of the thirteenth century. The type was imitated at Bamberg – inside the cathedral is a figure of the beheaded Dionysius; his escort, a smiling angel bearing the martyr's crown, is also extant.

The legend of a saint who had been ousted from his position as the church's main patron was sometimes used to decorate a subsidiary entrance. Stephen, for example, was the original patron saint of the Paris cathedral, subsequently Notre Dame, and this is presumably why he has a portal on the south transept. Portal iconography might also be linked with altar dedications. Sens cathedral had two transept chapels, one dedicated to the Baptist, the other to the Virgin, and these were matched by a Baptist's cycle and a Coronation on the corresponding entrances in the west façade.

40

Saints appear in hosts at the Last Judgment. At Paris and Amiens they are placed in the archivolts. 145; 164, 165
On the Chartres south transept the entire triple doorway has to be understood as a single, extended 106
representation of the Last Judgment, in which the martyrs and confessors on the walls and buttresses
take part. Nor are the jamb figures mere local saints, but rather great saints of the Church: Stephen,
Clement of Rome, Laurence, Vincent, Martin of Tours, Jerome, Gregory the Great. The tympana and 116, 117, 121
archivolts show scenes illustrating the saints' good works and acts of intercession, for example Stephen's
prayer, 'Lord, lay not this sin to their charge'. It was only when an extension was made to the pro- 114
gramme with the building of the porch that a few little-known local saints were added, for example
Laudomarus and Avitus. A number of the saints depicted at Chartres cannot now be identified. Where 123
there are no distinctive attributes or subsidiary scenes on the socle, we have no clue to guide us. Many
of the designations now current go back no further than the middle of the nineteenth century. Thus the
warrior saint on the Martyrs' portal at Chartres is usually taken for Theodore, but Delaporte favours 116
Maurice, who was also a soldier saint. A recent fancy is the Roland of the heroic epic, which only goes
to show that notions of portal iconography are still apt to be confused. Chartres, Amiens and Rheims
all have quite a few saints we cannot name; the figures are uncharacterized, so even a scrutiny of local
calendars of feast days would not take us much beyond the realm of hypothesis.

The Christian iconography of the twelfth and thirteenth centuries embraced images and cycles which
seldom or never appear in the portal programmes. One has only to examine the themes of glass painting
to become aware of a field in which legends and narrative sequences were allowed much greater scope.
The cycles on church portals, even on gothic portals, remained representative and symbolic in character,
largely to the exclusion of mere narrative for its own sake. This explains why illustrations of saints'
legends remain such a rarity. The public ministry of Christ, the miracles, the Passion, are all conspi-
cuous by their absence. The christological cycles of capitals at Chartres and Etampes are exceptions, 4; 31
like the Passion on the Rheims west portal. With the jubés the situation is entirely different. On them 214, 215
the preference was for narrative sequences, the best French example being the jubé of Bourges. 294

The range of images found on church portals is by no means encyclopædic in the sense of a scholastic
Speculum. Secular themes are almost totally absent, and when they appear relate to the ecclesiastical
character of the cycles. The Liberal Arts, personifications of secular subjects in the curriculum, were 6; 15
represented solely because they were a necessary preliminary to the study of theology. Many portals
carry Zodiacs and Calendars, at Chartres combined with an Ascension, at Senlis and Paris on Coronation 7; 42; 152
portals, at Amiens and Semur-en-Auxois in conjunction with hagiographical programmes. They are 169; 291
among the small minority of sculptures which reflect something of the life of the period and its daily
round, in the same way that illustrated calendars became the incunabula of early modern landscapes.
However, it would have been unthinkable to introduce such a sequence at the centre of an ecclesiastical
programme. The place for a Calendar was on the socle, the doorposts or the archivolt. Secular themes
remained on the periphery, and it is quite fallacious to see these representations of hearth and harvest
as glorifications of human labour. Zodiac and Calendar charted the annual cycle within which the
Church celebrated its feasts, and this was presumably the reason they were displayed at the entrance
to a cathedral or abbey church. With these themes the range of secular subjects is virtually exhausted.
One can mention, however, the trumeau of the Virgin's portal in Paris, which shows on one side the
Six Ages of Man, paralleled on the other by Six Seasons or Temperatures; these personifications are 154
matched numerically by Zodiac and Calendar scenes on the doorposts.

Joseph Sauer has remarked that the church portal cycles 'compress all the rich content of the church
into its doorways, providing the index to what can be read inside'. The vitality and artistic variety of
the sculptures on gothic portals may make this comparison seem bookish and colourless, yet it hits the
mark. At the entrance to the gothic church, the stages in the redemption of man are presented in the
concordance of the Old and the New Testaments. Here is the image of Judgment; to it belong not only
the Virgin and the saints, but also the virtues to be practised and the vices to be shunned.

METHODS OF REPRESENTATION

INTRODUCTION

The architectural sculpture of the early twelfth century, when called on to represent the human figure or to render scenes and groups, adopted procedures used in painting, or by workers in such materials as precious metals and ivory. Gothic sculpture at first followed the same course, using methods of representation borrowed from other skills. The thirteenth century brought a change: in the large masons' yards, the demand for extended figure cycles, some of them intended for positions high above the ground, produced new methods of working. As a result, sculpture now developed its own technique for the treatment of figures, a technique grounded on the specific factors encountered in the handling of the block. The forms thus evolved influenced in their turn sculpture's sister arts: book illustration and glass painting, goldsmith's and ivory work.

This was naturally not a simple process, and it depended on a number of external circumstances. In the twelfth century, gothic sculpture formed one stream out of many in north-west European art, and was stimulated by the others. The individual workshops were always turning to fresh models. After 1220 this state of affairs no longer prevails. The picture becomes more uniform, though it by no means lacks nuances; the individual yards and, within the yards, the individual workshops, have their own peculiarities and customs.

There were other tendencies, outside the field of mere workshop practice, which helped to promote these changes in style. In the twelfth century, figures and scenes, flora and fauna, were still, as in all earlier medieval art, reproduced from established models. To have authority, to be authentic, any representation must be capable of association with tradition, as guaranteed by earlier pictorial testimony. An animal drawing was correct, not if it was done according to nature but if it agreed with the illustration in a zoological text-book. Plants and foliage were copied not from living examples but from patterns, which might indeed be varied, but for ornamental reasons and not with a view to realism. In the thirteenth century we find a change. Villard de Honnecourt, writing *c.* 1230, says of the drawing of a lion: 'Note that it has been drawn from the life.' Whether the statement is plausible and the resulting picture – to a modern eye – convincing are matters of secondary importance. What Villard found necessary to remark was that he had worked not from a pattern book nor from the *Physiologus* (bestiary) but 'al vif'. If one compares the capitals of the north transept portal of Saint-Denis, which dates from *c.* 1170, with those of the Rheims west doorways, the meaning of this 'al vif' becomes clear: on the one, classical acanthus ornament, on the other, roses no longer rooted in some antique exemplar but plucked from native hedges. There is a passage in the Emperor Frederick II's book on falconry which sheds light on this change of attitude in the thirteenth century: 'Intentio vera nostra est manifestare ea quae sunt sicut sunt' ('It is our intention to show things *as they are*').

'Then Judith fell upon her face, and put ashes upon her head, and uncovered the sackcloth wherewith she was clothed; and . . . Judith cried with a loud voice . . . (Judith 9:1). This is illustrated by a Chartres sculptor working about 1220 in a way that strikes even the modern observer as natural and full of feeling. Compare this with the figures of Christ's ancestors at Senlis, carved about fifty years before:

35, 55

49
208

91
44, 45

42

figures admittedly expressive, but hardly to be described as natural, or filled with individual life. The vehemence of the movements conforms to an ornamental line, and the expressive gestures follow fixed formulas. Here we have the power to express through stylization, but not the immersion in the individual figure's capacity for expression, as we find it later in the Chartres Judith.

Thus as we pass from the twelfth century to the thirteenth, we find a shift in the ratio of convention and experience. Even so, the fruits of observation remained noticeably partial in practice. Take, for example, the Chartres Solomon: the bearing, and the turning movement of the wrists, seem calculated 92 to heighten the figure's animation in a way that speaks of a 'study from nature'. But the figure as a whole remains highly stylized. The lower part of the trunk is very much too long, the upper part too short, and on top of this we have a large head. As is well known, antique sculpture observed a strict canon which brought the parts of the human body into a balanced relationship. Medieval sculpture, even in the thirteenth century, knew no such law. The Chartres Solomon is certainly more animated and more corporeal than the figures of the west façade, sixty years earlier in date, but it is no less disproportioned. 10 Much of the aesthetic appeal such a figure holds for the modern beholder seems to lie in this unbalanced relationship between closeness to life, the sensuousness of the individual motifs, and the highly stylized appearance of the whole.

Individual fields of representation differed greatly in the scope they allowed for the recording of actual experience. The leaf or flower decoration of a capital can at times astonish us by its realism. Calendar sequences were already, and in the thirteenth century became increasingly, occasions for 169 realism. The head-shaped corbels of Rheims, inspired by no identifiable text, may in a few cases depict 257 faces the sculptor had actually observed. On tomb monuments, however, the thirteenth century still shrank from portraiture and kept to generalized types; the object of the monument was not, after all, to commemorate the dead man's appearance. Biblical and legendary scenes all had some textual foundation, and in the thirteenth century too their portrayal followed fixed iconographical conventions. It is here that the relation between convention and experience becomes much more complicated. The Queen of Sheba can be clad in the dress of the thirteenth century; not so a trumeau figure of Christ produced at 204; 237 the same date and in the same place. How much the appearance of the figures is a reflection of the life and manners of the period can only be conjectured, by studying individual monuments and making wide-ranging comparisons. In any case, the scope for such reflections of contemporary life was strictly limited, in view of the commitment to the Church as patron and the biblical and hagiological nature of the images portrayed.

It is not my intention to produce a concise history of gothic sculpture in the twelfth and thirteenth centuries; to do so might give the reader the impression that the monuments succeed one another as a coherent process, filled with a higher spiritual meaning. It seems better, having surveyed the tasks gothic sculpture had to perform and the themes it embraced, to conclude with some observations on methods of representation adopted by individual workshops or groups.

THE ROYAL PORTALS OF CHARTRES AND SAINT-DENIS, AND ASSOCIATED WORKS

The jamb figures on the centre doorway of the Chartres west portal show an unusual elongation and their 10, 11 bearing, while not rigid, is tense. Movements and gestures are determined by the original shape of the block, which was long and narrow. The joints make sharp angles, the contour of the shoulders is not rounded but angular. Traced on the body surface is a multitude of fine lines, to indicate the folds of garments made in some delicate material. The strict axiality governing the figures' appearance is also reflected in the heads. In most cases the hair is parted in the centre, and the two halves of the face are

43

in almost complete symmetry. No attempt is made to point up facial expression, which appears completely unruffled, though the play of the features is not extinguished – indeed these quiet heads possess a quite uncommon eloquence.

The schooling of the workshop responsible for these figures poses a problem which has engaged art historians since the end of the last century. Though there is nowadays substantial agreement that the _Ill. 1–3_ jamb figures from the west doorways of Saint-Denis are earlier than those at Chartres, they appear to be so very different that Saint-Denis has never been regarded as a possible training ground. On the _Ill. 4_ other hand, three statues known to have been preserved in the cloister at Saint-Denis until the eighteenth century come close to those at Chartres, though it is not clear which were the earlier. The same applies 21 to the lintels of La Charité-sur-Loire. Furthermore, we cannot hope to answer the crucial question concerning the figure style which the Royal Portal, the Saint-Denis cloister and La Charité have in common by reference to monuments all of the same kind.

It is not disputed that _c._ 1145 there were no models for this figure style in northern France. Hence the most obvious course is to hunt for parallels in the art of regions which in preceding decades had experienced a flowering of romanesque sculpture. Wilhelm Vöge, the first scholar to grapple seriously with the problem, looked to Provence for its solution. Just as the influence of Provence is noticeable in the northern poetry of the twelfth century, so, he argued, might the romanesque portals of the Midi have influenced the Royal Portal at Chartres. Vöge thought the immediate model was Saint-Trophime at Arles, but Richard Hamann, who adopted Vöge's general thesis, plumped instead for Saint-Gilles. The question is still open. It must be said, however, that there are doubts as to whether the Provençal monuments are in fact earlier than Chartres. Furthermore, the similarities between Saint-Gilles and the Royal Portal are only very general. Hamann's theory that the same master – 'der junge Chartreser' – was active in both places can certainly be dismissed. A more probable explanation is that the formal resemblances between the Provençal and the northern monuments are the effect of sources they have in common.

The fact is that during the third decade of the twelfth century the romanesque sculpture of Burgundy had evolved a figure style which could well be a direct precursor to Chartres. Thus in the church of Saint-Lazare at Autun and the Madeleine (the abbey church) at Vézelay one finds figures with some of the Chartrain characteristics: elongation, delineation of drapery by fine lines running parallel, narrow heads with smooth barely modelled surfaces. Even assuming there is a connection, it must be admitted that at Chartres the models were drastically altered. The stylistic effect is totally different: the forms have acquired a new severity and tautness, the placing of the motifs is more deliberate and systematic. However, these changes may have been due in part to external circumstances. Burgundian romanesque was free from the strict commitment to the block, a commitment imposed on Chartres in advance by the commission to create, on the model of Saint-Denis, a figure-decorated portal with statues on the jambs. Moreover, the cycle at Chartres is quite different from that of Autun or Vézelay, and it may be that the new iconographical patterns influenced the formation of the style. With these reservations, the indication of Burgundy as the starting point for the Chartres west portal still holds good, and to date seems the most plausible solution to our problem.

It seems that a large workshop was engaged on the Royal Portal, and distinguishing the hands responsible for the Chartres west front became fashionable among art historians in their attempts to rewrite the art history of the twelfth and thirteenth centuries in terms of individual artists. In the two 14 outer figures on the left wall there is not the same taut and energetic treatment of the forms we find on the centre doorway. The folds over the joints and body curves are applied as large concentric rings – 31 Vöge likens them to tattoo marks. We find the same technique on the Etampes portal: here the motifs are 13, III merely drawn on the surface and have no functional connection with the statue's attitude and gestures. The inner figures on the right wall show a similar procedure – knees are indicated by circles or lines on

III Chartres cathedral, west portal, right doorway. Detail of Old Testament figure, from the left jamb (cf. pl. 12, 13). 1145–55

the drapery and where the material of the mantle puckers up from the arm it forms ornamental curves.

Ill. 1 As Vöge has observed, there is an affinity with the centre doorway of the west portal at Saint-Denis. It is only with these lesser, somewhat old-fashioned works to act as a foil that we can appreciate the discipline

10 and energy required to form the style of the jamb figures to the left of the centre doorway. Not a line is there without functional reason.

15 In the archivolts the situation is again different. The figures are more thickset, their attitude less constricted. Many of these differences may be due to the variation in technique. The block at the disposal of the archivolt sculptor is both broad and deep, permitting motifs like the upswept mantles of some of the Elders, for which there would be little opportunity on the jambs. But there are also differences which cannot be accounted for in this way. The general presentation is freer and more animated. The faces are more individual, more expressive, and show a surprising capacity for variation to match the subject: Grammar's face wears an air of severity; Music's head leans back as she listens; the scholars at their writing desks are depicted with furrowed brow. The accessories are rendered with surprising accuracy; the harps and stringed instruments of the Elders, Music's carillon, Grammar's bundle of rods, ready to chastize the half-naked schoolboy dealing his neighbour a cuff on the head. Implanted in these figures and groups is a feeling for actuality rarely found in the art of the Middle Ages. Gothic begins at Chartres with works which show a new appreciation of the human figure's capacity for physical and spiritual expression.

The smaller figures on capitals, doorposts and buttresses can only be mentioned in passing. The ornament covering the shafts of the jamb columns points clearly back to Saint-Denis. Saint-Denis possessed the first portal with statue-like jamb figures to be built in the royal domain, some ten years before the Royal Portal. Here again we are faced with the problem of sources; in this case, the sad state of preservation makes a style-critical judgment extremely difficult. It is obvious that Burgundy had

Ill. 1–3 nothing to do with Saint-Denis. The Saint-Denis jamb figures showed none of the axial stiffening found at Chartres. The only agreement with the Royal Portal is in parts of the cycle and the styles of dress depicted. As Vöge noted, many features of the Saint-Denis figures suggest inspiration from south-western France: possible models and points of departure are Saint-Etienne in Toulouse and the portal at Moissac.

The modest fragments which survive on the spot or in collections are not at all reminiscent of Chartres, nor in most cases do they indicate any connection with south-western France. The heads from the

3 archivolts are conspicuous, with their huge protuberant eyeballs framed by thick eyelids. The execution

9 is coarse, and there is a striking contrast between these heads and the eloquent countenances of the

2 Royal Portal. In the Calendar on the doorposts of the right opening the execution attains a different order of fineness. The ornament of the doorpost columns reveals a technical virtuosity which, by undercutting and drilling, has achieved in stone effects usually associated with goldsmith's and ivory work. Attempts to connect this repertory of decorative forms with patterns in Cistercian manuscripts do not convince. To a modern observer, the west doorways of Saint-Denis give a discordant impression. Even though it is by no means unknown in medieval art to encounter ornamental forms of great refinement alongside coarse and ungainly figures as part of the same ensemble, the contrasts here are nonetheless extraordinary.

Thanks to the accident of its better preservation, the Royal Portal of Chartres may have assumed too central a place in our conception of early gothic sculpture. Wilhelm Vöge believed in the existence of a 'School of Chartres', rather in the sense of schools of Italian, Flemish or German painting as we understand the term. In practice things were probably not so simple. For a start, the idea of a school of artists attached to a particular place does not fit a period in which the work was done by itinerant workshops organized in masons' yards, rather than by gildsmen and master craftsmen settled in towns.

16 A few portals seem in fact directly linked with Chartres. Le Mans is probably a follow-up of the Royal

17 Portal. The wall figures on the right are closely akin to the statues on the right jamb of the Chartres

46

centre doorway. The execution is cruder, and the figures are set back into the angles of the recessed jamb. 11
But even with such pronounced similarities, it should be remembered that from mid-century the figure types obviously enjoyed a wide circulation, and had probably found their way into the stock of pattern books. Furthermore, there are ways in which Le Mans deviates from Chartres. Some of the ornamentation is different, there are no precedents at Chartres for the relief figures on the doorposts, Le Mans is not 18 indebted to Chartres for the narrative cycle in the archivolt. At Chartres the composition was more firmly drawn together as a whole.

Another portal to be reckoned in the direct line of succession is Angers. Here the figures of the 32, 33 Chartres archivolts have become exemplars for jamb statues. The Moses at Angers resembles one of the Elders in the archivolt of the Chartres centre doorway. We note that the motif of the upswept mantle has 15 forfeited its freedom. In the jamb figure we are more aware of the commitment to the narrow block. Compared with the statues of the Chartres centre doorway, the figures at Angers give a broader and more 10, 11 squat effect. This is no reason for jumping to conclusions about their chronology, in the supposition, based on false analogies from other historical fields, that the sculptors of the twelfth century progressed step by step towards a correct rendering of human proportions. At Angers, however, one is struck by the greater freedom in the handling of the figures, when compared with the jamb figures of the Chartres centre doorway; see, for example, the female figure (next to Moses), the clutched mantle cords, the slight 33 lift given to the dress – features which do not recur until much later, in the thirteenth century. 98

Among the works in succession to Chartres we can also include the sculptures from Saint-Bénigne, Dijon. Some have thought it possible that Dijon preceded the portals of the Ile-de-France. There are a 22, 23, *ill. 8* number of reasons why this is unlikely, not least the individual forms of the portal architecture and the iconography of the jamb cycle. Of the works preserved at Dijon, it can be said that the tympanum with the Majestas, artistically of no great importance, is still in the old Burgundian tradition. Typically, figures and ground are not clearly differentiated in layers, as they are at Chartres. Furthermore, the 5 composition lacks the tautness of the early gothic tympana. It is thus all the more striking to find this Majestas tympanum differing so greatly from the tympanum showing the Last Supper, which is of much the same date. Here we have figures ranged one beside another in a peaceful attitude, their features tranquil and harmoniously proportioned, in a way strongly reminiscent of the right wall of the Chartres centre doorway. The composition is like a Chartres jamb – without activity or a sense of narrative. The event is formalized and the composition is strictly axial. There was no doubt a similar look to the style developing on the jambs of the main entrance, destroyed at the Revolution. Dijon is not the Burgundian model for the cycles of the royal domain. The old Burgundian sculpture had come to an end, yielding to the new forms of early Gothic.

Saint-Loup-de-Naud belongs to the same circle. The jamb is more modest in construction, the statues 24, 25 are somewhat awkward and timid. There are no examples of the arm bent at an acute angle, which at 10 Chartres emphasizes the edge of the block. Limbs and drapery are flatly spread out; the book in Paul's hands is unnaturally large. In fact there is something clumsy about the whole figure: those wide-open eyes, those deep furrows on the forehead, speak of such painful mental exertion that the effect is almost comic. It is odd too to see birds and griffins on the capitals starting up directly above the heads of the statues. There is an air of provincialism about it all, not without its individual charm.

The portal at Corbeil seems to have been among the more important works of the group. Here the figures were of the same elongated form as on the jambs at Chartres. The female statue in particular 30 surpasses Chartres in the refined rendering of the surfaces and delicate characterization of the fabric. Again, compared with any of the female figures at Chartres, the modelling of the bust is more candid, the hem of the garment ruffles more invitingly about the feet. The Corbeil portal must have been among the later works of the group. Its exceptionally elongated jamb figures are an impressive refutation of the idea, quite unhistorical, that the development of gothic sculpture was one long striving towards an increasingly correct rendering of human proportions. Beside Corbeil we can set, by way of contrast,

Saint-Loup-de-Naud, with its decidedly thickset statues. Where there is no canon, no theory of human proportions, new variations are always possible.

Nesle-la-Reposte, Ivry-la-Bataille and Saint-Germain-des-Prés had or still have portals of the Chartres type. To this list should be added Saint-Ayoul in Provins, and as an eastern offshoot, Château-Chalon. The fragments that remain at Bourges are important, though difficult to evaluate. Installed only in the thirteenth century, the north portal in particular seems assembled in a highly arbitrary fashion. The capitals with their ornamented tendrils and little naked figures have nothing to do with early Gothic. They show a freedom and looseness of composition unthinkable at Chartres. The Mary of the tympanum, with draperies falling in broad, sweeping folds, has a swirling liveliness unknown to her severely symmetrical counterpart at Chartres. With the Bourges portal before us, any idea that the royal portals followed a uniform stylistic development has to be abandoned. Here we find older traditions still active, models brought into play, which have nothing in common with Chartres. If the picture on the south portal is different, it is only a matter of degree. The jamb capitals, pieces of great virtuosity, are not comparable with works in the Ile-de-France; in theme, as in form, they are more lively, more capricious. Elsewhere there are pieces of similar type, derived from Bourges, which no one would associate with early Gothic. With the jambs it is different. Here the types are similar to Chartres, but show a divergence in execution: lines are more sharply drawn, folds more prominent. The figure of Moses perhaps compares with the Chartres Elders. Connections exist, yet Bourges seems an independent creation. Remnants of related works survive as far afield as the area east of the Loire.

One work Vöge linked especially with Chartres is the tympanum of the Porte Sainte-Anne of Notre Dame in Paris. He spoke of the 'Master of the two Virgins', meaning the 'master' of this figure and of the Chartres Virgin. This view has had to be challenged. The similarities are only partial and iconographical. There are refinements in the Paris tympanum – in the rendering of smooth surfaces and the deployment of figures – of which Chartres knows nothing. Moreover, as Vöge himself noticed, the lintel figures are in a divergent style. The little flat figures, seemingly punched out from the background, are covered with a pattern of oval folds and sharply delineated angles. Similar forms are seen in the jamb figures illustrated by Montfaucon, and the connections are confirmed by a torso preserved in the Musée de Cluny. Here, by contrast with Chartres, the folds are applied as it were graphically, and not used to clarify functional relationships. The Paris figure types recur in stained glass: they are closely approached in the scenes from the Infancy of Christ in a window of the Chartres west façade. Once again, we are made aware that the early gothic royal portals drew simultaneously on a great variety of sources.

The royal portals came into being between 1135 and 1170. They remained a regional type, which in France spread as far as Anjou and Berry and into Burgundy. French Gothic had not yet become the model for Europe; outside France the only portals of this type are at Rochester in England and Sanguesa in Spain. The sources contributing to the style varied: Saint-Denis drew on south-western France, Chartres on Burgundy, Paris and Bourges to some extent on sources of their own. The common ground was primarily the type; in execution we often find wide-ranging divergences.

SENLIS AND THE LAST TWO DECADES
OF THE TWELFTH CENTURY

In the twelfth century the regions immediately to the north of the French royal domain contained Europe's most important centres of goldsmith's work, the most notable being in the valley of the Meuse. From Reiner of Huy, active at the beginning of the century, down to Nicholas of Verdun, *c.* 1180, the products of these workshops exhibit a highly individual type of figure formation. While the romanesque sculptor of south-western France and Burgundy was hampered in the free development of his figures by

Marginal illustration references (left column):
48 25
Ill. 9; 11–14; 10
Ill. 24; 22
34–39
34, 35
6
36
38, 39
40
6
Ill. 25
Ill. 75
32; 37; ill. 8

the overriding demands of the architectural setting, the Mosan goldsmith can surprise us, in his chased and still more in his cast metalwork, by the freedom, the three-dimensional quality, of his figures in action. Works ranging from Reiner of Huy's font at Liège to the Cross pedestal of Saint-Omer show that the freely activated figure, unfettered by attachment to wall or column, had become a subject for experiment. These experiments were not without their influence on the gothic sculpture which since 1135 had been developing in the French royal domain.

One has only to glance at the archivolt of the west portal at Senlis, erected in or about 1170, to be struck by the powerful outward thrust of the highly activated figures. On each voussoir the depth of the block has been exploited to the full – the front edge can be seen on the stone carved with the Stem of Jesse, at the tip of the foliage. The space thus made available is filled with sturdy little figures, shown in a rotatory, corkscrew movement. They twist this way and that, the pull of their garments forming a restless curvature over their crossed and folded limbs. By contrast with the Royal Portal at Chartres, where the figures are in keeping with the architectonic framework of jambs and recessed arches, these Senlis statuettes are so filled with movement that they seem to be escaping from their architectural setting. The closest parallels to these restless little figures occur in the work of Mosan goldsmiths: one thinks of the Evangelists of the Saint-Omer Cross pedestal, or the statuette of *Mare* (the Sea) in the Victoria and Albert Museum, London. It must be obvious that such a highly individual style of archivolt figure could not have been achieved without the stimulus of pioneering work in a field not bound by the strict laws governing architectural sculpture. Admittedly, what we also see from these figures is that the new tasks demanded of sculpture, not to mention the new techniques – working the block from the edges rather than the surfaces – inspired the sculptors to greater intensity in the rendering of the lively, three-dimensional form. At Senlis one can imagine that even gothic sculptors had some of the feeling and fervour of a Pygmalion, an unusual occurrence in the Christian Middle Ages.

The archivolt arches enclosing the pair in the centre of the tympanum repeat the curving outlines of the figures. The impression of a scene in animated movement is heightened by the angels leaning forward from circular windows to face the bridal pair beneath the arch. This 'revelling in roundness' (Vöge) is the principal source of the sense of ecstasy and jubilation, and what is surprising is not so much the vehemence of the movement or the inexhaustible multiplicity of motifs but their alliance with the solidly corporeal forms of the new sculpture. The same phenomena can be observed in the jamb figures: bodily motion and an independent activity set up by the curving movement of the drapery, which transposes the forms into a state of extreme unrest.

Senlis remained an isolated case. The extent to which it may have depended on the reception and adaptation of models from elsewhere has already been indicated, but whatever the borrowings from elsewhere, this is not a workshop out of touch with the sculpture of the French masons' yards. Figure types like the John the Baptist point back to Saint-Denis. The lintel relief showing the Assumption of the Virgin has connections with Paris – archivolt fragments from Notre Dame show the same type of angel, with rounded spherical head and childlike eagerness of expression and gesture.

Correspondences with formulas and types used by the Mosan goldsmiths are met with in other works of gothic sculpture from the period 1170–90. At Saint-Denis, in addition to erecting new west doorways, Abbot Suger had commissioned windows for some of the ambulatory chapels. Among the surviving fragments is a medallion showing Aaron writing the letter T (*tau*), which is an almost literal reproduction of Mosan book illumination and enamel work. This in turn had some influence on the sculpture of Saint-Denis and its sphere, as is shown by the portal added to the north transept of the abbey church in the thirteenth century. Compared with Senlis, the method of adaptation is more schematic, more superficial. The figures have not been set in motion, and the creases purporting to show the stretch of the garment over the body beneath seem applied like lines in a drawing, instead of arising from the play of limbs. At Saint-Denis one might suspect that this is the result of restoration, but exactly the same effect is seen on the tympana at Mantes, which have not been touched. Elsewhere at Mantes, for example in

44, 45

42

43

43; *ill. 3*
41

48, 49, *ill. 28*

49

47, 48 the archivolts, the forms become more powerful and energetic, the curves more marked and exuberant, and we are back with Senlis again.

In twelfth-century art it is too soon to speak of practices tied to particular regions. The Church was the most important patron, and with its institutions knew no regional boundaries. Admittedly, particular types of architecture, portal forms, or figure cycles might establish themselves for a decade or two in one region – the major monuments influencing the minor – but there is no regional tradition of the kind found in the later medieval period, when the craft organization was quite different. The picture presented by Champagne in the early stages of Gothic is quite striking in its lack of uniformity. Take Rheims, for example, where the extant monuments are bewildering in their variety. The royal statues installed in 1140–50 at Saint-Rémi perhaps point to Saint-Denis; the head of Lothaire recalls the figures on the left doorway of the west portal of Saint-Denis. Leaf borders on the tympanum (now in the Rheims museum) from a secular building are reminiscent of repoussé work, while the flowing outlines of the graceful little figures might have been traced with a pen. In the tomb monument transposed in the thirteenth century to form the cathedral's north transept portal there is nothing vehement. The drapery, whether of figures or hangings, swings in broad arcs and descends in long folds. The calmness and stillness, which might be taken as conventions suitable for a tomb monument, in fact here belong to the style of a workshop whose activity can be traced elsewhere at Rheims. Some scholars feel these sculptures resemble the chased figures of the Heribert reliquary at Deutz. There is certainly nothing comparable in the Ile-de-France. The great cycle from Châlons-sur-Marne survives only in part, and for the moment a stylistic judgment is virtually impossible, though some figures are similar to those of Saint-Denis (north transept). There is one capital relief on which the melodious flow of the figures, the rounding out of the forms and the gentle passivity of the movements call to mind the angels from the Rheims tomb monument. Scenes from the life of Christ carved on another capital recall Mosan miniatures, as found, for example, in the Psalter fragment Ms A78 preserved in the Kupferstichkabinett of the Staatliche Museen, Berlin.

It will be seen that the picture is by no means uniform, although only a selection of the monuments is discussed and reproduced here. One gets the impression that after 1170 the earlier stimulus to gothic sculpture, initially from Languedoc and latterly from Burgundy, had become a spent force. The new models came from the north, from regions bordering the birthplace of early Gothic, and they stemmed from goldsmiths' work and painting rather than monumental sculpture. The regions south of the Loire, and likewise Burgundy, were sinking to a provincial level, to be overrun in the thirteenth century by the gothic sculpture of the royal domain.

The marginal references to the left of the columns read: 28, ill. 15; Ill. 2; 55; 56, 57; 52–54; 52; 49; 53; 56; 54

RETROSPECTIVE TENDENCIES IN SCULPTURE IN THE THIRTEENTH CENTURY

In the history of the figurative arts in Europe an ambo made in 1181 by the goldsmith Nicholas of Verdun for the monastery of Klosterneuburg in Lower Austria is of epoch-making importance. Even in the context of the sculpture of gothic cathedrals in northern France, this pioneering work cannot be ignored. It reveals a hitherto unsuspected capacity to animate the human figure, a new exuberance of movement, gesture and facial expression; it is as though medieval art had made its first encounter with the antique, in all its radiant sensuality. The stylistic origins remain a mystery; Nicholas was a Mosan goldsmith, but we look in vain for models for his figure style in the earlier work of the region. Some have thought of Sicily or the East, but here again no really convincing evidence of a possible connection has come to light. The consequences were enormous. The figures Nicholas produced during the decade 1180–90 gained still further in power of expression, as can be seen from the prophets and apostles of the shrine of

the Magi in Cologne cathedral. The following decade brought a similar upheaval in cathedral sculpture – though whether this was directly influenced by Nicholas and his œuvre remains a very open question. In addition to the Meuse region, there were other places – Halberstadt, Winchester, Santiago, Venice – where the figurative arts were now taking a new direction.

In French sculpture, the first important centre to register the change was Laon. Compare the archivolt figures of the Coronation portal with those of Senlis or Mantes, and the profundity of this change becomes clear. For the first time we observe what might be called a natural relationship between the bodies of the calm enthroned figures and the draperies flowing round them. The fabric dips gently between the knees, it accompanies the thighs in downward hanging arcs or breaks at the feet in gentle waves against the socle. The vehement activity of the Senlis figures was not only overdone but also, because of the curved forms, highly artificial in its composition. Here everything is much more tranquil, much less expressive – yet for the first time the whole figure seems imbued with life. More astonishing still is the archivolt of the Virgin's portal. Look at the Sibyl: in the unclasped mantle, the long robe concealing yet revealing the form beneath, the hand gripping and lifting the material of the garment, there are similarities with motifs used forty years earlier in a female figure on the portal at Angers, but their transformation now creates an impression of liveliness. Such comparisons make clear what deep significance lay behind the new interest in models from antiquity.

The second workshop of gothic sculpture to respond *c.* 1190 to the great change in European figurative art was Sens. On the Baptist's doorway the figures in the tympanum and archivolt exhibit motifs taken over from Mantes. The socle reliefs show something different. Flowing garments, light as veiling, play about a tall, upright figure. The contours are curved, the windings still follow the dictates of an ornamental line, yet at the same time they reflect the living form of the personages portrayed – sensuous, animated beings. The Sens figures are more sensitive, more flowing than the sterner statuesque figures on the Virgin's portal at Laon. In the Stephen of the trumeau of the centre doorway the dalmatic does not feature straight running folds, but neither are there any bold curves. The material spreads itself in tranquil swinging movements and broad arcs, the hands close gently on the book, the face with its almond-shaped eyes has a serenity almost without accent. Also characteristic is the fine head of an apostle, presumably from the jamb of the centre doorway: the hair plays loosely about the oval face, the physiognomy, with its slanting eyes and curved lips, gives a relaxed effect. One is tempted to think of Hellenistic heads – yet here the realism is lacking, there is a want of strength, as well as of energy, in the sculptural form. But how, one wonders, did Sens come to make the transition from the archivolt of the Baptist's doorway to these later, totally different works? Was it through contacts with Laon? The theory is seductive – but the marked differences tell against it. A closer approach to the sources of this figure style might be by way of glass painting, that is to say the Sens windows.

Laon and Sens are the points of departure for the sculpture of the early thirteenth century. Admittedly, the formal vocabulary of these workshops, the first to turn to antique models for inspiration, shows a delicacy and subtlety that was not attained elsewhere. In the bustle of the large yards the finer nuances of the style's formation were often lost to view. Braine is in the direct line from Laon: the surviving sculptures certainly have a sensuous radiance, which is as evident in the burlesque drama of the Hell scenes as it is in the maidenly grace of the bending Mary. However, they do not possess the same delicacy of drawing and of contour as that displayed in the archivolt at Laon.

On the Coronation portal at Chartres, figure types found in the Laon archivolts have been adopted as the stylistic basis for a sequence of jamb figures. Here, too, the drapery stretches over the body in thin lines and follows limbs and gestures in gentle movements. The attributes are held with care. The facial surface is symmetrically curved, drawn far apart. Another striking feature in these figures is their breadth. Instead of being worked from the edge, as on the Royal Portal, the block appears to have been worked from one of the sides. The figures have no real depth; they are taken from wide but shallow blocks, in their original appearance presumably somewhat like heavy planks. With this goes a distinctly

70, 71, *ill. 48, 49*

44, 45; 46

70, 71, *ill. 52*

33

58, *ill. 35*

61

62

64

73–75

Ill. 50–52

83

85

10

relief-like conception, which leads the gestures along in front of the body, indicates *contrapposto* motifs in the drapery, but does not develop them by a three-dimensional play of limbs. As a result, the

83, 86 row of figures gives a highly decorative effect, so much so that a figure like the John the Baptist, with his tense bearing and expressive countenance, becomes unusually arresting, since it is so out of keeping with the general harmony. The portal shows throughout an admirable sureness in the delineation of har-

78, 79 monious contours, in achieving a graceful play of lines. The baldachin on its slender columns, its moulded arch adorned with small rosettes, crowns the enthroned pair in the tympanum like a priceless diadem. The fine ridges of the drapery folds have an air of asperity, and there is nothing playful about the draping of the material over the carefully profiled plinths. There is a nobility in the gestures which

80, 81 is formally perfect. The same ceremonious calm prevails in the archivolt – movements, gestures, expression, all are muted. Nothing remains of the rapture, the joyous excitement, of the corresponding

44, 45 figures at Senlis. All directness is renounced. This is a dispassionate, highly formal and ceremonious manner of representation. It is also far from being the formal language of Nicholas of Verdun. Laon was more lively, more sensitive. The formal vocabulary of the very early thirteenth century has here become a medium for decorative composition.

110, 111 Similar traits, with a greater rigidity of line, are displayed in the row of Apostles on the jambs of the Chartres Judgment portal. Here, too, one has the impression of figures carved from broad shallow blocks, worked up as reliefs rather that statues. Hands and arms splay against the broad expanse of drapery; note too the backs of the hands – so flat and smooth that one can almost see layer after layer being flaked away from the horizontal block. The equalizing tendencies are more pronounced than on the Coronation portal. Strict ordering of the total composition is the aim, not the attempt to impart life and feeling to individual figures. Statuary motifs, the stressing of *contrapposto*, are repressed by a schematically uniform delineation of the drapery.

Ill. 52; 98 left The Laon Sibyl has a later counterpart in a female statue in the north porch at Chartres. In the porch statues the form is freer, the roundness more pronounced, than on the walls of the portal. The ultimate location of the statues played a part in determining the techniques used on them in the workshops. Even so, the differences between Laon and Chartres are characteristic: the porch statue has a volume which is

96, 97 positively cylindrical. The gestures hug close to the body and the pleating of the flowing drapery looks like the flutings on the drum of a column. Even here in the porch, this is a figure style without passion. The female statue on the right, next to the centre doorway, is motionless. The draperies fall in broad lines, smooth and straight; the bell shape made by the folds where they billow on to the polygonal socle avoids all hint of disturbance from a rippling movement. There is constraint in the gestures, the large flat face, with its narrow eyes, looks calm and untroubled. One admires the sureness in the economic use of the craftsman's resources, which leads to a noble effect, even when passion is wanting. The statues of the Chartres transept are not all of this stamp; the formal language of antiquity is not everywhere reduced to graceful routine.

In a memorable essay, Vöge described the 'master' to whom he attributed the sculptures of the

88–93 Chartres Solomon doorway as a 'pioneer in the study of nature'. Here again we have to reckon with a workshop rather than an individual sculptor: the jamb figures, for a start, are not all from one hand, but throughout we recognize an energetic attempt to make vivid living figures emerge from the block.

92 Solomon no longer stands on the axis of the jamb column; his pacing motif carries him away from the column, as though he would detach himself from the architectural setting. Here the *contrapposto* is no mere formula rendered by the lines of the drapery: the leg bearing the weight of the body is masked beneath the straight fall of the material, while on the opposite side the calf, knee, and thigh are exposed to view, as though beneath a transparent veil. One might describe this as an attempt to grapple with statuary problems single-handed, and the result is not without power. Even the *outré* constriction of the hips and the emphatic crooking of the wrists are perhaps signs of the struggle to liberate the living form from the constraint of the block. The rendering of the drapery follows no fixed, pattern-book,

52

scheme. Its aim is apparently to reflect the body's every protuberance, movement and twist. But all these advances stop at details, since there is no canon of proportions, no anatomy to learn from. The sculptor has to fall back on empirical observation, which focuses on the separate motif, never on the whole. The whole remains extremely stylized, determined by formal habits of an earlier date – as a glance at one of the Sens socle reliefs makes plain. 61

Animation of the outward form goes hand in hand in this case with heightened capacity for expression. The royal pairs on the Chartres west portal are totally inactive. But here the Queen of Sheba is 11 shown pacing, as it were approaching. At her feet is one of her retinue, a Moor, bearing a cup filled with 92 the coins she has brought as a gift. Further, the queen from the south is turned towards Solomon the Wise in a questioning attitude, while he, from his place higher up on the jamb, raises his expressive, finely curled head as though to listen. The change of form, the encounter with motifs of an earlier period, thus provides the sculptor with new opportunities for a convincing presentation of the biblical content as drama, drawing not only on the texts but on life.

Portrayal of ecclesiastics offered the craftsman the ever-present temptation to devote and limit his skill to the faithful imitation of sumptuous liturgical vestments and insignia. There are eloquent and dismaying witnesses to this in the martyr statues on the south transept of Chartres. Regimented in 116, 117 bearing, each performing the same ritually prescribed gestures – they might have been made from a stencil. But the desire for greater animation and individuality made some headway even with this species. On the right jamb of the Confessors' portal at Chartres the huge statues are pivoted, like Solomon, 121 against the shafts. Next to the doorpost we have a towering Martin: with head held high, his high forehead topped by the mitre, he dispenses blessing. At the far end we have Gregory, whose spiritualized features wear an absent expression – he is intent on hearing the voice of the Holy Spirit, speaking through the dove perched on his shoulder. Between them we have the man of letters, small in stature, his head uncomely but individualized: Jerome the translator, wresting from Synagogue the text of Holy Writ. Each figure bears an individual stamp.

Without the model of the Chartres Solomon or the Chartres Modesta there would have been no 92; 98 Strasbourg Synagogue. Here the formal language rises to a pitch of emotion which is all the more 133, 135 moving and impressive because it goes with such delicacy of figure formation. In the Death of the Virgin 131, II it attains an intensity in the portrayal of pain and grief which has invited comparison – by no means gratuitously – with the heads of the Laocoön group in the Vatican. Comparison with the Assumption on the lintel at Senlis, some fifty years earlier in date, once again makes plain the significance of antique 43 models for gothic sculpture. In power of expression the two reliefs are equal, but the vehemence of the curved, exaggerated forms at Senlis is transmuted at Strasbourg. The excitement imparted to the outward form, to gesture, facial expression and drapery, now reflects a strong feeling of emotion. The formal language is not only expressive but also sensitive.

The Isaiah of the Rheims west façade is of the same type as its counterpart at Chartres, and may derive 219; 83, 85 directly from it. Compared with the slender, noble forms at Chartres, the Rheims prophet appears something of a monster. The forms are massive, projecting, with an enormous head on broad shoulders. At Rheims the blocks seem always to have been larger than those used by other workshops. As a result the volume is unbalanced, with over-emphasis on the weight-bearing leg, and the giant figure has small feet and slender ankles. The thoroughly uncanonical proportions immediately hit the eye, and comparison with any antique sculpture would show up the difference.

Rheims cathedral poses the problem of the encounter with antiquity in a new guise. Whereas with Nicholas of Verdun and the sculptors of Laon and Sens we have to reckon with only indirect contacts with such sources (possibly by way of the Christian East), the Rheims sculptors have in a few instances made a study of classical sculpture. The path gothic sculpture had taken since its beginnings in the third decade of the twelfth century was probably bound to lead, sooner or later, to a confrontation with the free sculpture of antiquity. At Rheims the whole idea of the statue was involved in just such a

241
111 debate. The John of the Rheims Judgment portal, for example, is differentiated from its counterpart at Chartres by a totally different approach to the sculptural problems. At Rheims the jamb figure of John, a thickset bulky figure, stands conspicuously free, detached from the shaft of the column. Above feet set close together the outlines draw widely apart, the shoulders are disproportionately enlarged, the side with the weight-bearing leg is made prominent by an accumulation of falling fabric. Placed beside anything antique such a figure, because of the misunderstanding of weight distribution and displacement of statuary problems from the body to the drapery, would again appear alien and misshapen. One sometimes hears the expression 'Rheims classicism' – a figure of this kind then gives it the lie. It bears no relation to antiquity as a canon setting standards. On the other hand, in the thirteenth century such a figure is notable for its volume, its assertion of independence of the portal architecture, and its *outré* attempt at *contrapposto* effect.

The sources of the antique motifs at Rheims cannot be positively identified. The Rheims workshop had contacts with Chartres, which placed them from the start within the same tradition. A figure like 241 John may also have absorbed motifs from Roman sculpture, but incorporated into a style becoming current around 1230, which has not been learned directly from the antique. The figures on the left 246 jamb of the Calixtus portal appear, at a quick glance, thoroughly 'antique'. But the angel on the left 94 reproduces drapery motifs from a Chartres Isaiah, the Eutropia modifies the drapery of a Chartres 95 Elizabeth. At the outset the figures were no doubt based on the Chartres types as contained in a pattern book. In the transposed form an effort has been made to modify their column-like appearance. The bodies are more rounded, more compact, the play of the limbs is less restricted, the draperies hang more loosely, their pleating is more lavish. It certainly looks as though other and fresh impressions have intervened – perhaps derived, though this is not certain, from Roman sculptures. The effect produced is by no means antique: large voluminous forms embellished with minute detail. These figures, on their tendril-covered socle, seem displayed like church plate or precious reliquaries: dignified vestments rather than living forms.

240 The Peter of the Judgment portal is, like the John, poised on feet set close together, and shows the same projection of the outline at hips and shoulders, the same accumulation of falling fabric on the side of the weight-bearing leg. The rendering of the drapery is different. In place of flaccid arcs and folds in loop-shaped valleys, we have sharp ridges, angular enclosures, harsh wrinkling. Attitude and drapery are tense, full of expressive energies. This marks another abrupt dialectical change in the understanding of the antique form: the aim is not the rounding of the folds but their harsh disruption, not to solve the problems of weight distribution but to achieve an expressive effect through pointing up the drapery. It was no coincidence that the style which gave rise to the Bamberg Elizabeth had its beginnings here.

The head of the Rheims Peter, with its energetically modelled cranium and curling hair modelled in the antique style, has been compared with a portrait of Antoninus Pius. Technical details – the drillings in the hair locks for example – certainly point to a knowledge of Roman sculptures. The physiognomy, however, remains in the tradition of Petrine iconography, and neither in the curling of the moustache nor in the cut of the eyebrows is there a literal imitation of classical models. The zealous, demanding expression on this Apostle's face is clerical, medieval, certainly not classical. Thus the antique is not here an ideal to be revived for the sake of its canonical validity; study of the antique, like the study of nature, is an auxiliary tool, whose function is to promote more life-like representation, and to free 253 sculpture from traditional formulas. The face of the angel in the chevet chapel at Rheims is stylized in the thirteenth-century manner. The luxuriant hair, an imitation of the coiffure of Roman ladies, is reminiscent of a full-bottomed wig.

Likewise, the most famous reflection of the antique in the sculpture of the thirteenth century, the 199, IV Visitation group on the Rheims west façade, differs from its classical models through what it seeks to

IV Rheims cathedral, west portal, centre doorway. Visitation group, from the right jamb (cf. pl. 193). Approx. 1230–33

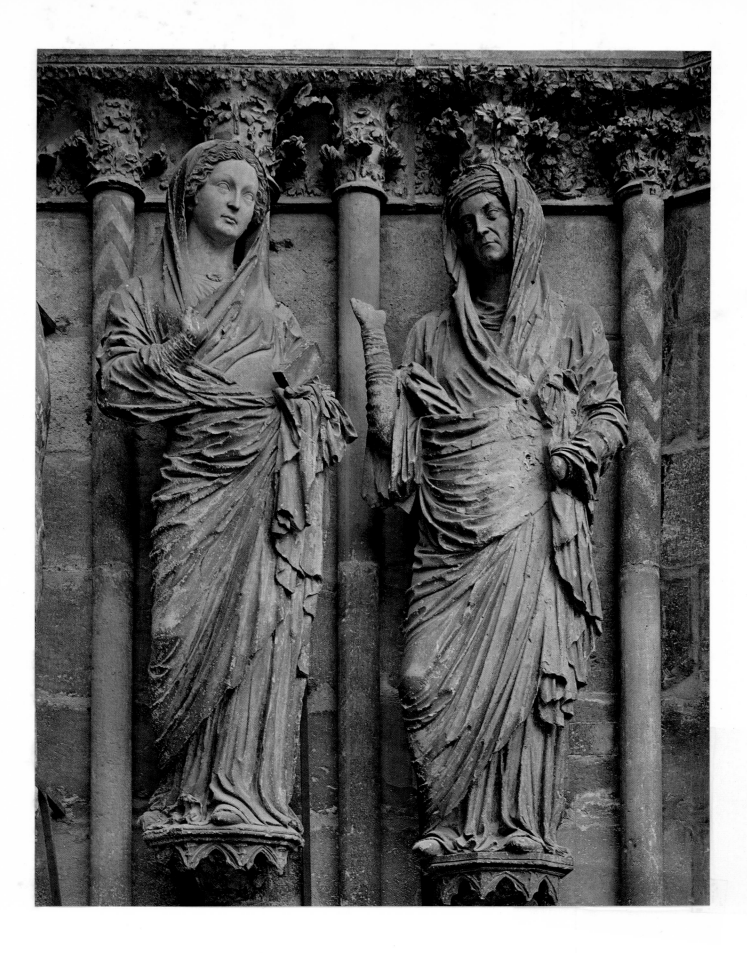

achieve. When the thirteenth-century sculptor, in order to depict their prophetic encounter, renders the biblical figures of Elizabeth and Mary in the style of the classical female statue, there is no question of an imitation of the ancients in a spirit of humanism or classicism. The variation in the forms, the delicate tension of the drapery folds, the linear rendering of the faces, the isolation of the solemn gesture of salutation, all point ultimately to a relation between content and form which differs fundamentally from the antique. Here every line is full of expression, and the group as a whole exudes a feeling of promise which no classical model could have transmitted. The humble inclination of this Elizabeth's head, with its sensitive and almost sentimental delineation of old age, despite all conceivable borrowings of vocabulary, is not antique in style. In all its encounters with the antique or with models in the antique style, this sculpture was merely looking for ways of presenting with greater conviction, greater vividness, a message which ran counter to the classical world.

THE NEW FIGURE STYLE: FROM THE CORONATION PORTAL OF NOTRE DAME, PARIS, TO THE ROYAL STATUES OF RHEIMS CATHEDRAL

At Amiens, as at Chartres, the Queen of Sheba wears a full-length girdled robe and a mantle draped across both shoulders. Respectfully, she has removed her (restored) crown, and appears to be listening, with slightly bowed head, to Solomon's utterance; there is no indication of pacing, no hint that the queen from the south is approaching Solomon. The attitude is column-like in its rigidity and no movement of limbs can be detected beneath the thick straight folds of her clothing. She stands on a domed socle, on which the hem of her dress is spread as though frozen. There is no play of facial features; beneath an unlined forehead lodge rather unexpressive eyes. The smooth surfaces of the cheeks encompass a small, unemphatic mouth. The king has turned towards his visitor; his left shoulder pivots slightly forward, from the gesture of his hands it is clear that he is engaged in exposition. However, he too stands rigid as a column – the limbs are hidden beneath the stiff folds of his tunic, the stuff of the mantle lies across the front of his body, as firm and harsh as metal. Its folds are not rounded and buoyant, but angular.

This stylizing of the human figure made its first appearance on the Coronation portal of Notre Dame in Paris. A royal pair on the jambs of Saint-Germain-l'Auxerrois shows the same type, more feebly executed. In the composition on the tympanum of the Paris Coronation portal, strict order prevails. Enthroned in the lintel are frontally depicted figures which are outlined in sharp relief against the neutral background. The activity round the Virgin's tomb is depicted without a trace of emotion; this Assumption is as remote from the whirling tumult of Senlis as it is from the emotional grief of Strasbourg. The figures, symmetrically disposed, unite in a solemn ceremony. The tone is muted, the gestures restrained – whether they indicate grief or meditation is impossible to decide. The crystalline clarity and severity of form are seen at their most characteristic in the figure of Peter. The countenance is unblemished, the attitude one of composed solemnity; the drapery folds are drawn together as firm surfaces, they do not play in curves and arcs over rounded limbs. This noble apostle-figure gives an impression not of animation but of distance, of perfect coolness. Similarly, the dialogue between the Queen of Sheba and Solomon at Amiens is reduced to a few sparing gestures. There are no sensuous radiations from the

56

paired figures on the jambs of the Amiens Coronation portal. Hands held in front of rigid bodies execute spiky, angular movements. The Elizabeth is an old woman with sharp profile and stern features. Her body is concealed beneath the thick, stiff folds of the garment as though by a nun's habit. The effect is frosty.

This revolution in style, which began on the Paris Coronation portal, led to the cultivation of new forms of gothic jamb figure. It entailed a total departure from the models which had first gained currency at Laon and Sens and whose influence is still manifest in the Visitation group at Rheims. When one looks at the standing figures in the archivolt of the Paris portal, one is at once struck by the complete straightness of the pose. No distinction is made between the weight-bearing and free-moving leg; the statuary motifs are frozen into a column-like rigidity. The drapery falls in straight lines, all trace of emotion or passion is avoided in the expression. This is the stylization now becoming current in the big yards, with Amiens in the van. It is well suited to the standardized production of large figure-cycles, of the kind already to be observed on the Chartres transept.

152, 153

Compare the sequence of Chartres Apostles with the sequence at Amiens, and the differences in formal treatment become clear. The Chartres figures look slender and column-like beside the massive stone blocks at Amiens. The finely delineated drapery at Chartres accentuates still further the slender, elongated dimensions of the limbs. At Amiens, the sculptor treats the figures like massive cylinders, to which broad, rigid, tubular folds are applied at regular intervals. Take the three figures on the left: all hint of *contrapposto* is renounced. This drapery style is lifeless, lacking in imagination. The human figure has been subjected to a stencilling operation, just as decorated shafts and columns were cut to a pattern in the masons' yards.

110, 111
162

Cultivation of the new style of figure was no doubt encouraged by the change in architecture, and perhaps by a certain rationalization of working methods in the masons' yards. The exterior dimensions of a façade as vast as Amiens would scarcely permit the delicate, fine linear rendering of forms that could be practised at Laon or Sens. Even the Coronation portal in Paris, in size quite modest, when compared with Amiens reveals great subtlety in its handling of detail. At Amiens the procedure is coarser, more mechanical. This may be due in part to the magnitude of the task, and perhaps also to an accelerated tempo of working. That there was a standing temptation in the big yards to simplify the treatment of figures and so save time is obvious enough. The porch statues at Chartres are eloquent examples, though they still use motifs which hark back to antiquity. So far as art history is concerned, however, these external factors are peripheral, interesting only because of their triggering effect. What is important to notice is that the new style of drapery and figure has its own capacity for expression, which transformed the methods of representation not only in sculpture but also in painting.

161

97

We saw that in the Rheims Peter the exaggeration and hardening of the rendering of drapery led to a heightening of the emotion. We notice something similar when we compare the trumeau Christ of Amiens with its counterparts at Rheims or Chartres. The Chartres Christ, with its calmly spreading forms and flattened face, produces a noble and dignified effect, but with no specific accent. The Rheims figure presents a fuller and freer appearance. In its movement there is tranquillity, and it exudes an air of mildness and classical beauty. Amiens, however, shows a totally different sharpness; the narrow ridges and rod-like lines, characteristic of the new drapery style, harbour energy and zest. This is more abrupt, colder and more rational than Chartres or Rheims.

240
163
109
237

In the Prophets' statues on the Amiens buttresses we see that the drapery rendering has been simplified to an extreme degree. In the case of Habbakuk or Zephaniah the hem of the undergarment displays the same rigid folds, resembling the profile of a clustered pier, as those of the Amiens Apostles. Zephaniah's mantle is drawn over both shoulders. On the right the material hangs completely straight, clearly marking the edge of the block. The right hand with the banderole is raised, lifting the material with it. The left hand, carried up obliquely across the breast, is as it were bandaged beneath the material of the mantle. The arm bending towards the central axis of the figure had been among the stock motifs of

170, 171

162

10, 11 gothic jamb figures since it first appeared on the Royal Portal at Chartres. The technical reason for it was the sculptor's restriction to the block, which prevented a free, three-dimensional deployment of the limbs. It must further be noted that the Amiens Zephaniah has clearly been made specifically as a corner figure. Here, however, the summary rendering of the drapery surfaces does not result in mere stiffness, nor again does it compel a merely clumsy effect. Just as the gothic pier, while showing none of the entasis of the classical column, nevertheless produces the effect of form filled with energy, so a draped gothic figure of this kind is placed like a projecting wedge on the edge of the wall. The block is not shaped and animated as a whole by the action of the body, but this makes individual lines of movement appear all the more sharp and dynamic; they point the figures, producing a conscious effect. Hence while gothic statues of this advanced stage have nothing really harmonious about them, they can possess a provocative elegance, an extra refinement and pungency of expression.

156 With this tendency to pointedness goes the increased importance attached to the outline. Here again the Paris Coronation portal led the way. The Beheading of John the Baptist on one of the socle reliefs is shown only in side view. The little figures stand out in sharp relief against the background. Most impressive is the figure of Salome: an unnaturally slender figure clad in a girdled ankle-length garment with a braid of hair falling below the waist. The fixing on a *single* feature, together with the modish

204 attire, produces a brilliant effect. The Rheims Queen of Sheba is more imposing, more gorgeous: the swing of her clothing as she walks, the gathering and parting of the mantle, the slight turn towards Solomon – here is a wealth and variety the Paris figurine does not possess. An almost classical beauty in the body merges harmoniously into the High Gothic composition of the drapery. But here too the specific effect, the air of the *grande dame*, is achieved by bunching the form into a few bold lines. One

92 need only look back to her Chartres counterpart to recognize what was achieved by the changeover from the delicately linear, classical rendering of drapery to the heavier, simpler forms. An extreme

188 example of the way point was given to a figure is the Madonna of the Paris transept: with the elongated, appearance of the lower half of the body is combined a bold rendering of the drapery, the lines of which leap up to converge on the left hip. The impression of heightened animation is, however, an illusion; the small head with its smooth and pointed face is neat but dry.

It was at Rheims *c.* 1230 that the displacement of the classicizing rendering of drapery by plain surfaces or the harsh rupture produced its most astonishing effects. The change is already noticeable

240, 241 in the jamb figures of Apostles on the Judgment portal: in Peter, and still more in Paul, a transformation of the traditional fold motifs is in progress, and gives rise to some distinctly expressive lines. Then in

237 the Christ we find predominantly smooth surfaces traversed by a few long folds. The Eutropia of

246; 259 the Calixtus portal and the Eve next to the rose window of the transept have much in common. Indeed, the heads are so closely comparable – pointed ovals, with the same sparse, lightly undulating hair and narrow eyes – that one might think of them as by the same hand. But while the rendering of Eutropia's drapery shows what can only be described as a hypertrophy of classicizing motifs, the surface of the figure of Eve is smooth. The material of her garment either fits close to the body without creasing, or else lies across it in a few large folds. This is a radical departure from the classicizing rendering of drapery.

The stylistic revolution unfolds still more impressively in the royal statues at Rheims and in the

264 archivolt of the rose window in the transept. A king in the east aedicule of the south transept displays a

261 rendering of drapery still fully in the style of the north porch at Chartres. The so-called St Louis on the west side of the north transept displays the combination of large tranquil surfaces traversed by long

237; 260 folds, which also characterizes the Christ of the Judgment portal. In the so-called Philip Augustus the activated drapery motifs have become frigid and unwieldy. The urge to give point works up to an

262, 263 excess of emotion. In the archivolt of the south rose the violent actions are represented in angular,

91 harshly disruptive, splintering forms. Compared with the Judith of the Solomon portal at Chartres, the effect is more piercing, more abrupt, sharp to the point of bitterness.

58

THE STYLE OF THE FIGURE OF JOSEPH
ON THE WEST FAÇADE AT RHEIMS

On the tympanum of the Paris centre doorway, the composed, formal language of the Coronation 153
portal is already yielding to another manner of representation. In the apex of the tympanum, the 147
intercessors and the angel with the cross are still wholly in the style of the Virgin's portal, but the angel
with the lance, and the Judge, display new forms. It is not merely that the drapery is gathered into
tauter, larger folds; the physiognomies have also changed. The face of the Judge is not rounded but a
pointed oval; the eyes, like the mouth, are drawn up at the outer corners, the hair makes restless waves
or coils in ringlets. Iconographically this Judge is very much the type characterized by a severe and
solemn countenance, yet there is something affected in the presentation. The same differences are to be
noted in the fragments which survive from the lintel. One, from the right-hand corner, displays the 146
tranquil self-contained forms we know from the Coronation portal. On the opposite side we find
pointed drapery folds; the facial expressions are more piquant, the surrounding locks of hair are
rendered in an agitated, life-like manner. The line is becoming more fidgety, more mobile, the sculptor's
'handwriting' more spirited and calligraphic. One has to ask, too, whether the well-bred touch, the
element of over-refinement, perhaps reflects one of the social aspirations of the epoch. We lack the
criteria which might provide an answer; in any case, even figures whose forms are among the most
surprising, on closer examination show themselves fully in line with types handed down by icono-
graphic tradition, and the connection between art and life is presumably always of a reciprocal nature.
The fact remains, however, that this is not a question which would readily occur to anyone looking,
for example, at the Coronation portal at Senlis.

The so-called Childebert from the trumeau of the refectory of Saint-Germain-des-Prés may have 175
originated within the sphere of influence of the atelier of Notre Dame, or at least of its immediate suc-
cession. It displays a dancer-like affectation of pose and gesture, and a pronounced elegance of facial
type. The wavy hair, smoothed back from the narrow face with its high straight forehead, is fashioned
into a great roll at the neck, the moustache curls itself round a pointed mouth, the beard stands out like
a garland framing cheeks and chin: a coiffure which might have been artificially contrived with
curling tongs to give a modish, impeccably groomed effect. Whether in fact it reproduces a contem-
porary hair style is hard to say. We have to remember that methods of rendering hair were adopted,
not without modification of both the motifs and the manner of presentation, from ancient sources.
Even so, there is a persistent air of courtliness. If one looks back at, say, the Chartres Solomon, the
feeling that Childebert reflects more the conventions of contemporary life is hard to resist.

In the cultivation of such types Paris apparently led the way. Among the sculptural works within
the orbit of Paris in the second quarter of the thirteenth century is the Baptist's tympanum at Rouen. 182
In the banquet scene we find the same affected, modishly stylized manner. All the forms have point
and grace: note the poses of the kneeling servants, of Salome at her balancing act. There is formaliza-
tion in the pointed yet surprisingly true-to-life rendering: the dog begging in front of the table, the
bald-pated jester pointing to the royal couple above, Herodias turning towards her spouse with a
movement at once affected and langorous. Not a single detail conflicts with pictorial tradition or with
the meaning of the text – this is no profane scene depicted at whim. Since the twelfth century, however,
the relationship between the pattern and its artistic realization has clearly altered. Here again the scene
perhaps reflects something of court etiquette, which might account for the affected, stilted presentation.
The exaggeration and pointedness, noticeable in gothic sculpture in general from the second quarter
of the thirteenth century, are here still further intensified in meaning.

Admittedly, in the context of church art such influences could take effect only within strictly
defined limits. This is demonstrated by the Apostles of the Sainte-Chapelle in Paris. Here, too, the same 184, 185

tendencies are seen: the restless disruption of the drapery surfaces, the calligraphy of the features, the finely stranded curls – all are in the tradition of the Judge of Notre Dame's centre portal. Just as the latter presented a countenance of implacable severity, so here too the over-refined, excitable forms serve a conception which is dignified and solemn. Indeed, it has to be said that compared with the Apostles of Chartres, which are of a wholly traditional type, the figures made for this reliquary chapel attached to the royal palace are more serious in conception. It is precisely through their refinement, their choiceness of form, that the whole appearance of these statues attains a new intensity of expression. In any case, we should not expect at this period to find a dividing line between the courtly and the ecclesiastical. Indeed, a sepulchral monument erected at Royaumont for the king's son, Louis of France, in 1260 displays an effigy which might be called Franciscan in its simplicity.

As mentioned earlier, in the thirteenth century martyr saints with their angel escorts were grouped together as large-scale figures on portal jambs. The earliest surviving example is to be found on the Calixtus portal at Rheims. At the side of St Nicasius an angel in antique dress paces forward, swinging a censer. His head, with its coronet of hair, is not turned, the facial features show no trace of emotion. At Amiens the escorting angel is rigid as to stance and bearing, but the head is inclined and the suggestion of a smile appears round the mouth. On the west façade at Rheims, in the angel to the left of St Dionysius, the rendering of movement is more pointed: he steps towards us with wings outstretched, the backward position of the right leg is clearly indicated, and he looks over his left shoulder at the martyr.

In style this angel belongs chronologically in the same period as the Visitation, though in comparison with the figures of Mary and Elizabeth the movements are admittedly more angular and the drapery more taut. With the later Rheims angels the statuary forms have become things of delicacy and grace. The slender figures seem to sway as they walk, indeed to float rather than to tread the solid earth, and the round heads with their lightly sketched tresses incline towards the martyr – bow to him, one might say – as he walks to his tomb. The fine-drawn, sensitive faces, are lit by ravishing smiles. Here again the brilliant presentation, the lightness and the charm, do not point to a secularization of the church's message. On the contrary, compared with earlier angels which have survived at Chartres, Amiens and Rheims itself, one might almost speak in terms of a fervent intensification of the sacred content, of supreme ecstasy. The figure of the martyr, so precious and worthy of veneration, is accompanied by roses on the capitals, and around him play the celestial smiles of angels. In the history of Christian sculpture it is not until we reach Bernini that we again meet figures in which corporeal beauty and religious ecstasy are so completely merged.

The Presentation in the Temple owes its importance to the prophetic words spoken by Simeon to Mary: 'Behold, this child is set for the fall and rising again of many in Israel; and for a sign which shall be spoken against; (Yea, a sword shall pierce through thy own soul also,) that the thoughts of many hearts may be revealed.' (Luke 2:34–35). As the author of this prophetic saying, Simeon earned himself a place on the gothic Coronation portal. Portrayals of the Presentation nearly always include Joseph, making it clear that he has entered the Temple behind the Virgin. At La Charité he follows behind her bearing the sacrificial doves, his gaze fixed expectantly on Simeon. On the Paris north portal the portrayal is similar: the respectfully covered head, the hands occupied with the basket containing the offering, the old man's face, gazing earnestly at Simeon – witness to a momentous event.

In the famous Joseph of Rheims this same content is raised to the highest degree of intensity. The oncoming and pivoting movements of this tall figure flow into one another in the tautened draping of the mantle, as if in the whirl of an elaborate dance. The inclined head turns toward the solemn event taking place between Mary and Simeon, even as the heads of the angels described above were turned towards the martyr. The type is more youthful than in previous portrayals of Joseph; the face beneath the pointed Jew's cap, with flying locks and eloquent eyes, bears the marks of high-strung sensibility. The whole figure is vibrant from top to toe.

60

This union of preciosity and emotion, of elegance and expressiveness, has remained unsurpassed. In many later works at Rheims it yields to a quieter mood, a more gentle feeling. The Passion cycle on the left doorway of the west portal contains moving representations of Christ's sufferings. The face of the large figure of Christ at Emmaus, on the rose window storey of the west façade, is deeply soulful. The figure of the Resurrected Christ, turning towards Thomas, despite its huge dimensions shows graceful, finely delineated features. Surely it was no coincidence that precisely this style of figure representation was taken up by the mystics of south-west Germany and perpetuated in the so-called 'devotional pictures'. There is an affinity here which goes deeper than one merely of form. 214, 215 228 227

THE DIFFUSION OF GOTHIC SCULPTURE

Gothic sculpture radically altered the formal appearance of the Church's traditional cycle of images. One might say, indeed, that it was rejuvenated. The figures of Christ, the Virgin, saints and prophets took on a new appearance. These types were accepted throughout western Christendom, and it was not only in architecture that Gothic now became the universal European style. The angels in the transept of Westminster Abbey, the cross in front of the jubé of Naumburg cathedral, the Virgen Blanca in the cathedral at Toledo, the Maries of Giovanni Pisano, are all a reflection of the sculptures of Rheims and Paris. Throughout Europe, local traditions were being ousted by the new ideal.

In Gothic's land of origin the sculpture of the great yards passed its peak soon after the middle of the thirteenth century. Ambitious new projects like the west doorways of Auxerre cathedral, which were begun by a workshop from Rheims, remain exceptions, and progress on them was significantly halting. At Notre Dame in Paris portals were erected on the south transept and the long choir, but these were isolated undertakings not to be compared with the gigantic projects of the first half of the century. Sculptors who probably came from Rheims were at work on the royal burial place at Saint-Denis even during the 1260s, but this was an unusual and unique commission, properly speaking outside the field of development centred on the masons' yards. Bishops were declining in importance and prestige, and the older religious orders and congregations had lost the position they held in the second half of the twelfth century. Commissions were drying up. At Beauvais and Cologne, where cathedrals lay unfinished, there could be no question of executing great portals or even of making a start. The mendicant orders, the Franciscans and Dominicans, despite their decisive role in the architectural history of the latter part of the thirteenth century, created no demand for sculpted cycles. Late portal layouts like the south portal at Amiens and the centre portal at Auxerre have rambling narrative programmes – ingeniously exact in the rendering of detail, but interpreted in a manner that is lacking in imagination and systematic planning. 283–287 187; 271 273 279

Gothic sculpture originated in the masons' yards of the Ile-de-France; it stands in the tradition of a highly developed, highly accomplished craftsmanship. Initially this may have been taken over from the schools of romanesque sculpture in Burgundy and south-western France, later it became autonomous in the masons' yards and even the minor works show evidence of high-quality training. With the transplantation of Gothic to other regions, however, there is a noticeable falling-off in technique. A coarseness of execution impairs a head such as the Peter at Chablis, which in type surely derives from heads at Rheims. The cut of the brows, the lines of the eyelids, and the delineation of the locks bear the marks of stumbling, undifferentiated chiselling. The face with its boorish expression might be taken for a peasant's, were it not that all the historical circumstances prove the contrary. The same Peter type recurs in distant Bordeaux, and the gruff type of physiognomy becomes the stock property of a widely scattered group of portal sculptures, which includes Saint-Thibault-en-Auxois and Semur-en-Auxois, and as a remote outlier, Le Mans. These are Rheims motifs, roughly on the lines of the 289 305 288; 291

204 'Odysseus' head, imported into the provinces by workshops of second rank. Even in these crude imitations, one detects an exceptional strength.

The propagation of northern ecclesiastical art in the south of France was the result of the conquest of the Midi by the Crown. Admittedly, these monuments grafted into alien soil are often deadly dull. 307; 308, 309 Portal layouts like Bazas or Dax vie in scope with Paris or Amiens, but they are stamped as imitations, 296 almost pedantic in their exactness. There is something of this even in the great portal façades of Poitiers 292; 300–303 and Bourges. Occasionally a spark of inspiration can be seen – at Charroux we find sculptures which reflect all the agility and sharpness of northern works, but these are exceptional. The fervour with which Germany, Spain, at times even England, grasped the forms of gothic sculpture and transformed them, was apparently wanting in the south of France. A remarkable coldness envelops these great portal compositions of the Midi; their hallmark is an air of sterile imitation.

THE PLATES

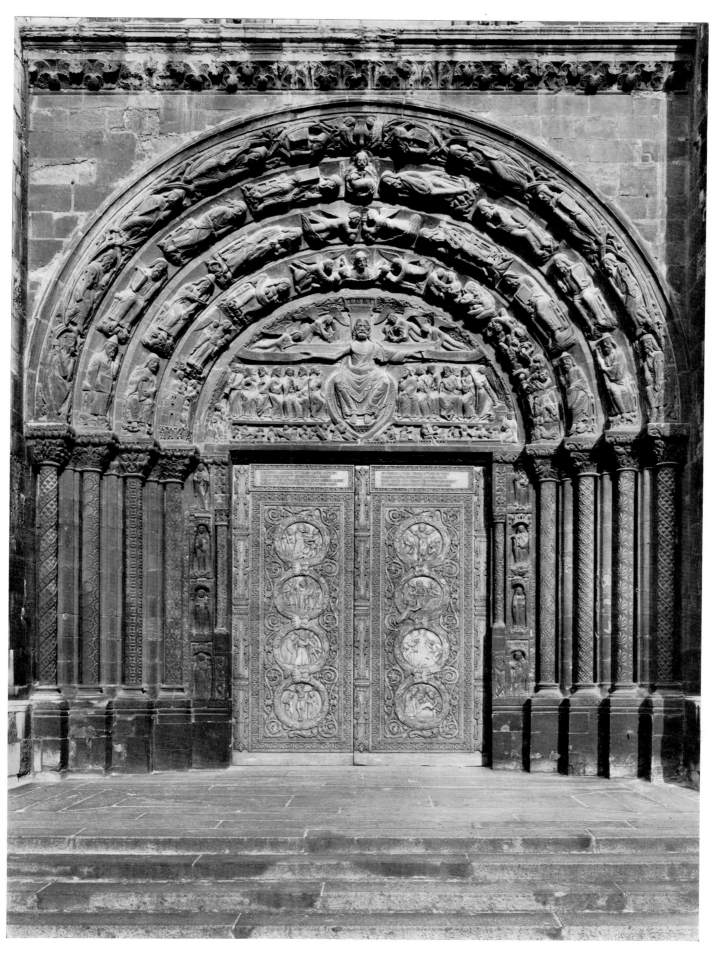

1 Saint-Denis, abbey church, west portal, centre doorway. Tympanum and inner arch of archivolt: Last Judgment.
Outer arches: Elders of the Apocalypse. Doorposts: Wise and Foolish Virgins. Before 1140

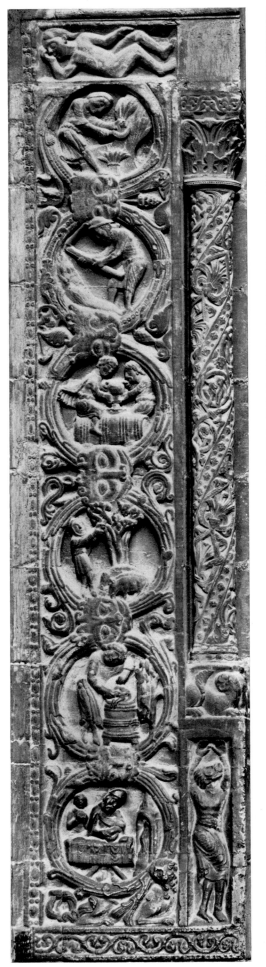
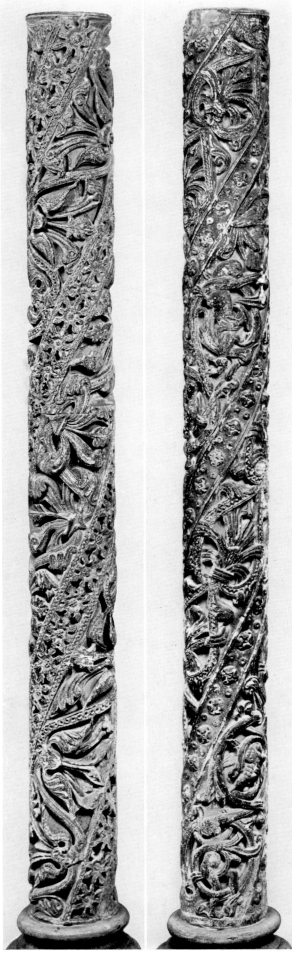
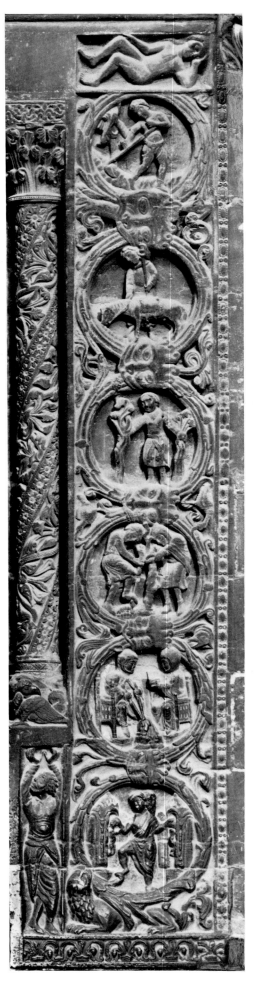

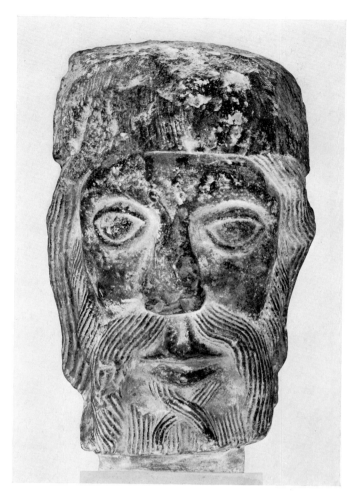

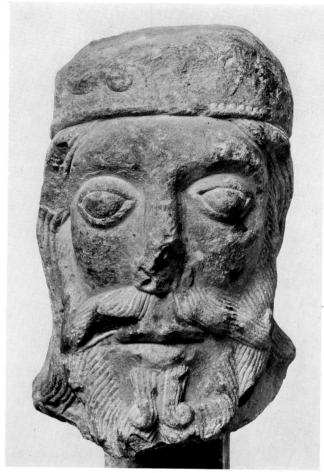

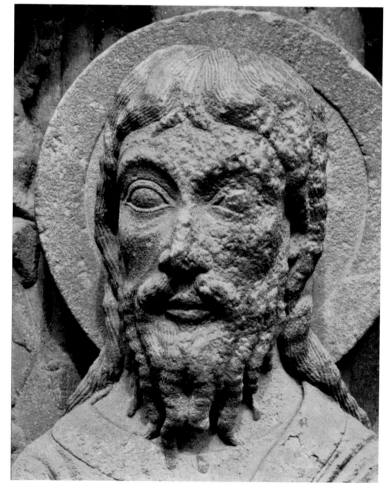

2 Saint-Denis, abbey church, west portal.
Left, right. Doorposts of right doorway:
Calendar. Before 1140.
Middle. Column shafts from doorposts of side
doorways. Before 1140. (Paris, Musée de Cluny)

3 *Top*. Saint-Denis, abbey church, west portal.
Heads from the archivolt of the centre doorway.
Before 1140. (Paris, Louvre).
Bottom. Chartres cathedral, right doorway,
west portal. Head of a figure from the right
jamb. 1145–55

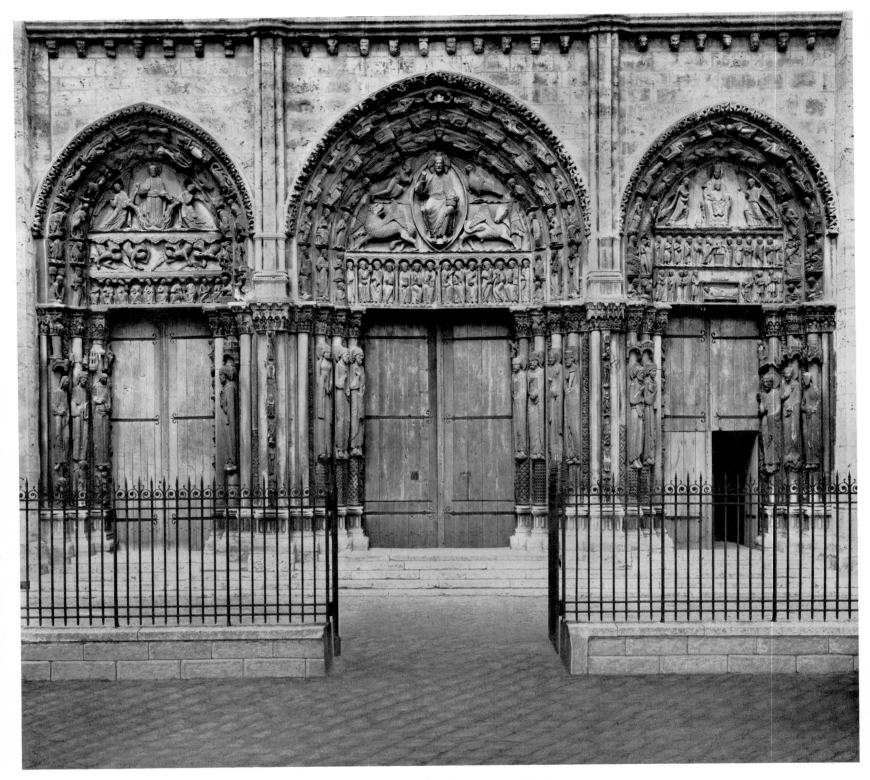

4 Chartres cathedral. West portal. 1145–55

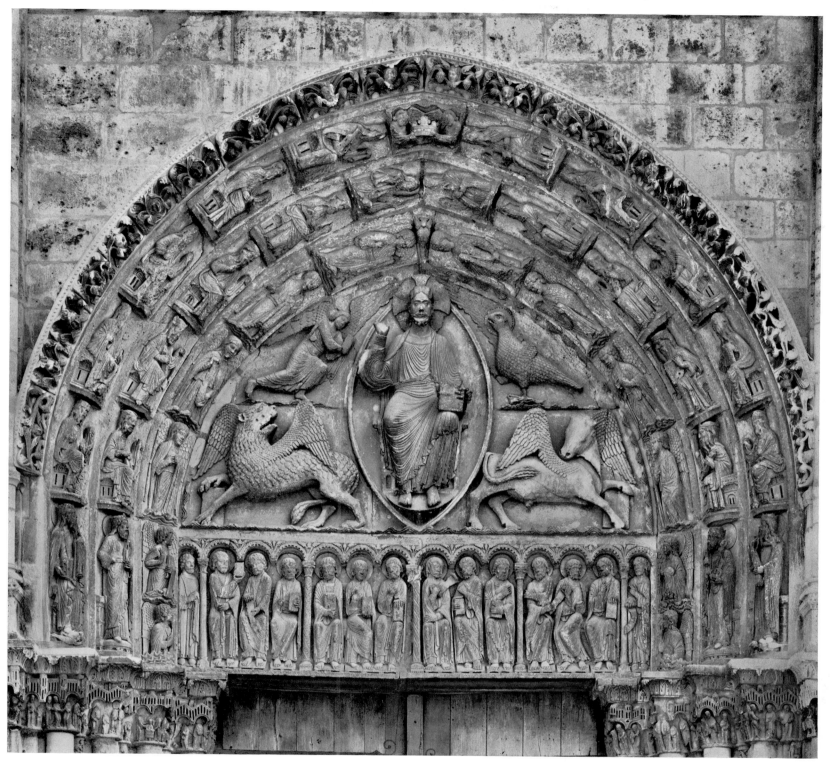

5 Chartres cathedral, west portal, centre doorway. Tympanum: Majestas Domini. Lintel: apostles.
Archivolt: Elders of the Apocalypse. 1145–55

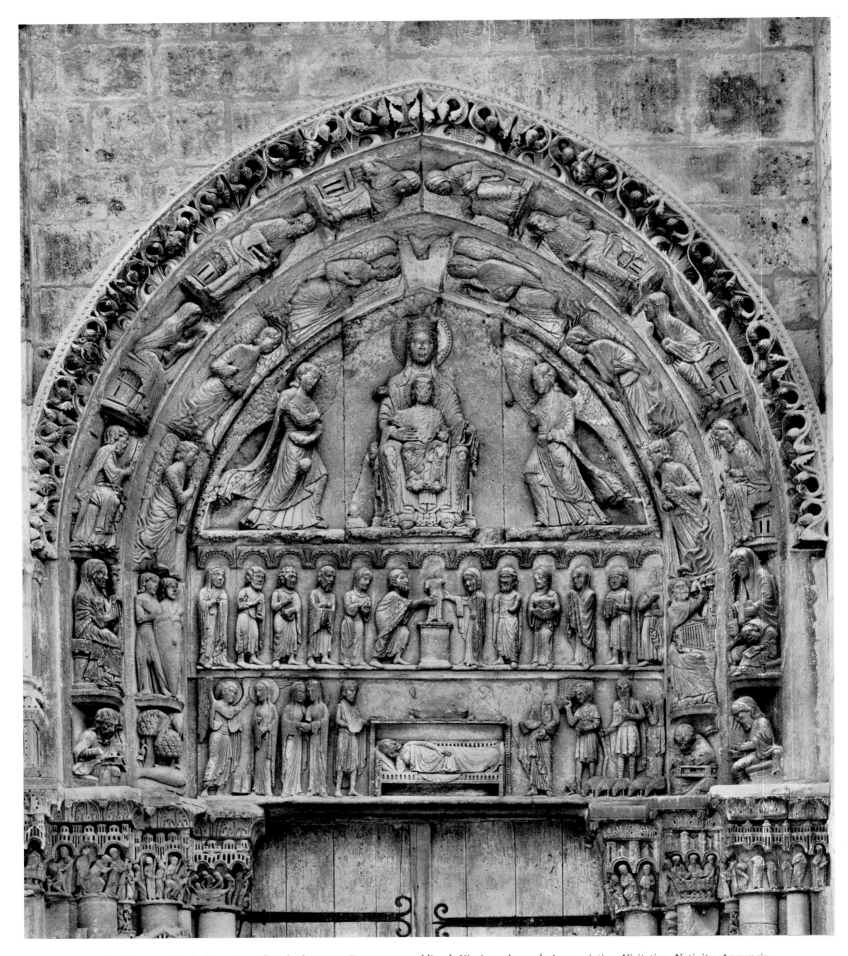

6 Chartres cathedral, west portal, right doorway. Tympanum and lintel: Virgin enthroned; Annunciation, Visitation, Nativity, Annunciation to the Shepherds, Presentation in the Temple. Archivolt: the Liberal Arts. 1145–55

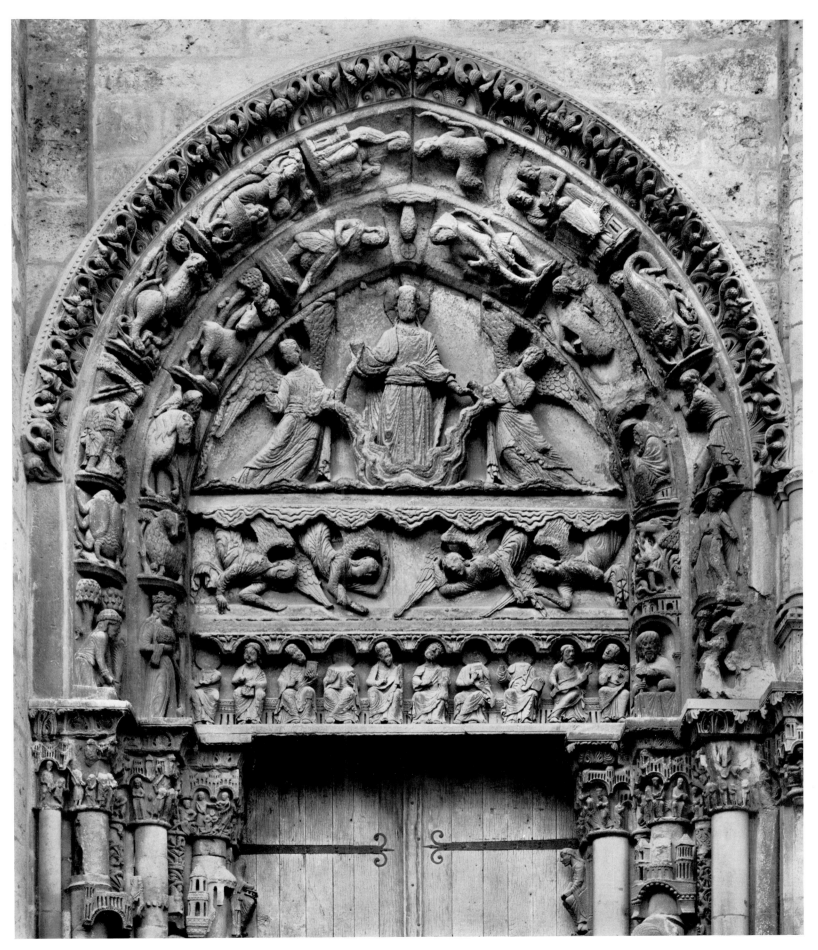

7 Chartres cathedral, west portal, left doorway. Tympanum and lintel: Ascension.
Archivolt: Zodiac and Calendar. 1145–55

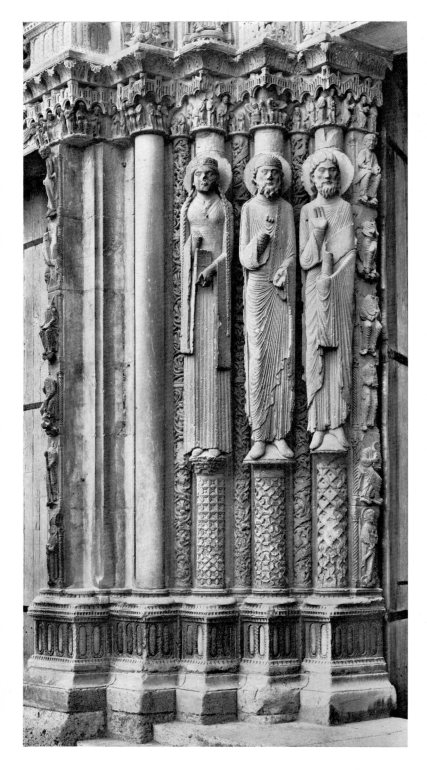
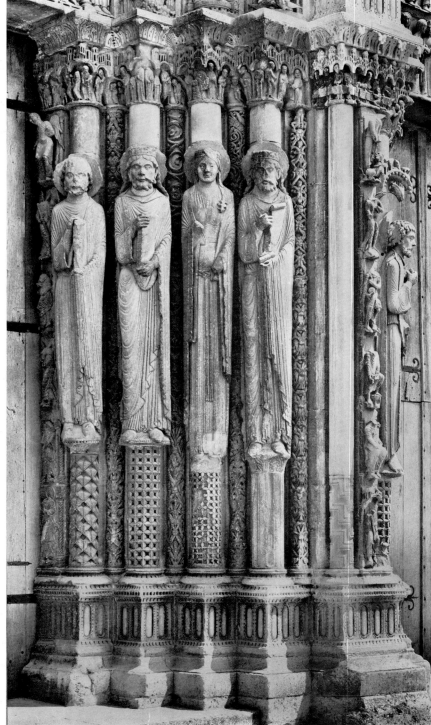

8–11 Chartres cathedral, west portal, centre doorway. Left and right jambs: Old Testament figures. 1145–55
9 Figure from the left jamb

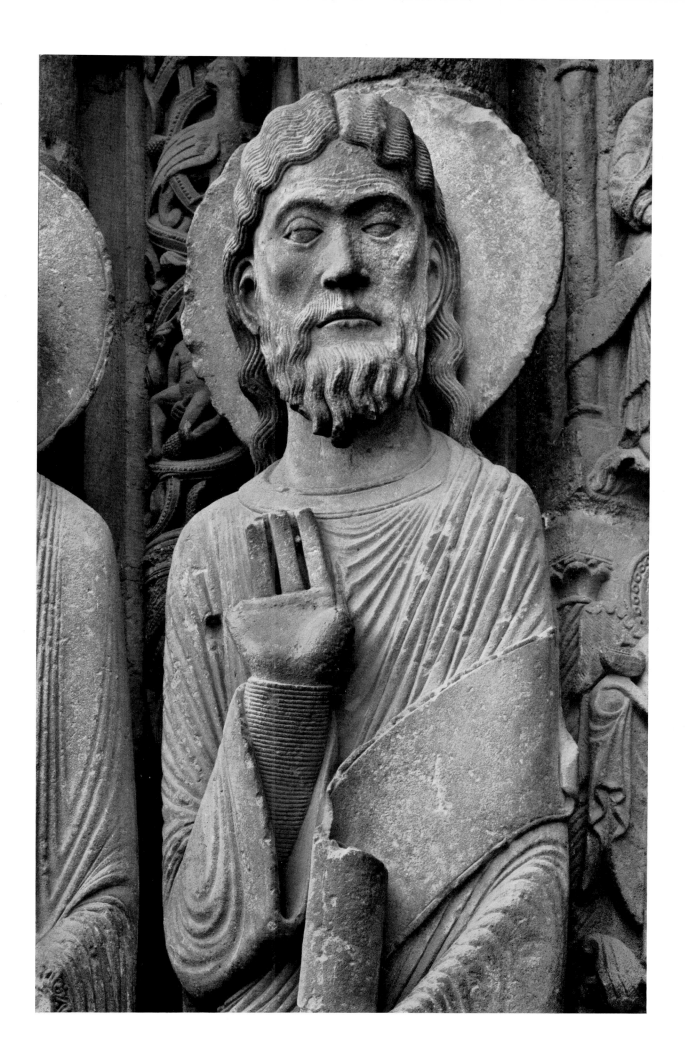

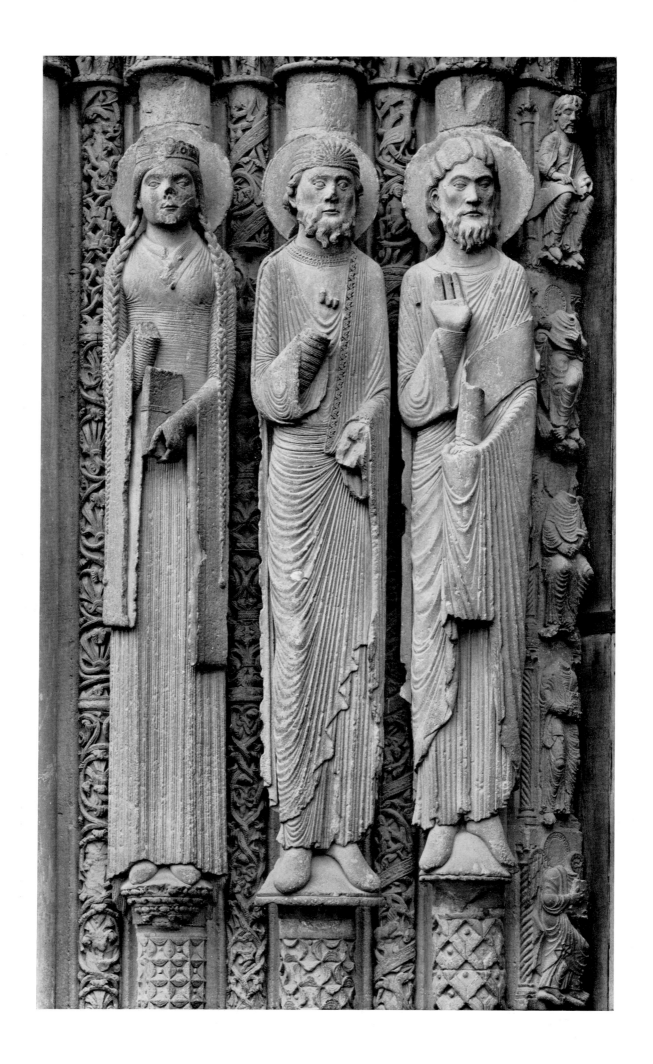

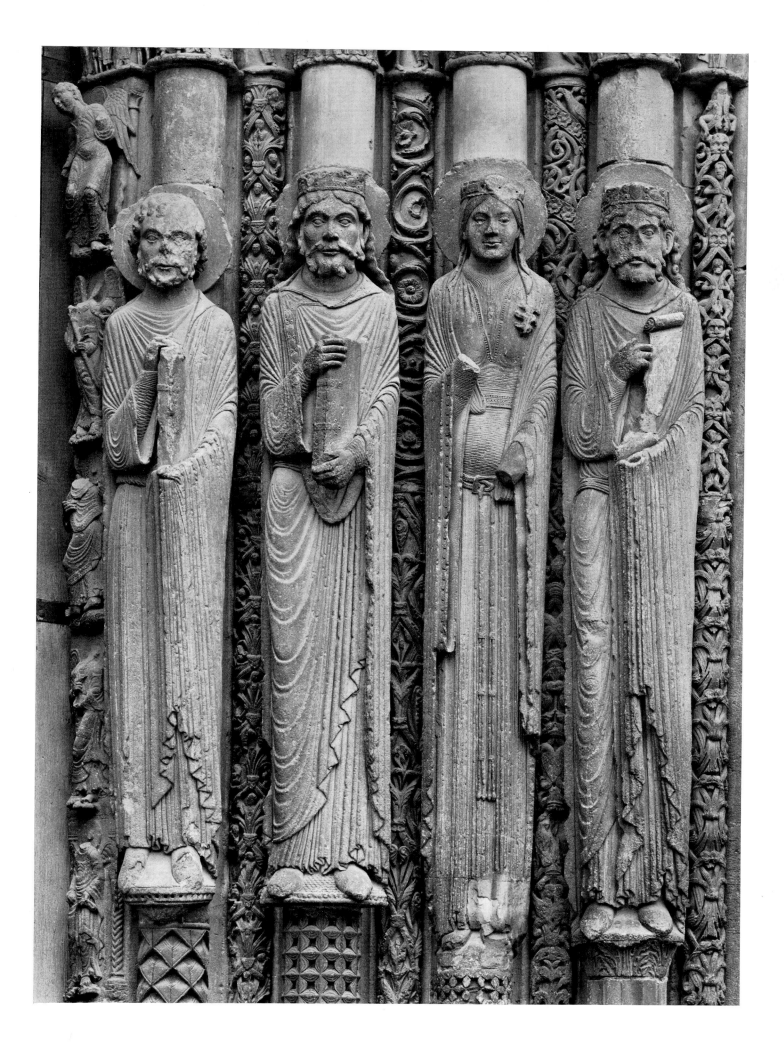

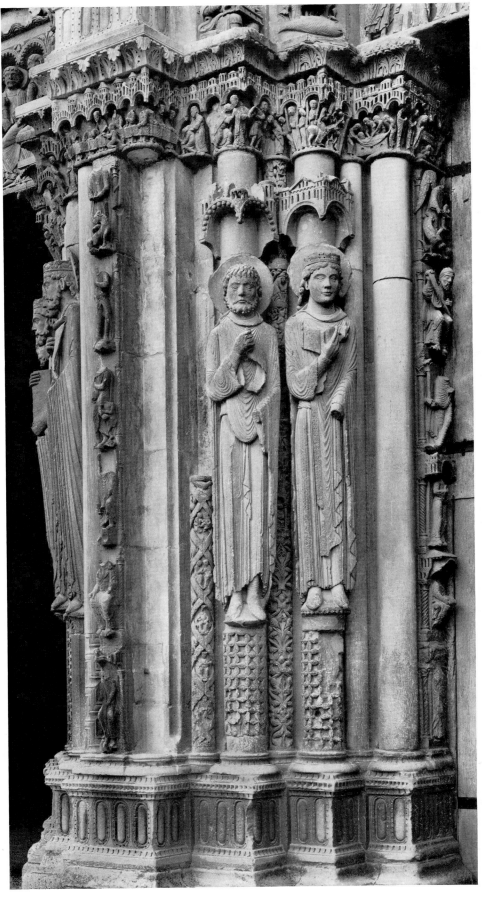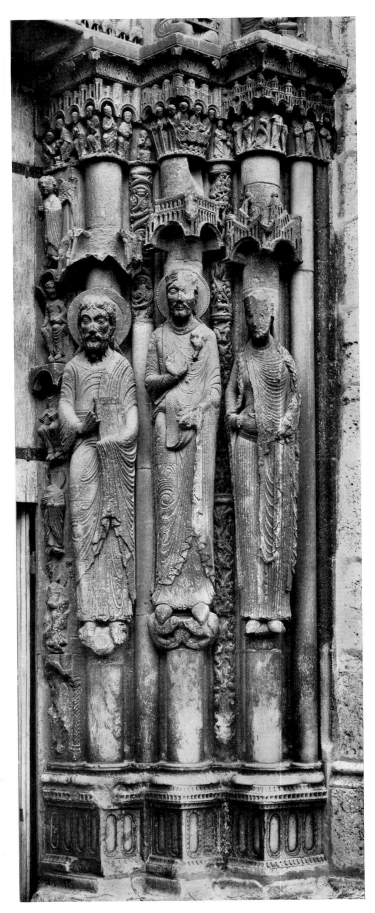

12 Chartres cathedral, west portal, right doorway. Left and right jambs: Old Testament figures. 1145–55

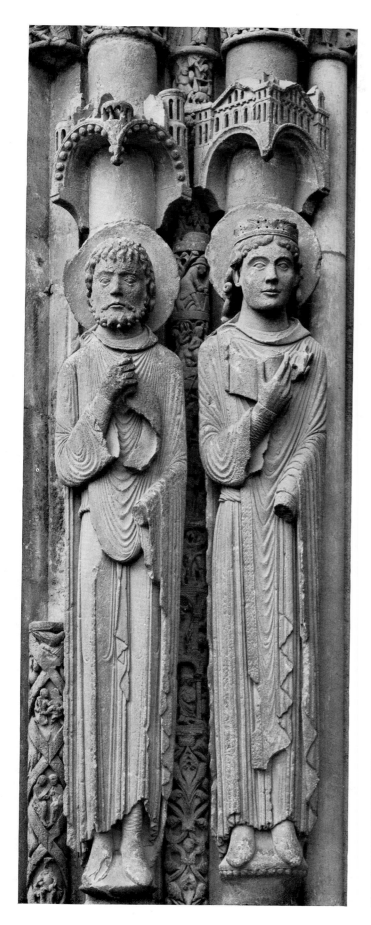
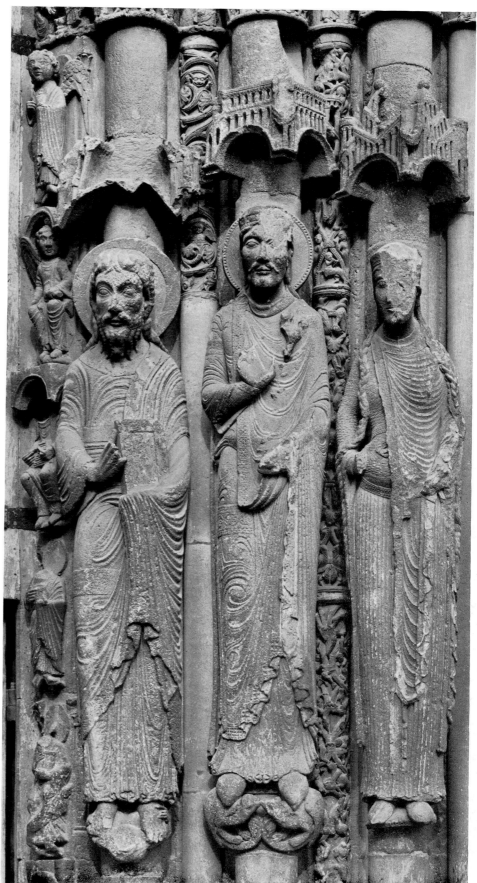

13 Chartres cathedral, west portal, right doorway. Left and right jambs: Old Testament figures. 1145–55

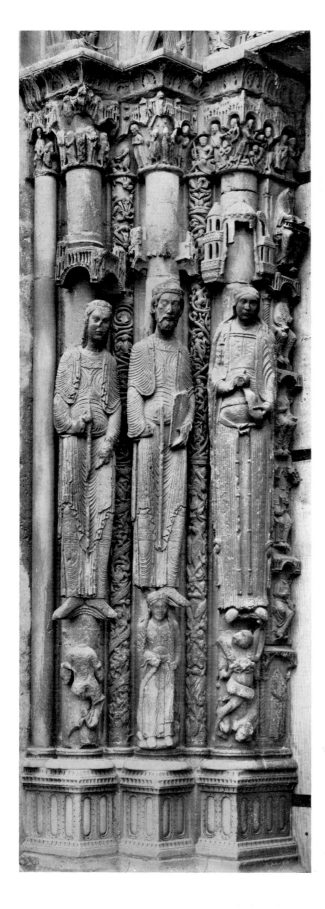

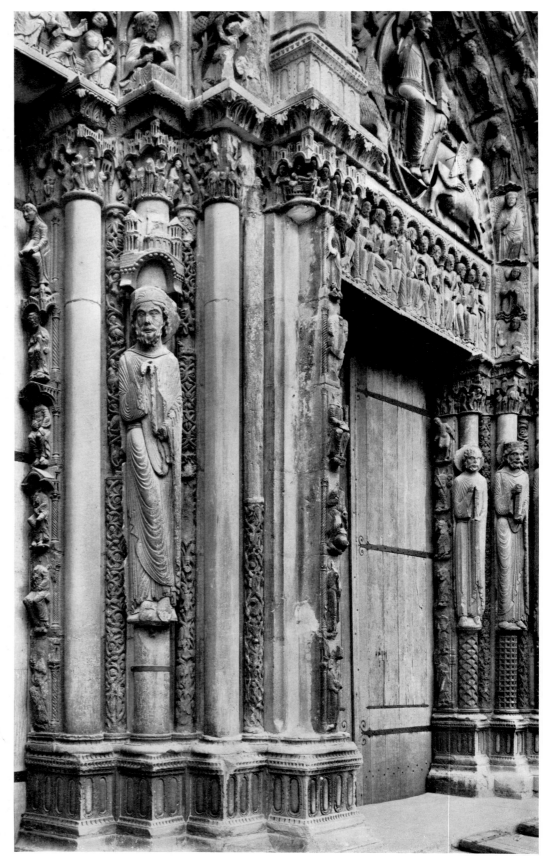

14 Chartres cathedral, west portal, left doorway. Left jamb: Old Testament figures. Right jamb. Moses. 1145–55

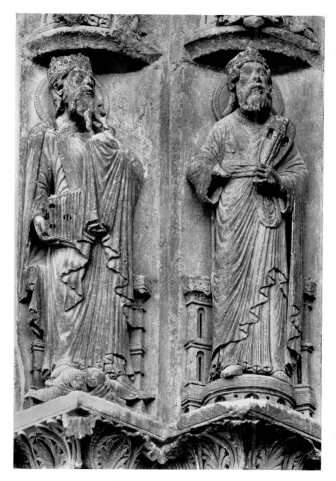
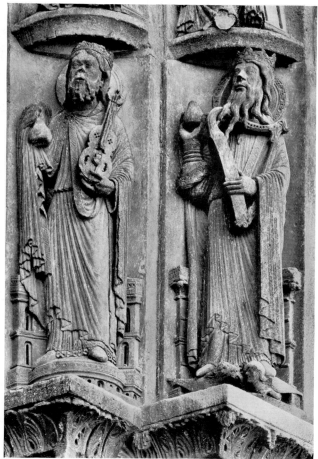

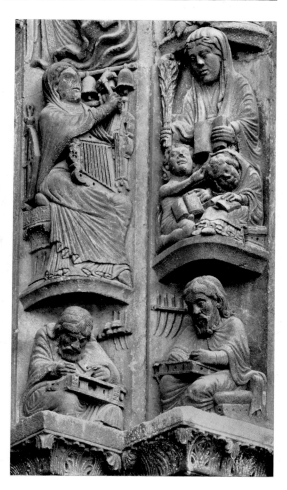

15 Chartres cathedral, west portal.
Top. Archivolt figures of centre
doorway: Elders of the Apocalypse.
Bottom. Archivolt figures of right
doorway: Liberal Arts. 1145–55

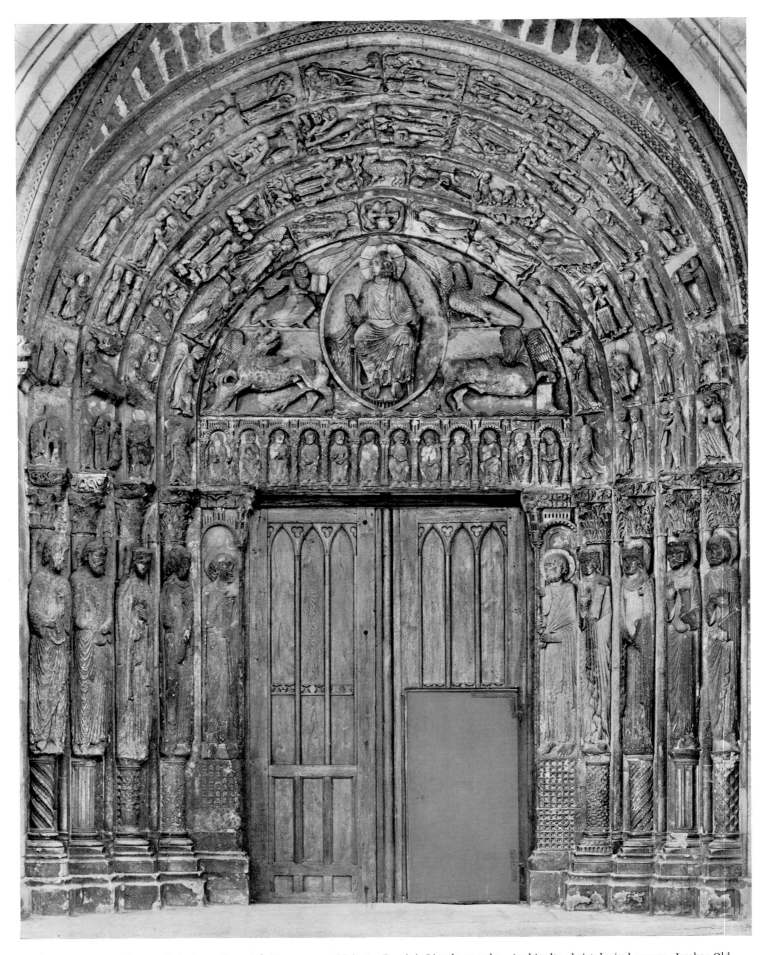

16, 17 Le Mans cathedral, south portal. Tympanum: Majestas Domini. Lintel: apostles. Archivolt: christological scenes. Jambs: Old
Testament figures, Peter and Paul. Before 1158. 17 Right jamb: Peter, Old Testament figures

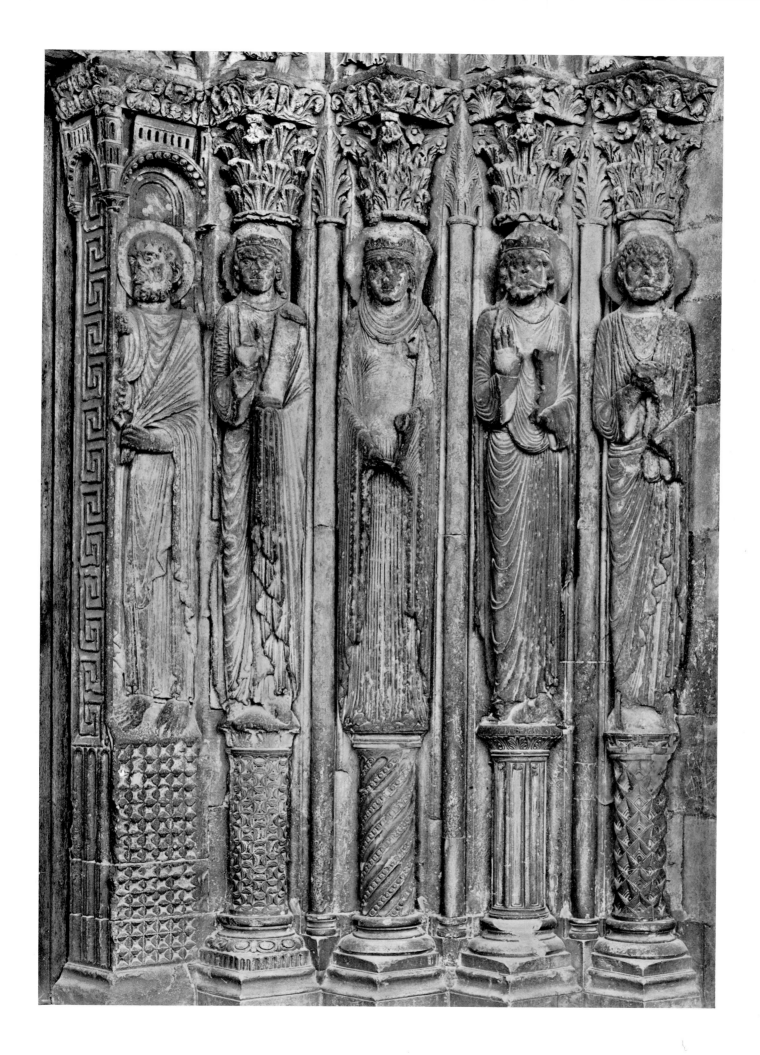

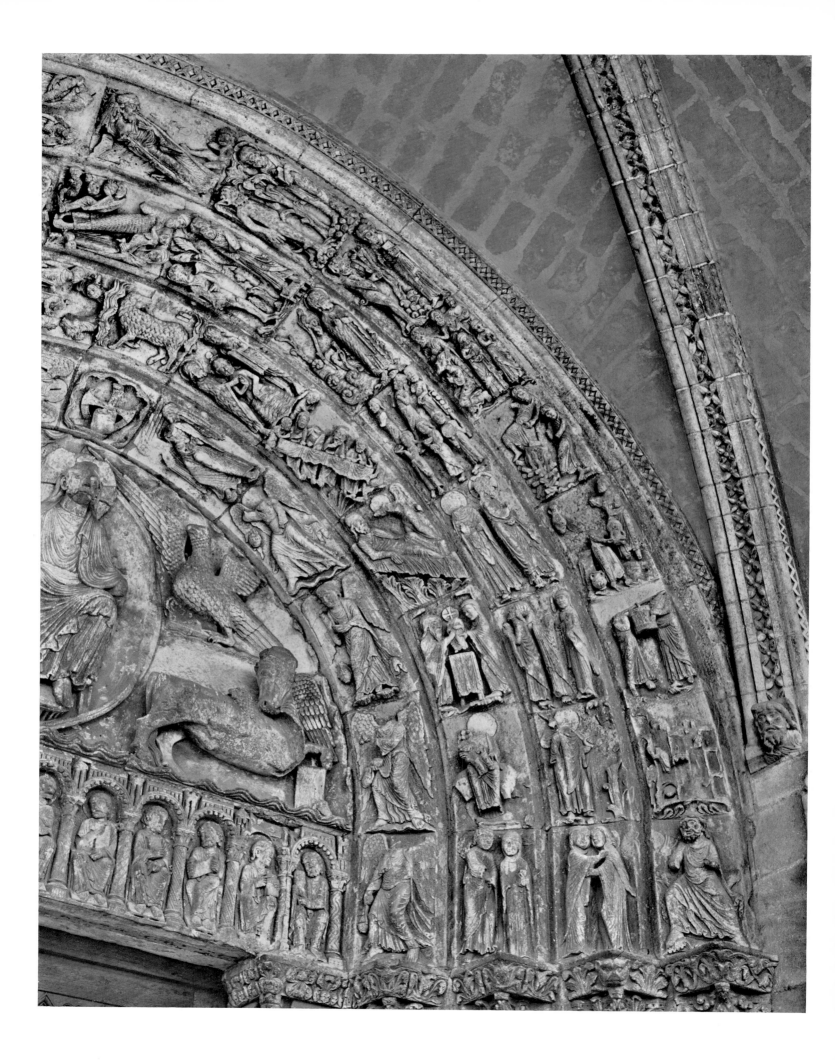

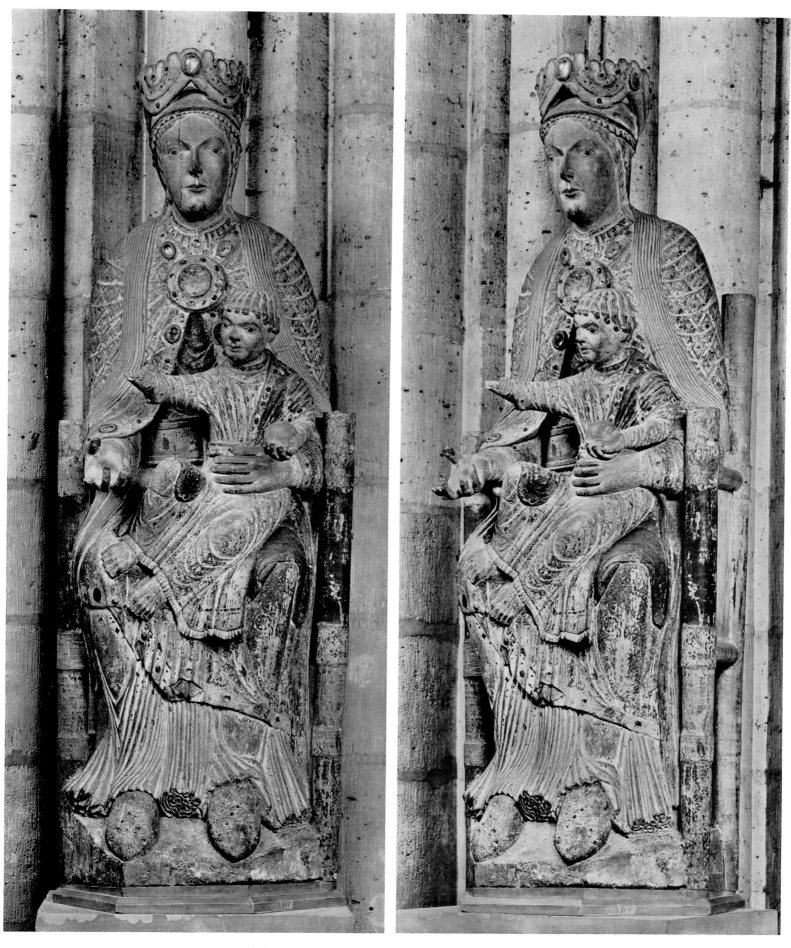

18 Le Mans cathedral, south portal. Archivolt: angels and christological scenes. Before 1158
19 Saint-Denis, abbey church. Virgin enthroned, from Saint-Martin-des-Champs. About 1160

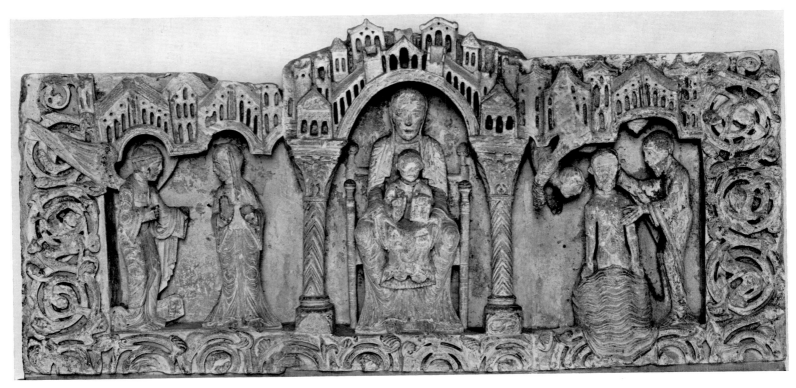

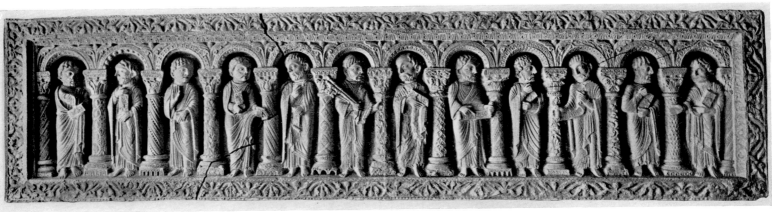

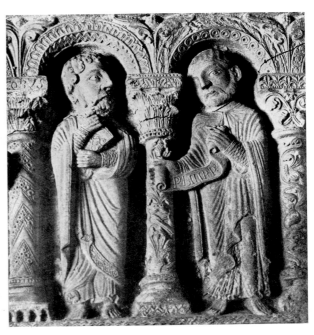

20 *Top*. Relief from Carrières-Saint-Denis: Virgin enthroned, Annunciation, Baptism of Christ. After 1150. (Paris, Louvre)
Middle and bottom. Saint-Denis, abbey church. Relief slab: apostles; details of Peter and Paul; unidentified apostle and Philip. Before 1151

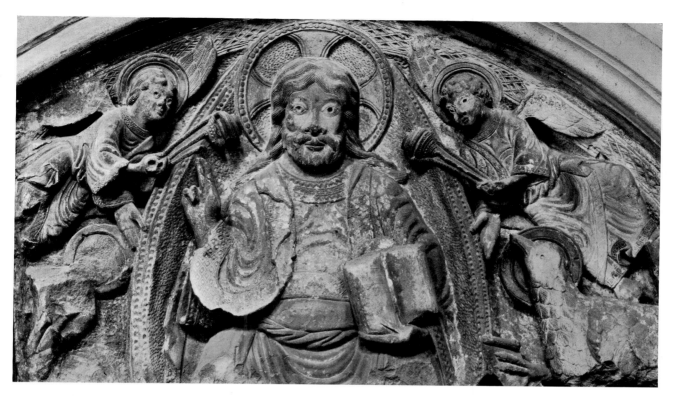

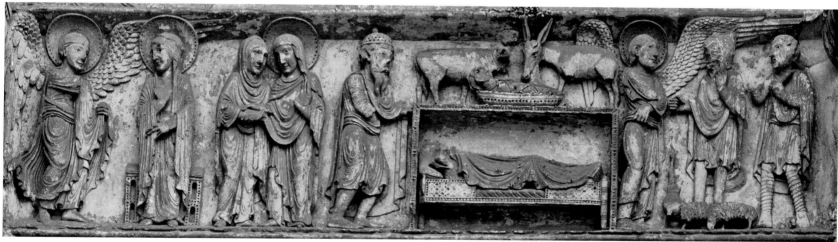

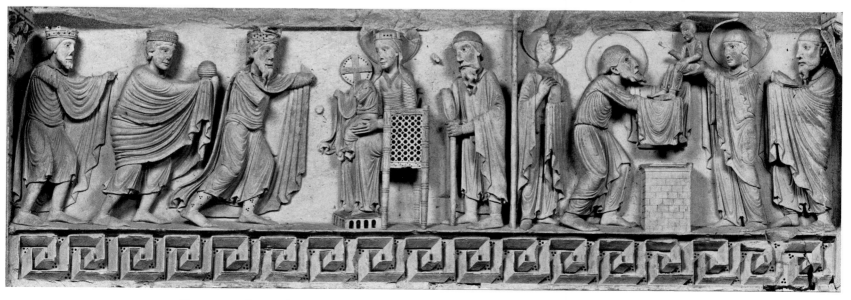

21 *Top*. Issy-les-Moulineaux, parish church. Tympanum fragment: Majestas Domini. 1150–60
Middle and bottom. La Charité-sur-Loire, priory church, west portal.
Middle. Lintel of outer left doorway: Annunciation, Visitation, Nativity, Annunciation to the Shepherds.
Bottom. Lintel of inner left doorway: Adoration of the Magi, Presentation in the Temple. Between 1140 and 1155

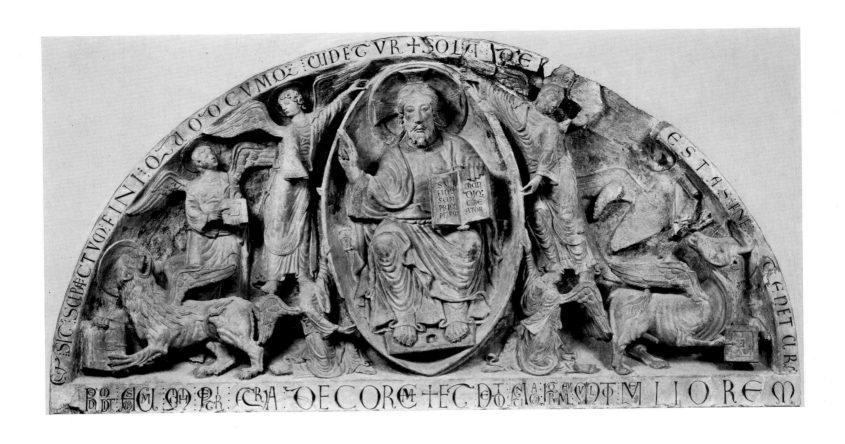

22, 23 Dijon, Saint-Bénigne, tympana.
Majestas Domini and detail; Last Supper. About 1160. (Dijon, Musée Archéologique)

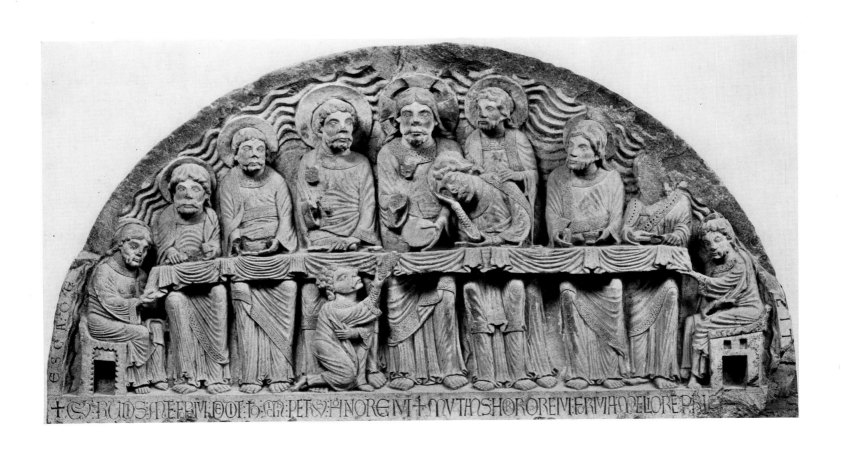

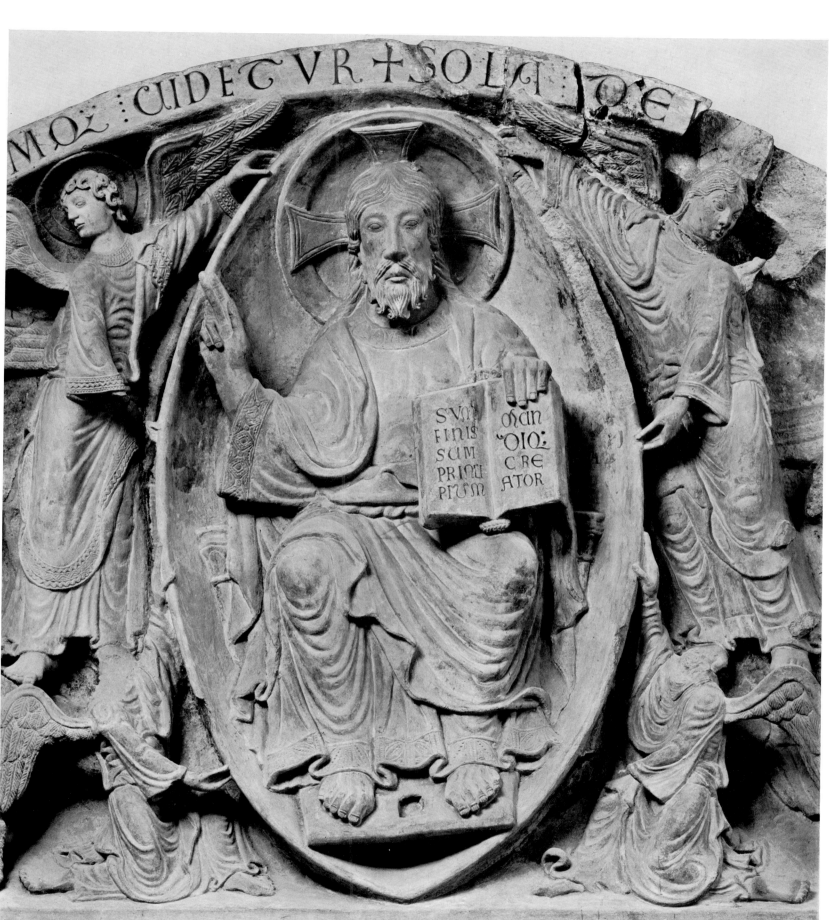

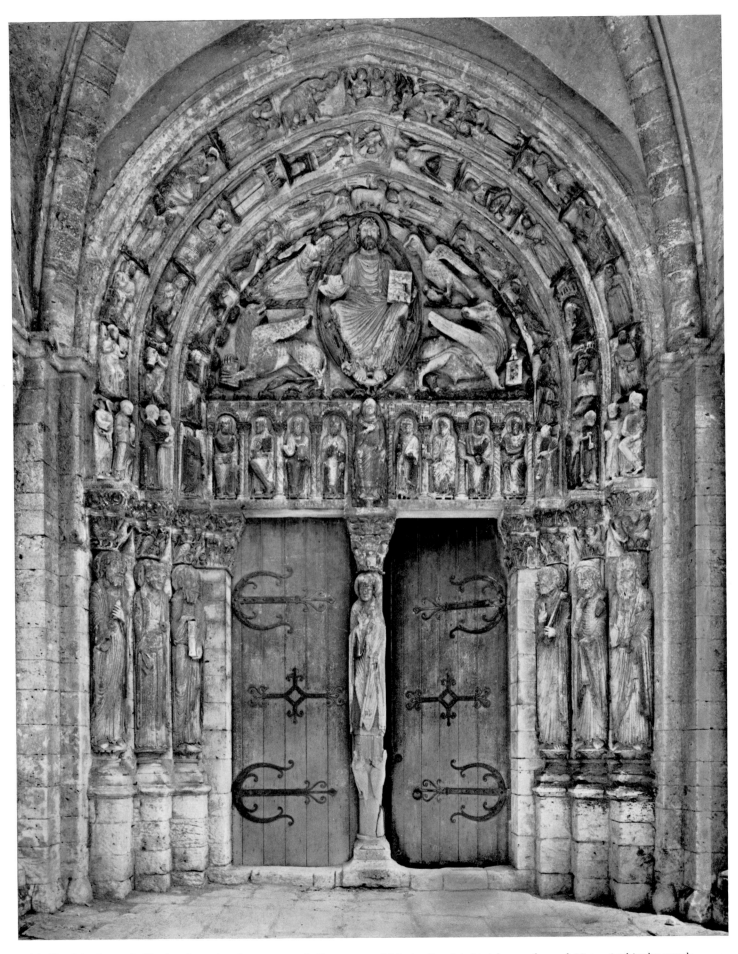

24, 25 Saint-Loup-de-Naud, priory church, west portal. Tympanum: Majestas Domini. Lintel: apostles and Mary. Archivolt: angels,
Infancy of Christ, life of St Lupus. Jambs: Old Testament figures, Peter and Paul. About 1160
25 Left jamb: Old Testament figures and Paul

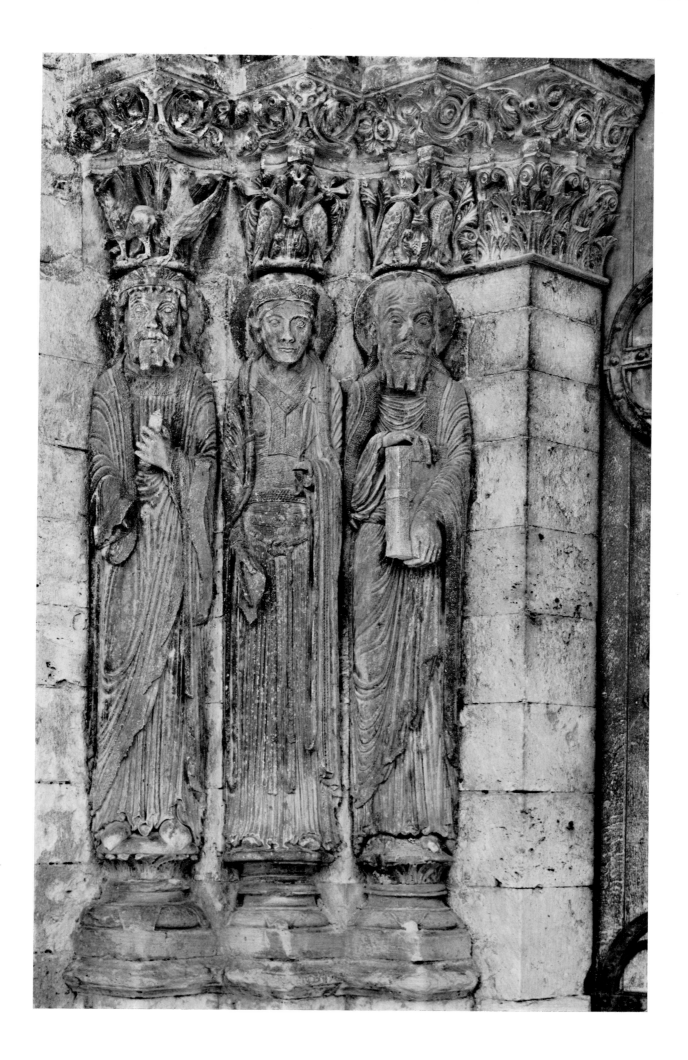

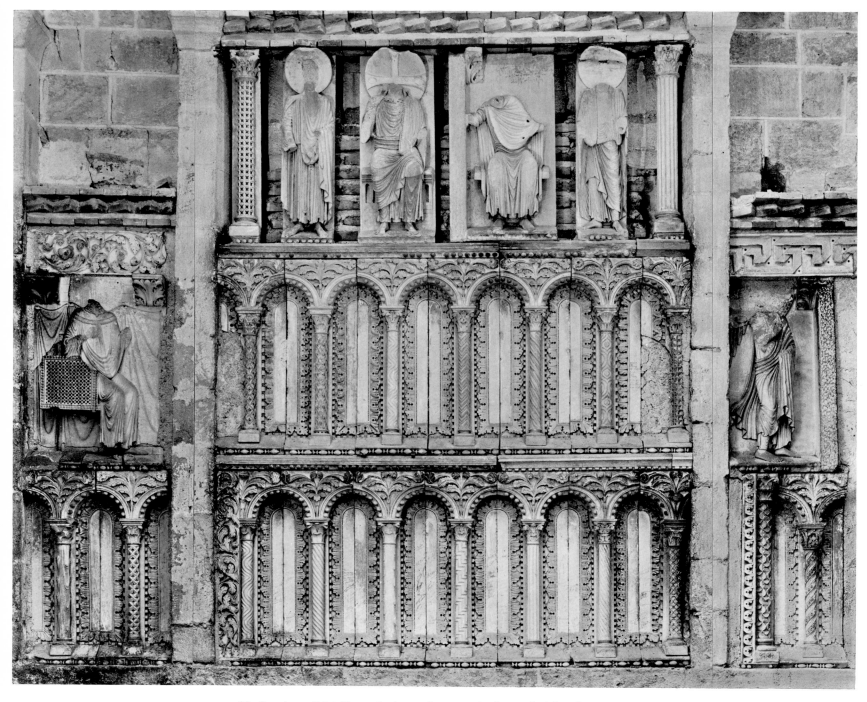

26 Souvigny, Saint-Pierre. Sculpture fragments in the north aisle. About 1150

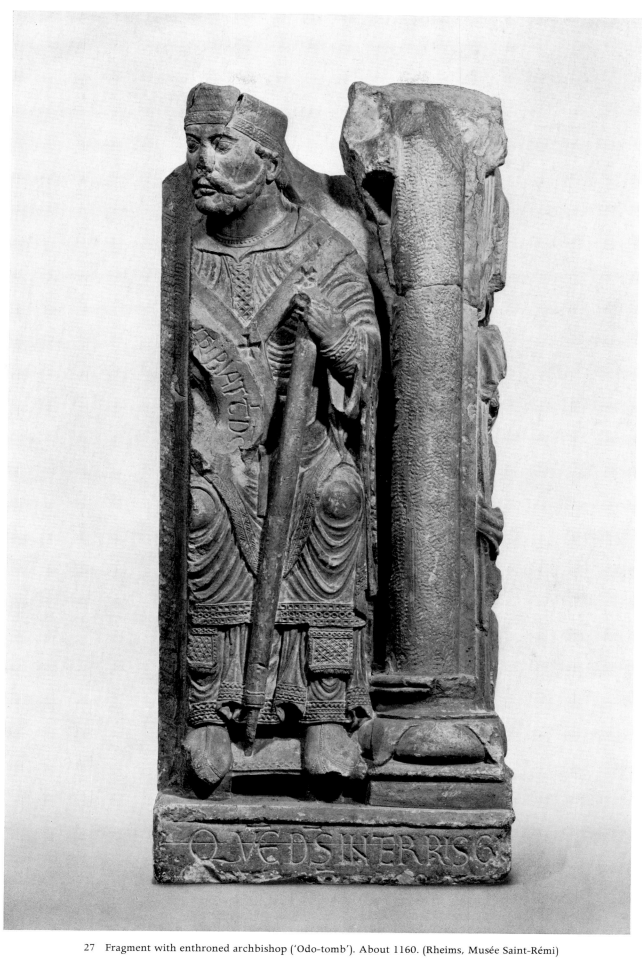

27 Fragment with enthroned archbishop ('Odo-tomb'). About 1160. (Rheims, Musée Saint-Rémi)

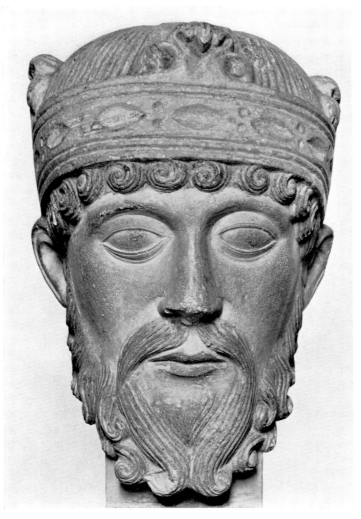

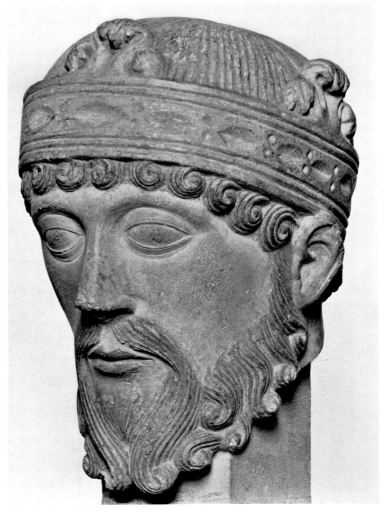

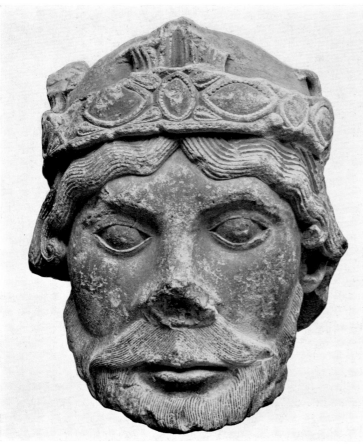

28 *Top.* Head of King Lothaire. 1140–50. (Rheims, Saint-Rémi)
Bottom. Head of a king. About 1160. (Frankfurt, Liebieghaus)

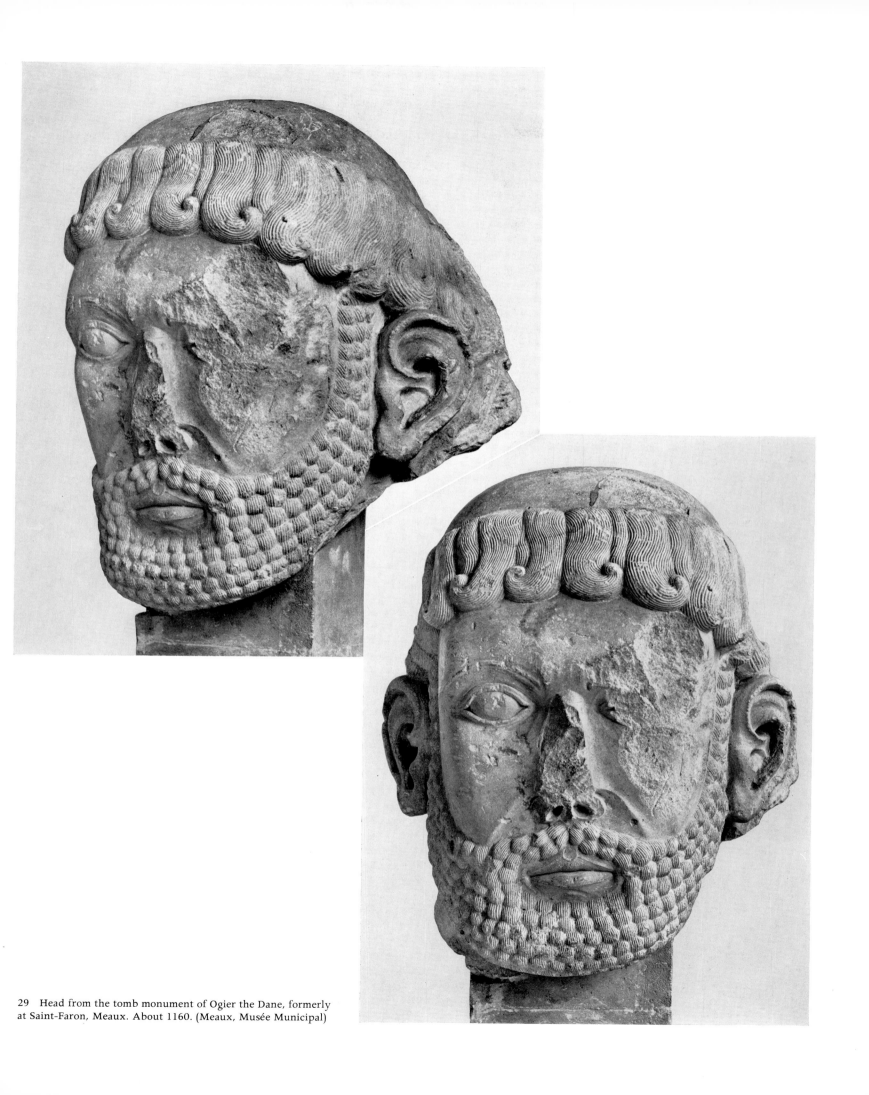

29 Head from the tomb monument of Ogier the Dane, formerly
at Saint-Faron, Meaux. About 1160. (Meaux, Musée Municipal)

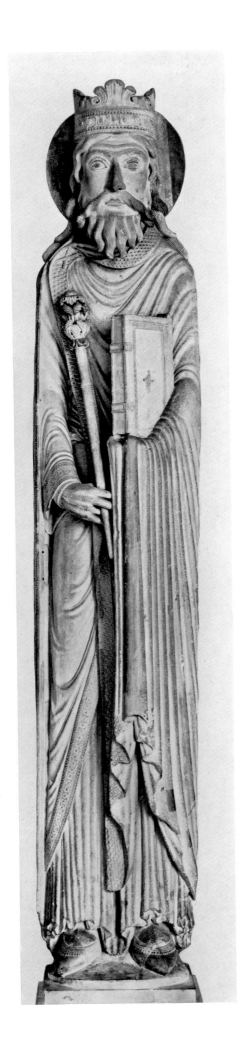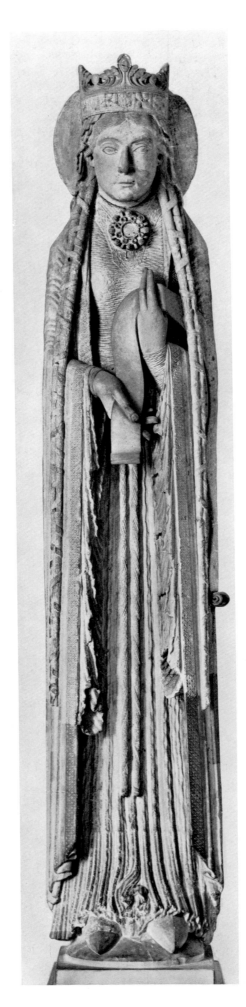

30 Statues from the jamb of the west
portal of Notre Dame, Corbeil: Old
Testament figures. 1140–50

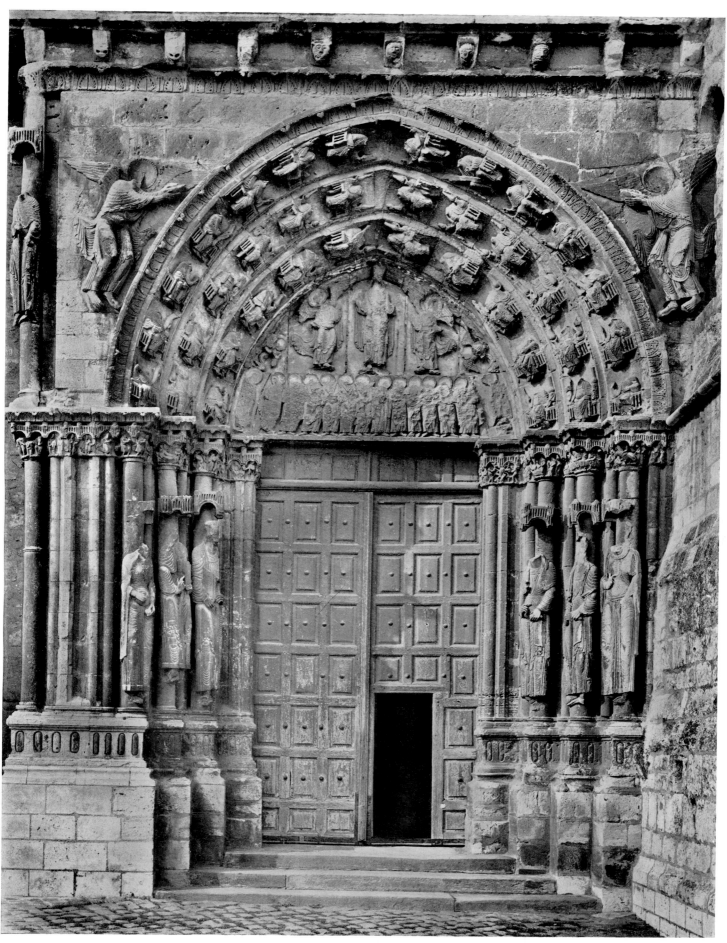

31 Etampes, Notre Dame, south portal. Archivolt: Elders of the Apocalypse. Jambs: Old Testament figures. 1140–50

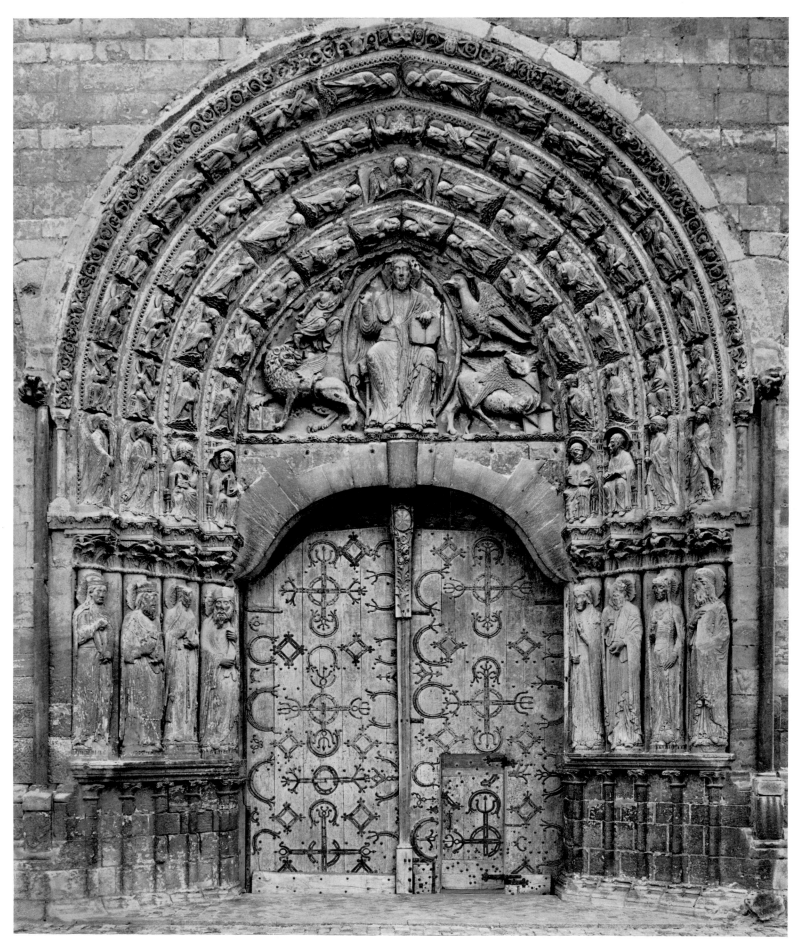

32 Angers cathedral, west portal.
Tympanum: Majestas Domini. Archivolt: apostles, angels, Elders of the Apocalypse. Jambs: Old Testament figures. 1150–60

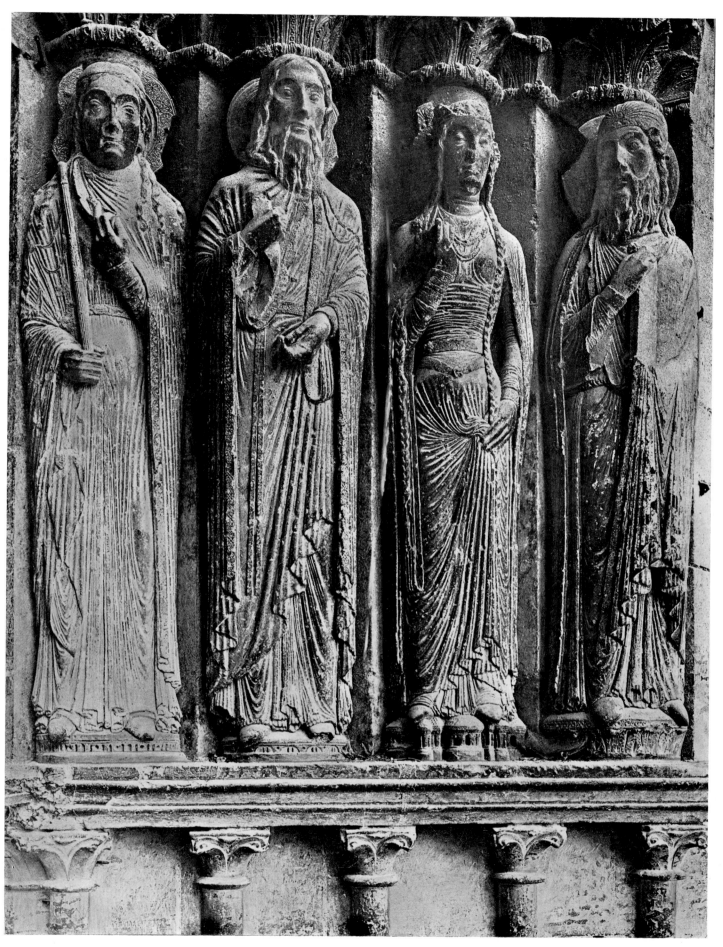

33 Angers cathedral, west portal. Right jamb: Old Testament figures, including Moses at right. 1155–60

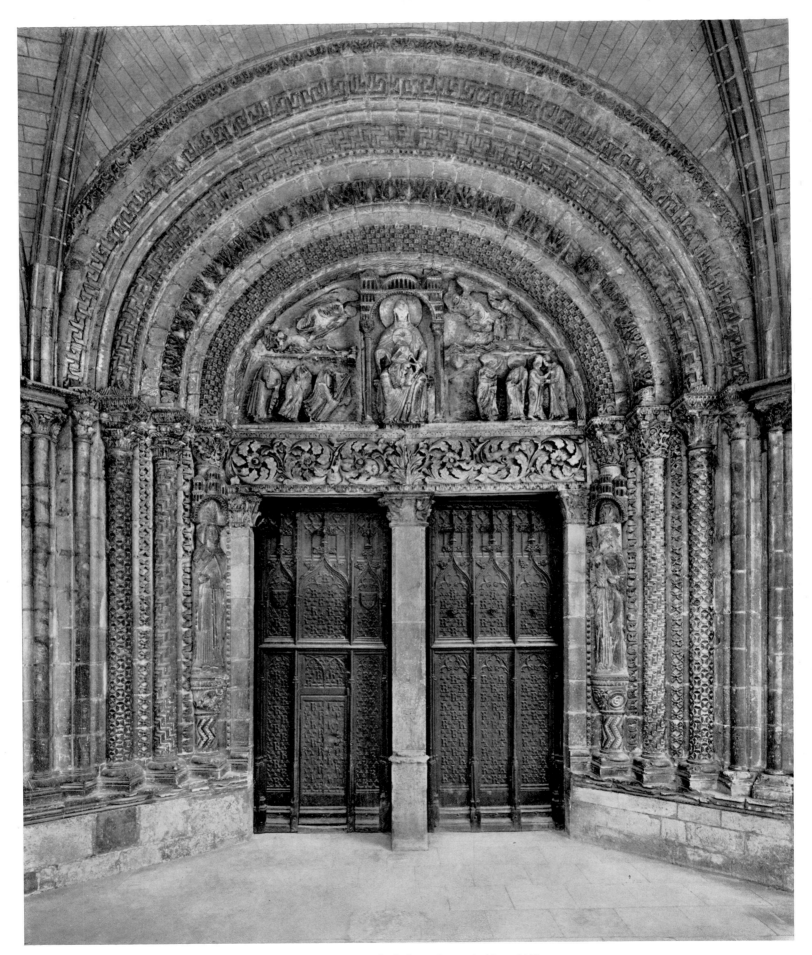

34, 35 Bourges cathedral, north portal. About 1160

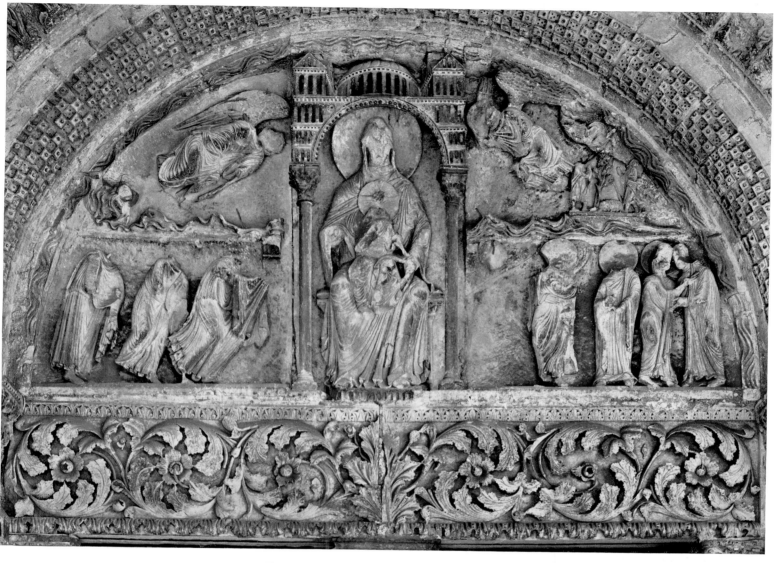

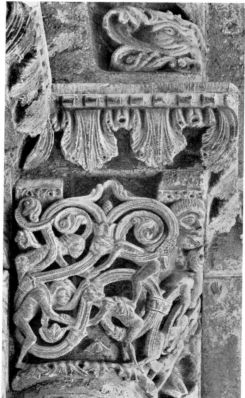

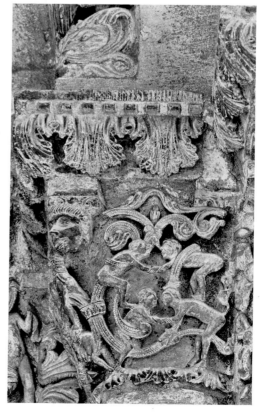

35 *Top*. Tympanum: Virgin enthroned, with
Adoration of the Magi, Annunciation, Visitation,
Annuciation to the Shepherds.
Bottom. Details of capital on right jamb

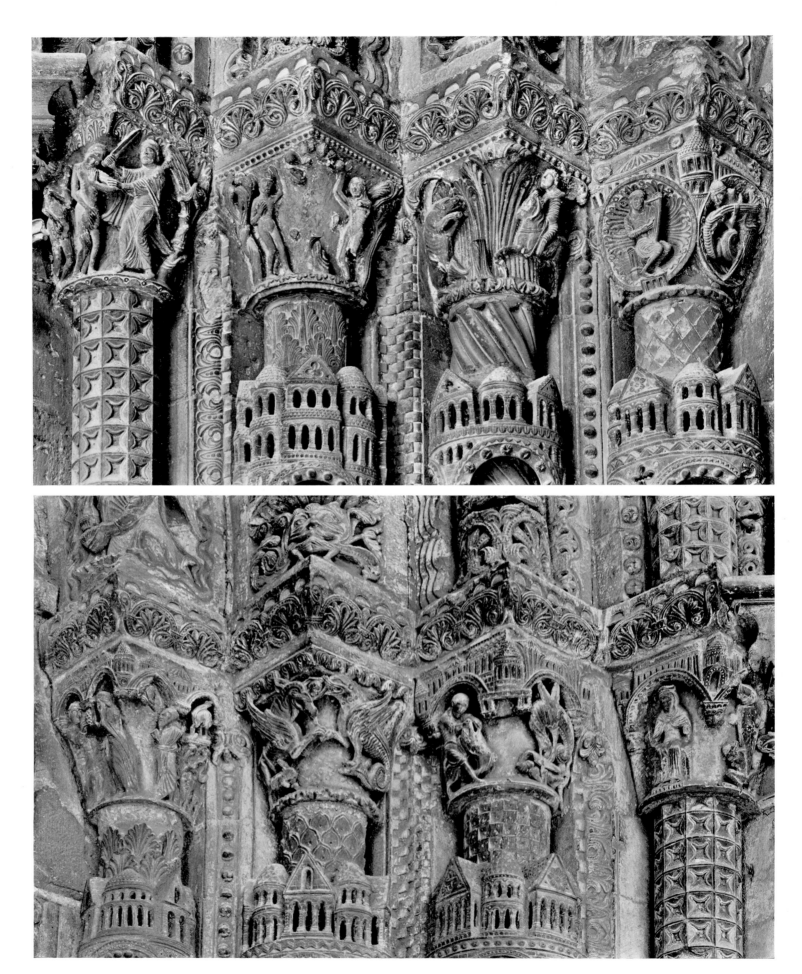

36 Bourges cathedral, south portal. About 1160. *Top*. Capitals from the left jamb: Expulsion from Paradise, Fall, huntsman, David.
Bottom. Capitals from the right jamb: Noah with grapes, sacrifice of Isaac, pair of griffins, Samson with the lion, unidentified scene.

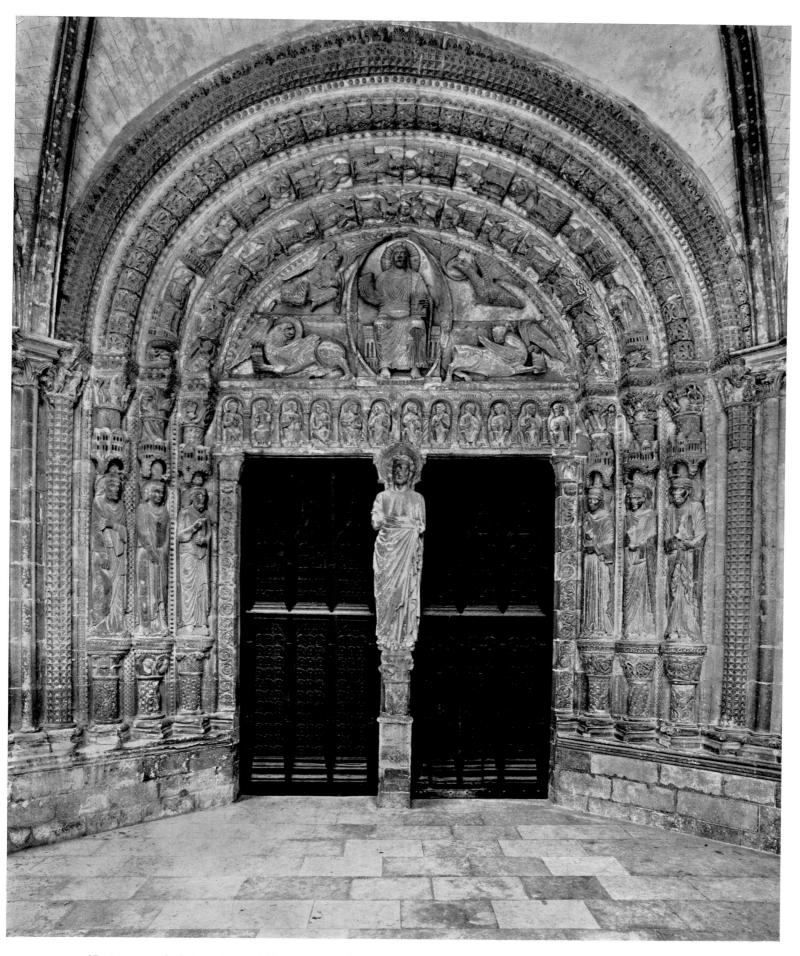

37 Bourges cathedral, south portal. Tympanum: Majestas Domini. Lintel: apostles. Archivolt: Elders of the Apocalypse.
Jambs: Old Testament figures. About 1160. Trumeau: Christ. 1240–50

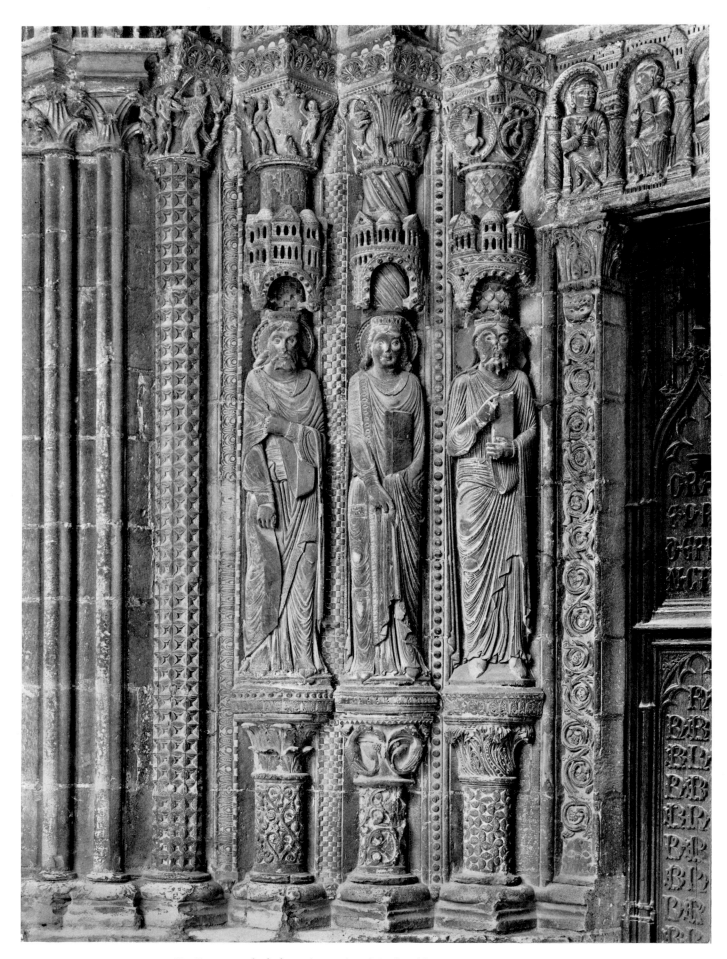

38 Bourges cathedral, south portal. Left jamb: Old Testament figures. About 1160

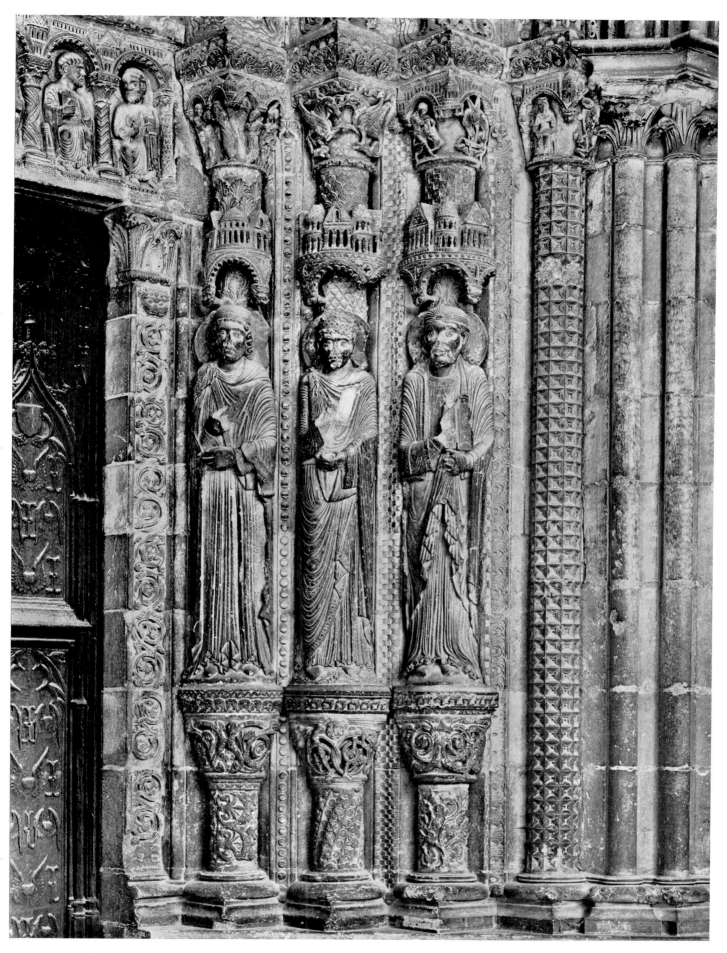

39 Bourges cathedral, south portal. Right jamb: Old Testament figures, including Moses at right. About 1160

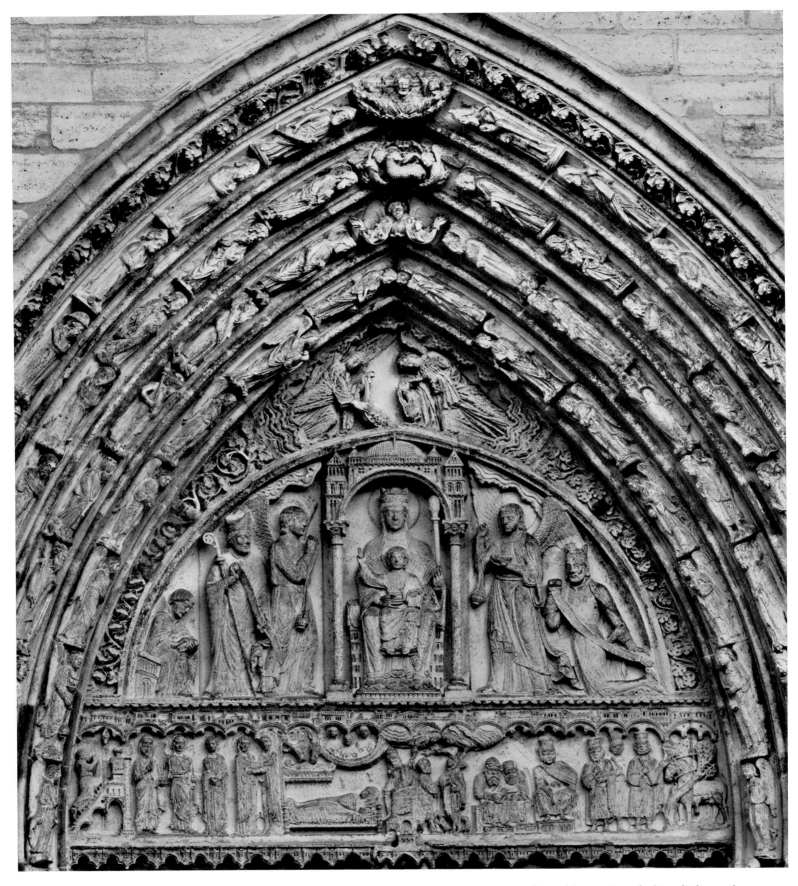

40 Paris, Notre Dame, west portal, right doorway (Porte Sainte-Anne). Tympanum: Virgin enthroned between angels, king, bishop and
scribe. Lintel: Purification of the Virgin, Annunciation, Visitation, Nativity, Annunciation to the Shepherds, the Three Magi before Herod
and his counsellors. Shortly after 1160

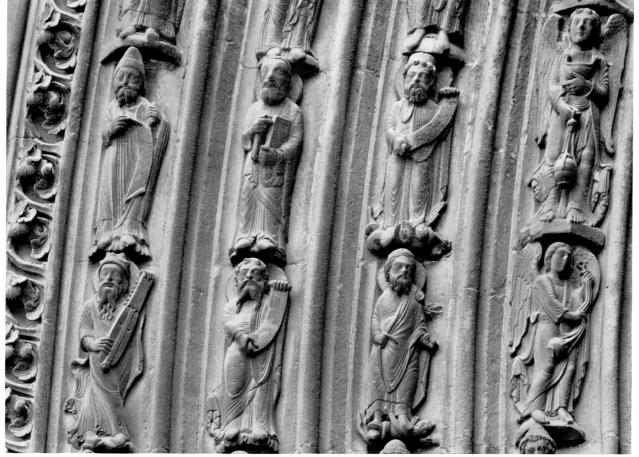

41 *Top*. Archivolt fragments from
Notre Dame, Paris: (left) Christ of the
Apocalypse, with sword; (right)
angels, Agnus Dei. (Paris, Louvre).
Middle and bottom. Paris, Notre Dame,
west portal, right doorway (Porte
Sainte-Anne). Archivolt figures:
angels, prophets, Elders of the
Apocalypse(?). Shortly after 1160

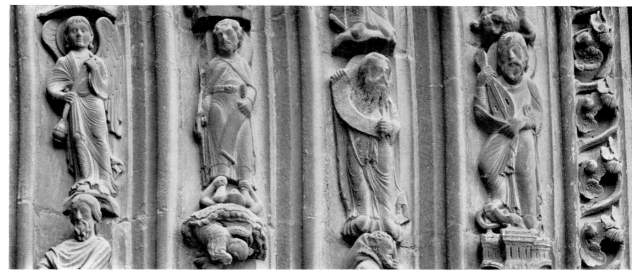

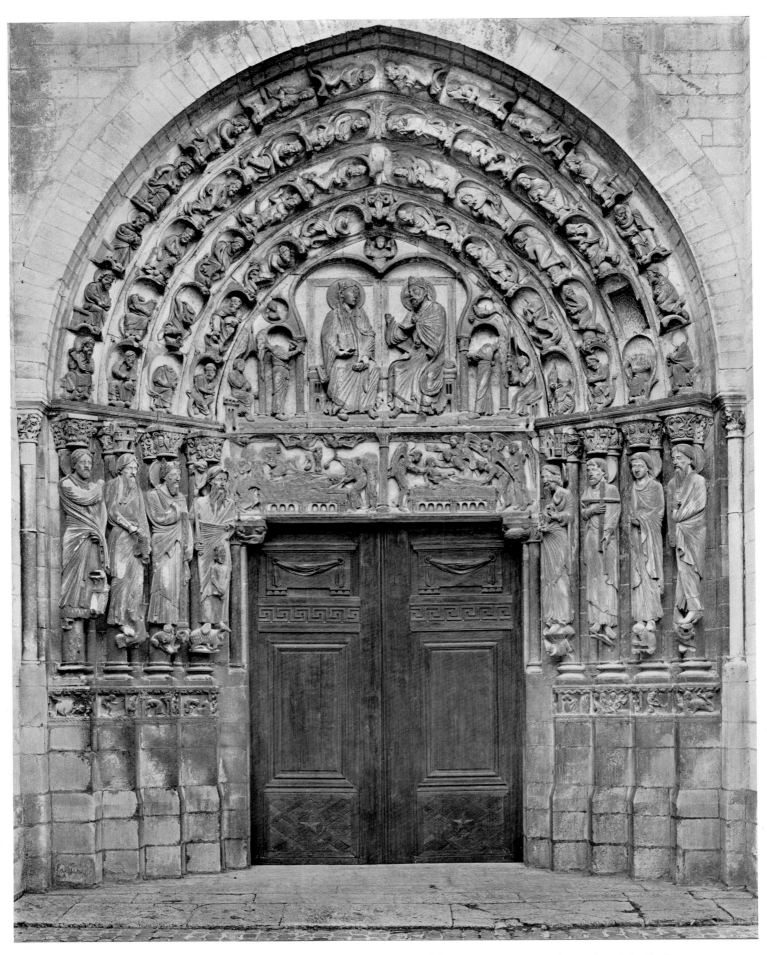

42 Senlis cathedral, west portal, Lintel: Death and Assumption of the Virgin. Tympanum: Coronation of the Virgin.
Archivolt: Stem of Jesse and prophets. Jamb: typological Old Testament figures, Calendar. About 1170

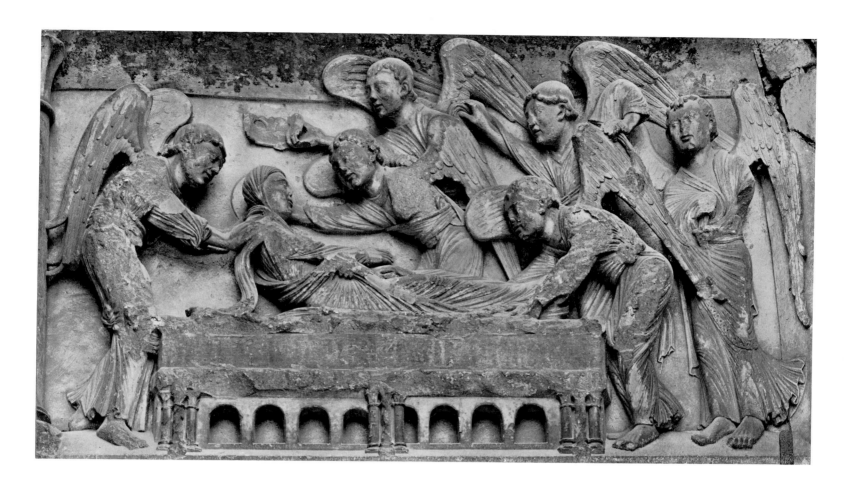

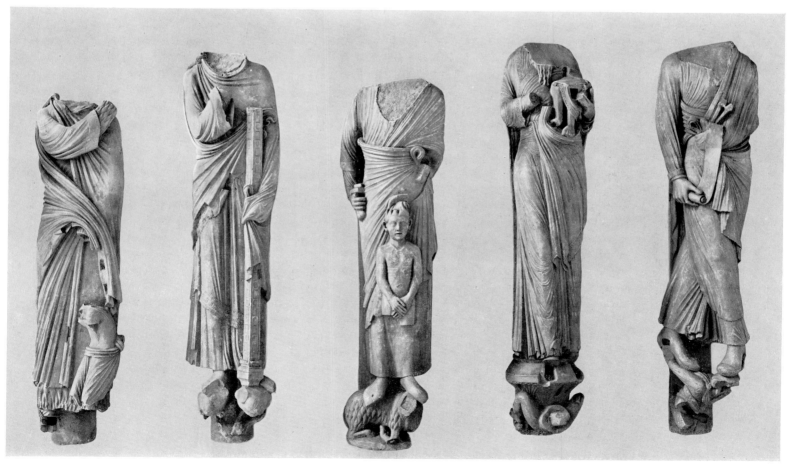

43 Senlis cathedral, west portal. *Top*. Lintel, detail: Assumption of the Virgin.
Bottom. Casts of jamb figures before restoration: John the Baptist, Moses, Abraham, Simeon, David. About 1170. (Paris, Musée des Monuments français)

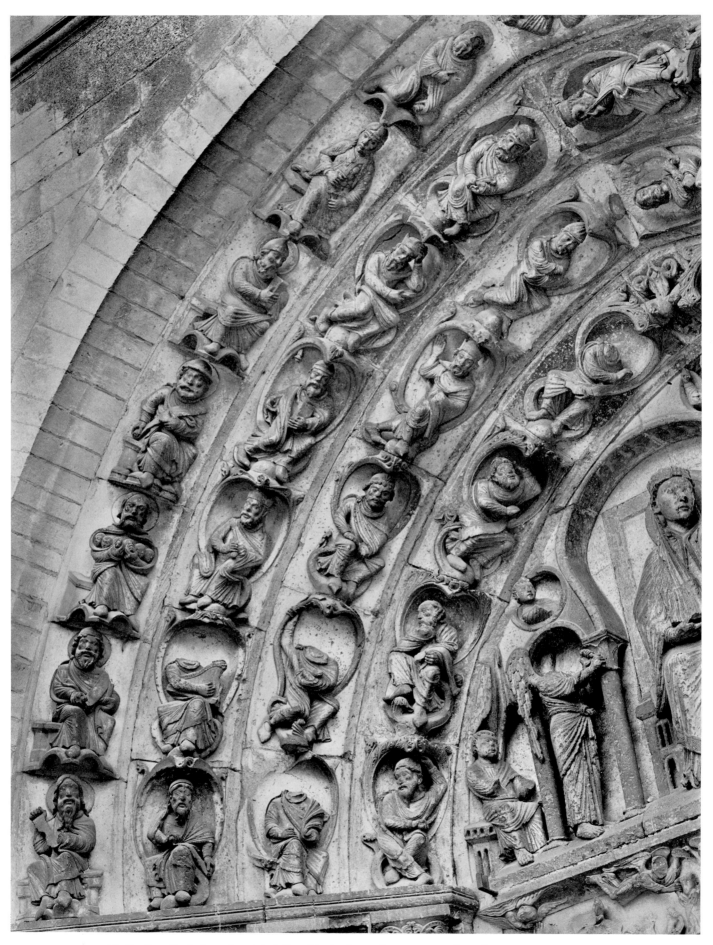

44 Senlis cathedral, west portal. Left archivolt: Stem of Jesse, patriarchs and prophets. About 1170

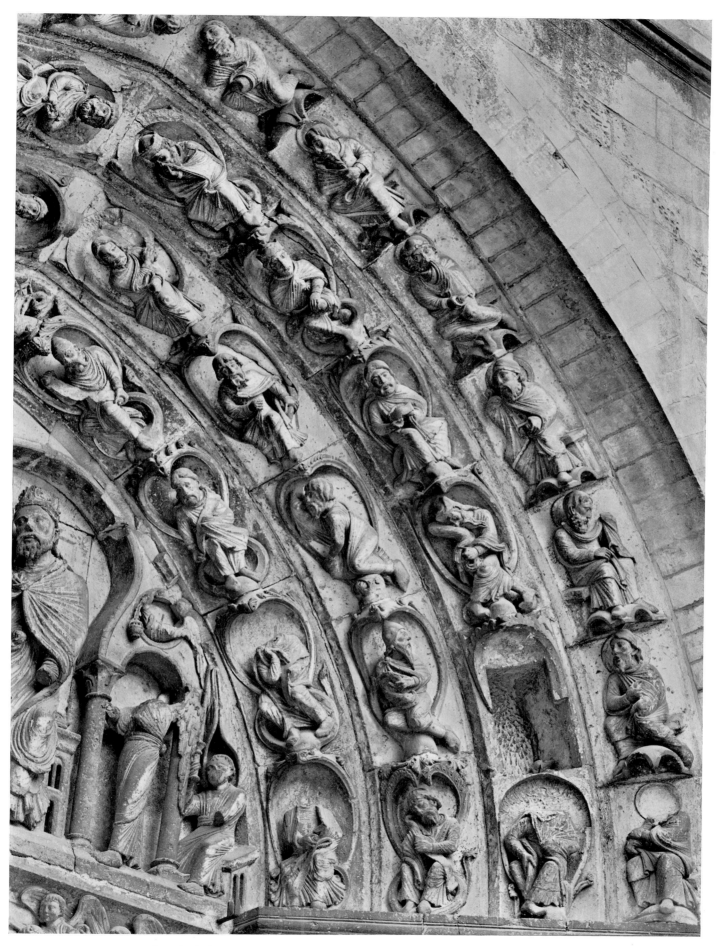

45 Senlis cathedral, west portal. Right archivolt: Stem of Jesse, patriarchs and prophets. About 1170

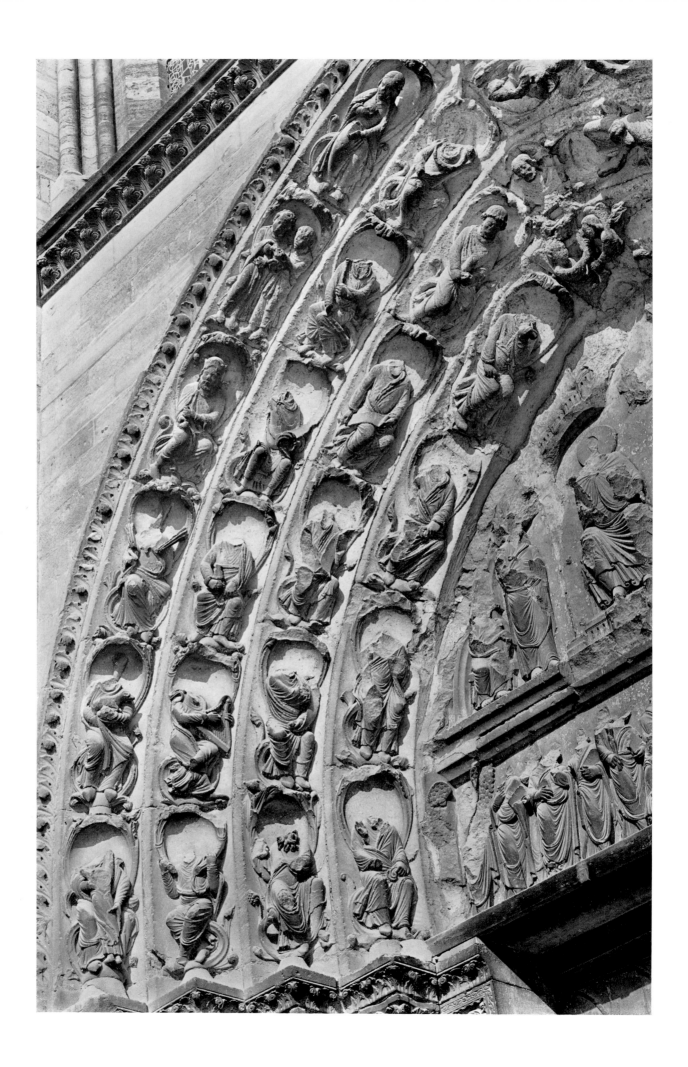

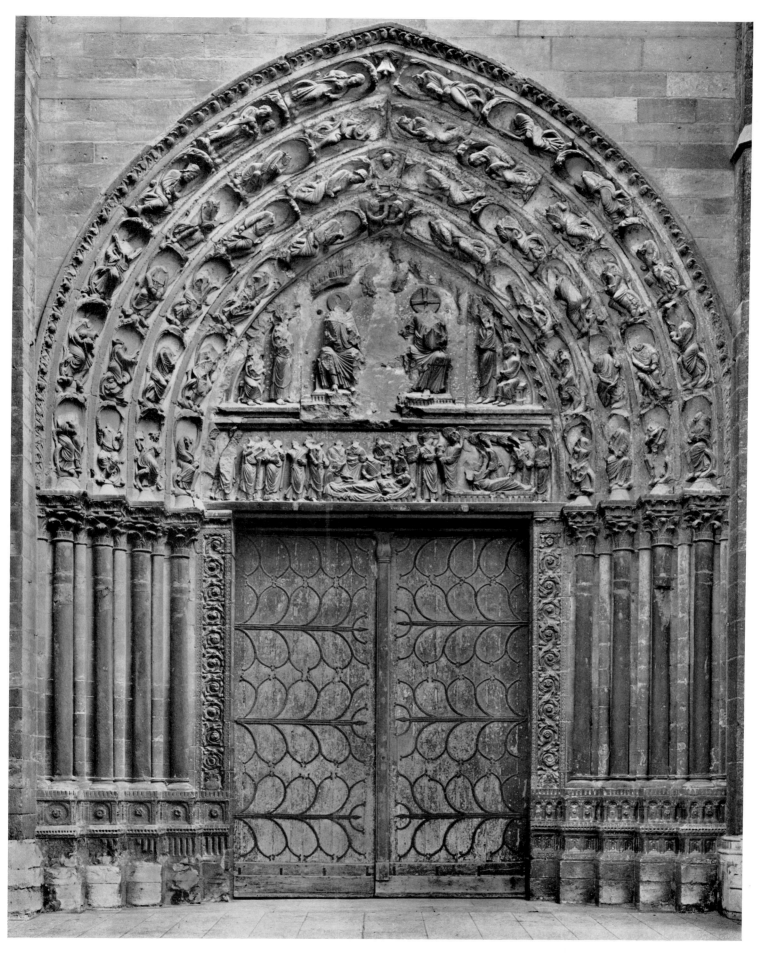

46, 47 Mantes, Notre Dame, collegiate church, west portal, centre doorway. Tympanum and lintel: Death of the Virgin, the Assumption and Coronation. Archivolt: Stem of Jesse, patriarchs, prophets, Sibyl(?). About 1180

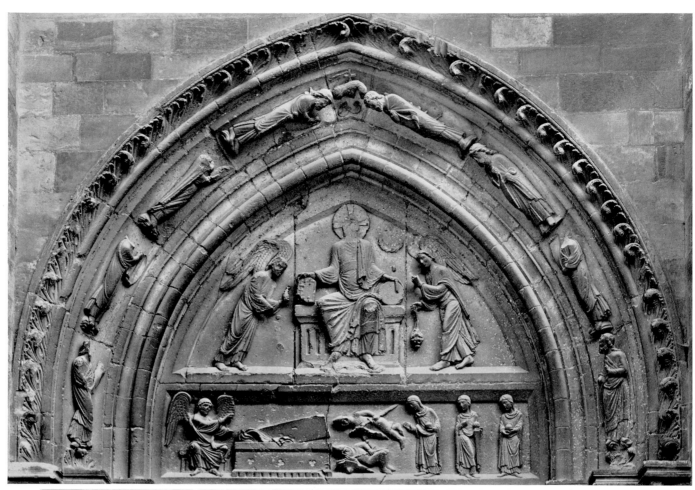

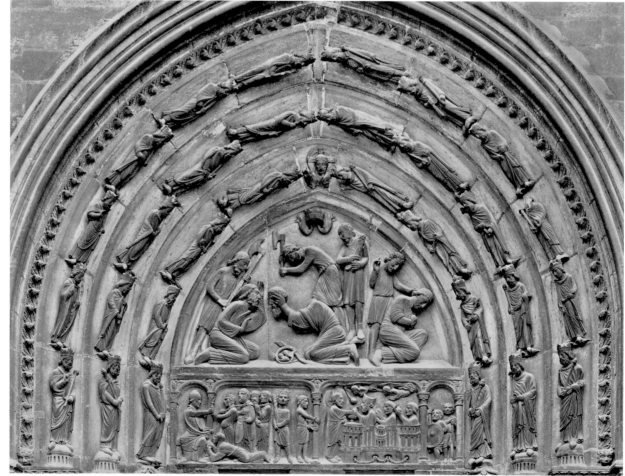

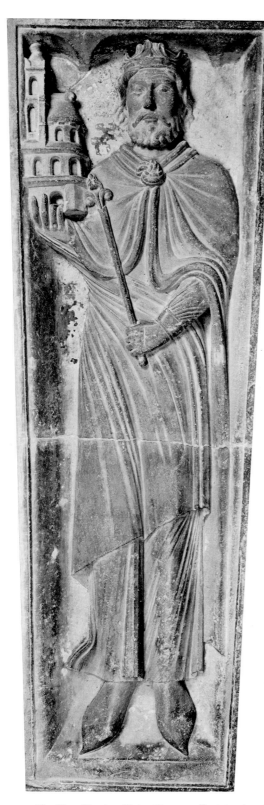
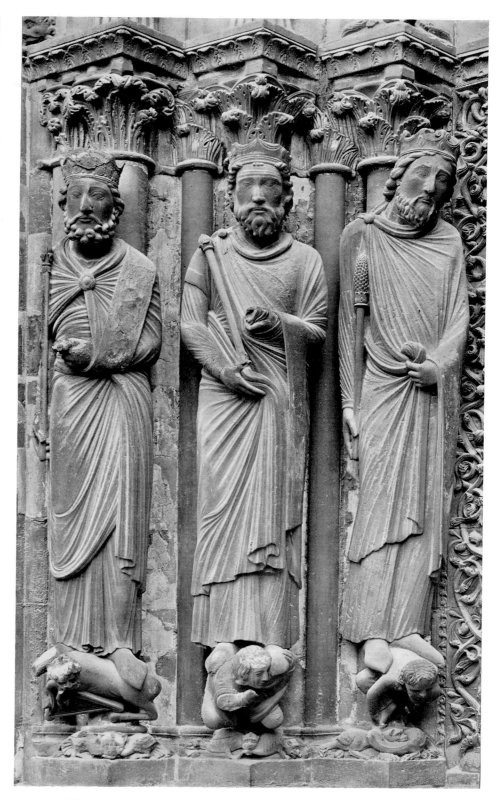

48 *Top.* Mantes, Notre Dame, collegiate church, west portal, left doorway. Lintel: Women at the Tomb. Tympanum: enthroned Christ
with the book with the seven seals, shaft of cross and crown of thorns, flanked by angels. Archivolt: prophets. About 1170.
Bottom. Saint-Denis, abbey church, north transept portal. Tympanum and lintel: martyrdom of St Dionysius and his companions. Archivolt:
kings. About 1175

49 *Left.* Saint-Denis, abbey church. Tomb monument of Childebert I, from Saint-Germain-des-Prés, Paris. About 1170–75.
Right. Saint-Denis, abbey church, north transept portal. Left jamb: kings. About 1170–75

50 (overleaf) *Top left.* Head of Moses from the jamb of the centre doorway of Notre Dame, Mantes. About 1180. Mantes, Dépôt lapidaire.
Top right. Head of a jamb figure from the west portal of Senlis cathedral. About 1170. (Senlis, Musée du Haubergier).
Bottom left. Head of David, from jamb of Porte Sainte-Anne, Notre Dame, Paris. Shortly after 1160. (New York, Metropolitan Museum of Art).
Bottom right. Head from Notre-Dame-en-Vaux, Châlons-sur-Marne, probably from the jambs of the south portal. Between 1160 and 1170.
(Paris, Louvre)

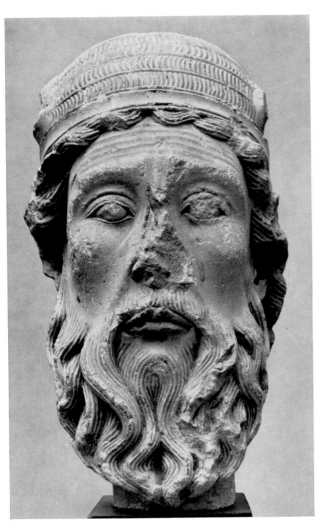
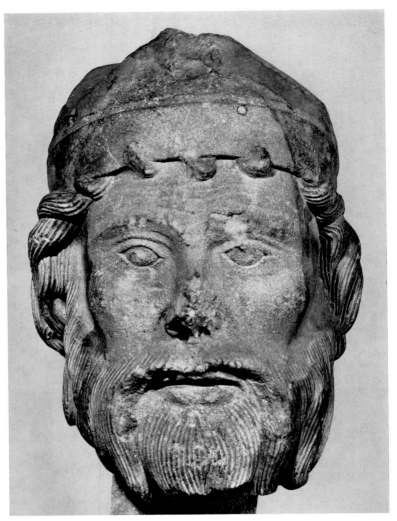
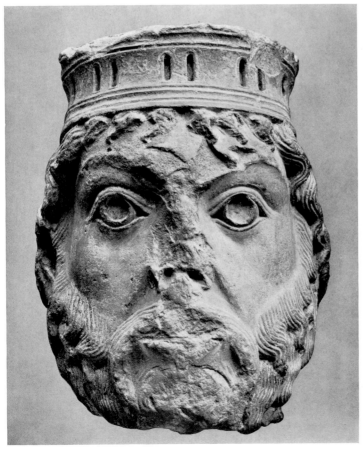
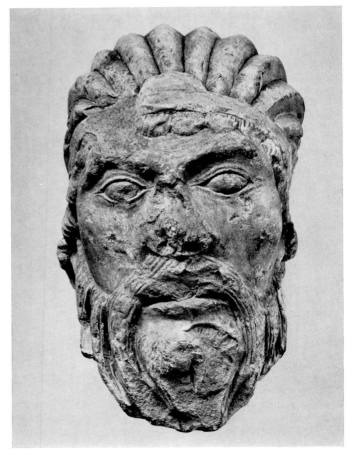

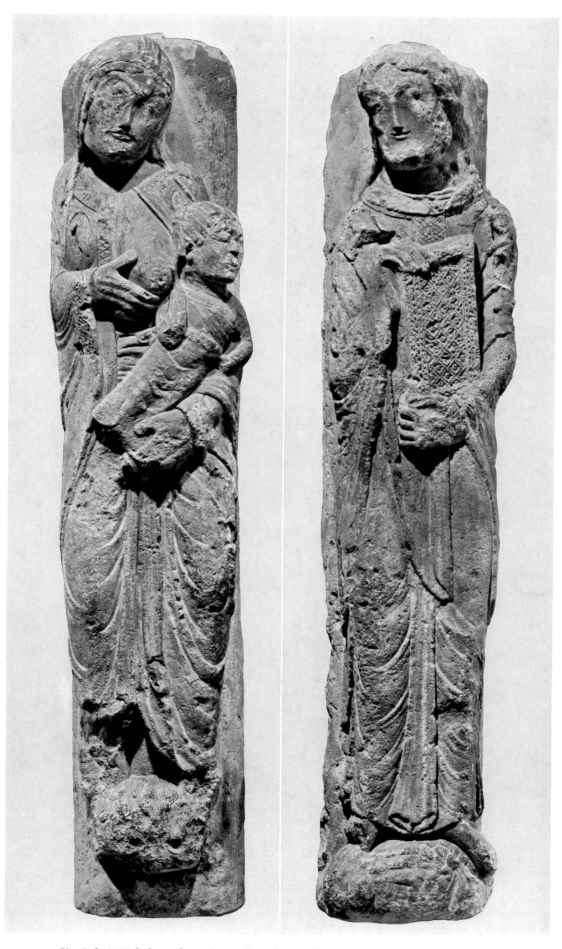

51 *Left*. St Nicholas, refusing his mother's breast. *Right*. An ecclesiastic. 1150–60.
(Saint-Maur-des-Fossés, Musée de la Société Archéologique)

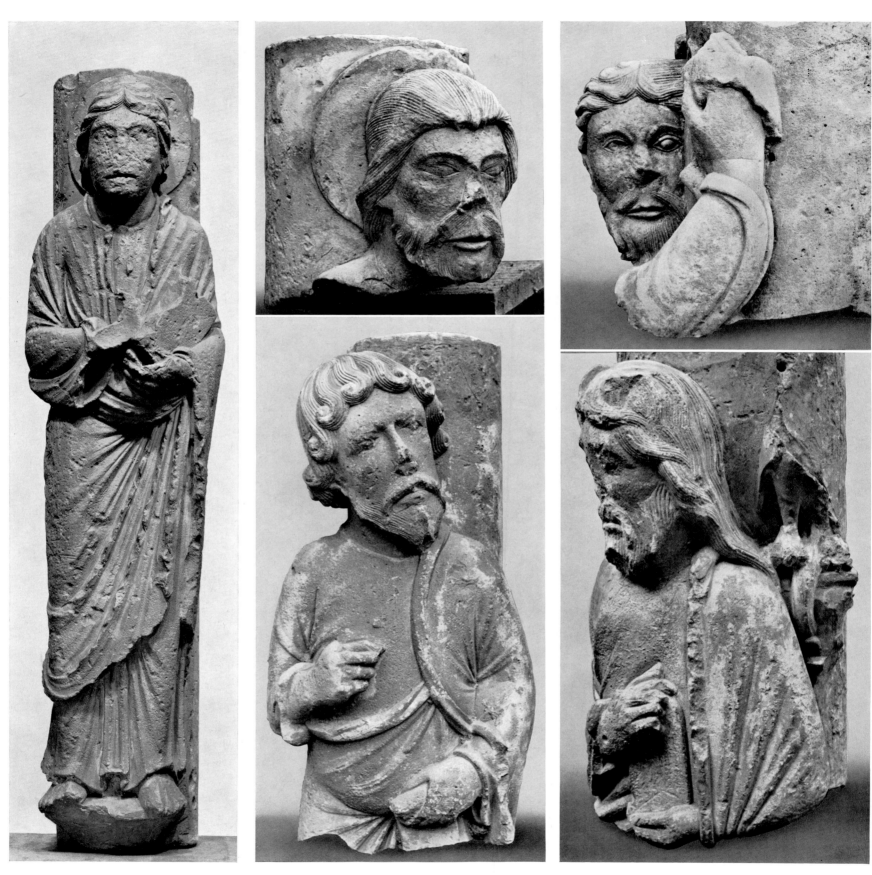

52 Châlons-sur-Marne, Notre-Dame-en-Vaux, column figures from the cloister. Before 1184.
Left. Apostle (now in the Museum of Art, Cleveland, Ohio). *Middle.* Apostle(?); prophet(?).
Right. Prophet; Moses with the brazen serpent and the Tables of the Law

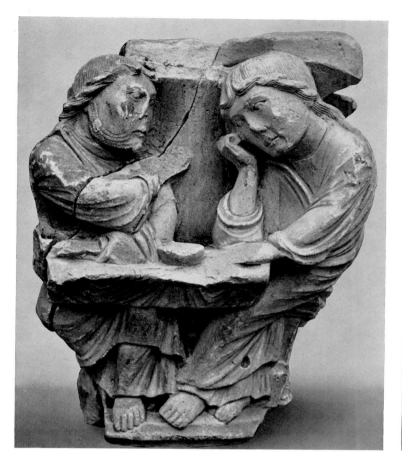

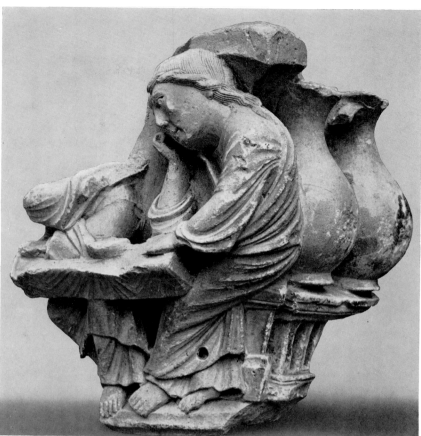

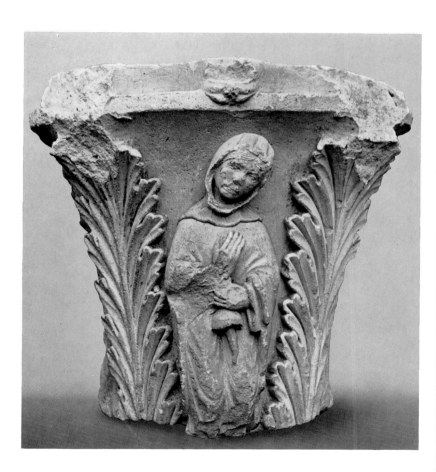

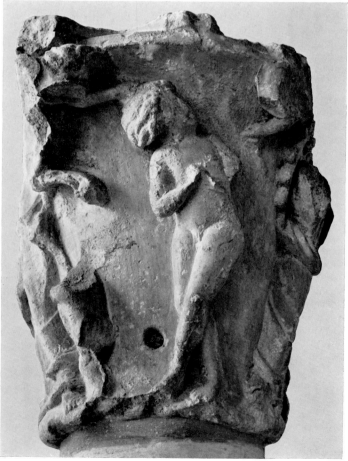

53 Châlons-sur-Marne, Notre-Dame-en-Vaux, capitals from the cloister. Before 1184. *Top*. Fragments showing the Marriage at Cana.
Bottom. One of the Foolish Virgins, and (right) one of the Damned (now in the Musée Municipal)

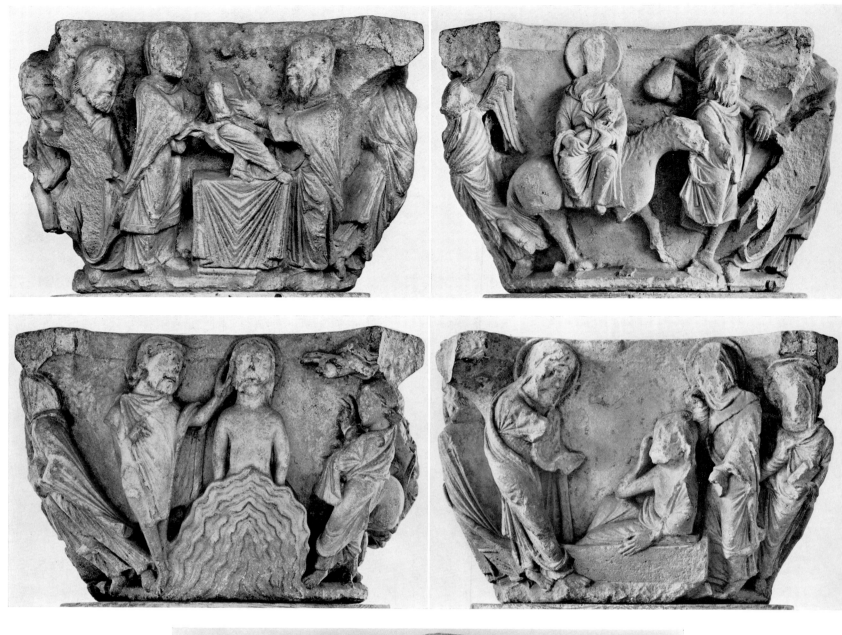

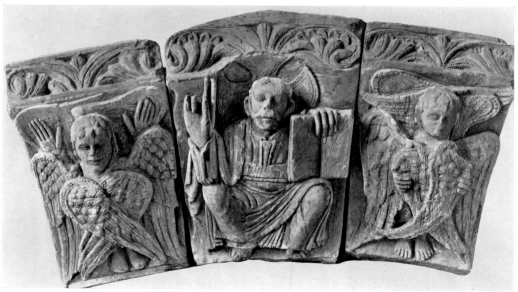

54 *Top and middle.* Capital from a wayside cross at Fagnières, originally from the cloister of Notre-Dame-en-Vaux(?): Presentation in the Temple, Flight into Egypt, Baptism of Christ, Raising of Lazarus. Before 1184. (Châlons-sur-Marne, Musée Municipal).
Bottom. Archivolt fragments from the destroyed abbey church of Honnecourt: Christ between seraphim. Third quarter of the twelfth century. (Honnecourt, parish church)

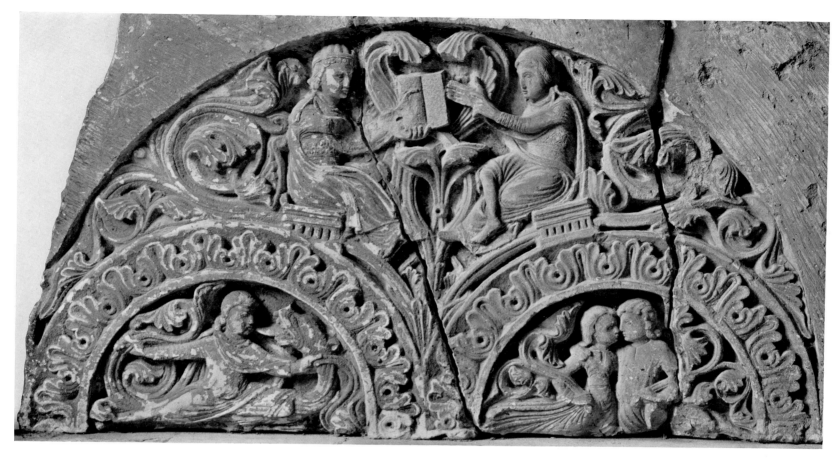

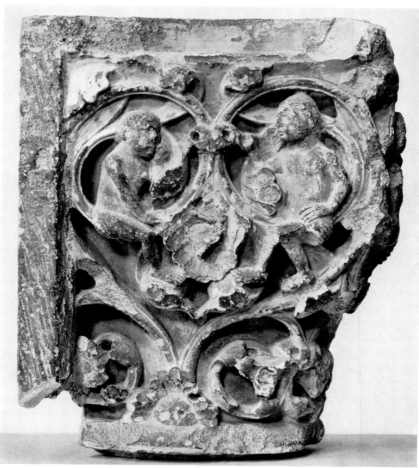

55 *Top*. Tympanum from a secular building(?): figures in disputation, a fight with a dragon, a loving couple. 1160–70
Bottom. Capital with tendril ornament and small figures. About 1170. (Both now in the Musée Saint-Rémi, Rheims)

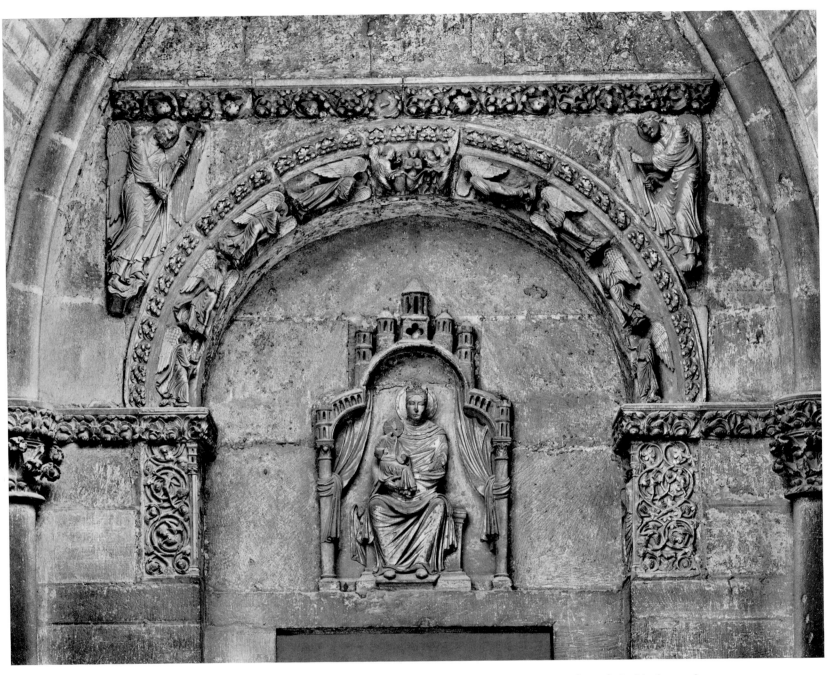

56 Rheims cathedral, north transept, right doorway (Porte romane). Tympanum: Virgin enthroned. Archivolt: angels.
In the spandrels: angels with processional crosses. About 1180

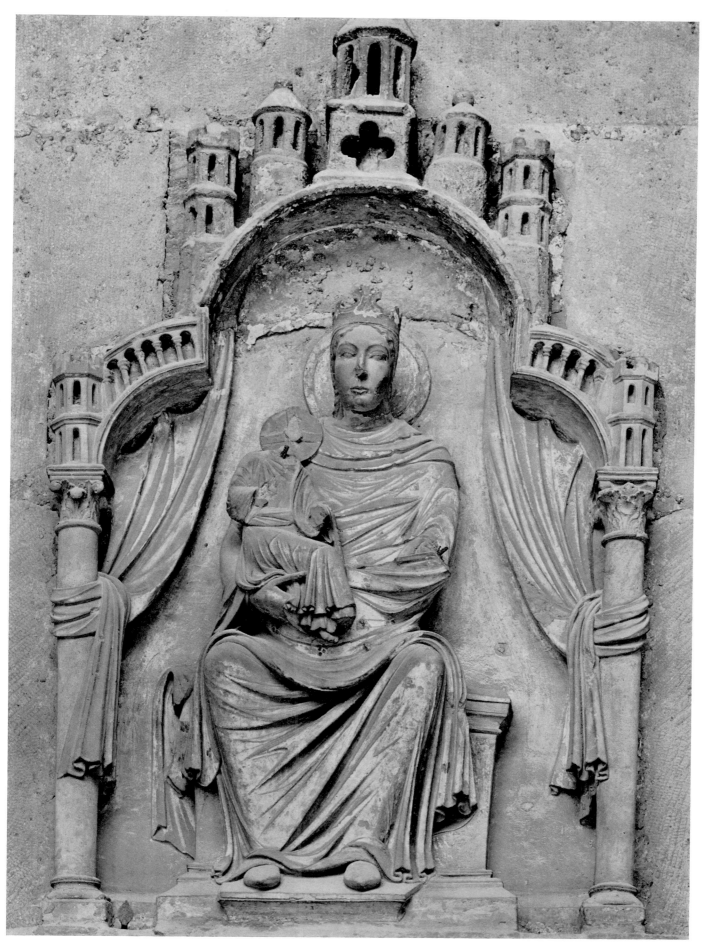

57 Rheims cathedral, north transept, right doorway (Porte romane).
Virgin enthroned, detail of tympanum. About 1180

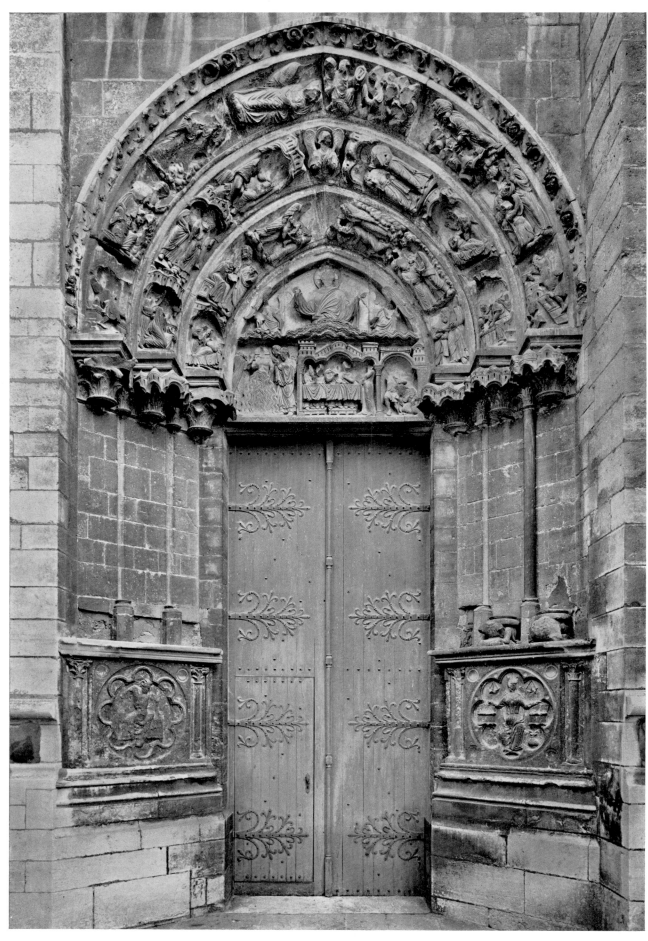

58 Sens cathedral, west portal, left doorway. Tympanum: Baptism of Christ, Herod's banquet, beheading of John the Baptist; in the apex, Christ between angels. Archivolt: life and legend of John the Baptist.
Socle: Avaritia and Largitas. After 1184

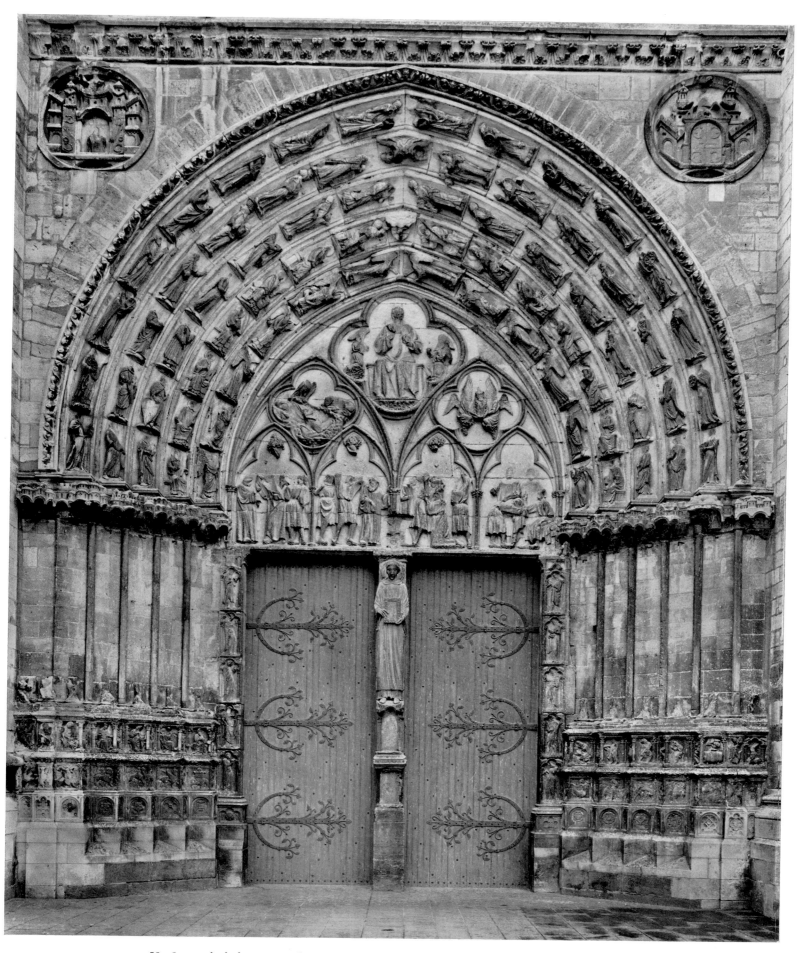

59 Sens cathedral, west portal, centre doorway. Tympanum: martyrdom of St Stephen. After 1268.
Spandrels: the gate of Paradise, open and closed. Trumeau: St Stephen. Doorposts: (left) Wise Virgins, (right) Foolish Virgins.
Socle: Liberal Arts, Calendar. About 1200

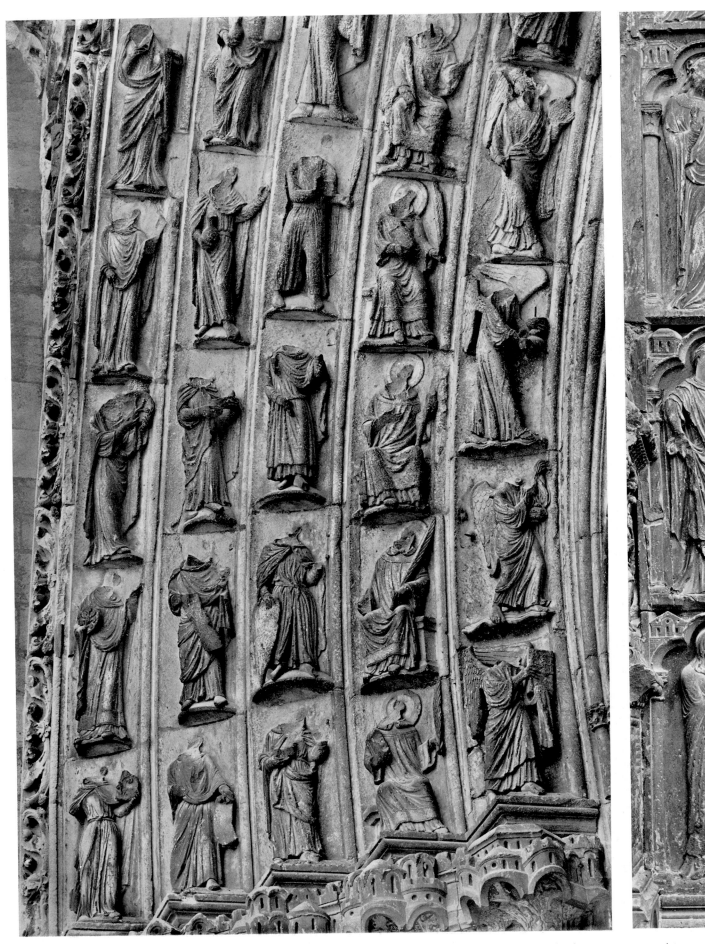

60 Sens cathedral, west portal, centre doorway. *Left*. Detail of the left archivolt: angels, deacons, martyrs, virtues.
Right. Wise Virgins, detail from the left doorpost. About 1200

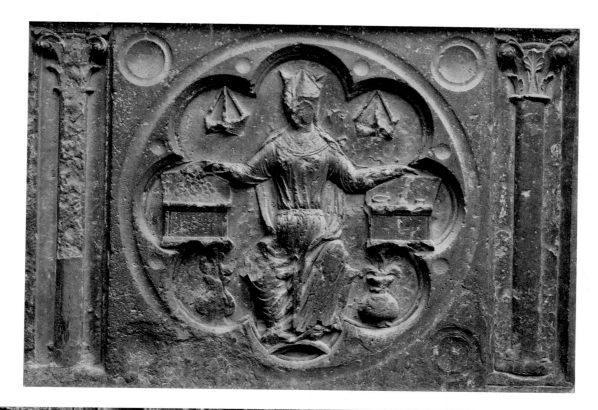

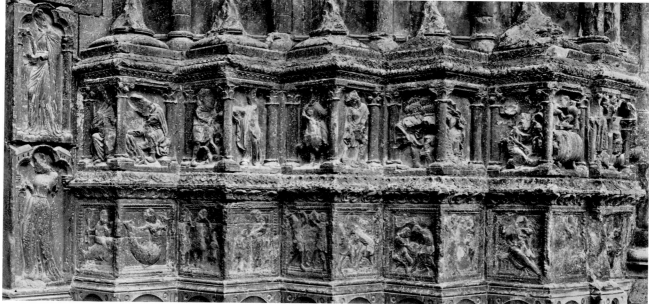

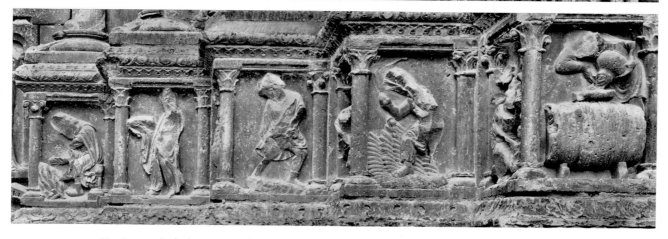

61 Sens cathedral, west portal. *Top.* Left doorway, right jamb. Socle relief: Largitas. After 1184.
Middle and bottom. Centre doorway, right jamb. Socle relief: Calendar, Mare, Terra, siren, fabulous beings, secular themes. About 1200

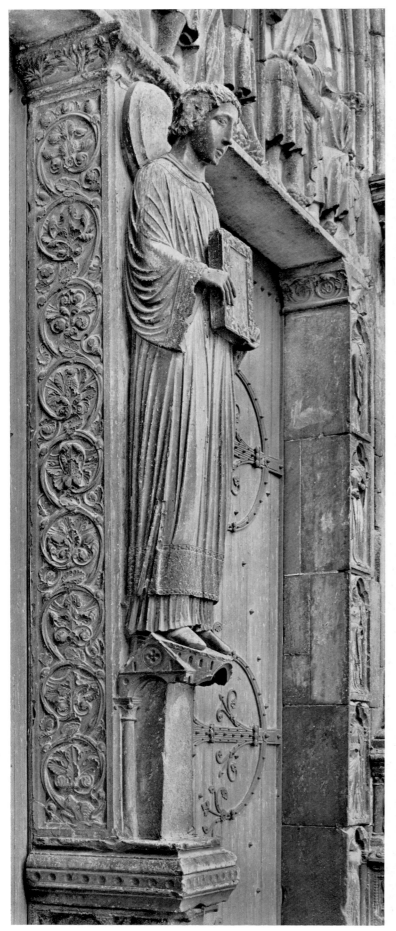
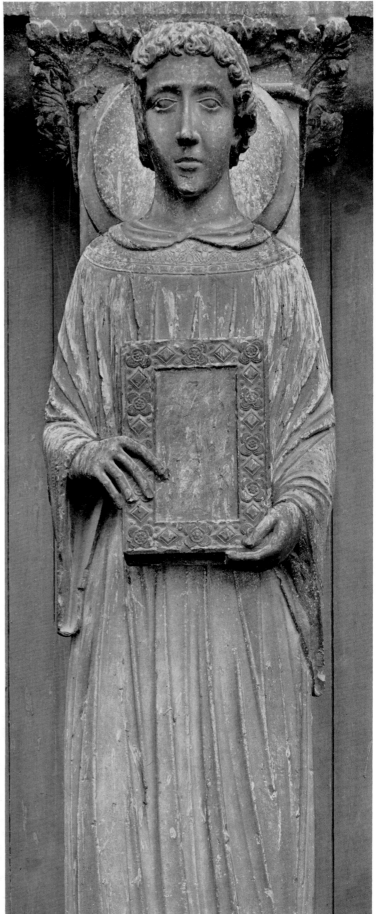

62 Sens cathedral, west portal, centre doorway. Trumeau: St Stephen. About 1200

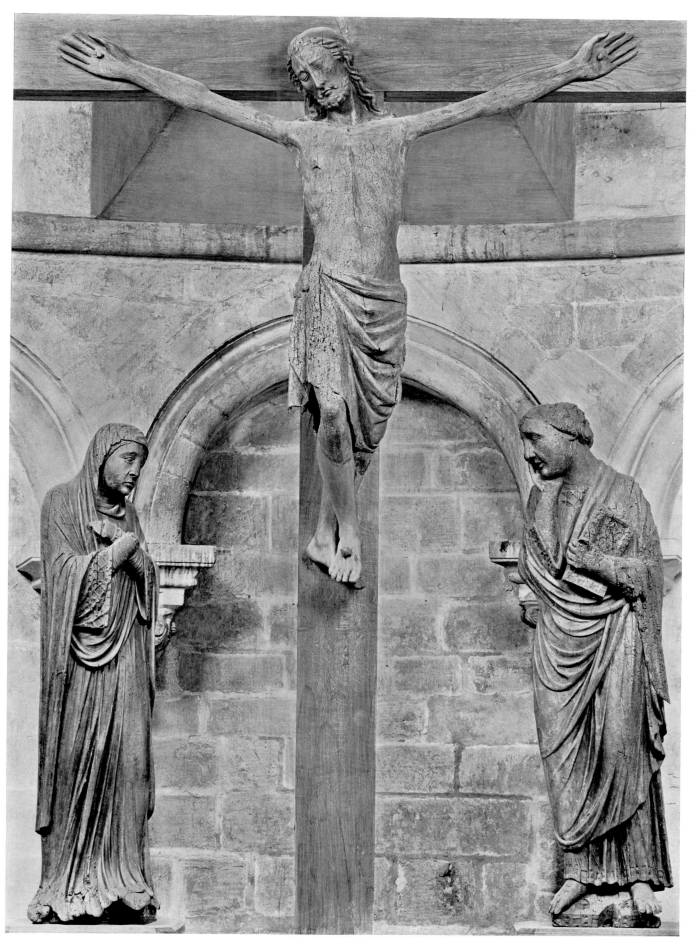

63 Crucifixion group from Cérisiers. About 1200 and 1260. (Sens cathedral)

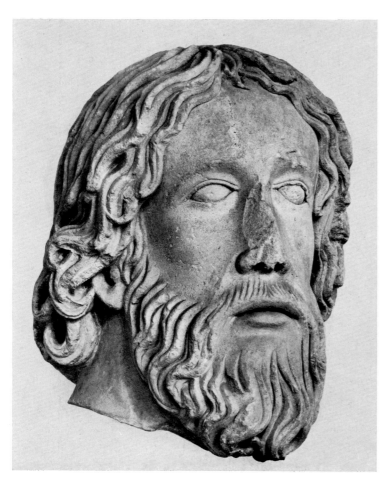

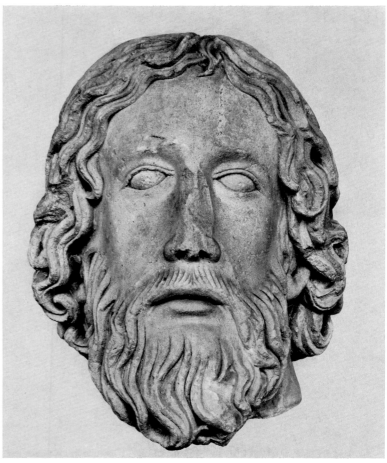

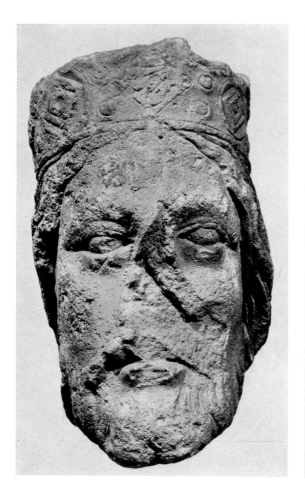

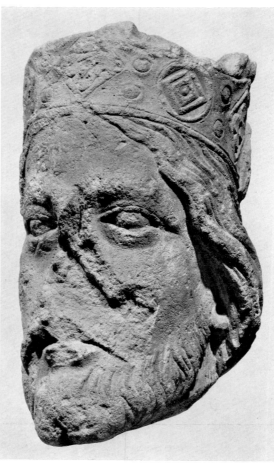

64 *Top*. Head of an apostle(?),
perhaps from the jamb of the centre
doorway of the west portal, Sens
cathedral. About 1200. (Sens,
Palais Synodal).
Bottom. Head of a king. About
1190. (Sens, Musée Municipal)

65 Saint-Denis, abbey church.
Figures from the basin of the
monastery fountain: Dives, Paris;
Ebrietas, Neptune; Diana (originally
Terra?), Lupus. About 1200

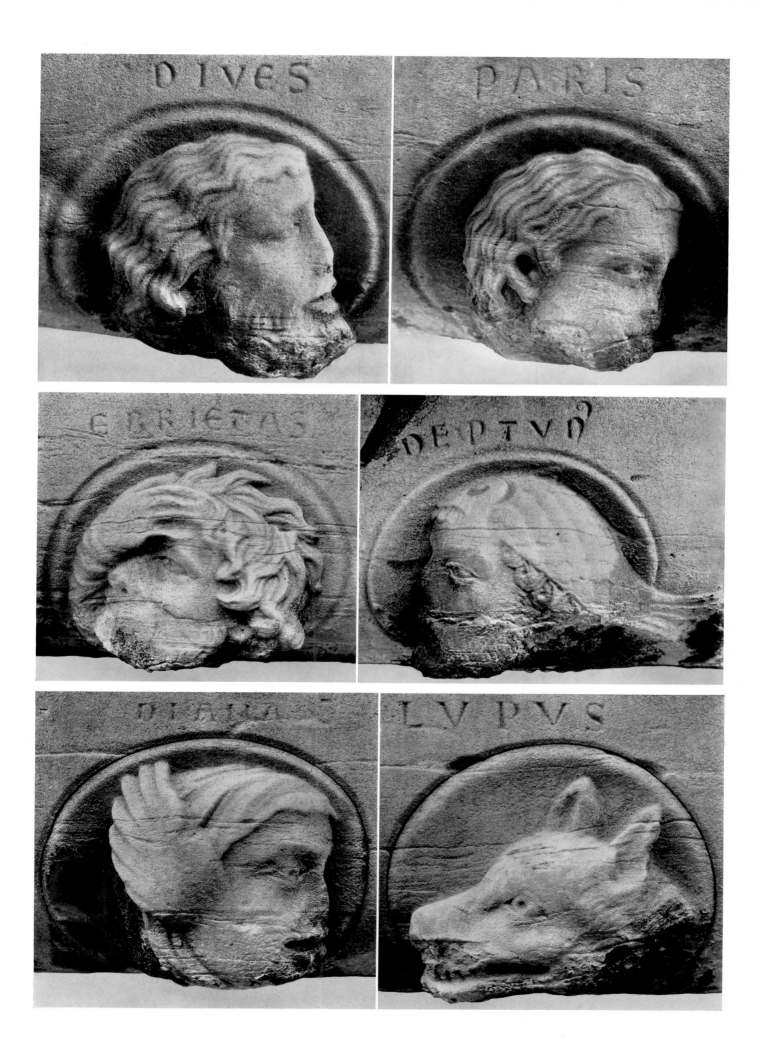

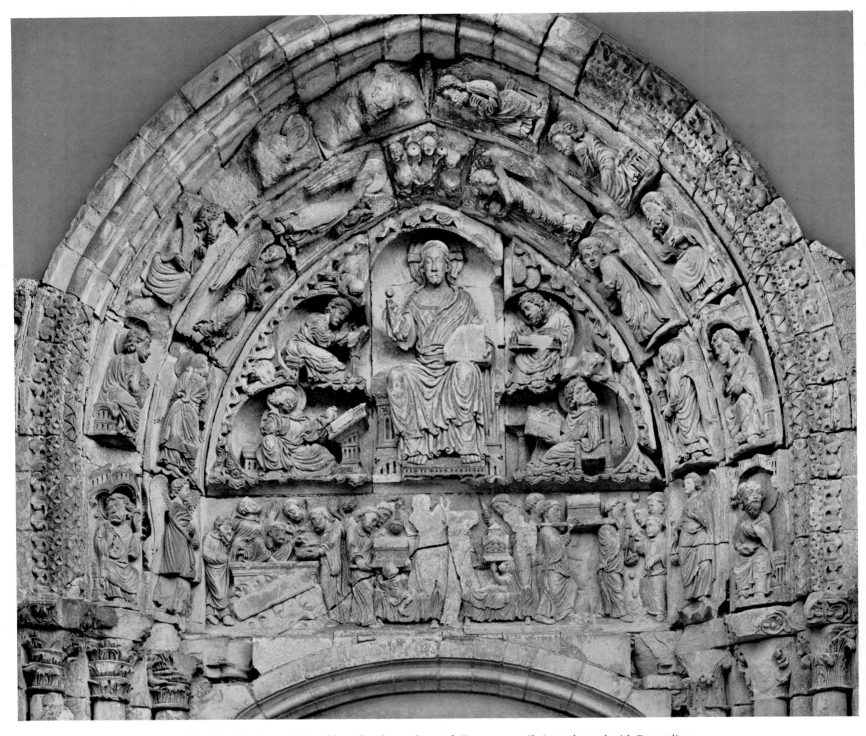

66 Saint-Benoît-sur-Loire, abbey church, north portal. Tympanum: Christ enthroned with Evangelists.
Lintel: translation of the relics of St Benedict. Archivolt: angels, apostles. About 1200

67 *Top*. Saint-Pierre-le-Moutier, priory church, portal leading formerly to the cloister.
Tympanum: Christ enthroned with Evangelists. Archivolt: angels. Early thirteenth century.
Bottom. Germigny l'Exempt, parish church, west portal. Tympanum: Adoration of the Magi, Annunciation. 1215–20

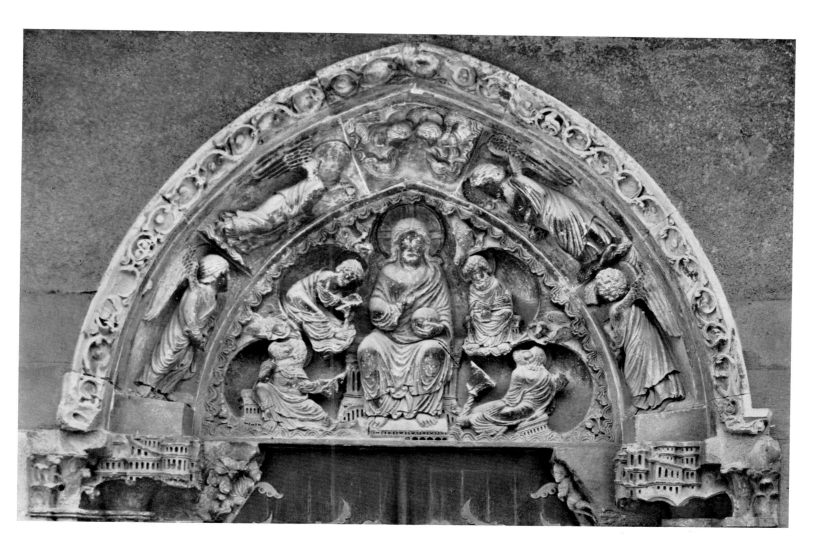

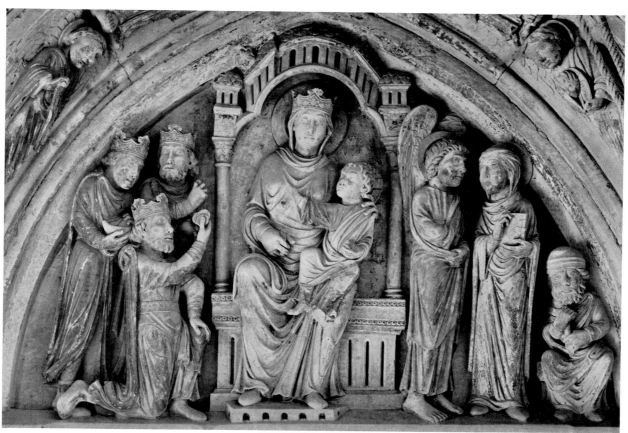

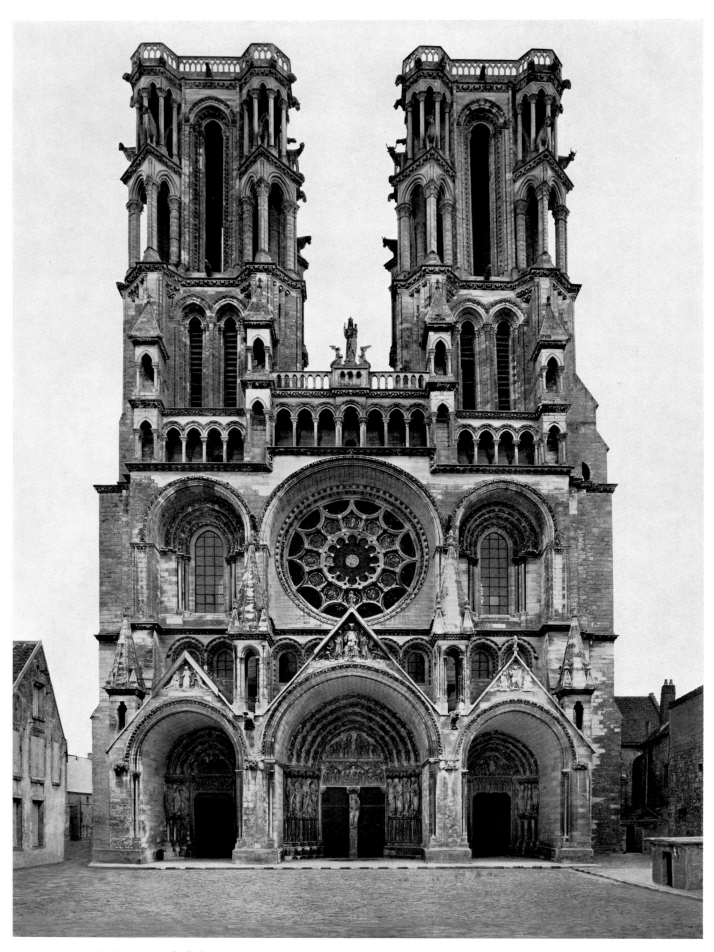

68, 69 Laon cathedral, west façade. 69 *Top*. Right doorway, lintel: separation of the Blessed from the Damned.
Middle and bottom. Left doorway, tympanum: Adoration of the Magi. Lintel: Annunciation, Nativity, Annunciation to the Shepherds.
1195–1205. (Casts taken before restoration; Paris, Musée des Monuments français)

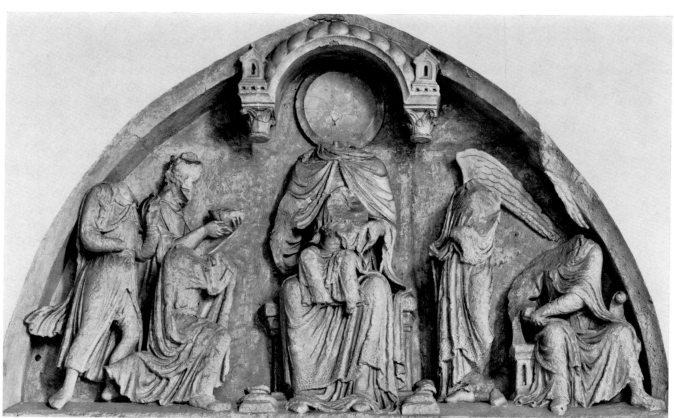

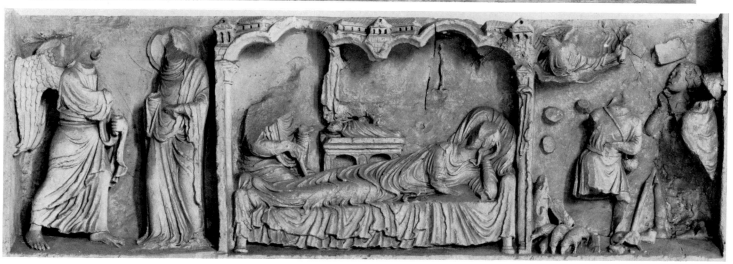

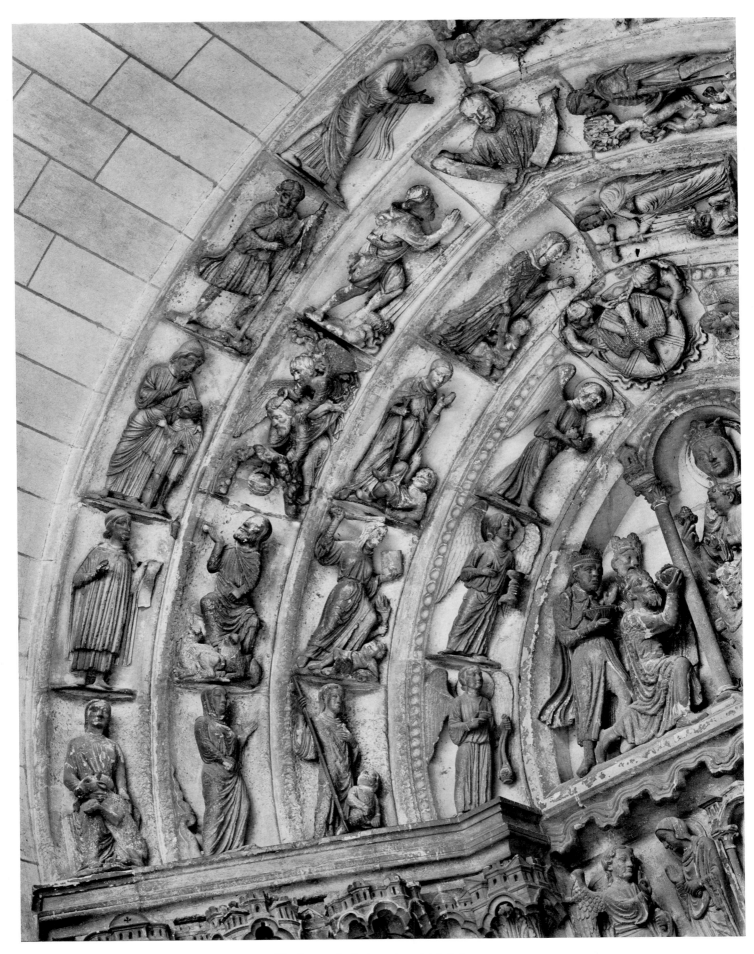

70 Laon cathedral, west portal, left doorway.
Left archivolt: angels, virtues, prefigurations of Mary's virginity. 1195–1205

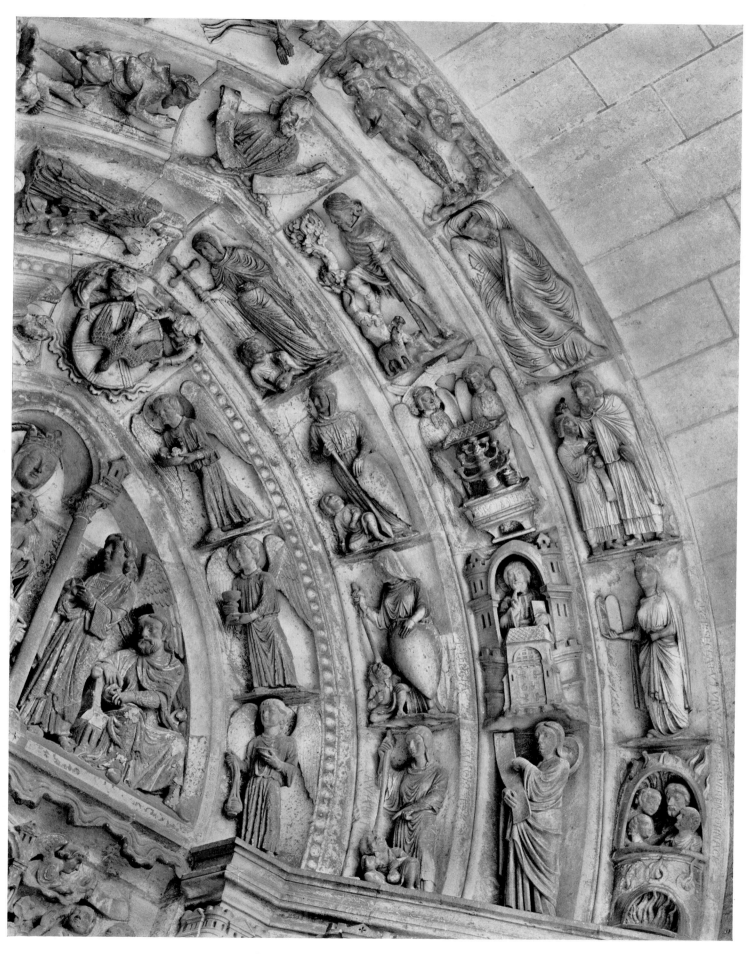

71 Laon cathedral, west portal, left doorway.
Right archivolt: angels, virtues, prefigurations of Mary's virginity. 1195–1205

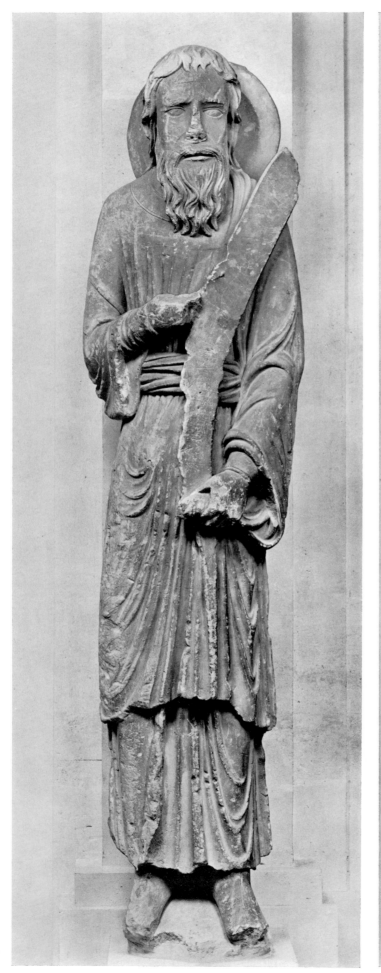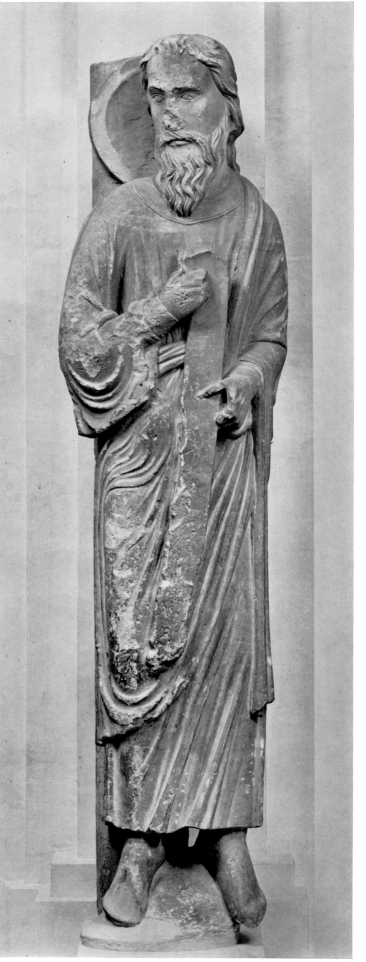

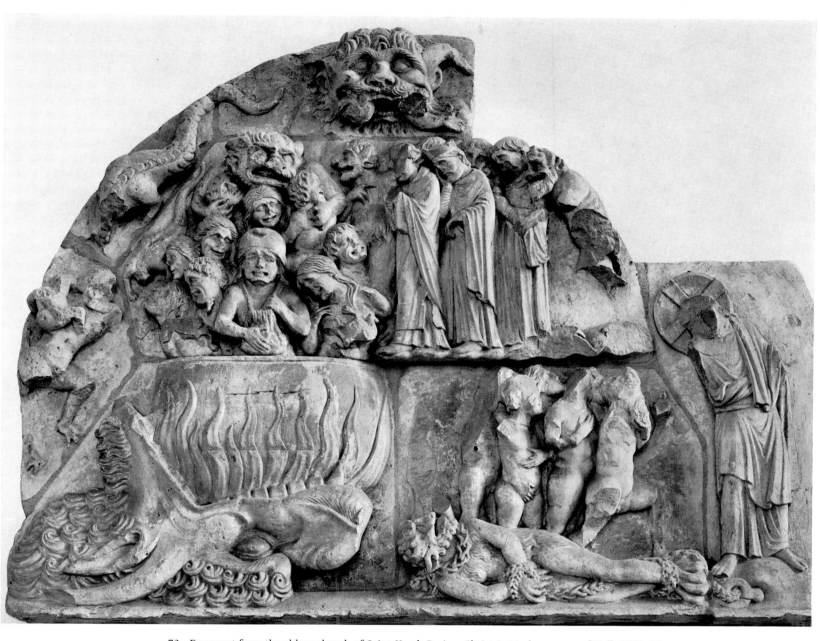

73 Fragment from the abbey church of Saint-Yved, Braine. Christ in Limbo, scenes of Hell. 1205–15.
(Soissons, Musée Municipal)

72 Prophets. About 1200. (Laon, Musée Municipal)

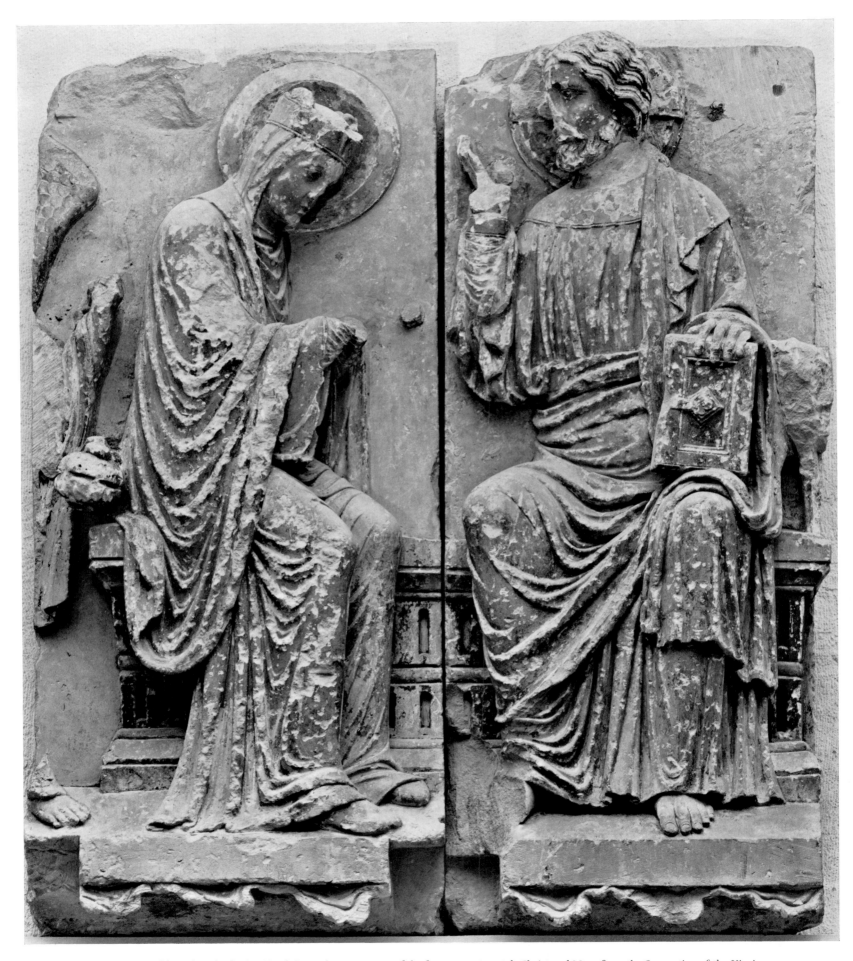

74 Braine, abbey church of Saint-Yved. From the tympanum of the former west portal: Christ and Mary from the Coronation of the Virgin.
1205–15

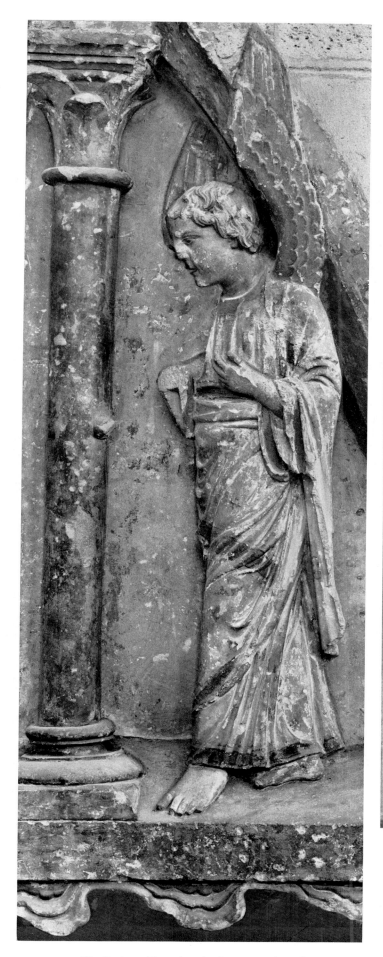

75 Braine, abbey church of Saint-Yved, sculptures from the former west portal. *Left*. Fragment from the tympanum: angel from the
Coronation of the Virgin. (Soissons, Musée Municipal). *Right*. Archivolt figure: king from the Stem of Jesse. 1205–15

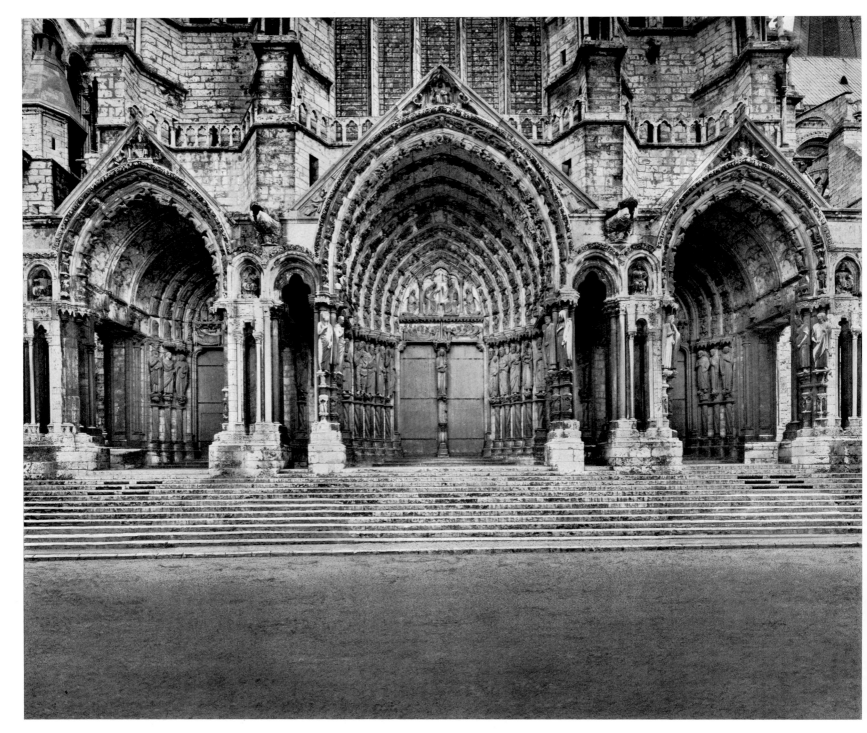

76 Chartres cathedral, north transept portal

77 Chartres cathedral, north transept, centre doorway. Tympanum: Coronation of the Virgin.
Lintel: Death and Assumption of the Virgin. Archivolt: angels, Stem of Jesse, prophets.
Jambs: typological figures from the Old Testament. Trumeau: St Anne. 1205–10

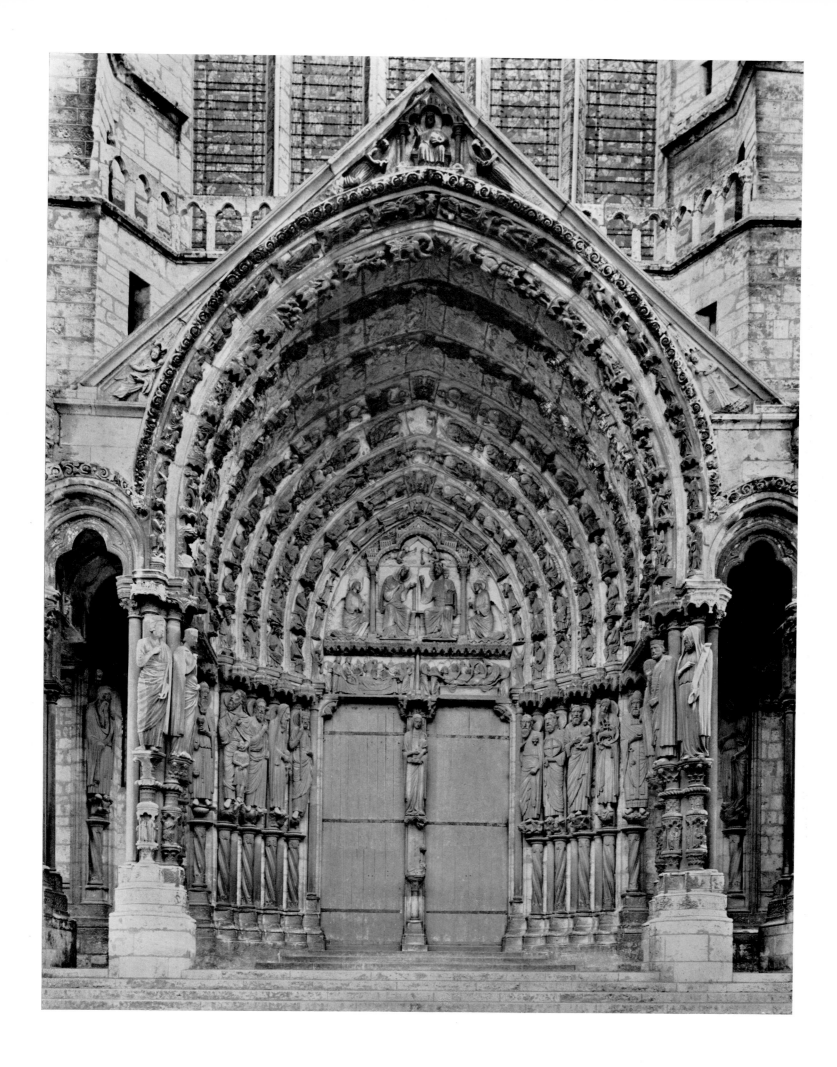

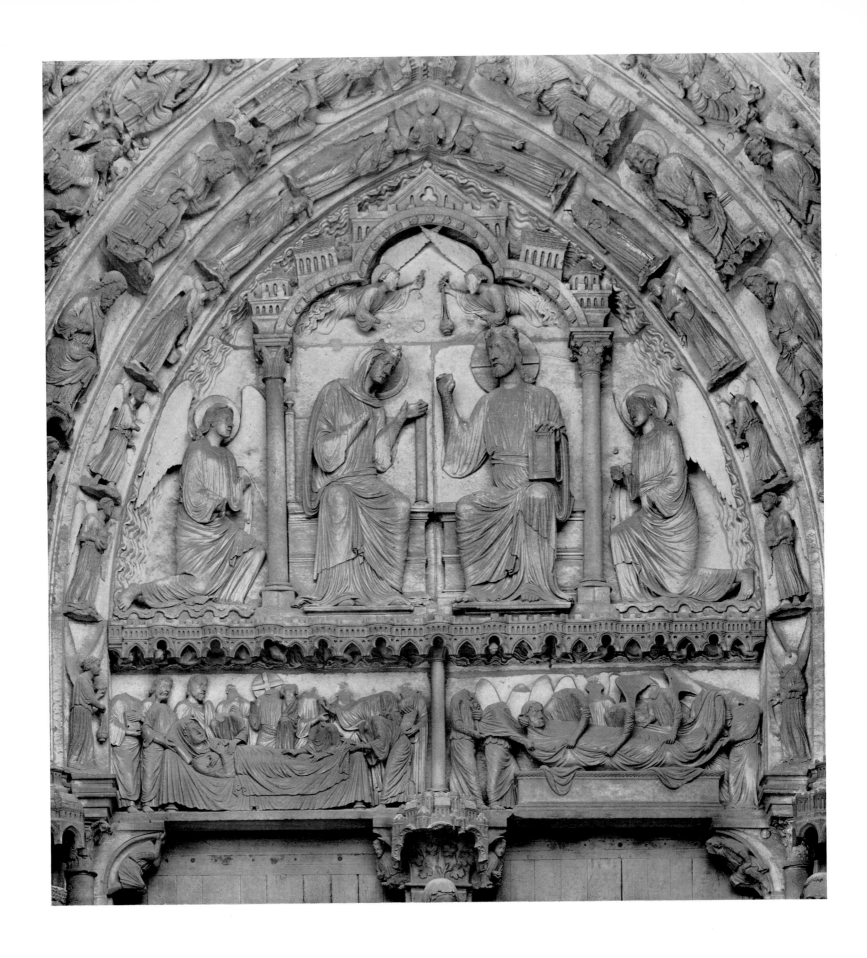

78, 79 Chartres cathedral, north transept, centre doorway. Tympanum: Coronation of the Virgin.
Lintel: Death and Assumption of the Virgin. 1205–10.
79 Detail of tympanum: Coronation of the Virgin

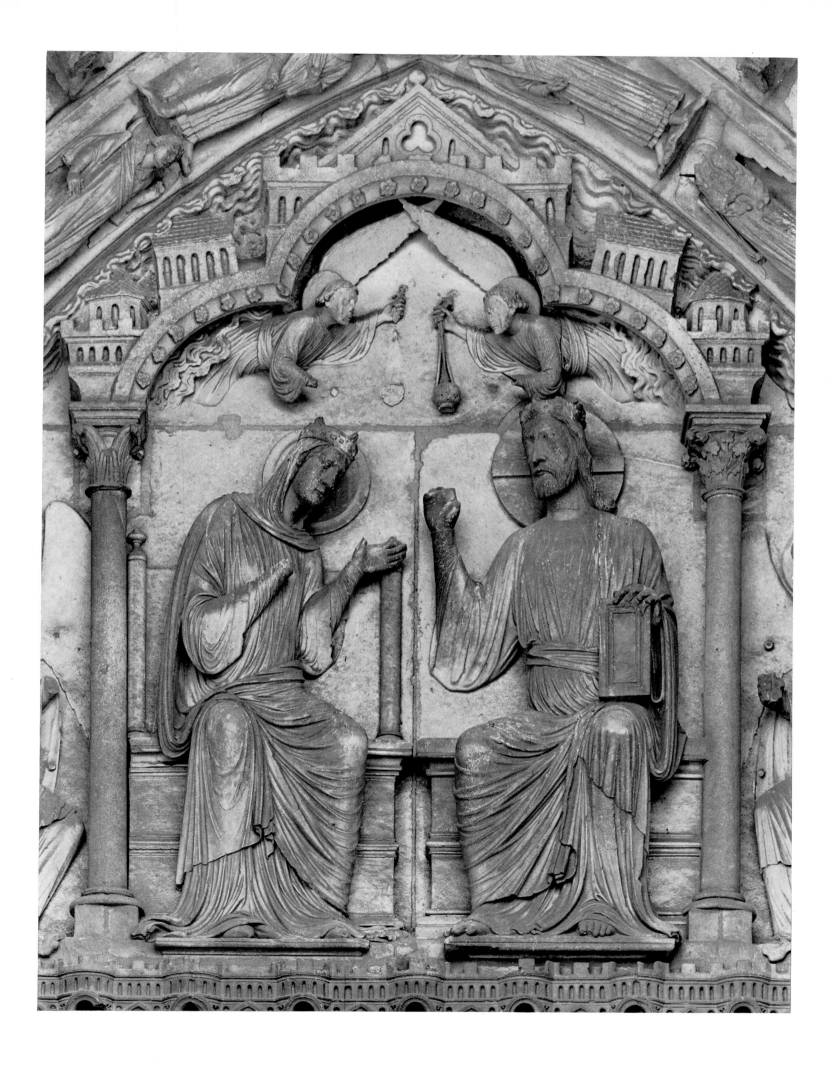

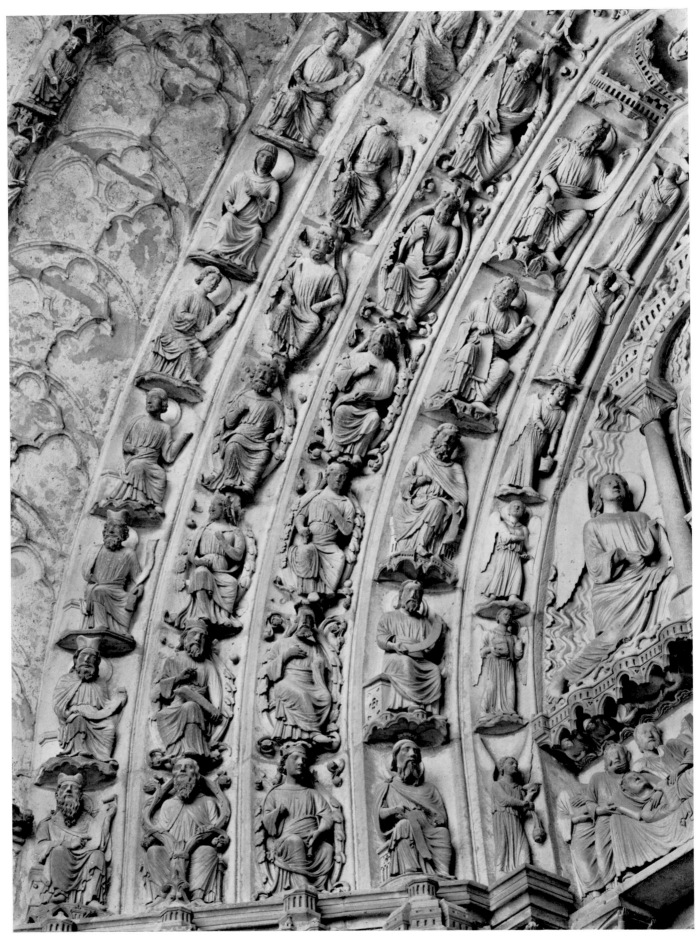

80 Chartres cathedral, north transept, centre doorway.
Left archivolt: angels, Stem of Jesse, prophets and figures from the Old Testament. 1205–10

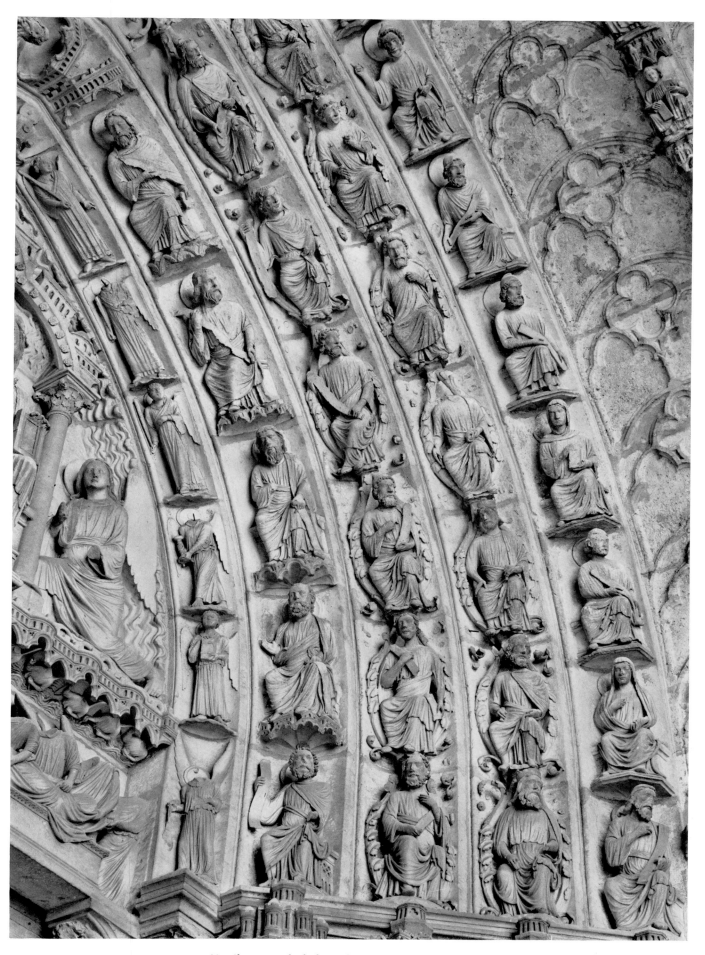

81 Chartres cathedral, north transept, centre doorway.
Right archivolt: angels, Stem of Jesse, prophets and figures from the Old Testament. 1205–10

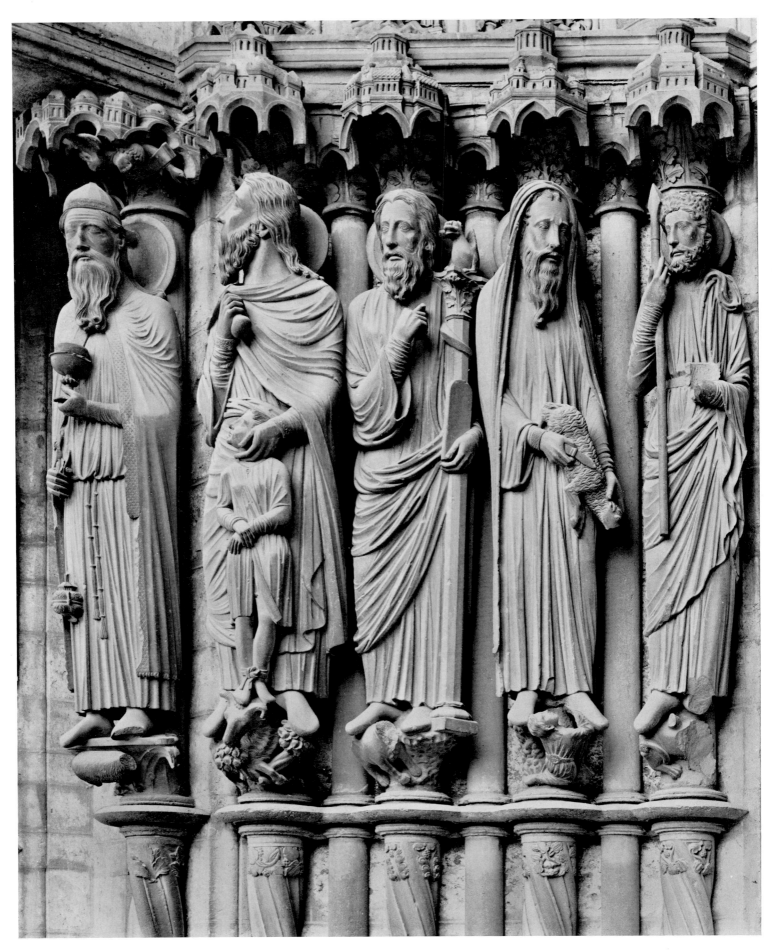

82 Chartres cathedral, north transept, centre doorway.
Left jamb: Aaron or Melchizedek, Abraham, Moses, Samuel, David. 1205–10

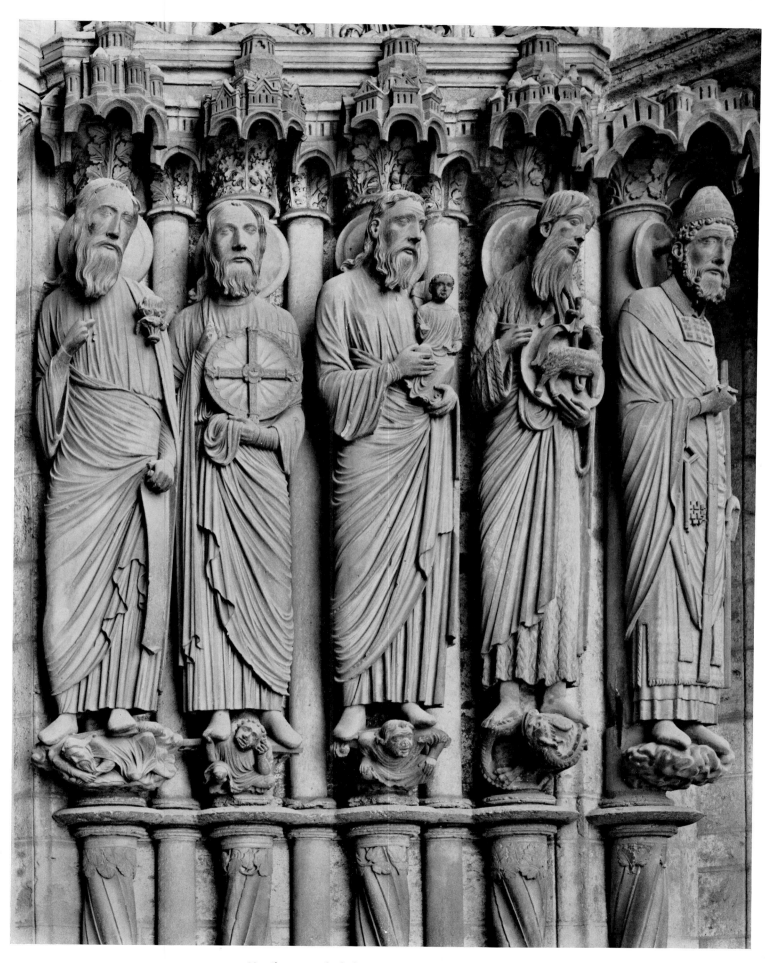

83 Chartres cathedral, north transept, centre doorway.
Right jamb: Isaiah, Jeremiah, Simeon, John the Baptist, Peter. 1205–10

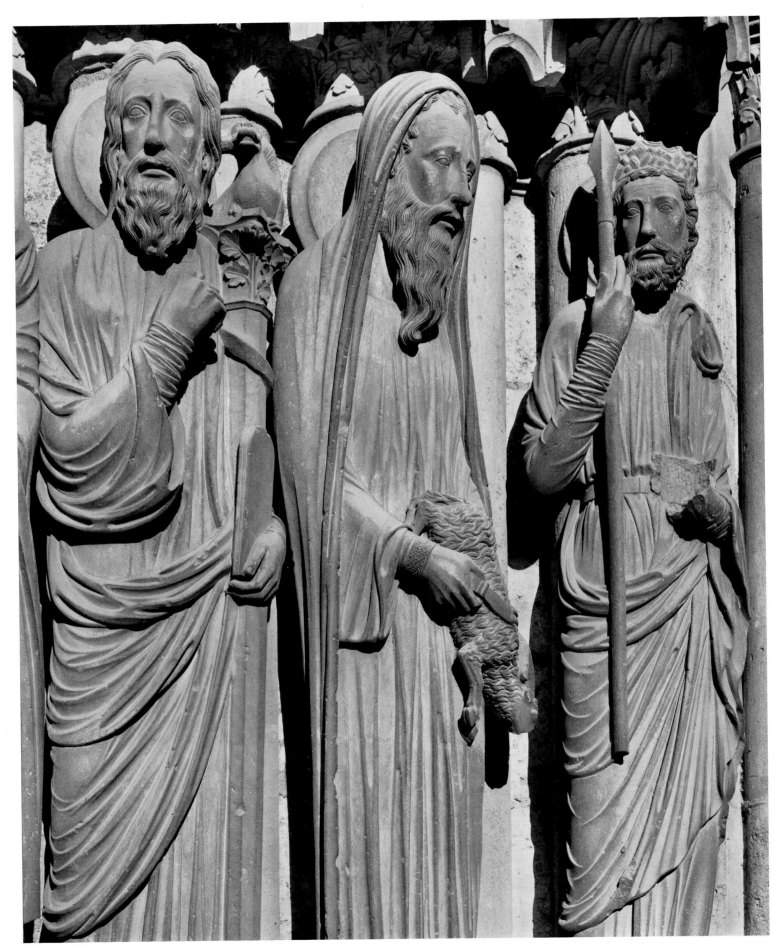

84 Chartres cathedral, north transept, centre doorway. Detail of left jamb: Moses, Samuel, David. 1205–10

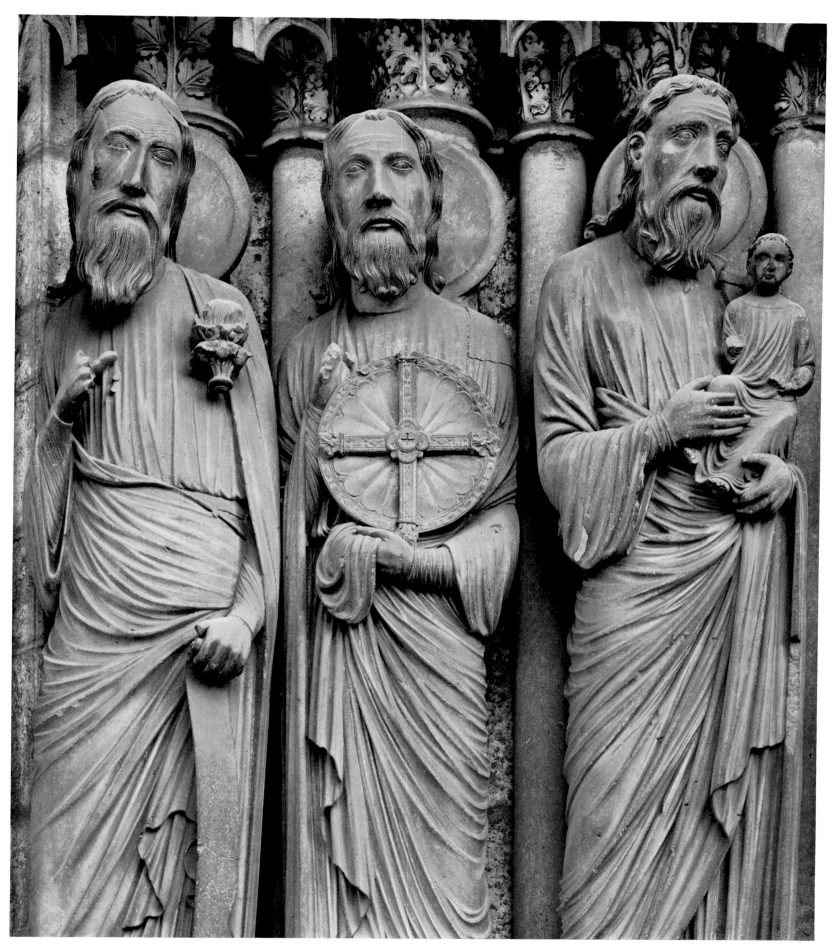

85 Chartres cathedral, north transept, centre doorway. Detail of right jamb: Isaiah, Jeremiah, Simeon. 1205–10

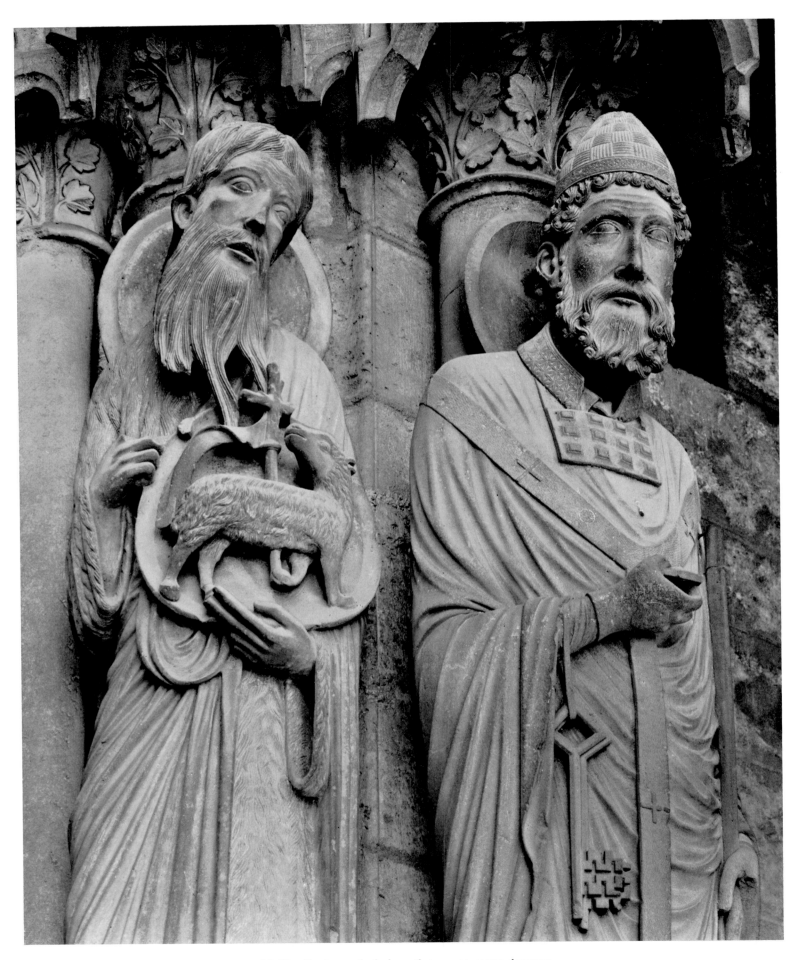

86, 87 Chartres cathedral, north transept, centre doorway.
86 Detail of right jamb: John the Baptist, Peter. 87 Trumeau: St Anne. 1205–10

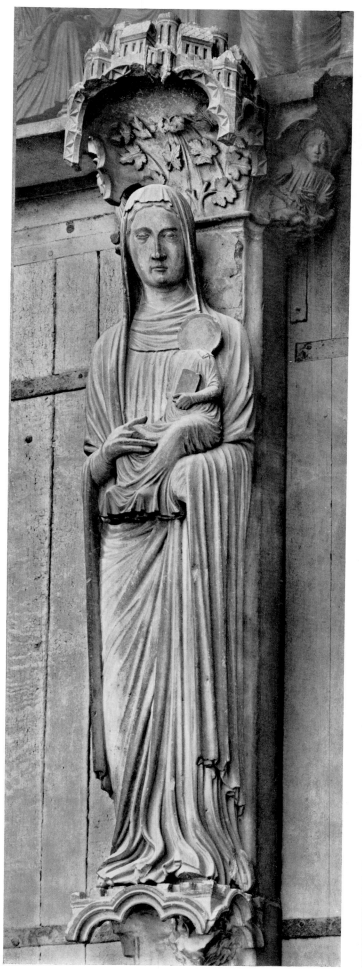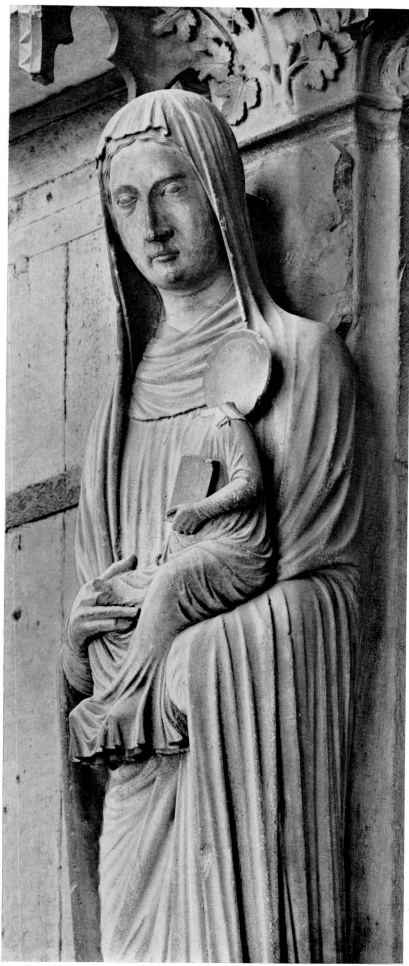

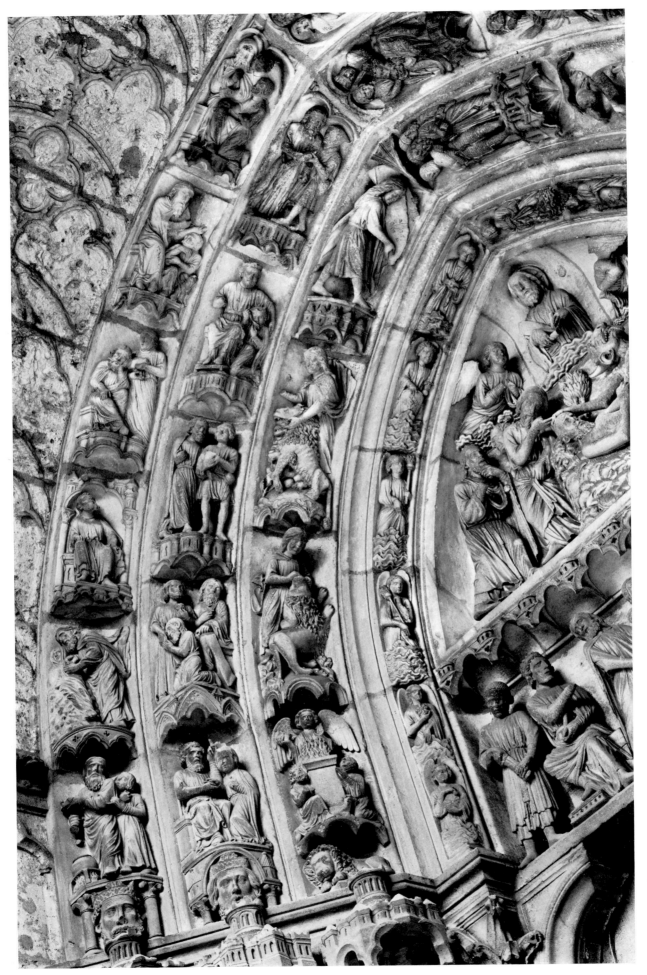

88 Chartres cathedral,
north transept, right
doorway. Left archivolt:
(reading from the inside)
the stories of Samson,
Esther and Tobias.
About 1220

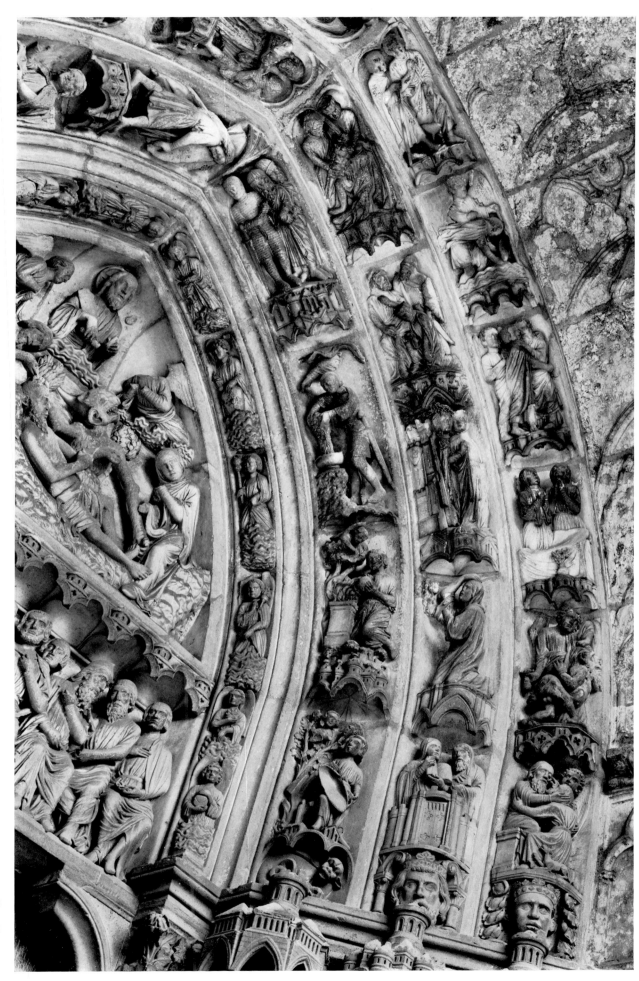

89 Chartres cathedral, north transept, right doorway. Right archivolt: (reading from the inside) the stories of Gideon, Judith and Tobias. About 1220

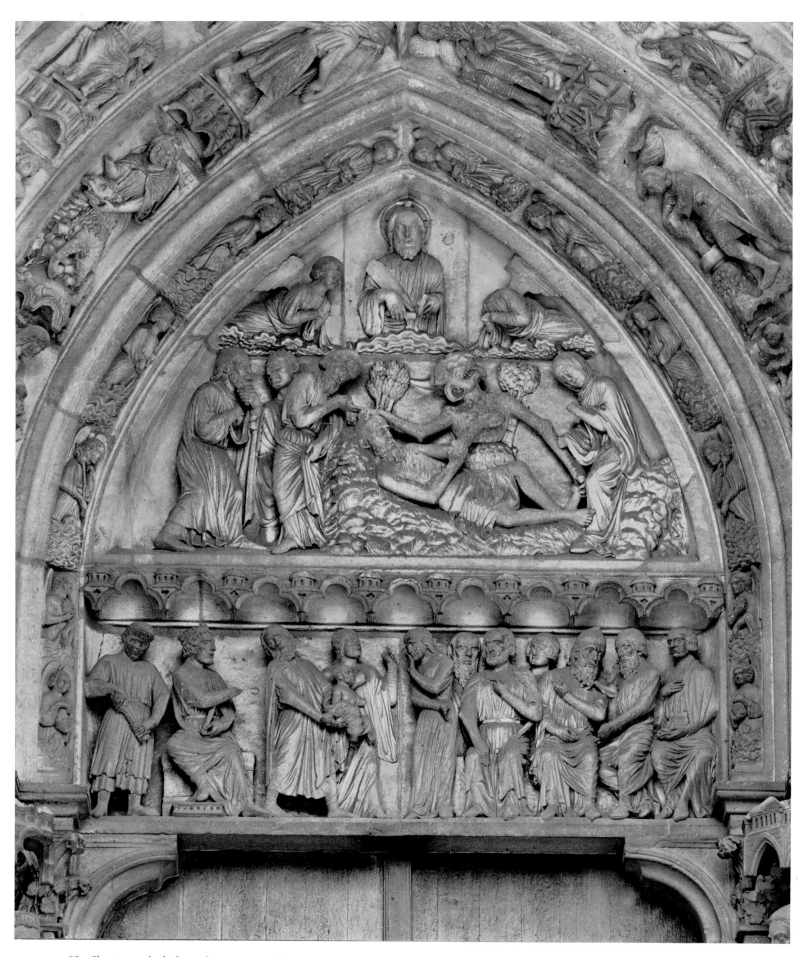

90 Chartres cathedral, north transept, right doorway. Tympanum: Job afflicted by leprosy, with his wife and the three friends. Lintel: Judgment of Solomon. About 1220

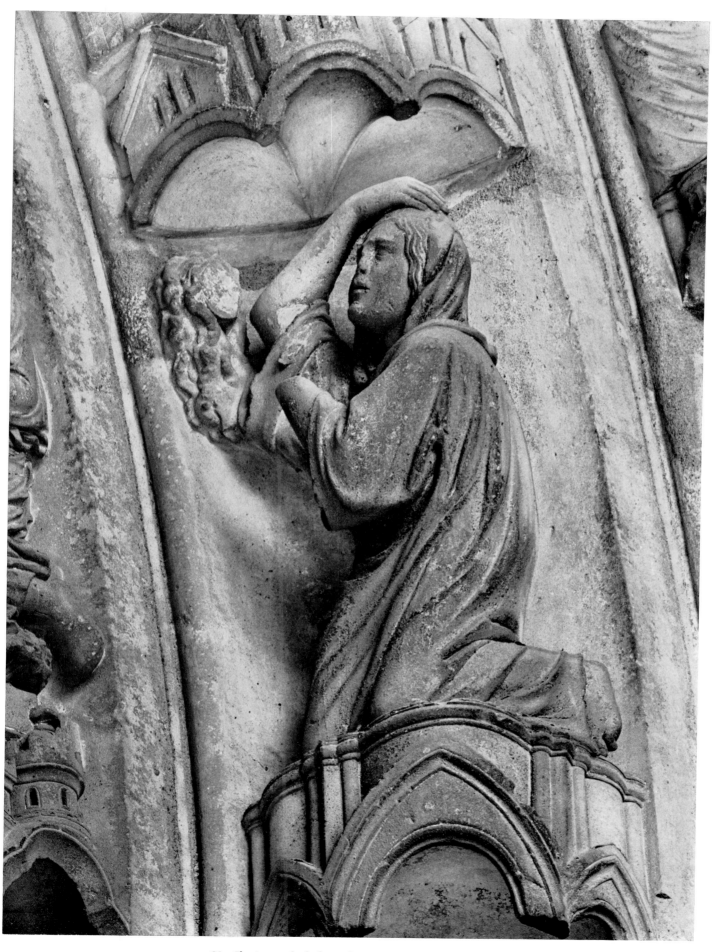

91 Chartres cathedral, north transept, right doorway.
Detail of right archivolt: Judith strewing her head with ashes. About 1220

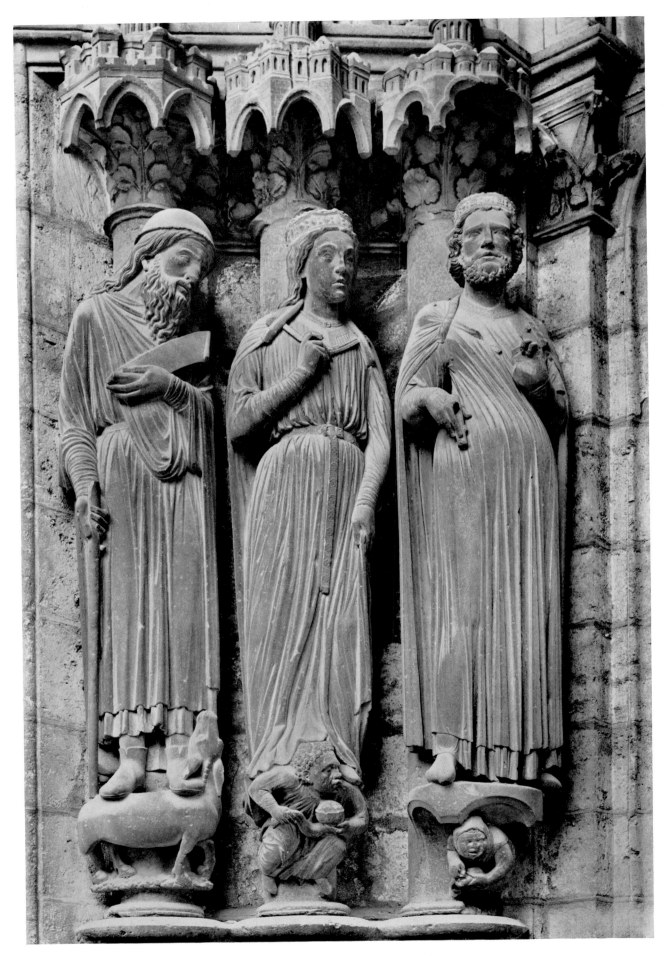

92 Chartres cathedral, north transept, right doorway.
Left jamb: Balaam, Queen of Sheba, Solomon. About 1220

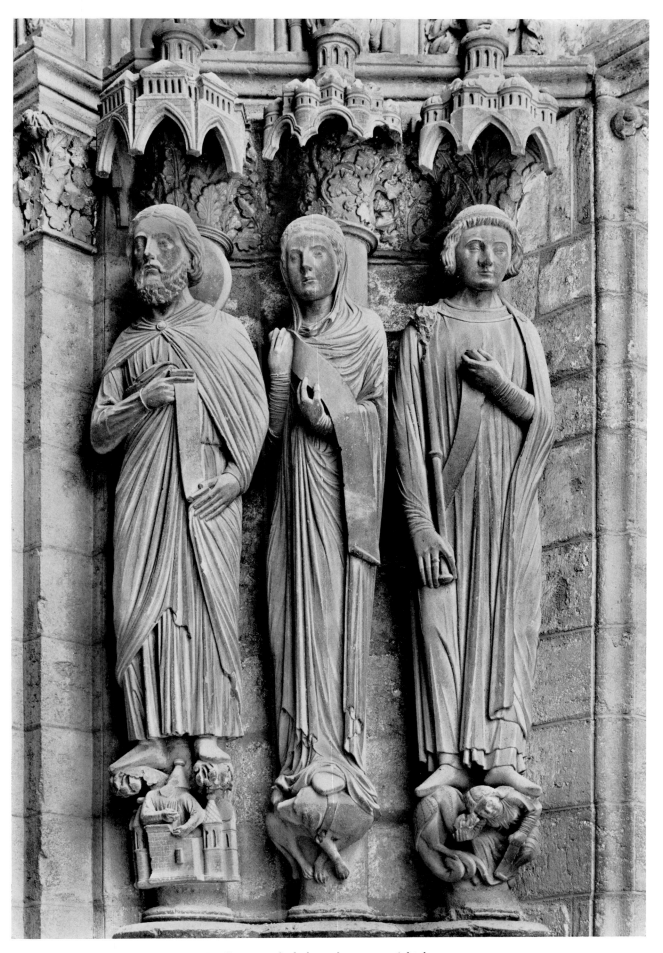

93 Chartres cathedral, north transept, right doorway.
Right jamb: unidentified Old Testament figure, Asenath(?), Joseph. About 1220

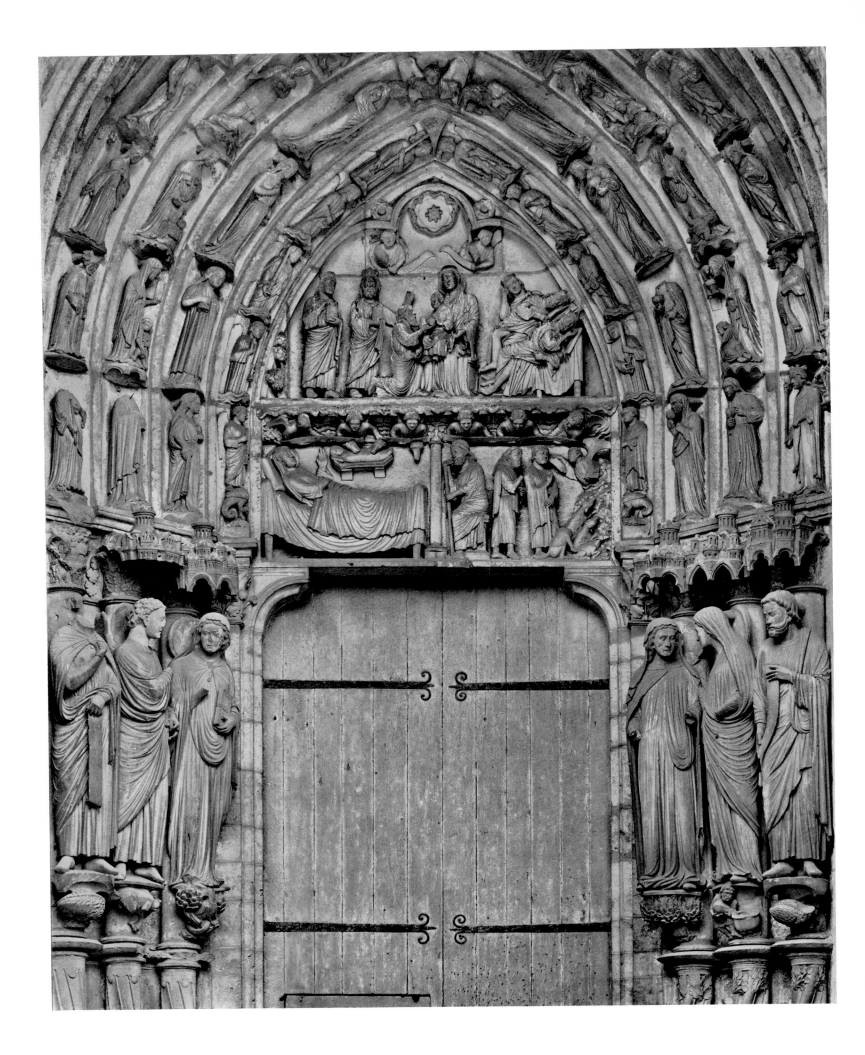

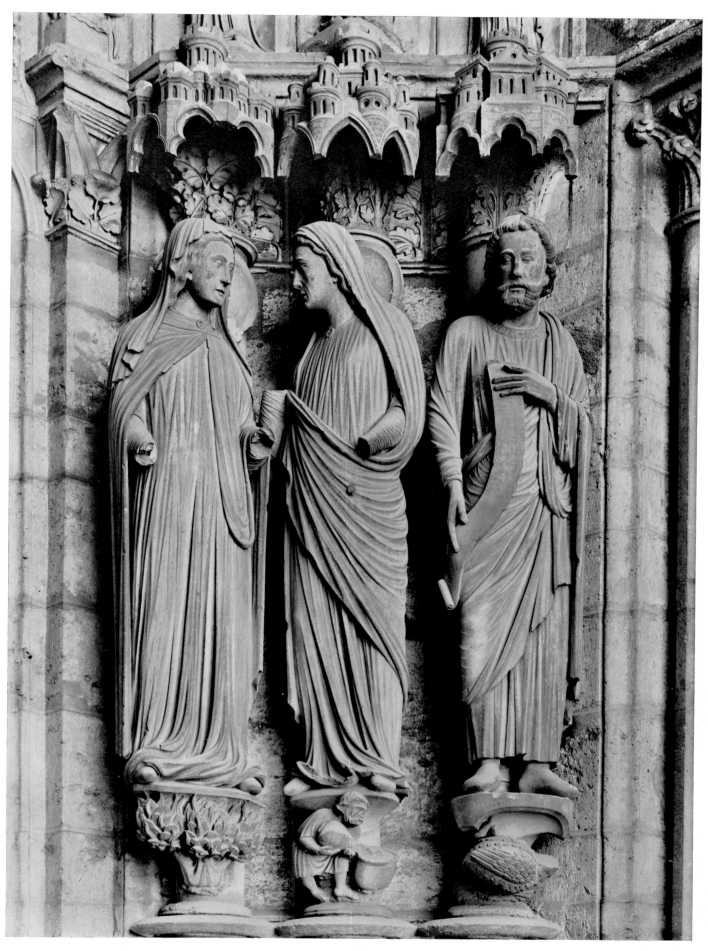

94, 95 Chartres cathedral, north transept, left doorway. Jambs: (left) prophet, Annunciation; (right) Visitation, prophet.
Lintel: Nativity, Annunciation to the Shepherds. Tympanum: Adoration and Dream of the Magi.
Archivolt: (reading from the inside): angels, Wise and Foolish Virgins, Virtues. About 1220. 95 Right jamb

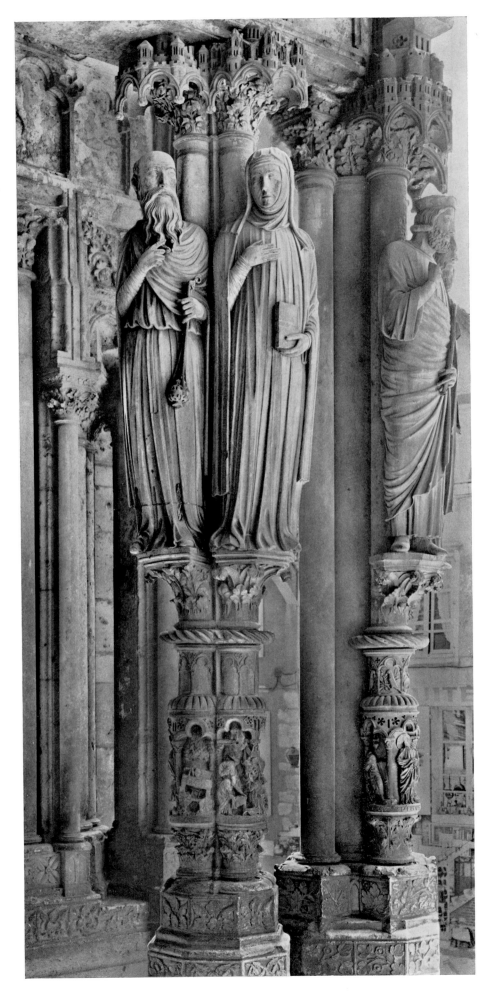

96, 97 Chartres cathedral, north porch. Old Testament
figures: priest, woman, king.
97 Detail: figures of priest and woman. 1220–30

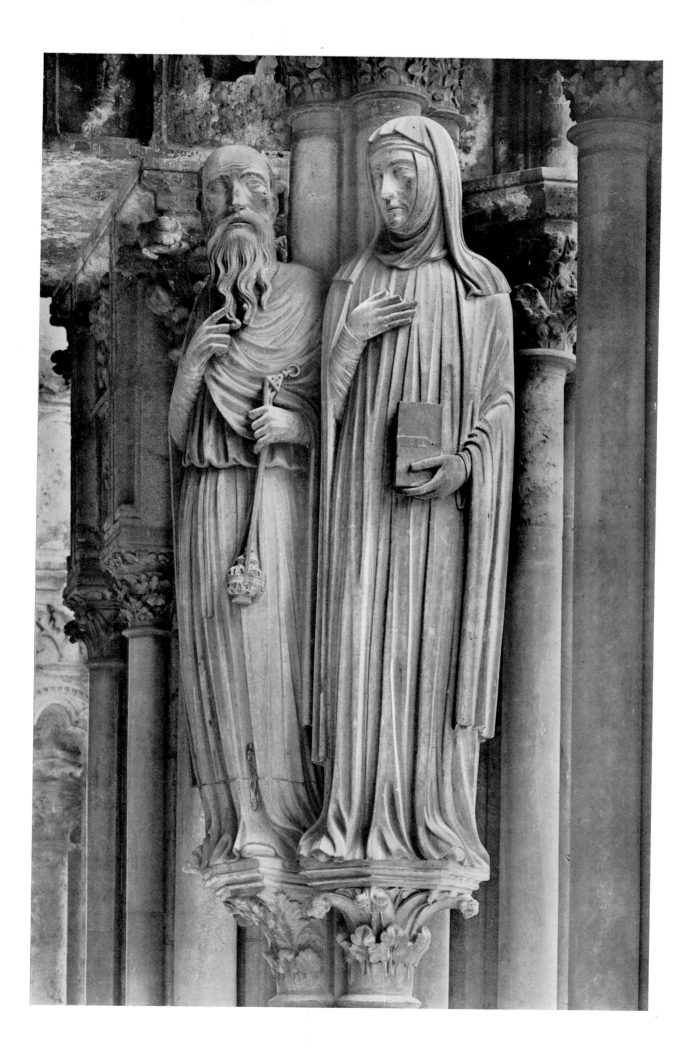

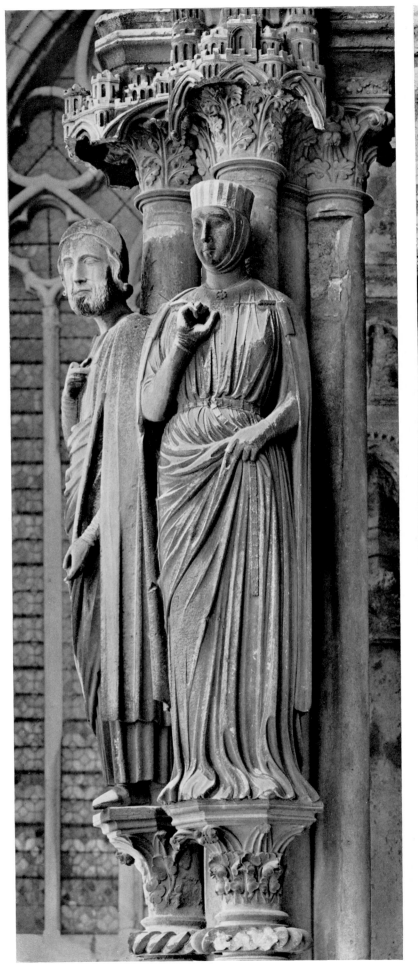
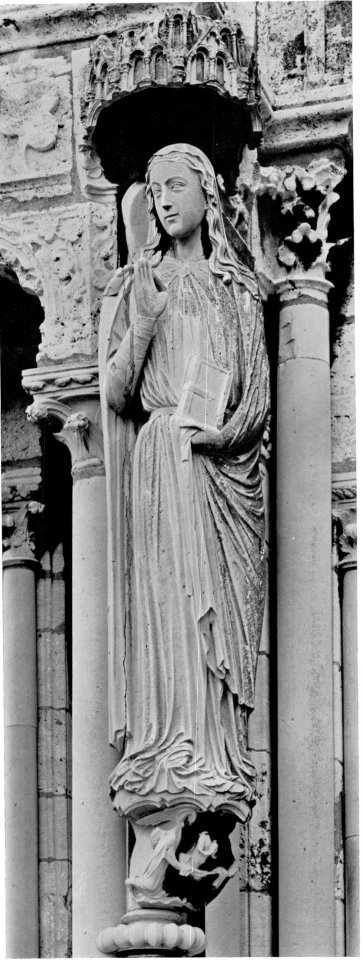

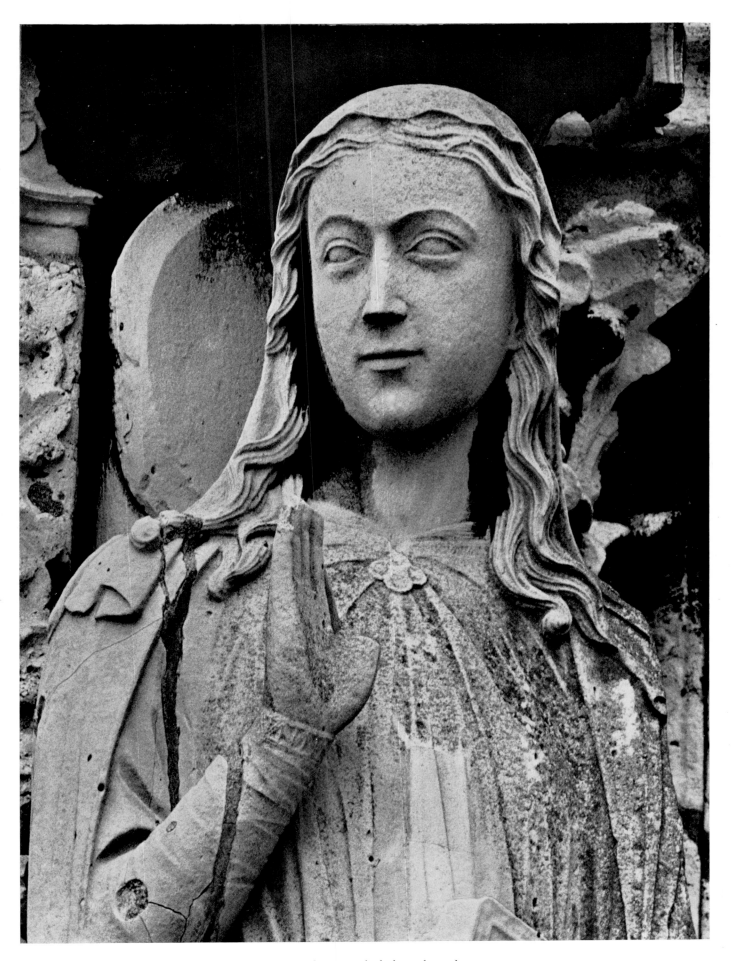

98, 99 Chartres cathedral, north porch.
98 *Left*. Two Old Testament figures. *Right*. St Modesta. 1220–30. 99 St Modesta, detail

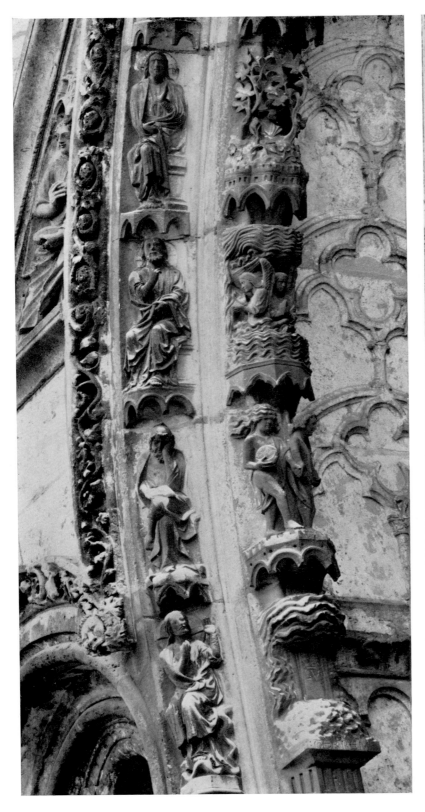
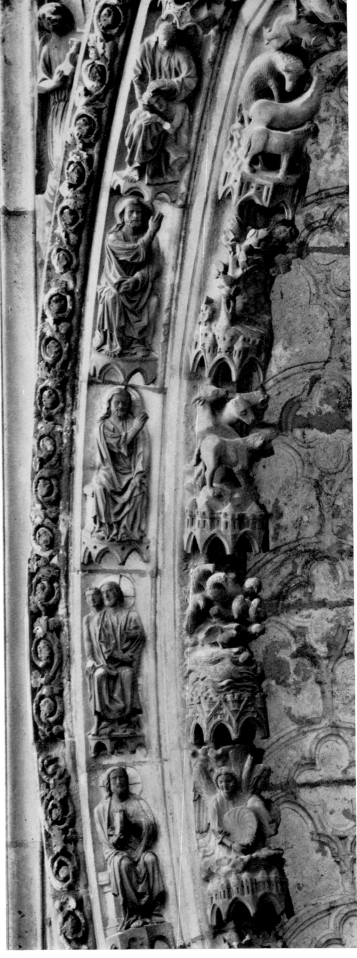

100 Chartres cathedral, north porch. Centre arch: the Creation. *Left*. Reading from the bottom: separation of the waters; creation of the sun and moon; God the Father adored by angels; creation of the plants. *Right*. Reading from the bottom: God the Father, angels with stars; creation of the fishes and birds; creation of four-footed beasts; God, and creation of Paradise; creation of Adam and four-footed beasts. About 1220–30

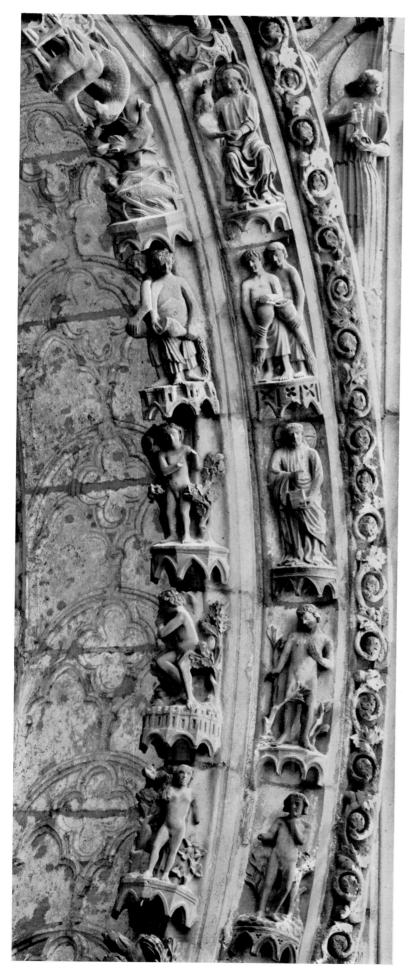
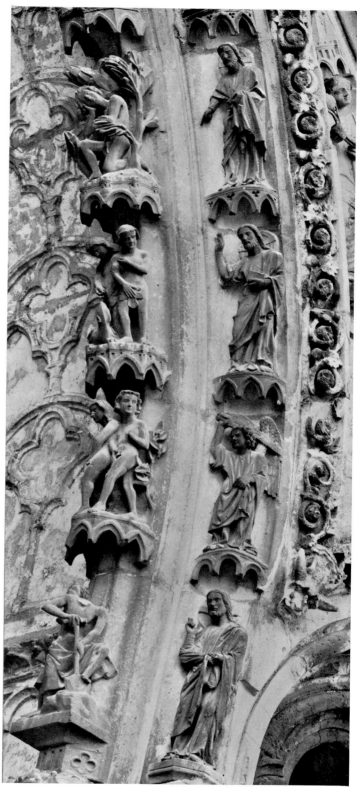

101 Chartres cathedral, north porch. Centre arch: the Creation. *Left*. Reading from the top: creation of Eve, fishes and birds; rivers of Paradise; God with Adam; Adam asleep, and Adam standing among plants; the Fall. *Right*. Reading from the top: God calls Adam; interrogation of Adam and Eve; expulsion from Paradise; Adam and Eve at work. About 1220–30

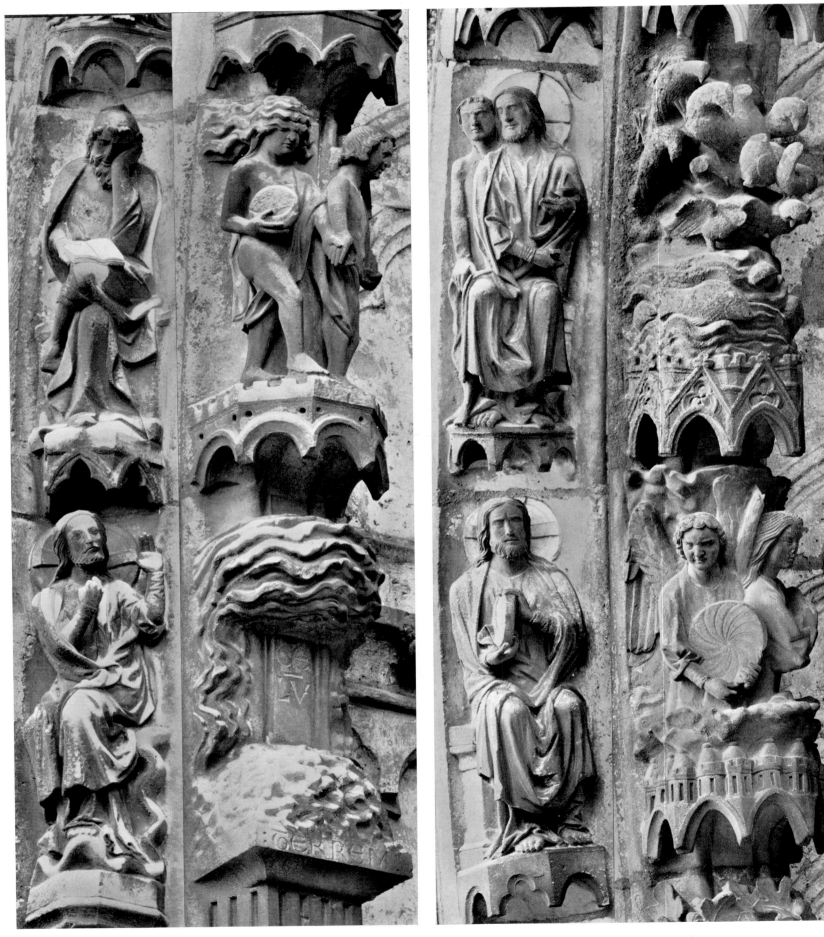

102 Chartres cathedral, north porch. Details of centre arch. *Left*. Separation of the waters; creation of the sun and moon.
Right. God the Father, and angels with stars; creation of the fishes and birds. About 1220–30

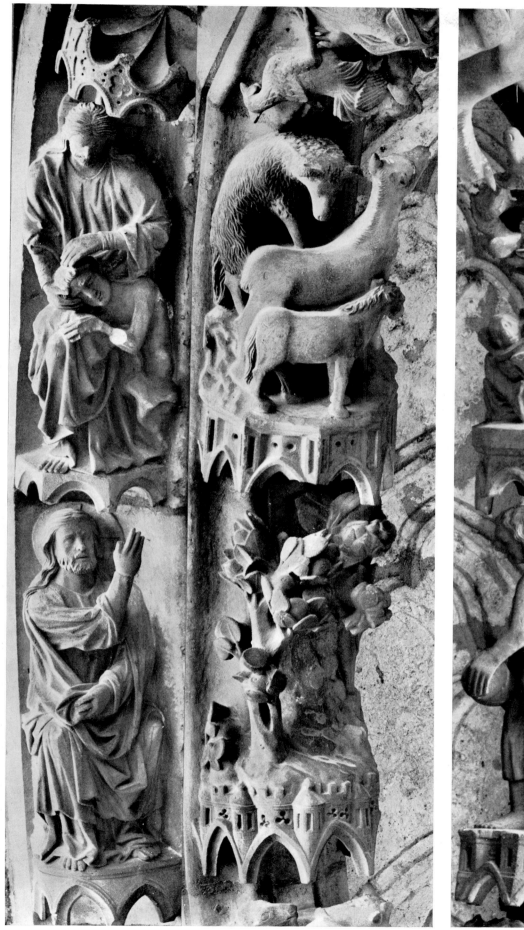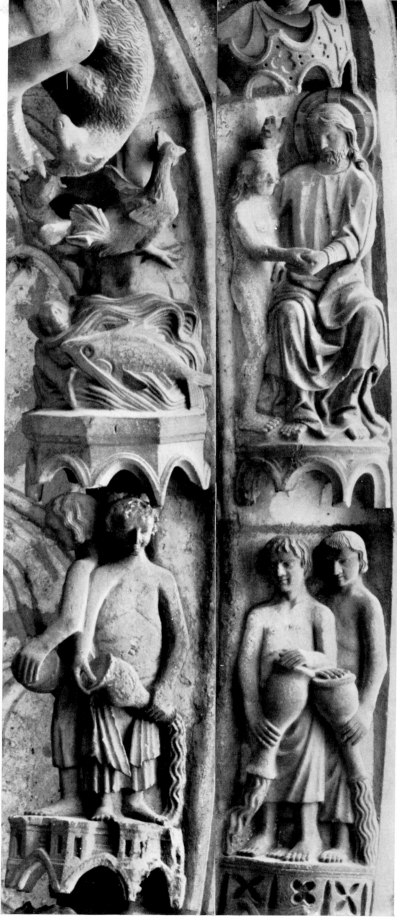

103 Chartres cathedral, north porch. Details of centre arch. *Left*. Creation of Paradise; creation of Adam, and four-footed beasts.
Right. Creation of Eve, and fishes and birds; rivers of Paradise. About 1220–30

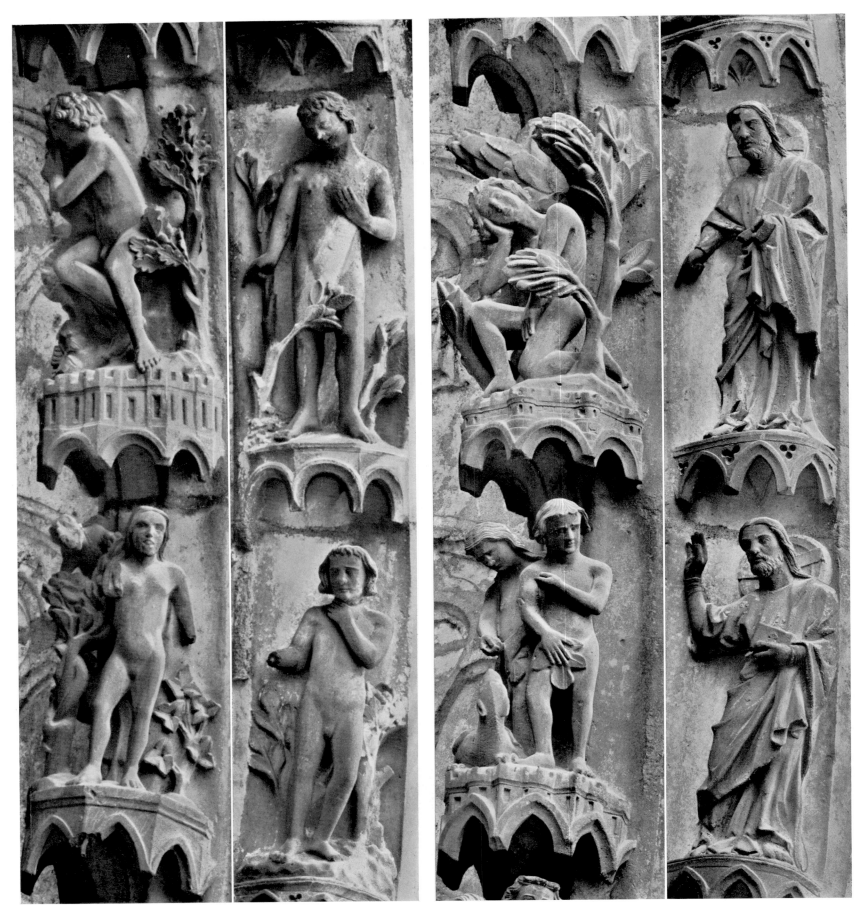

104 Chartres cathedral, north porch. Details of centre arch.
Left. Adam asleep, and Adam standing among plants; the Fall. *Right*. God calls Adam; interrogation of Adam and Eve.
About 1220–30

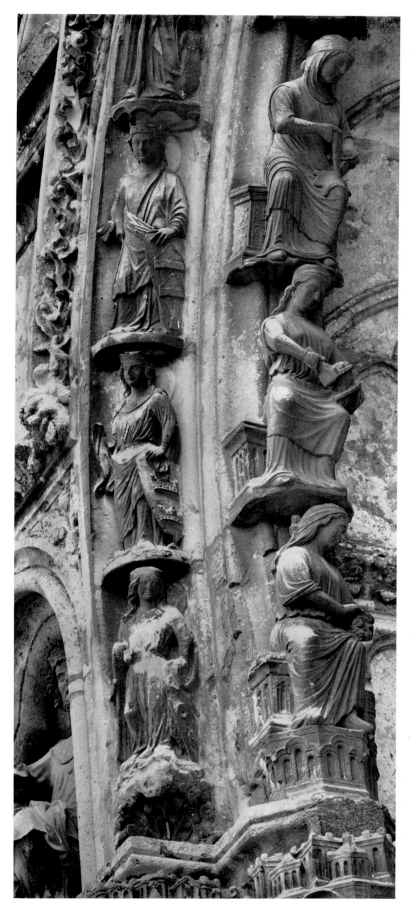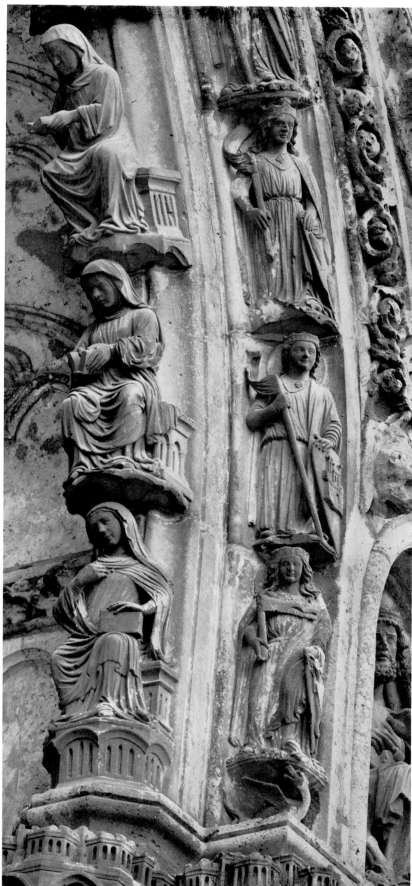

105 Chartres cathedral, north porch. Details of left arch.
Left. Vita activa: preparation of wool; (outer arch) blessings of the body: (reading from the bottom) Pulchritudo, Libertas, Honor.
Right. Vita contemplativa: meditation and reading; (outer arch) blessings of the soul: (reading from the bottom) Securitas, Sanitas, Potestas(?). About 1220–30

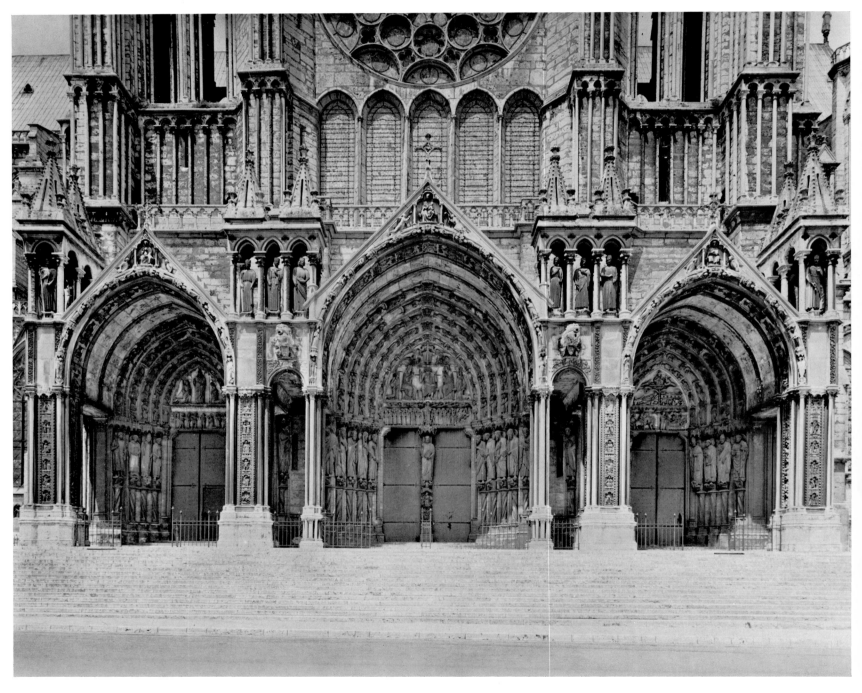

106 Chartres cathedral, south transept portal

107 Chartres cathedral, south transept, centre doorway.
Tympanum and lintel: Last Judgment. Archivolt: Paradise, Hell, angelic choirs.
Trumeau: Christ. Jamb: apostles. 1210–15

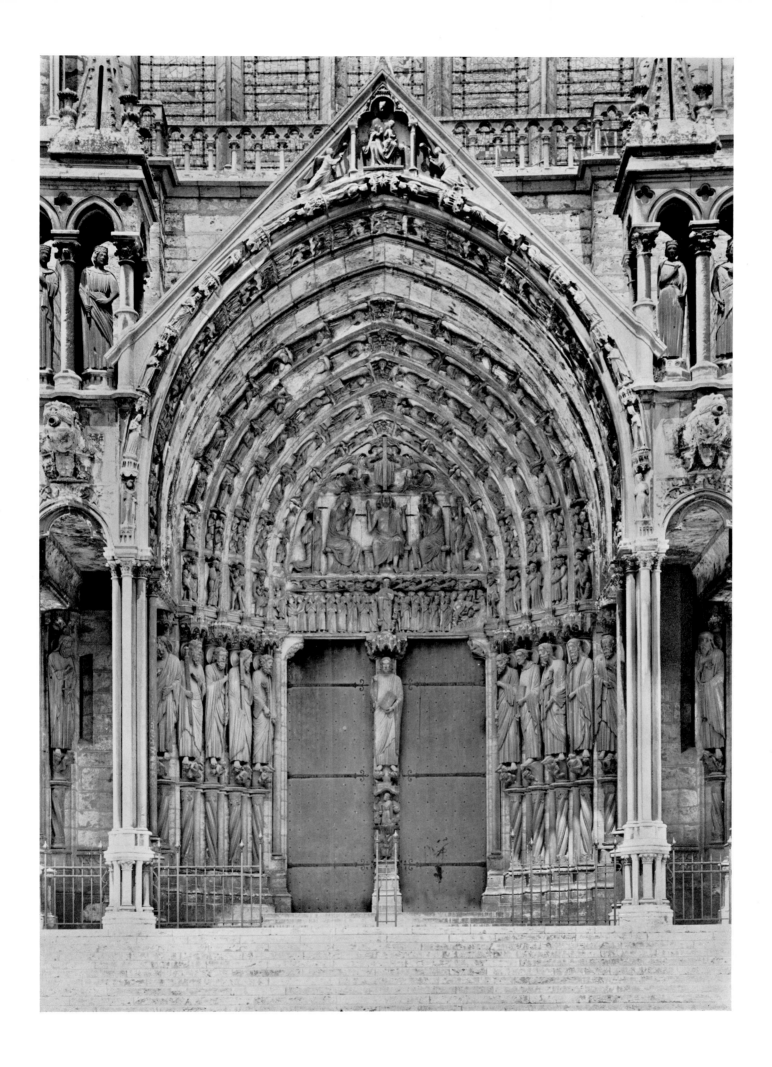

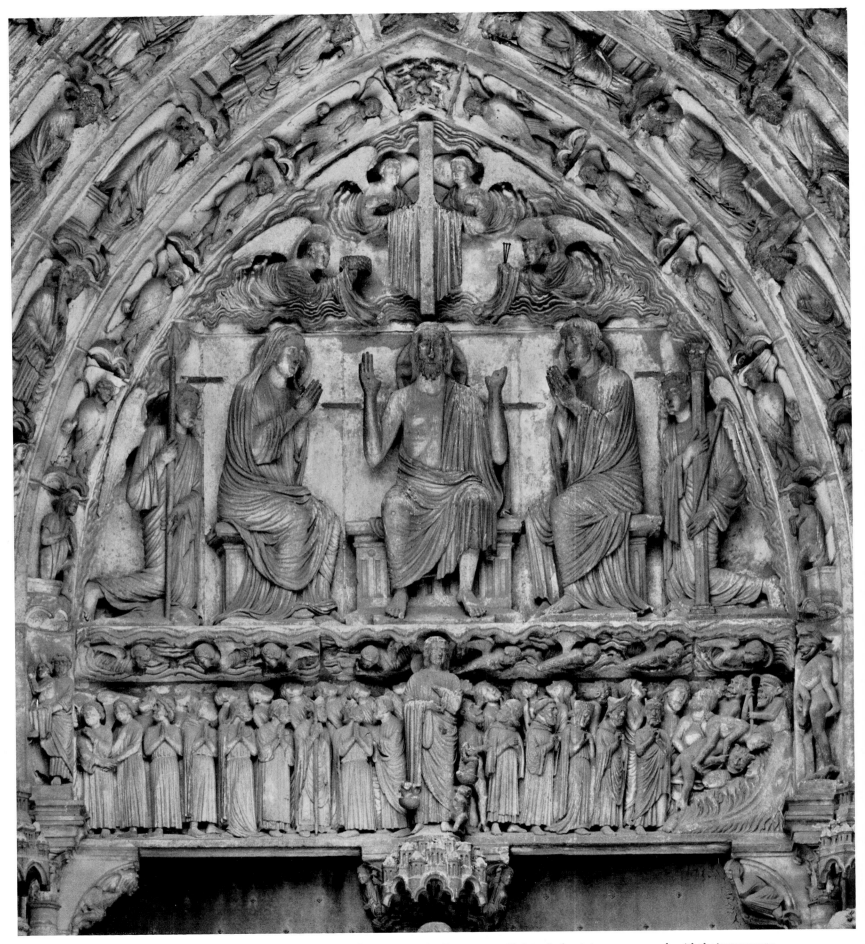

108, 109 Chartres cathedral, south transept, centre doorway. 108 Tympanum: Christ as Judge, intercessors, angels with the instruments of the Passion. Lintel: separation of the Blessed from the Damned.
109 Trumeau: Christ over lion and dragon; on the socle, unidentified donor-scenes. 1210–15

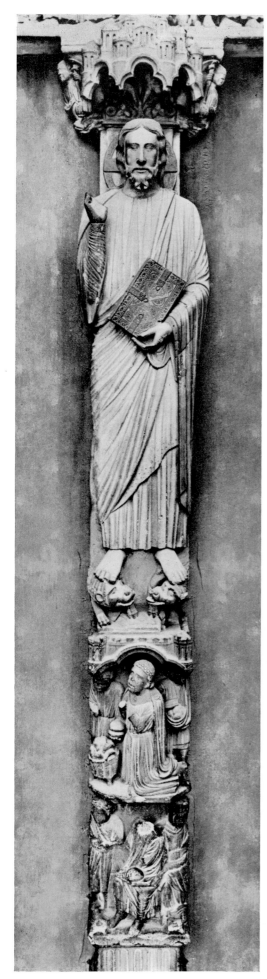
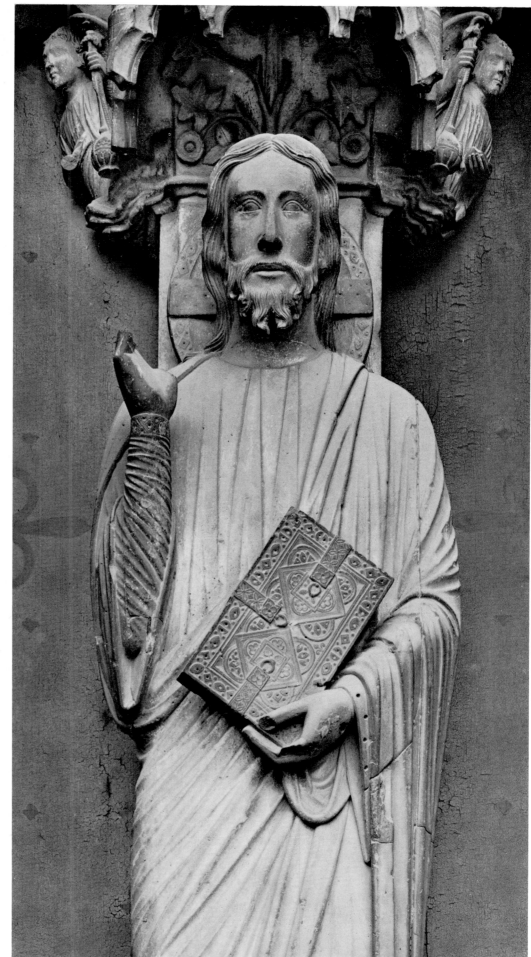

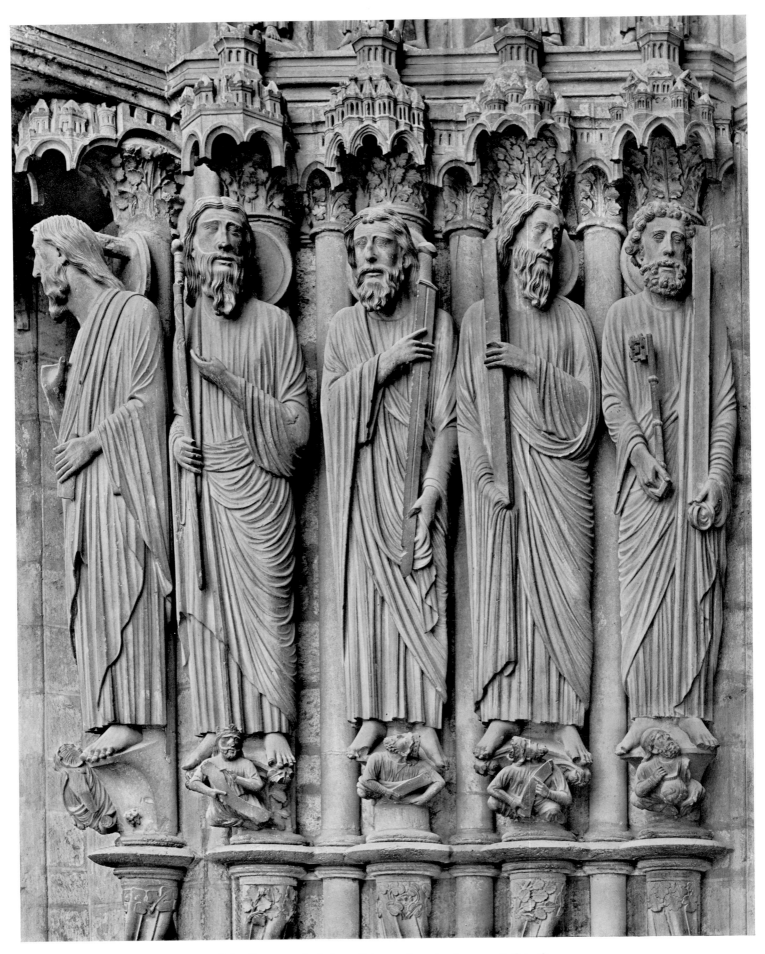

110 Chartres cathedral, south transept, centre doorway. Left jamb.
Apostles: (from the right) Peter, Andrew, Philip, Thomas, Matthew. 1210–15

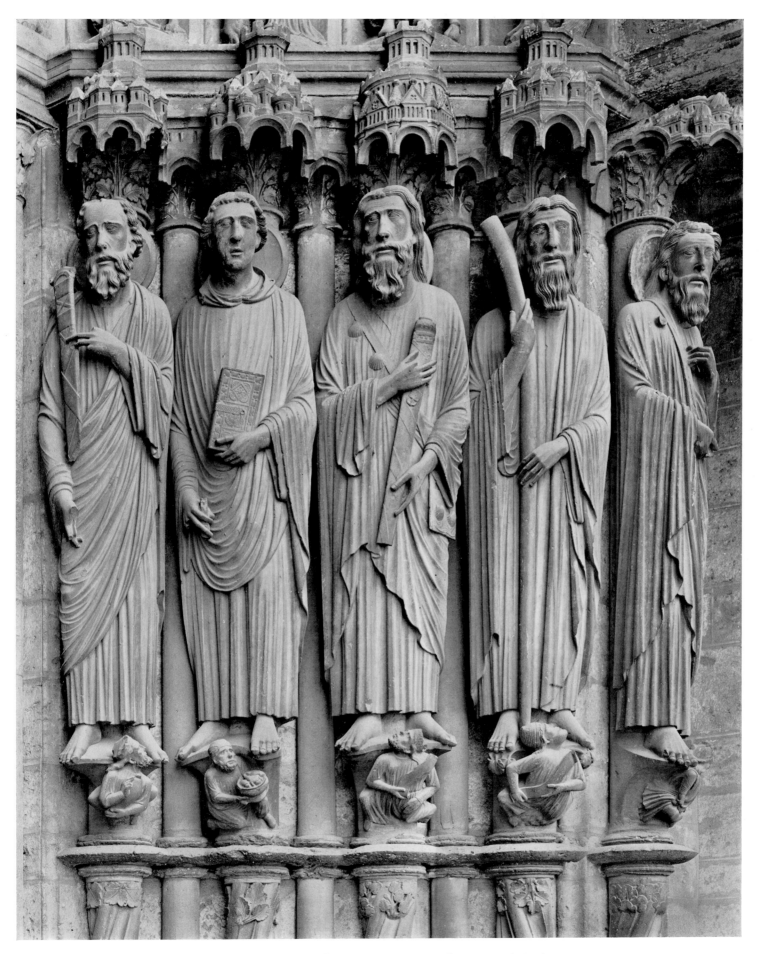

111 Chartres cathedral, south transept, centre doorway. Right jamb.
Apostles: (from the left) Paul, John, James the Greater, James the Less, Bartholomew. 1210–15

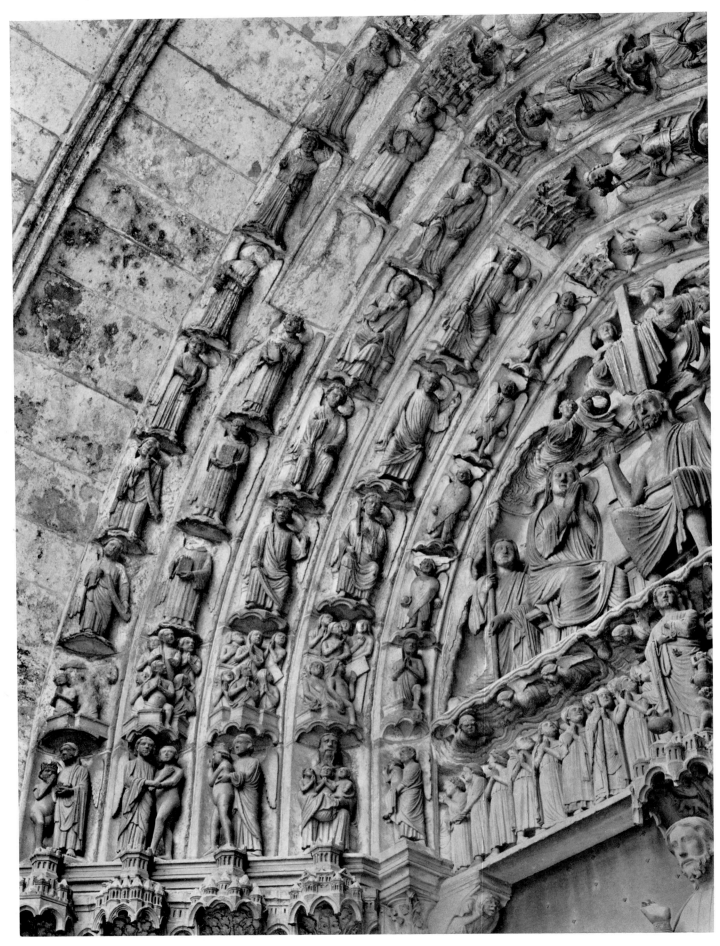

112 Chartres cathedral, south transept, centre doorway.
Left archivolt: (reading from the bottom) Paradise; the resurrected; angelic choirs. 1210–15

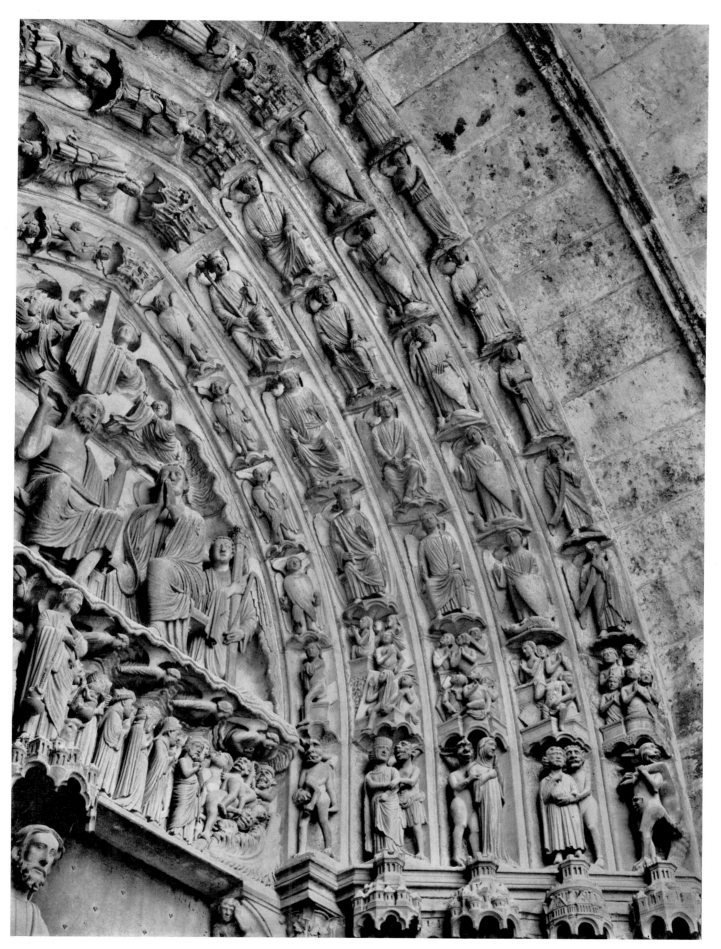

113 Chartres cathedral, south transept, centre doorway.
Right archivolt: (reading from the bottom) Paradise, the resurrected; angelic choirs. 1210–15

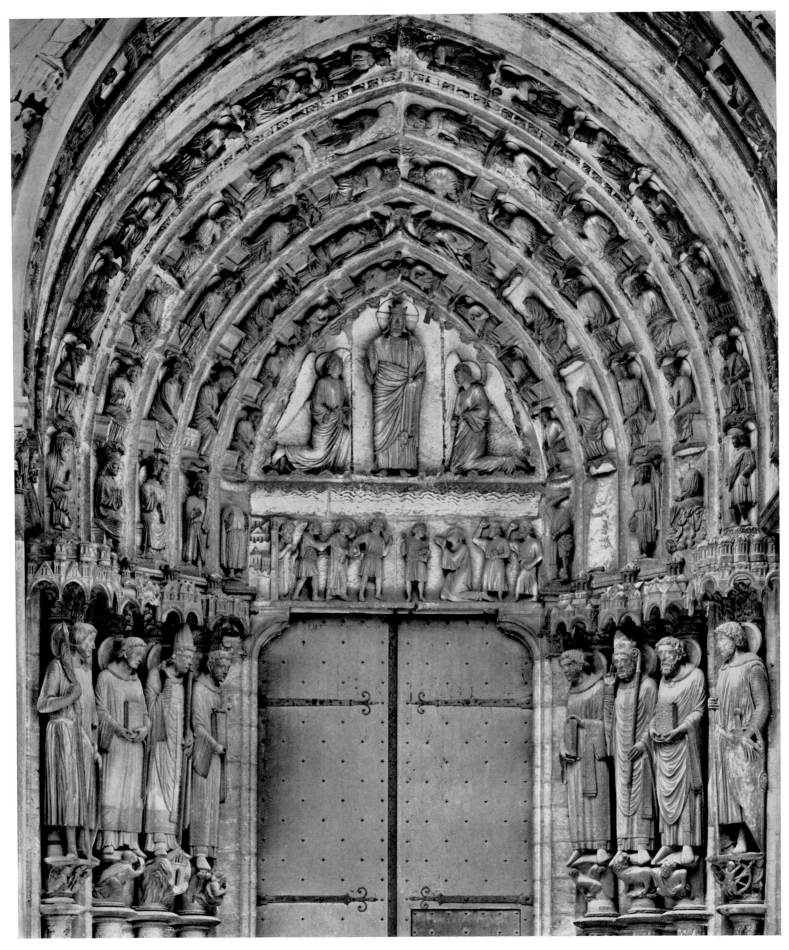

114, 115 Chartres cathedral, south transept, left doorway. Jambs: martyrs.
Lintel and tympanum: martyrdom of St Stephen. Archivolt: enthroned martyrs. 1210–15 and 1230–35.
115 Detail of left jamb: soldier saint, possibly Theodore. 1230–35

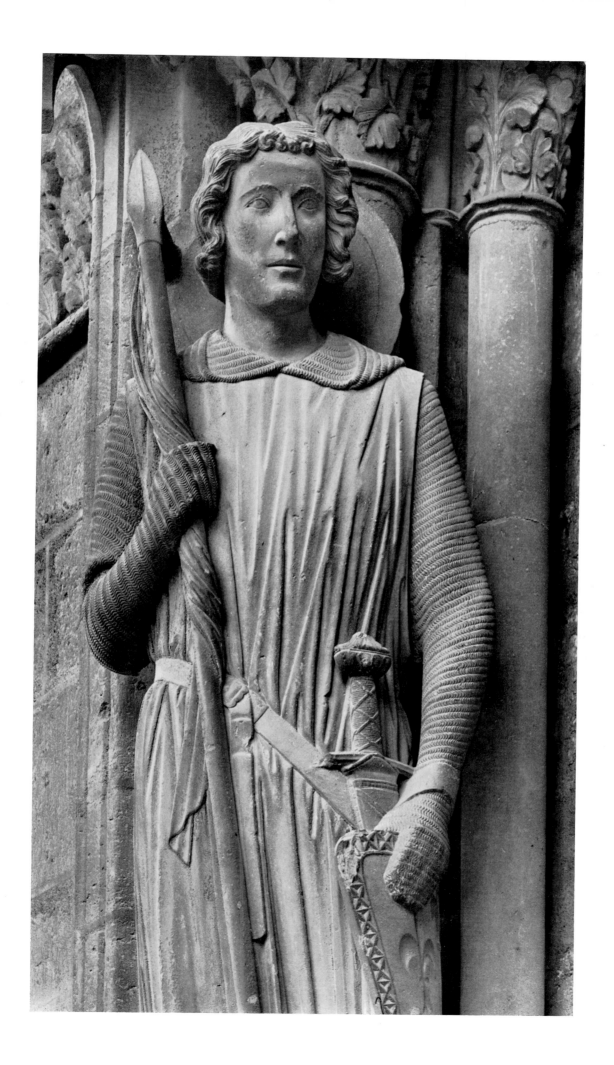

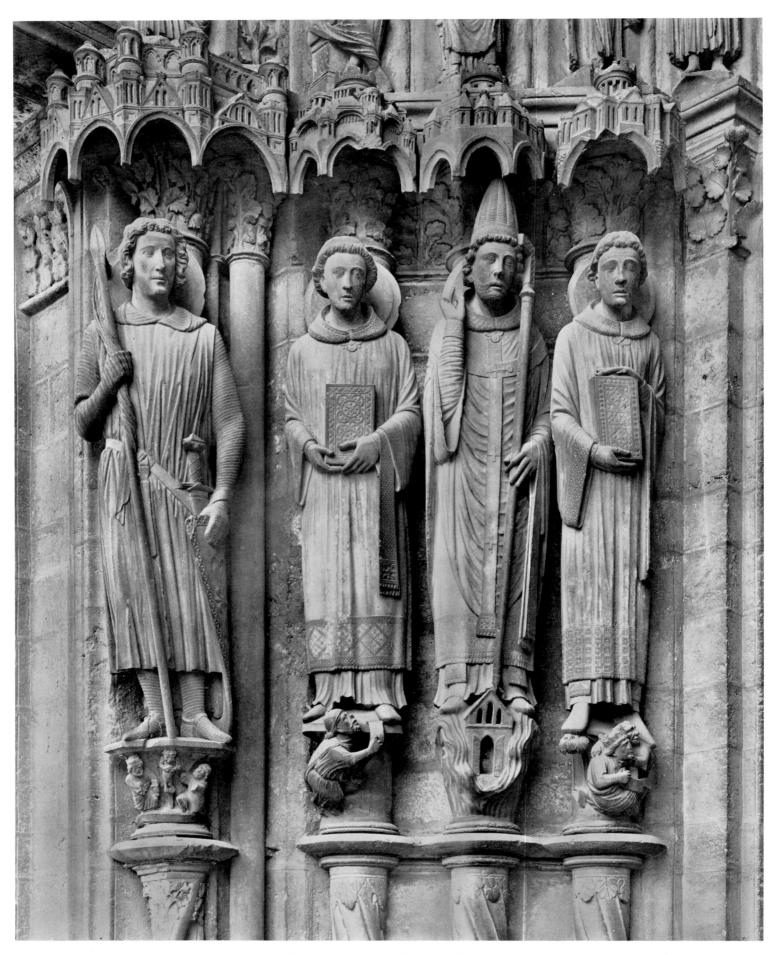

116 Chartres cathedral, south transept, left doorway.
Left jamb: (from the left) soldier saint, possibly Theodore, 1230–35; Stephen, Clement of Rome, Laurence, 1210–20

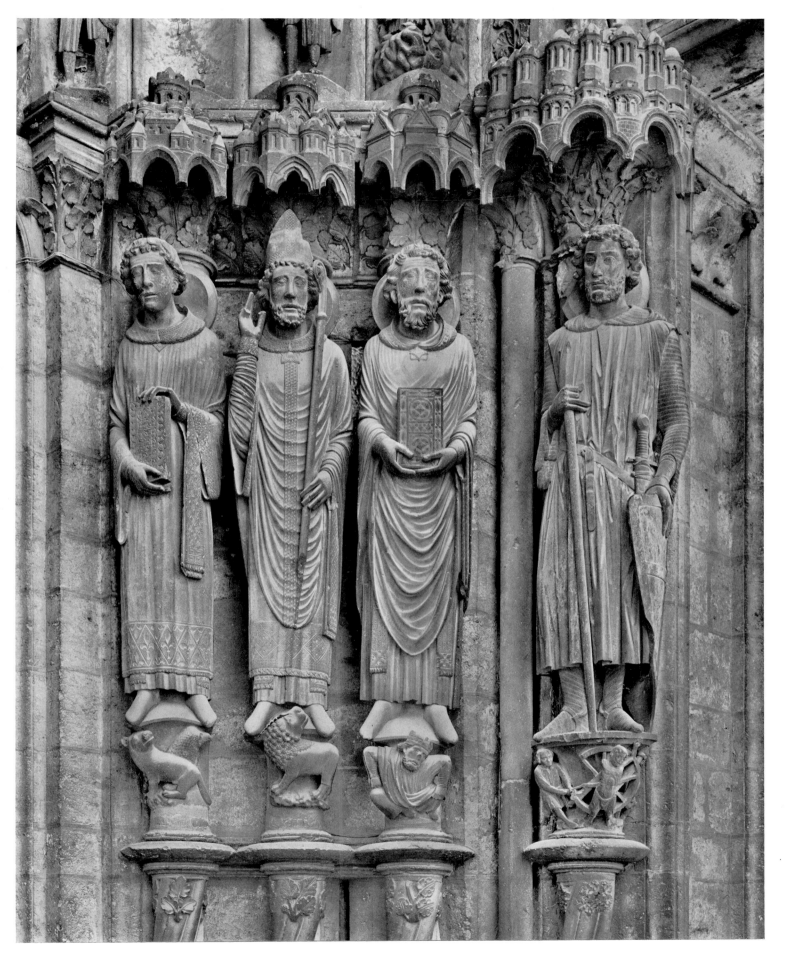

117 Chartres cathedral, south transept, left doorway.
Right jamb: (from the left): Vincent, Dionysius(?), Piatus(?), 1210–20; George, 1230–35

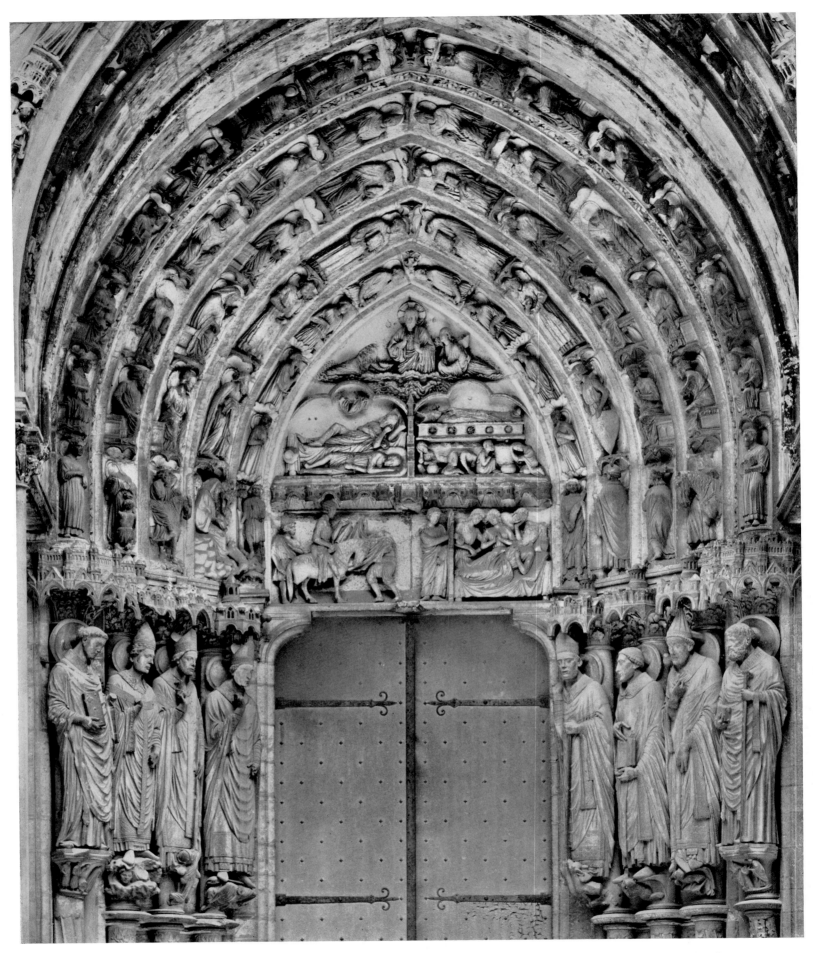

118 Chartres cathedral, south transept, right doorway. Lintel and tympanum: left, St Martin's gift of his cloak, and (above) his dream;
right, St Nicholas' gift of money, and (above) cripples at his tomb; apex, Christ.
Archivolt: angels and confessors. Jambs: confessors. About 1220 and 1235

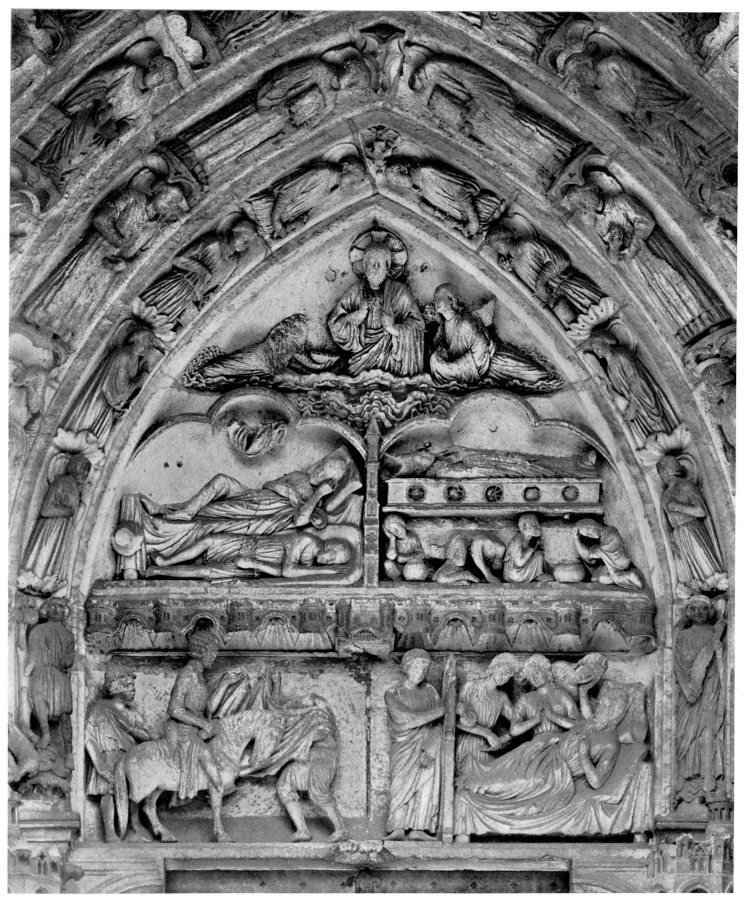

119 Chartres cathedral, south transept, right doorway. Lintel and tympanum: left, St Martin's gift of his cloak, and (above) his dream;
right, St Nicholas' gift of money, and (above) cripples at his tomb; apex, Christ. About 1220

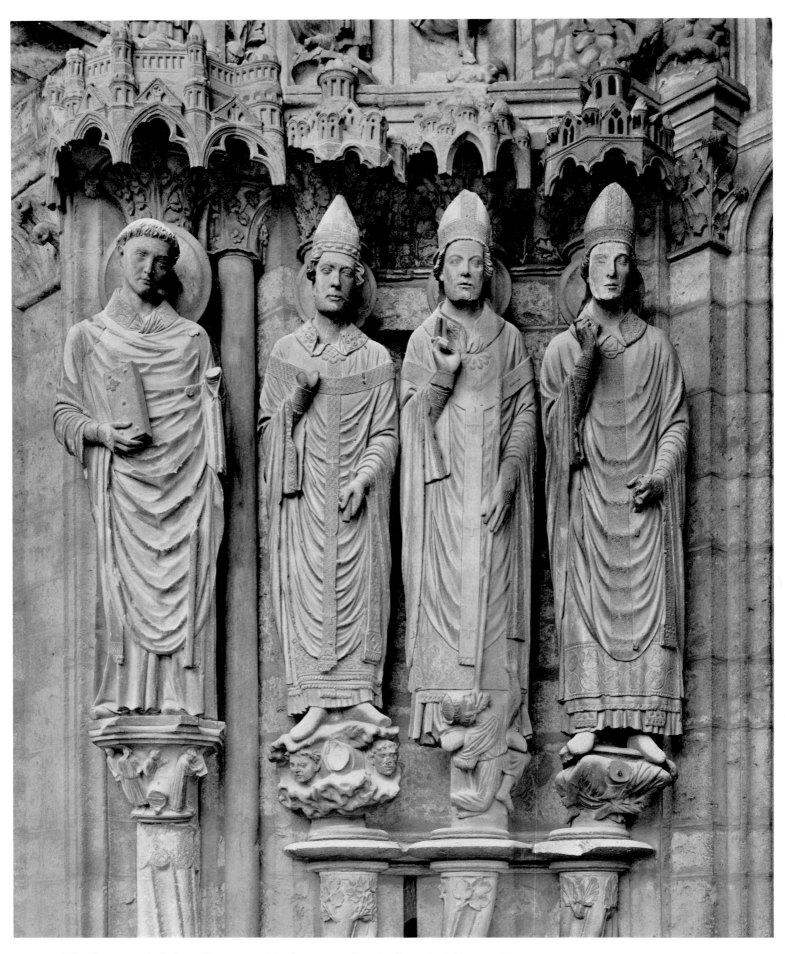

120 Chartres cathedral, south transept, right doorway. Left jamb: (from the left) St Laudomarus, about 1235; a pope (Leo the Great?), an archbishop (Ambrose?) and a bishop (Nicholas?), about 1220

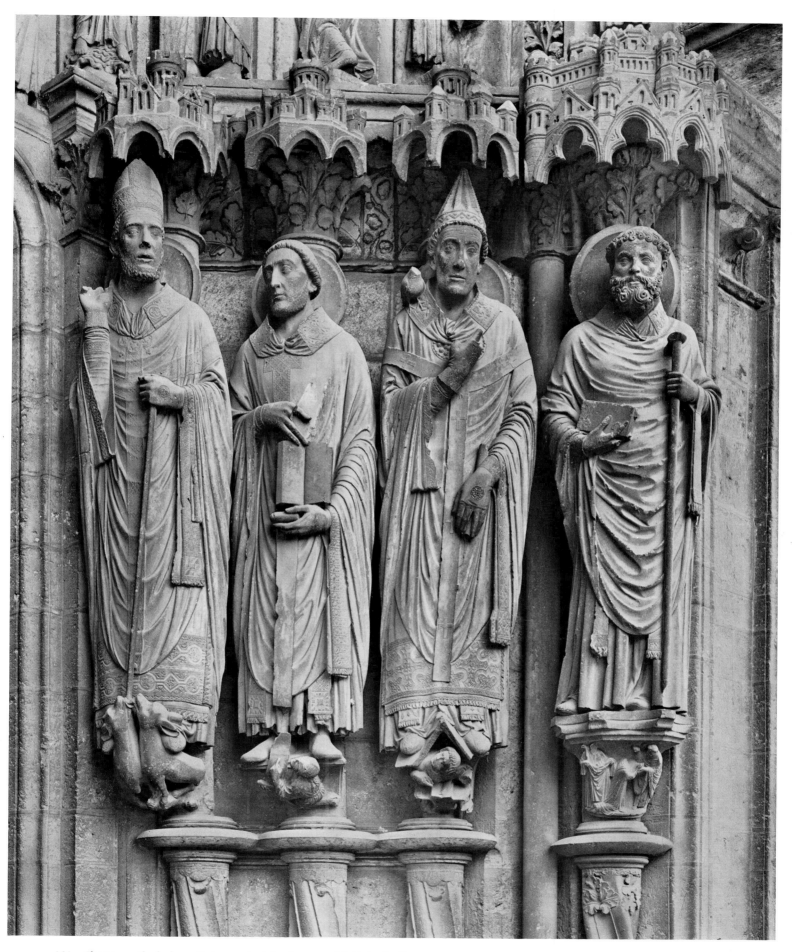

121 Chartres cathedral, south transept, right doorway, Right jamb: (from the left) Martin of Tours, Jerome, Gregory the Great, about
1220; St Avitus, about 1235

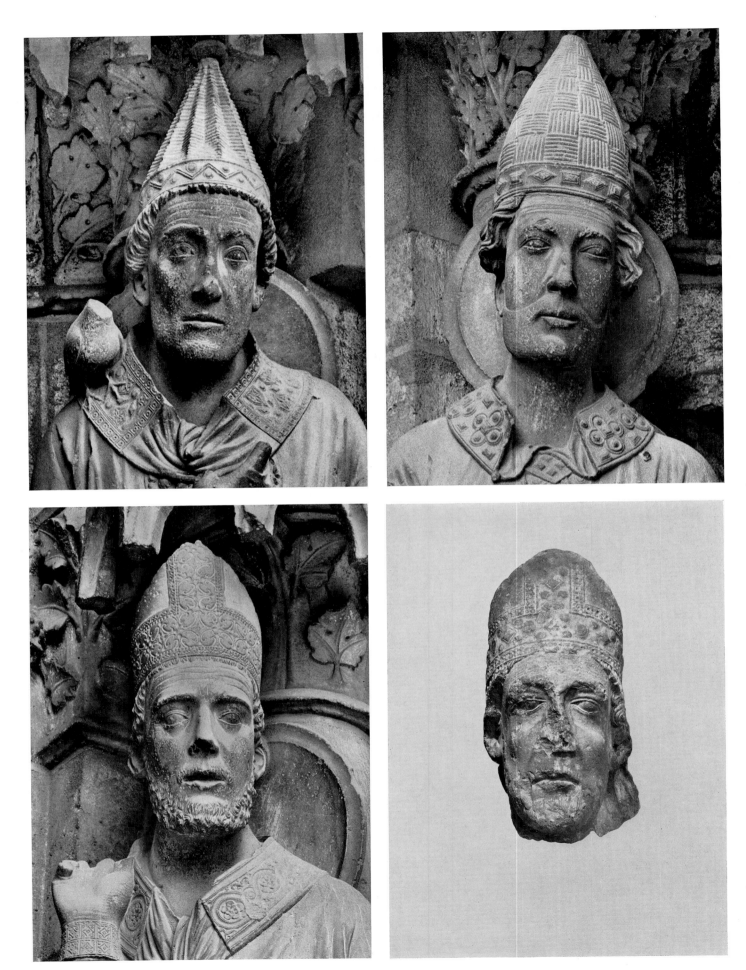

122 Chartres cathedral, south transept, details from the right doorway. *Top*. Gregory the Great, and a pope (Leo the Great?).
Bottom left. Martin of Tours. All about 1220.
Bottom right. Bishop's head, from a tomb monument in the destroyed church of Notre-Dame-de-Josaphat, perhaps Renaud de Mouçon
(died 1217), bishop of Chartres. (Lèves, Asile d'Aligre)

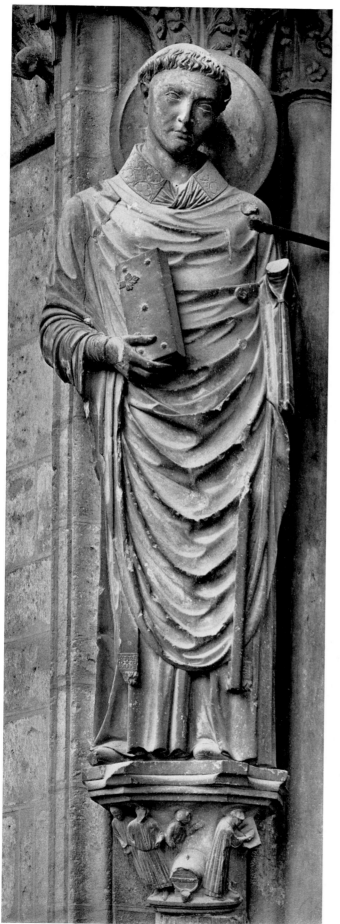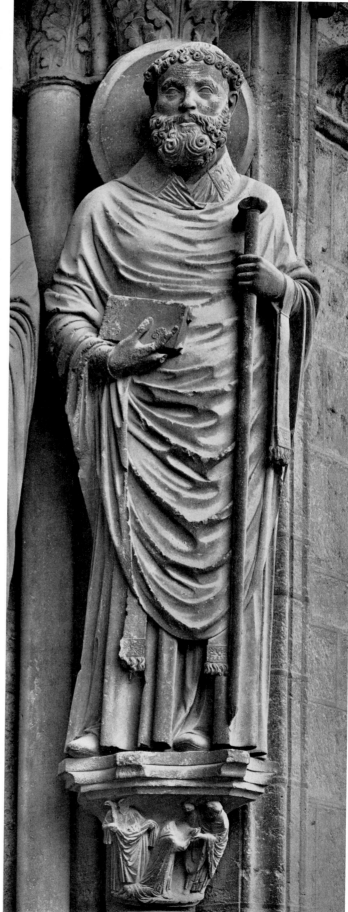

123 Chartres cathedral, south transept, right doorway. Details: (from the left jamb) St Laudomarus; (from the right jamb) St Avitus.
About 1235

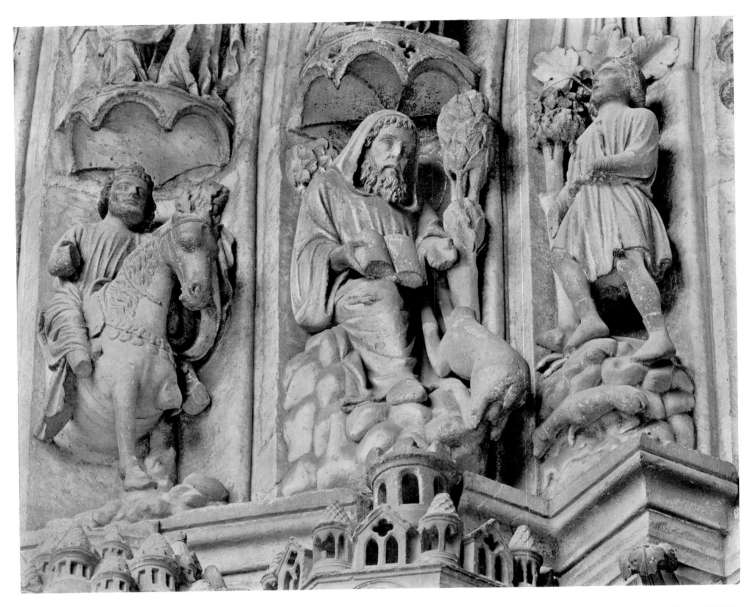

124 Chartres cathedral, south transept, right doorway. *Top.* Detail from the left archivolt: St Giles with the hind pursued by dogs and huntsmen. *Bottom.* Console figures beneath statues on the right jamb: (from the left) dogs, beneath Martin; Synagogue, beneath Jerome; Peter, beneath Gregory. About 1220

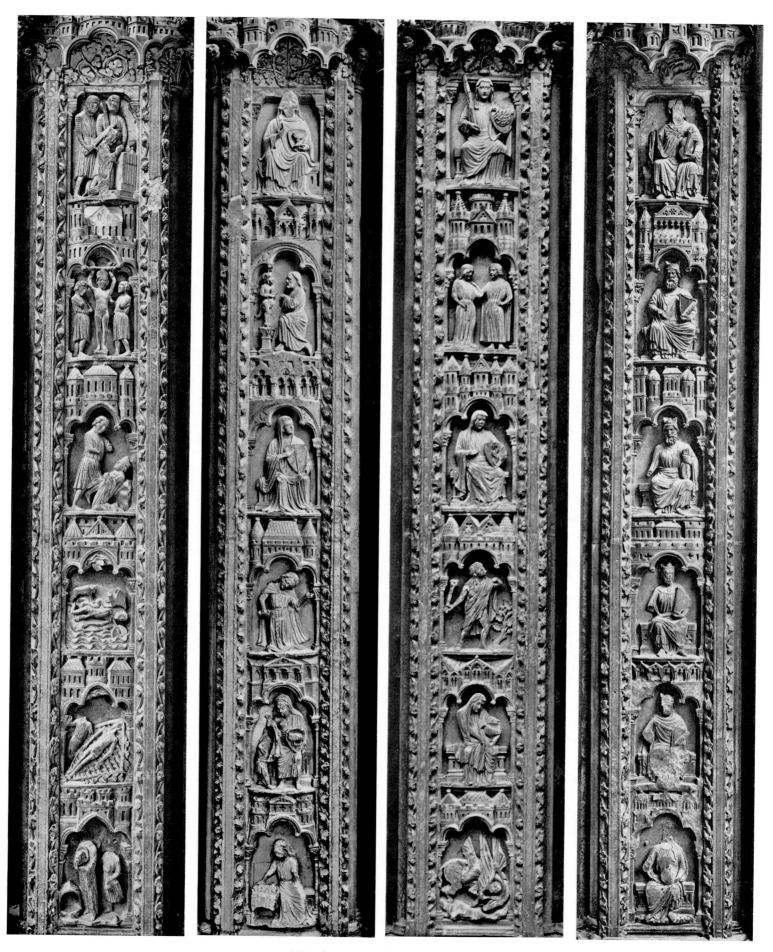

125 Chartres cathedral, south porch.
Scenes on pillars before the left (outside left) and centre doorways: martyr scenes, Virtues and Vices, Elders of the Apocalypse. About
1230–40

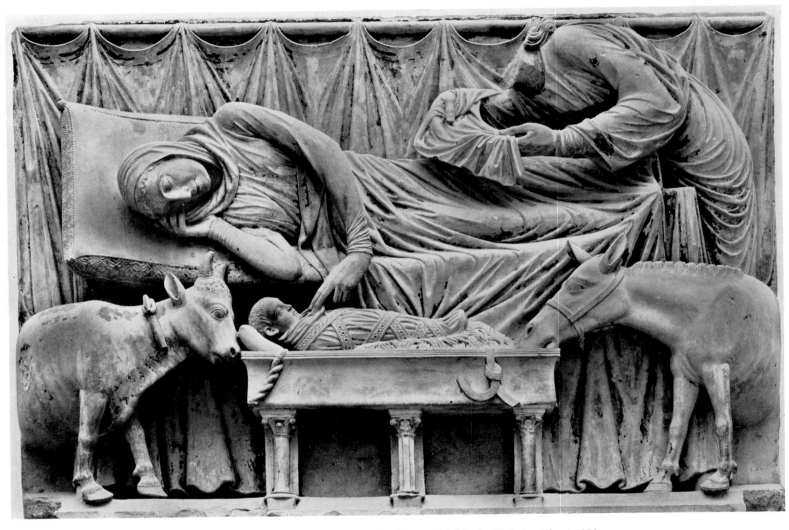

126 Chartres cathedral, relief from the destroyed jubé: the Nativity. About 1230

127 Chartres cathedral, reliefs from the destroyed jubé.
Top. Dream of the Three Magi (the head of the middle figure restored after a plaster cast). About 1240.
Bottom. Annunciation to the Shepherds. About 1230

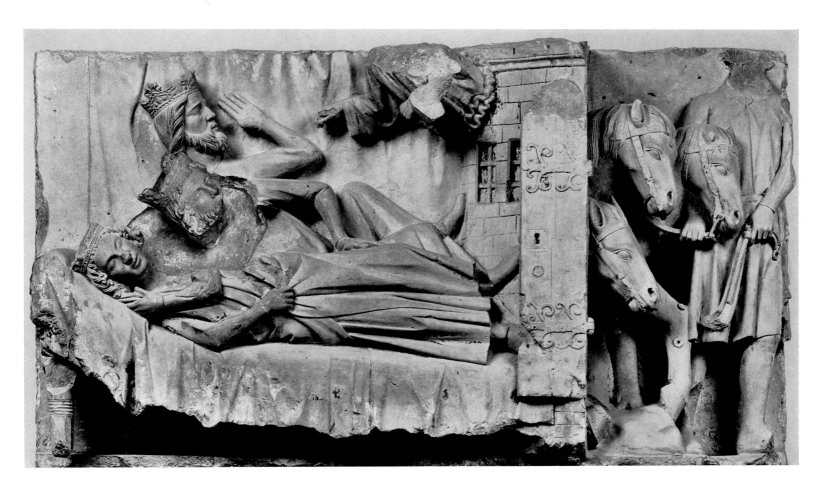

128 *Top*. Head of Peter from a jamb figure (west portal of Notre-Dame, Dijon?). About 1230. (Dijon, Musée Départemental des Antiquités). *Bottom*. Two heads of apostles from the jambs of the south portal of Strasbourg cathedral. About 1230. (Strasbourg, Musée de l'Œuvre Notre-Dame)

129　Fragments of jamb figures from the former south portal of Sainte-Madeleine, Besançon.
Top. Melchizedek (Besançon, Sainte-Madeleine). *Bottom*. Moses, and Samuel (Besançon, Musée d'Archéologie). All 1225–30

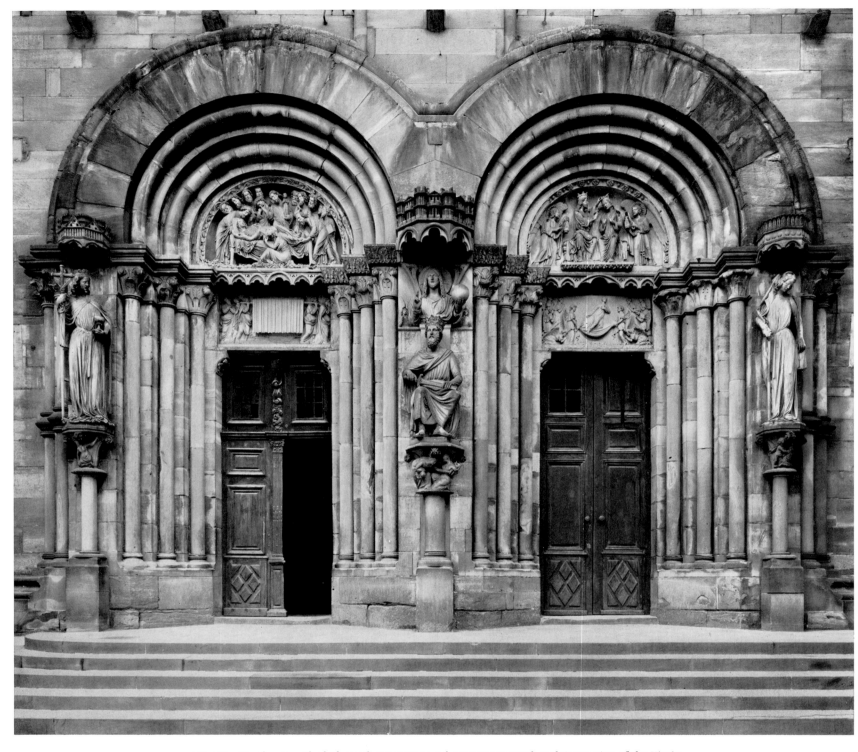

130,131 Strasbourg cathedral, south transept portal. Tympana: Death and Coronation of the Virgin.
Flanking the doorways: Ecclesia and Synagogue (copies). About 1230. 131 Details of tympana.
The lintels, showing the bearing of Mary's body to the tomb and her Assumption are restored, likewise, the central figure of Solomon.

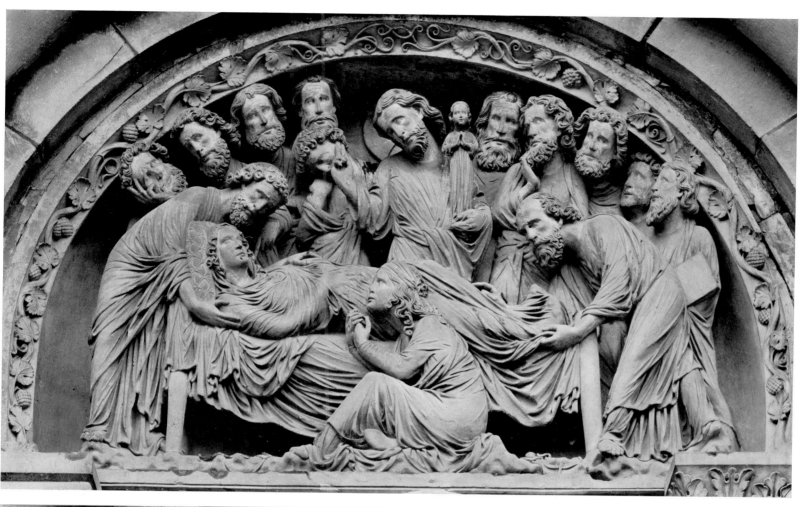

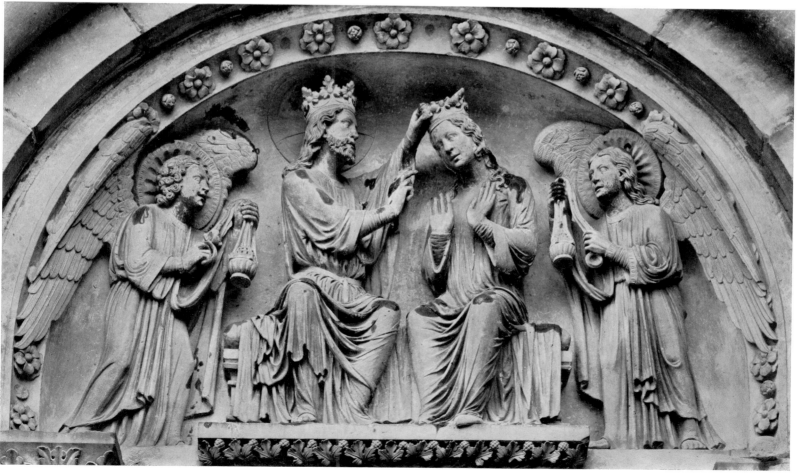

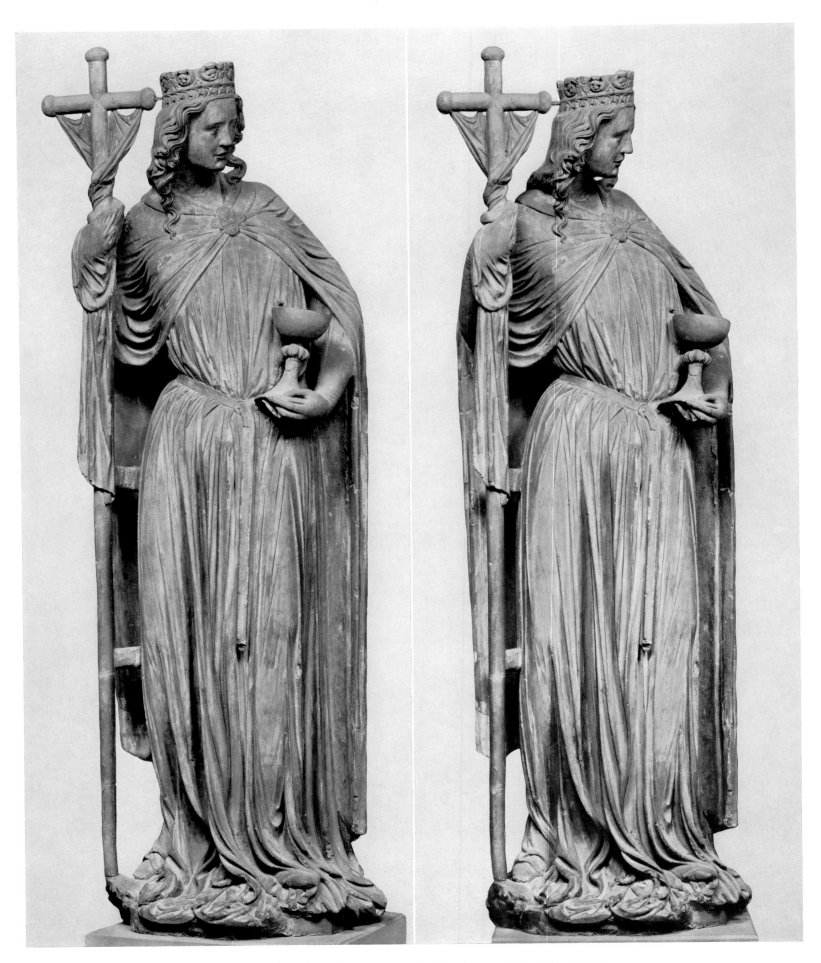

132 Ecclesia, from the south transept portal of Strasbourg cathedral. About 1230.
(Strasbourg, Musée de l'Œuvre Notre-Dame)

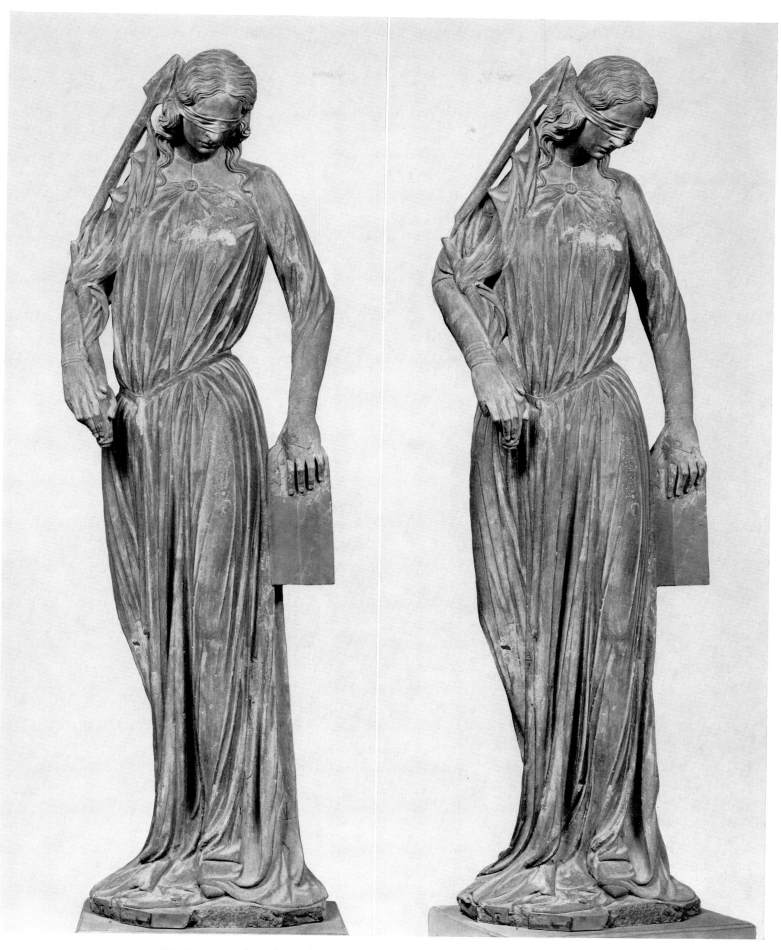

133 Synagogue, from the south transept portal of Strasbourg cathedral. About 1230.
(Strasbourg, Musée de l'Œuvre Notre-Dame)

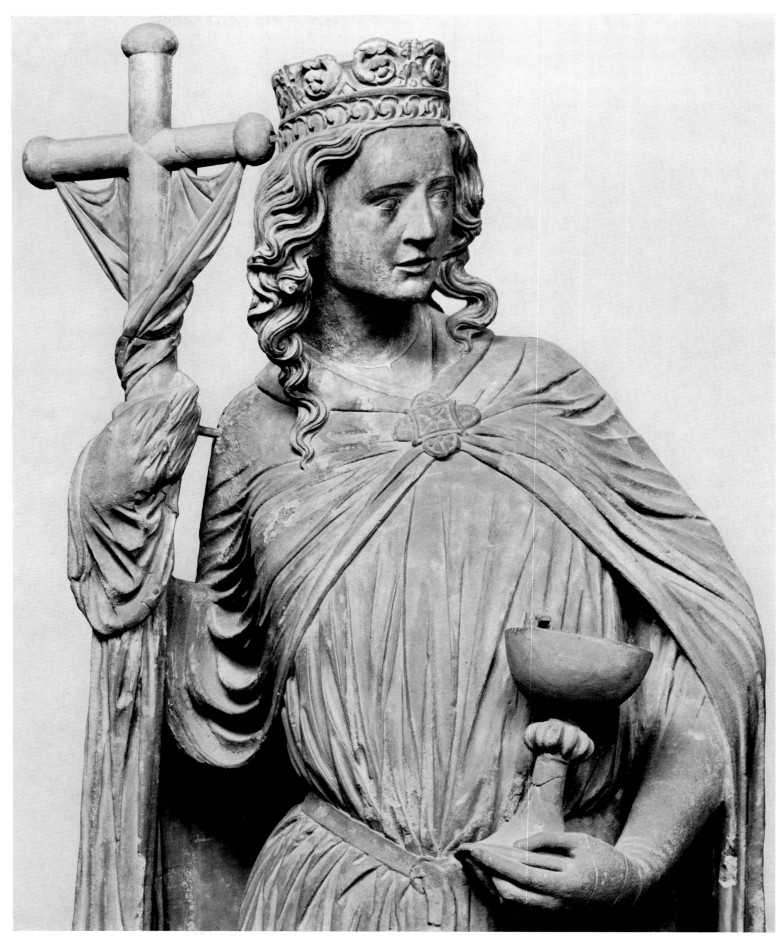

134 Detail of Ecclesia from the south transept portal of Strasbourg cathedral (cross and chalice renewed). About 1230.
(Strasbourg, Musée de l'Œuvre Notre-Dame)

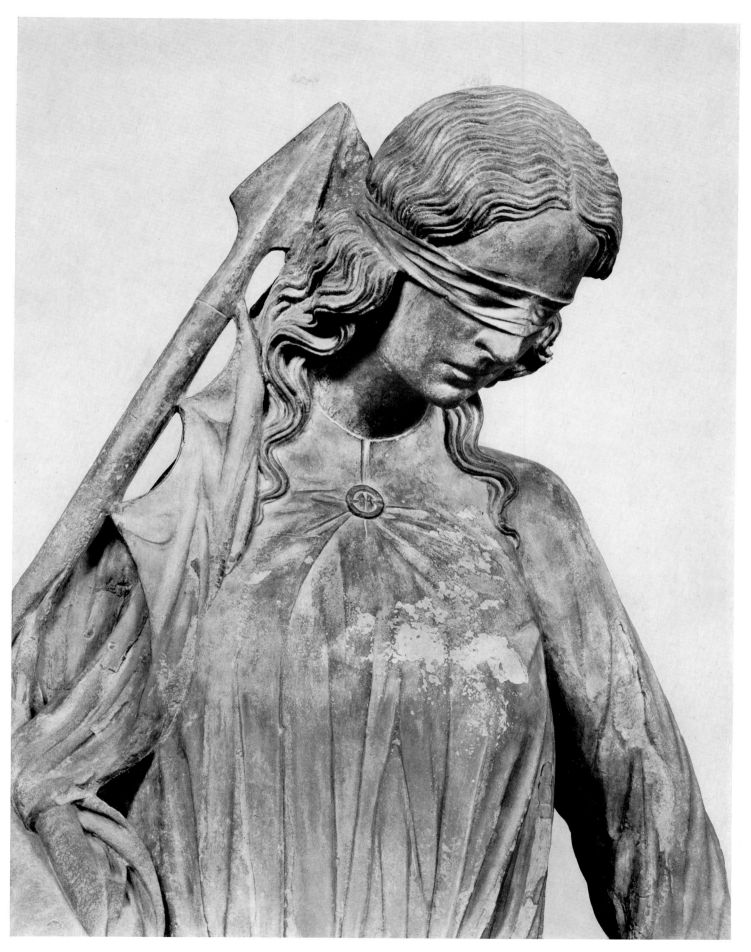

135 Detail of Synagogue from the south transept portal of Strasbourg cathedral. About 1230.
(Strasbourg, Musée de l'Œuvre Notre-Dame)

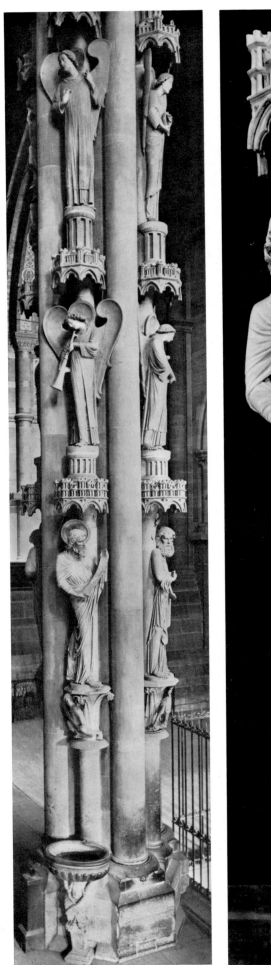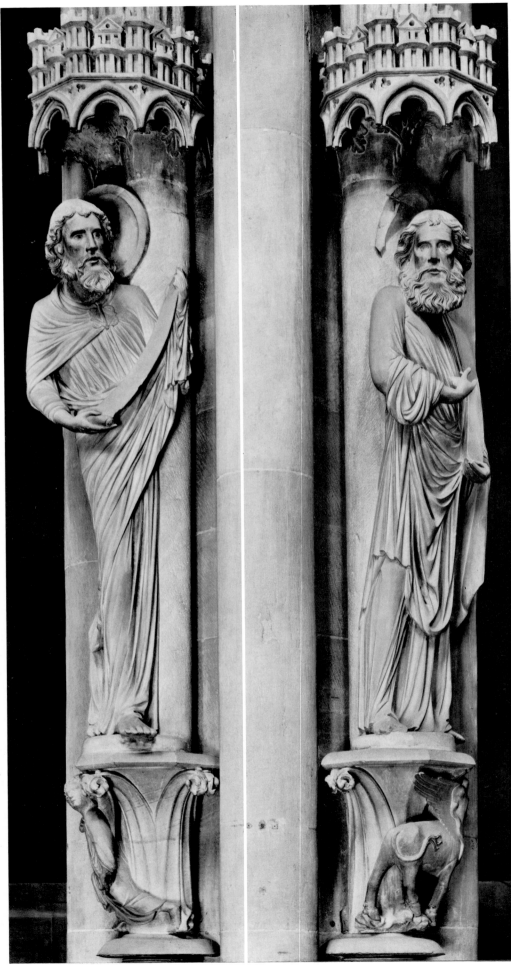

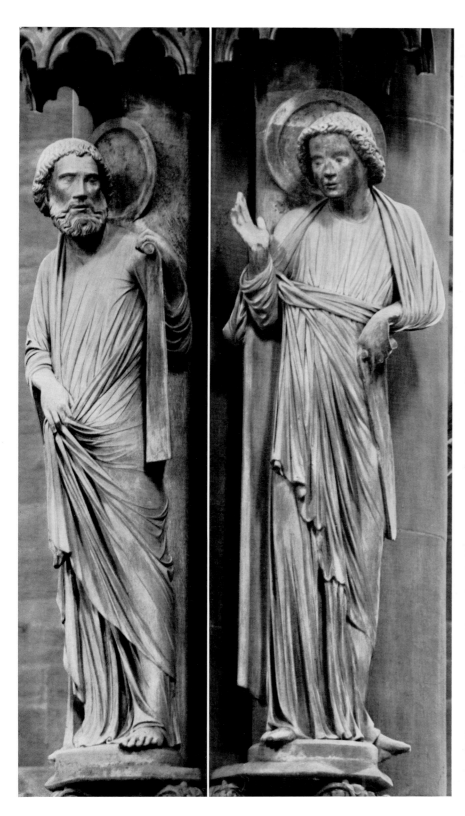

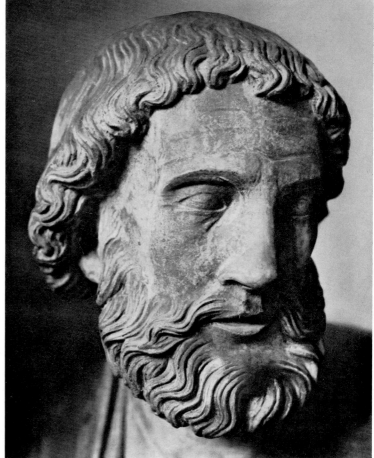

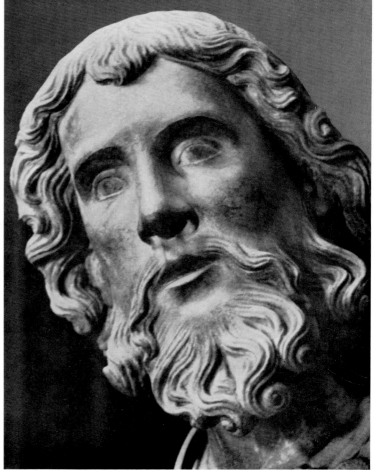

136, 137 Strasbourg cathedral, south transept. Judgment Pillar, and details.
136 *right*: Matthew and Luke. 137 *left*: Mark and John. 137 *right*: Mark and Matthew.
About 1230

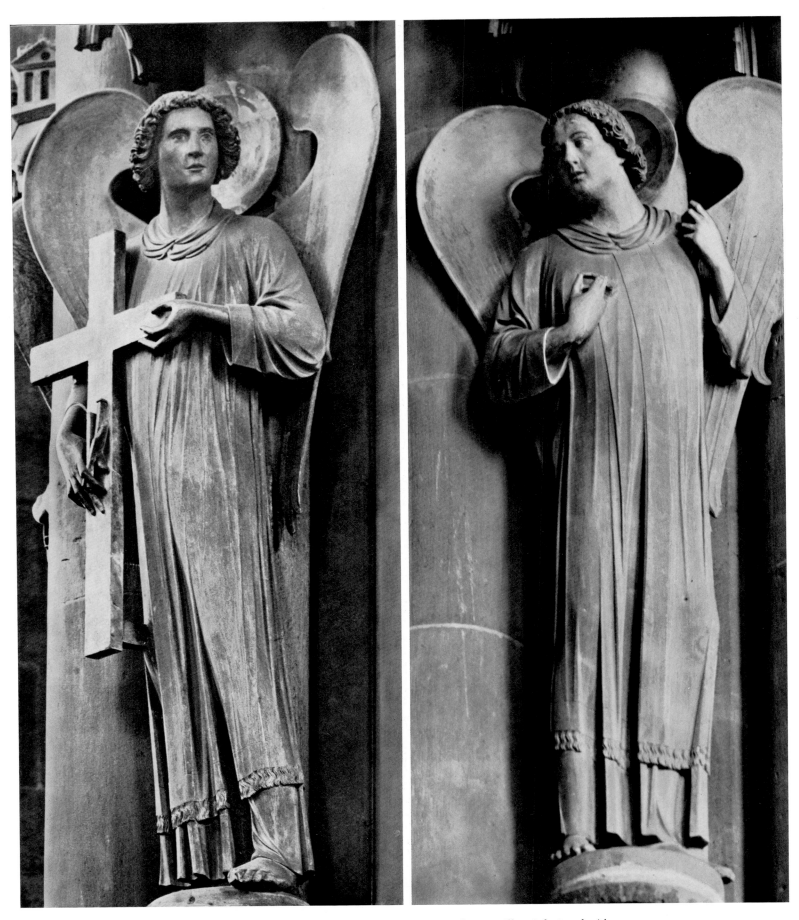

138 Strasbourg cathedral, south transept. Figures on the Judgment Pillar. *Left.* Angel with cross.
Right. Angel, formerly with lance. About 1230

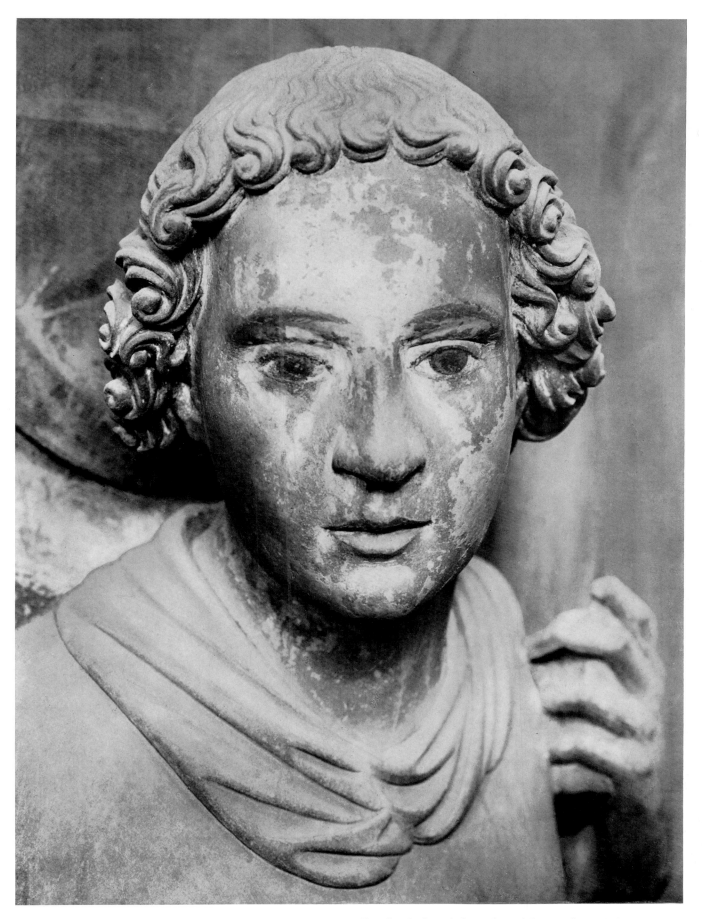

139 Strasbourg cathedral, south transept, Judgment Pillar: detail of angel, formerly with lance. About 1230

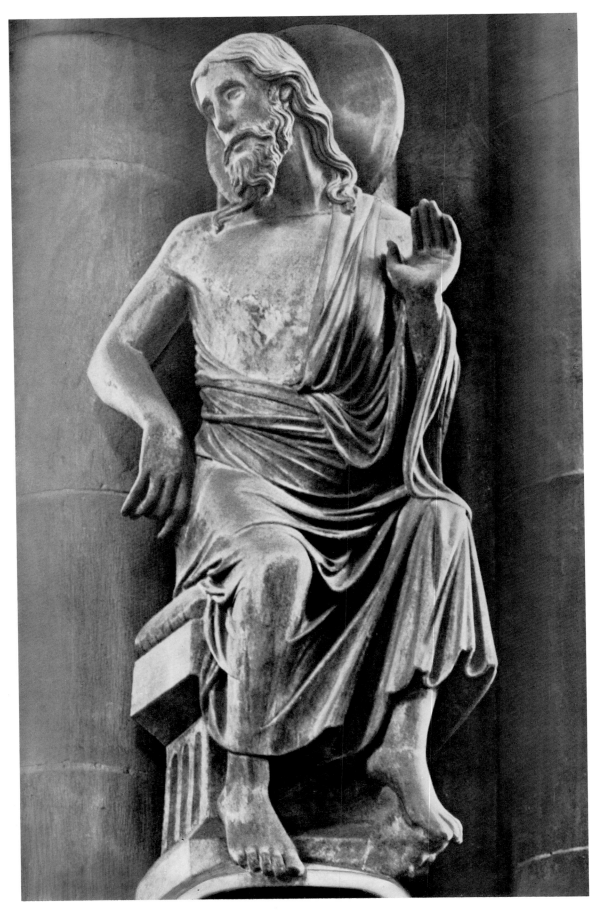

140 Strasbourg cathedral, south transept.
Judgment Pillar: detail of Christ as Judge. About 1230

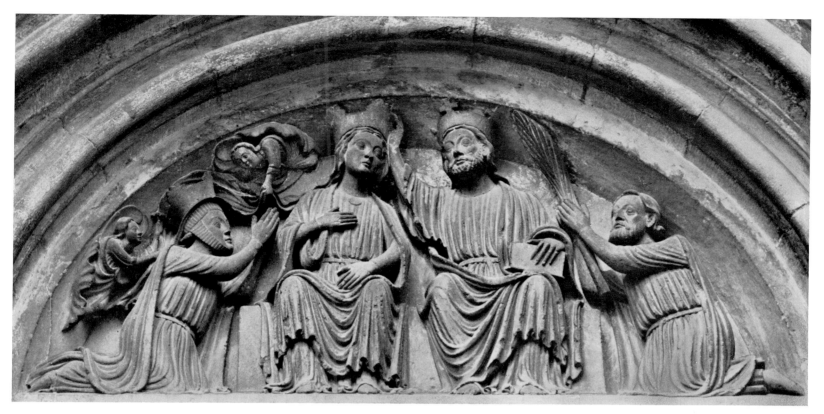

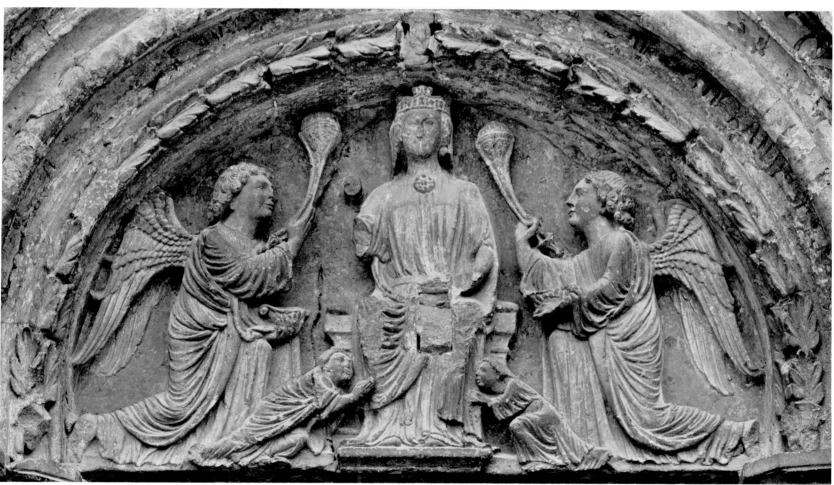

141 *Top*. Lemoncourt, parish church, west portal. Tympanum: Coronation of the Virgin, and donors. About 1230
Bottom. Donnemarie-en-Montois, Notre Dame, south portal. Tympanum: Virgin enthroned with angels and adoring figures. 1220–30

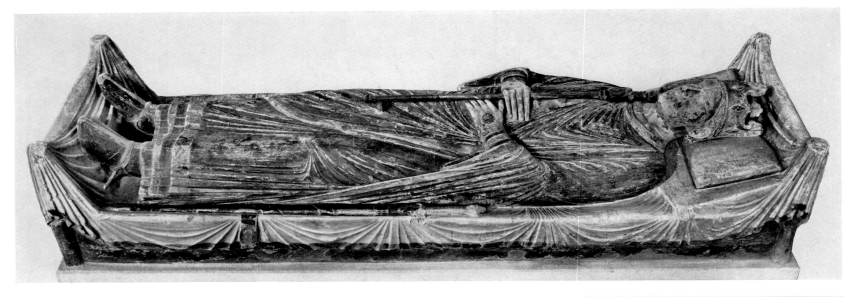

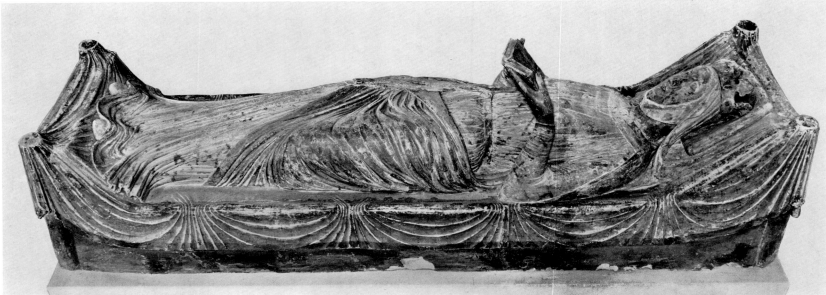

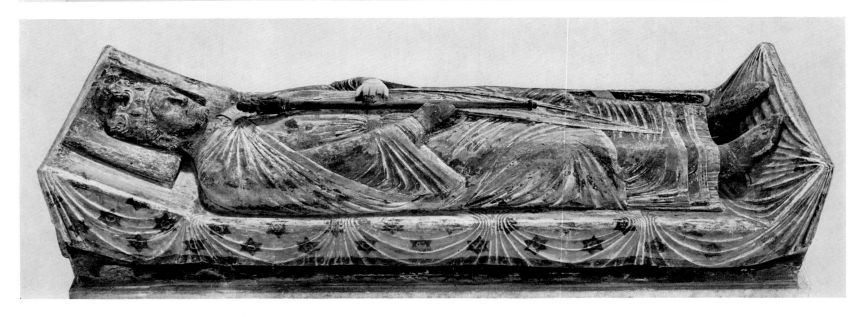

142 Fontevrault, abbey church, tomb monuments of the Plantagenets.
Top. Henry II of England (died 1189), early thirteenth century.
Middle. Eleanor of Aquitane (died 1204), 1220–30. *Bottom*. Richard I (died 1199), early thirteenth century

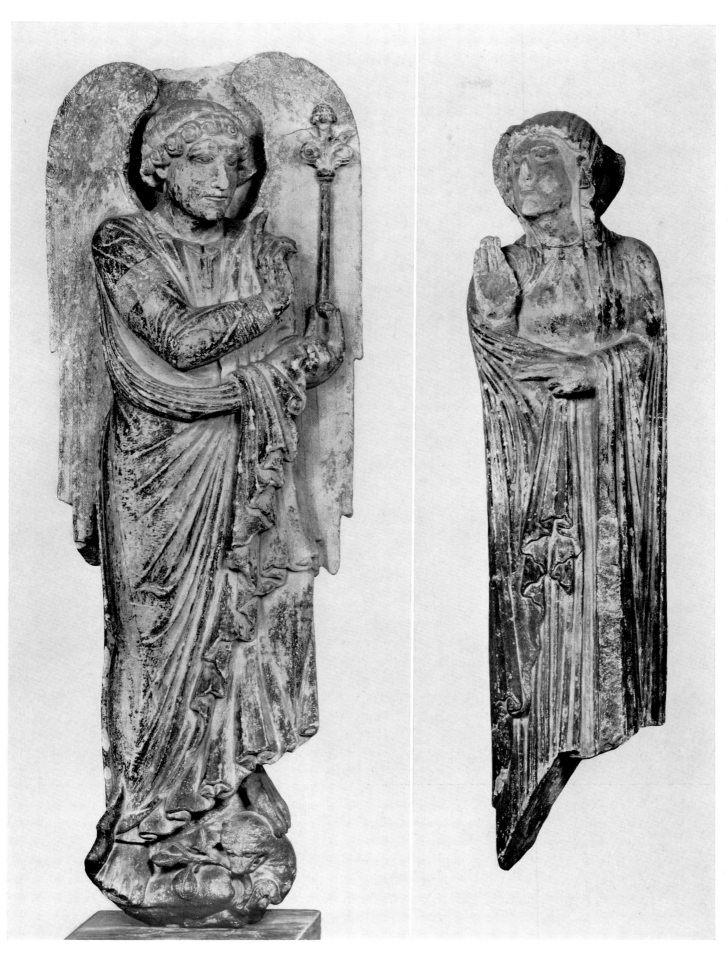

143 Gabriel and the Virgin from an Annunciation group. First quarter of the thirteenth century.
(Toulouse, Musée des Augustins)

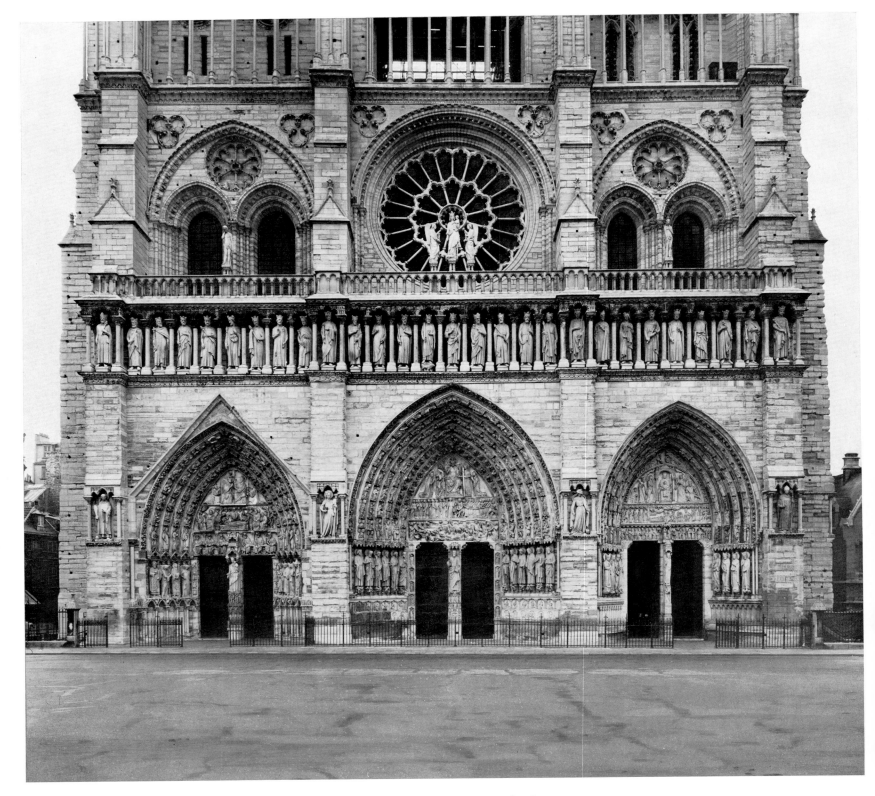

144 Paris, Notre Dame, west façade

145 Paris, Notre Dame, west portal, centre doorway.
Tympanum and archivolt: Last Judgment. Jamb: apostles (renewed). Trumeau: Christ (renewed).
Socle: Virtues and Vices. Beginning of the thirteenth century; before 1230

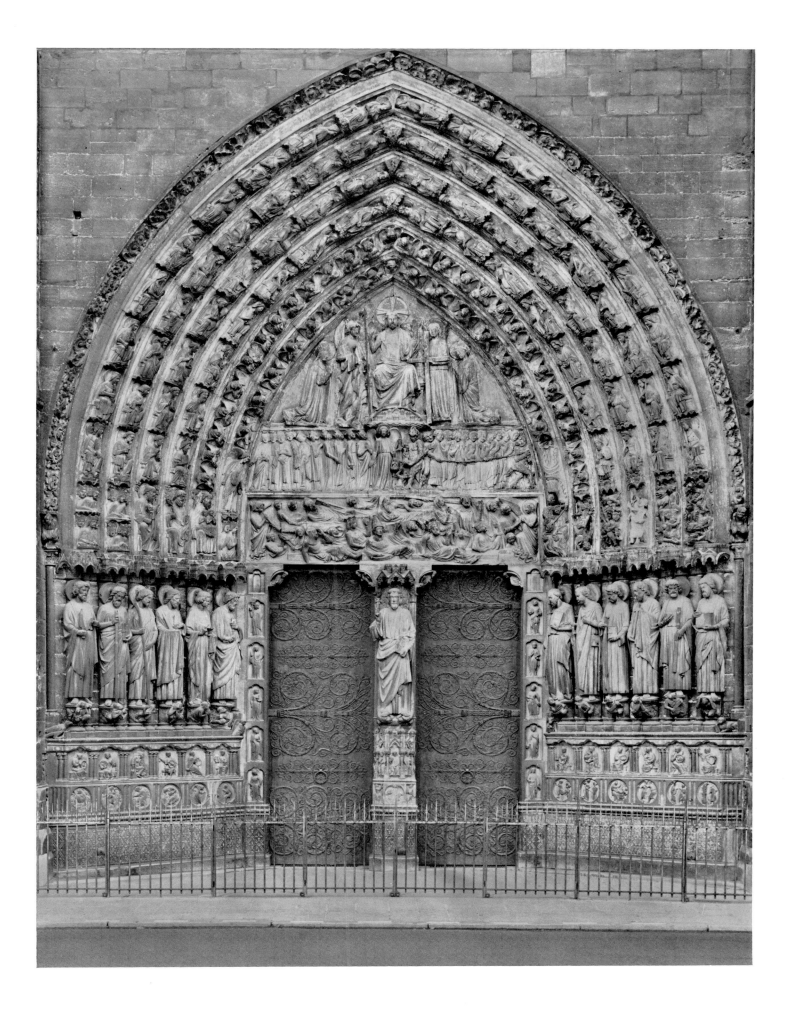

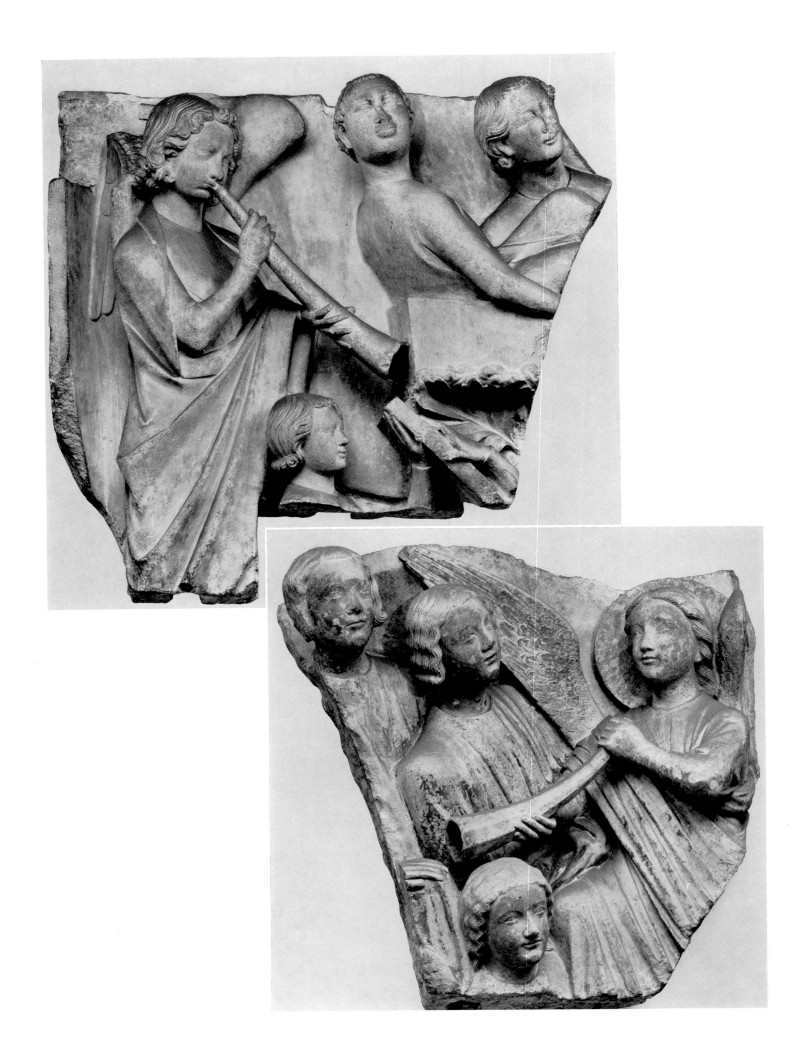

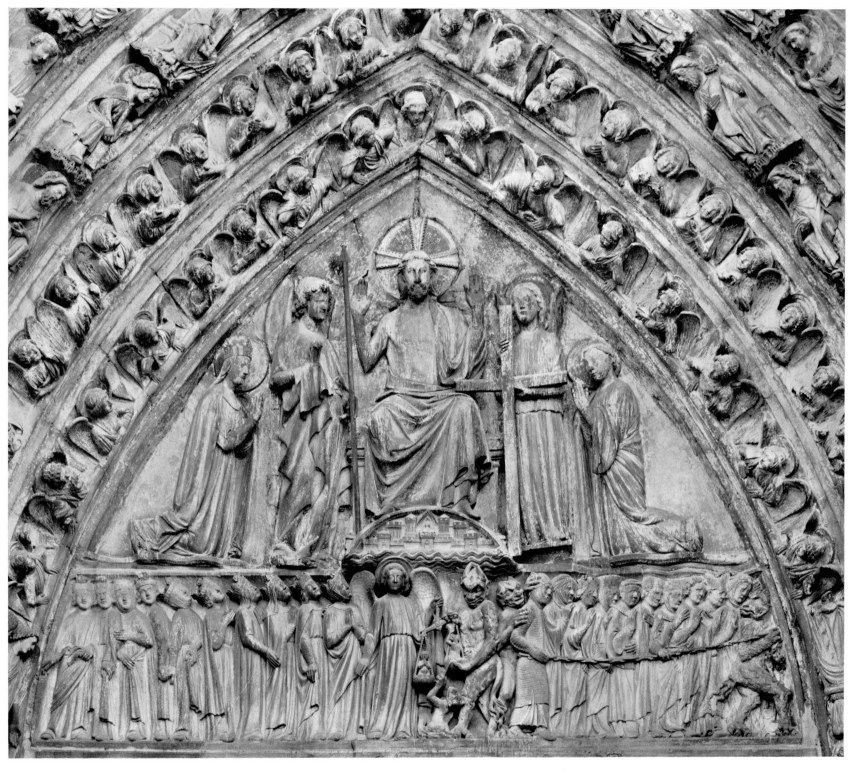

147 Paris, Notre Dame, west portal, centre doorway. Tympanum: Last Judgment. 1220–30

146 Lintel fragments from the west portal (centre doorway) of Notre Dame, Paris: angels with trumpets, the resurrected. 1220–30
(Paris, Musée de Cluny)

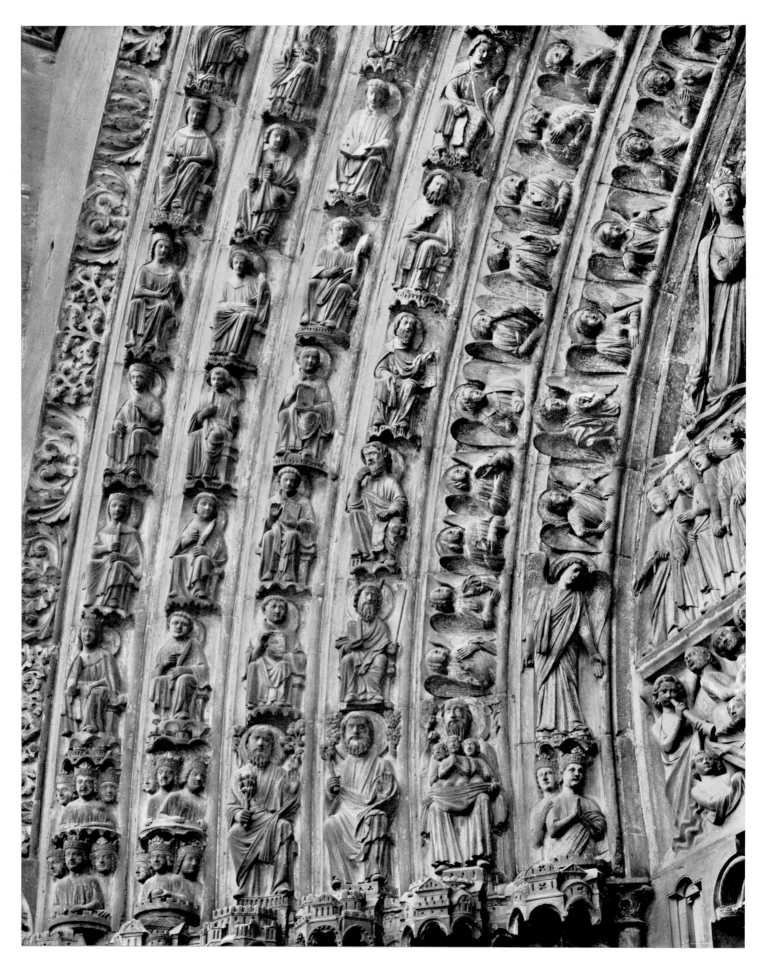

148 Paris, Notre Dame, west portal, centre doorway. Left archivolt: (bottom register) Paradise;
(above, reading from the right) angels, patriarchs and prophets, ecclesiastics, martyrs, virgins. 1220–30

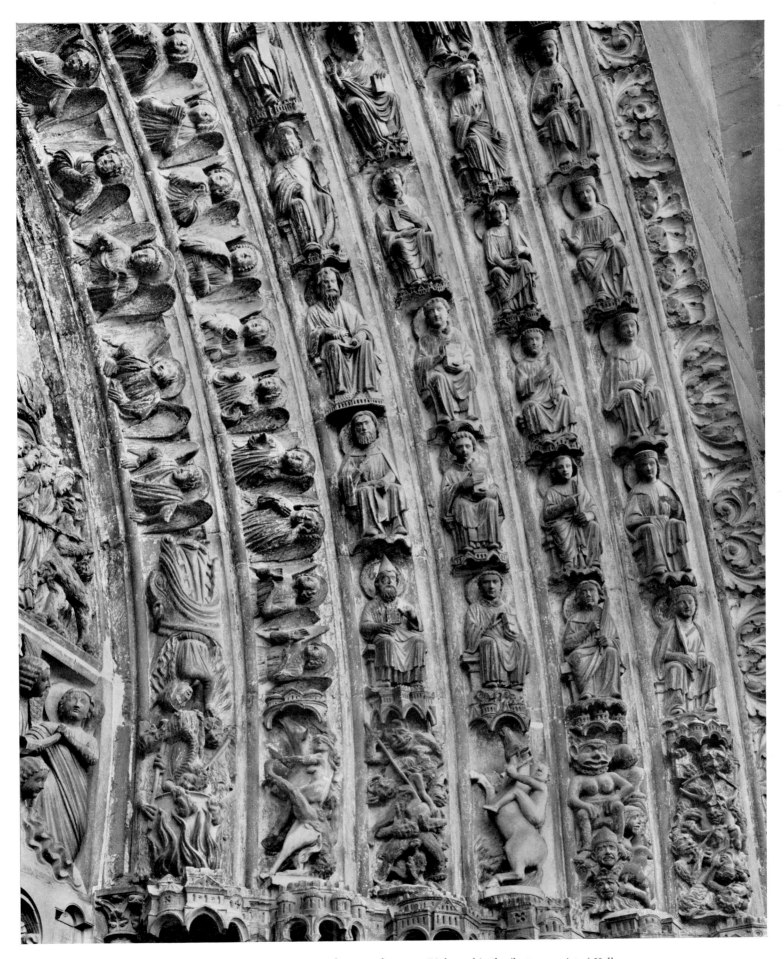

149 Paris, Notre Dame, west portal, centre doorway. Right archivolt: (bottom register) Hell;
(above, reading from the left) angels, patriarchs and prophets, ecclesiastics, martyrs, virgins. 1220–30

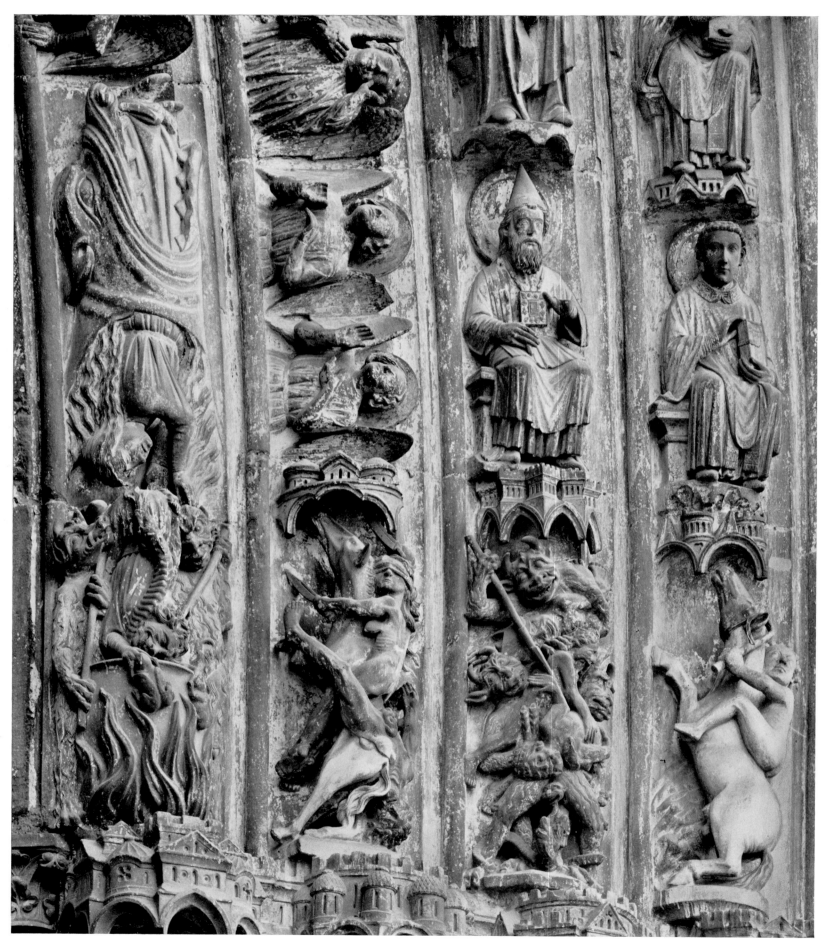

150 Paris, Notre Dame, west portal, centre doorway.
Details of right archivolt: Hell scenes, riders of the Apocalypse(?); (above) angels, Aaron, an ecclesiastic. 1220–30

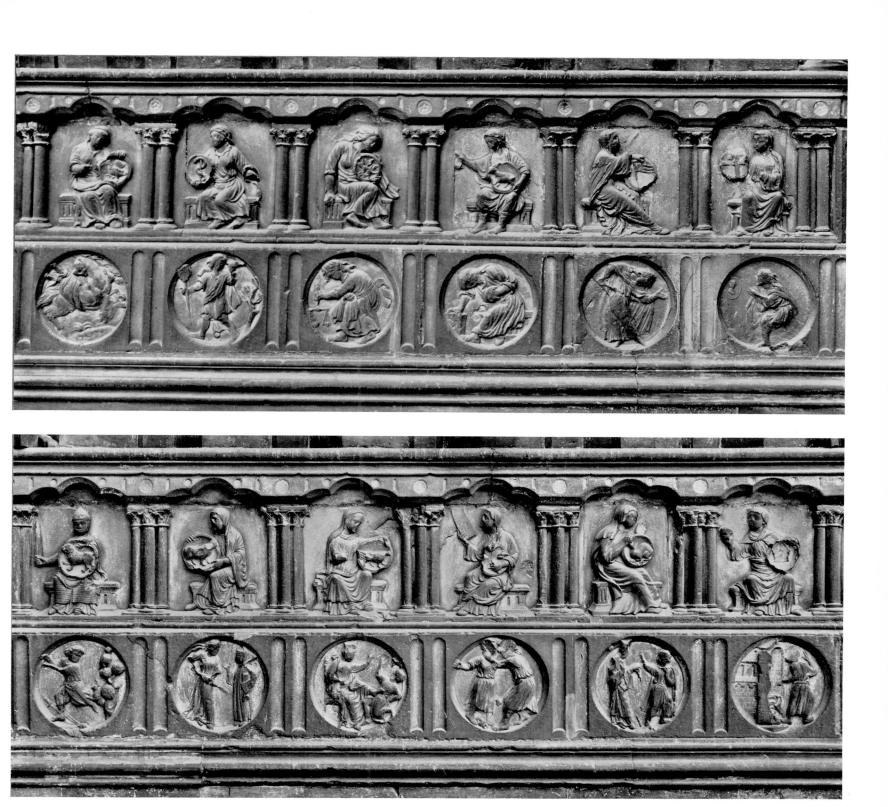

151 Paris, Notre Dame, west portal, centre doorway.
Socle reliefs on the jambs: Virtues and Vices. 1220–10 and restorations of 1770–71

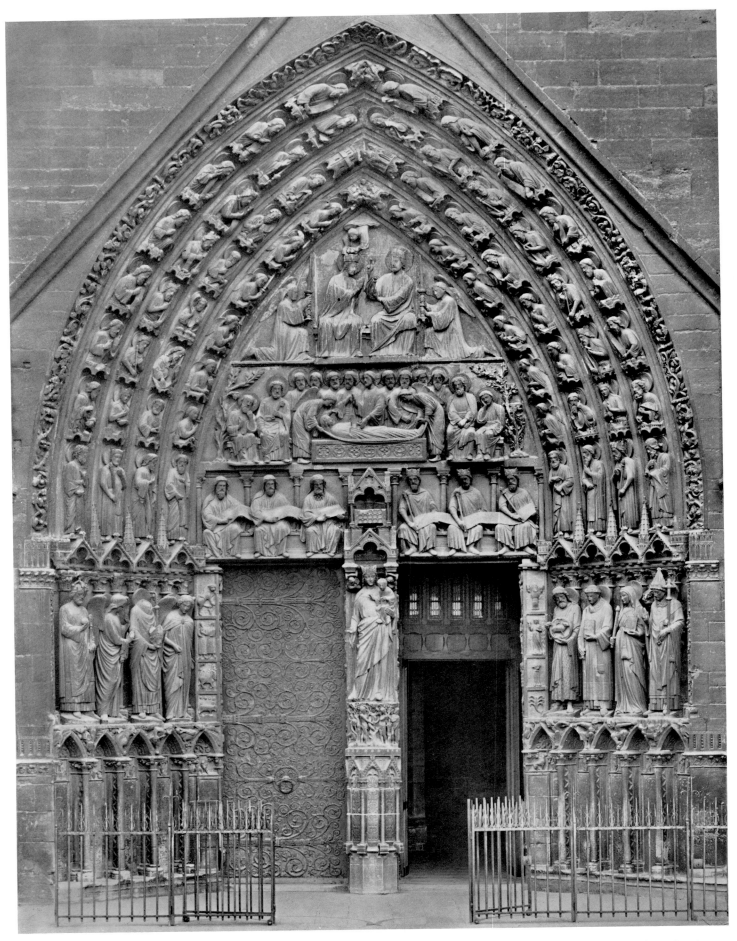

152, 153 Paris, Notre Dame, west portal, left doorway. Jambs: emperor (Charlemagne), St Dionysius flanked by angels; John the Baptist, Stephen, Geneviève, Pope Leo III. Trumeau: Virgin and Child. (All the foregoing figures have been renewed.) Lintel and tympanum (pl. 153): Ark of the Covenant flanked by kings and patriarchs or prophets; Assumption and Coronation of the Virgin. Archivolt: angels, prophets and kings. 1210–20

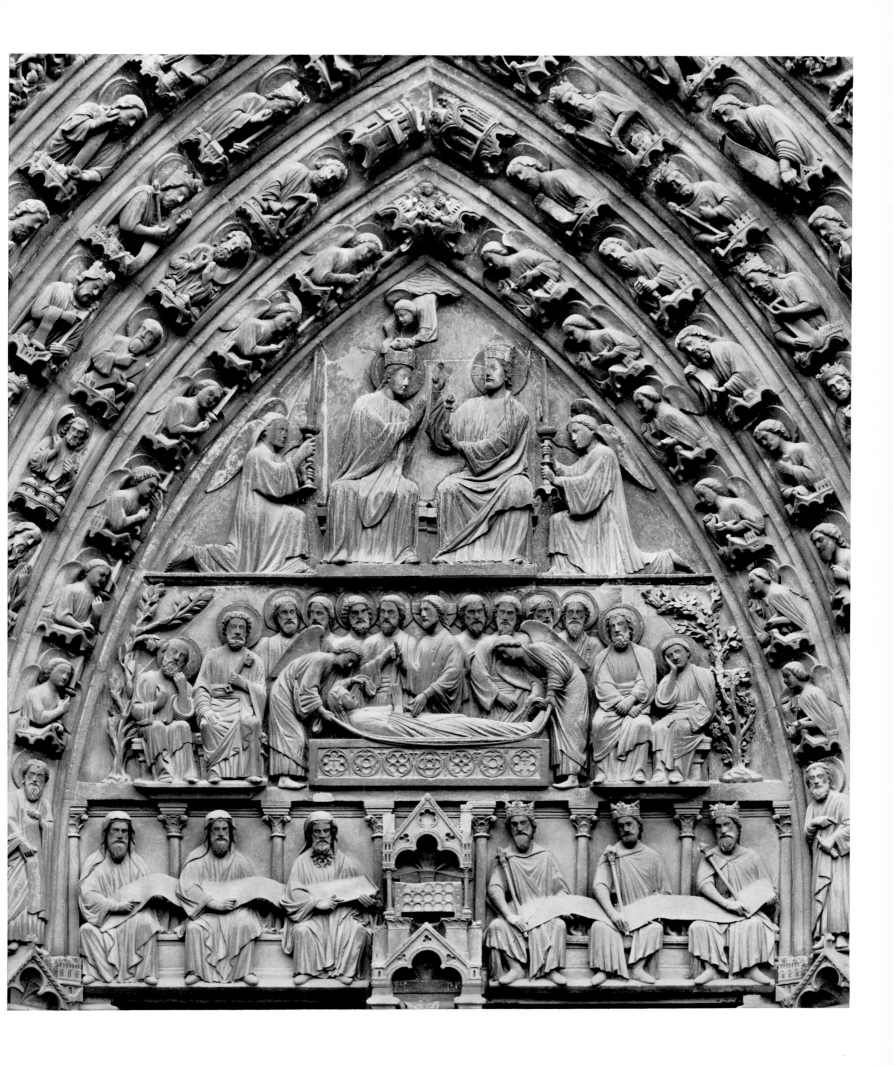

154 Paris, Notre Dame, west portal, left doorway. *Left*. Post adjacent to the left jamb: plant ornament. *Middle*. Side faces of the trumeau: allegorical figures of (left) Ages of Man, (right) temperatures(?). *Right*. Detail of left doorpost: (reading from bottom) Taurus, Gemini and Leo from the Zodiac, and April, May and July from the Calendar. 1210–20

155 Paris, Notre Dame, west portal, left doorway. Right archivolt: angels, (second and fourth arches) patriarchs and prophets, (third arch) kings. 1210–20

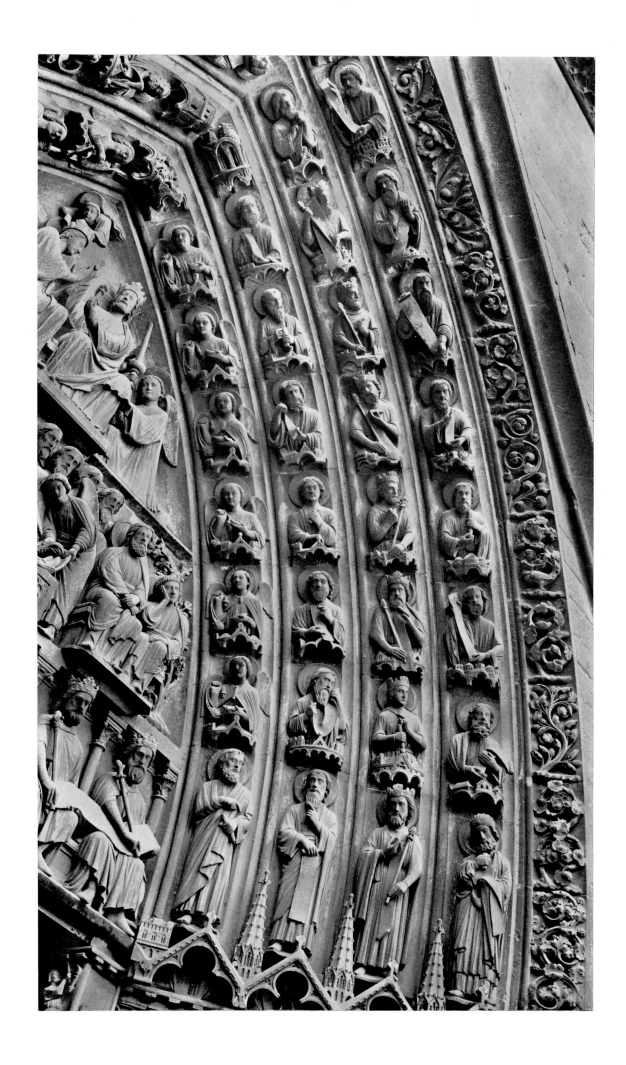

156 Paris, Notre Dame, west portal, left doorway. Socle reliefs: fall of the angels, beheading of St Dionysius; Michael; beheading of John the Baptist, stoning of St Stephen. 1210–20

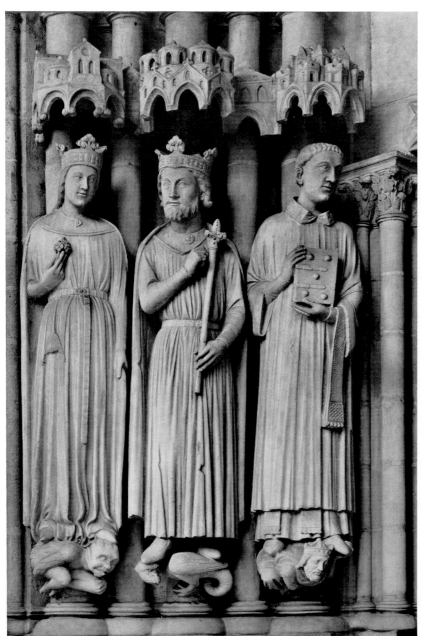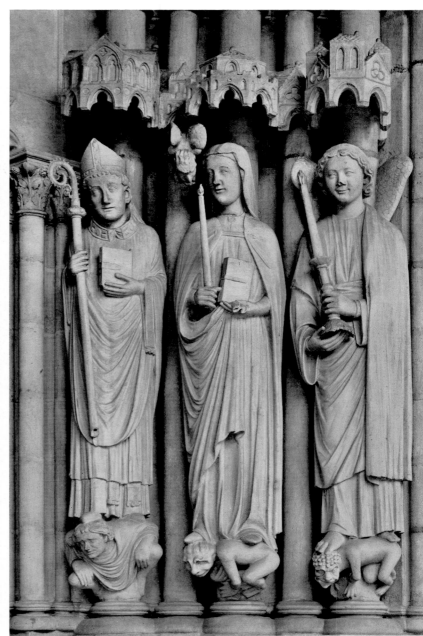

157 Paris, Saint-Germain-l'Auxerrois, west portal.
Left jamb: royal pair (Solomon and the Queen of Sheba?), deacon (Vincent?).
Right jamb: bishop (Marcellus or Landericus?), Geneviève, angel. 1220–30

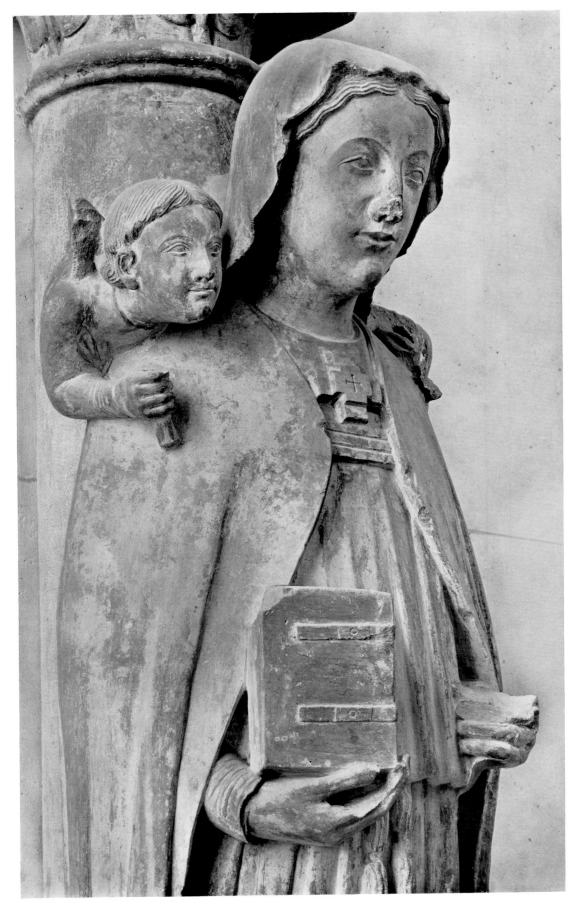

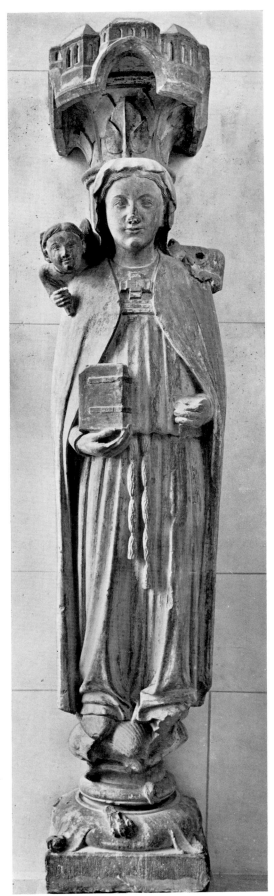

158 Figure of St Geneviève, from the west portal of the abbey church of Sainte-Geneviève. 1220–30. (Paris, Louvre)

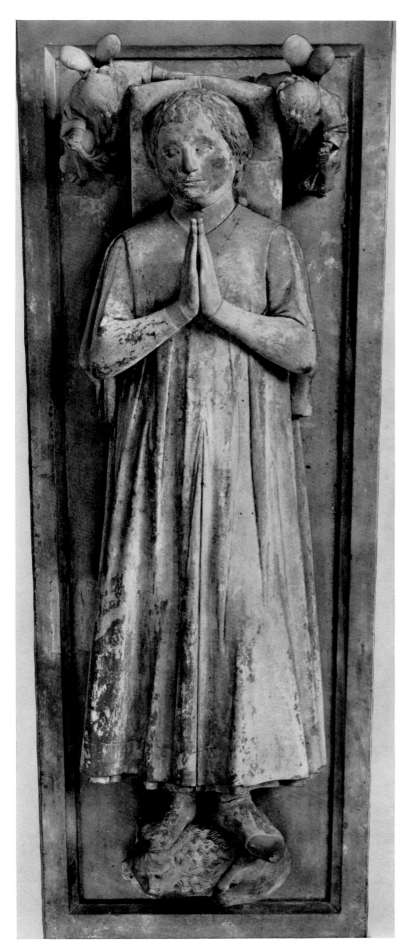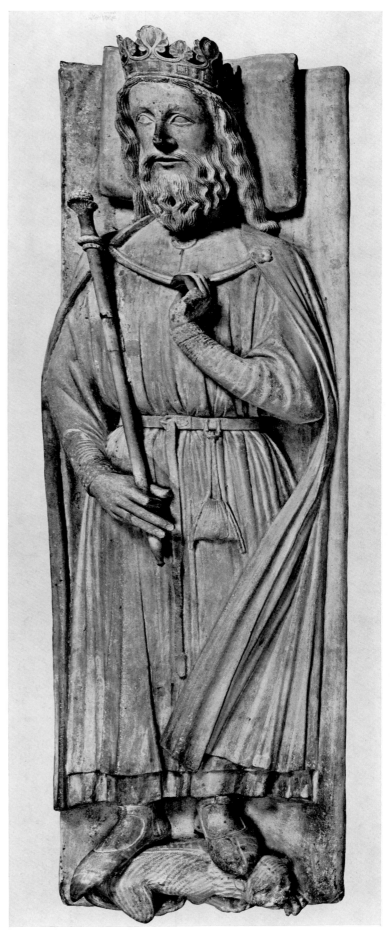

159 *Left*. Tomb monument of Philip of France from Royaumont. Shortly after 1235.
Right. Tomb monument of Clovis I, from Sainte-Geneviève, Paris. 1220–30.
(Both now in the abbey church of Saint-Denis)

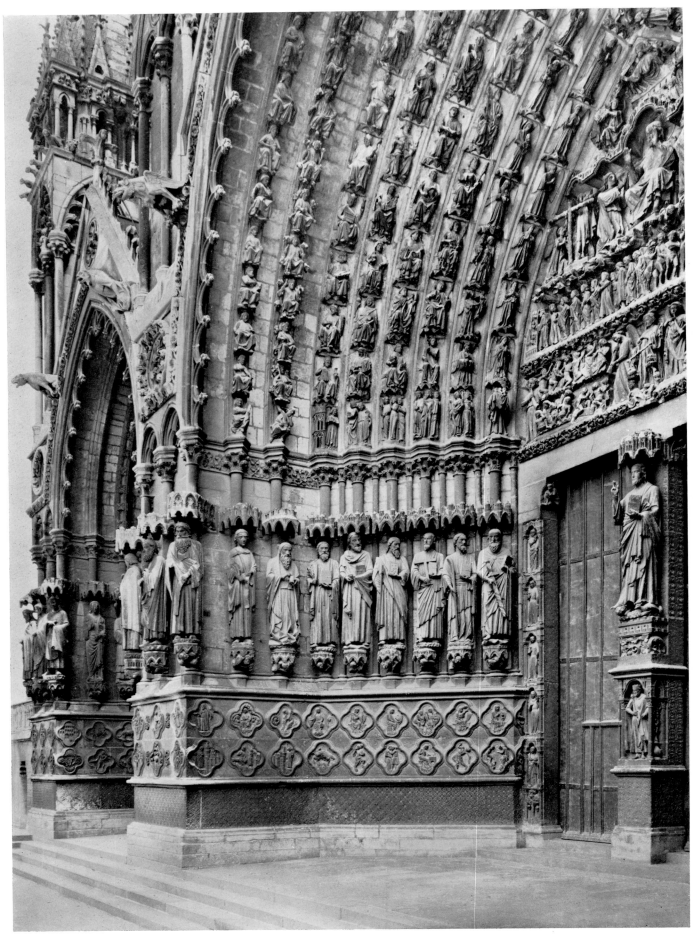

160 Amiens cathedral, west portal, centre doorway. Left jamb: major prophets, apostles. Doorpost: Wise Virgins.
Trumeau: Christ. Tympanum and archivolt: Last Judgment. 1225–35

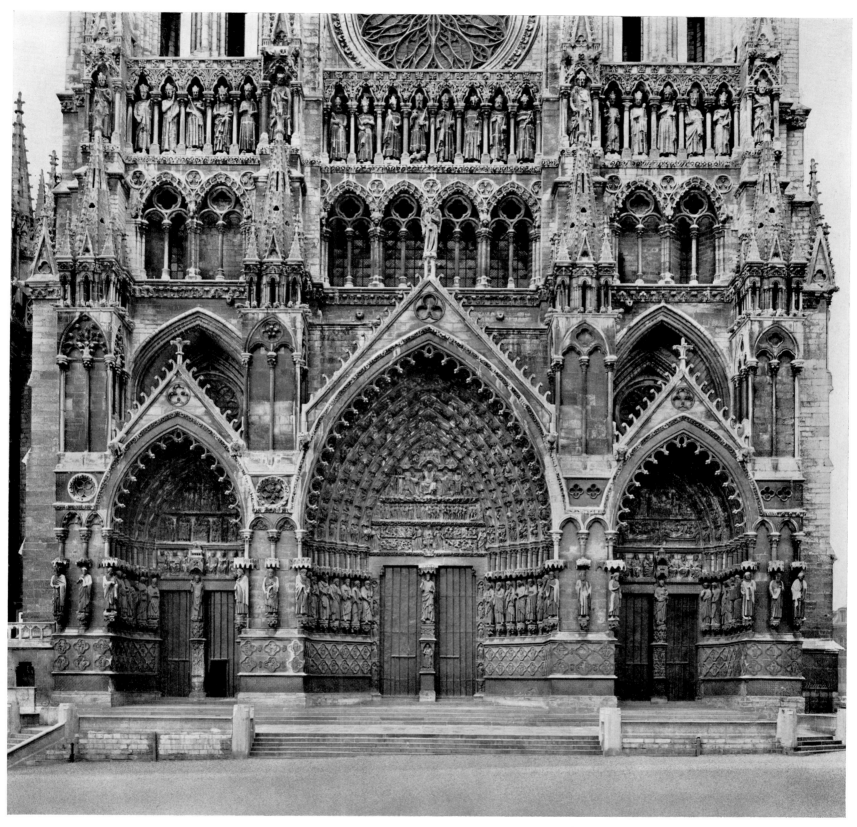

161 Amiens cathedral, west façade. 1220–35

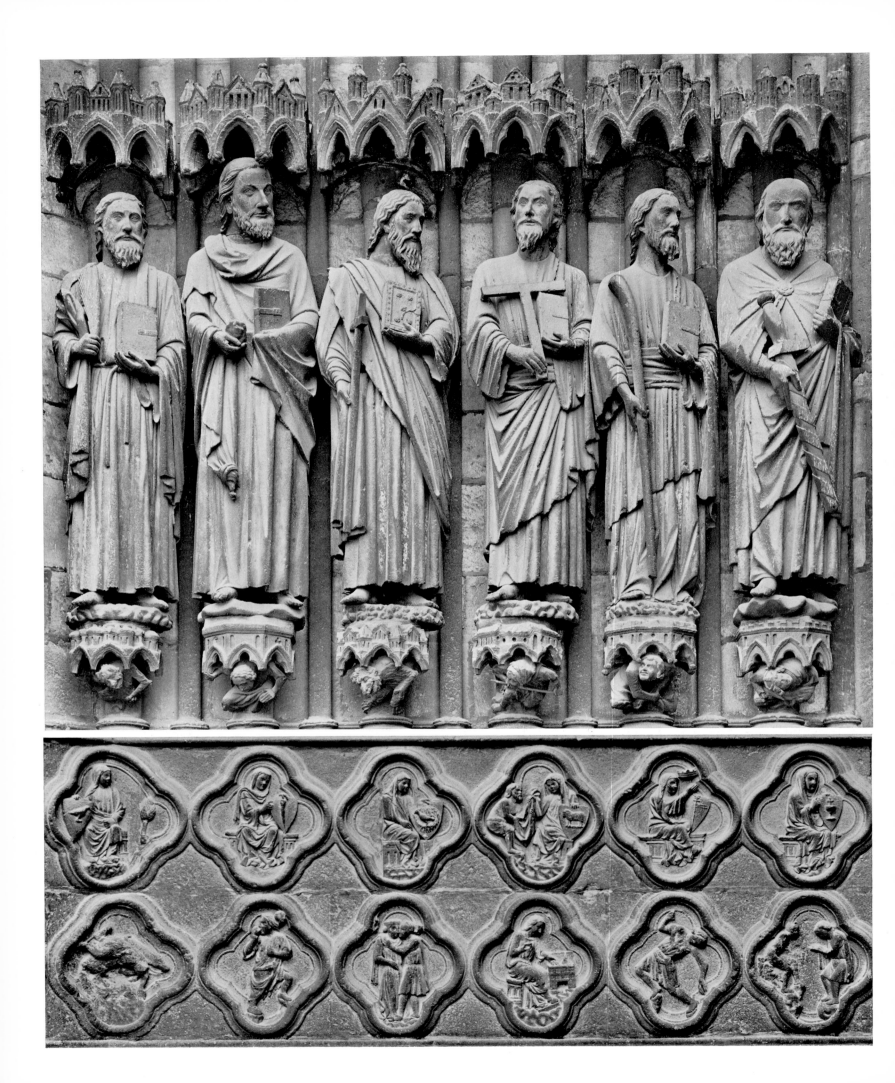

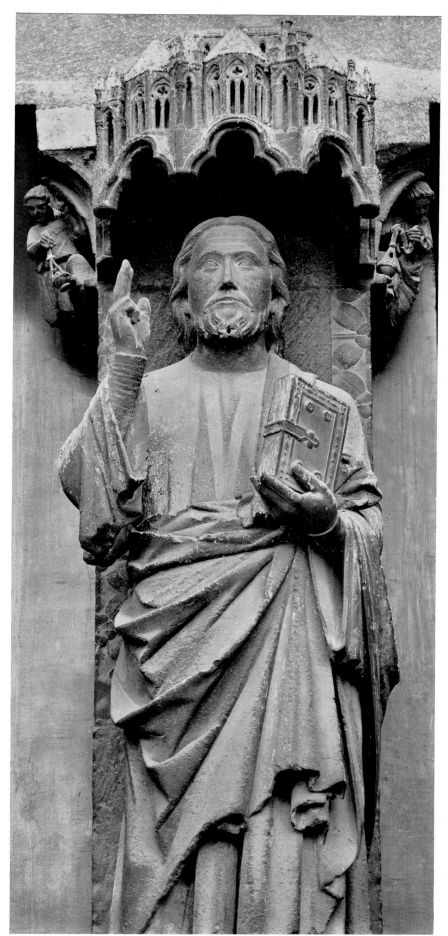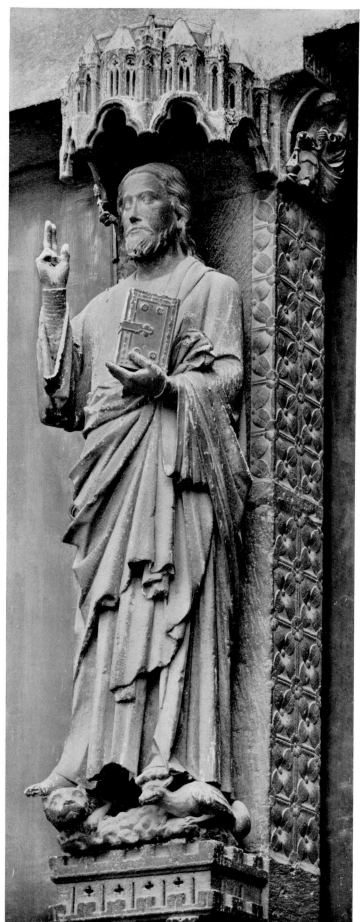

162, 163 Amiens cathedral, west portal, centre doorway.
162 Left jamb: apostles; (on the socle) Virtues (top row) and Vices.
163 Trumeau: Christ over lion and dragon. 1220–35

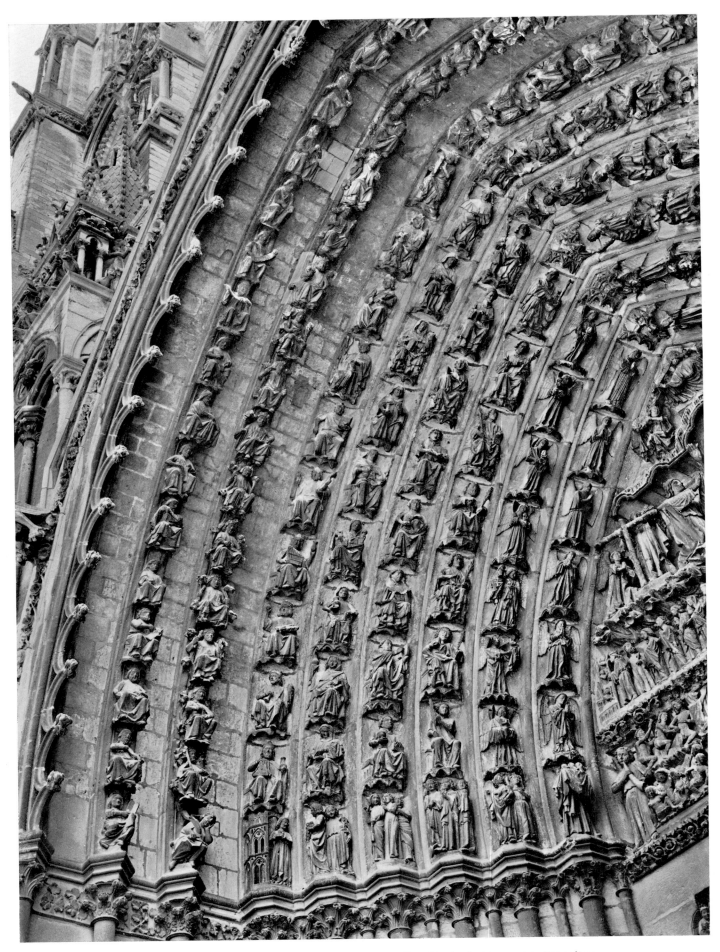

164 Amiens cathedral, west portal, centre doorway. Left archivolt: (bottom register) Paradise;
(above, reading from the right) angels, martyrs, ecclesiastics, female figures, Elders of the Apocalypse, Stem of Jesse. 1220–35

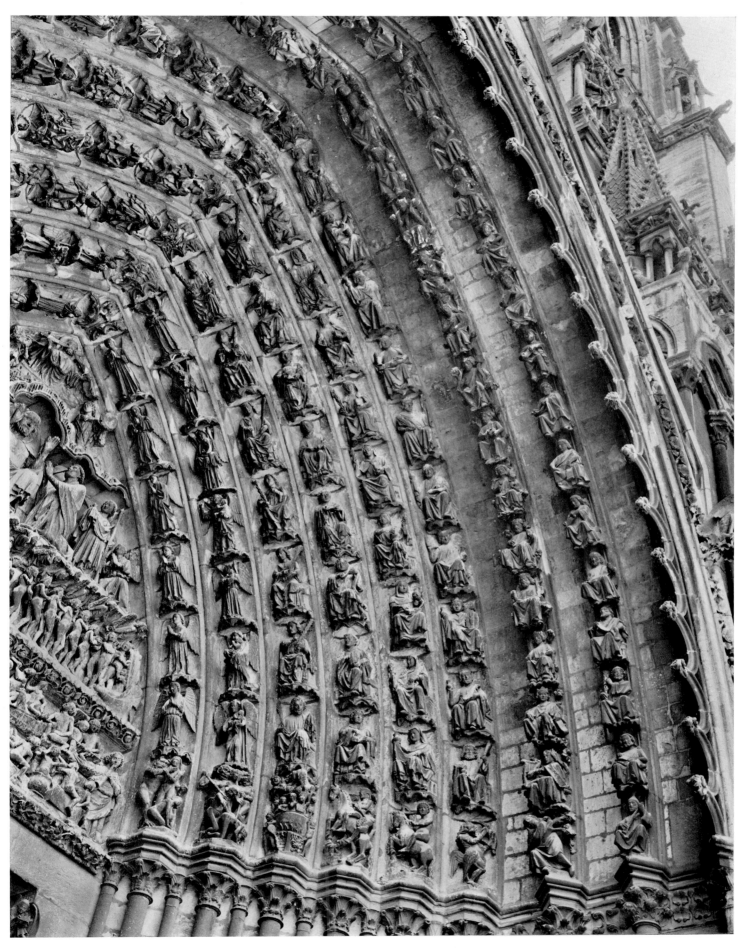

165 Amiens cathedral, west portal, centre doorway. Right archivolt: (bottom register) Hell;
(above, reading from the left) angels, martyrs, ecclesiastics, female figures, Elders of the Apocalypse, Stem of Jesse. 1220–35

167 Amiens cathedral, west portal, right doorway.
Right jamb: Annunciation, Visitation, Presentation in the Temple. 1220–30

166 Amiens cathedral, west portal, right doorway.
Left jamb: (*left*) Queen of Sheba, Solomon; (*right*) Herod, the Three Magi. 1220–30

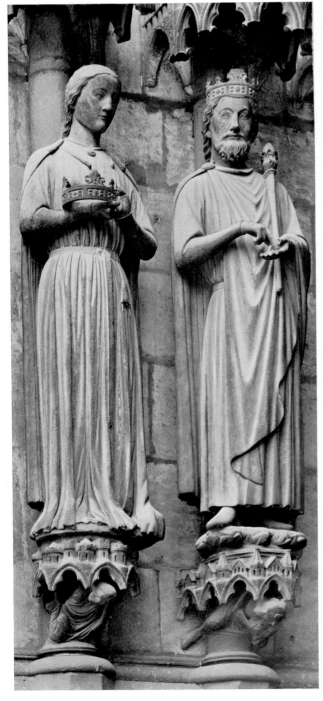

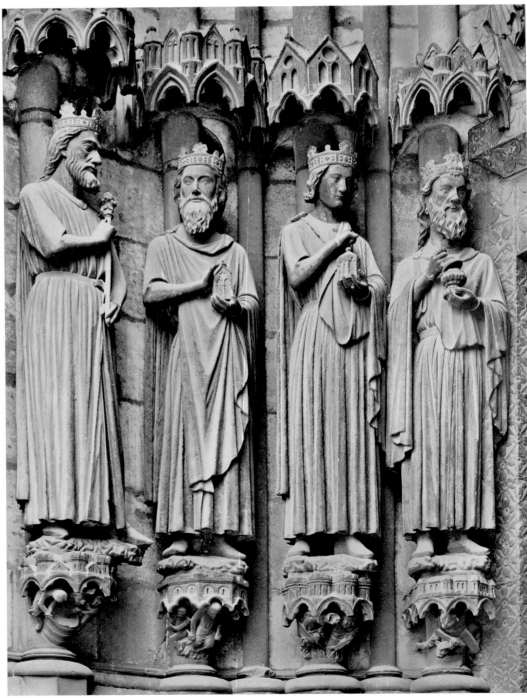

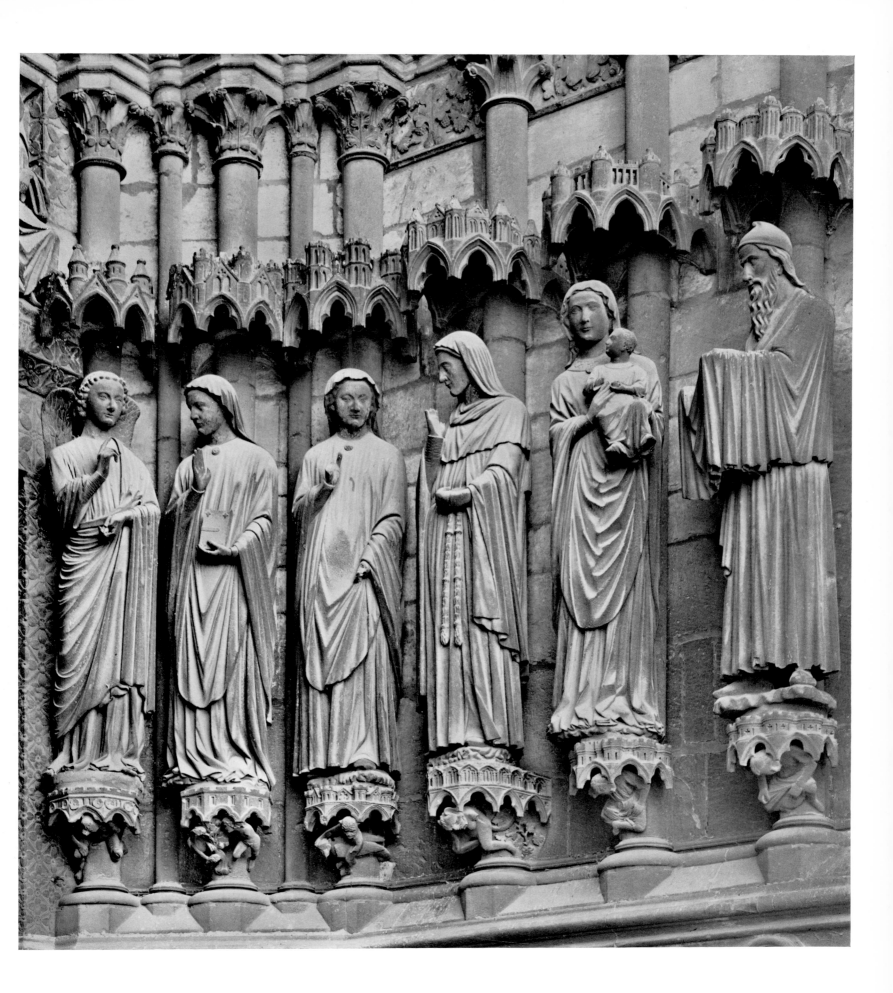

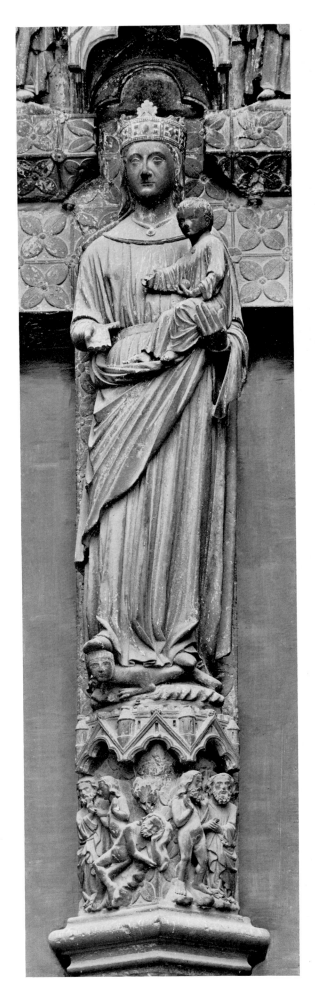

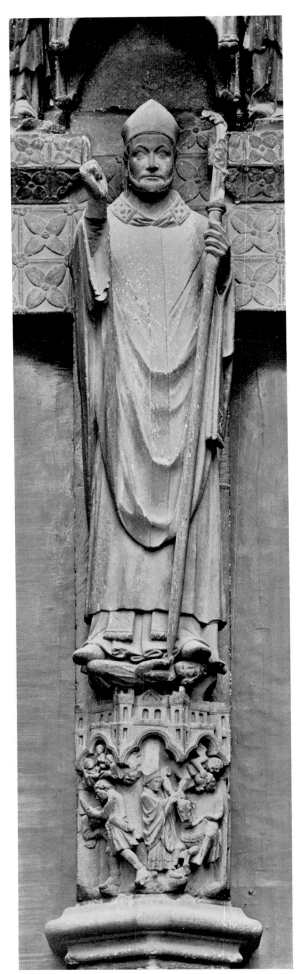

168 Amiens cathedral, west portal. *Left*. Right doorway, trumeau: Virgin and Child; (on the socle) the creation of Eve, God speaking to Adam. 1220–30. *Right*. Left doorway, trumeau: St Firmin; (on the socle) the saint's martyrdom(?). 1225–35

169 Amiens cathedral, west portal, left doorway, left jamb. Angels and saints (from the left): Ulphia(?), Aceolus(?), Acius(?), Honoratus(?); (on the socle) Zodiac and Calendar. 1225–35

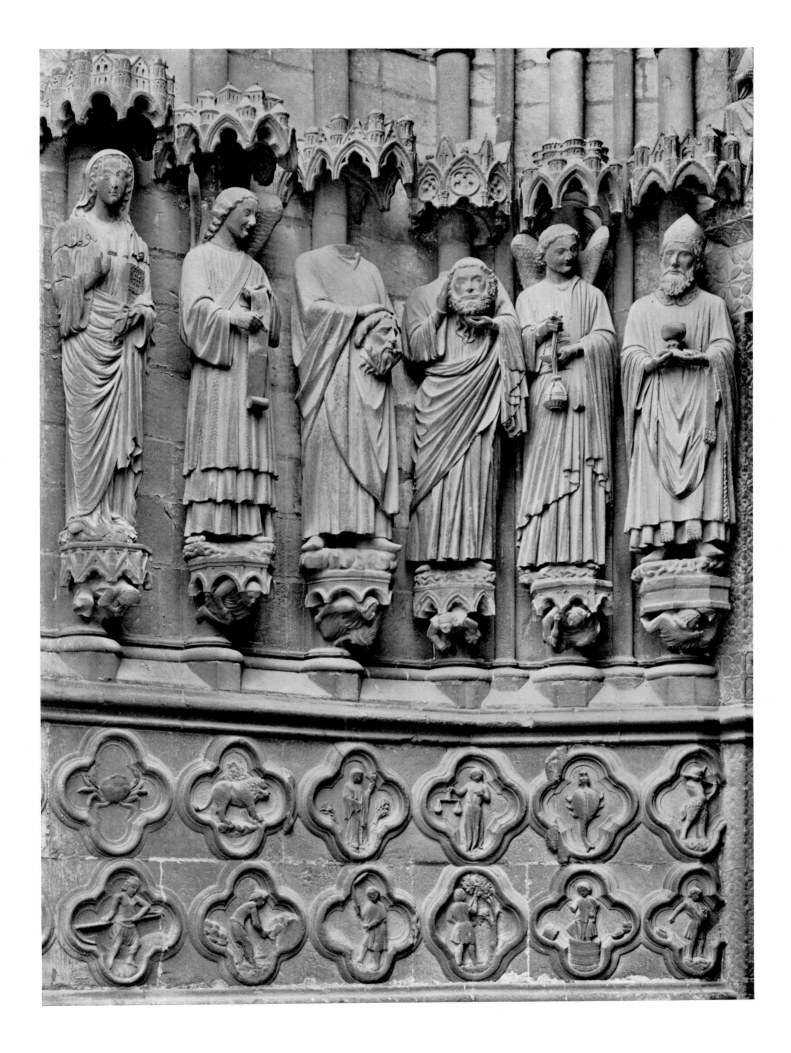

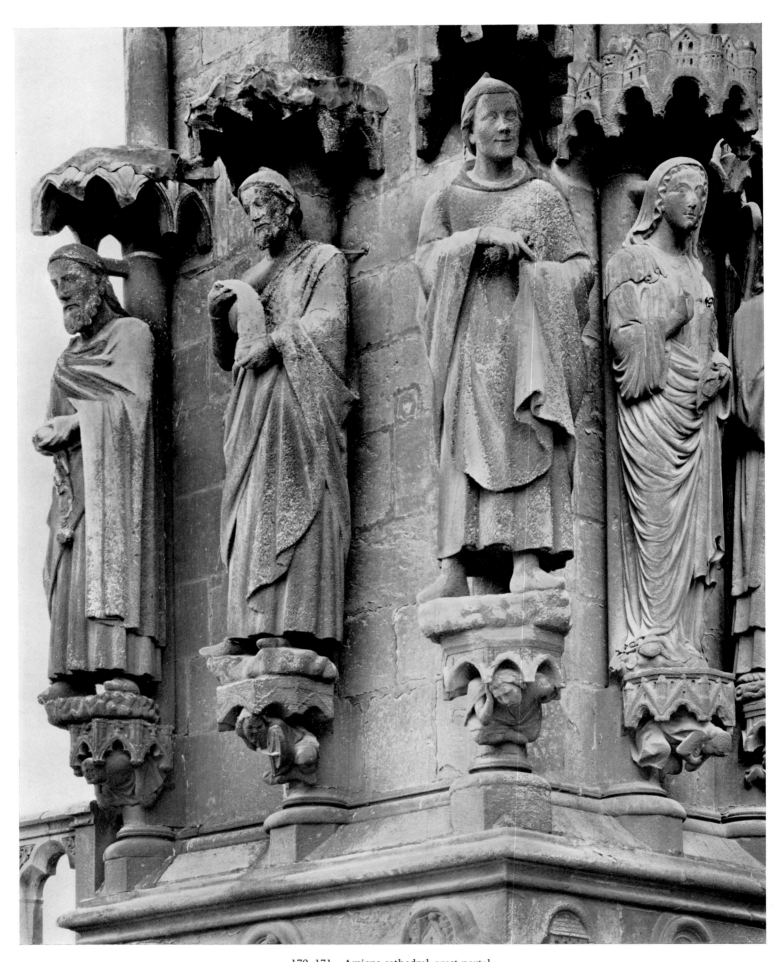

170, 171 Amiens cathedral, west portal
170 Statues on the north buttress. Prophets: Malachi, Zechariah, Haggai; (on the jamb) St Ulphia(?)
171 Statues on the buttress between the left and centre doorways: St Luxor(?), the prophets Zephaniah and Habakkuk. 1220–35

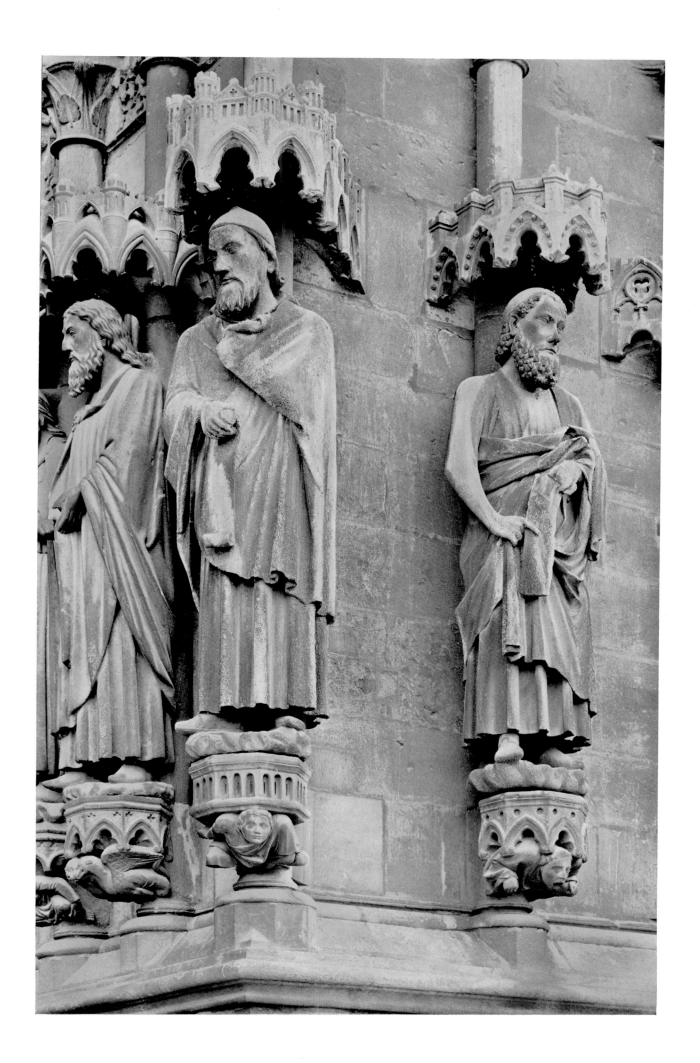

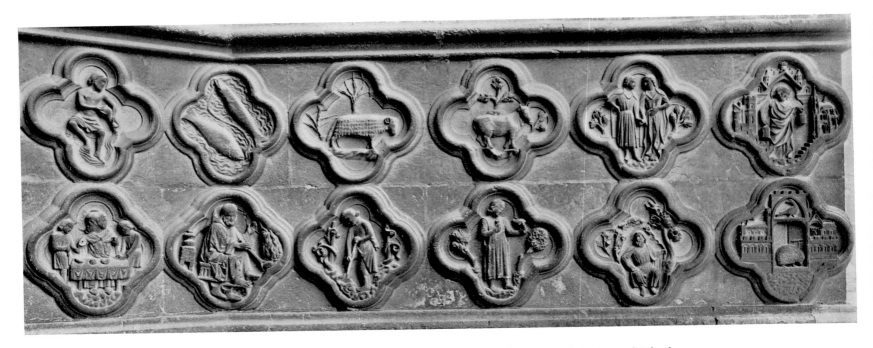

172 Amiens cathedral, west portal. *Top*. Left doorway, socle of the right jamb: Zodiac and Calendar.
Bottom. Right doorway, socle of the right jamb: (left) the blind Zacharias leaving the Temple, and, below, Zacharias writing the name
John; (top, centre) Flight into Egypt; (top right) overthrow of Egyptian idols; (bottom right) the Holy Family returning home; (bottom,
centre) the twelve-year-old Jesus in the Temple; 1225–35

173 Amiens cathedral, west portal. *Top*. North buttress: socle scenes beneath Malachi, Zechariah and Haggai (cf. pl. 170).
Bottom. Buttress between the centre and left doorways: socle scenes beneath Zephaniah, Habakkuk and Nahum. 1225–35

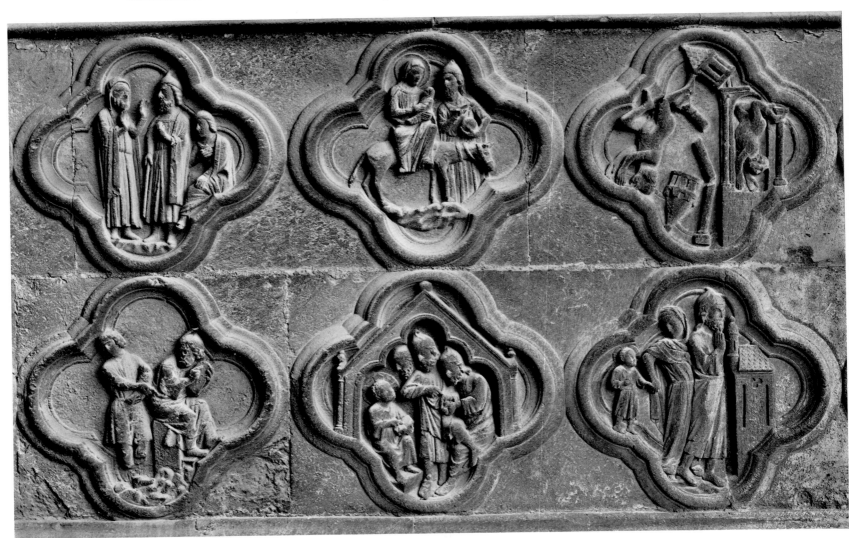

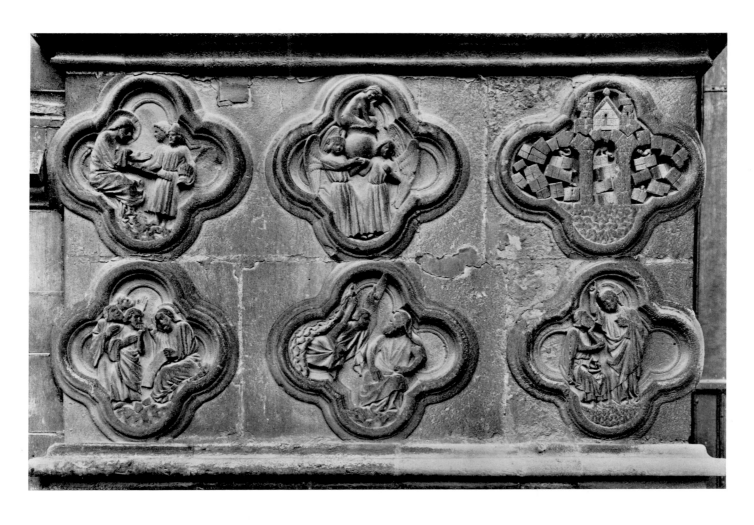

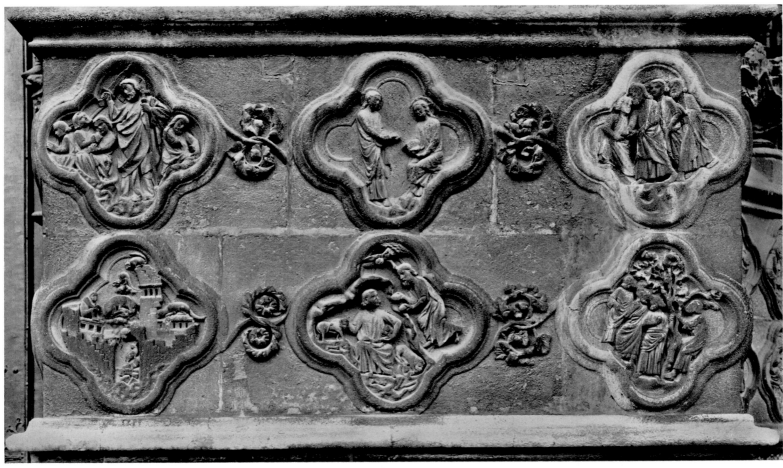

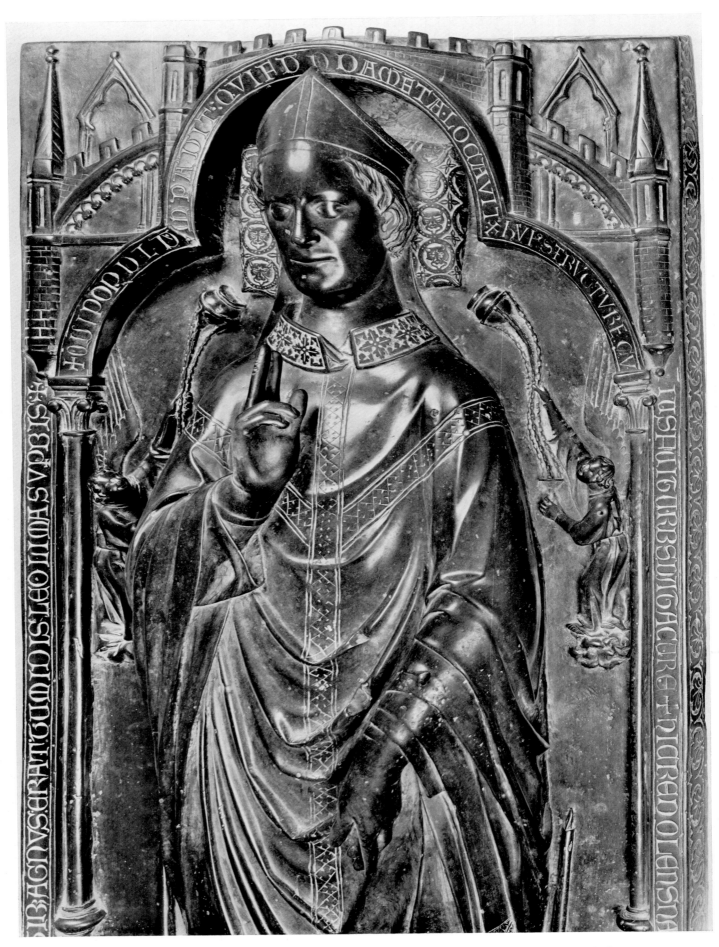

174 Tomb monument of Bishop Evrard de Fouilloy (died 1222). Shortly after 1222. (Amiens cathedral)

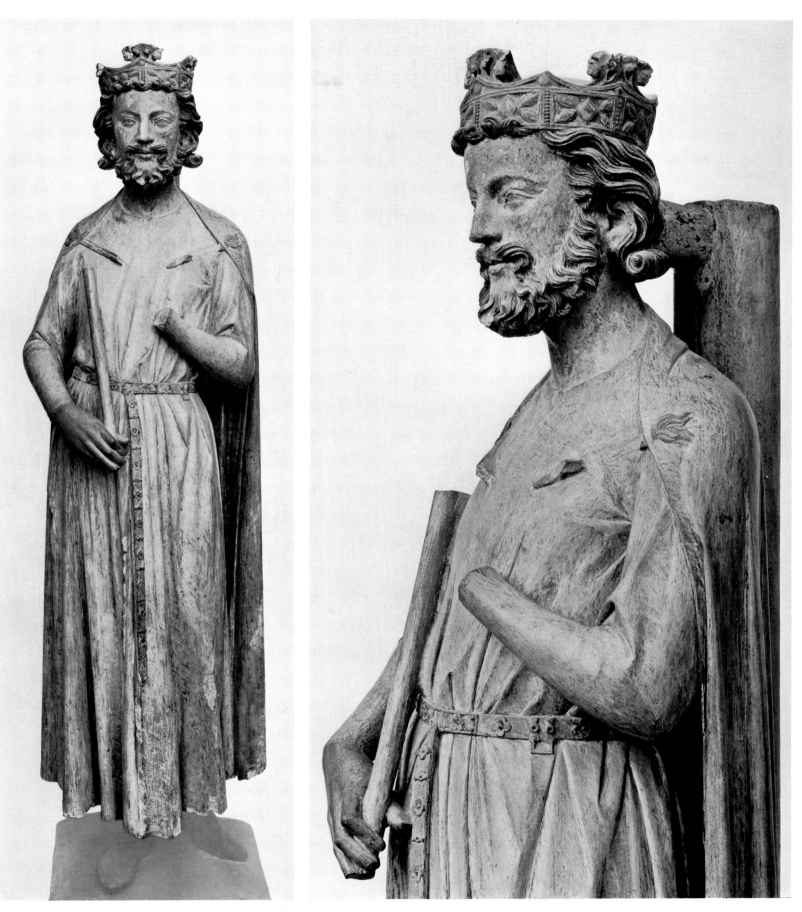

175 'King Childebert'. Trumeau figure from the portal of the former refectory of the abbey of Saint-Germain-des-Prés, Paris. About 1240. (Paris, Louvre)

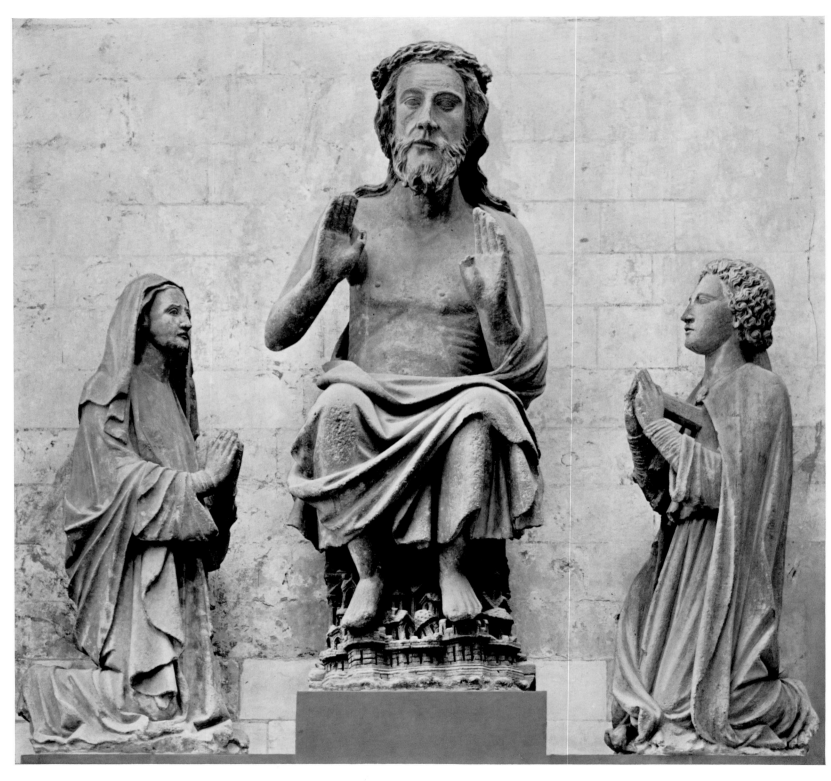

176, 177 Saint-Omer cathedral. Christ as Judge, with Mary and John, from Thérouanne. 1235–40.
177 Detail of Christ

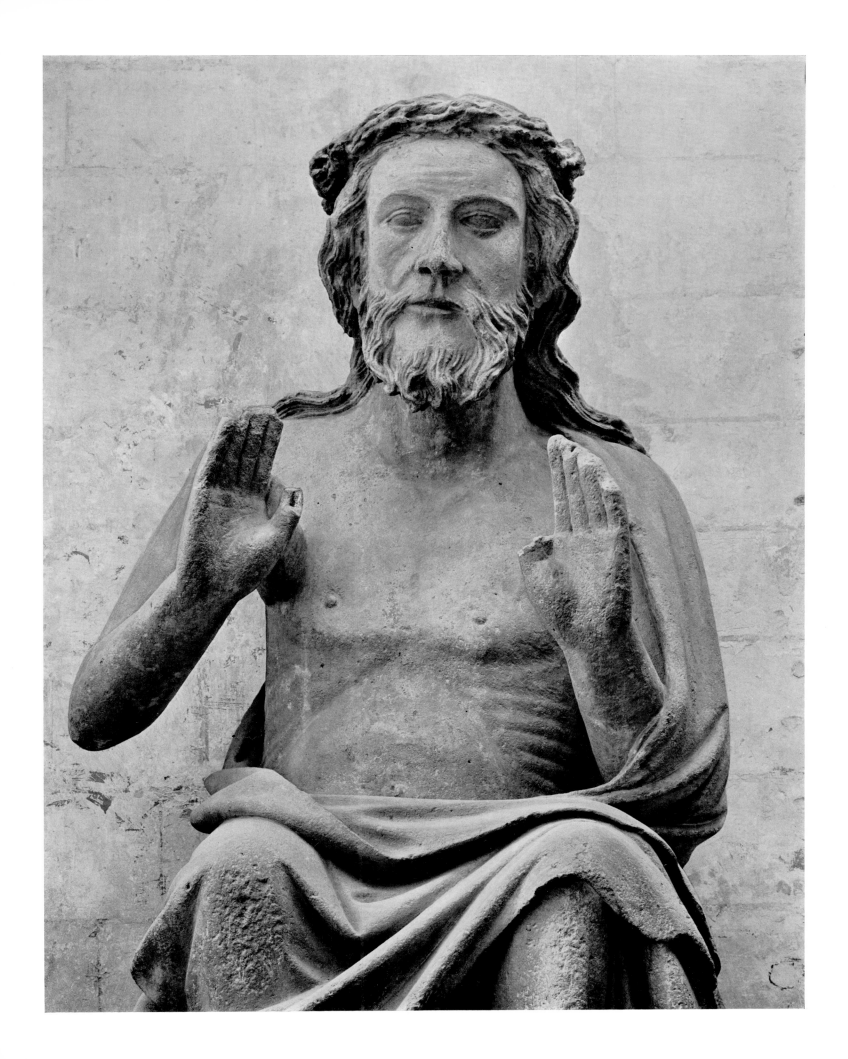

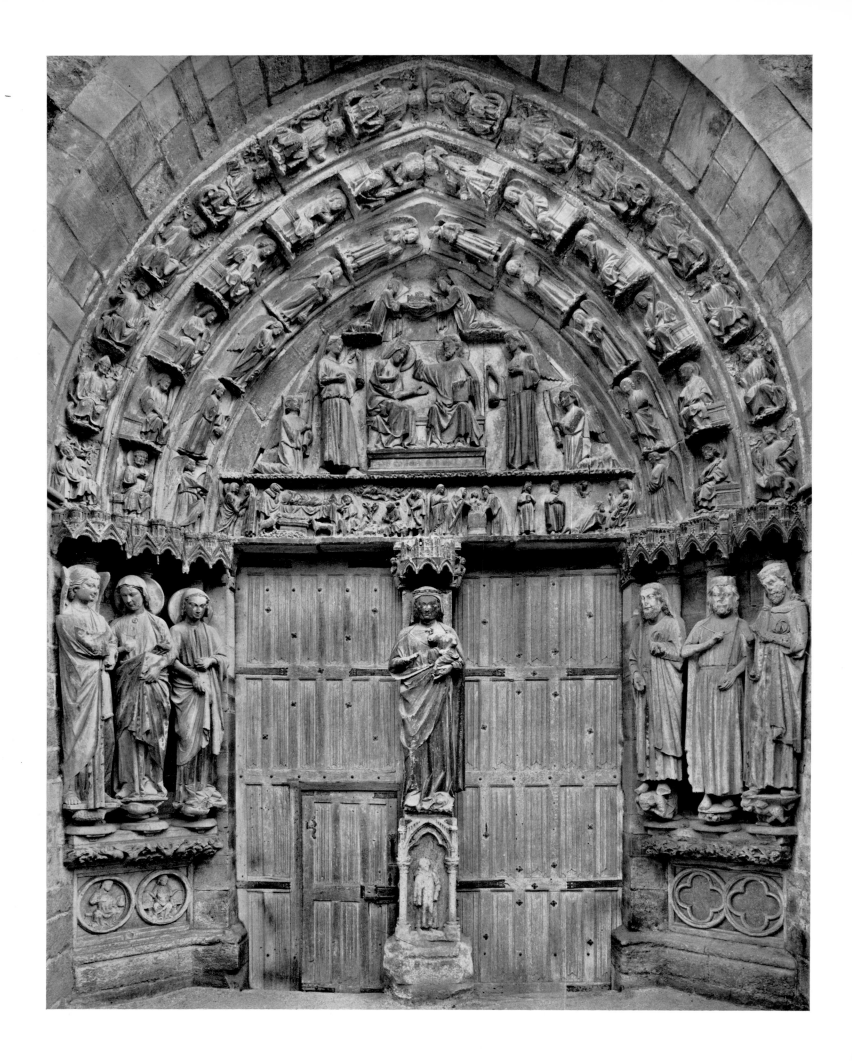

178, 179 Villeneuve-l'Archevêque, priory church, west portal.
Tympanum: Coronation of the Virgin. Lintel: Visitation, Nativity, Annunciation to the Shepherds, Presentation in the Temple,
Adoration of the Magi. Archivolt: angels, apostles with instruments of their martyrdom, Stem of Jesse. Trumeau: Virgin and Child.
179 Jambs: (left) Annunciation, Elizabeth(?); (right) Aaron(?), Solomon, David. About or shortly after 1240

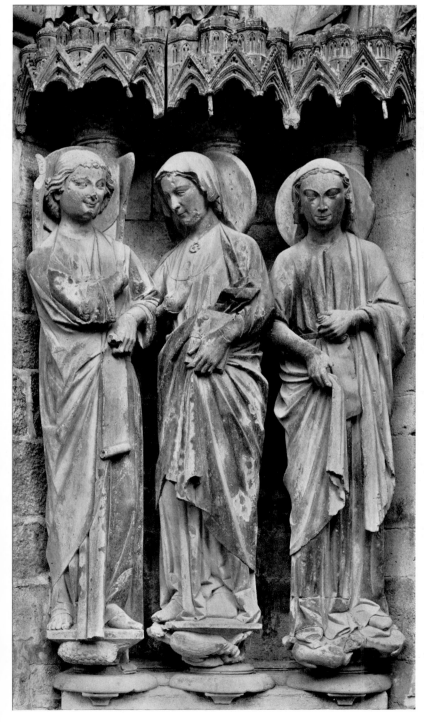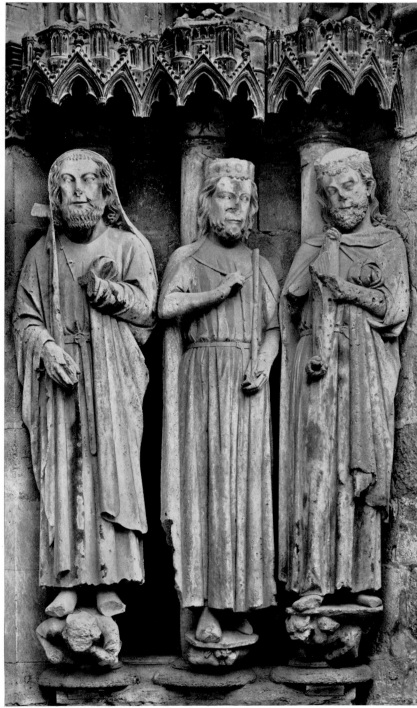

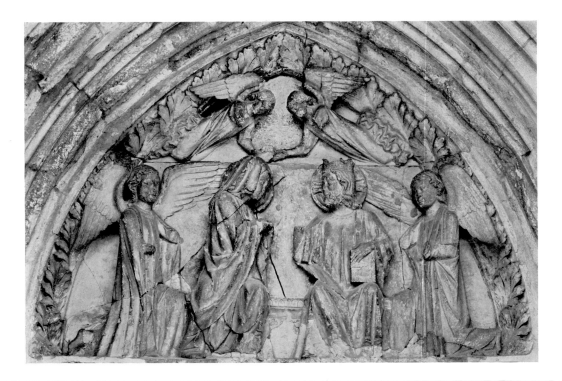

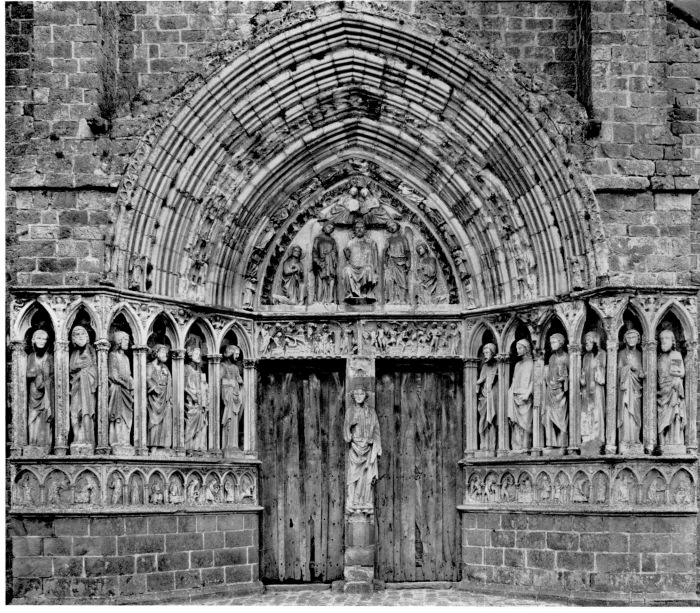

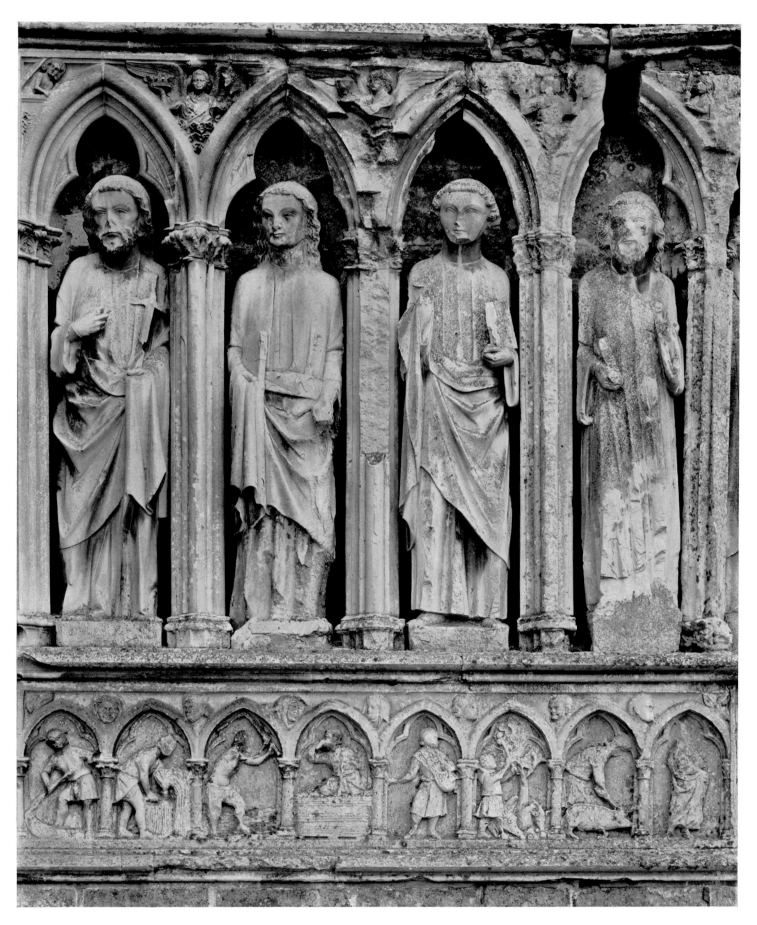

180, 181 Rampillon, Saint-Eliphe. 180 *Top.* South portal, tympanum: Coronation of the Virgin. About 1240.
Bottom. West portal, tympanum and lintel: Last Judgment. Jambs: apostles. Trumeau: St Elphius.
Socle: Calendar, with at one end the Presentation in the Temple, at the other the Adoration of the Magi.
181 Right jamb: apostles; (on the socle) Calendar. 1240–50

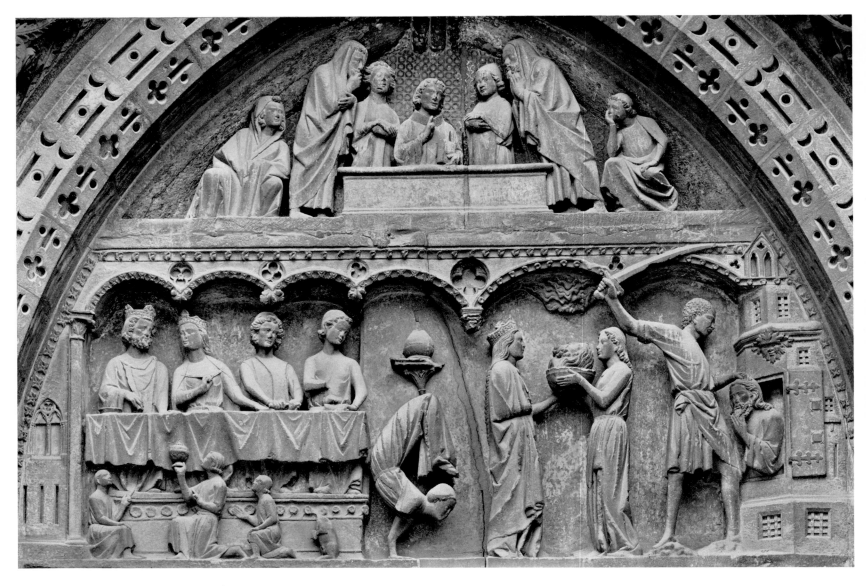

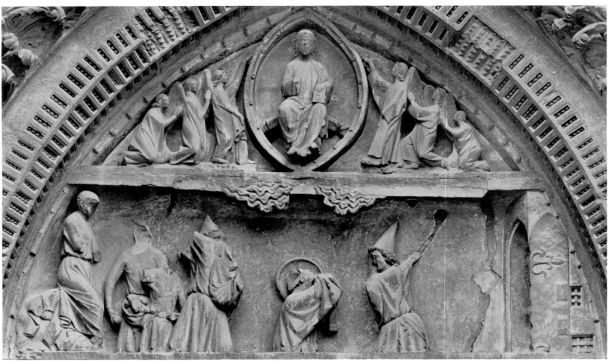

182 Rouen cathedral, west portal. *Top.* Left doorway, tympanum: Herod's banquet, dance of Salome, beheading and burial(?) of John the Baptist. *Bottom.* Right doorway, tympanum: stoning of St Stephen; (in the apex) Christ flanked by angels. About 1240

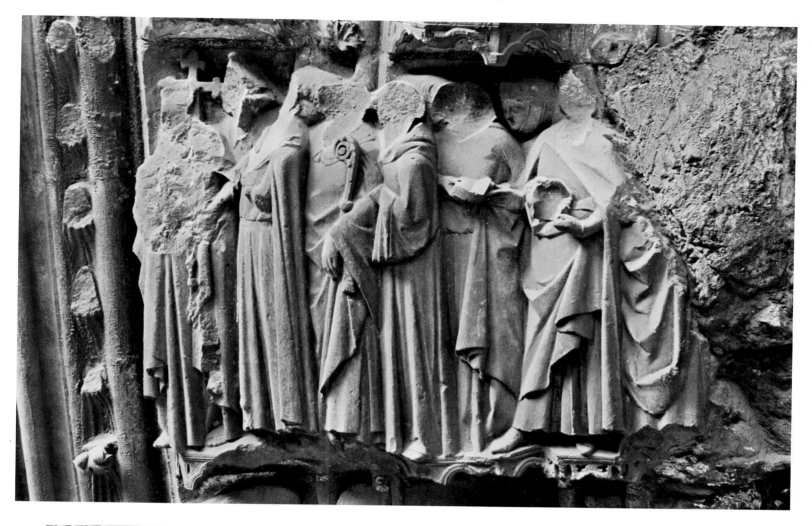

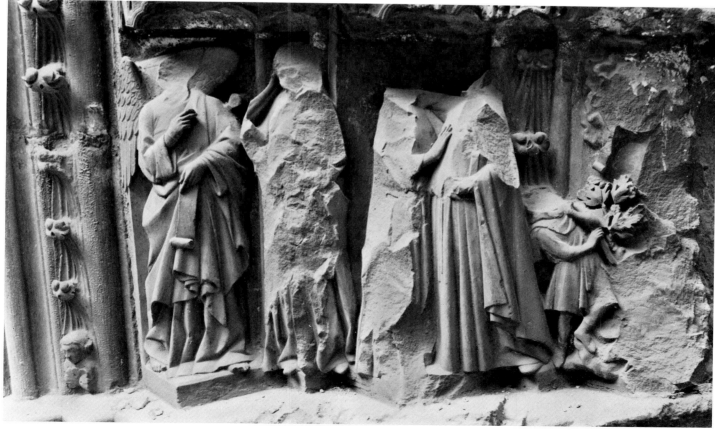

183 Saint-Denis, abbey church, south transept portal: archivolt figures.
Top. Procession of the Blessed(?). *Bottom*. Annunciation, Visitation, Annunciation to the Shepherds. 1240–50

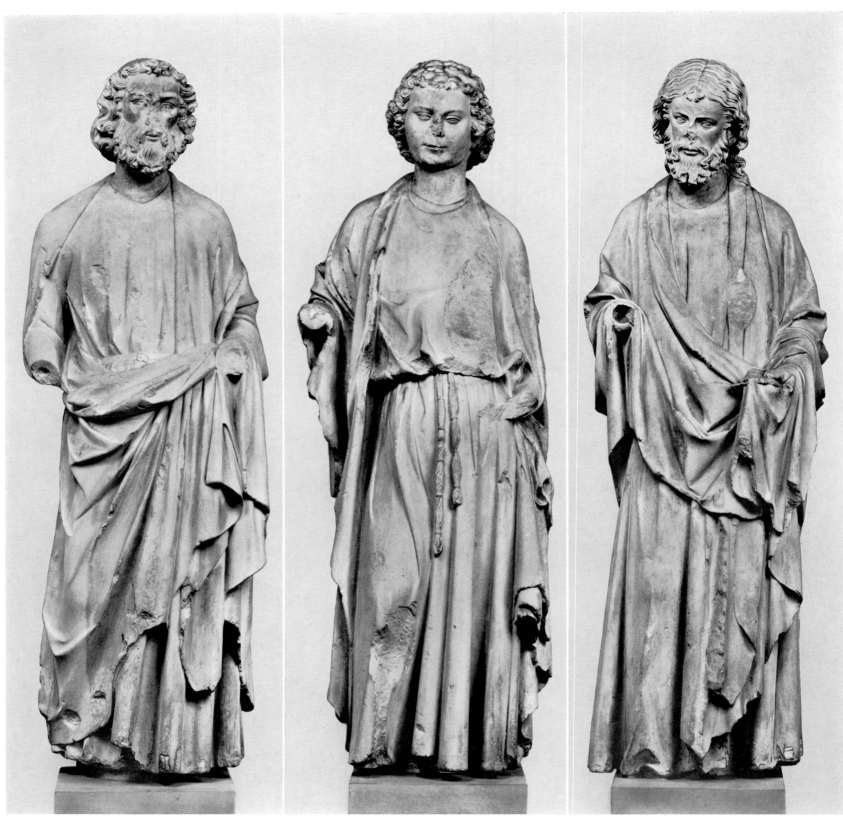

184 Three apostles, including John (centre), from the Sainte-Chapelle, Paris. Between 1241 and 1248.
(Paris, Musée de Cluny)

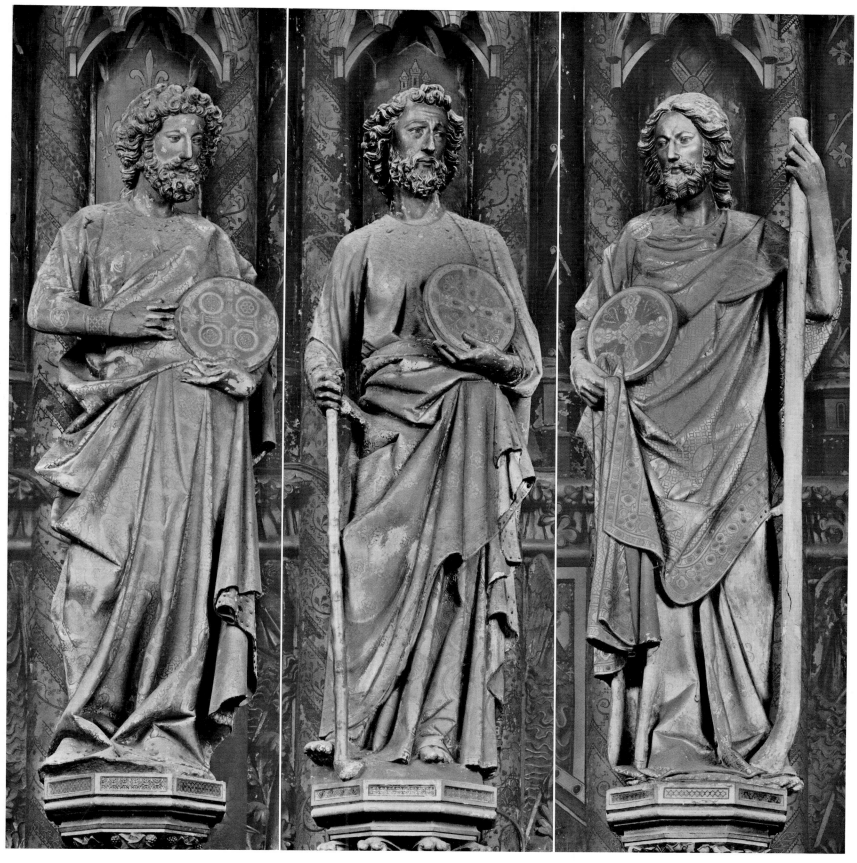

185 Paris, Sainte-Chapelle, upper chapel. Three apostles, including James the Less (right).
Between 1241 and 1248

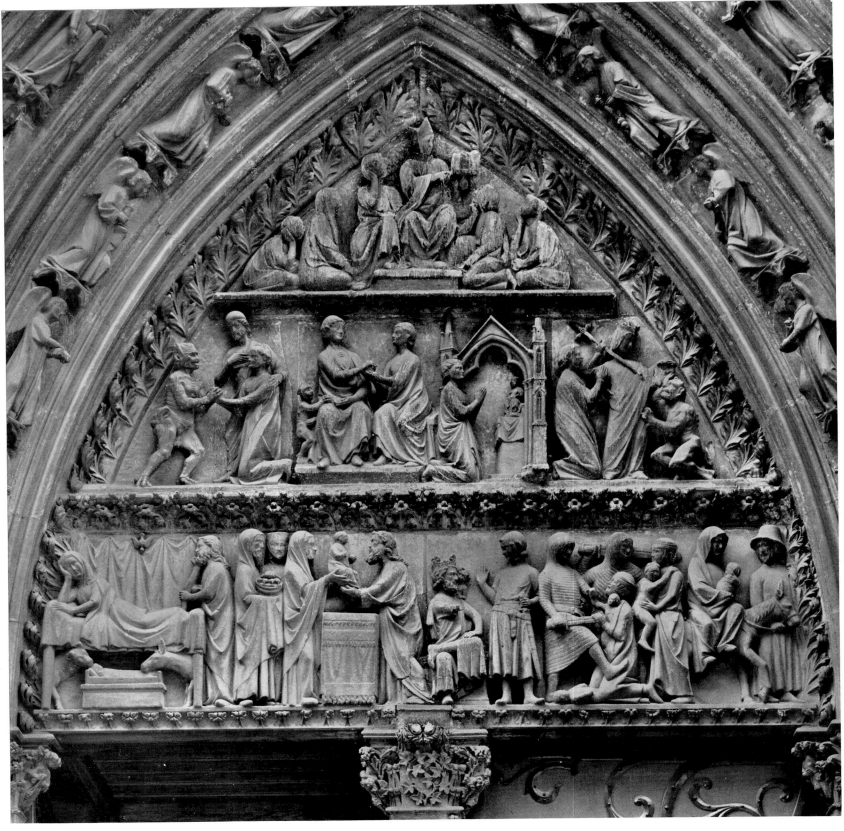

186 Paris, Notre Dame, north transept portal, tympanum. Bottom register: Nativity, Presentation in the Temple, Massacre of the Innocents, Flight into Egypt. Middle register: Theophilus sells his soul to the Devil, distributes largesse, prays before an image of the Virgin, who (far right) banishes the Devil. Top register: the bishop displays the Devil's pact to the populace. About 1250

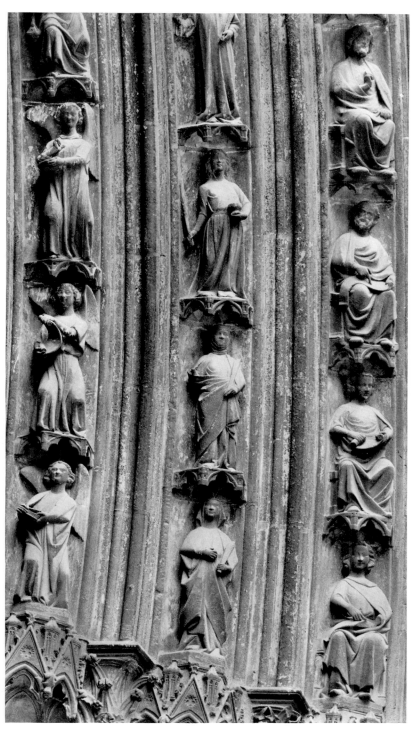

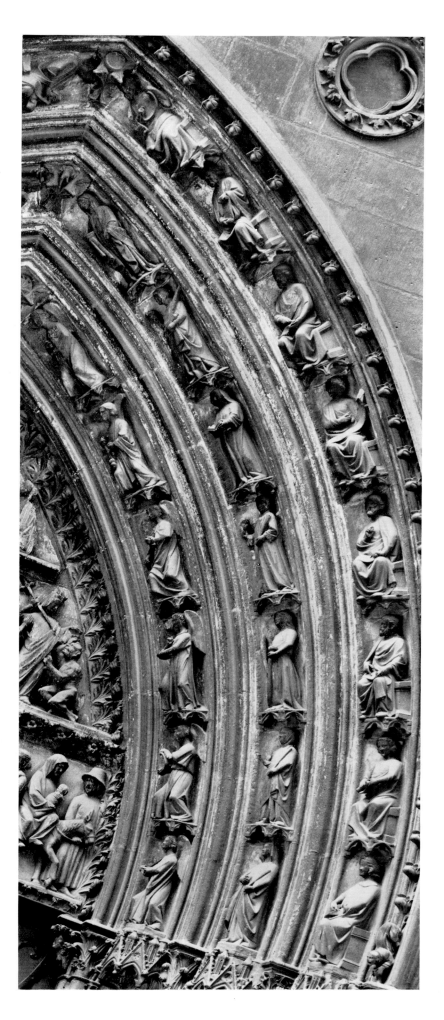

187 Paris, Notre Dame, north transept portal.
Right archivolt: angels, female figures, enthroned male figures. About 1250

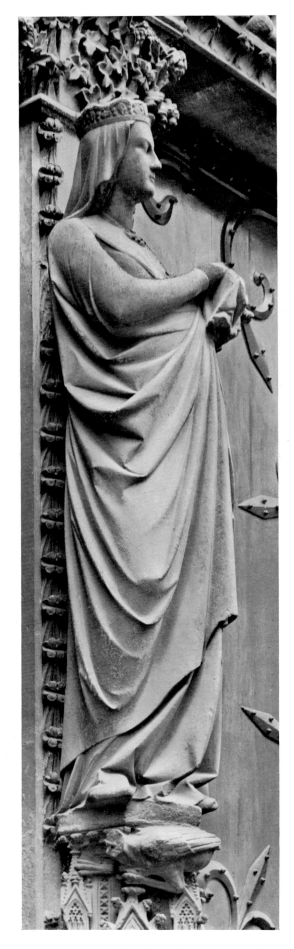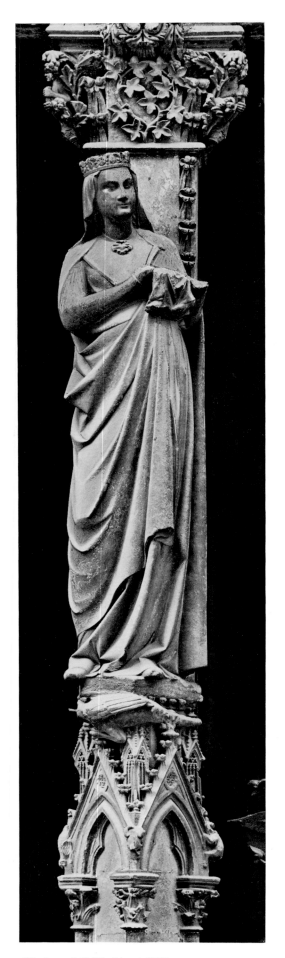

188 Paris, Notre Dame, north transept portal. Trumeau: Virgin and Child. About 1250

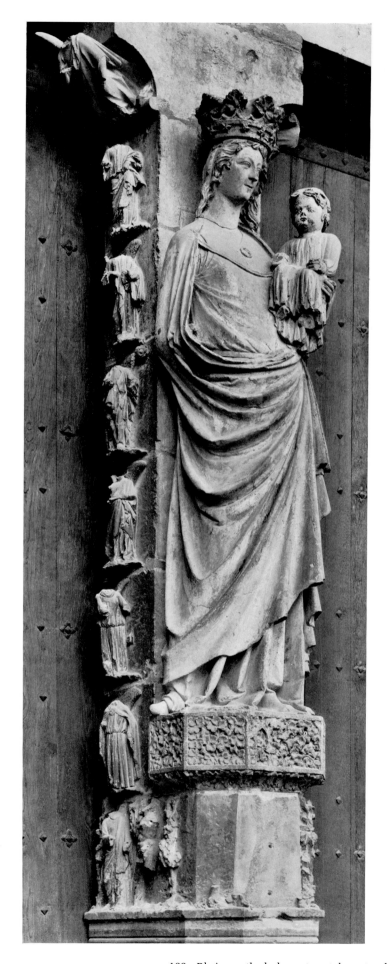
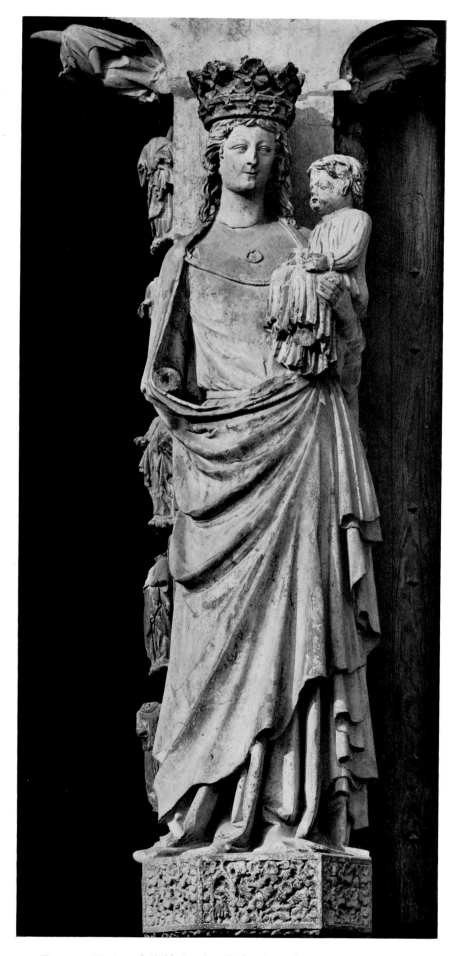

189 Rheims cathedral, west portal, centre doorway. Trumeau: Virgin and Child; (on the side faces) angels.
Approx. 1245–55 and (Child and crown) 1617

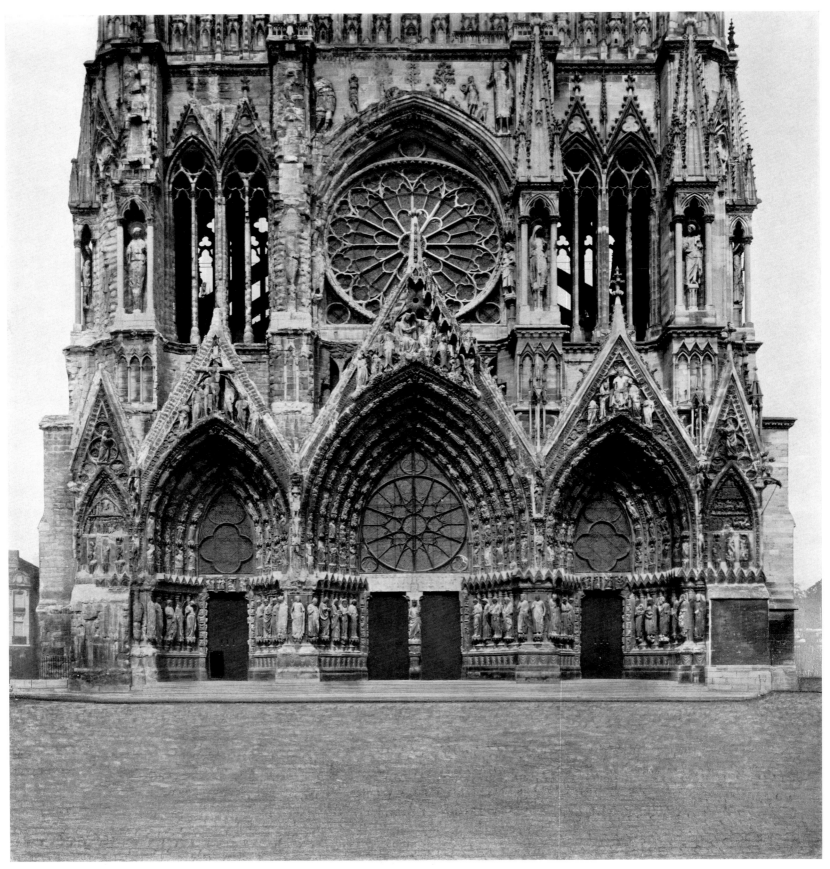

190 Rheims cathedral, west façade

191 Rheims cathedral, west portal, centre doorway. In the gable: Coronation of the Virgin. Approx. 1245–55

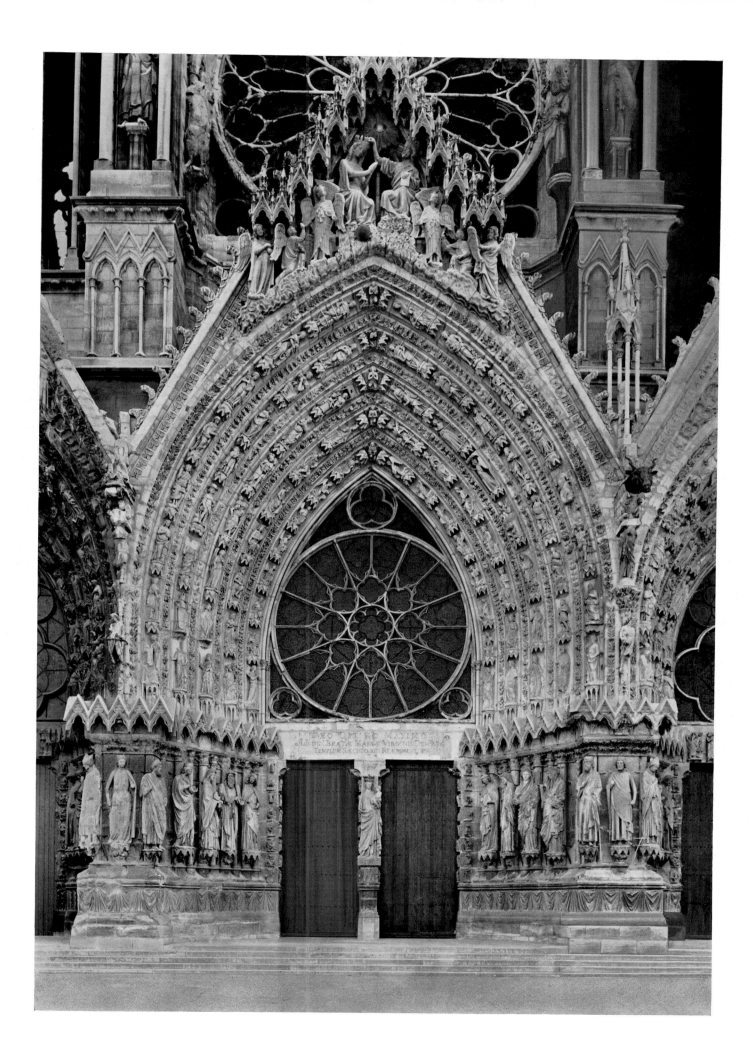

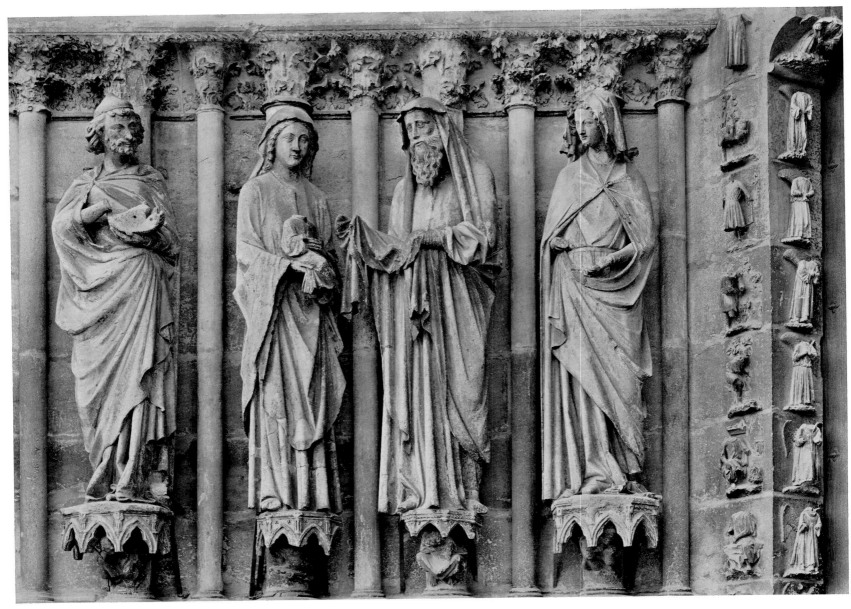

192 Rheims cathedral, west portal, centre doorway.
Left jamb: Presentation in the Temple, with (from the left) Joseph, Mary, Simeon, Mary's maidservant.
Doorpost: outer face, Calendar; inner face, praying angels. Installed approx. 1245–55

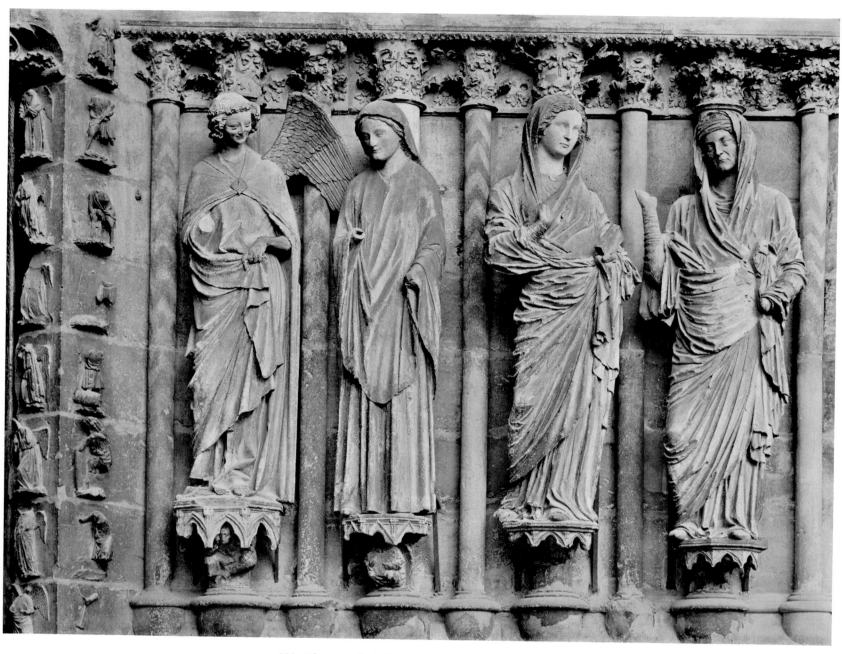

193 Rheims cathedral, west portal, centre doorway.
Right jamb: Annunciation and Visitation. Doorpost: outer face, Calendar, inner face, praying angels.
Installed approx. 1245–55

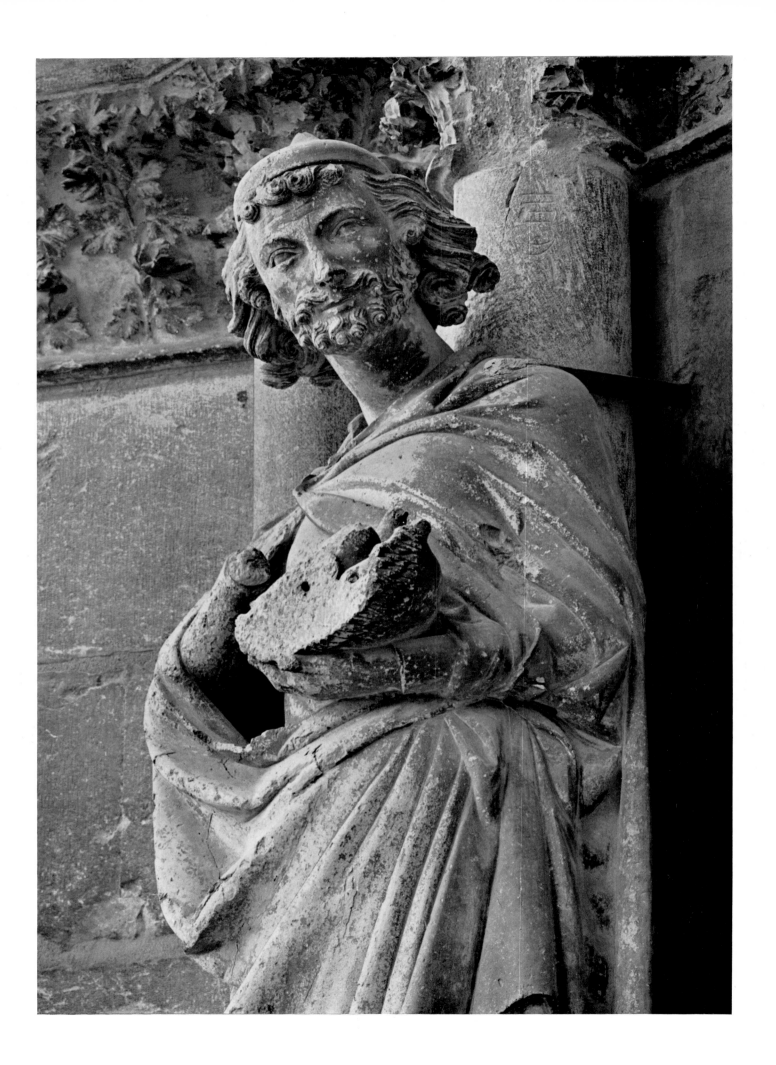

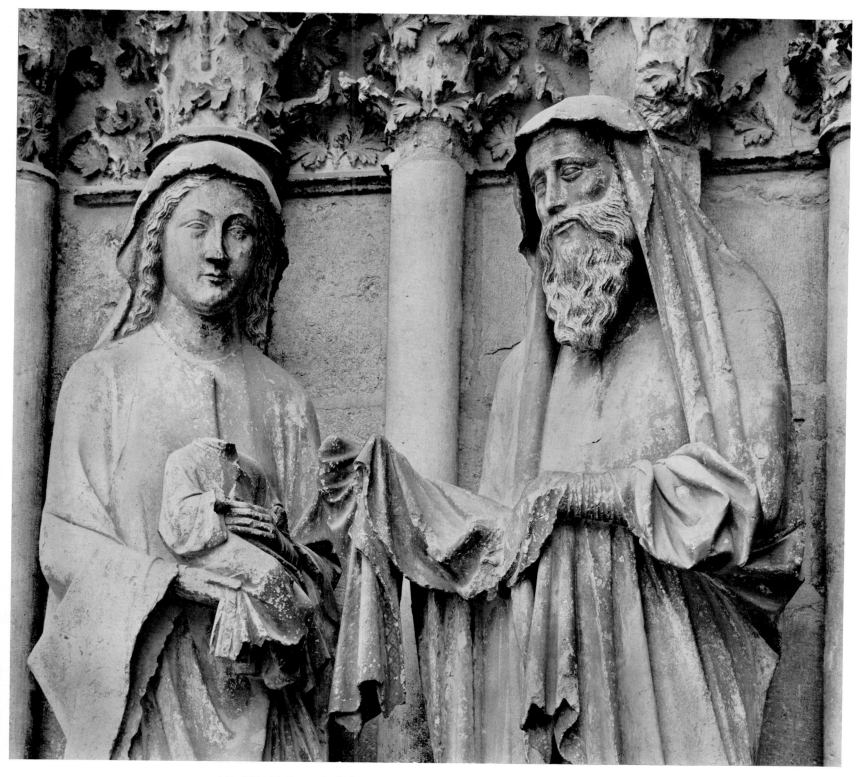

194, 195 Rheims cathedral, west portal, centre doorway. Figures from the left jamb.
194 Joseph. Approx. 1245–55. 195 Mary and Simeon. Approx. 1230–33

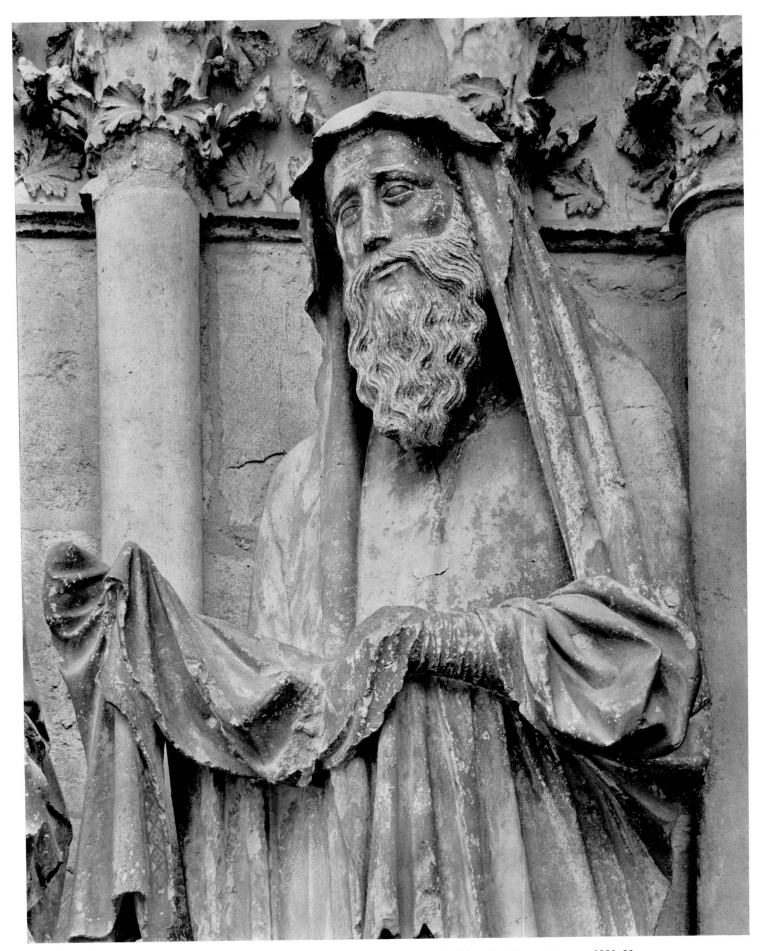

196 Rheims cathedral, west portal, centre doorway. From the left jamb: Simeon. Approx. 1230–33

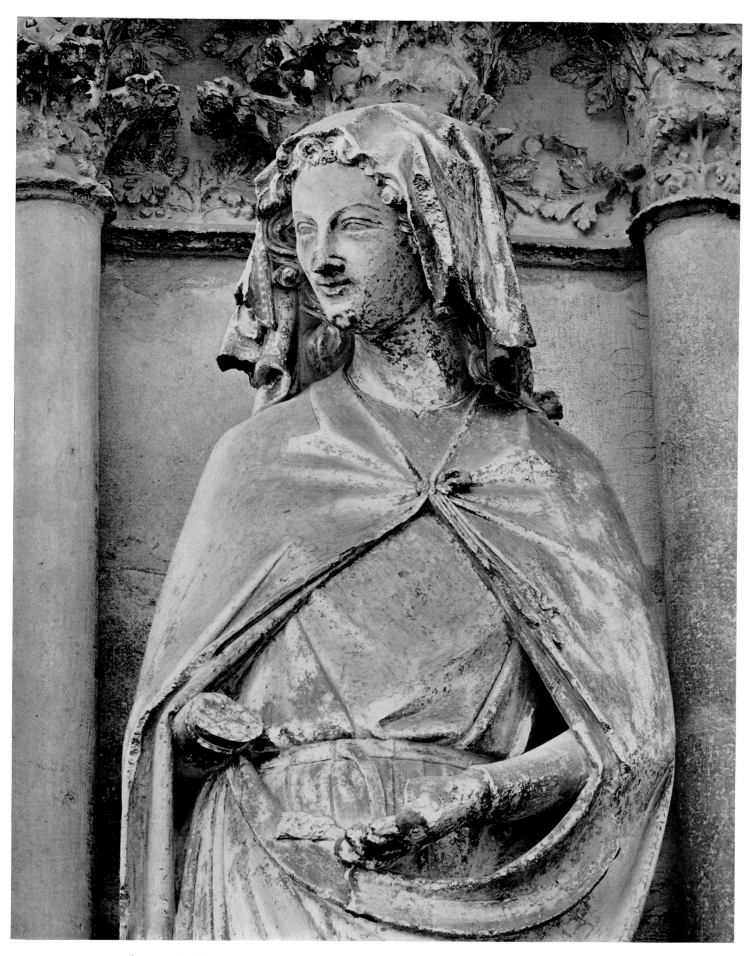

197 Rheims cathedral, west portal, centre doorway. From the left jamb: Mary's maidservant. Approx. 1245–55

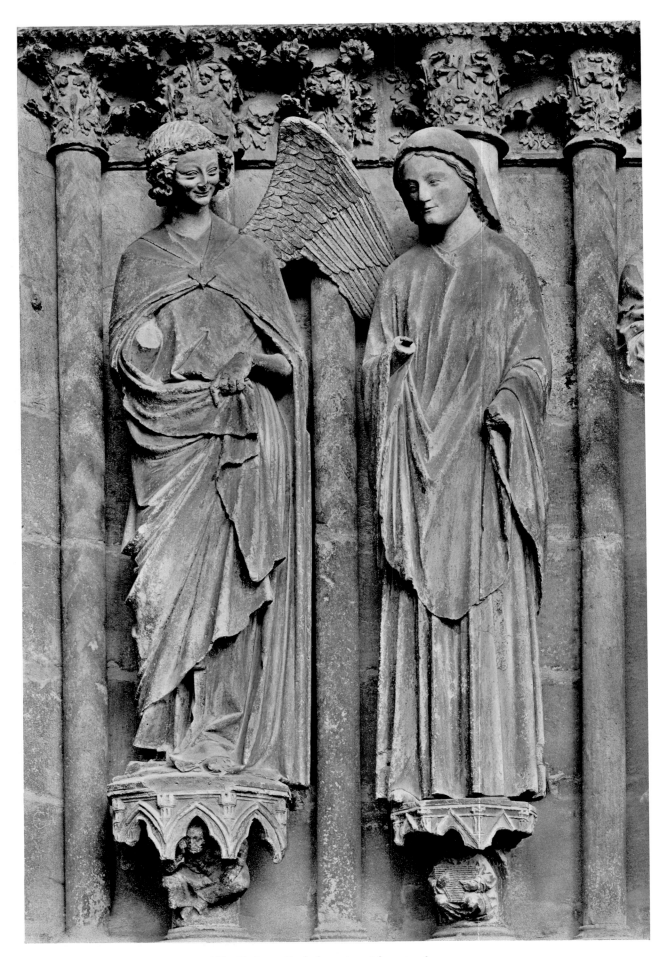

198 Rheims cathedral, west portal, centre doorway.
From the right jamb: Annunciation. Angel approx. 1245–55; Virgin approx. 1230–33

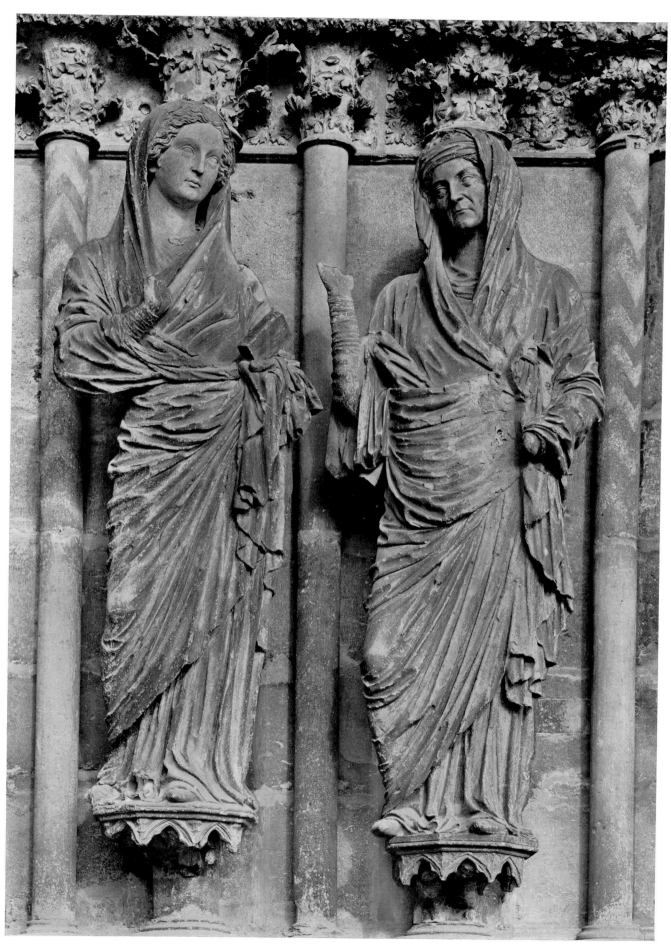

199 Rheims cathedral, west portal, centre doorway.
From the right jamb: Visitation. Approx. 1230–33

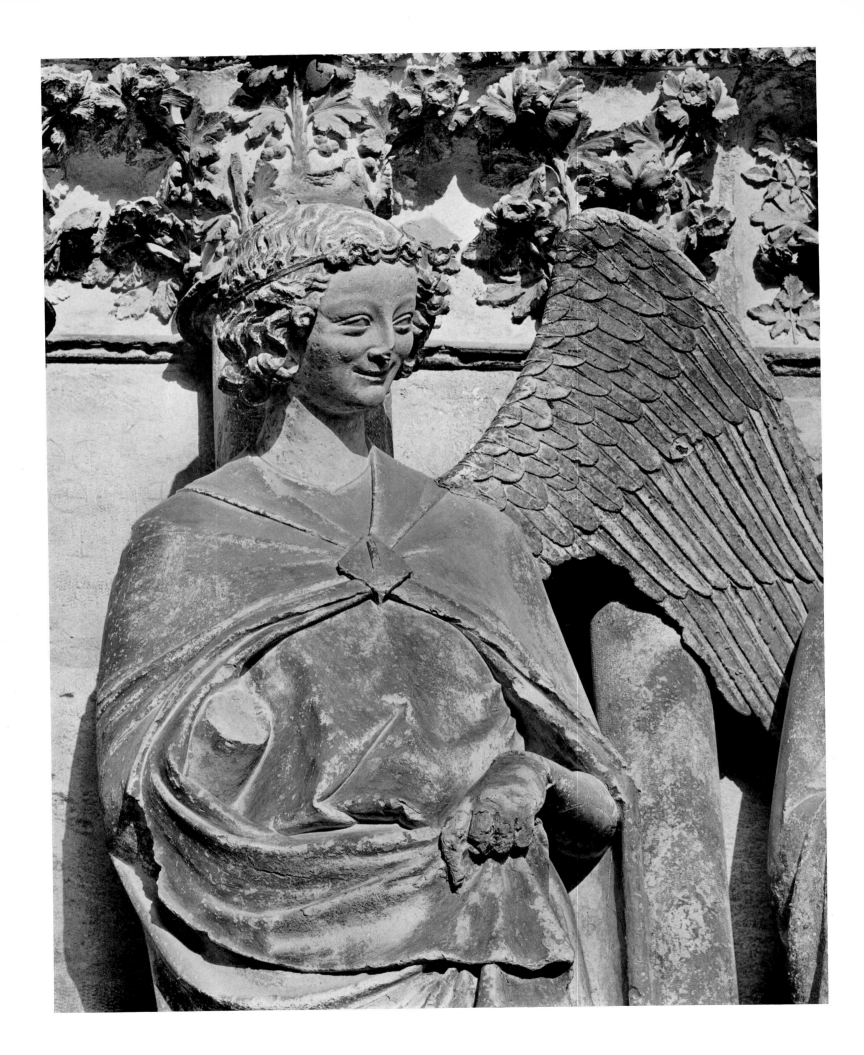

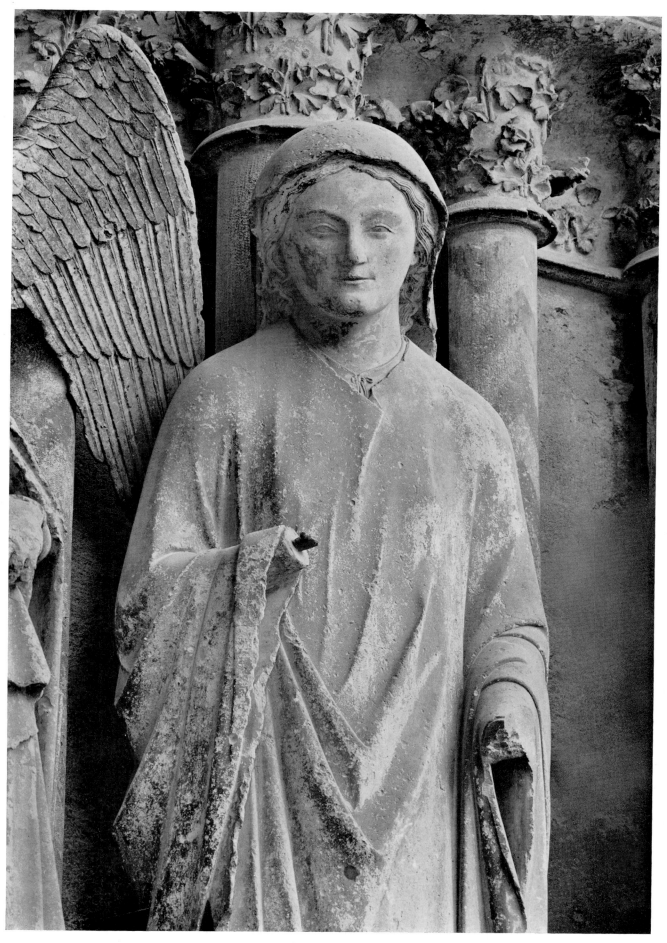

200, 201 Rheims cathedral, west portal, centre doorway.
From the right jamb: details of the angel and Virgin of the Annunciation group. Angel approx. 1245–55; Virgin approx. 1230–33

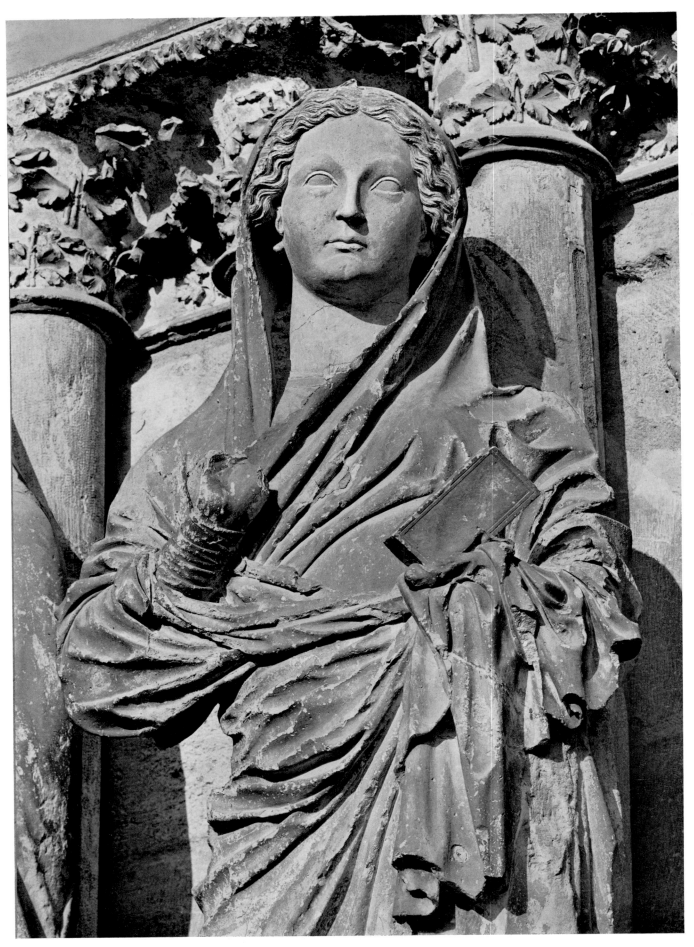

202, 203 Rheims cathedral, west portal, centre doorway.
From the right jamb: details of Mary and Elizabeth from the Visitation group. Approx. 1230–33

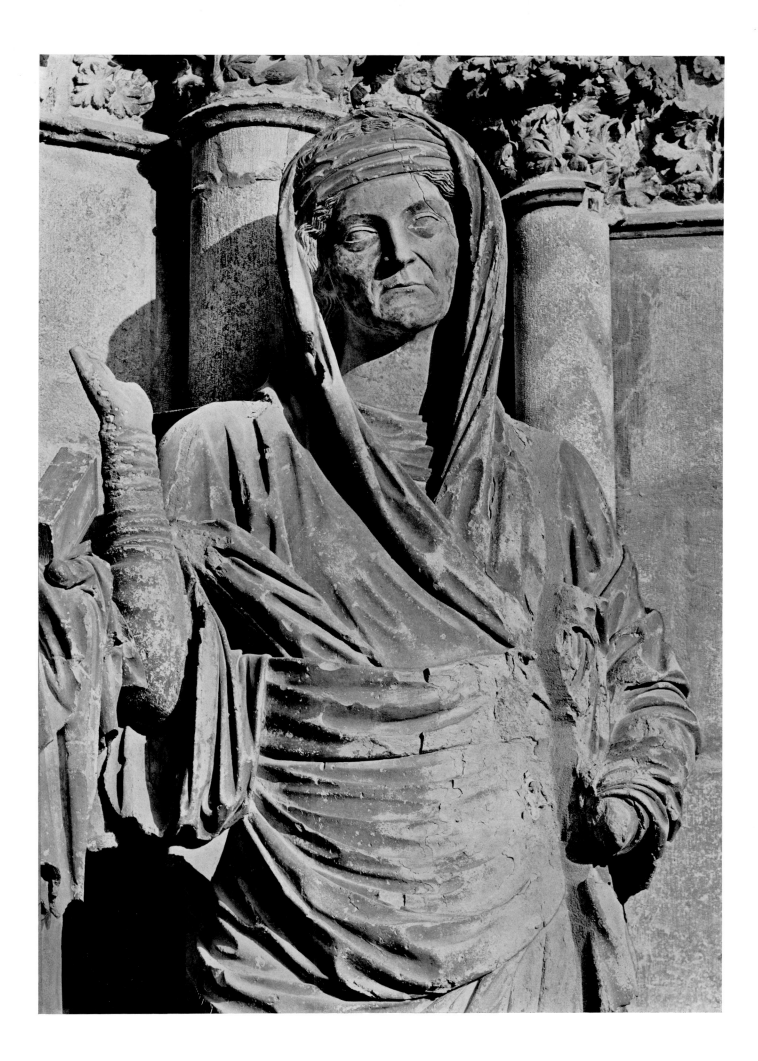

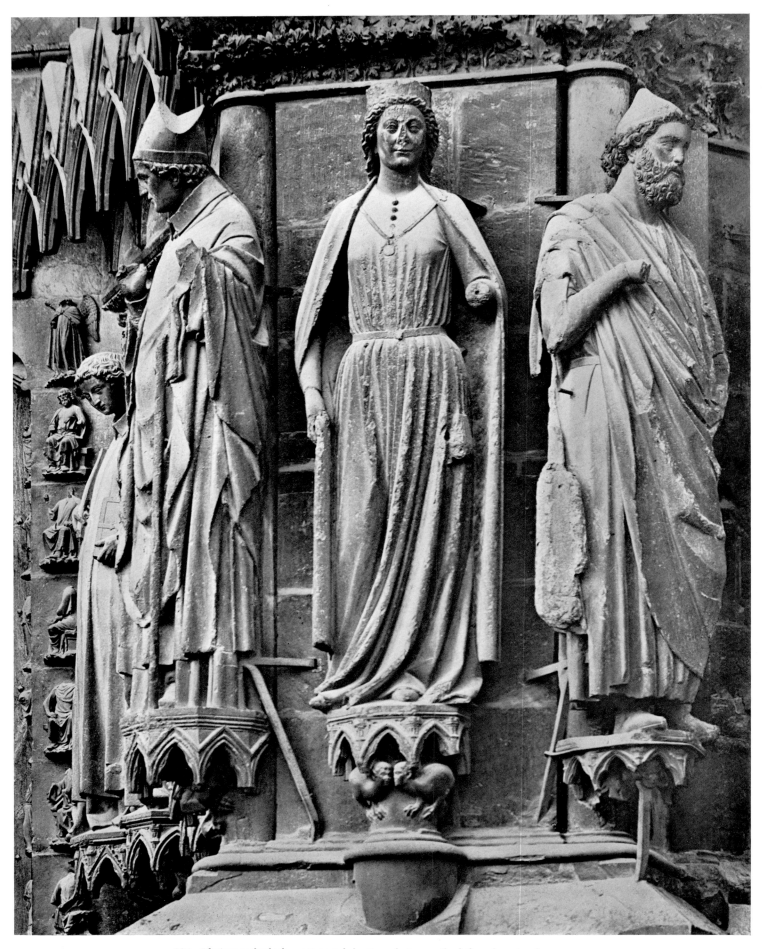

204 Rheims cathedral, west portal, buttress between the left and centre doorways.
Figures of a bishop, Queen of Sheba, and a prophet ('man with the Odysseus head'), possibly Isaiah. Approx. 1230–33

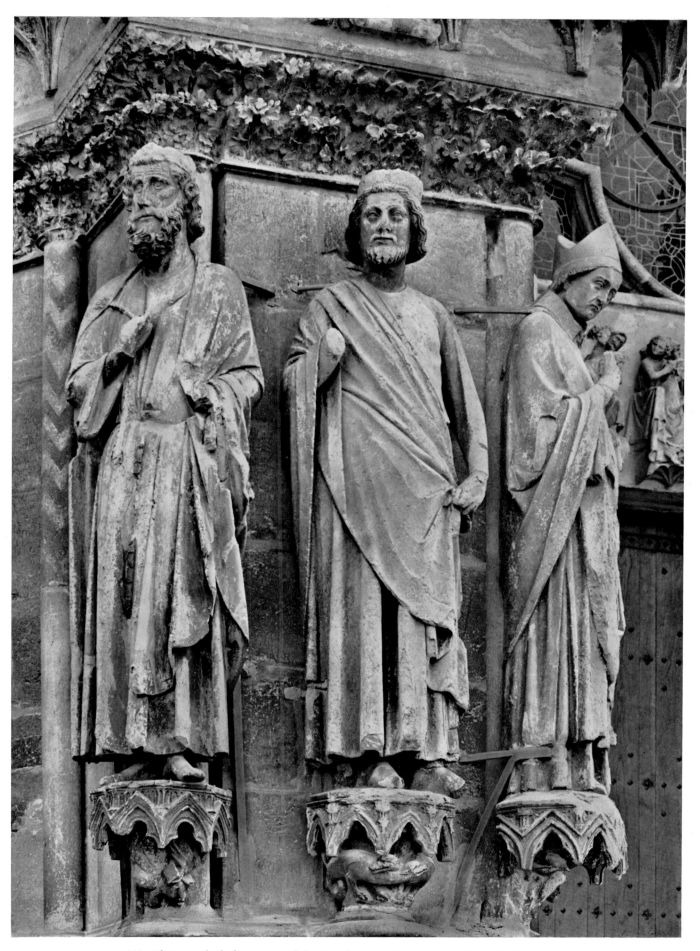

205 Rheims cathedral, west portal, buttress between the centre and the right doorways.
Figures of David(?), Solomon, and a bishop. Approx. 1230–33

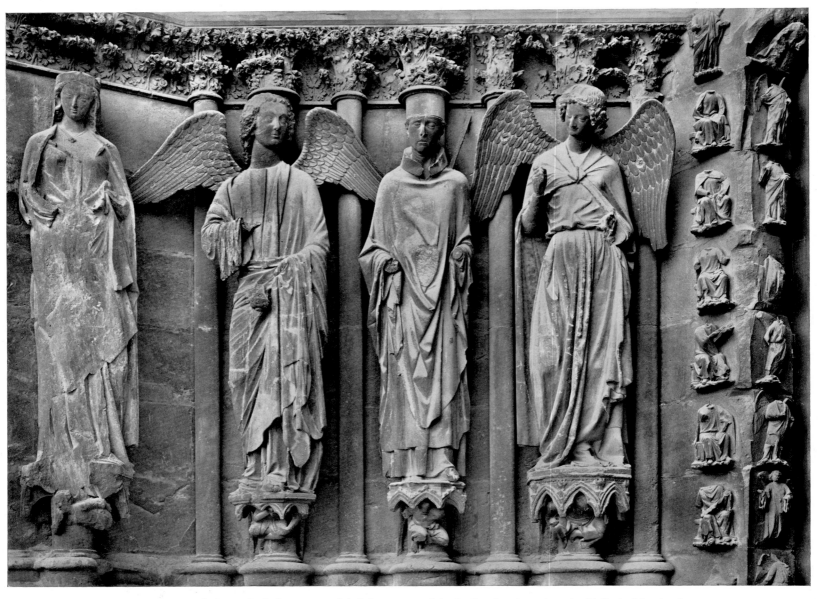

206 Rheims cathedral, west portal, left doorway. Left jamb: female saint, Dionysius(?) flanked by angels. Doorpost: (outer face) enthroned male figures; (inner face) angels. Approx. 1230–33 and 1245–55

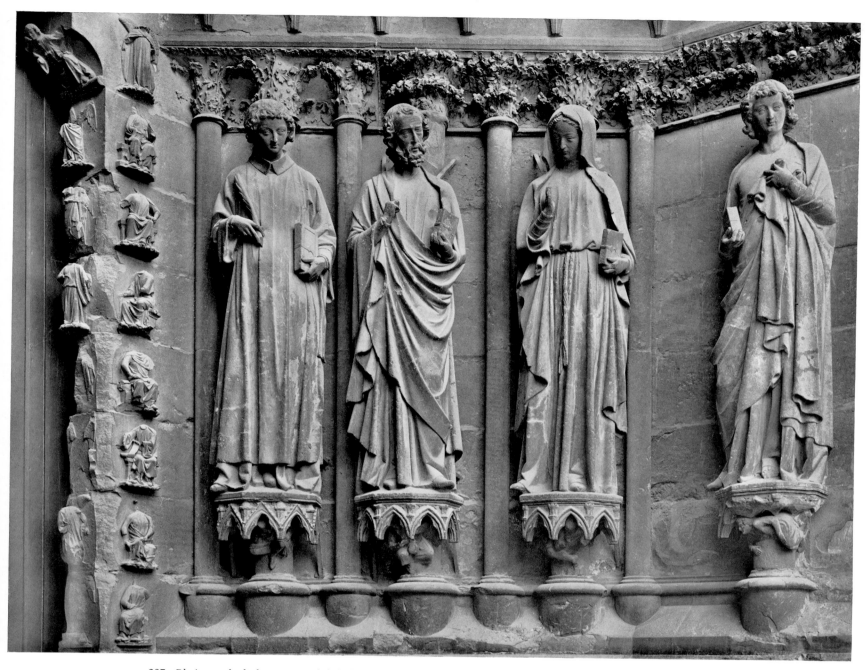

207 Rheims cathedral, west portal, left doorway. Right jamb: saints, on the right probably John the Evangelist.
Doorpost: (outer face) enthroned male figures; (inner face) angels. Approx. 1245–55

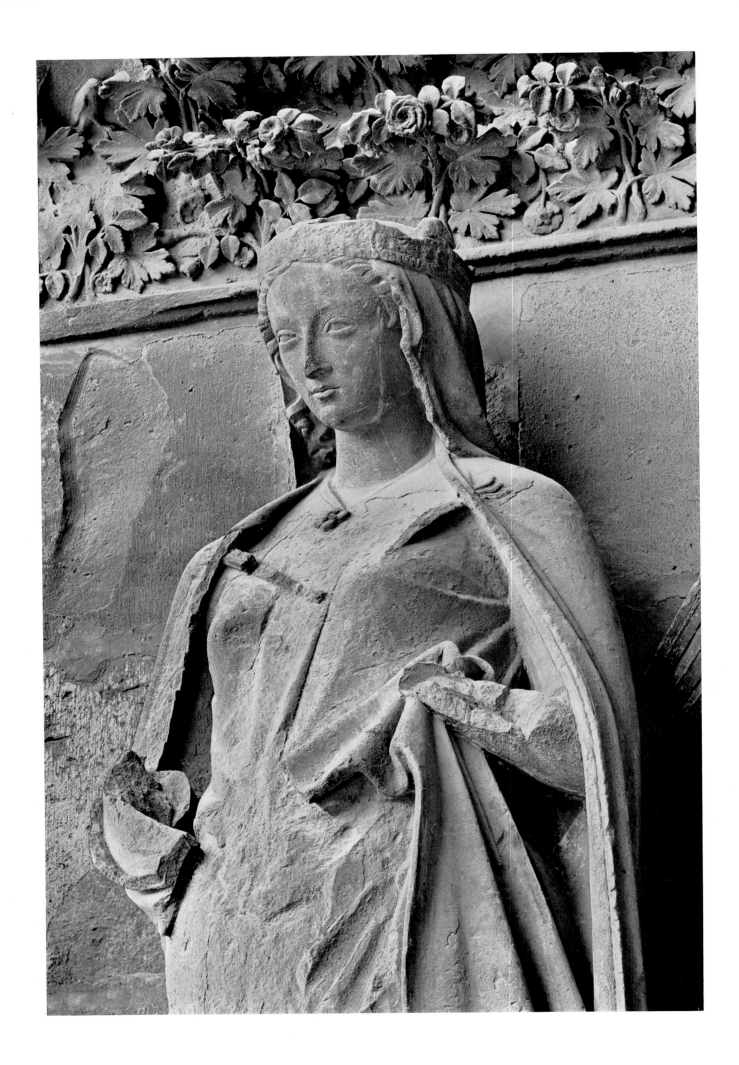

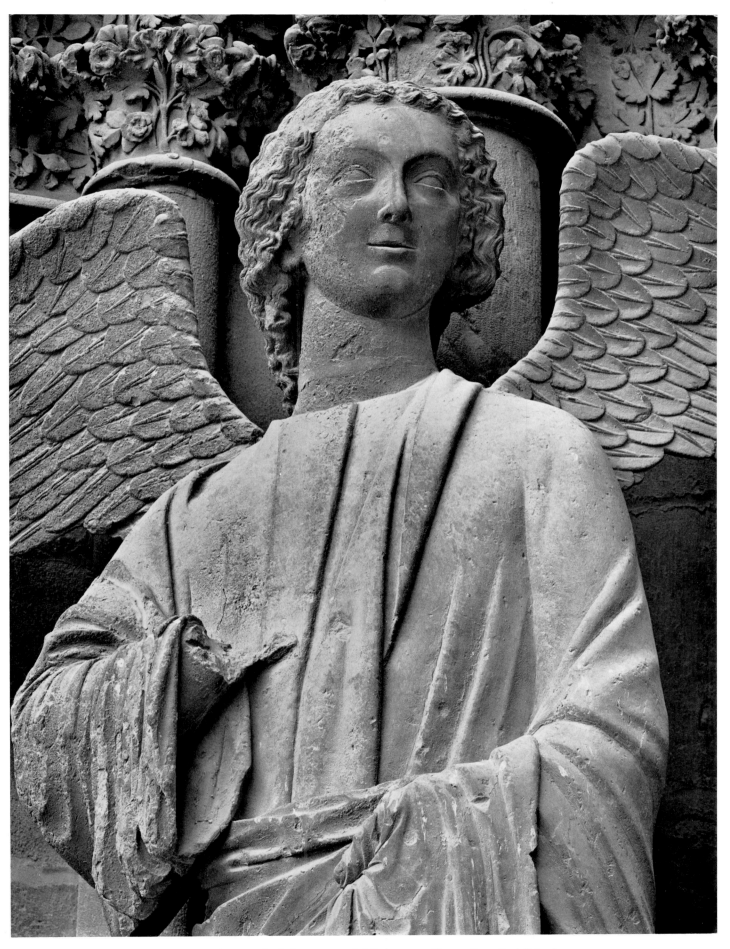

208, 209 Rheims cathedral, west portal, left doorway. Figures from the left jamb.
208 Female saint. Approx. 1245–55.
209 Angel. Approx. 1230–33

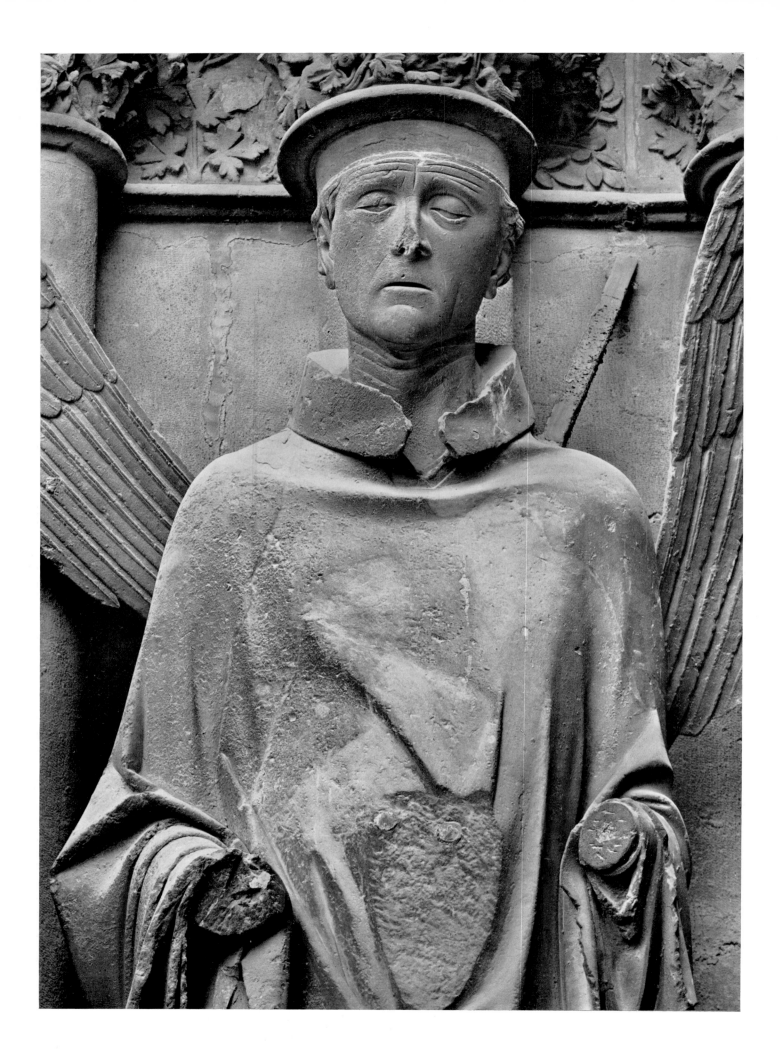

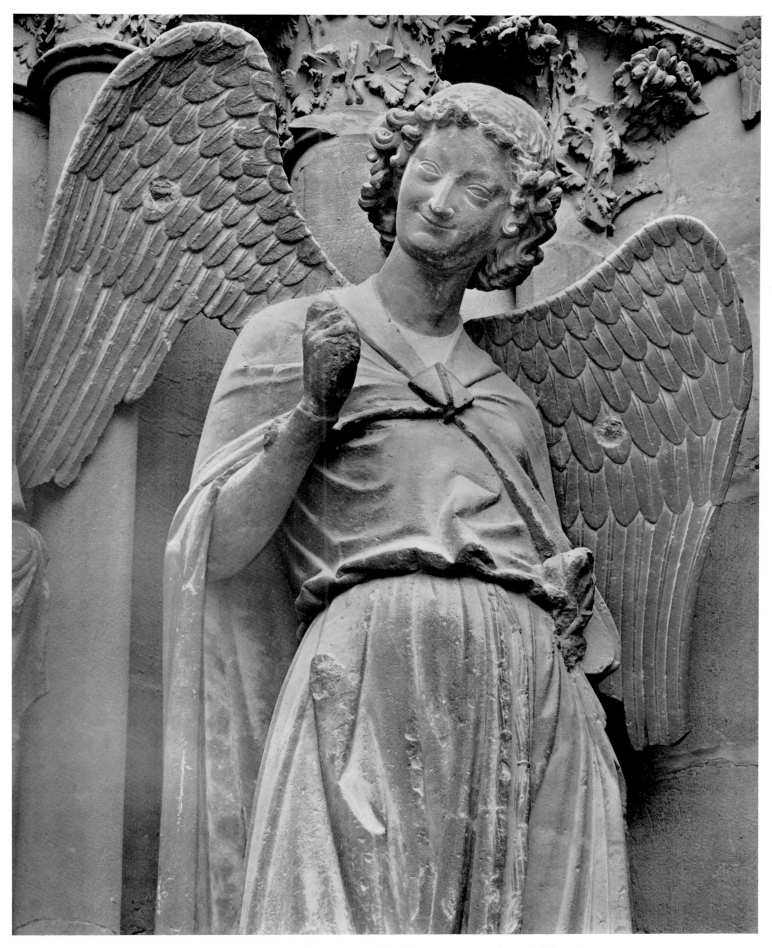

210, 211 Rheims cathedral, west portal, left doorway. Figures from the left jamb.
210 St Dionysius(?). Approx. 1230–33.
211 Angel. Approx. 1245–55

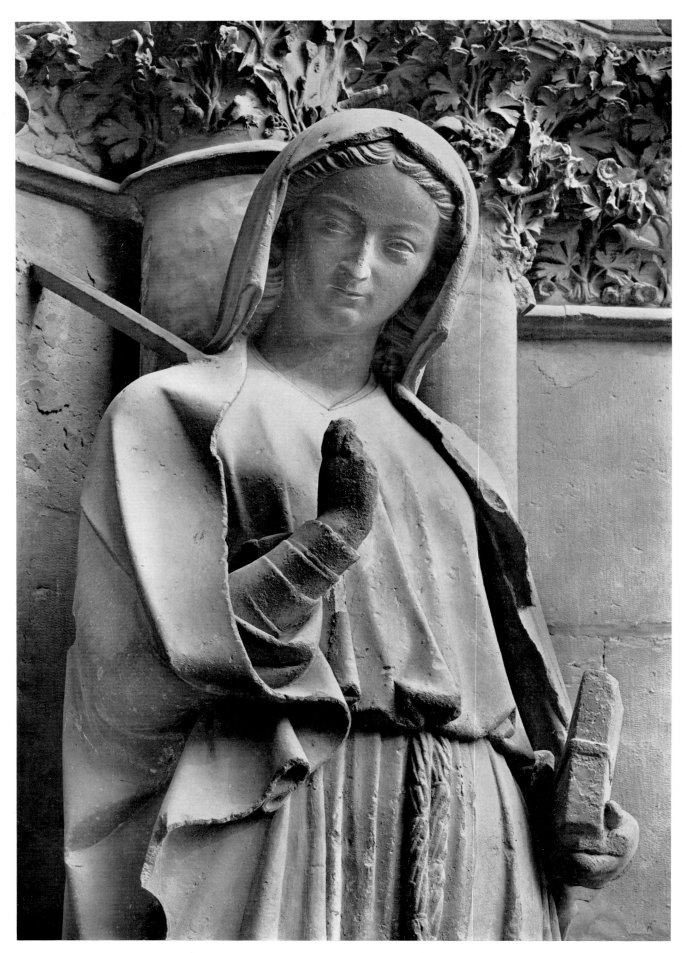

212 Rheims cathedral, west portal, left doorway. From the right jamb: female saint. Approx. 1245–55

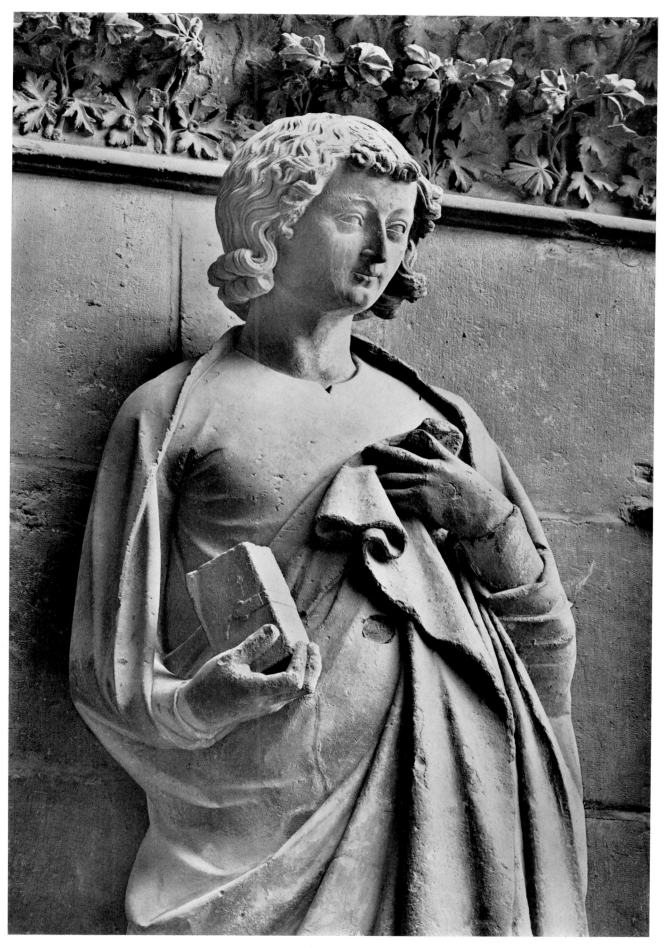

213 Rheims cathedral, west portal, left doorway. From the right jamb: John the Evangelist(?). Approx. 1245–55

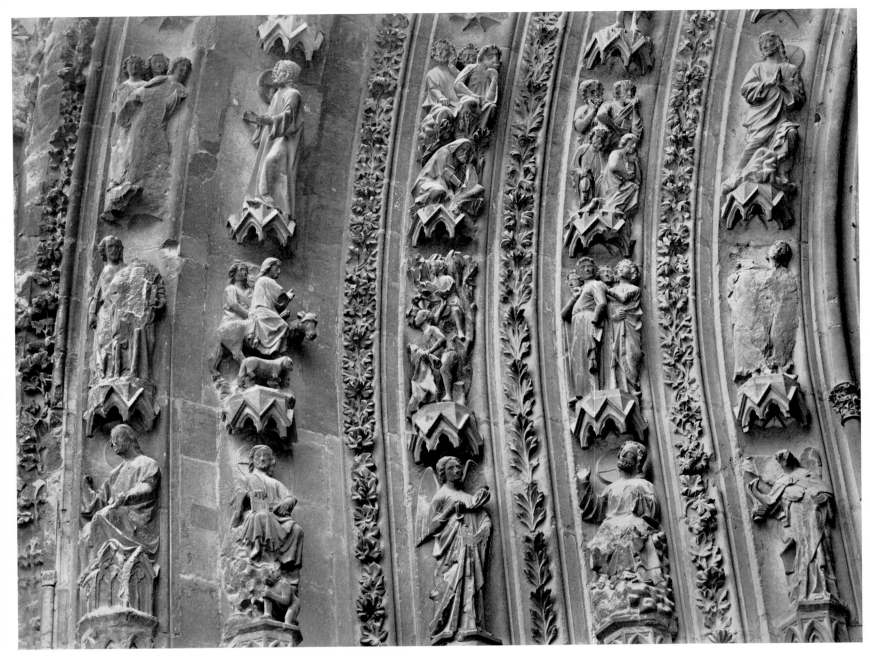

214 Rheims cathedral, west portal, left doorway.
Left archivolt: (bottom register) Temptation of Christ; (middle register) Entry into Jerusalem;
(top register) Christ on the Mount of Olives. Approx. 1245–55

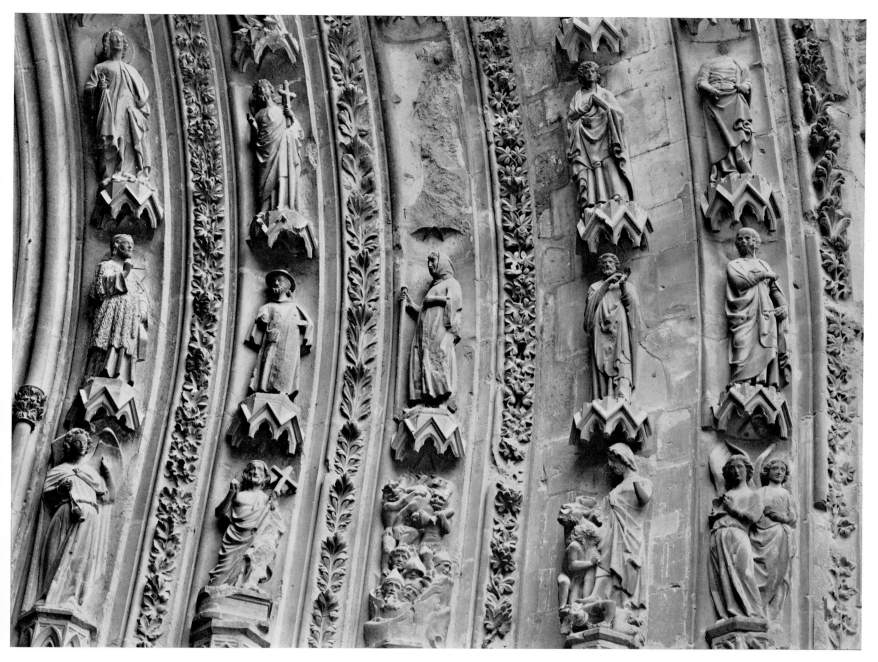

215 Rheims cathedral, west portal, left doorway.
Right archivolt: (bottom register) Christ in Limbo, Hell scene, Resurrection, angel with censer; (middle register) Emmaus;
(top register) Christ with disciples (the four apostles top right have been renewed). Approx. 1245–55

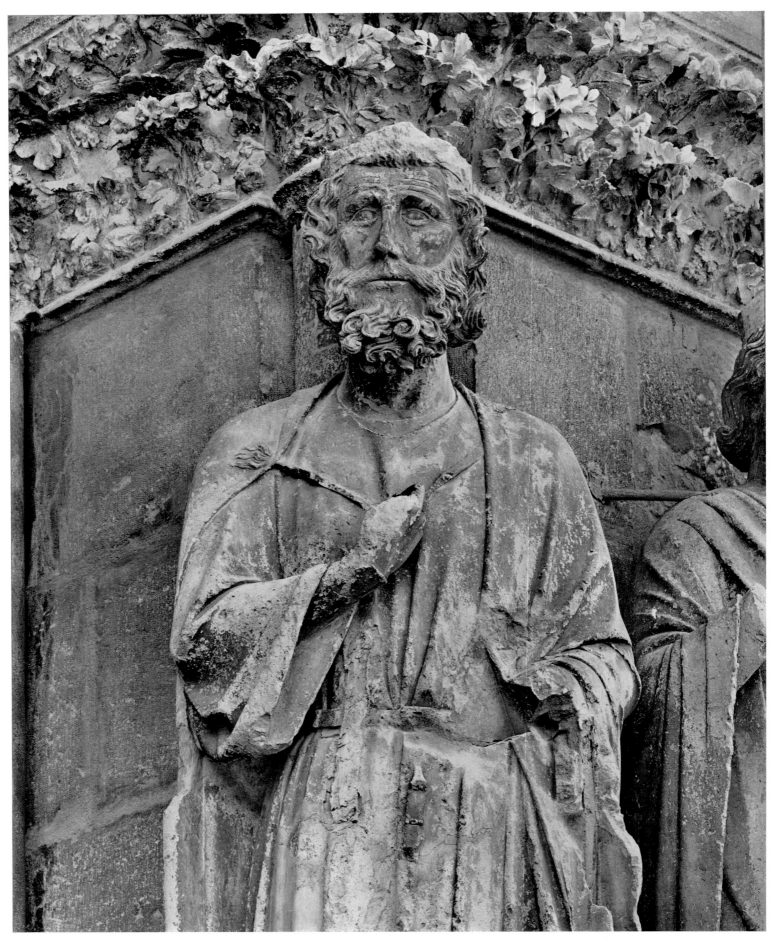

216 Rheims cathedral, west portal. From the buttress between centre and right doorways: David(?).
Approx. 1230–33

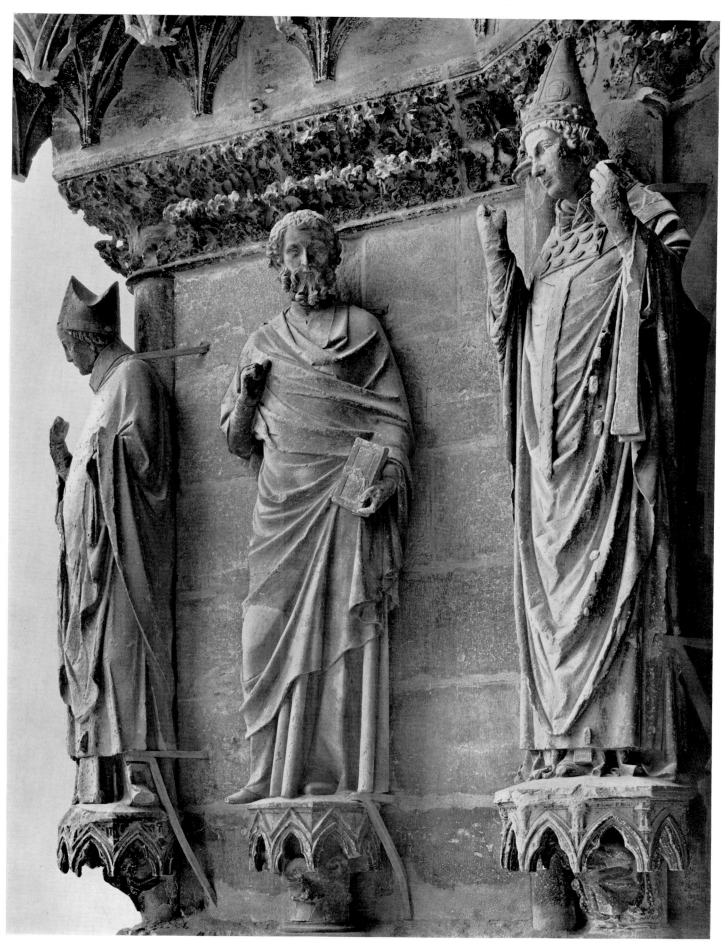

217 Rheims cathedral, west portal, right doorway. Detail of left jamb: bishop, approx. 1230–33;
male figure, approx. 1245–55; Pope Calixtus, approx. 1230–33

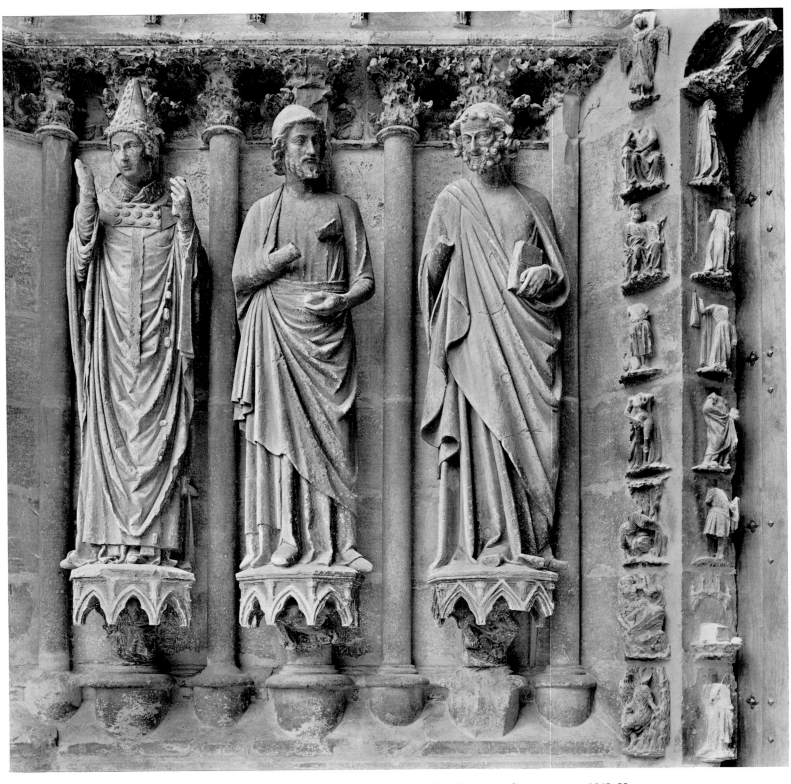

218 Rheims cathedral, west portal, right doorway. Left jamb: Pope Calixtus, approx. 1245–55.
On the doorpost: Virtues and Vices, and unidentified figures. Approx. 1245–55

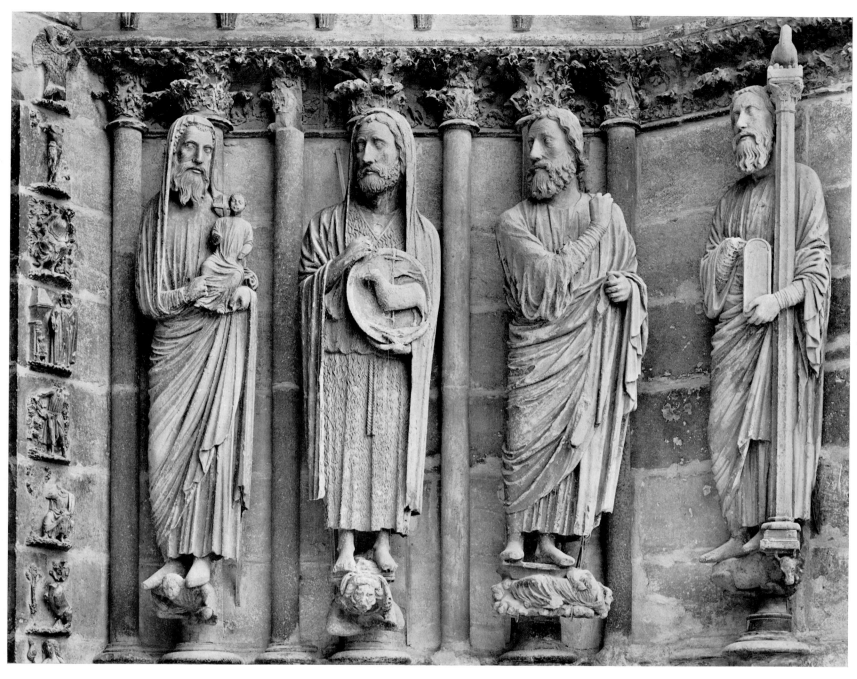

219 Rheims cathedral, west portal, right doorway. Right jamb: Simeon, John the Baptist, Isaiah, Moses. About 1220.
On the doorpost: unidentified secular scenes. Approx. 1245–55

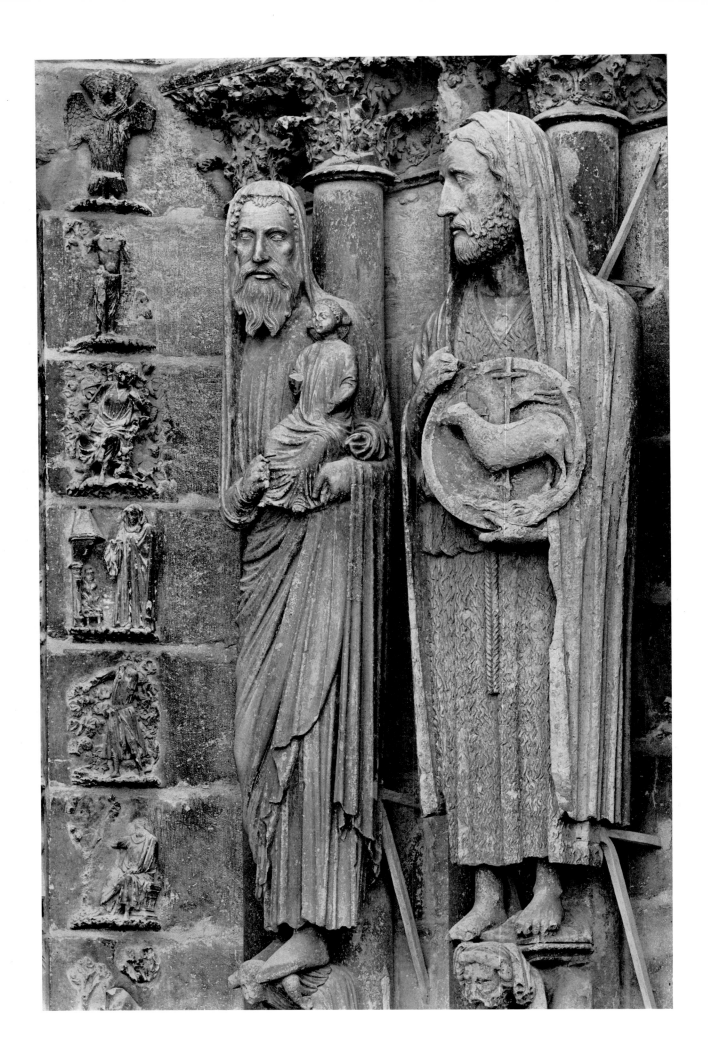

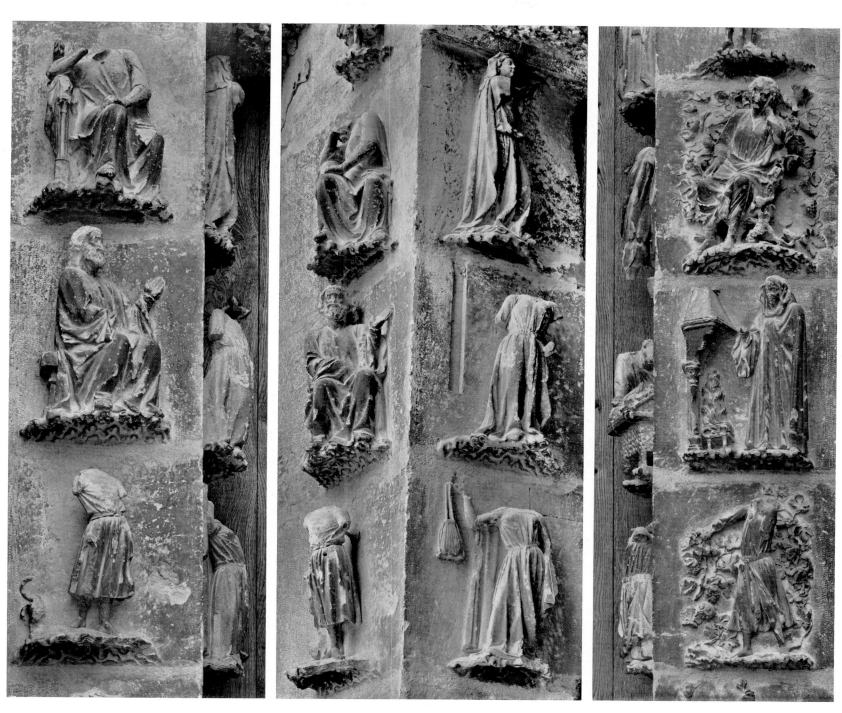

220, 221 Rheims cathedral, west portal, right doorway.
220 From the right jamb: Simeon, John the Baptist. About 1220. On the doorpost: unidentified secular scenes.
221 *Left and middle.* From the left doorpost: on the outside, Ages of Man(?); inside, Virtues(?); at the top, Largitas(?);
at the bottom, Spes(?). *Right.* From the right doorpost: unidentified scenes. Approx. 1245–55

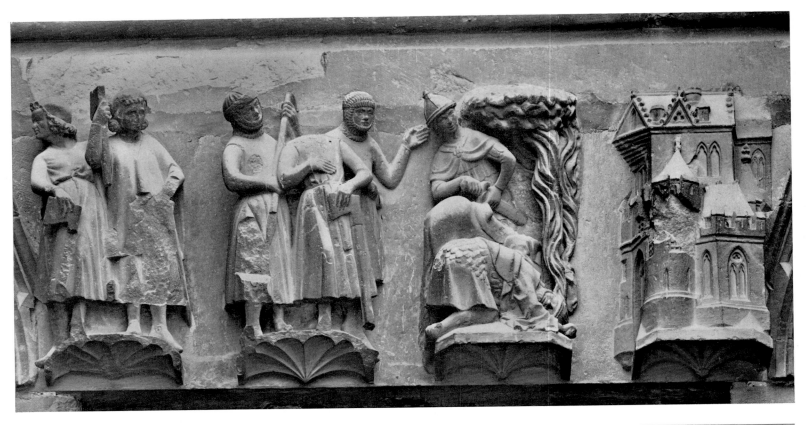

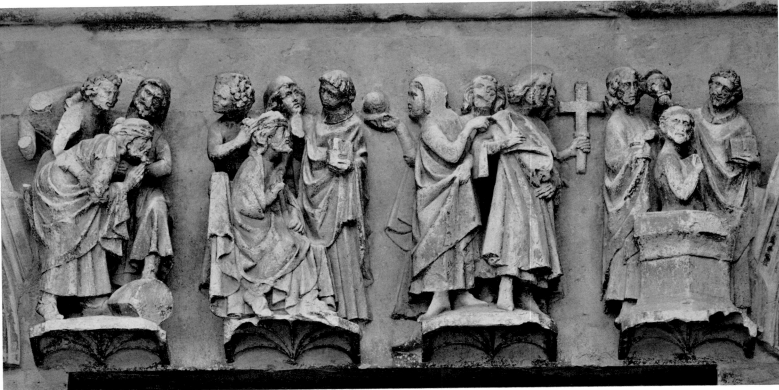

222 Rheims cathedral, west portal. *Top*. From the lintel of the left doorway: conversion of Saul.
Bottom. From the lintel of the right doorway: baptism of Paul. Approx. 1245–55

223 Rheims cathedral, west portal, right doorway. Detail of archivolt: scenes from the Apocalypse.
Approx. 1245–55

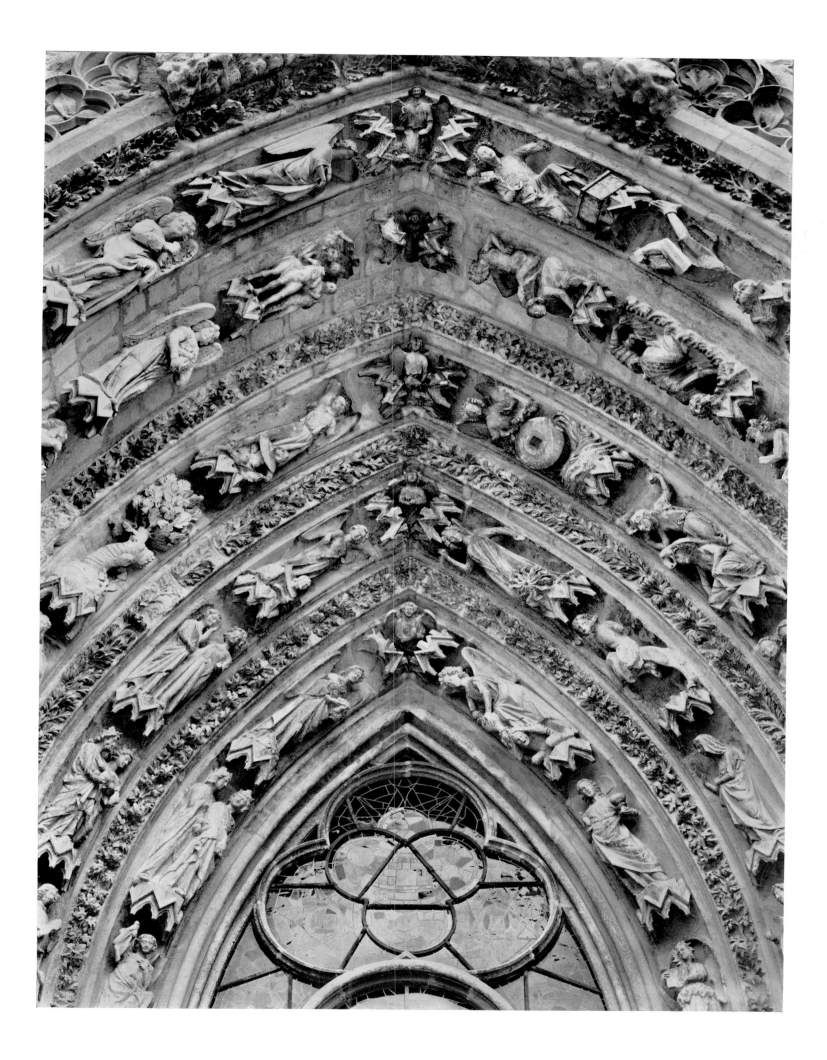

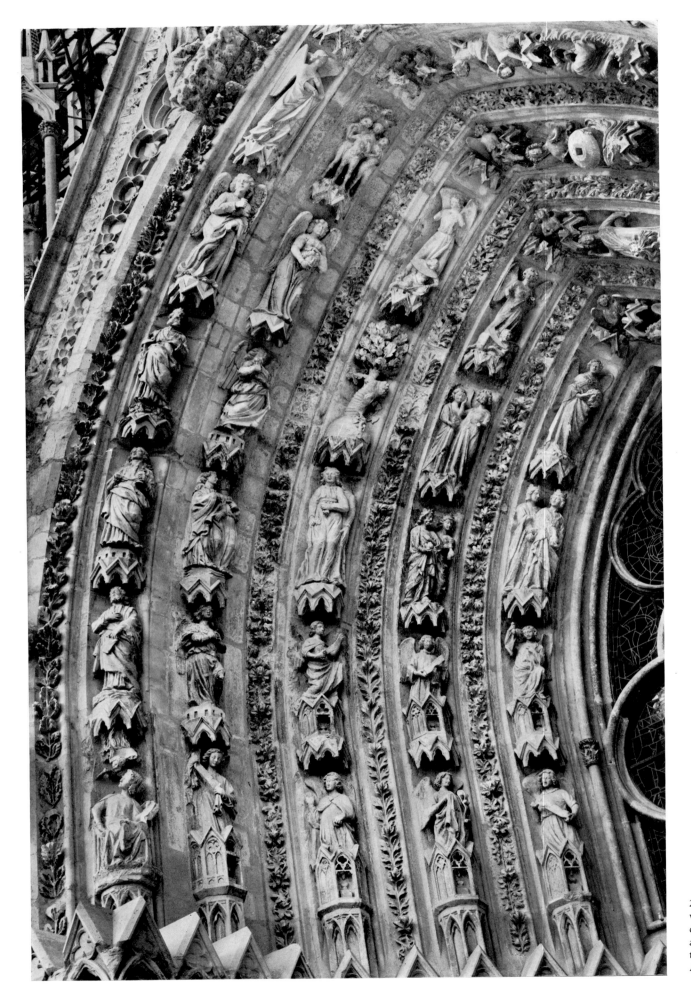

224 Rheims cathedral, west portal, right doorway. Detail of left archivolt: scenes from the Apocalypse. Approx. 1245–55

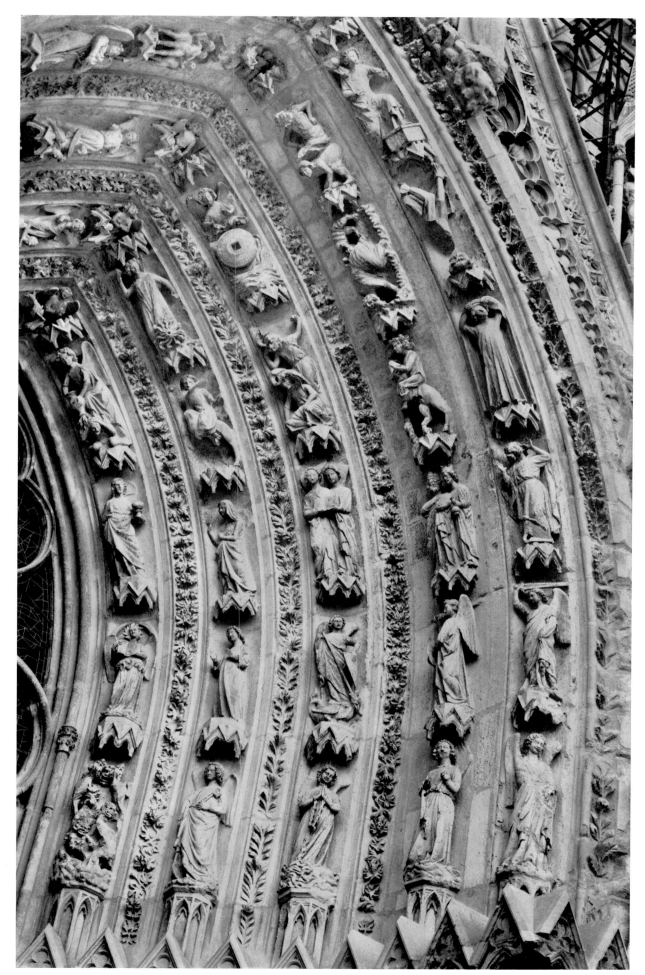

225 Rheims cathedral,
west portal, right
doorway. Detail of right
archivolt: scenes from
the Apocalypse.
Approx. 1245–55

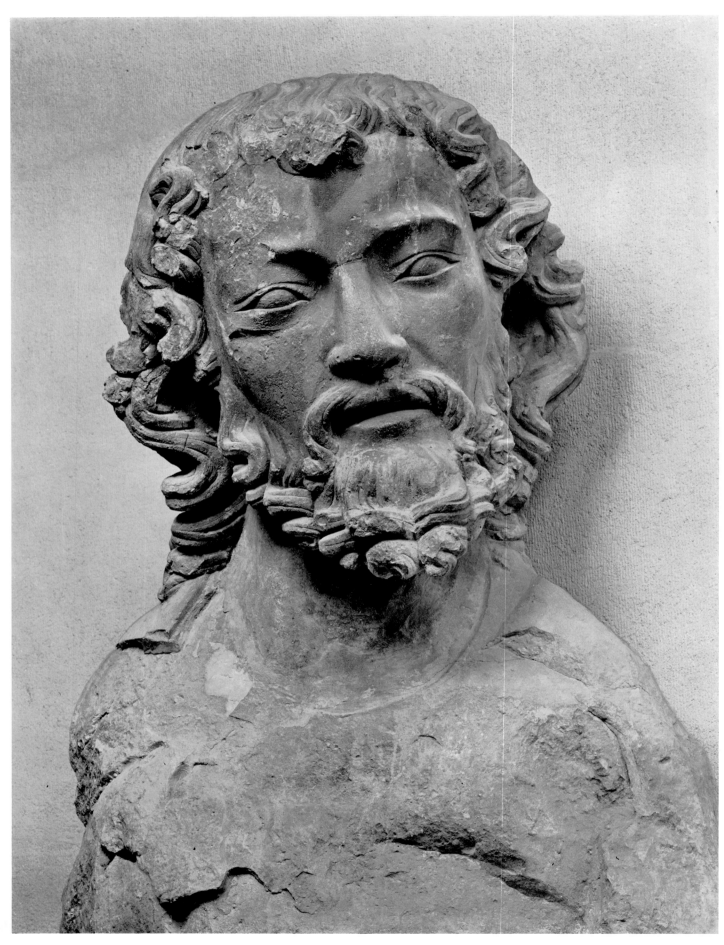

226 Rheims cathedral. From buttress aedicule on the north tower of the west façade: Doubting Thomas.
About or after 1260 (removed after 1918).

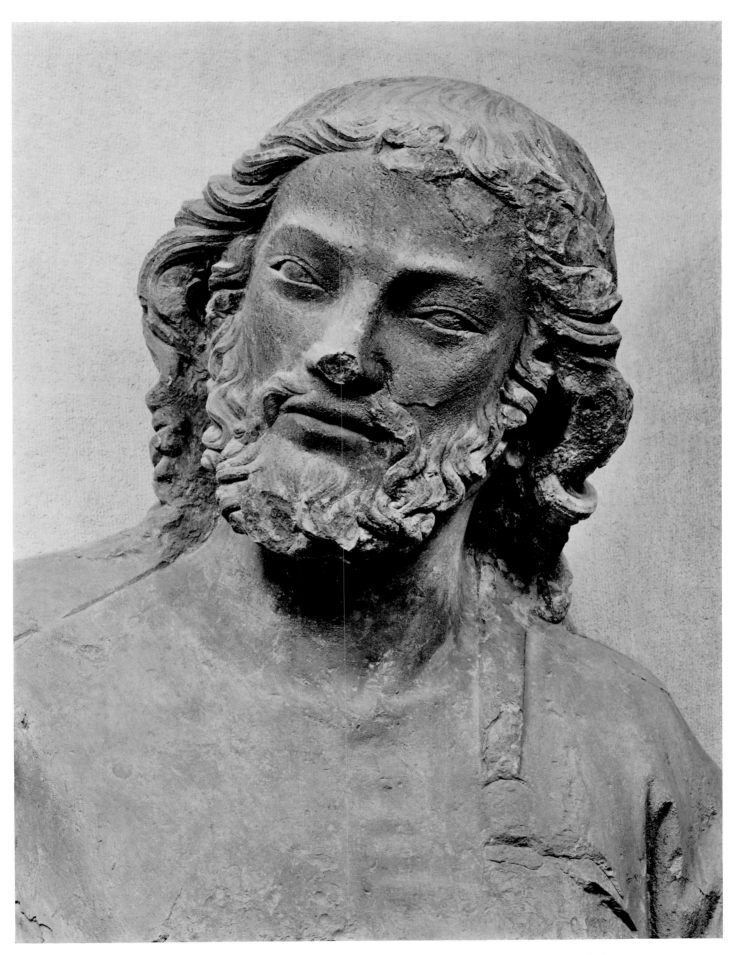

227 Rheims cathedral. From buttress aedicule on the north tower of the west façade: resurrected Christ.
About or after 1260 (removed after 1918)

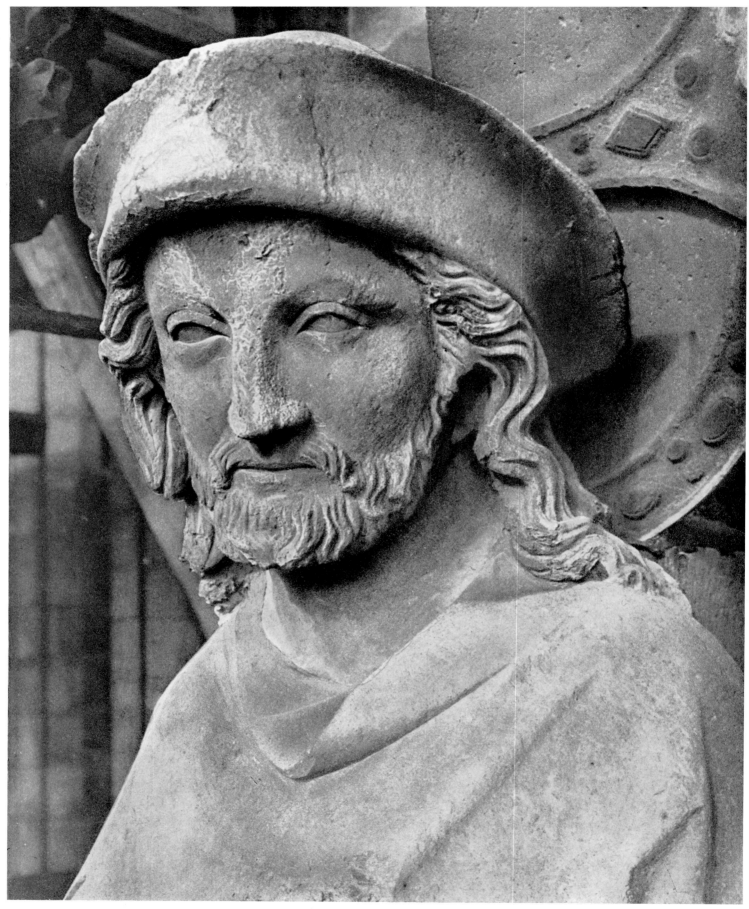

228 Rheims cathedral, west façade, rose storey (destroyed 1914). Christ at Emmaus. About 1260
229 Rheims cathedral, west portal, centre doorway.
Interior west wall: (right) story of John the Baptist; (left) life of the Virgin, with typological scenes.
Trumeau: Nicasius. Lintel: beheading of John the Baptist and burning of his bones. Approx. 1250–60

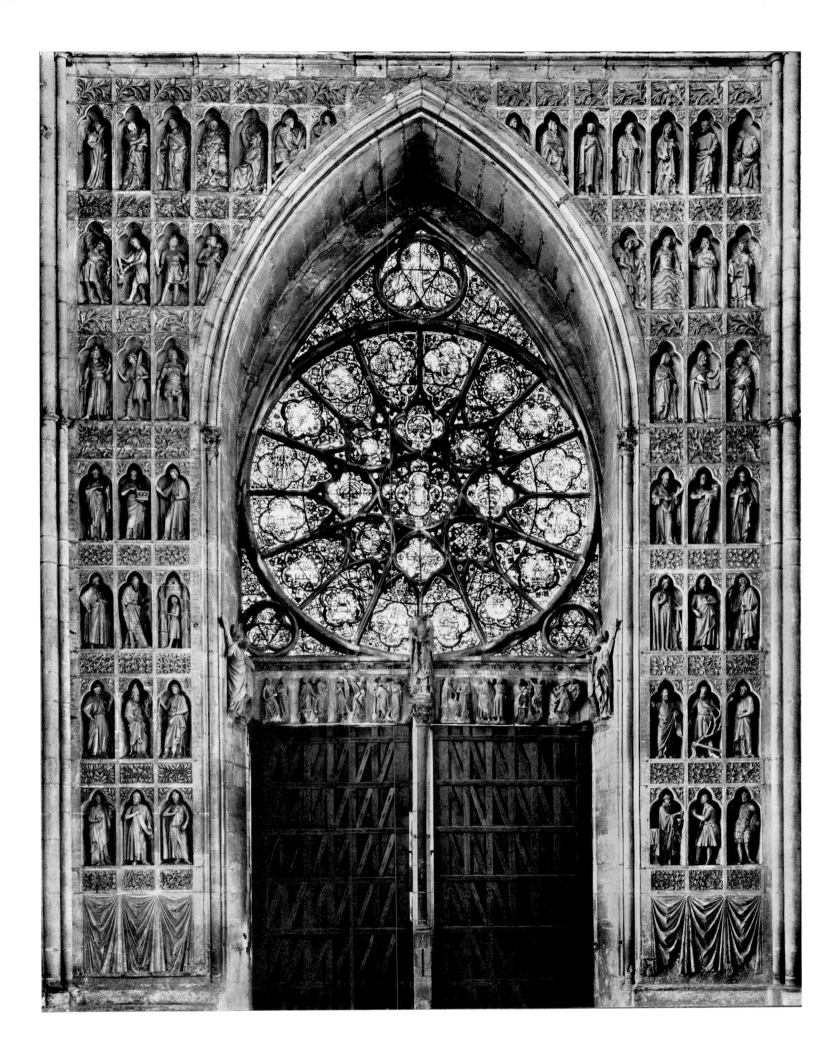

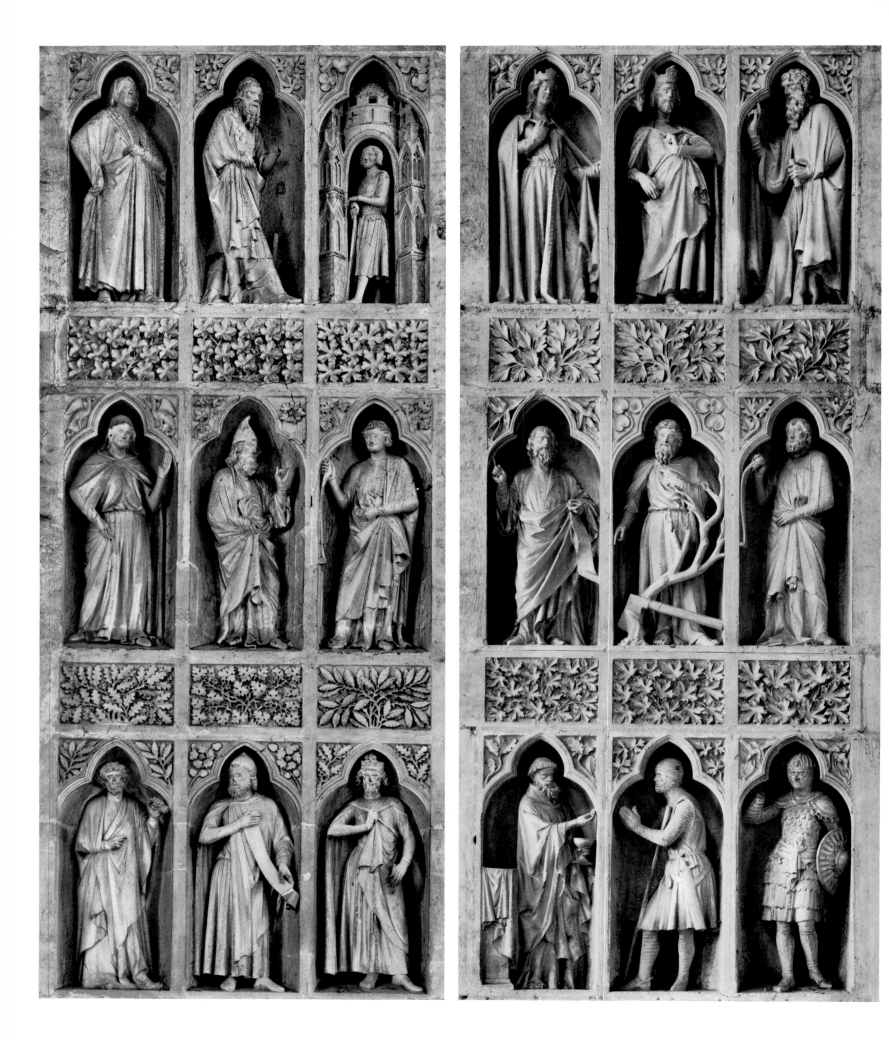

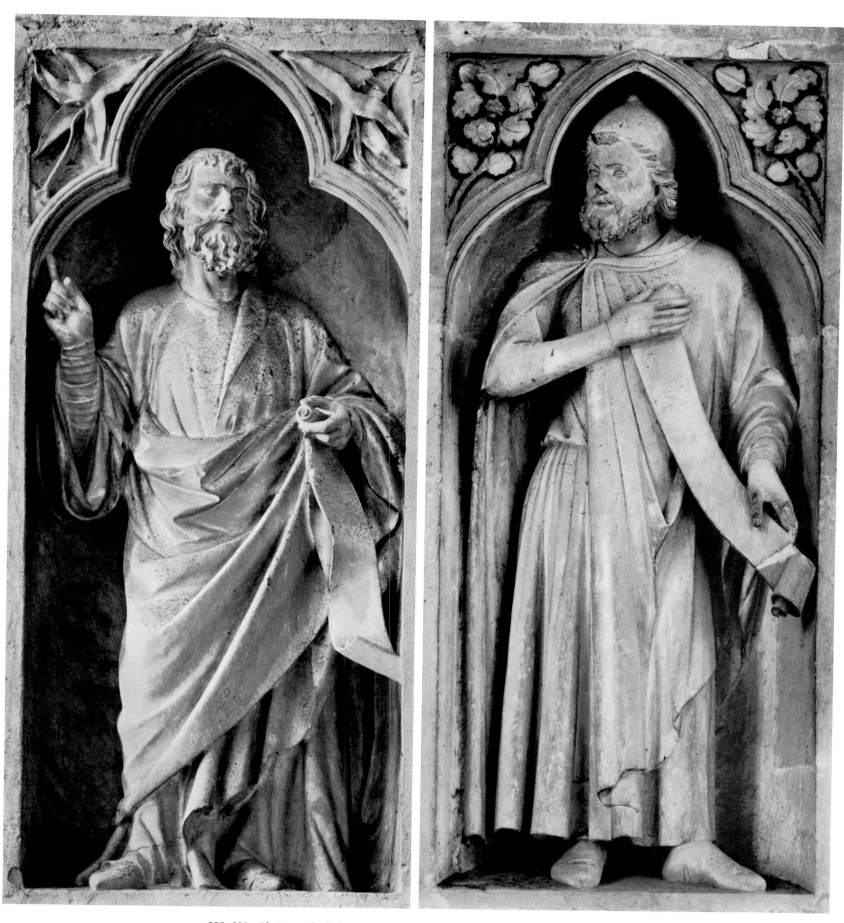

230, 231 Rheims cathedral, west portal, centre doorway. Details of interior west wall.
230 *Left*. Bottom register: male figure, prophet (pl. 231 right), David(?). Second register: annunciation to Anne and Joachim.
Third register: Anne and Joachim before the Golden Gate. *Right*. Bottom register: figure in armour receiving Communion.
Second register: John the Baptist preaching (pl. 231 left). Third register: John before Herod and Herodias. Approx. 1250–60

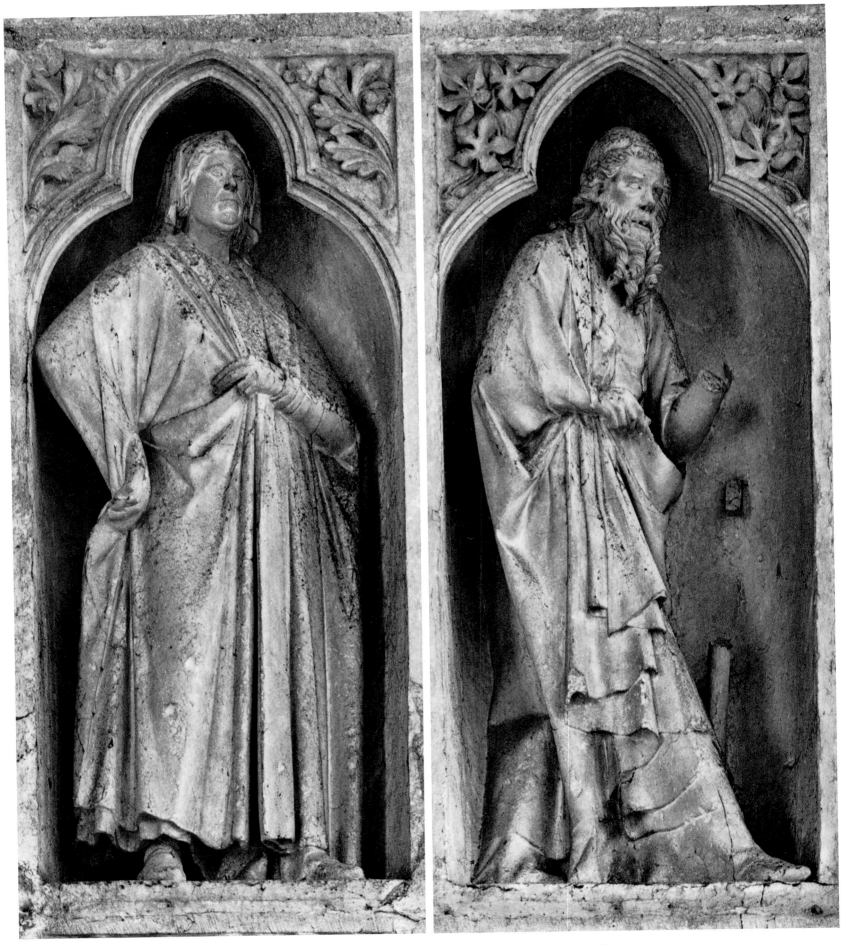

232 Rheims cathedral, west portal, centre doorway. Details of interior west wall.
Left side, third register: Joachim and Anne. Approx. 1250–60

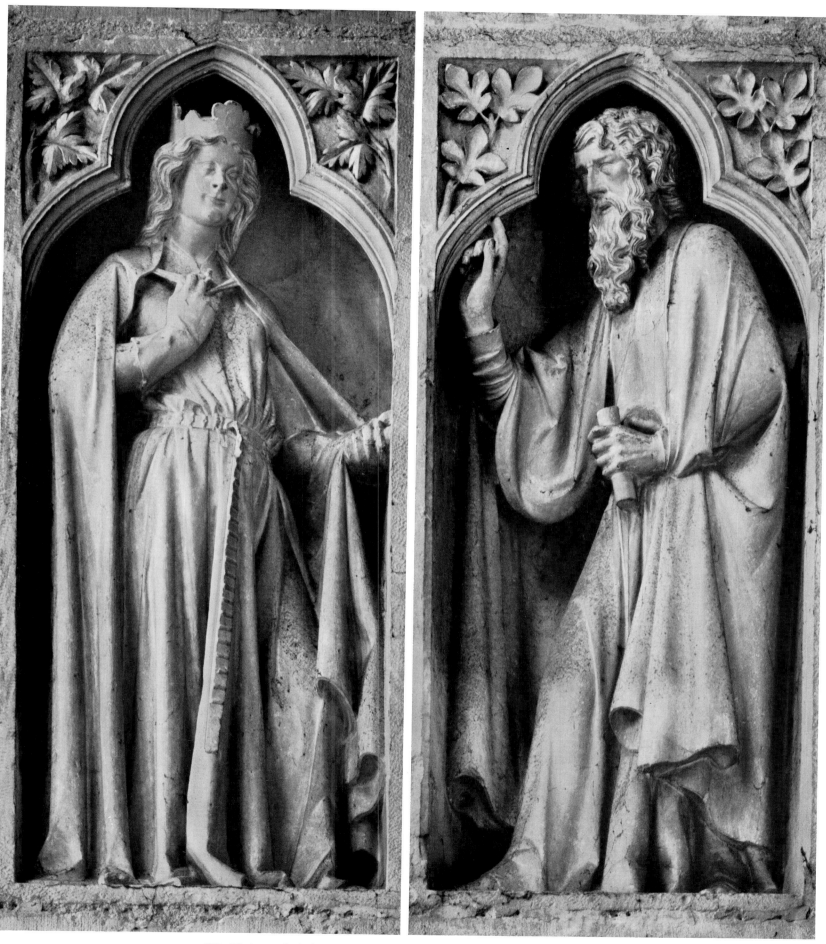

233 Rheims cathedral, west portal, centre doorway. Details of interior west wall.
Right side, third register: Herodias, and John the Baptist. Approx. 1250–60

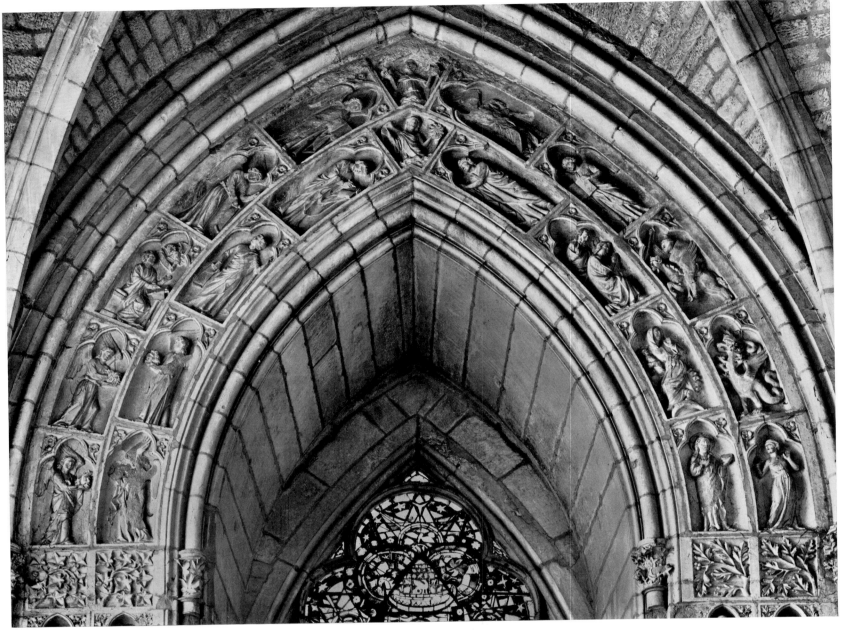

234, 235 Rheims cathedral, interior west wall. 234 South aisle: scenes from the Apocalypse. Approx. 1250–60.
235 North aisle: detail showing (from the bottom): calling of Matthew, raising of Jairus' daughter, and unidentified scenes.
Approx. 1250–60

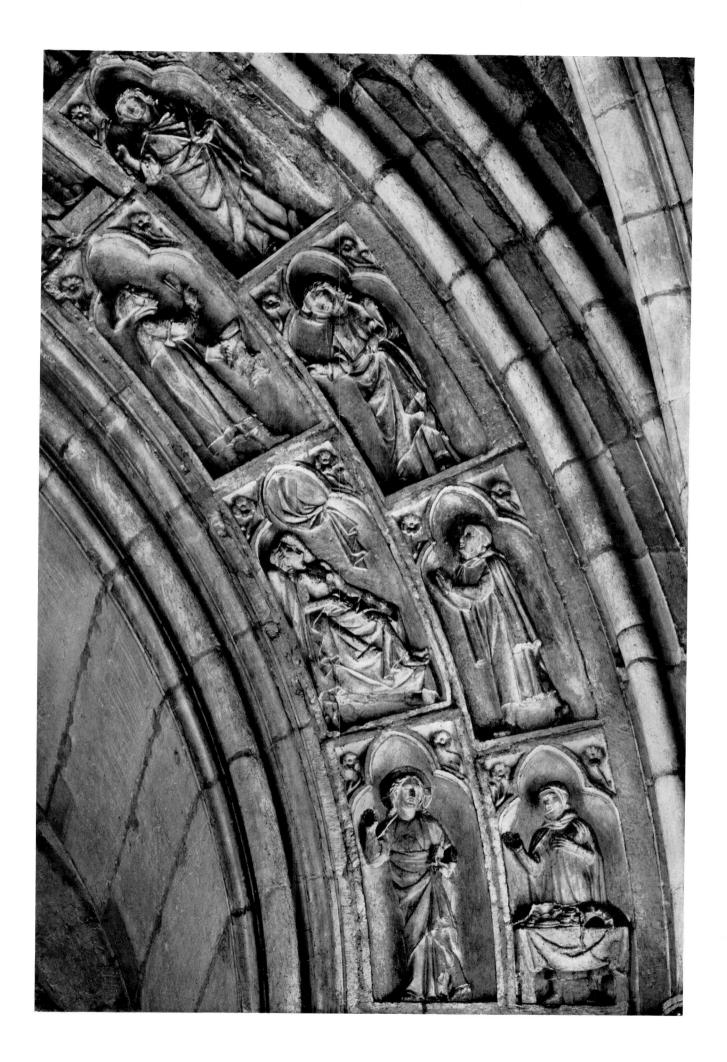

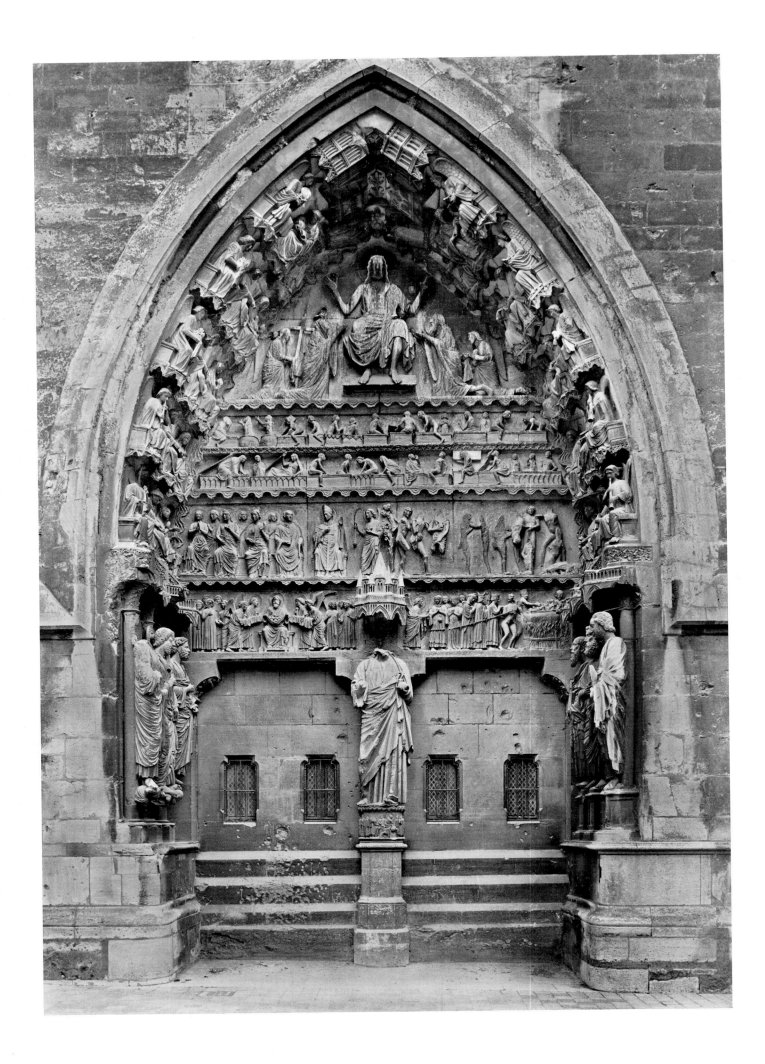

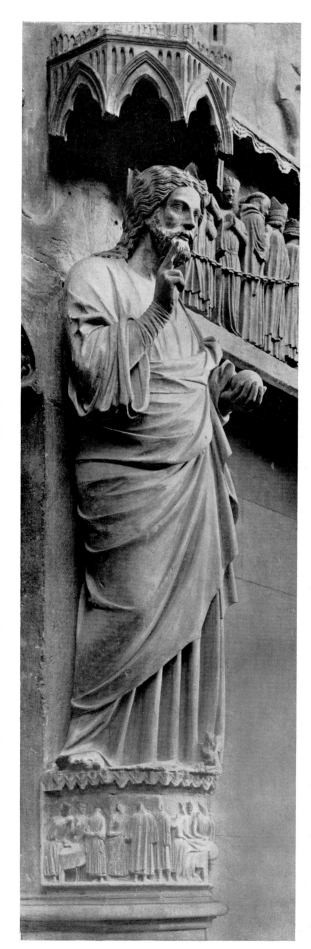

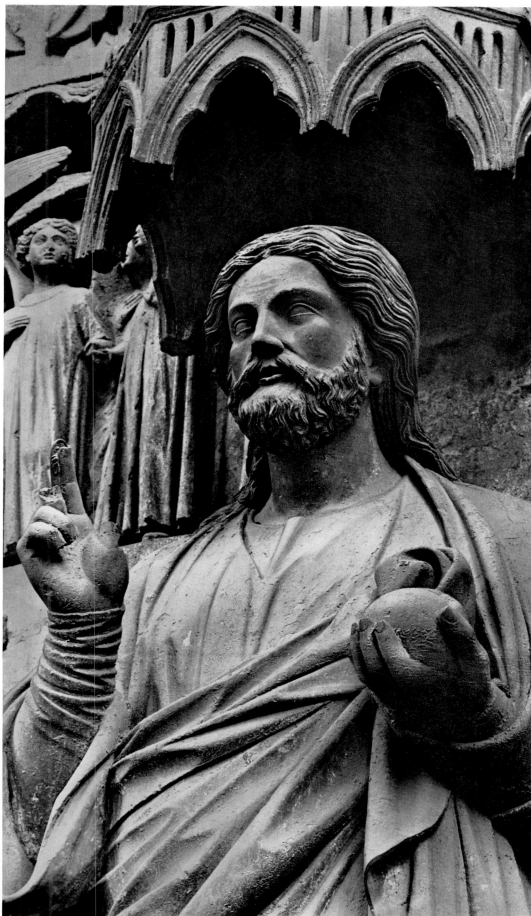

236, 237 Rheims cathedral, north transept: Judgment portal. About 1230.
237 Trumeau, and detail of Christ (photographed before 1914)

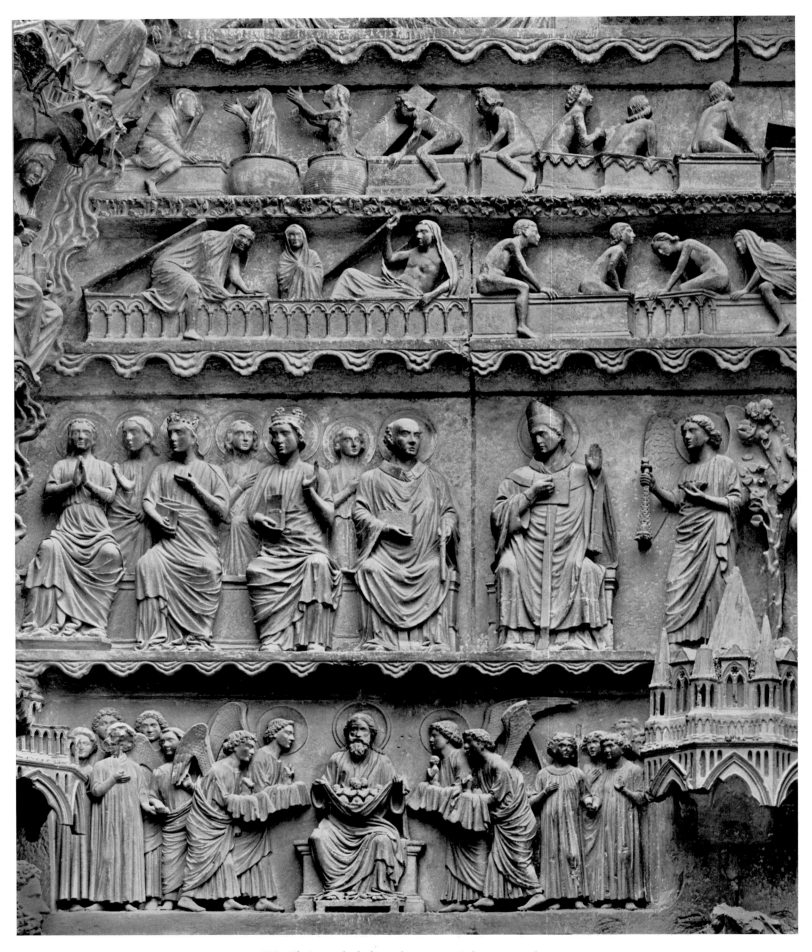

238 Rheims cathedral, north transept, Judgment portal.
Detail of tympanum: resurrection of the dead; Paradise; souls in Abraham's bosom. About 1230

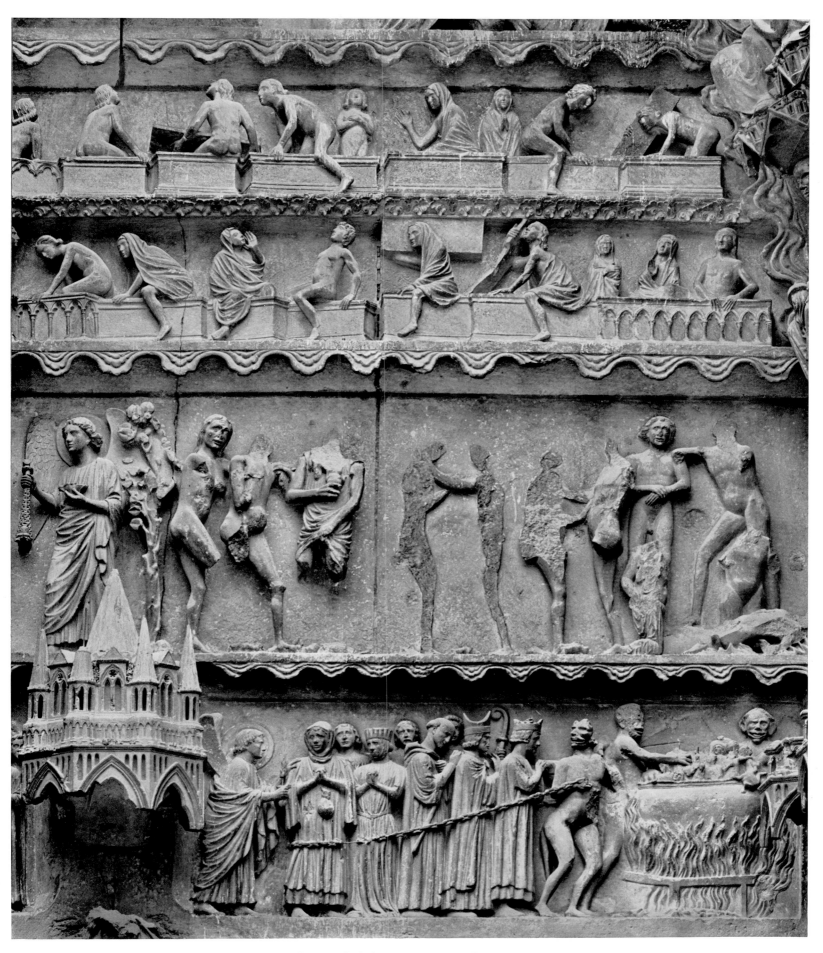

239 Rheims cathedral, north transept, Judgment portal.
Detail of tympanum: resurrection of the dead; Damned, procession to the cauldron of Hell. About 1230

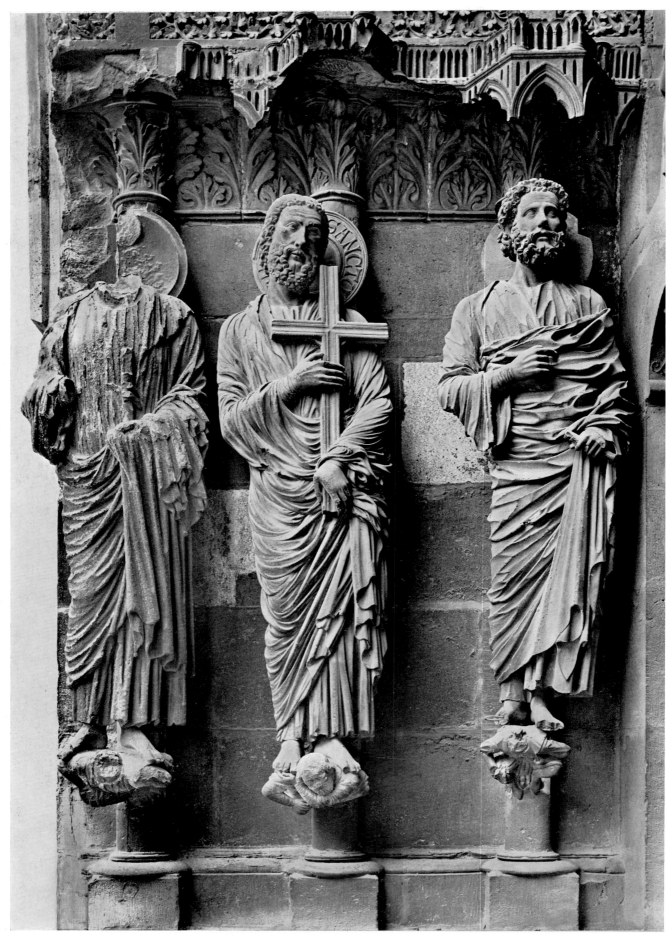

240 Rheims cathedral, north transept, Judgment portal.
Left jamb: Bartholomew, Andrew, Peter. About 1230

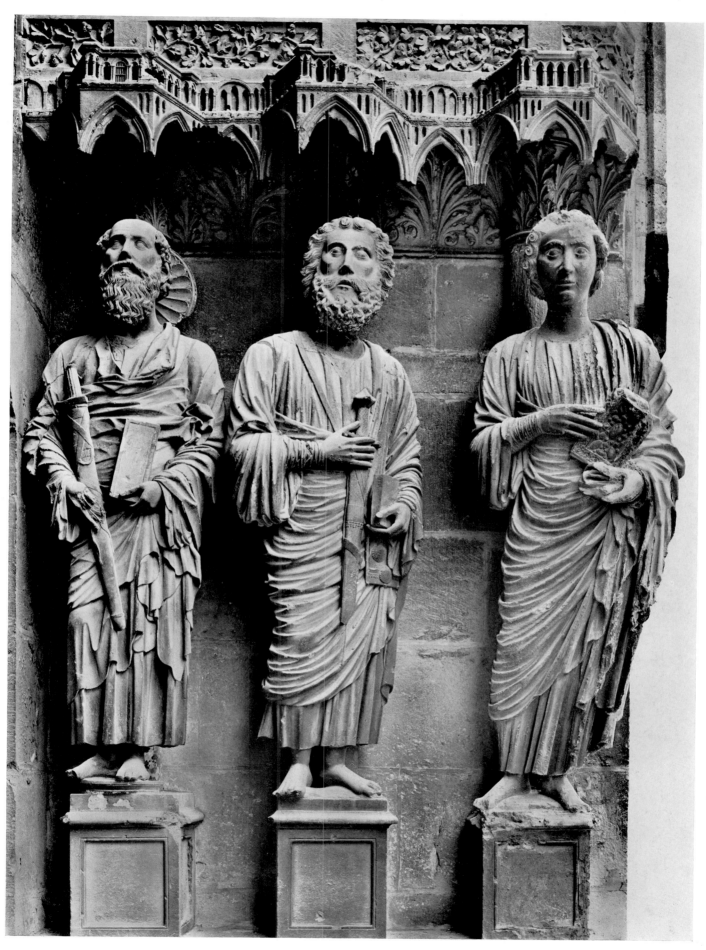

241 Rheims cathedral, north transept, Judgment portal.
Right jamb: Paul, James the Greater, John. About 1230 (socle renewed)

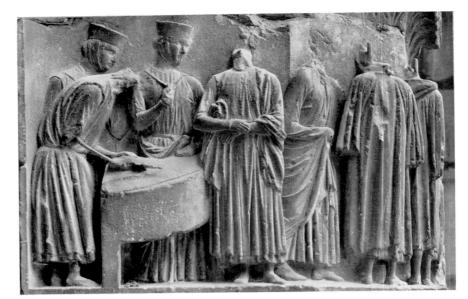

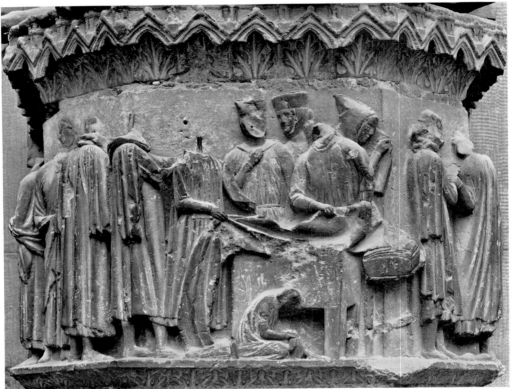

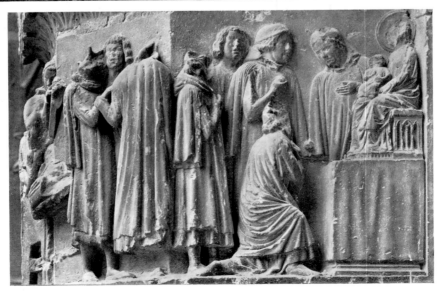

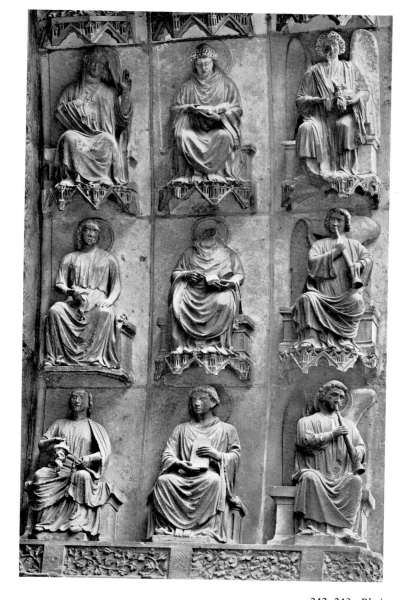

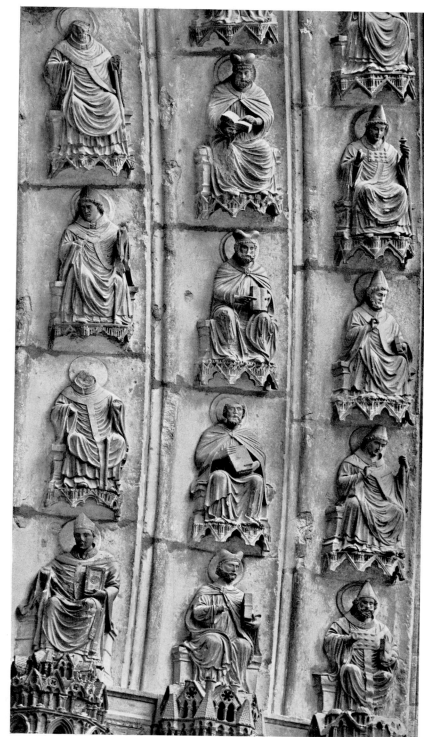

242, 243　Rheims cathedral, north transept.
242　Judgment portal. Trumeau socle: story of a deceitful cloth merchant(?). About 1230.
243　*Left.* Judgment portal, detail of archivolt: Foolish Virgins, ecclesiastics, angels with trumpets and crowns. About 1230.
Right. Calixtus portal, detail of archivolt: bishops, high priests(?), popes. Approx. 1225–30

244, 245　(overleaf) Rheims cathedral, north transept. Calixtus portal and detail of tympanum.
Archivolt: popes, high priests(?), bishops. Trumeau: St Calixtus. Jambs: (left) St Nicasius flanked by an angel and Eutropia;
(right) St Remigius flanked by an angel and an unidentified figure.
245　Tympanum: martyrdom of St Nicasius, baptism of Clovis; miracles of St Remigius; story of Job. Approx. 1225–30

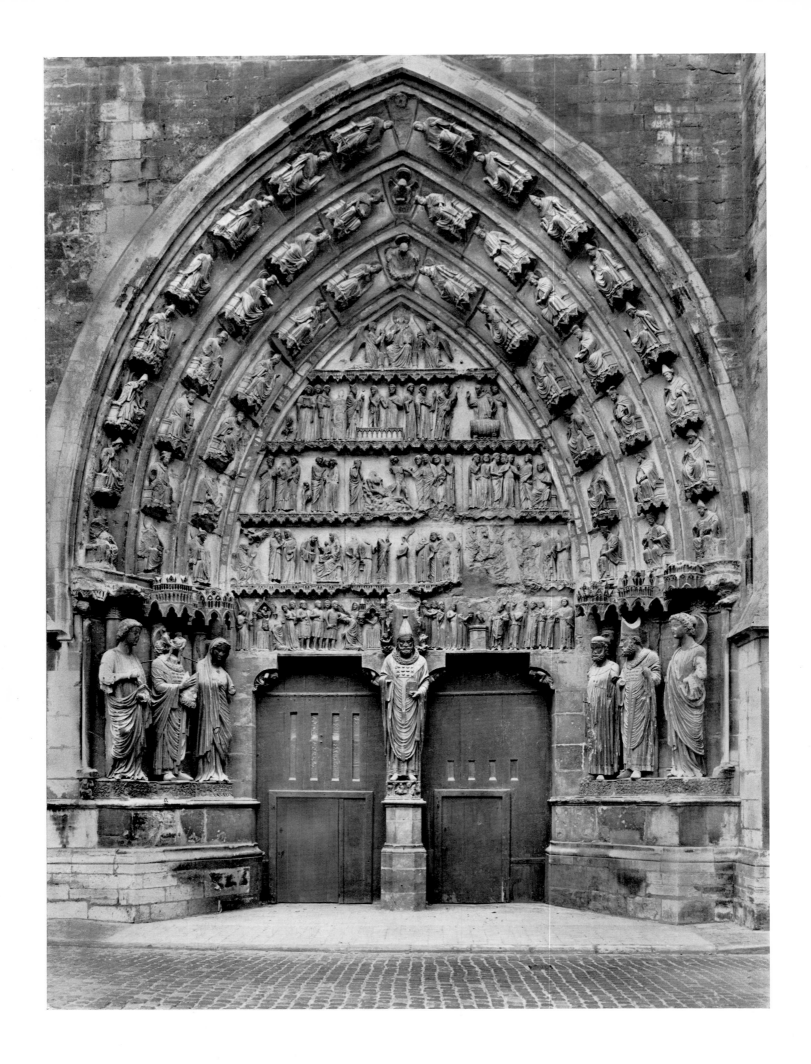

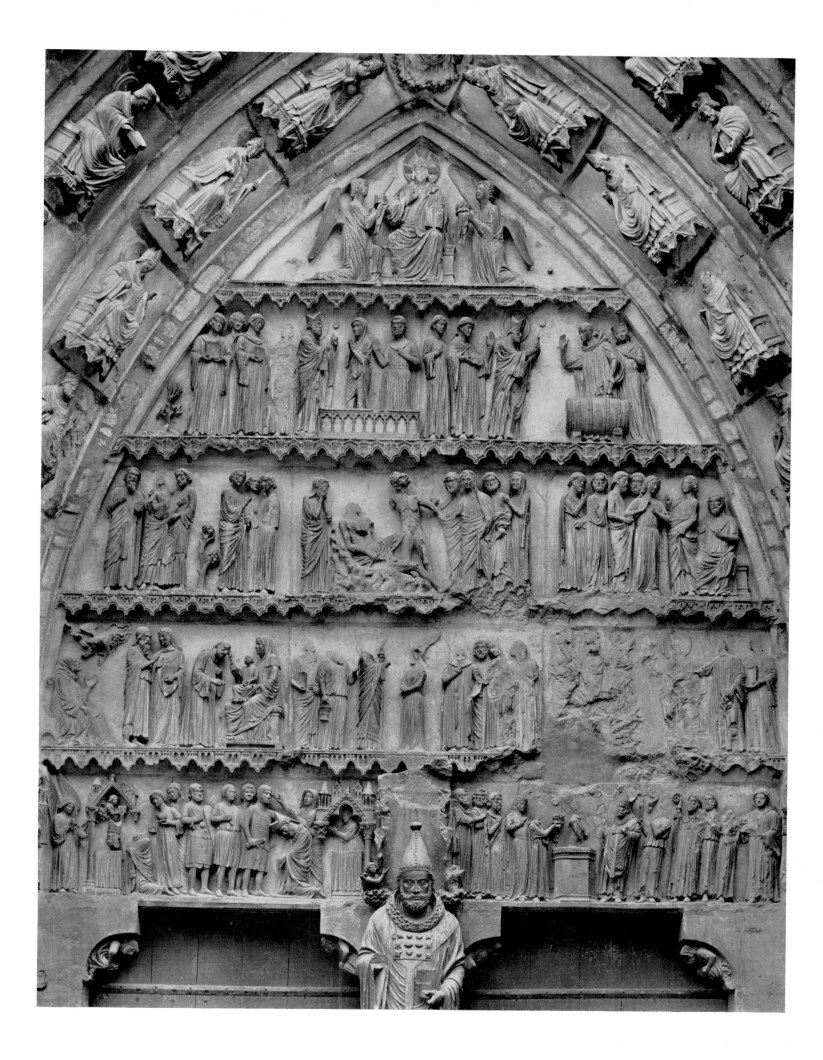

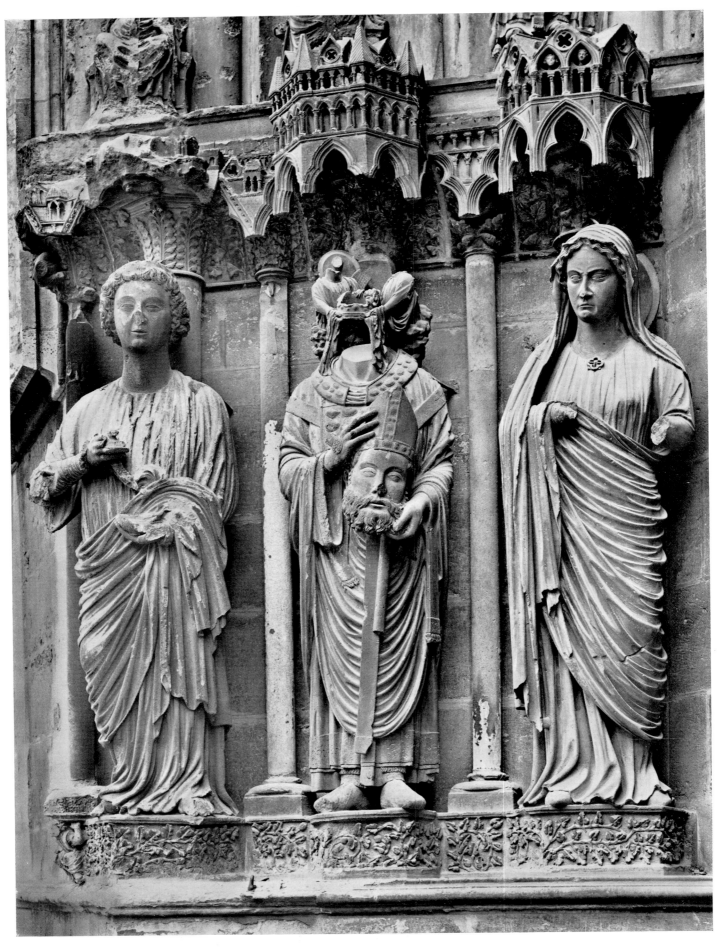

246 Rheims cathedral, north transept, Calixtus portal.
Left jamb: St Nicasius flanked by an angel and Eutropia. Approx. 1225–30

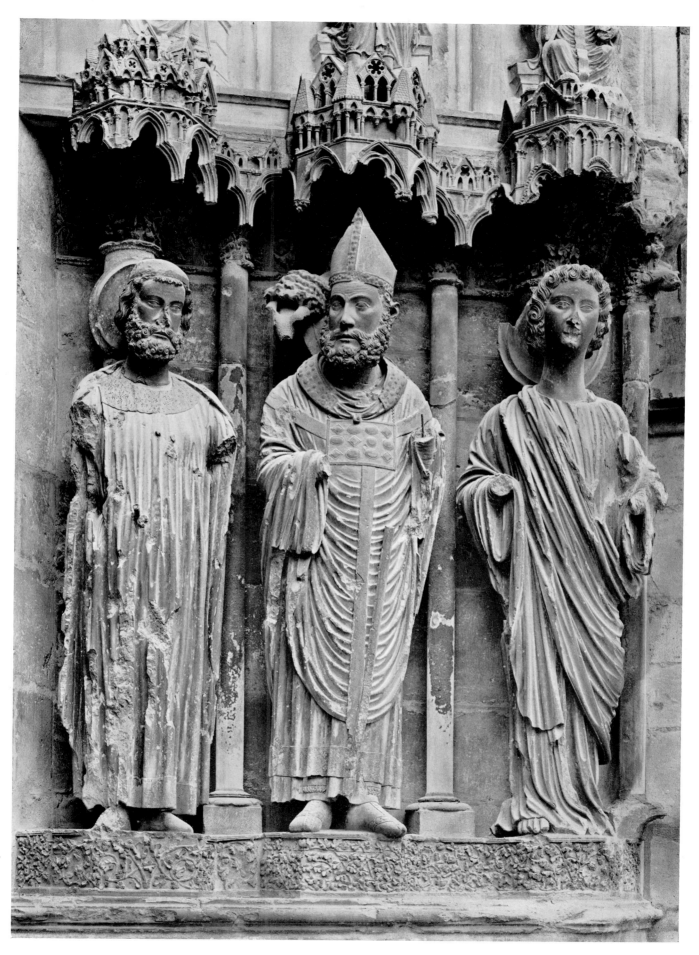

247 Rheims cathedral, north transept, Calixtus portal.
Right jamb: St Remigius flanked by an angel and an unidentified figure. Approx. 1225–30

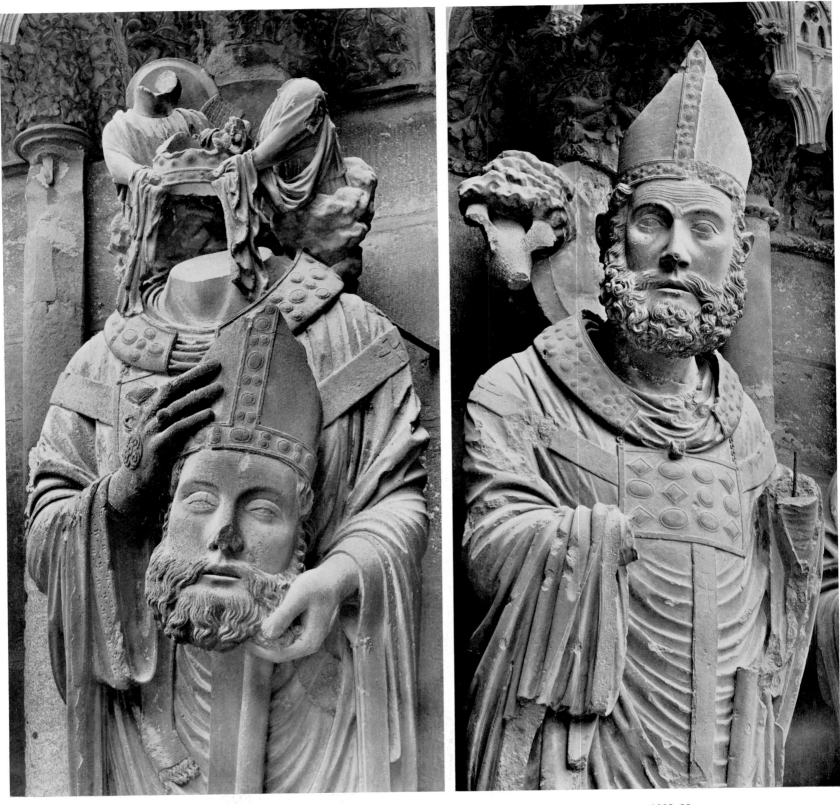

248 Rheims cathedral, north transept, Calixtus portal. *Left*. St Nicasius. *Right*. St Remigius. Approx. 1225–30

249 Rheims cathedral, north transept, Calixtus portal. Detail of trumeau: St Calixtus. Approx. 1225–30

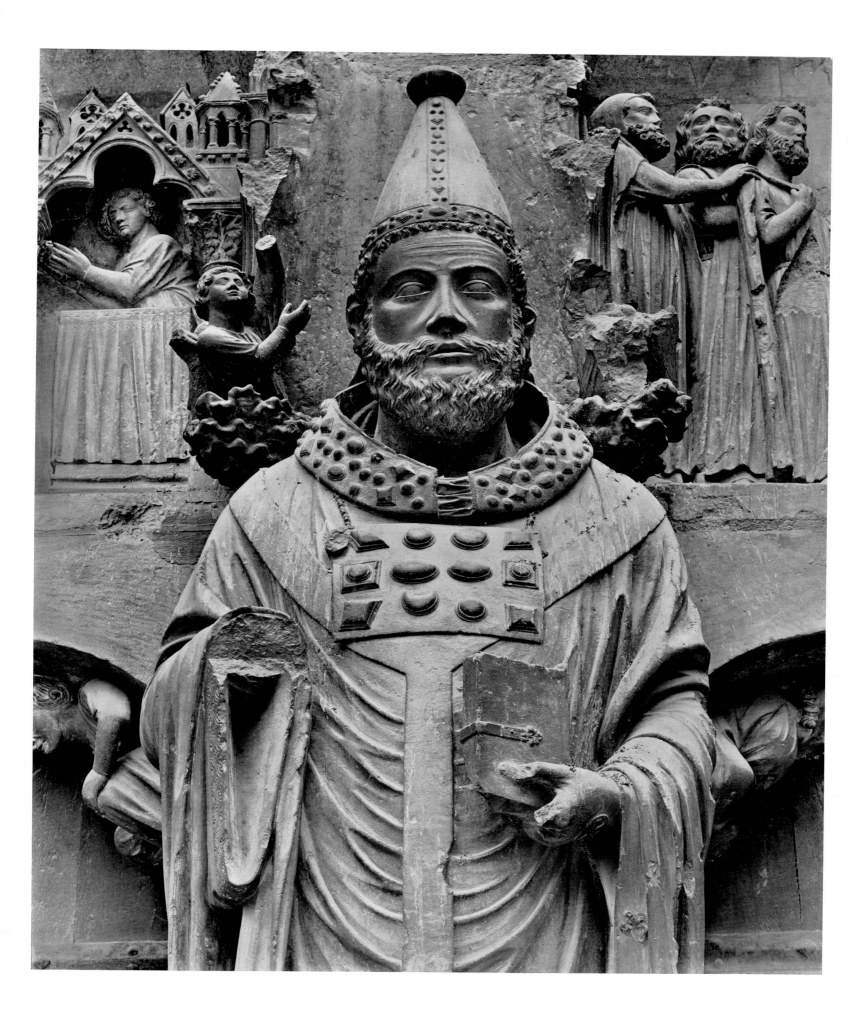

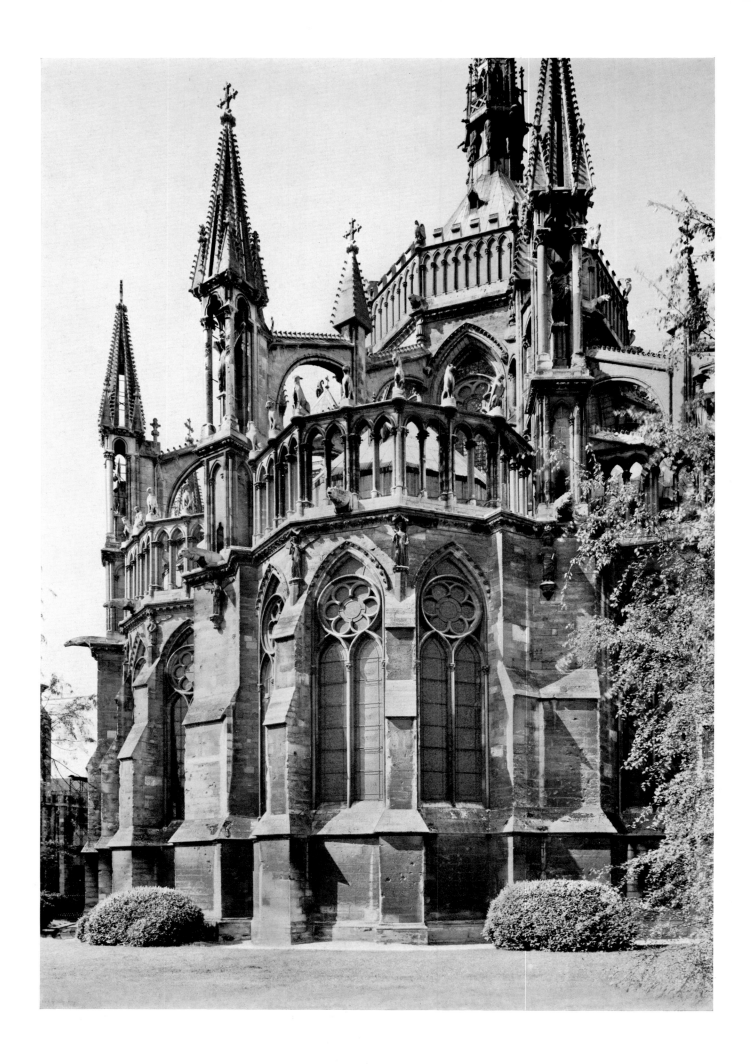

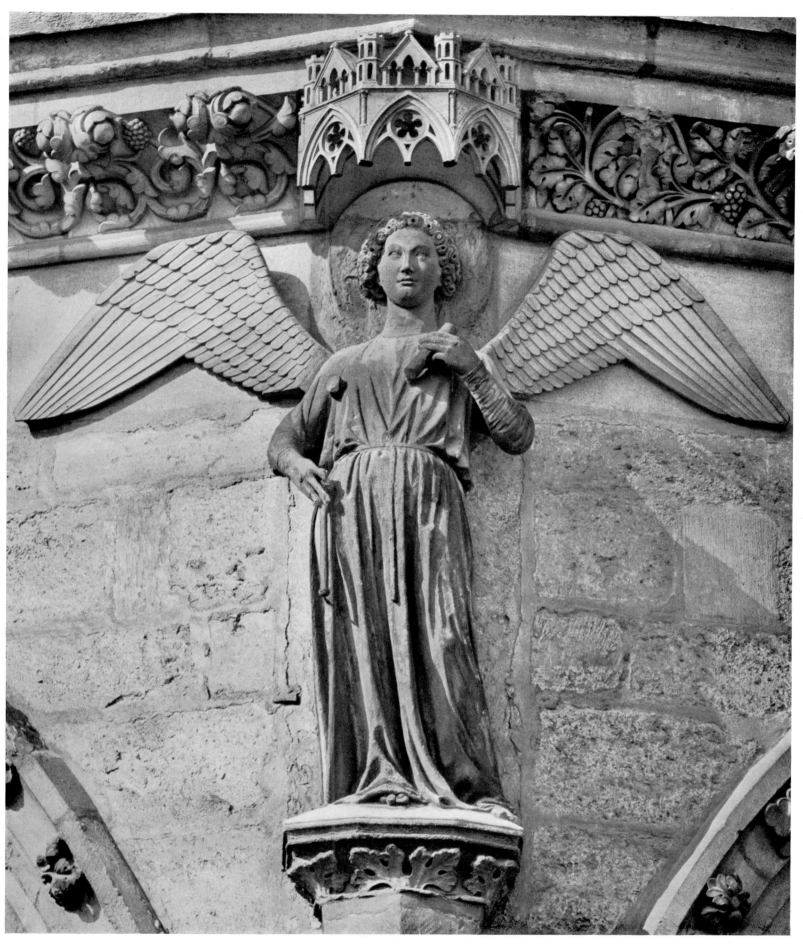

250, 251 Rheims cathedral, exterior of chevet. 251 Angel, formerly with sceptre (north side, second chapel).
About 1230

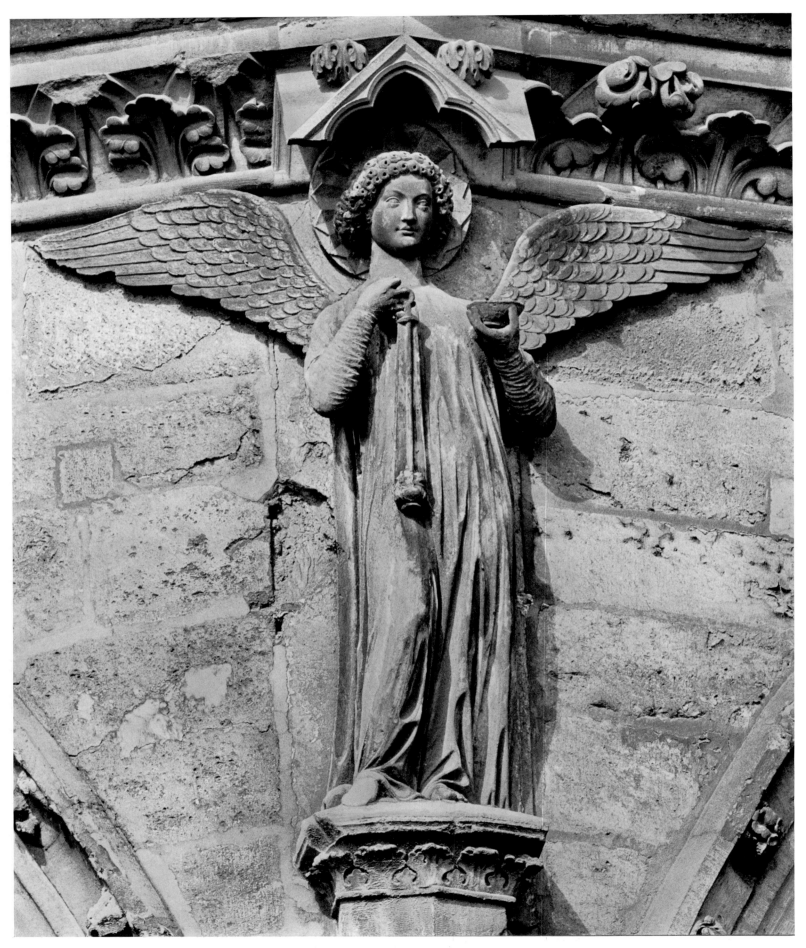

252 Rheims cathedral, chevet. Angel with censer and incense boat. About 1230

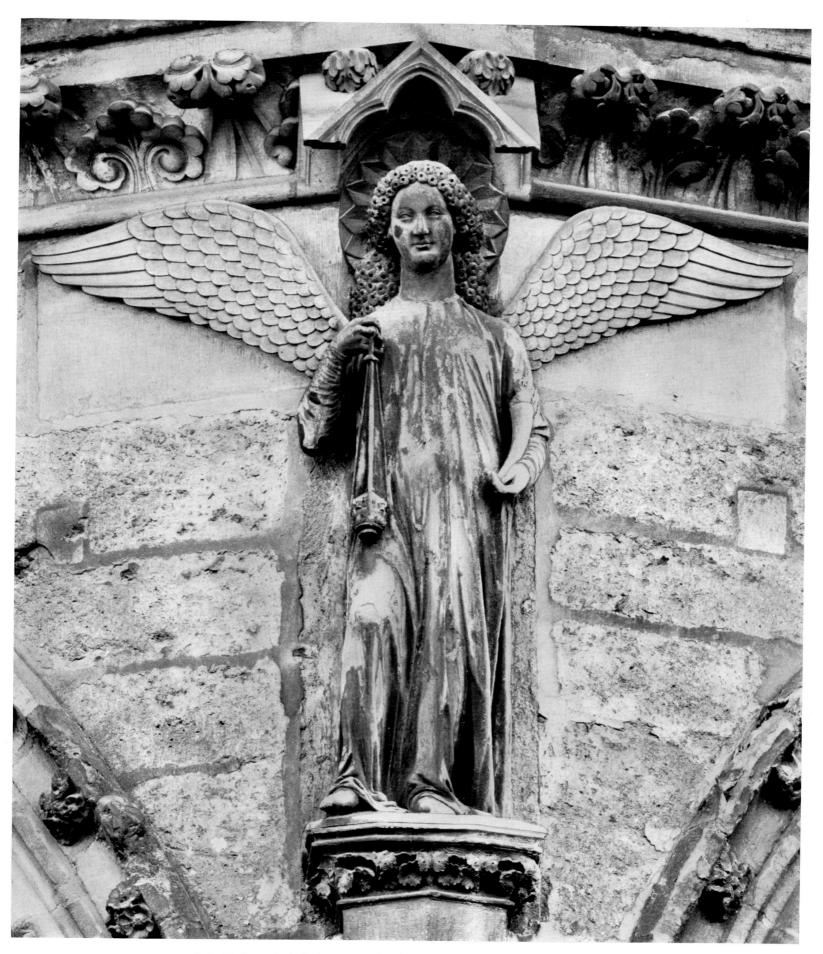

253 Rheims cathedral, chevet. Angel with thurible and horn-shaped vessel. About 1230

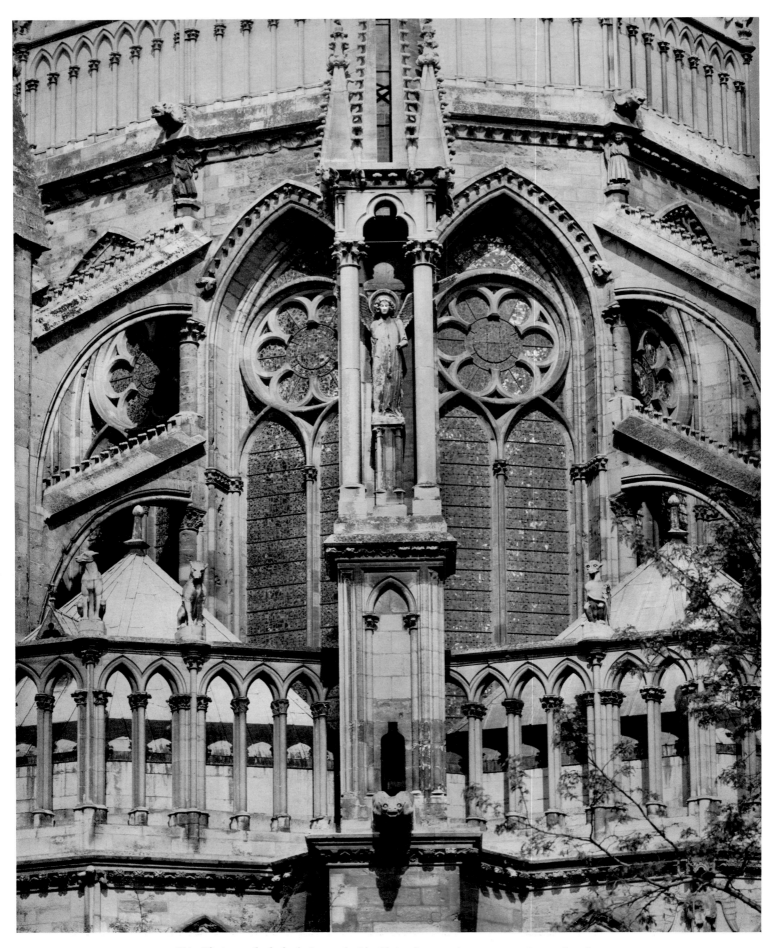

254 Rheims cathedral, choir, south side. Flying buttress between two chevet chapels.
In the aedicule: standing angel. Before 1241

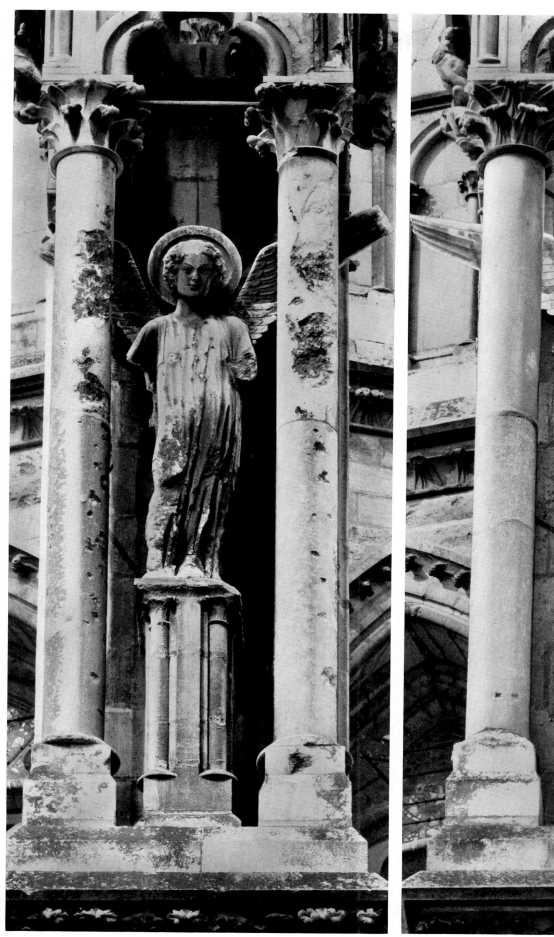
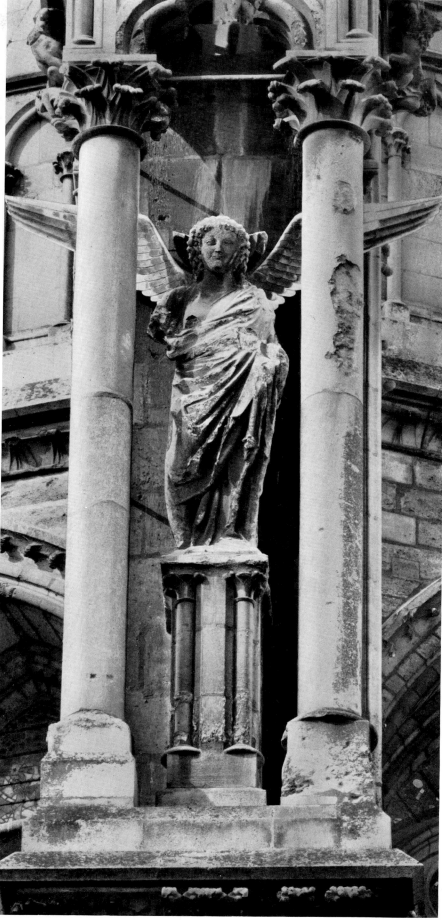

255 Rheims cathedral, choir. Buttress aedicules with angels, to south and north of the chevet.
Before 1241

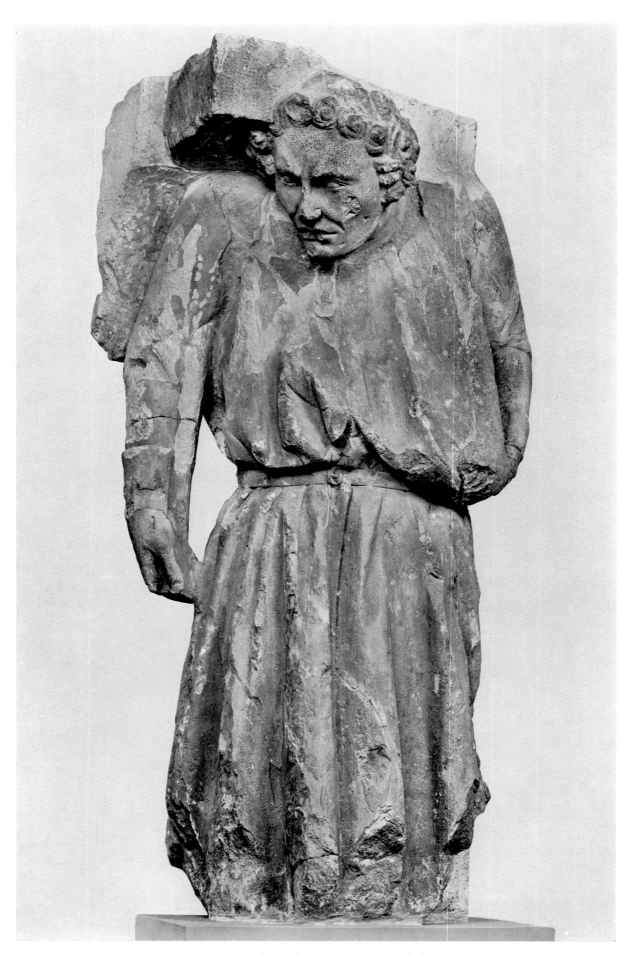

256 Rheims cathedral. Atlas figure from the choir (removed after 1918). Before 1241

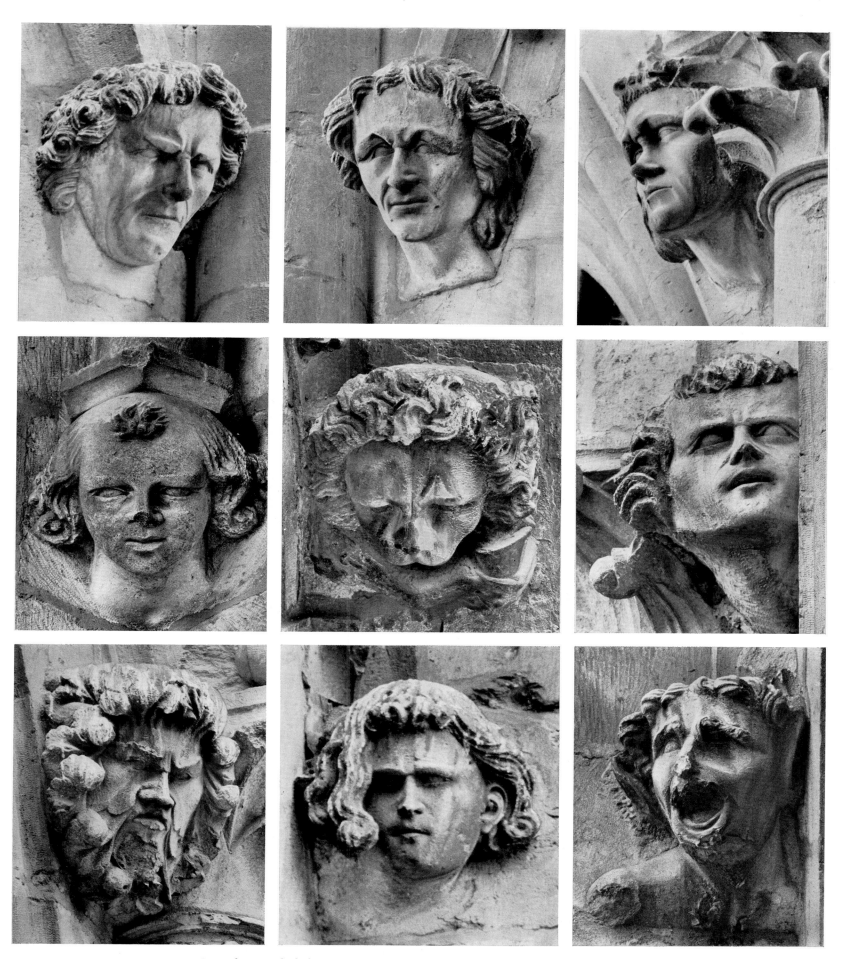

257 Rheims cathedral, corbel heads. *Middle left*. North tower, beneath the rib vaulting. *Middle right*. South transept, triforium. *Remainder*. Windows of choir. Before 1241

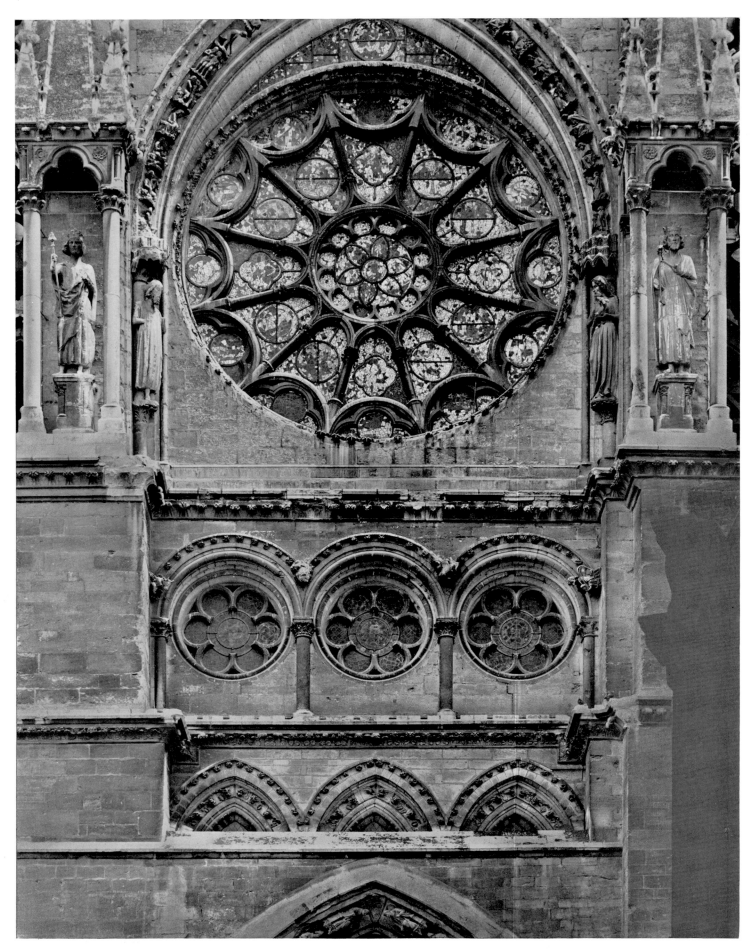

258 Rheims cathedral, north transept façade. Kings, Adam and Eve; around the rose window, the Creation. Before 1241

259 Rheims cathedral, north transept. Eve, cast of figure in the rose window storey. Before 1241.
(Musée des Monuments français, Paris)

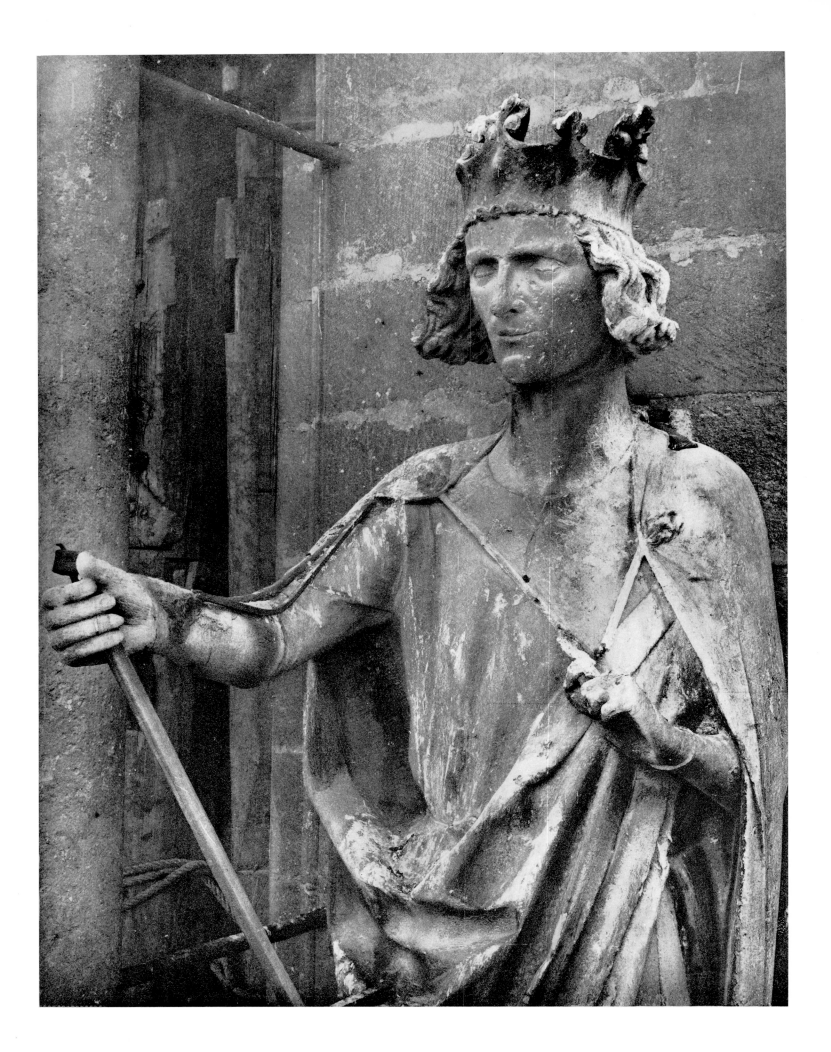

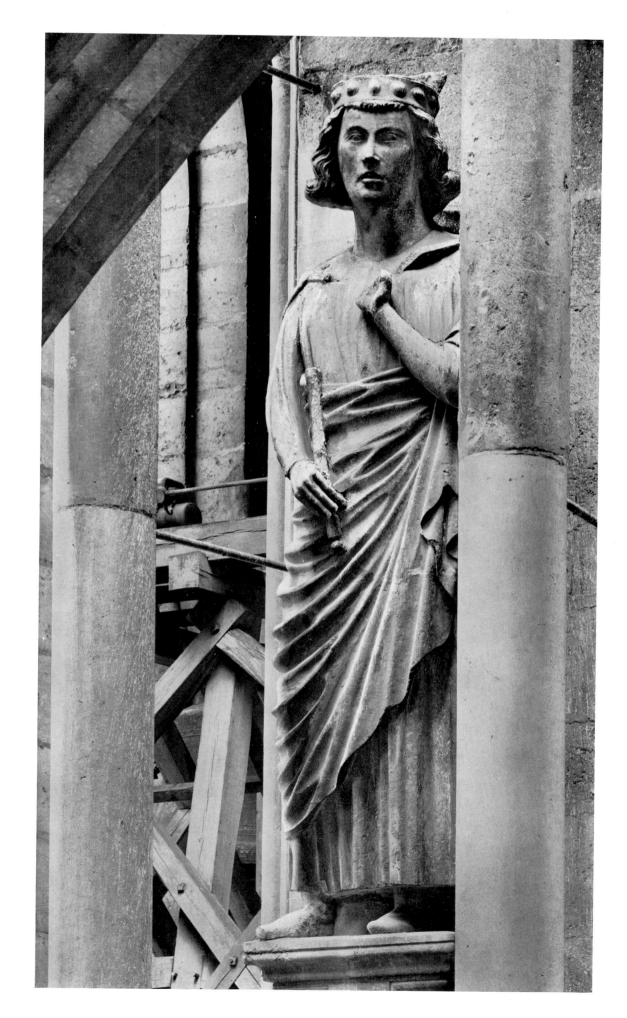

260, 261 Rheims cathedral,
north transept façade.
260 King ('Philip Augustus'),
buttress to the left of the rose.
261 King ('St Louis'), buttress
pier on the west.
Both before 1241

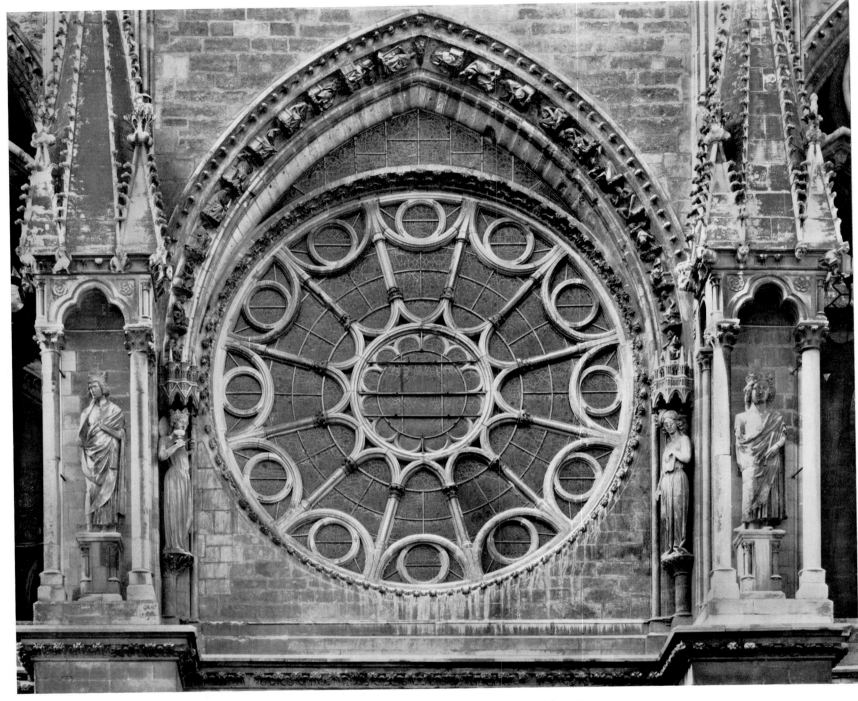

262, 263 Rheims cathedral, south transept façade. Before 1241.
262 Rose storey: aedicules with kings; archivolt with apostles and Old Testament figures, and Ecclesia and Synagogue below.
263 Details of archivolt: Old Testament figures, with Moses(?) bottom right and Job(?) fifth right, Jonah(?) fourth left

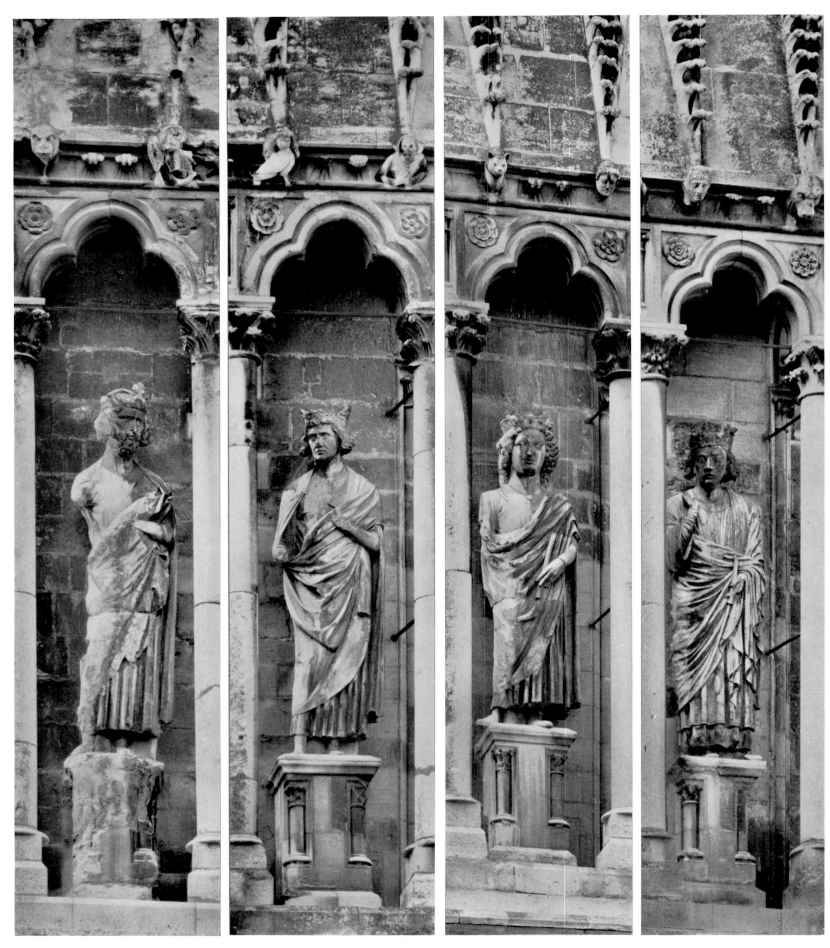

264 Rheims cathedral, south transept façade. Statues of kings in the four buttress aedicules. Before 1241

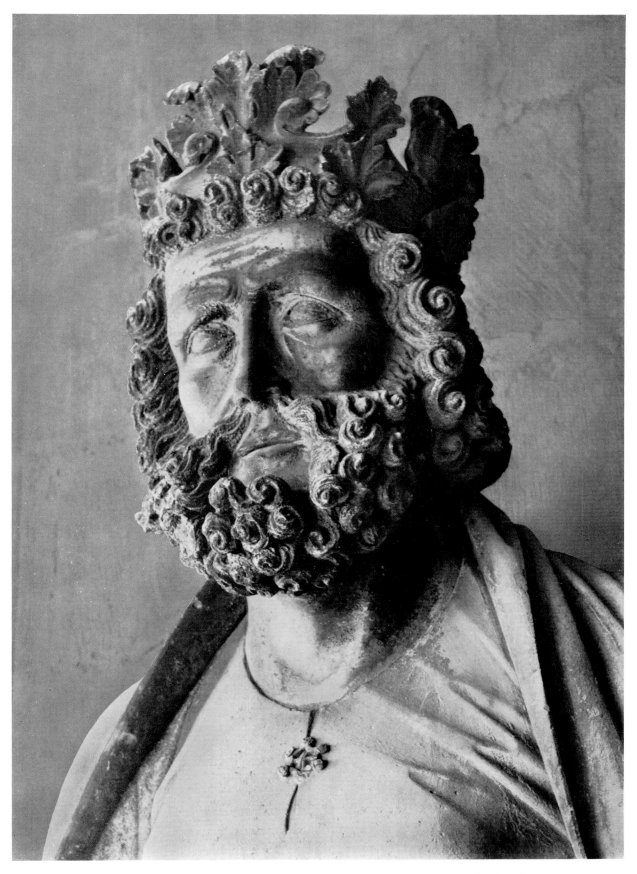

265 Rheims cathedral, south transept, east side. Detail of king in the buttress aedicule. Before 1241

267 Paris, Notre Dame, south transept portal. Tympanum: story of St Stephen.
Archivolt: angels (inside), martyrs, confessors. (The jamb and trumeau figure of St Stephen have been restored.)
Blind tympana, left and right: legend of St Martin's cloak. 1260–65.
For the reliefs on the buttress piers, see pl. 270

266 Paris, Notre Dame. Remains of four jamb figures from the south transept portal. 1260–65. (Now in the north tower)

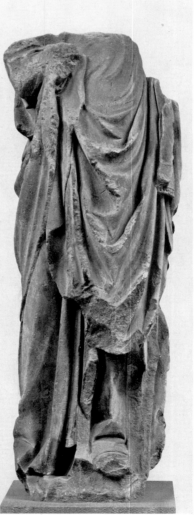
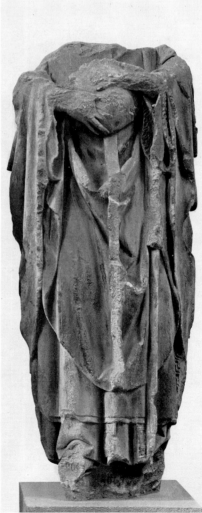

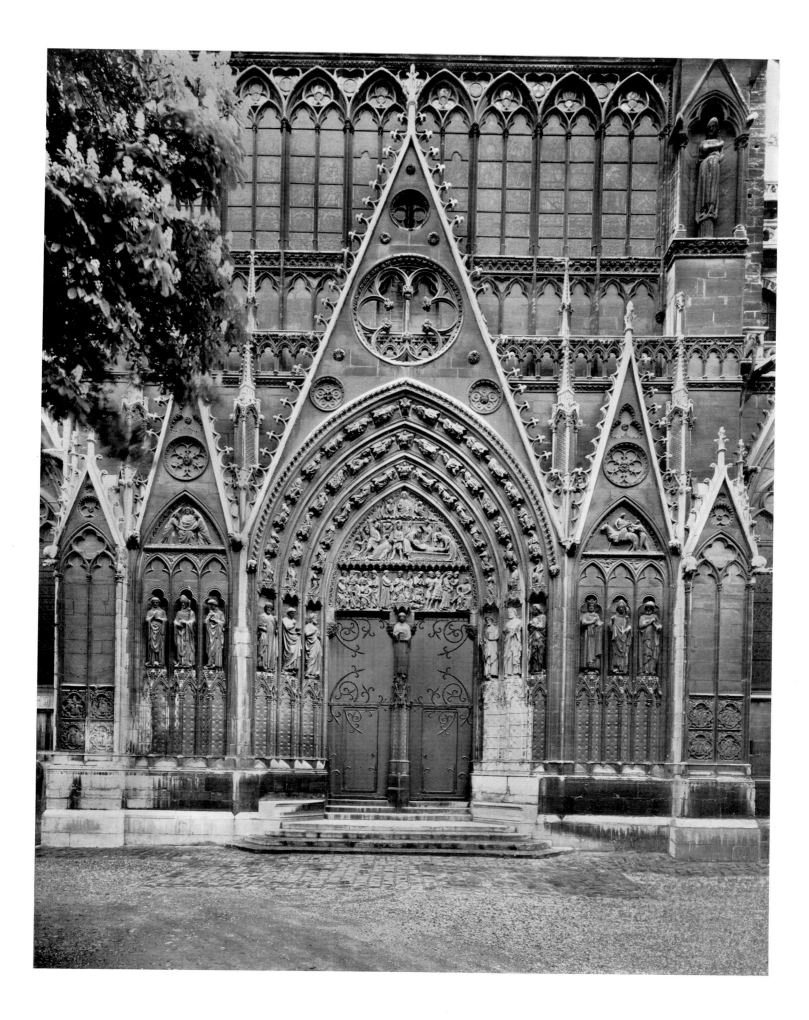

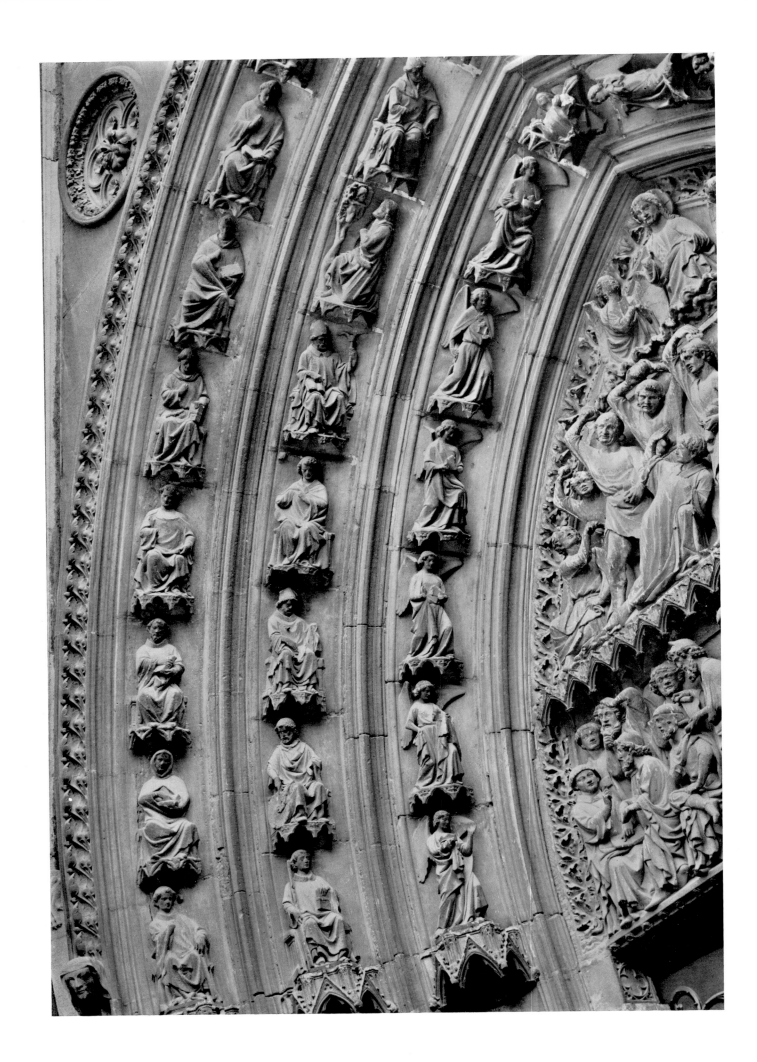

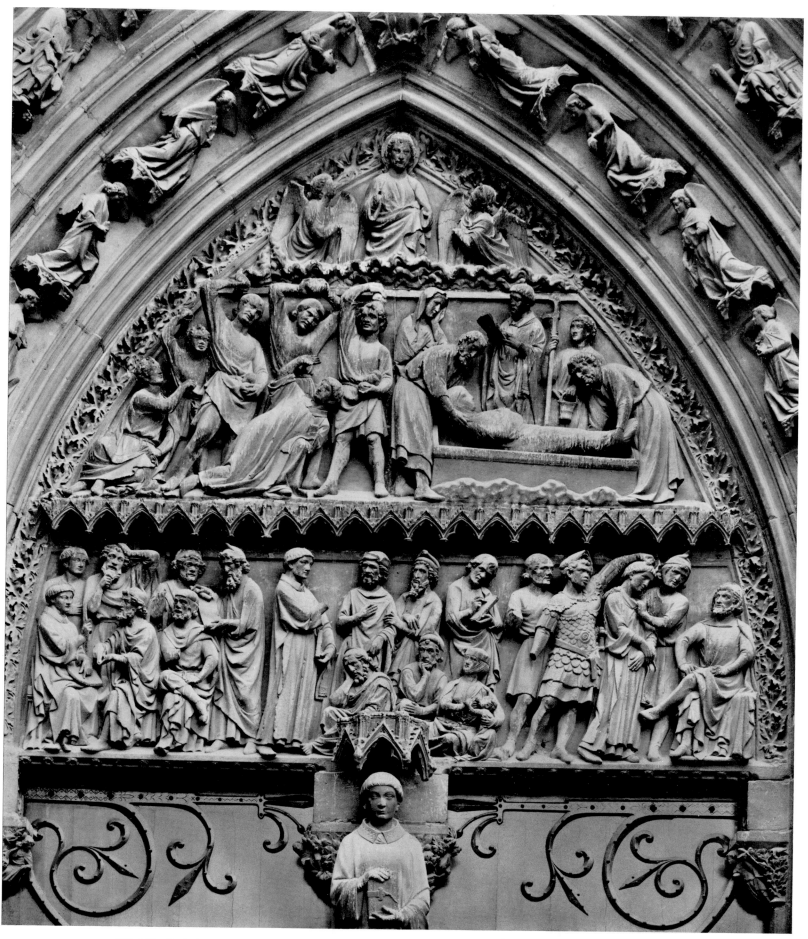

268, 269 Paris, Notre Dame, south transept portal. 268 Archivolt: (from the inside) angels, martyrs, confessors.
269 Tympanum: story of St Stephen (disputation, sermon, trial, stoning, burial); in the apex, Christ, flanked by angels. 1260–65

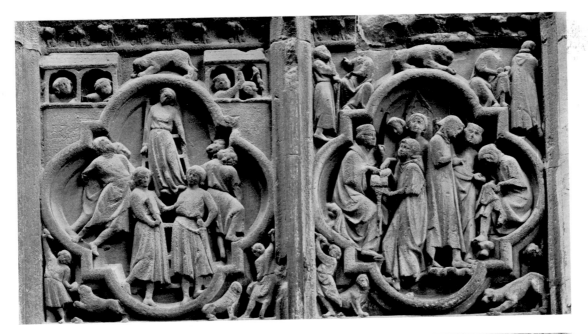

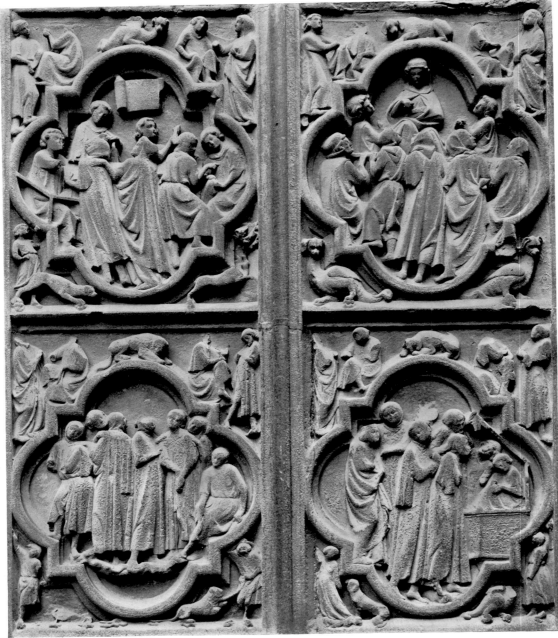

270, 271 Paris, Notre Dame.
270 South transept. Reliefs on the
buttress piers: unelucidated scenes,
possibly of legal processes. 1260–65.
271 Porte rouge. Tympanum:
Coronation of the Virgin; the
kneeling figures are perhaps St
Louis and Margaret of Provence.
Archivolt: scenes from the Legend
of St Marcellus. About 1260

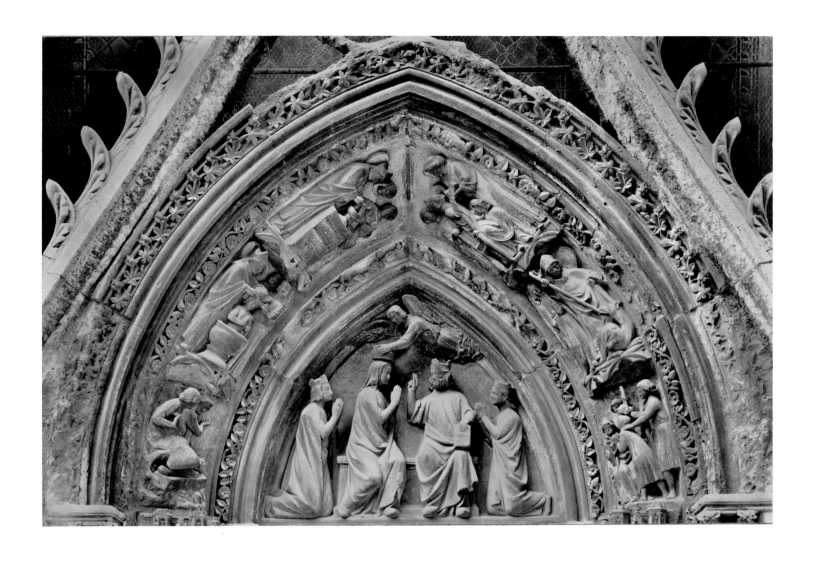

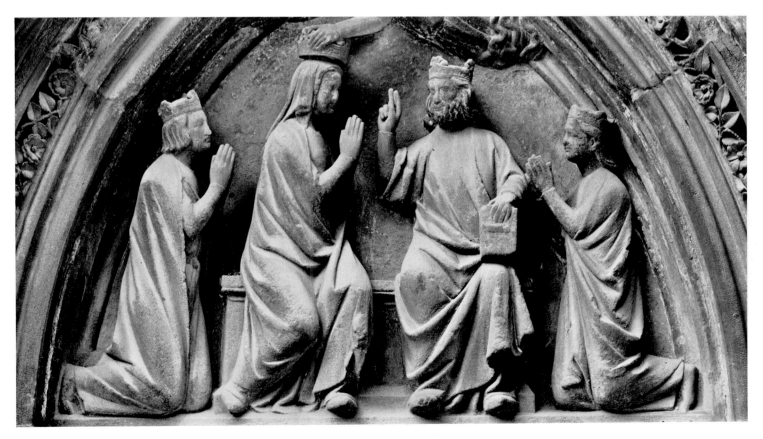

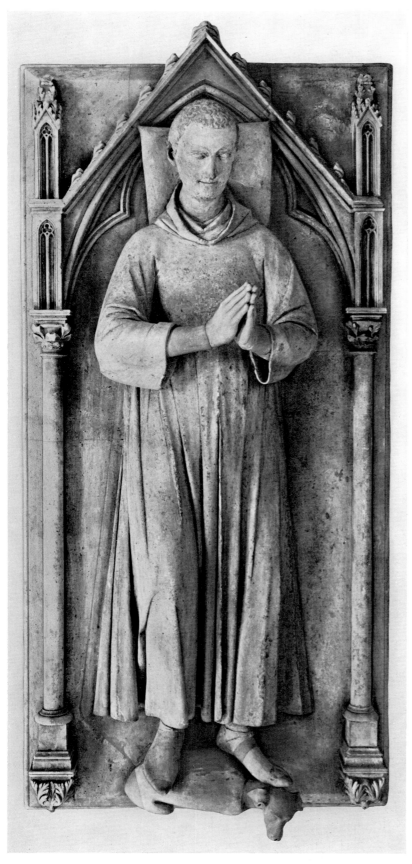
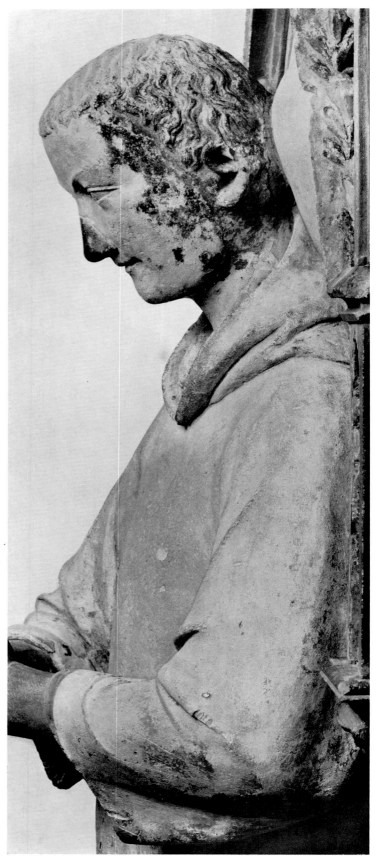

272 Saint-Denis, abbey church. Tomb monument (from Royaumont) of Louis of France. Post 1260

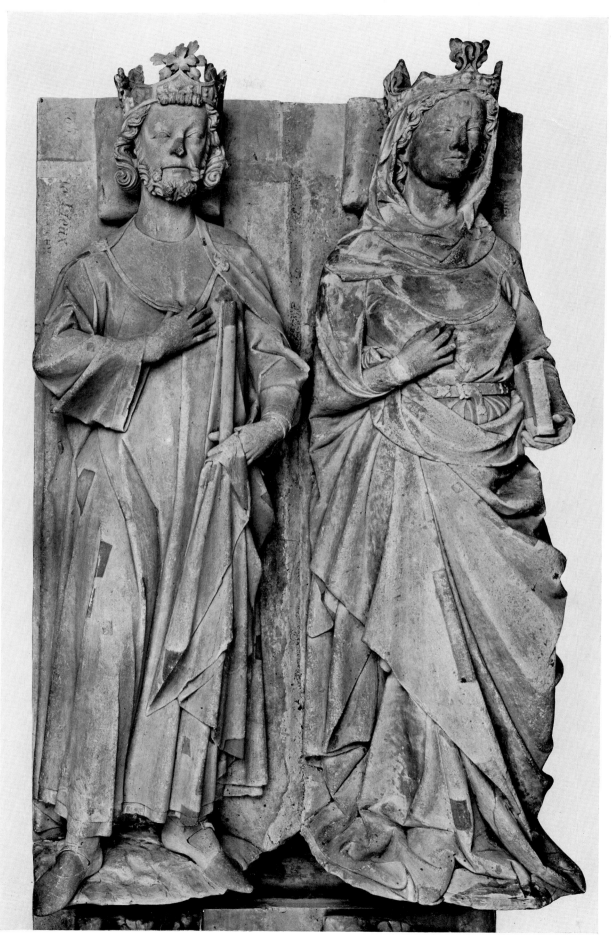

273 Saint-Denis, abbey church. Tomb monument of Robert the Pious and Constance of Arles. 1263–64

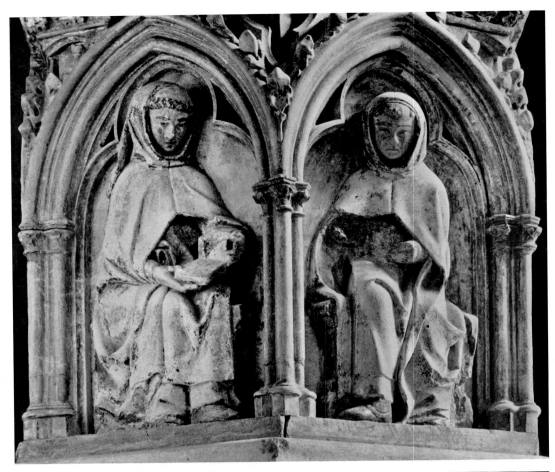

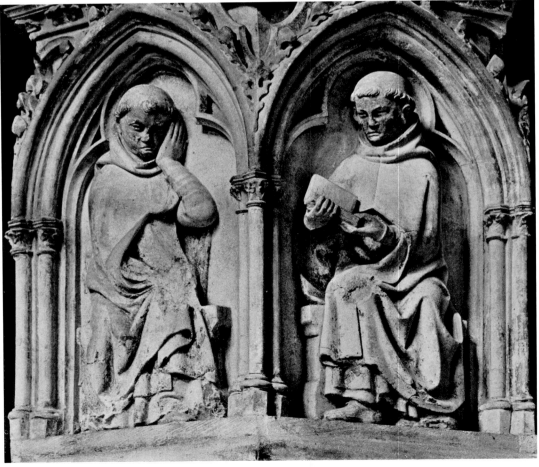

274 Provins, Hôpital Général. Tomb monument for the heart of Count Thibaut V of Champagne. Shortly after 1270

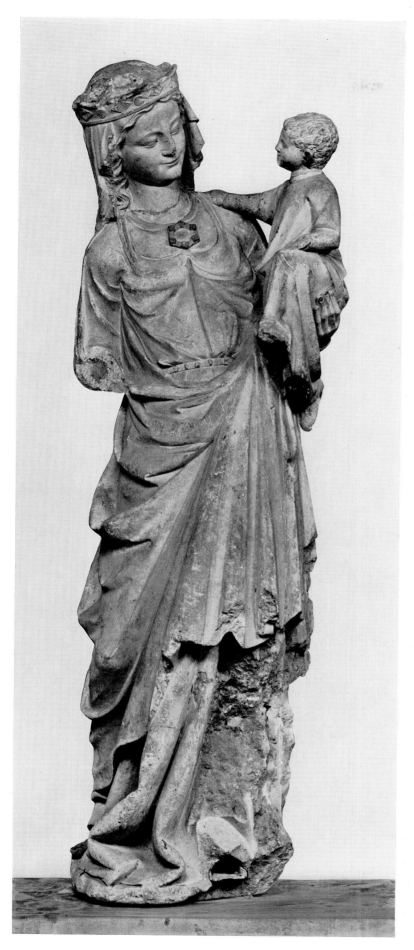
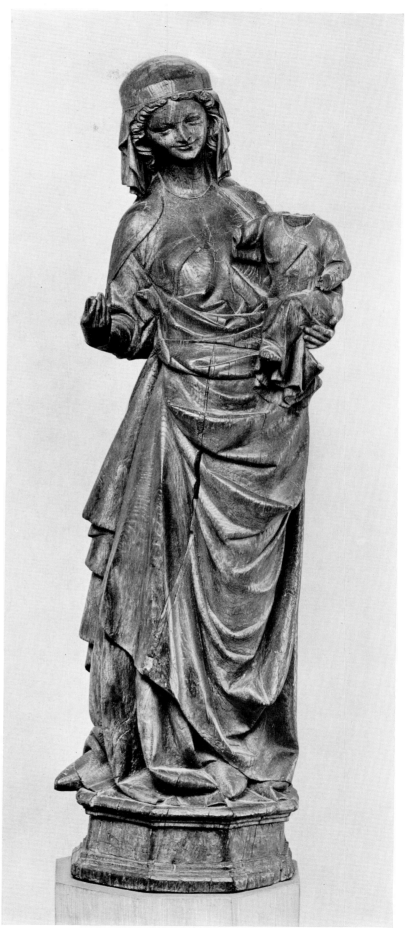

275 *Left*. Virgin from Saint-Corneille, Compiègne (former abbey church). About 1270. (Compiègne, Saint-Jacques).
Right. Virgin from Abbeville. About 1270. (Paris, Louvre)

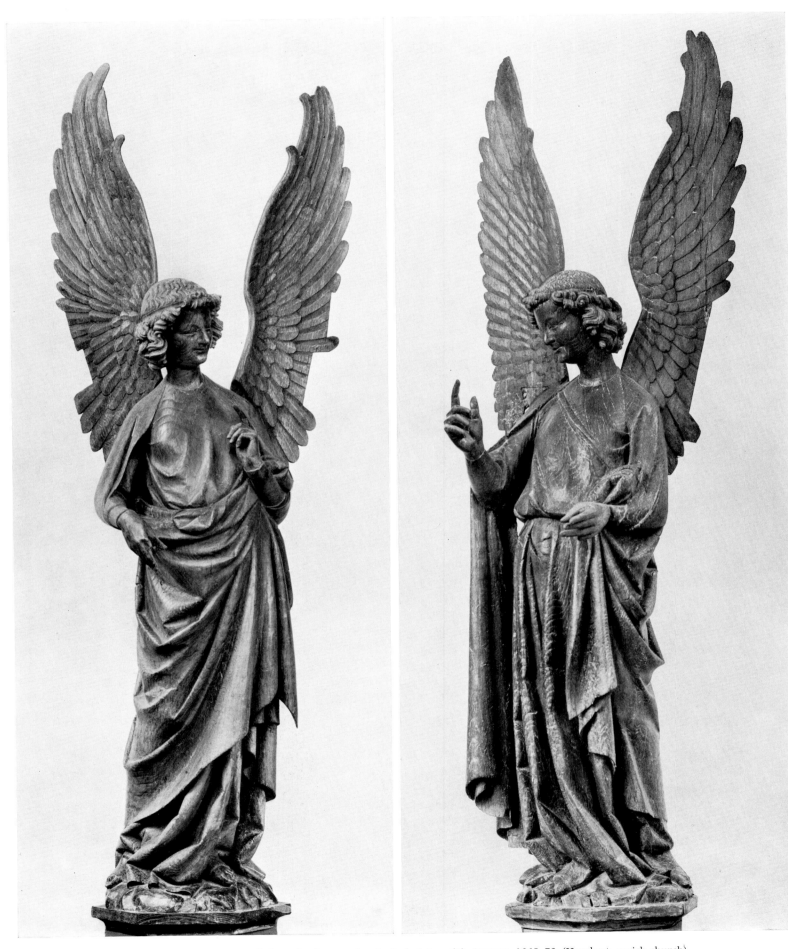

276　Angels (wings restored) from the destroyed cathedral at Arras(?). Approx. 1265–70. (Humbert, parish church)

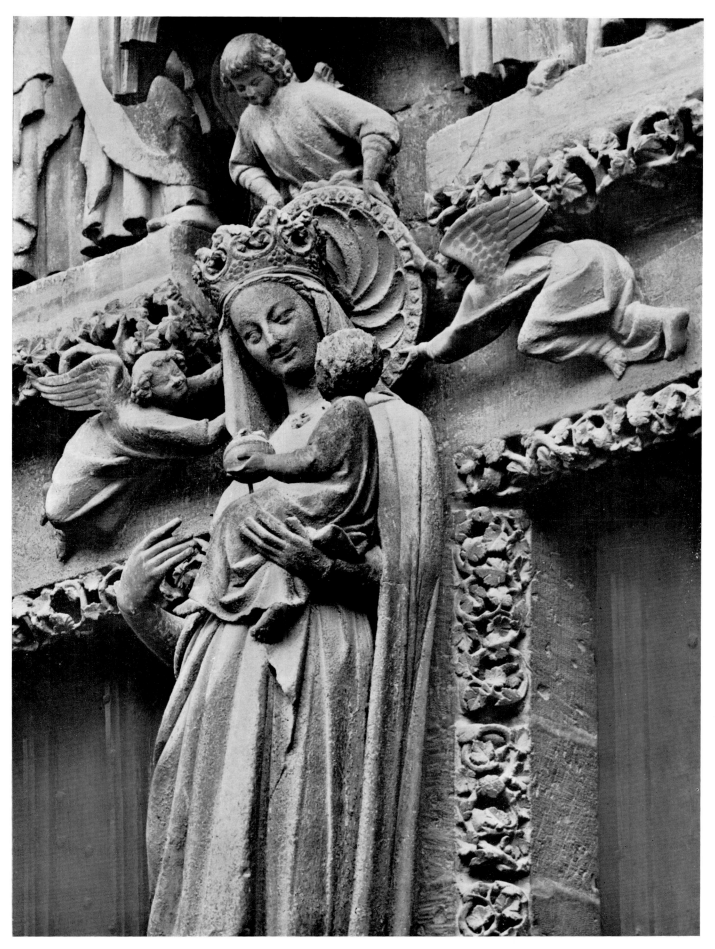

277 Amiens cathedral, south transept portal. Trumeau: Virgin and Child (Vierge dorée). Between 1259 and 1269

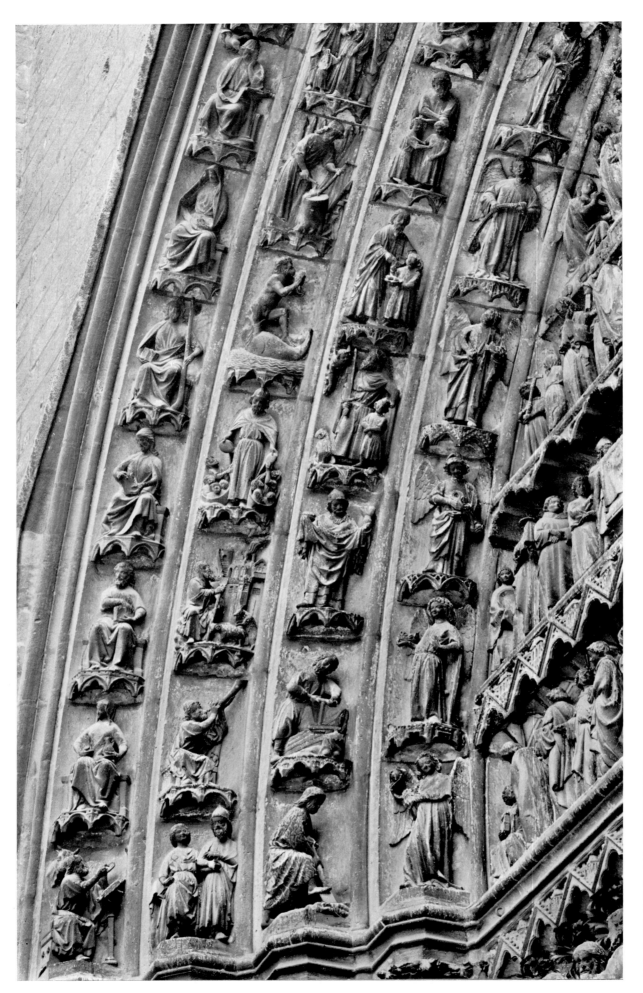

278, 279 Amiens cathedral, south transept portal.
278 Left archivolt: (reading from the inside) angels, Old Testament figures, prophets, New Testament figures.
279 Portal. Trumeau: Virgin and Child (Vierge dorée). Tympanum: scenes from the life of St Honoratus. Lintel: apostles. Archivolt: angels, Old Testament figures, prophets, New Testament figures. Jambs: angels, unidentified figures. Between 1259 and 1269

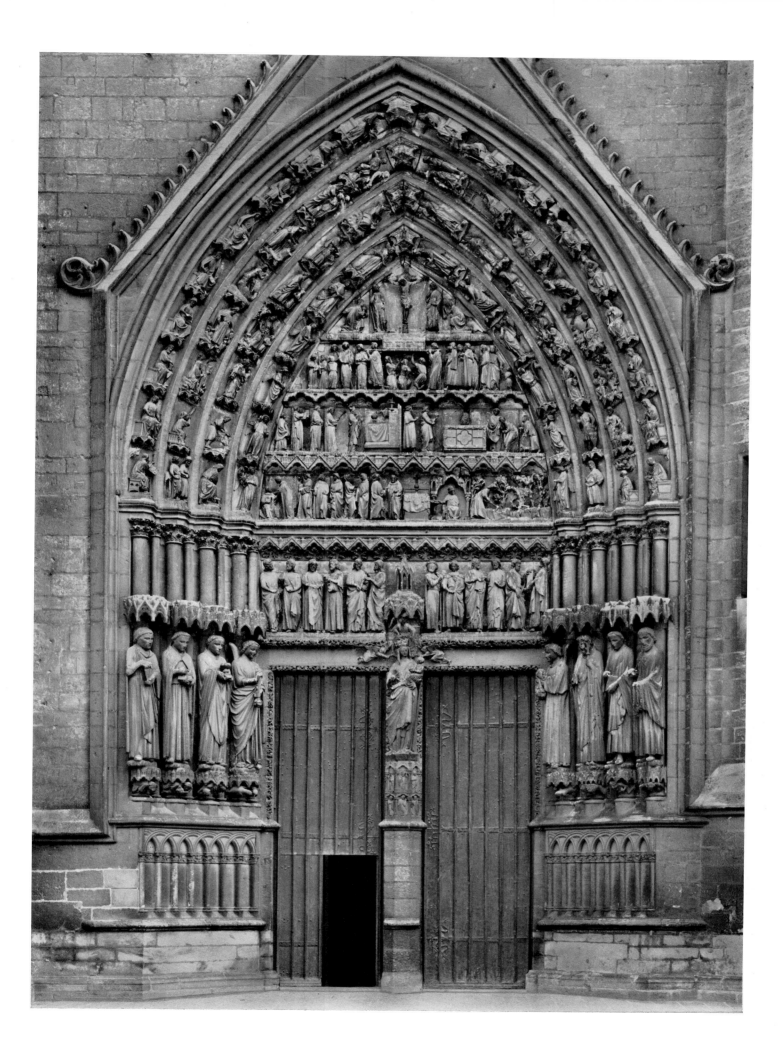

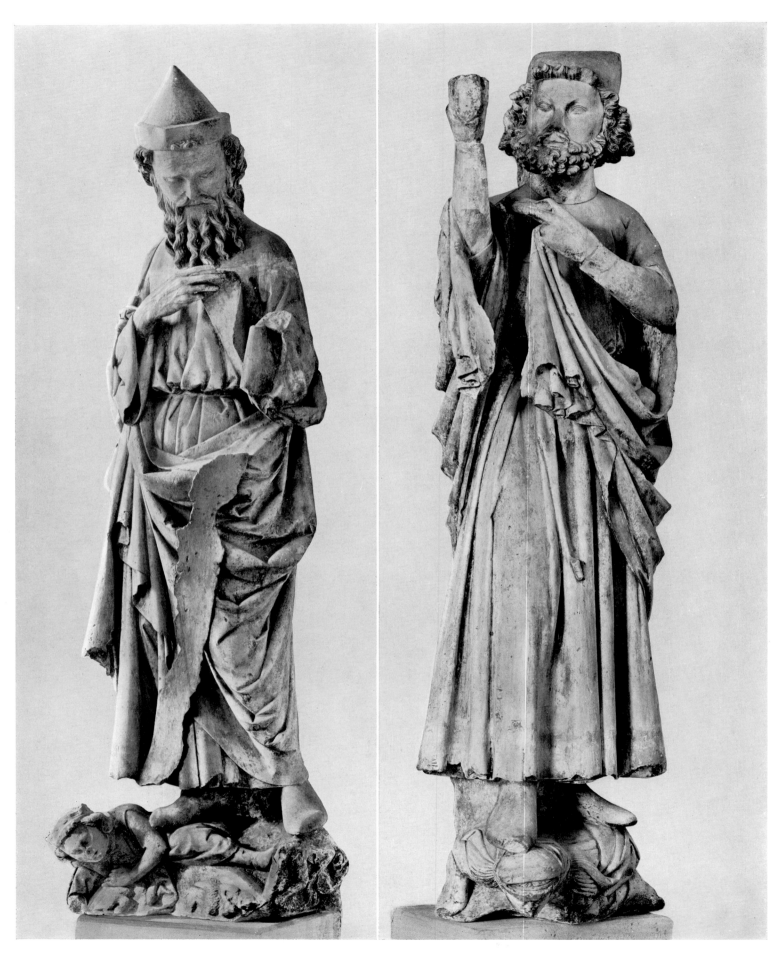

280 Old Testament figures. About 1270 (Troyes, Musée des Beaux-Arts)

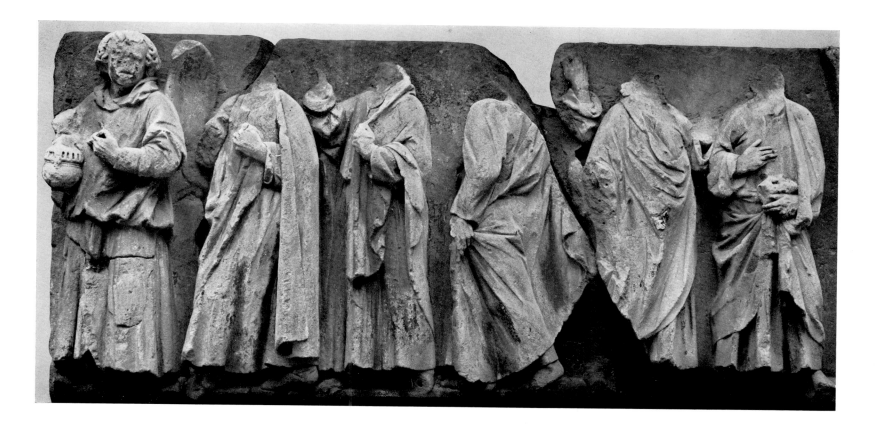

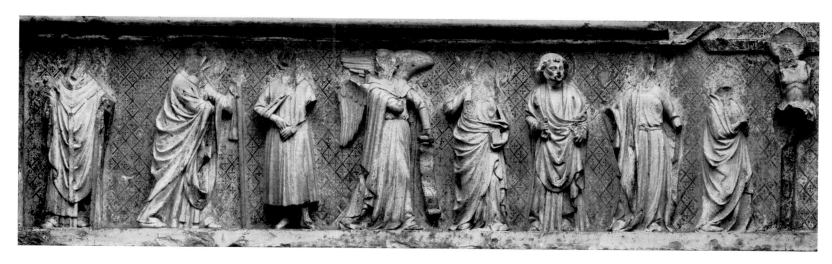

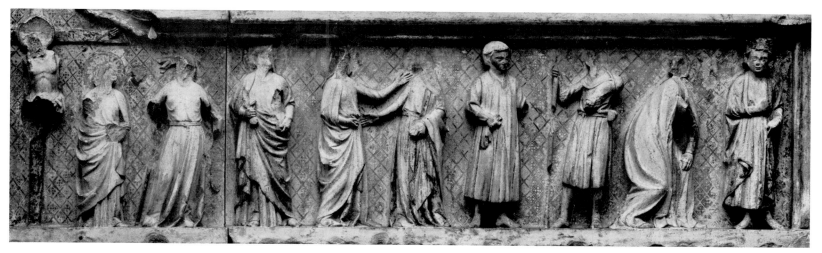

281 *Top*. Relief depicting apostles, from the portal of Notre-Dame-la-Ronde, Metz. 1240–50. (Metz cathedral, crypt).
Middle and bottom. Altar retable from Saint-Germer-de-Fly. Crucifixion group, with on either side, Mary and John, Ecclesia and
Synagogue, Peter and Paul, Annunciation and Visitation; content of the remaining scenes not clear. 1259–66. (Paris, Musée de Cluny)

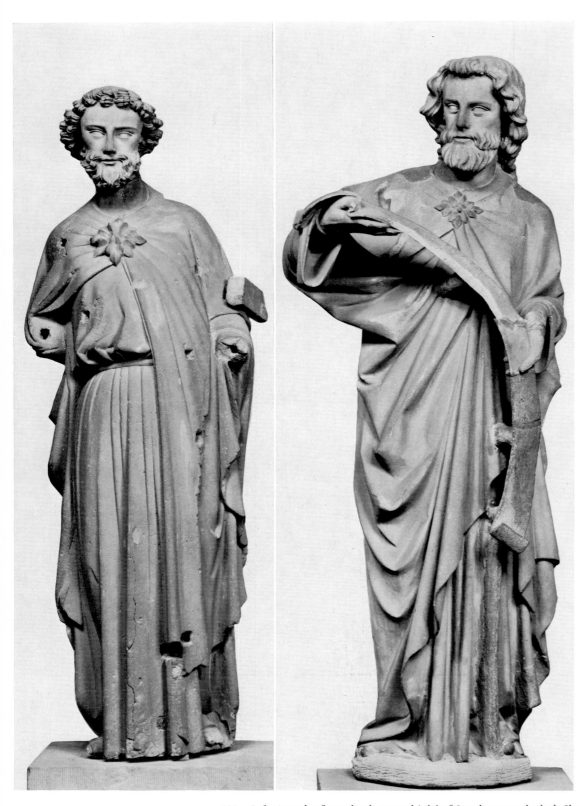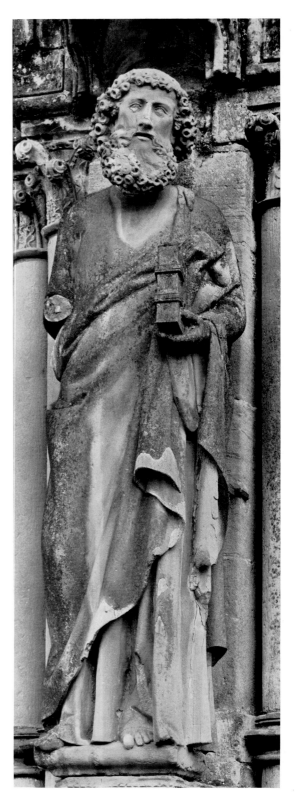

282 *Left*. Apostles from the destroyed jubé of Strasbourg cathedral. Shortly before 1261.
(Strasbourg, Musée de l'Œuvre Notre-Dame).
Right. Neuweiler, SS. Peter and Paul (collegiate church), north portal. St Paul. 1240–50

283 Auxerre cathedral, west portal, right doorway. Tympanum and archivolt: Infancy of Christ, story of John the Baptist.
On the right: the judgment of Solomon. About 1260

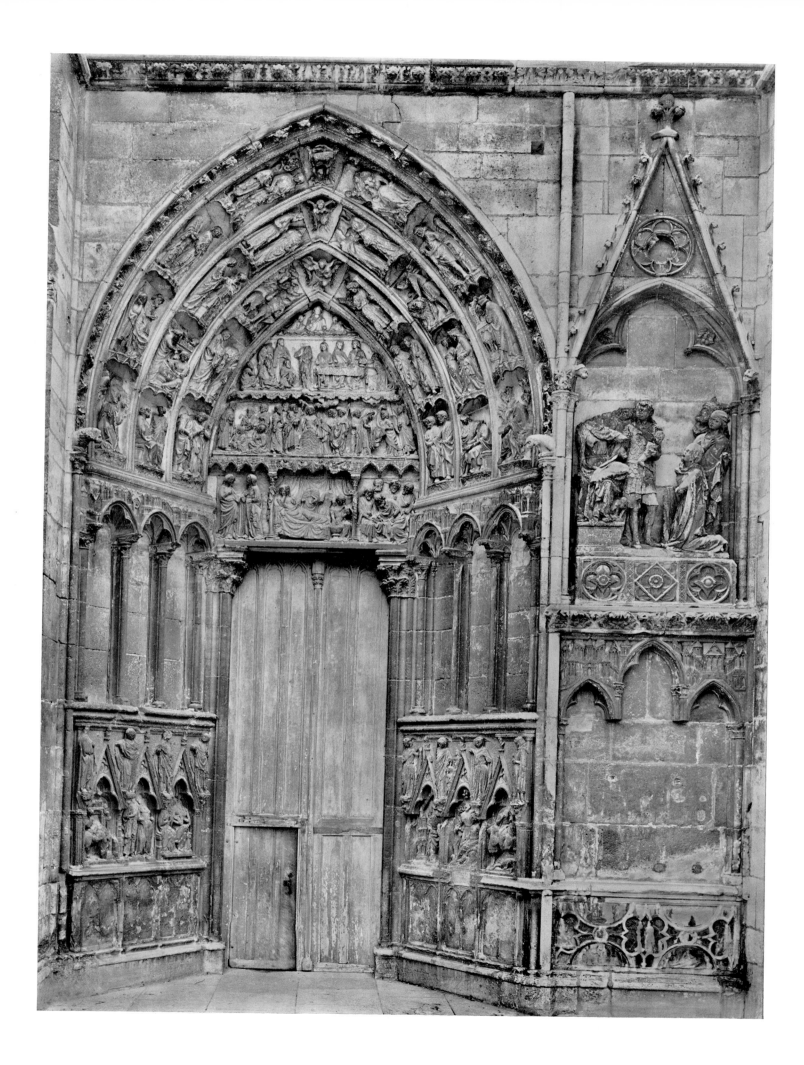

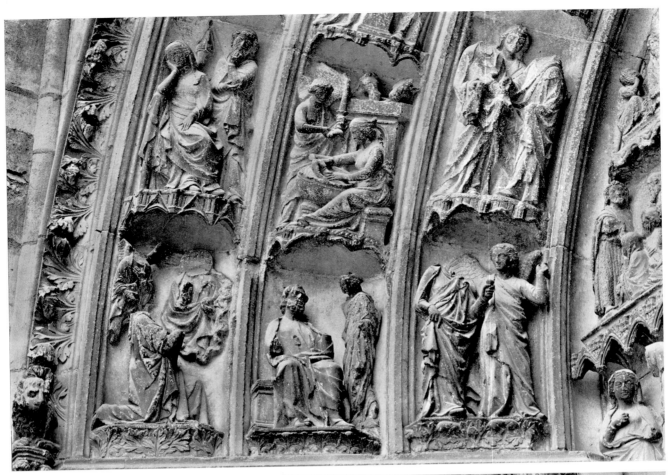

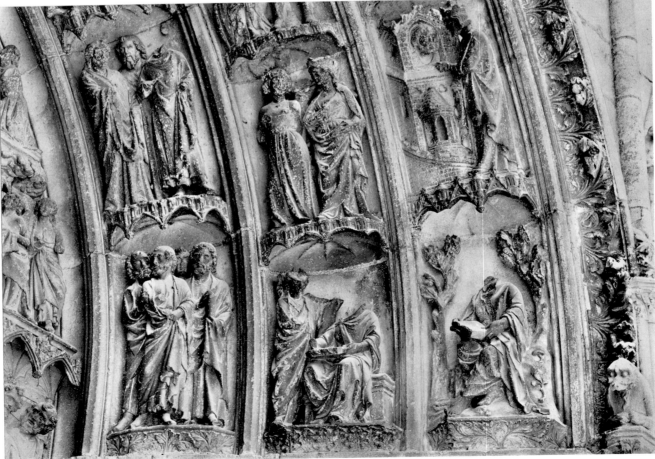

284 Auxerre cathedral, west portal, right doorway, archivolt. *Top*. Detail of left side: Infancy of Christ.
Bottom. Detail of right side: scenes from the life of John the Baptist. About 1260

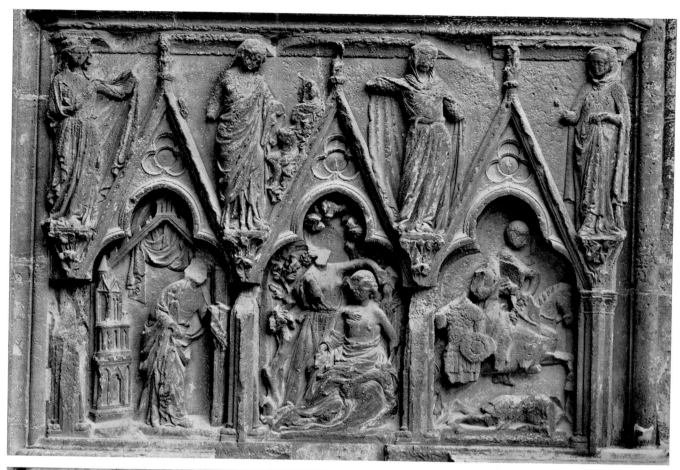

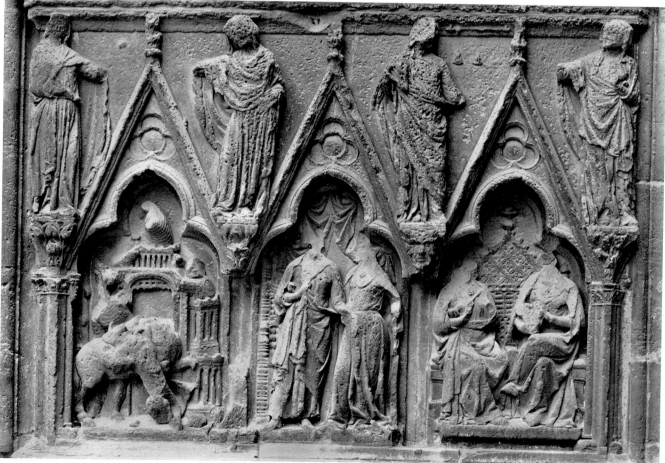

285 Auxerre cathedral, west portal, right doorway. Jamb socles: story of David and Bathsheba; (between the gables) Philosophy (top left) and the Liberal Arts. About 1260

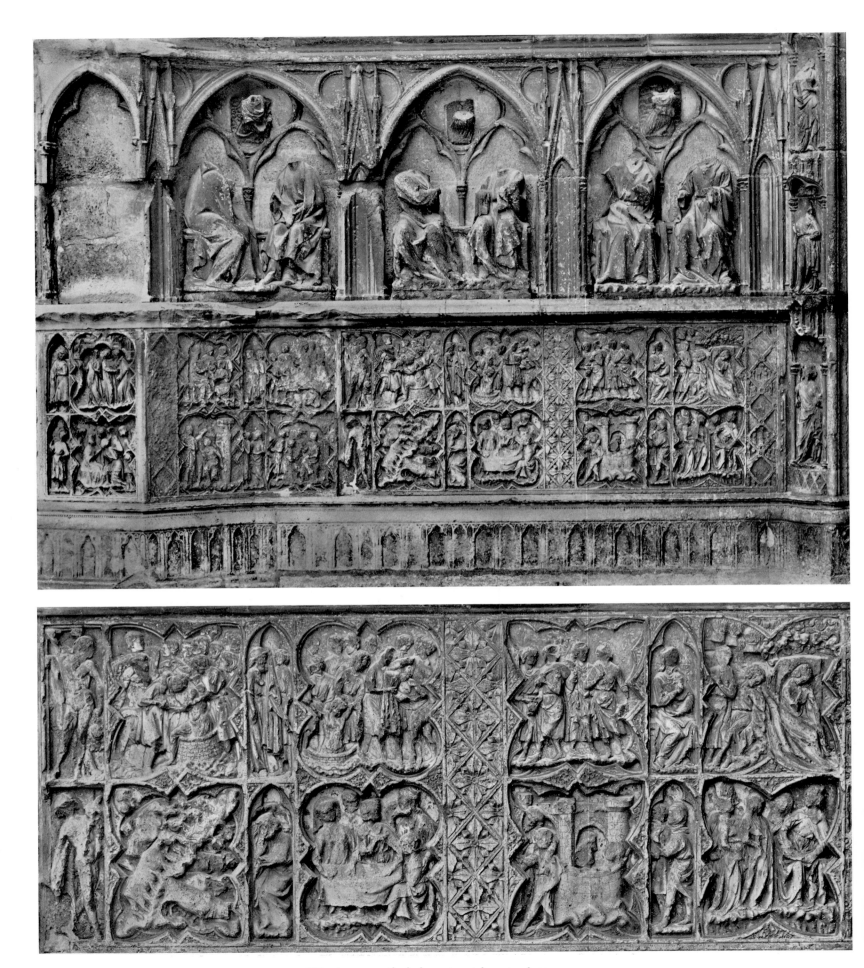

286 Auxerre cathedral, west portal, centre doorway.
Top. Socle, left jamb: in the niches, prophets(?), and (below) the story of Joseph.
Bottom. Detail from the story of Joseph. About 1270

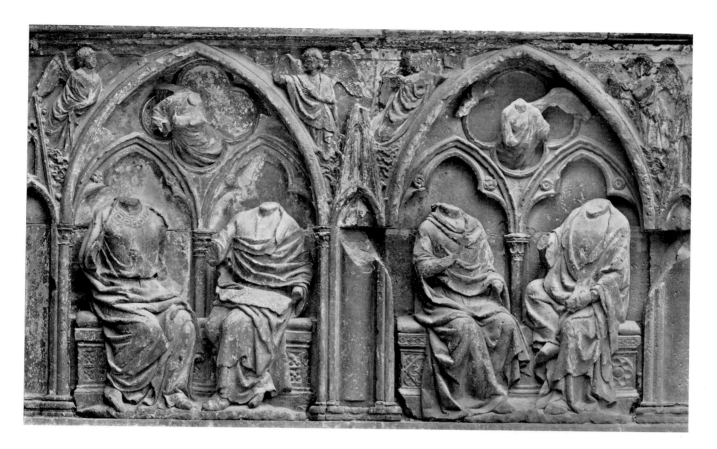

287 Auxerre cathedral, west portal, centre doorway, right jamb. Details of socle decoration.
Top. Prophets(?) and, far left, a Sibyl(?). *Bottom*. Story of the prodigal son; in the centre medallion, Luxuria.
About 1260

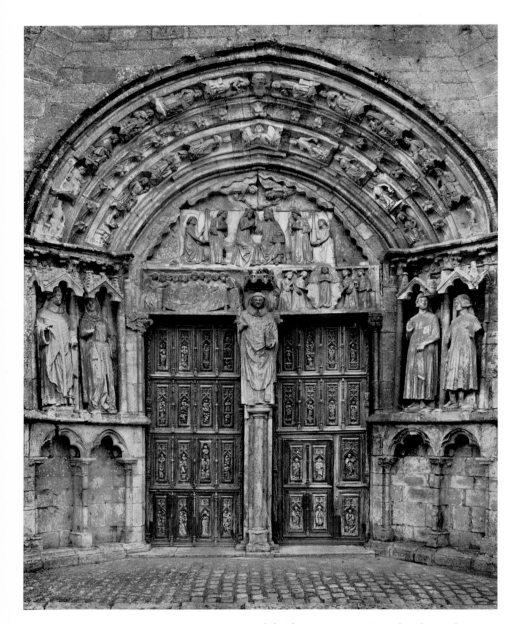 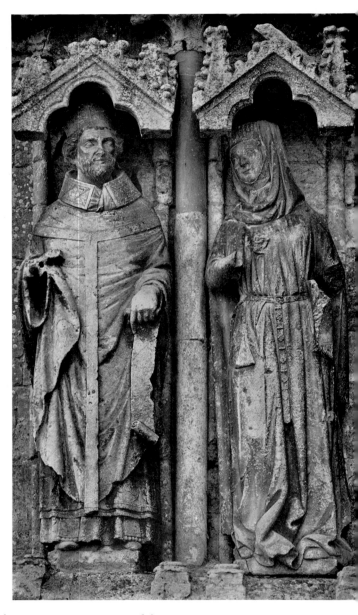

288 Saint-Thibault-en-Auxois, priory church, north transept portal. Tympanum: Coronation of the Virgin.
Lintel: Death and Assumption of the Virgin. Archivolt: Wise and Foolish Virgins (inside), Old Testament scenes.
Jambs: left, bishop and female figure; right, two male figures. Trumeau: St Theobald.
Right. Detail of left jamb. 1240–50

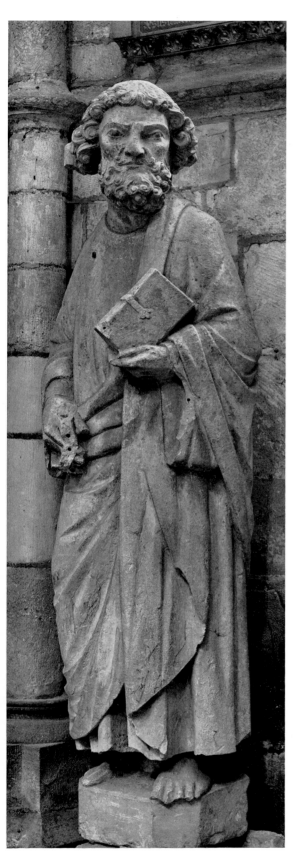
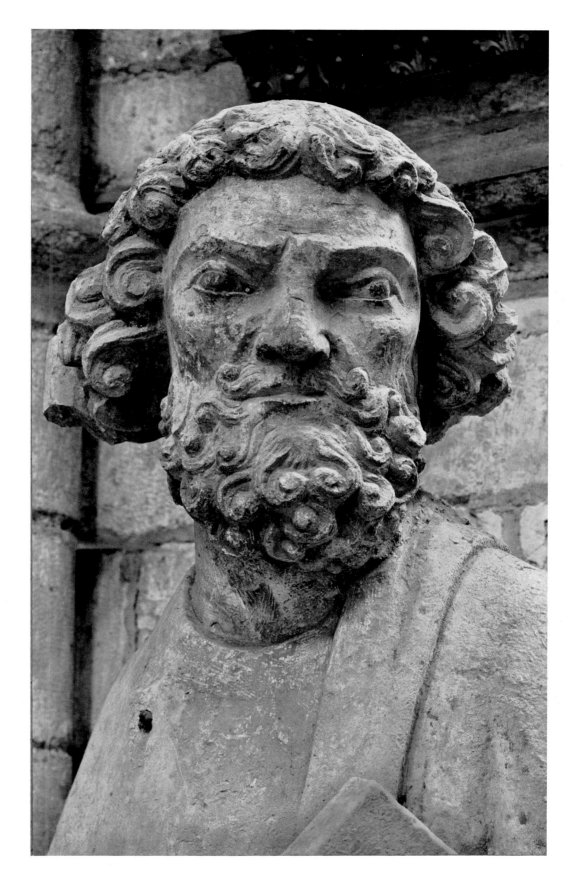

289 Chablis, Saint-Martin. St Peter, from Saint-Pierre, Chablis. About 1250

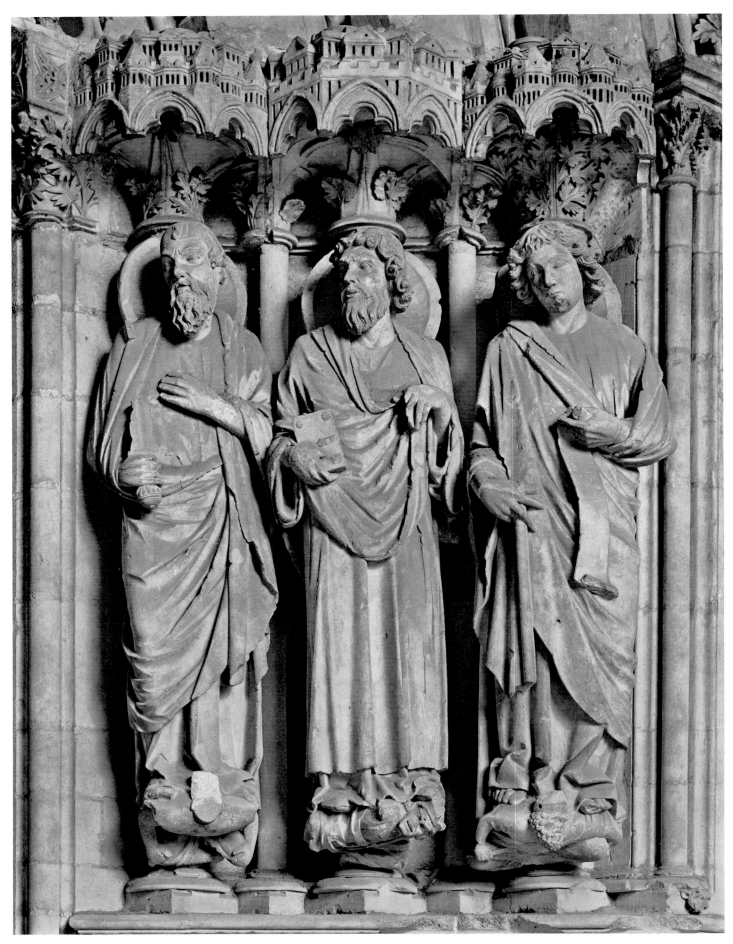

290 Le Mans, Notre-Dame-de-la-Couture, west portal. Right jamb: Paul and two other apostles.
About or shortly after 1248

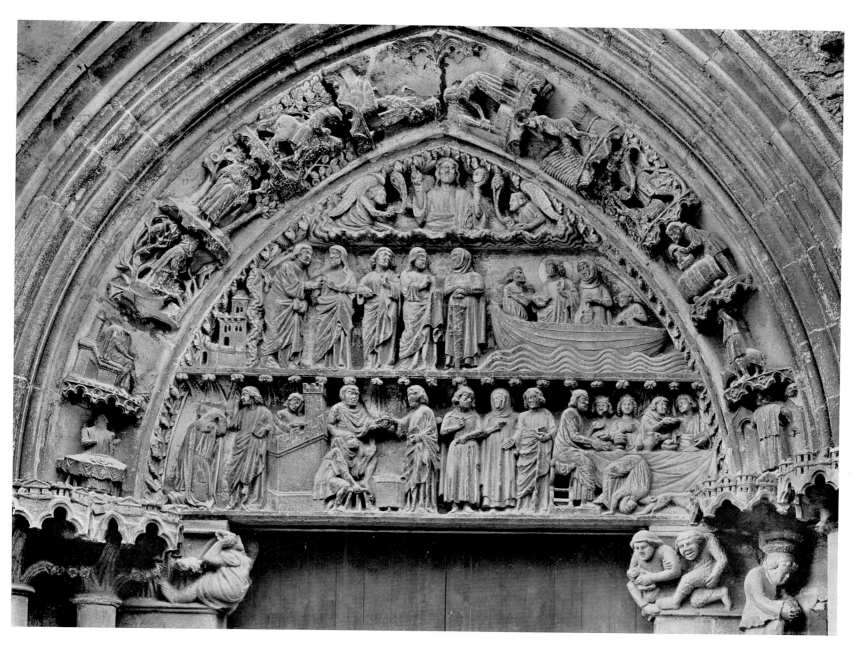

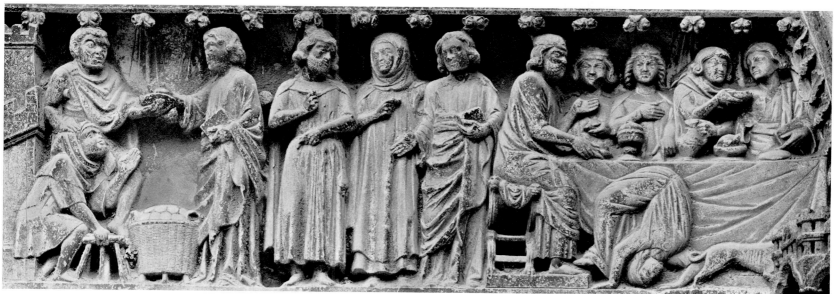

291 Semur-en-Auxois, Notre Dame, north transept portal. Tympanum: story of the apostle Thomas in India.
Archivolt: Calendar. 1249–50

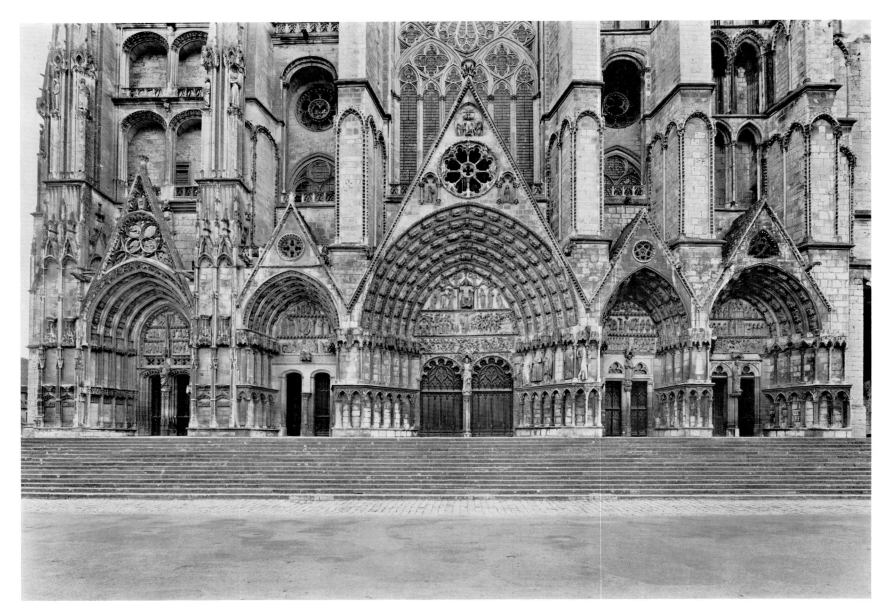

292 Bourges cathedral, west façade. 1240–60/early sixteenth century

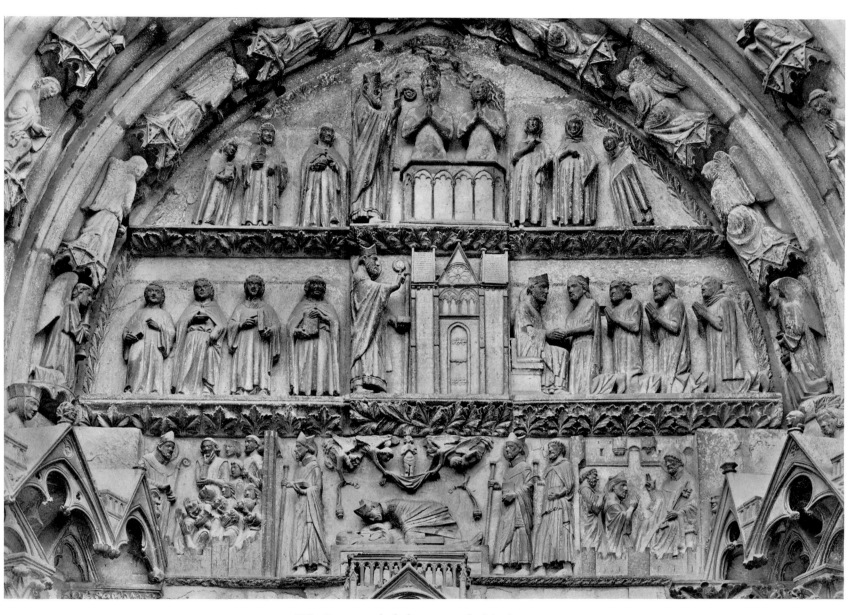

293 Bourges cathedral, west portal, right doorway.
Tympanum: Ursinus is despatched by Peter on his mission to Bourges and on arrival baptizes the Roman senator Leocadius.
About 1240

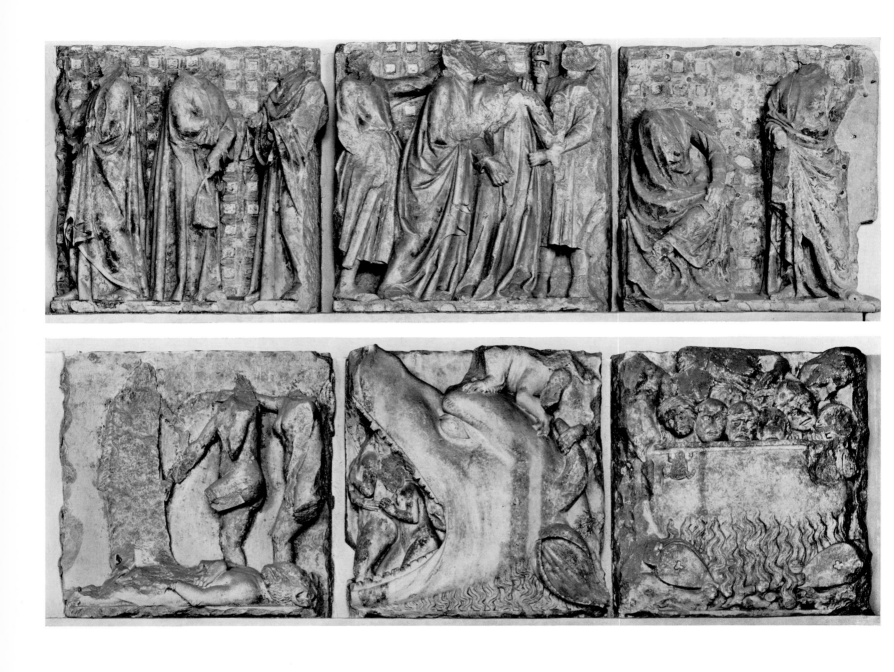

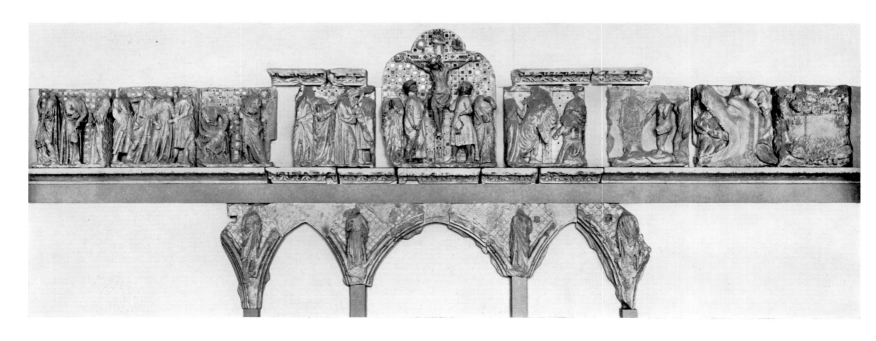

294 Fragments from the former jubé of Bourges cathedral.
Top. Payment of the thirty pieces of silver, kiss of Judas, maidservant or Christ before Pilate.
Middle. Christ in Limbo.
Bottom. Free reconstruction of the jubé. Towards 1260. (Paris, Louvre)

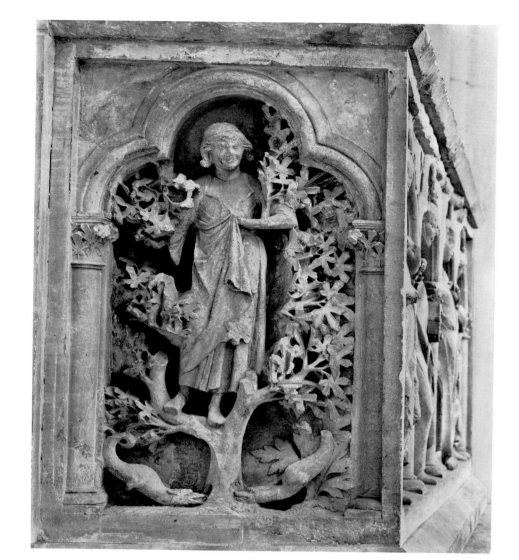

295 Joigny, Saint-Jean. Tomb monument of Adelais of Champagne, from Dilo abbey. About 1260.
Top. Foot end: parable from the story of Barlaam and Josaphat.
Bottom. Side view: arcade with two male and two female figures.

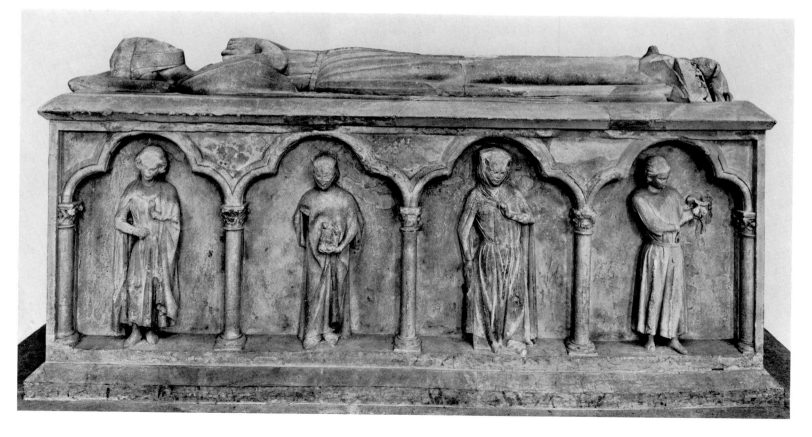

296 Poitiers cathedral, west portal. About 1250

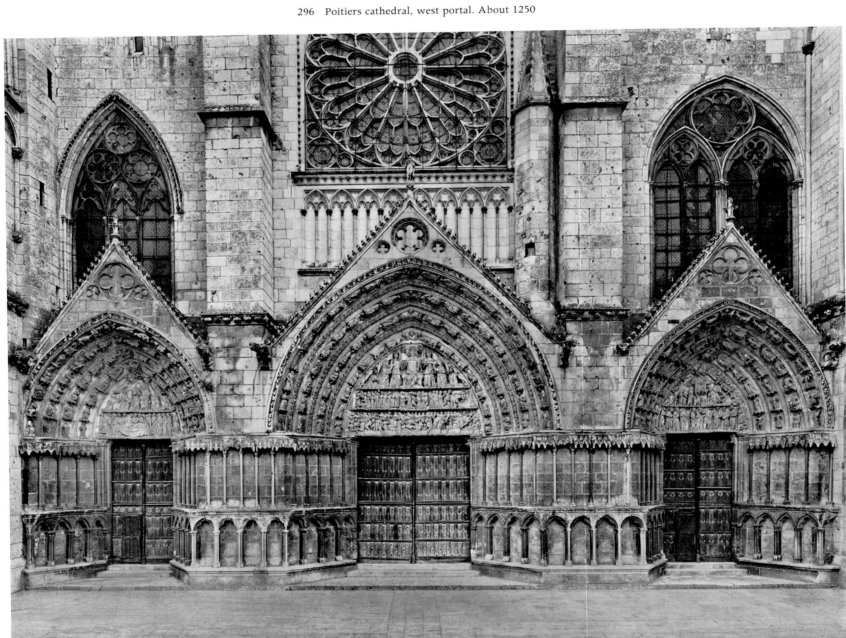

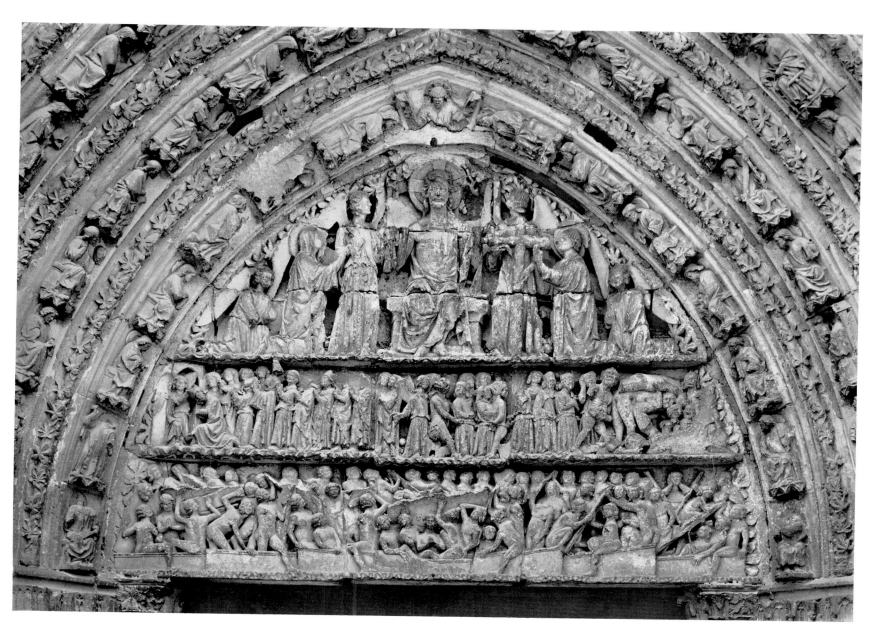
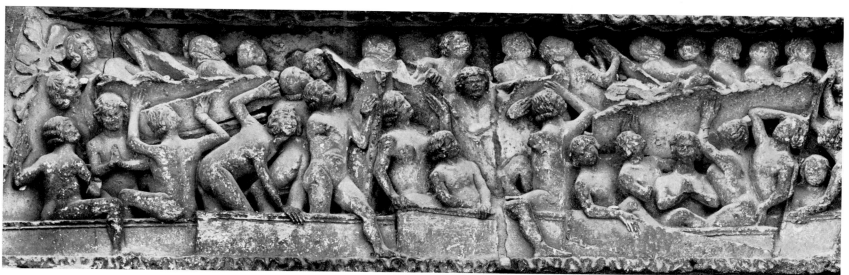

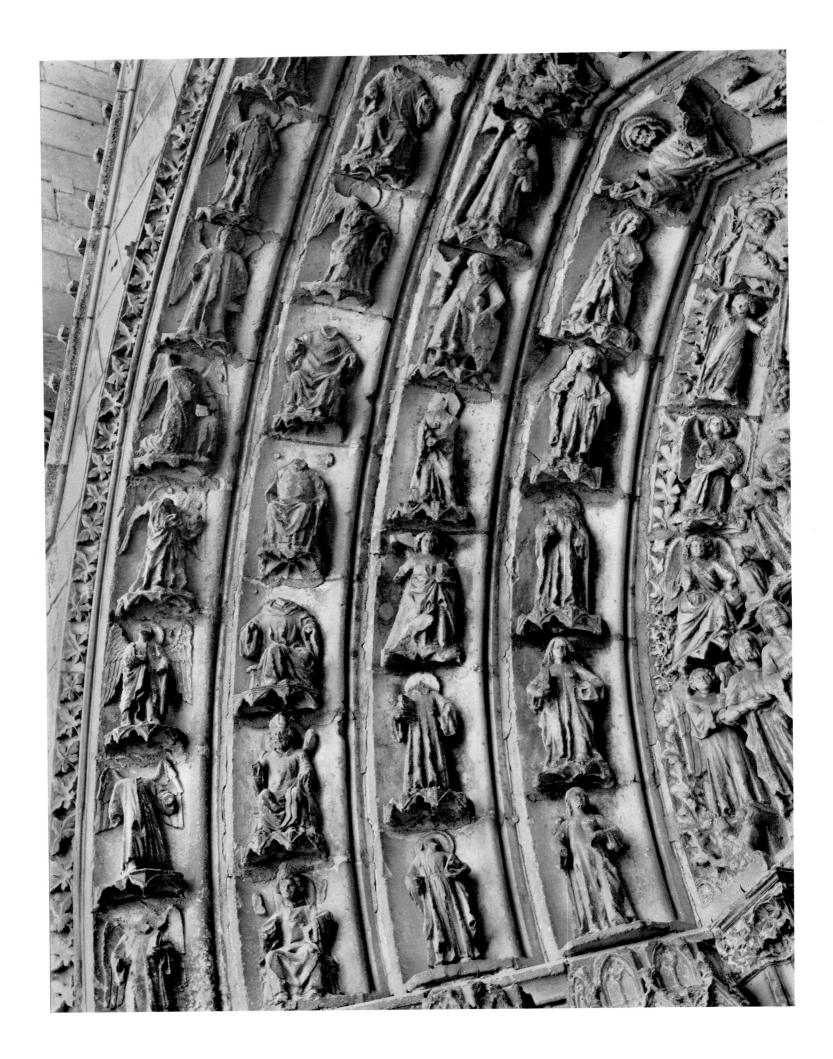

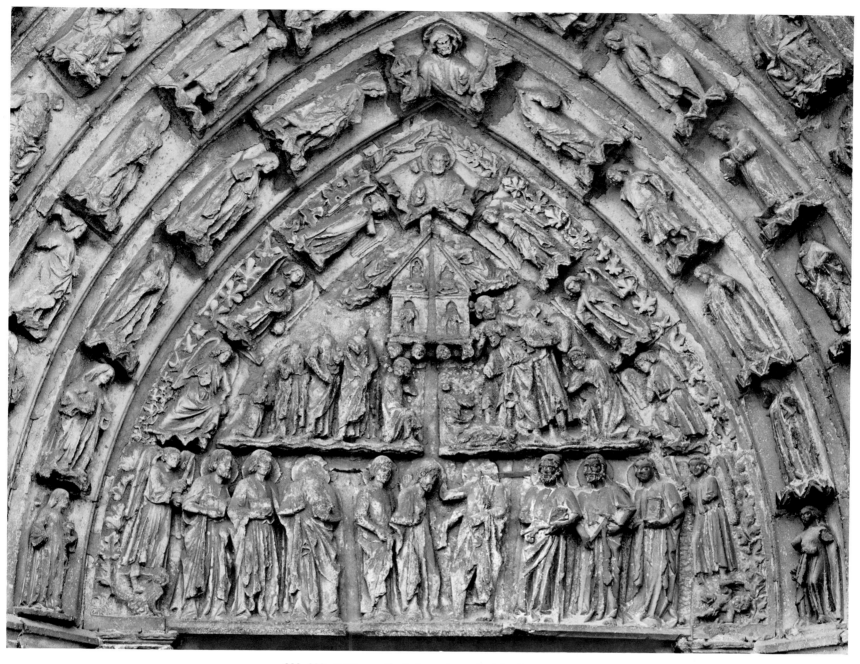

298, 299 Poitiers cathedral, west portal, right doorway.
298 Left archivolt: (from the outside) angels, ecclesiastics, martyrs, Wise Virgins.
299 Tympanum: (bottom register) Doubting Thomas, (above) almsgiving and the palace built in Heaven.
Archivolt: Wise Virgins (left), Foolish Virgins (right); martyrs. About or shortly after 1250

300 Charroux, Saint-Sauveur, former abbey church.
Foolish Virgins, possibly from the archivolt of the centre doorway of the west portal. About 1250.
(Saint-Sauveur, chapter house)

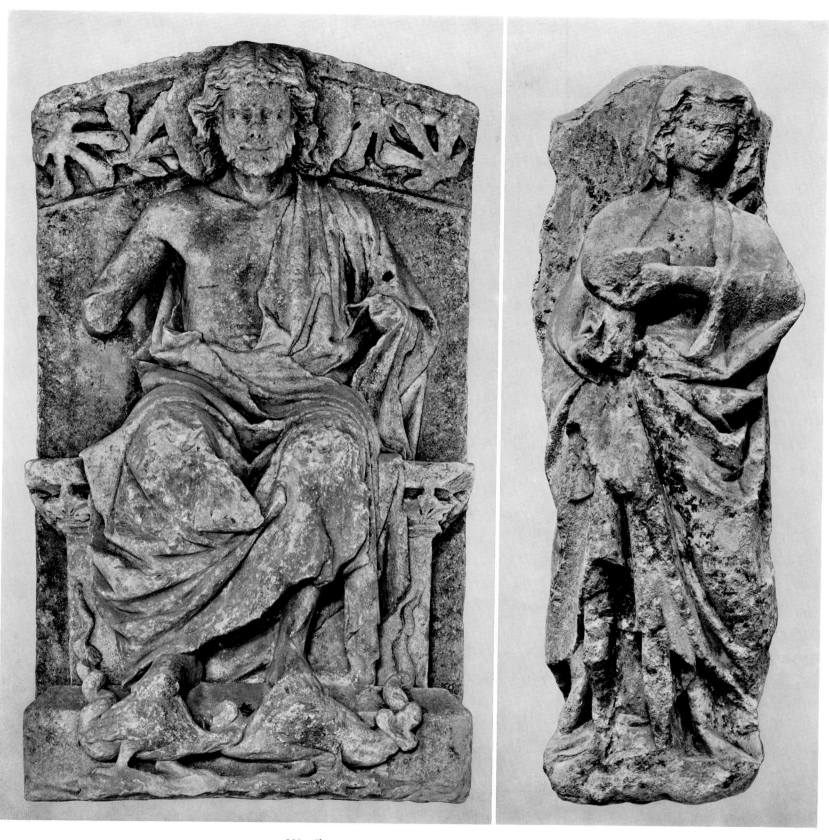

301 Charroux, Saint-Sauveur, former abbey church.
Christ as Judge, and one of the Wise Virgins, possibly from the tympanum and archivolt of the centre doorway of the west portal.
About 1250. (Saint-Sauveur, chapter house)

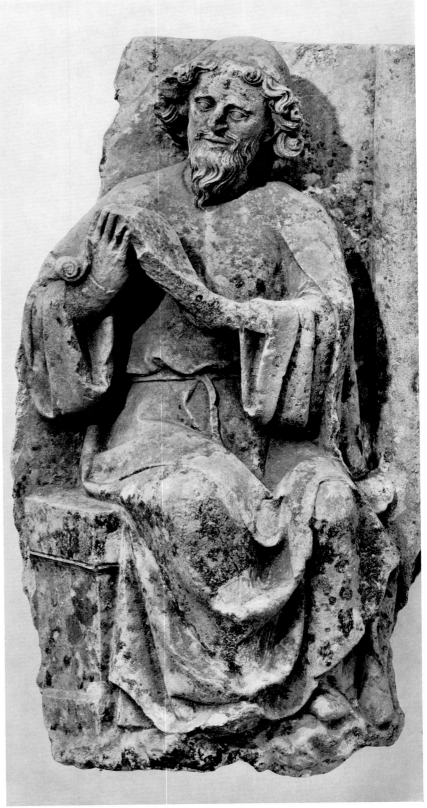

302 Charroux, Saint-Sauveur, former abbey church.
King and prophet, possibly from the archivolt of the centre doorway of the west portal. About 1250.
(Saint-Sauveur, chapter house)

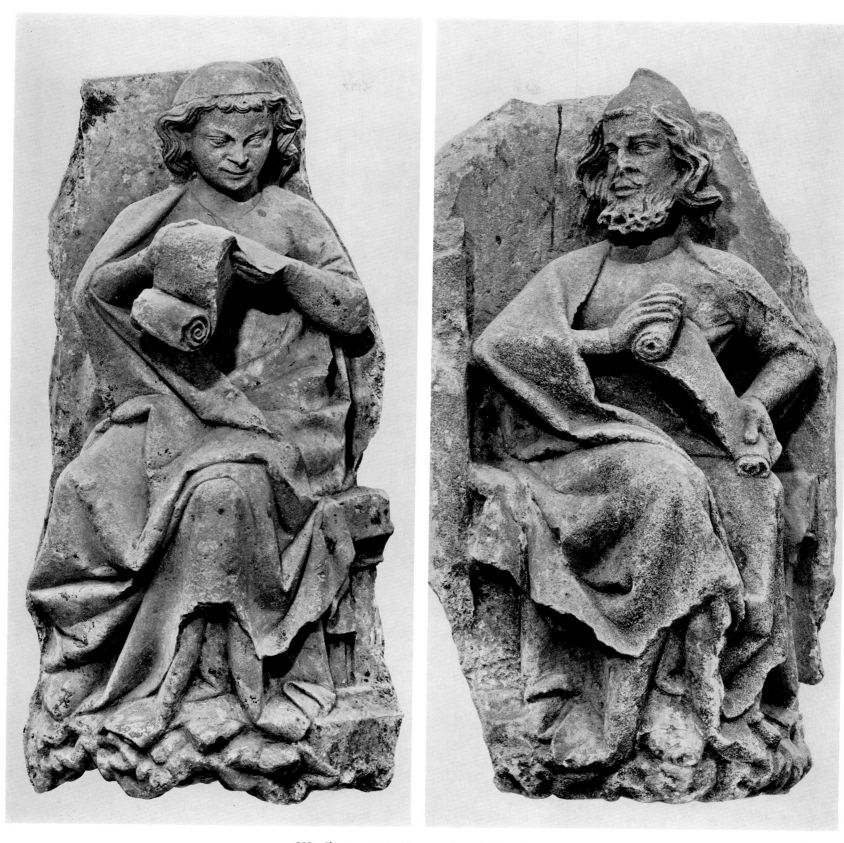

303 Charroux, Saint-Sauveur, former abbey church.
Two prophets, possibly from the archivolt of the centre doorway of the west portal. About 1250.
(Saint-Sauveur, chapter house)

304, 305 Bordeaux, Saint-Seurin, collegiate church, south portal. Last Judgment and apostles.
Early thirteenth century and about 1250.
305 Left jamb: Andrew and Peter. About 1250

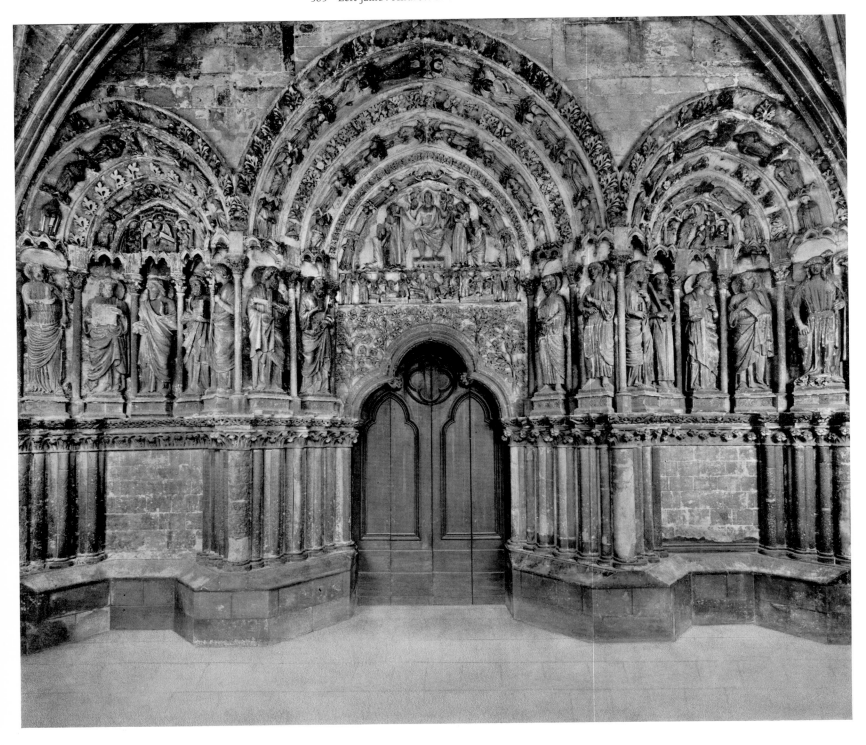

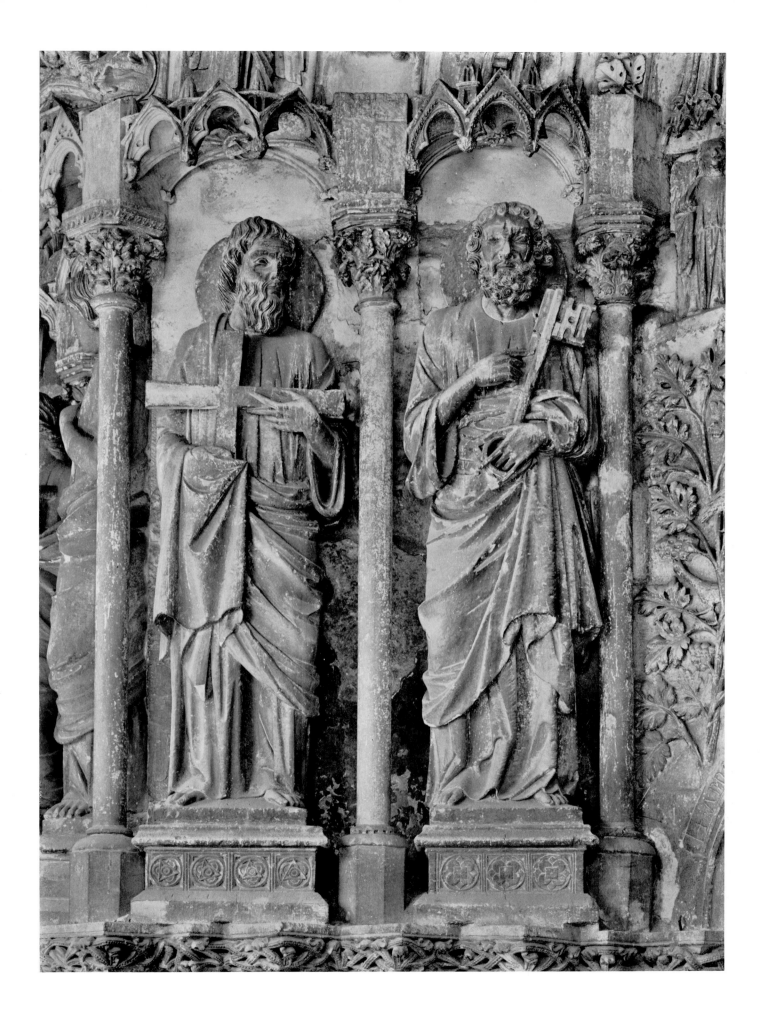

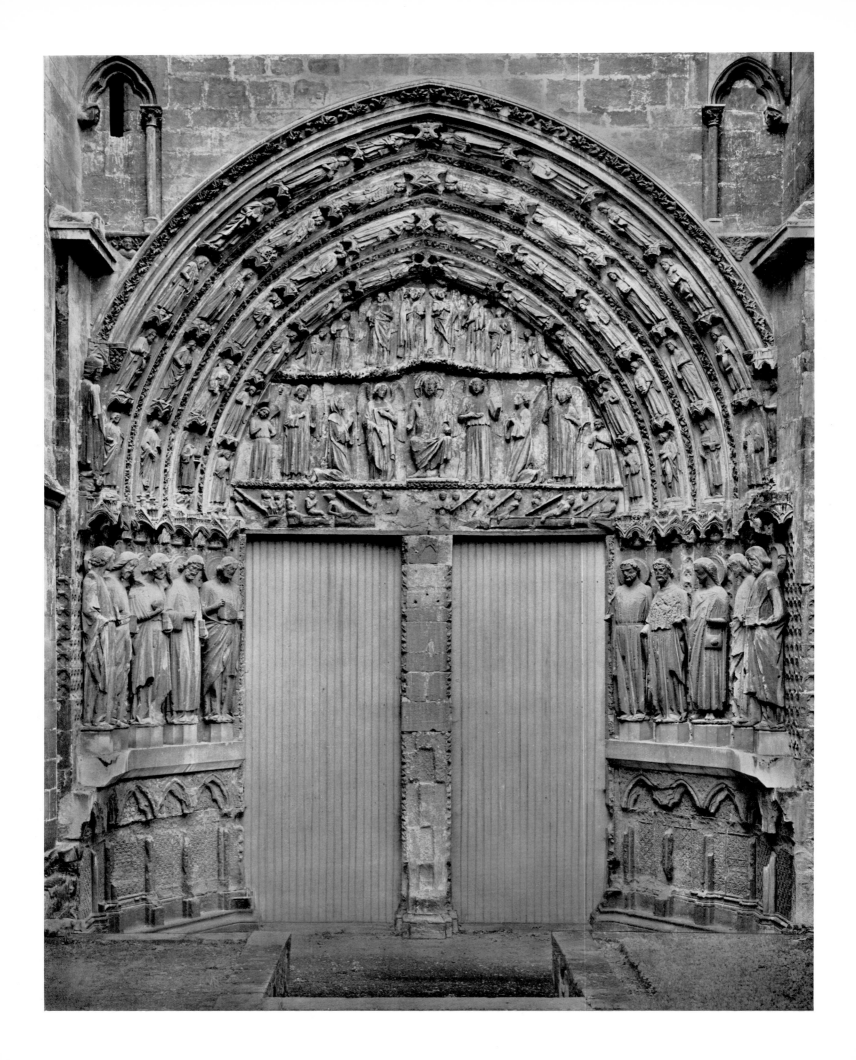

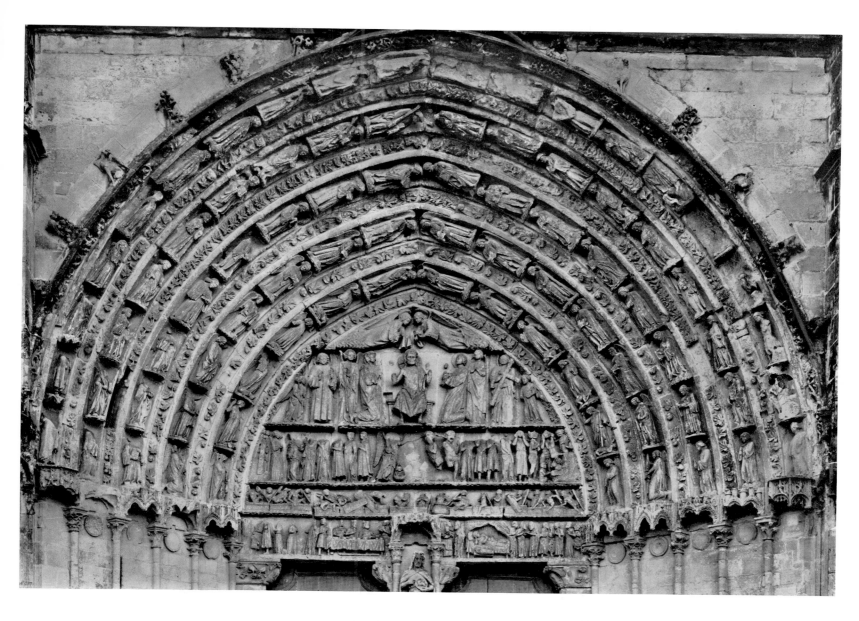

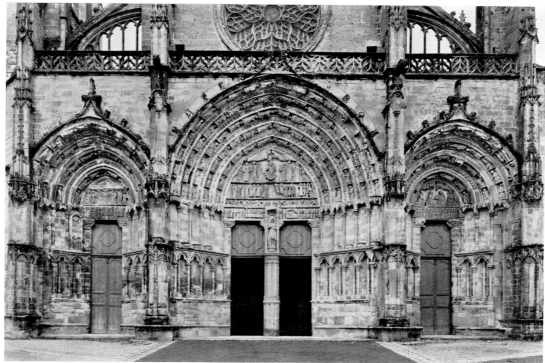

306 Bordeaux cathedral, Portail Royal.
Tympanum and lintel: Last Judgment.
Jambs: apostles. About 1260(?)

307 Bazas cathedral, west portal.
Top. Centre doorway. Tympanum: Last
Judgment; (below) story of John the
Baptist. Archivolt: standing figures of
angels and ecclesiastics.
Bottom. General view. About 1250

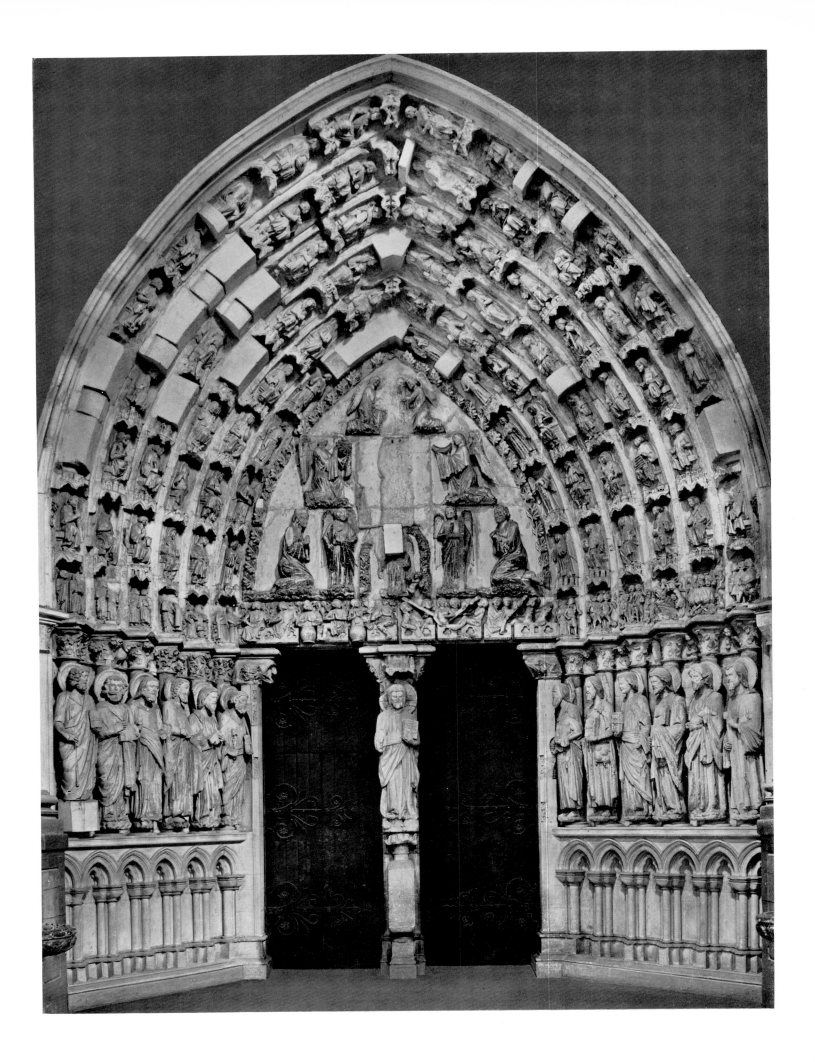

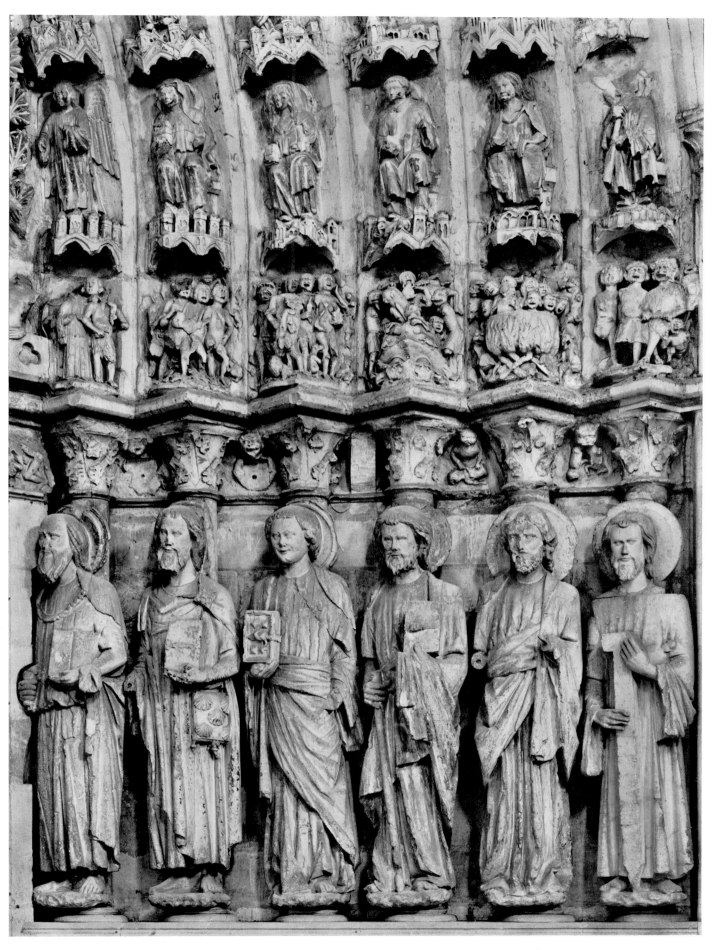

308, 309 Dax cathedral, former west portal, now in the north transept. Last Judgment.
309 Right jamb and detail of archivolt. Apostles and Hell scenes. Third quarter of the thirteenth century

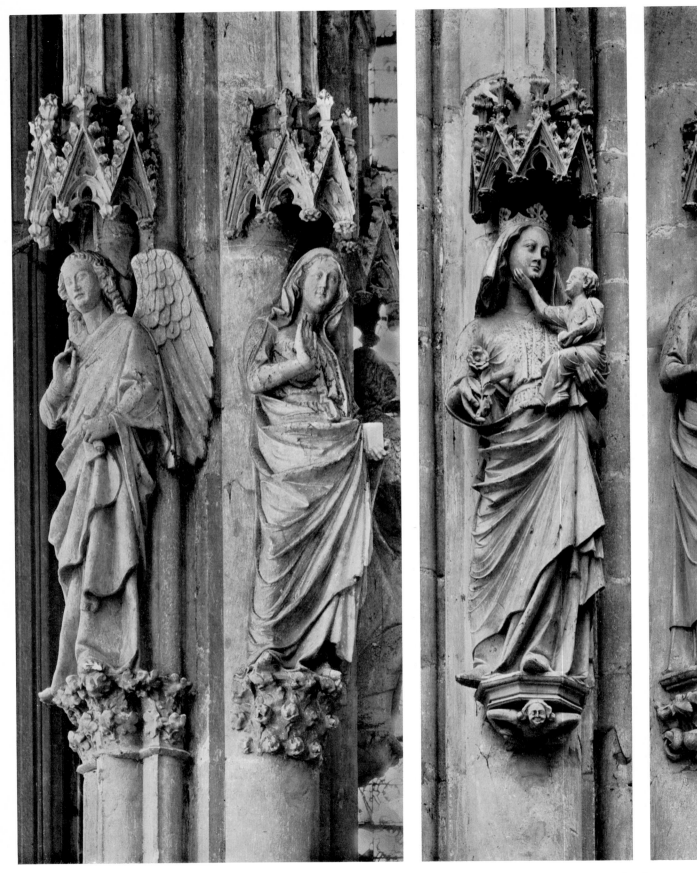

310 Carcassonne cathedral. *Left*. Annunciation, on the north pillar at the entrance to the choir.
Middle and right. Virgin and Child, St Nazarius(?), on the north-east pier of the crossing. About 1280

DOCUMENTATION

COMPILED BY
WILLIBALD SAUERLÄNDER
AND RENATE KROOS

THE WEST PORTALS OF THE ABBEY CHURCH OF SAINT-DENIS AND CHARTRES CATHEDRAL, AND THEIR SPHERE OF INFLUENCE

Pl. 1–3 top, ill. 1–3

SAINT-DENIS (SEINE), ABBEY CHURCH WEST PORTAL

The abbey of Saint-Denis was founded in the seventh century, with Dionysius, first bishop of Paris, as its patron saint. In the same century the kings of France started using the abbey church as their burial place. The abbey had custody of the royal insignia and standard, and from the twelfth century the French king described himself as 'vassal of St Dionysius'. Suger, who was abbot from 1122 to 1151, was regent of France during the Second Crusade (1147–49). It was Suger who commissioned the west doorways of the abbey church, the carvings on which are the earliest in the development of gothic sculpture.

State of preservation. 1771: removal of the jamb figures and lintels from all three doorways, and of the trumeau figure from the centre doorway; renovation of the left tympanum. The destroyed jamb figures are reproduced in Montfaucon's *Monumens de la Monarchie françoise,* 1729 (ill. 1–3); there is a drawing of the trumeau figure in the Bibliothèque Nationale, Paris. 1793: damage to sculptures still *in situ.* 1812: construction of steps leading up to the portal – the present height of the threshold is estimated as 5 ft 10 in. above the original level. 1839–40: inexpert restoration of the portals by the architect Debret. All heads renewed, renovation of the left tympanum, jamb shafts, and parts of the archivolts.

Individual pieces now preserved in museums. In the Louvre, three heads and a pair of heads, from the archivolts of the centre and right doorways (pl. 3); in the Musée de Cluny, doorpost columns from the side doorways (pl. 2 middle). Three heads of doubtful authenticity and provenance, which have been linked with the jamb figures, are preserved in museums at Baltimore (Md) and Cambridge (Mass.).

Programme. On the walls of the three doorways there were twenty jamb figures, six for each side entrance and eight for the centre doorway. The subjects were drawn from the Old Testament, kings and queens intermingled with patriarchs and prophets; the only identifiable figure is that of Moses, with the Tables of the Law. This jamb cycle is the earliest example of the type characteristic of royal portals in northern France. On what principle the biblical figures were chosen is still not clear; the possibility that they represent the genealogy of Christ as recorded in Matthew 1 is ruled out by the presence of Moses. Whether, as modern scholars have suggested, the Old Testament rulers were intended as types representing the kings of France is impossible to say. There are no indications in the sources, and against the theory is the fact that the cycle spread to other churches unconnected with the royal house. Probably the only decisive factor in drawing up the programme was the typological relationships between the Old and New Testaments.

CENTRE DOORWAY (pl. 1)

In the tympanum, the Last Judgment. Christ, as judge, is shown enthroned, his arms outstretched before the cross; in his hands are inscribed scrolls. On either side of him are the apostles, as assessors, and to the right Mary, interceding. In the bottom zone we see the bodies resurrected. The kneeling figure at the feet of the Judge has been restored and cannot, as is sometimes suggested, be an authentic portrayal of Abbot Suger. The judgment scenes continue in the inner archivolt: on the left, in succession, the gates of Paradise, an angel and Abraham, each with the blessed; the hell scenes on the right have been restored. In the three outer archivolts, the Elders from the Book of Revelation; on the doorposts and in the spandrels of the tympanum, the Wise and Foolish Virgins. This is the earliest example of a gothic Judgment portal; it shows no connection with romanesque Judgment portals of southern France or Burgundy. The construction of the programme, with the central figures of the Judgment scene in the tympanum and the Wise and Foolish Virgins on the doorposts, is followed in two later Judgment portals, at Notre Dame in Paris (pl. 145) and Amiens cathedral (pl. 161).

RIGHT DOORWAY

The tympanum shows the last communion of St Dionysius and his companions, Rusticus and Eleutherius. The doors of their prison are guarded by sentries. On the right the

379

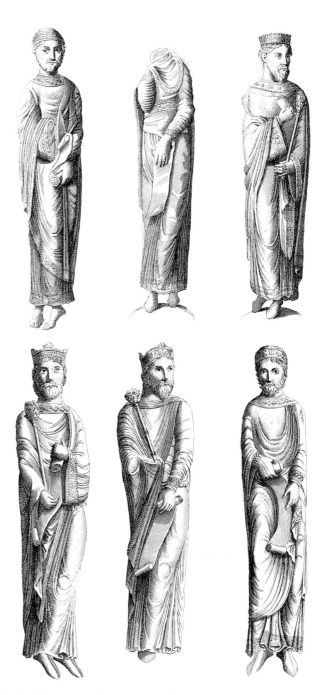

other saint especially venerated in the locality. The doorposts are carved with a Calendar (pl. 2, left and right), each month being contained within a medallion framed by tendrils sprouting from a lion's mouth. The months from January to June are shown in ascending order on the right, those from July to December in descending order on the left. Calendars were very commonly displayed on church portals, but the order found at Saint-Denis is unusual; it was used

Ill. 1 Saint-Denis, abbey church. West portal, centre doorway. Jamb figures. Before 1140. (After Montfaucon I, pl. 17)

figure of the Roman prefect, Fescennius Sisinnius. On the left stands Larcia, a pagan lady who according to the legend witnessed the miracle of the communion and was converted. The Dionysius legend continues in the inner arch of the archivolt: below we see the executioners, and above, Dionysius, Eleutherius and Rusticus, wafted on ribbons of cloud to a celestial sphere. This is the first in a long line of gothic portals to depict the church's patron saint, or some

Ill. 2 Saint-Denis, abbey church. West portal, left doorway. Jamb figures. Before 1140. (After Montfaucon I, pl. 16)

again, after 1200, for the Calendar of the Coronation portal of Notre Dame in Paris (pl. 152, 154 right).

LEFT DOORWAY

The doorposts are carved with a Zodiac, following the same sequence as the Calendar opposite. The signs occupy rectangular fields, surrounded by leaf-decorated frames. In other places Zodiac and Calendar are linked, each month and its sign being shown in juxtaposition. Distribution between two doorways is exceptional. The tympanum contains a mosaic, the theme of which is unknown; comparable examples are found only in Italy. The freely restored relief seen in the tympanum dates from the nineteenth century. The outer archivolt, where the figures have been restored, but not completely renewed, is thought to have depicted the *Traditio Legis*.

STYLE AND DATING

To judge from Montfaucon's illustrations, the jamb figures were the work of three different sculptors or workshops, each assigned to a particular doorway. Appearances suggest that the sculptors of this statue sequence, the first in northern France, came from Languedoc. The figures from the left doorway (ill. 2) bear a surprising resemblance to the statues from the chapter house of Saint-Etienne, Toulouse. The same is true of the jamb figures and doorpost statuettes of the centre doorway (ill. 1). The figures from the right doorway (ill. 3) can be compared with the tympanum of Saint-Pierre, Moissac. The figures in the archivolts of the side doorways appear to be different, and their elongated proportions may point to models from western France.

There is a striking delicacy in the execution of the ornamental elements (doorpost columns [pl. 2, middle], capitals, bases, Zodiac). The motifs suggest borrowings from applied art or from painting.

To sum up, a variety of styles formed the sculptures on the west doorways of Saint-Denis. Though it is now impossible to reach a definite conclusion, the predominating models seem to have come from Toulouse and its sphere of influence.

The oratory chapels in the upper storey of the church's west end were dedicated on 9 June 1140, so the portal was presumably started soon after 1130.

B. de Montfaucon 1729, vol. I, p. 193; F. de Guilhermy 1891, p. 265; W. Vöge 1894, p. 80 ff.; R. de Lasteyrie 1902, p. 33 ff.; P. Vitry/G. Brière 1908, p. 48 ff.; E. Mâle 1947 (5), p. 391 f.; M. Aubert 1929, p. 4 ff.; M. Aubert 1945; C. Goldscheider 1946; M. Aubert 1946, p. 189 f.; M. Aubert, M. Beaulieu 1950, p. 57; W. S. Stoddard 1952; L. Godecki 1953; S. McK. Crosby 1953; J. E. v. Borries 1955; A. Katzenellenbogen 1959, p. 27 ff.; A. Lapeyre 1960, p. 19 ff.; J. Formigé 1960; B. Kerber 1966, p. 30 ff.; *see also* Appendix to Bibliography.

Ill. 4

SAINT-DENIS (SEINE), ABBEY CLOISTER FIGURES

The abbey of Saint-Denis probably possessed not only the earliest figure-decorated gothic portal but also the earliest cloister with column figures. For this the romanesque cloisters of south-west France and northern Spain, in which the pillars were decorated with reliefs, had already prepared the way. Montfaucon reproduces three figures – two kings and a male figure wearing a ribbed cap – which according to him and to Dom Plancher stood in the oldest part of the cloister. In the first half of the thirteenth century

Ill. 3 Saint-Denis, abbey church. West portal, right doorway. Jamb figures. Before 1140. (After Montfaucon I, pl. 18)

381

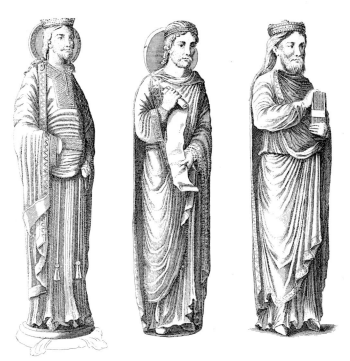

Ill. 4 Saint-Denis, abbey. Column figures from the cloister. Before 1151. (After Montfaucon I, pl. 10)

the cloister of Saint-Denis underwent extensive remodelling. It is impossible therefore to decide in which wing, prior to the eighteenth century, these figures were preserved. Abbot Suger gives an exact description of the new work on the west façade and the choir, but makes no mention of the cloister. The statues illustrated by Montfaucon could be dated, merely on the basis of style-criticism, to the abbacy of Suger, shortly before 1151. While the figures bear no relation to the sculptures of the west doorways, they come surprisingly close to the jamb figures of the Royal Portal at Chartres (pl. 12, 13). It seems, therefore, that after the completion of the west doorways sculptors were still active at Saint-Denis, working in the style of the Head Master of Chartres and his pupils. The 'Dagobert' figure (ill. 5) and the 'Crosby' relief (pl. 20) point to a similar conclusion, although their style is not in literal agreement with that of the cloister figures. Which came first, the cloister figures at Saint-Denis or the statues on the west doorways at Chartres, remains an open question.

It has been claimed that a figure of a king, now in the Metropolitan Museum in New York, which resembles the king in Montfaucon's plate, hailed originally from the cloister at Saint-Denis. A similar claim has been made on behalf of the king's head in the Liebieghaus at Frankfurt-on-Main (pl. 28 bottom), but it does not match the figures illustrated by Montfaucon. Sundry double capitals and bases now in the Musée de Cluny and the Louvre were undeniably at Saint-Denis in the nineteenth century, and it is sometimes suggested that they came from the cloister, but this is not certain. We are left with Montfaucon's

illustration as the only unquestionable testimony to the twelfth-century sculptures from the cloister of Saint-Denis.

B. de Montfaucon 1729, vol. I, p. 57 f.; U. Plancher 1739, vol. I, p. 521; W. Vöge 1894, p. 197 ff.; M. Aubert, M. Beaulieu 1950, p. 61; V. K. Ostoia 1955; J. Formigé 1960, p. 18 ff.; B. Kerber 1966, p. 44 ff.; L. Pressouyre 1967 (I).

Ill. 5

SAINT-DENIS (SEINE), ABBEY CHURCH KING DAGOBERT(?)

The abbey of Saint-Denis traced its foundation back to the Merovingian king, Dagobert I (629–639). Until the end of the eighteenth century a relief, obviously of considerable dimensions and showing a king, was to be seen on the north aisle at the church's west end (ill. 5). The king was draped in an outspread mantle and his feet were placed on the backs of two beasts (lions?). When Montfaucon saw the figure, the attributes were already missing. Antiquarians of the seventeenth and eighteenth centuries took it for a representation of the abbey's founder. It was thought possible that the relief was made for the cloister in Suger's time and replaced by a new sculpture in the thirteenth century. A sculpture which would fit this description – a figure of a king, made about 1265 and identified as Dagobert by a Latin verse inscription (ill. 101) – could in fact be seen in the cloister down to the eighteenth century. Despite that, the original intentions regarding the earlier figure are still a

Ill. 5 Saint-Denis, abbey church. King Dagobert(?). Before 1151. (After Montfaucon I, pl. 12)

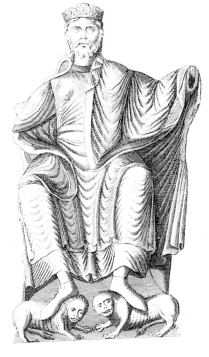

matter of guesswork. It is quite likely that the relief was made while Suger was still alive, that is before 1151. Like the cloister statues (ill. 4) and the 'Crosby' relief (pl. 20),

it shows no affinity with the sculptures of the west doorways. There is an unmistakable resemblance to the portal at Etampes (pl. 31) and to statues at Chartres which resemble Etampes (pl. 14 left). The motifs show a striking agreement with early medieval representations of rulers. The twelfth-century sculpture may be based on an earlier model.

M. Félibien 1706, p. 534; B. de Montfaucon 1729, vol. I, p. 162; E. Viollet-le-Duc 1867, vol. IX, p. 32f.; W. Vöge 1894, p. 232f.; A. Lapeyre 1960, p. 223f.; J. Formigé 1960, p. 56; B. Kerber 1966, p. 36f.

Pl. 3 bottom-15, colour pl. I, III, ill. 6

CHARTRES (EURE-ET-LOIRE), CATHEDRAL OF NOTRE DAME
WEST DOORWAYS ('ROYAL PORTAL')

In France the cathedral of Chartres was the most important place of pilgrimage to the Virgin. There was in addition a cathedral school, which in the eleventh and twelfth centuries possessed outstanding teachers such as Fulbert, Bernard, Thierry and Guillaume de Conches.

Sources and dates. The external factor leading to the erection of the famous Royal Portal on the cathedral's west façade was a fire which swept the city on 5 September 1134. The fire admittedly spared the existing cathedral – an eleventh-century building – but seems to have given cause for new building work to the west of the early romanesque nave. A start was made on the north tower (known as the 'clocher neuf'), which was originally intended to be free-standing; between 1134 and 1138, and again between 1139 and 1142 we hear of donations 'ad opus turris' or 'ad aedificationem turris'. The portal layout was presumably not yet planned. In 1145 Robert de Torigny, abbot of the Benedictine monastery on Mont-Saint-Michel, reports from Chartres on the building work in progress on the cathedral, 'cuius turres tunc fiebant'. By that time, then, the south tower (known as the 'clocher vieux') was also being built. The decision to build a twin-towered façade is presumably linked with the planning of a triple portal to lie between them, fronting the nave of the early romanesque church. This helps us to arrive at a starting date for the west doorways: at the latest, 1145. The south portal of Le Mans cathedral (pl. 16), which undoubtedly looks back to Chartres, was completed in 1158. We can thus reasonably assume that the sculptures at Chartres came into being between 1145 and 1155.

Installation and construction of the portals. The side doorways are of different widths – 7 ft 8 in. on the north, 7 ft 4 in. on the south; in both cases the tympanum and the lintel have been truncated, and the bottom stones of the archivolt shortened, to fit the position they now occupy. Observation of these and other features made it natural to wonder whether the Royal Portal originally stood in another position – east of the towers, perhaps level with the axis

Ill. 6 Chartres cathedral, west elevation. (After Dehio/Bezold IV, pl. 407)

of the first High Gothic bay. Transposition as an afterthought to the narrower space on the west front between the two towers would then explain why some portions had to be recut. Against this theory are strong objections raised by

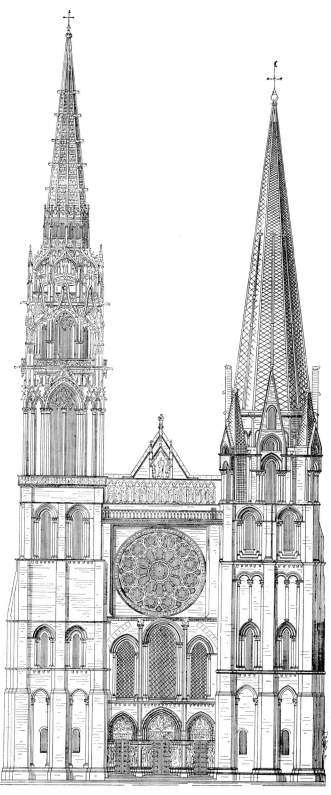

recent archaeological investigations, reinforced by general considerations in the context of the history of architecture. A compromise solution, by which it is proposed that the Royal Portal was planned and made in two stages, is hardly acceptable. The most likely supposition is that all parts of the Royal Portal were created between 1145 and 1155, but that when work started the intended site was wider than the one it occupies. Whether it ever in fact stood elsewhere, or whether the plan was changed during its execution, is for the moment impossible to decide.

To appreciate the unique features of the triple portal composition we must start by looking at the peculiarities of the site. The side aisles of the early romanesque building were blocked by the towers, leaving only the width of the nave available for the doorways. The only structure above the portals was the exterior wall of a chapel, pierced by three large windows; there was no need, therefore, to interpose strongly divisive buttresses between the portal bays. The brief to erect a triple portal in a narrowly confined space thus provided an opportunity to weld the three doorways into a unified composition – hence the decision in favour of greatly elongated proportions. The openings are tall and narrow, and the archivolts have stilted pointed arches. The jambs are arranged in a way that virtually eliminates the division between the separate doorways; socle and capital frieze flow evenly across jambs, doorposts and buttresses, interrupted only by the door openings. Jamb figures – originally twenty-four in number – occupy not merely the recesses but also the corners of the narrow buttresses and the doorposts; the whole jamb area is thus covered with ornamented columns and figures. The centre tympanum is made to dominate the others: it is slightly set back, rises higher, and the subdivisions are larger. It is separated from the lateral tympana by narrow moulded borders. The idea of stepping up to a central point is repeated, with even greater effect, in the group of windows just above the portals (ill. 6). More than half a century would pass before a similar harmonization of a triple doorway was achieved, first at Amiens (pl. 161) and then at Rheims (pl. 190). In the twelfth century the composition of the Royal Portal remains unique.

PROGRAMME

Jamb figures. Nineteen out of the original twenty-four survive, representing kings, queens, patriarchs and prophets of the Old Testament. The problem of their identity and of the meaning of the cycle has given rise to much speculation. Moses (pl. 14 right), identifiable as at Saint-Denis by the Tables of the Law, is the only figure we can safely give a name to. The genealogy of Christ (Matt. 1) as the key to the programme has rightly been rejected, and we can also dismiss the idea that each figure represents the author of a book of the Old Testament. The most we can assert is that this is an Old Testament cycle which opens a portal programme spanning the whole history of the redemption of man. Chartres was not a royal foundation, so any link between the biblical kings and the kings of France is even less likely than at Saint-Denis.

Capital frieze, doorposts, buttresses. On the jamb capitals, an extensive historical cycle. For parallel examples of this arrangement see Notre Dame at Etampes (pl. 31) and figures from the destroyed portal at Corbeil (pl. 30). Starting from the centre doorway, going north, we have the story of Joachim and Anna, followed by Christ's infancy down to the Massacre of the Innocents at Bethlehem; going south we meet isolated scenes from the life of Christ, from the Presentation in the Temple to the sending forth of the apostles. Not all the events are in chronological order. Happenings of great importance are placed in prominent positions: the Nativity is shown on the front of the north buttress (pl. 14 right), the Last Supper in the corresponding position on the south (pl. 12 left). The small figures on the doorposts and buttresses seem related – in part at least – to scenes in the capitals above: thus beneath the Last Supper we see a bloody sacrifice from the Old Testament, and beneath the Nativity, a representation of David with harp.

Tympana. The right doorway (pl. 6) features the Virgin enthroned, flanked by angels. It is possible, but by no means certain, that we have here the gilded statue of Mary donated by archdeacon Richer (died before 1156) for the entrance to the cathedral. On the lintel we see in the top zone the Presentation, in the bottom zone (left to right) the Annunciation, Visitation, Nativity and Annunciation to the Shepherds, with Christ appearing in each case on the centre axis (above on the altar, below in the crib). Whether this was done for compositional reasons or, as has recently been suggested, to underline the eucharistic associations of the events portrayed, is impossible to decide. The tympanum of the left doorway (pl. 7) has a representation of the Ascension, developed in three zones. At the bottom, ten apostles; about their heads, four angels, presumably proclaiming the Lord's Second Coming (Acts 1:11); at the apex, Christ on a cloud flanked by angels. In points of detail this presentation is difficult to reconcile with other known treatments of the Ascension – the seated apostles, in particular, are a most unusual feature.

After the portrayals in the right and left tympana of the beginning and ending of Christ's life on earth, in the tympanum of the centre doorway (pl. 5) is depicted the Second Coming. Here the programme of the Royal Portal reaches its culmination. Christ is shown enthroned in the mandorla (colour pl. I) surrounded by the Tetramorph; thronging round him are angels with scrolls and astrolabes (inner archivolt) and the four-and-twenty Elders of the Apocalypse, with crowns, harps and vials (middle and outer arches). Above Christ's head in the apex of the inner arch the hovering Dove, in the apex of the outer archivolt, angels bearing a (restored) crown. The composition, made up of elements with a long pictorial pedigree, brings together significant items from the visions described in Revelation, chapters 4, 5. On the lintel, another portent of the Last Days, namely the isolated standing figures at either end of the

384

beam, who are presumably the witnesses mentioned in Rev. 11:3. The apostles at Christ's feet are, however, the assessors of the Last Judgment (Matt. 19:28).

The archivolts of the side doorways carry secondary cycles, which reach outside the circle of biblical and apocryphal themes. Left doorway (pl. 7): signs of the Zodiac, each with its appropriate Calendar picture below – Gemini and Pisces, clearly for reasons of space, appear on the right doorway (inner arch, bottom left). Above the right doorway (pl. 6) the inner arch includes figures of angels with censers, who belong to the representation of the Virgin in the centre. The remaining places on the archivolt are taken by what appears to be a completely secular cycle: the Liberal Arts, i.e. disciplines inherited from antiquity which in the high Middle Ages made up the curriculum of the cathedral schools. They appear as female figures, as already personified in the literature of late antiquity. At their head is Grammar (outer arch, bottom right), with the rod for use on lazy pupils; facing her is Dialectic (outer arch, bottom left), with Rhetoric, the last of the basic disciplines, above. The remaining subjects are in the following sequence: Arithmetic, Geometry, Astronomy and Music, the last shown tuning a stringed instrument. Each subject has as its adjunct an authority from classical antiquity: the figure at the feet of Dialectic is presumed to be Aristotle (pl. 15 bottom left), at the feet of Music, Pythagoras (pl. 15 bottom centre), at the feet of Rhetoric, Cicero. The figure at the feet of Grammar could be either Donatus or Priscian (pl. 15 bottom right). In the twelfth and thirteenth centuries it is common to find representations of the Liberal Arts on churches with important schools attached. Chartres is the earliest example. Thierry of Chartres, chancellor of the cathedral school 1141–c. 1150, was the author of a compendium of the Liberal Arts, the *Heptateuchon*. This may have prompted the representation of the Liberal Arts on the Royal Portal, where they proclaim, at the entrance to the cathedral, the renown of the cathedral's school. It must be said, however, that the arrangement of the secular disciplines round the enthroned Mother of God points clearly to their ancillary role. The central theme of the Chartres Royal Portal is the redemption of man.

Style, distinction of hands. Here we are dealing with one of the larger workshops. That this is so is made likely by the sheer scope of the portal, while the very marked differences between the separate sculptural groups make it a certainty. However, with such a compact layout, there must have been one leading master responsible for the conception as a whole. The 'head master', as he has been called in German and English-speaking scholarship since the time of Wilhelm Vöge, was the sculptor of the centre tympanum (pl. 5, colour pl. I), and there can be no doubt that he also created the figures on the left jamb of the centre doorway (pl. 8 left, 9, 10). He had assistants who used the same formal language, but without his energy. They worked on the right jamb of the centre doorway (pl. 8 right, 11) and on the inside walls of the side doorways (pl. 12 left, 13 left, colour pl. III, pl.

14 right), and may also have carved the lintel of the centre doorway (pl. 5) and both lintels of the right doorway (pl. 6). The most important works of this group – those from the hand of the Head Master – characteristically combine sensitivity with dynamic severity, tectonic stylization with sensuous vitality, in a way matched, among other surviving French examples tending in the same stylistic direction, only by the portal statues from Corbeil (pl. 30) – and these perhaps surpass the Chartres figures.

The elements of the style's formation can be found in the Burgundian sculpture of Saint-Lazaire, Autun, and the exterior façade of Vézelay. There is little likelihood that this Burgundian formal language reached Chartres from Provence, whether via the sculptures on the façade of the abbey church at Saint-Gilles, or the cloister sculptures at Saint-Trophime in Arles, as variously suggested. What is more probable is that Provence and Chartres were engaged in a comparable transformation of common Burgundian models. There is a distinct possibility, however, that Chartres was not the first to introduce this stylistic trend into the Ile-de-France. The cloister sculptures of Saint-Denis (ill. 4) and the 'Crosby' relief from the abbey church may be earlier in date. If that is so, the workshop of the Head Master could have come to Chartres from Saint-Denis.

The figures on the outer jambs of the lateral doorways are by sculptors of the second rank, whose formal language, compared with that of the Head Master, must be described as antique. The two inner figures on the outside jamb of the right doorway (pl. 13 right, 3 bottom), are in close agreement with the statues of the centre doorway of the Saint-Denis west portal (ill. 1). Here the provenance of the Chartrain workshops is even plainer than in the work of the Head Master and his assistants. Of the three figures on the left jamb of the left doorway, the two furthest (pl. 14 left) are by a hand we meet again on the portal of Notre Dame at Etampes (pl. 31). Its formal language is characterized by harsh delineation and an inclination to mark out individual parts of the body – places where the joints are attached, abdomen, chest – by inscribing them with circular folds. Which came first, these Chartres figures or Etampes, is hard to say, but there is much that points to the Etampes portal as the earlier. The two remaining figures – the innermost on the left jamb of the left doorway (pl. 14 left) and the outermost on the right jamb of the right doorway (pl. 13 right) – stand on their own. They come astonishingly close to Burgundian sculptures at Autun and Vézelay (exterior façade and fragments in the Dépôt Lapidaire), closer in fact than the works of the Head Master and his circle, in which the process of transformation has gone further.

The small figures on the buttress piers, doorposts and capitals keep close to the style of these sculptors and remain unaffected by the disciplined formal language of the Head Master.

Also important as regards the connection with Saint-Denis are the richly ornamented intermediate shafts on the jambs (pl. 8, 10–14). Despite the variety of new motifs to be

observed in details, in general they adopt the formal habit of the doorpost columns at Saint-Denis.

The archivolts of all three doorways (pl. 5–7), and possibly the sculptures in the apex of the left and right tympana, are from the hand of a sculptor whose work can rank with that of the Head Master, to which it stands, however, in diametrical opposition. The Archivolt Master, as we may call him here, favours sturdy, almost stocky, proportions. His aim is not the severely tectonic stylization of the figure but the individualization of attitude and movement to produce characteristic expressions. In the Elders (pl. 15 top), as in the Liberal Arts and their attendant authorities (pl. 15 bottom), he shows an astonishing capacity for individualization. His physiognomies are not of the elongated type favoured by the Head Master, which in his hands, through the suppression of expressive features, present an appearance of great nobility; this master's heads are broader and more forceful, and the stylization of the face attempts to characterize rather than typify. The origin of this remarkable artist is not easy to uncover. He is not unaffected by the disciplined language of the Head Master, but the basic essentials of his style were not formed from Burgundy. On the other hand, a few of his figures, particularly the heads, show a surprising similarity to the portal sculptures of Saint-Pierre in Moissac. There is thus some reason to think that the Archivolt Master came originally from Languedoc. Whether he reached Chartres by way of Saint-Denis is impossible to say.

As a result of research in the last few decades, the Royal Portal of Chartres has had to yield its fame as the founder of the new gothic sculpture to the abbey church of Saint-Denis, whose sculptures were earlier in date. The Royal Portal nevertheless remains the work in which the characteristic features of the new style are displayed with incomparable lucidity. The construction of the portal, the arrangement of the programme and the interplay of the different sculptors reveal a capacity for a superior synthesis such as we do not find in the so-called romanesque sculpture of Burgundy, Languedoc and Aquitaine.

Bulteau 1887 ff., vol. II, p. 18 ff.; W. Vöge 1894; E. Lefèvre-Pontalis 1900; E. Lefèvre-Pontalis 1901–04; R. de Lasteyrie 1902, p. 1 ff.; E. Houvet 1919; E. Mâle 1947[5], p. 377 ff.; A. Priest 1923; M. Aubert 1929, p. 9 ff.; M. Aubert 1941; M. Aubert 1946, p. 176 ff.; W. S. Stoddard 1952; R. Hamann 1955, p. 280 ff.; E. Fels 1955; W. Sauerländer 1956 (I); A. Katzenellenbogen 1959; A. Lapeyre 1960, p. 19 ff.; W. Schoene 1961; B. Kerber 1966; A. Heimann 1968; see also Appendix to Bibliography.

Pl. 16–18

LE MANS (SARTHE), CATHEDRAL OF SAINT-JULIEN
SOUTH PORTAL

Following a fire, the nave of Le Mans cathedral was rebuilt under Bishop Guillaume de Passavant and dedicated in 1158. The portal opens into the fifth bay of the south aisle. It served as the main entrance from the town into the cathedral.

386

Some of the architectural parts were renewed in the nineteenth century.

PROGRAMME

Jambs. Eight Old Testament figures; in 1856 the banderole of the inside figure on the right still bore its original(?) inscription: SALOMO. *Doorposts.* Peter and Paul, standing in niches. *Tympanum.* Majestas Domini. *Lintel.* The twelve apostles. *Archivolt.* Inside arch, standing angels; outer arches, scenes from the life of Christ, from the Annunciation to the Temptation and the Marriage in Cana (pl. 18).

Style and dating. The connection between the workshops of Le Mans and the very recently completed Royal Portal at Chartres (pl. 4–15) is beyond dispute. The altered proportions, and the fact that the archivolt has round rather than pointed arches, are explained by the need to fit the portal into an aisle bay whose dimensions were already determined; there are thus no stylistic conclusions to be drawn. The arrangement on the jamb follows Chartres, but in modified, simpler form. The socles and intermediate shafts are left undecorated. The figures are pushed back into the angles of the recessed jamb and terminate directly below the capitals, on which the only decoration is acanthus. There is, however, no precedent for the wide doorposts with their shallow figure-niches.

The style of the jamb figures is formed principally from that of the figures on the right jamb of the Chartres centre doorway (pl. 11). This comes out clearly at Le Mans on the right jamb (pl. 17), in that many of the motifs correspond to those used at Chartres, though it is true that no figure is reproduced in its entirety. The same models can be detected also in the somewhat crudely worked tympanum: note the broadness of the forms. The doorpost figures belong to this same stylistic context, but the three outer figures on the left jamb present some divergent features. Here another and lesser hand has been at work, copying the statues of the left jamb of the Chartres centre doorway (pl. 10), but in a way that reduces the delicate but tense forms of the Chartrain models to schematic and superficial imitations. The style of the archivolt figures is probably based on the same Chartrain models, but the issue is complicated by the intervention of different iconographical patterns. No symbolical significance should be read into the at times odd distribution of the scenes, which arose through the use of an unusually comprehensive iconographic source with a penchant for narrative – see the Marriage in Cana or the Massacre of the Innocents.

The portal was presumably already complete when the nave was dedicated in 1158. The portico with ornamented rib vaulting is of the same date, but was made to match the forms of the first bay at the west end of the nave, not those of the portal.

E. Hucher 1842; A. Launay 1852, p. 10 ff.; E. Lefèvre-Pontalis 1889, esp. p. 73 ff.; W. Vöge 1894, esp. p. 191 ff.; R. de Lasteyrie 1902, p. 35; G. Fleury 1904, esp. p. 47 f.; E. Mâle 1947[5], esp. p. 392 ff.; M. Aubert 1929, p. 33 ff.; M. Aubert 1946, p. 193 ff.; W. S. Stoddard 1952, p. 32 ff.; A. Lapeyre 1960, p. 90 ff., p. 281 ff.; A. Mussat 1963, p. 104 ff.; B. Kerber 1966, p. 61 f.

Pl. 19

VIRGIN AND CHILD ENTHRONED, FORMERLY IN SAINT-MARTIN-DES-CHAMPS, PARIS (NOW IN SAINT-DENIS, ABBEY CHURCH)

This over life-size figure of the Virgin and Child was removed in 1792 from the priory of Saint-Martin-des-Champs in Paris and deposited in the Musée des Monuments Français, from which it later came to Saint-Denis. Whether it is identical with the 'Notre-Dame-de-la-Carole' mentioned in old descriptions of Saint-Martin-des-Champs is impossible to say.

The figure, in wood, bears traces of old (original?) colouring. The Child, like the Mother, wore a crown. The crowns, and the edges of the outer garments, have jewelled borders (restored).

The figures of the Virgin of the Royal Portal at Chartres (pl. 6) and Porte Sainte-Anne of Notre Dame in Paris (pl. 40) were of the Nikopoia type, with the Child portrayed frontally in his mother's lap. The Saint-Denis piece shows a clear divergence from this type. Although the rendering of the drapery, with its regular stratification of the folds, points definitely to the Ile-de-France in the period after 1150, there are also stylistic features – the more lanky proportions and more curving outlines – which differentiate the work from the figures of the Chartres and Paris tympana. A figure – also in wood – in the church at Jouy-en-Josas (Seine-et-Oise), which we can assume to be somewhat later in date, displays many corresponding features.

A. Lenoir 1821, vol. I, p. 178; L. Courajod 1876, vol. I, p. 5; R. de Lasteyrie 1884; M. Aubert 1929, p. 61; M. Aubert 1946, p. 289 f.

Pl. 20 top

RELIEF FROM CARRIERES-SAINT-DENIS (NOW PARIS, LOUVRE)

In 1845 three twelfth-century reliefs were discovered walled up behind an altar dedicated to the Virgin in the church of Carrières-Saint-Denis, north of Paris. Each of the three slabs was devoted to a separate scene: an Annunciation, a Virgin enthroned, and a Baptism of Christ. They were assembled, and the result has been taken to represent one of the earliest examples of an altar retable made in stone. Apparently the only question that remains open is whether the retable belonged originally to the furnishing of this particular church. It has been in the Louvre since 1915.

As has always been noted, the upper and lower edges of the slabs have been trimmed. The tendril ornament around the edges and the architectural motifs along the top indicate that all three reliefs formed part of the same ensemble. The present grouping of the fragments appears quite arbitrary. One would expect intermediate scenes between the Annunciation and the Baptism, and the harsh joins where the outer slabs meet that depicting the Virgin cannot correspond to the state as it was in the Middle Ages. The choice of scenes, not to mention the unrestrained tendril ornament with its animals and small naked figures, would be unusual for a retable, to say the least. Thus the possibility that the fragments come from some different, possibly architectural, setting should not be excluded.

Style and dating. Artistically, the fragments do not belong directly to the Saint-Denis/Chartres circle; at most there is some connection with the capital friezes at Chartres. Nor is there any real comparison with the sculptures of the Porte Sainte-Anne in Paris (pl. 40), so often cited in this connection. These figures, not very taut and activated in bending movements, look more like remodellings of prototypes in the romanesque sculpture of Burgundy – one thinks especially of Autun. There are also Burgundian parallels for the tendril ornament: one may compare, for example, a capital from the west part of the Madeleine at Vézelay, now in the Princeton Museum. These connections suggest a date for the Carrières-Saint-Denis fragments post-1150.

A. Didron 1845; E. Viollet-le-Duc 1867, vol. VIII, p. 36; C. Rohault de Fleury 1883, vol. II, p. 45; M. Aubert, M. Beaulieu 1950, p. 63 ff.; G. Zarnecki 1960, p. 160; B. Kerber 1966, p. 33 f.

Pl. 20 middle and bottom

THE 'CROSBY' RELIEF, SAINT-DENIS (SEINE), ABBEY CHURCH

This slab, with a twelfth-century relief, was discovered by S. McK. Crosby in 1947 in the transept of the abbey church of Saint-Denis. It was serving as the lid of a sarcophagus, with the carved side facing downwards. The relief shows the apostles, standing in the arches of an arcade. In the centre are Peter and Paul (bottom left); of the remaining figures, Matthew, Philip (bottom right) and James the Greater are named in accompanying inscriptions. The slab is framed by running ornament, elements of which remain in an unfinished state. It seems then that the slab was discarded without ever being used. What function it had been intended to fill is not clear. The carving on the side edges rules out the possibility of a lintel. If it was meant for the side wall of a sarcophagus, it is difficult to find a parallel twelfth-century example depicting the apostles. In the eyes of those who installed it in its present position, in the ambulatory chapel of Sainte-Ozanne at Saint-Denis, the slab was intended as a retable; however, if this were so, one would expect a christological reference at the centre. For the time being the problem must be regarded as insoluble.

Style and dating. The delicate, richly varied ornament which covers not merely the framing profile but also the bases, shafts and abacuses of the columns and the arches and spandrels of the arcade, matches the ornamental forms on the west portals of Saint-Denis. The style of the apostle figures, characterized by a composed attitude, placid gestures and smooth face and drapery surfaces, finds its closest parallels at Chartres and Dijon: at Chartres, on the lintels of the centre and right doorways of the Royal Portal

(pl. 5, 6), at Dijon on the west portal of Saint-Bénigne (pl. 22 bottom, ill. 8). The Crosby relief thus reflects the same phase stylistically as the 'Dagobert' (ill. 5) and the figures from the cloister of Saint-Denis (ill. 4). There were new sculptors working at Saint-Denis after the completion of the west portals but probably still before the death of Suger in 1151; their style is determined not, as with their predecessors, by Languedoc, but by Burgundy, and presents a parallel with the west façade at Chartres. As with the cloister figures, the question of priority vis-à-vis Chartres must remain open.

S. McK. Crosby 1947; S. McK. Crosby 1953, p. 55f.; W. S. Stoddard 1952, p. 60f.; P. Quarré 1957; J. Formigé 1960, p. 134f.; B. Kerber 1966, p. 46.

Pl. 21 top

ISSY-LES-MOULINEAUX (SEINE), SAINT-ETIENNE
TYMPANUM FRAGMENT

Issy-les-Moulineaux, a suburb of Paris close to the Porte de Versailles, belonged from the sixth century down to the Revolution to the abbey of Saint-Germain-des-Prés. The existing parish church is a post-medieval building, started in 1633. The fragment of an early gothic tympanum fragment bricked into an interior wall may have come from a portal of its medieval predecessor. There are no known reports as to its provenance.

In the centre, Christ enthroned in the mandorla, one hand raised in blessing, the other holding the open book. In the bottom corners the eagle of St John and the angel of St Matthew (destroyed almost beyond recognition). Near Christ's head two more angels grasping the mandorla and swinging censers. Thus the theme, as in many tympana of the royal domain, was the Majestas Domini. The type, however, is not identical with that found at Chartres (Royal Portal, pl. 5), Le Mans (pl. 16), Angers (pl. 32) etc. On the other hand, two angels grasping the mandorla are met with here and there in Burgundian tympana of the twelfth century depicting the Majestas. Stylistically, too, the fragment tallies neither with Chartres nor with the Porte Sainte-Anne of Notre Dame in Paris (pl. 40), nor with the west portal of Saint-Germain-des-Prés (ill. 10). The composition is freer and looser. The forms are surprisingly soft, in places positively flabby. With this goes a predilection for rich ornament: there are decorative borders not only to the draperies but also around the mandorla and at the edge of the tympanum. There seems to be a very close affinity with a tympanum preserved in the Musée Archéologique at Dijon (pl. 22 top, 23). Thus the style, as well as the type, shows a Burgundian connection.

The Issy fragment probably dates from the 1150s. Though not of the first rank, it reflects something of the manifold stylistic possibilities opening up in Parisian sculpture after the middle of the century.

P. Barret 1902; G. Fleury 1904, p. 168f.; M. Aubert 1929, p. 50; M. Dumolin, G. Outardel 1936, p. 333ff.; A. Lapeyre 1960, p. 161f.

Pl. 21 centre and bottom

LA CHARITE-SUR-LOIRE (NIEVRE), NOTRE DAME, PRIORY CHURCH
LINTELS

The priory church in La Charité-sur-Loire was one of the churches built in the wake of Cluny III. In its original form the five-aisled building featured a twin-towered façade which included five figure-decorated doorways dating from the twelfth century.

In this instance a wide centre doorway was flanked on either side by two narrower doorways which gave access to the lower storeys of the western towers. Following late gothic alterations and damage inflicted in the sixteenth century, all we have left of the twelfth-century portal are the two doorways on the north side, and of these the one nearer the centre has been removed to the interior of the south transept; the other is still incorporated in the old west façade.

PROGRAMME
The lintels of the two doorways form an iconographic unit. The sequence on the beam of the further doorway (pl. 21 centre) – Annunciation, Visitation, Nativity, Annunciation to the Shepherds – continues on the beam of the nearer doorway (pl. 21 bottom) with the Adoration of the Magi and the Presentation in the Temple.

Style and dating. The lintel reliefs are by two different hands. On the relief with the Nativity we have well-rounded figures dressed in wide loosely hanging garments. On the other, by contrast, the figures present a taut, almost rigid appearance and there is stiffly regular delineation of the draperies.

Characteristic of the technique is the use of the drill – nimbuses, crowns, head coverings all bear its marks, not to mention the furniture. Drill holes can again be observed in the meanders below the figure friezes, and on the capitals and abutments next to the lintel beams. The meander motif and the drill holes point to Burgundian works of the 1140s, such as Charlieu, Saint-Julien-de-Jonzy and the upper storey of the porch at Vézelay.

It is apparent that in terms of iconography and motifs there is considerable agreement with the right tympanum of the Chartres west portal (pl. 6). The differences are no less obvious. At Chartres the formal language is more monotonous, the scenic flow suppressed to produce a hieratical effect. La Charité presents a cycle related in form and content to that of Chartres, but in a freer rendering. There are many indications to suggest a date for both lintels somewhat earlier than the Royal Portal at Chartres. The earliest possible date is 1140.

R. de Lasteyrie 1902, p. 78f.; W. Vöge 1958, p. 41f.; A. K. Porter 1923, p. 125ff.; H. Beenken 1928; M. Aubert 1929, p. 26f.; A. Heimann 1939; M. Aubert 1946, p. 108f.; M. Anfray 1951, p. 279ff.; G. de Francovich 1952, p. 285ff.; A. Katzenellenbogen 1959, esp. pp. 9, 14; A. Lapeyre 1960, p. 117ff.; R. Raeber 1964; F. Salet 1965; B. Kerber 1966, p. 52; J. Vallery-Radot 1966; *see also* Appendix to Bibliography.

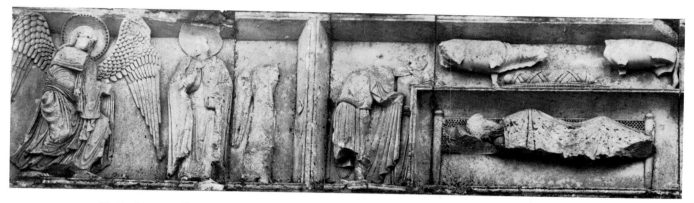

Ill. 7 Montmorillon, Saint-Laurent. Reliefs on the west façade: Annunciation, Nativity. After 1150

Ill. 7

MONTMORILLON (VIENNE), SAINT-LAURENT
RELIEFS ON THE WEST FAÇADE

The church of Saint-Laurent belonged to the hospital founded at Montmorillon by Robert du Peux after his return from the First Crusade. In 1107 the bishop of Poitiers founded a fraternity at Montmorillon, and in 1113 the Comte de Poitiers took the Maison-Dieu under his protection.

On the west façade of the largely rebuilt church there are some slabs with early gothic reliefs. They are at present sited above a seventeenth-century window, but before the window was installed they were lower down, directly above the apex of the undecorated west portal – traces of this positioning can still be detected on the façade. It is unlikely, however, that this was their original position, since the portal is more recent than the relief slabs, whose original purpose is thus still not clear. The subjects, reading from left to right, are: the Annunciation, Nativity (ill. 7) Annunciation to the Shepherds, Presentation, Adoration, and Flight into Egypt.

In Poitou these reliefs are stylistically an isolated case. Iconography and style point to Chartres (lintel of the left doorway, pl. 6) and more particularly to La Charité-sur-Loire (pl. 21 middle and bottom) and Souvigny (pl. 26). At Montmorillon the scenes are more widely spread out and include additional motifs. It does not follow that Montmorillon is an earlier treatment of a cycle repeated at La Charité and Chartres. On the contrary, we should assume that the sculptor of the Montmorillon slabs came from the workshop which had already been active at La Charité and Souvigny. He used an iconographic scheme which was also the basis of the Infancy scenes at La Charité and Chartres. In places his version is somewhat different, showing omissions or amplifications. External indications as to date are lacking; the reliefs probably date from shortly after 1150.

A. K. Porter 1923, esp. p. 125 ff.; R. Crozet 1948, p. 187 ff.; Ch. Grosset 1948; Ch. Grosset 1951; R. Crozet 1965; B. Kerber 1966, p. 52 ff.

Pl. 22, 23, ill. 8

DIJON (COTE-D'OR), SAINT-BENIGNE,
ABBEY CHURCH
WEST PORTAL

Until the Revolution, Saint-Bénigne was a Benedictine abbey. In the nineteenth century its church became the cathedral of the diocese of Dijon. The remaining portions of the monastic buildings now house the Musée Archéologique. Benignus, the abbey's patron, was a native of Asia Minor who preached the Gospel in Burgundy and is said to have suffered a martyr's death at Dijon in the second or third century.

The present church dates from the thirteenth century. The large centre doorway of the west portal was taken over from the previous structure, with only minor alterations. Its sculpture, destroyed in 1794, is known from an engraving in Dom Plancher's *Histoire de Bourgogne* (ill. 8), while a few fragments from the jambs and archivolts are preserved in the Musée Archéologique. Tympana from three smaller doorways have also survived, or are known from Plancher's book. The programme and arrangement of what was clearly an extensive portal layout can be inferred only by conjecture.

West portal, centre doorway. On the trumeau, Benignus, in ecclesiastical vestments but with ribbed cap and knobbed stick; in his left hand he held the martyr's palm. On the jambs: six Old Testament figures plus Peter and Paul. Tympanum: Majestas, depicting Christ – surprisingly – without the mandorla; around the enthroned figure, in addition to the symbols of the Evangelists, two cherubim and Ecclesia and Synagogue. Lintel: Infancy of Christ; at the centre, the Virgin enthroned. This lintel sequence starts in the right archivolt with the Annunciation and Visitation, followed by the Nativity, Annunciation to the Shepherds, journey of the Kings, and continues with the dream of the Kings on to the left archivolt. A second lintel, below the first, had already been removed in the fourteenth century and Plancher's engraving shows only its extremities, with

389

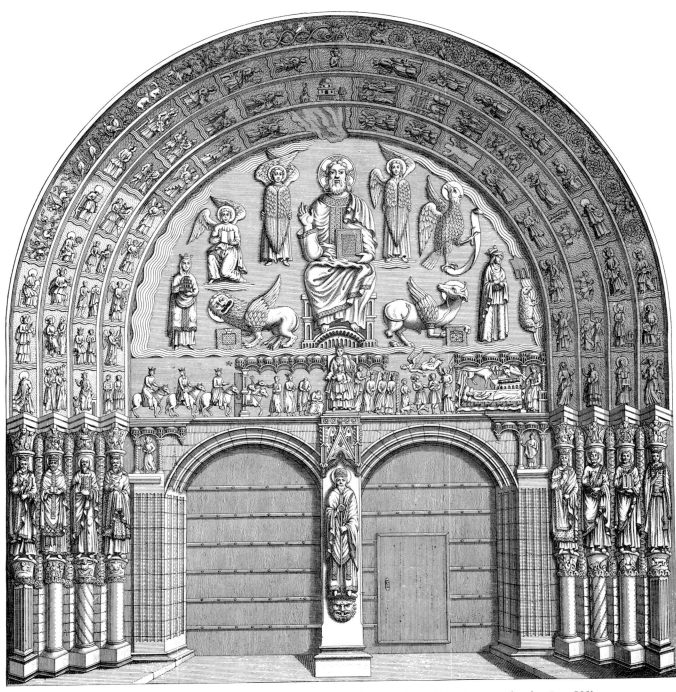

Ill. 8 Dijon, Saint-Bénigne, abbey church. West portal. Towards 1160. (After Dom Plancher I, p. 503)

single figures standing in an arcade. Archivolt (reading from the inside): angels; Massacre of the Innocents and Flight into Egypt, plus scenes no longer identifiable; Elders of the Apocalypse; more Elders, tendril and animal ornament. The portal thus combined the Majestas with the story of the Infancy of Christ. For a similar combination see the portal of Saint-Loup-de-Naud (pl. 24, 25).

Other tympana. A second tympanum, which has lost its sculpture, is now mounted on the north wall of the porch.

Judging from a partially preserved inscription, it corresponds to a tympanum illustrated by Plancher which showed the martyrdom of Benignus. Benignus stood between his tormentors and the figures of the 'Rex Aurelianus' and the 'Comes Terencius' who, according to the legend, ordered his execution. The only other example of an early gothic tympanum with the martyrdom of a patron saint is at Saint-Denis, above the right doorway of the west portal (see p. 379). It seems plausible that the Dijon tympanum may equally

390

have belonged to a side doorway of the early gothic façade. When new towers were erected on the flanks of the entrance façade in the fourteenth century, this side doorway was presumably demolished and the tympanum placed on the left wall of the porch, built at the same time.

Dom Plancher illustrates a third tympanum depicting the Last Supper. In Plancher's engraving it is shown attached to an archivolt decorated with single figures, seated and kneeling. The tympanum, shorn of its archivolt, is preserved in the Musée Archéologique at Dijon (pl. 22 bottom). It shows Christ surrounded by ten apostles. With his right hand, Christ blesses the bread, which in shape resembles a Host. John, leaning on the Lord's breast, and Judas, kneeling in front of the table, are in keeping with the current Western iconography. The institution of the Eucharist was a favourite subject for illustration above the entrance to monastic churches in Burgundy and southern France. The theme may have been made topical by regional heretical movements opposed to the celebration of the Mass. The most usual place for a Last Supper was the lintel, below a tympanum showing a Majestas or a Crucifixion; its portrayal on a tympanum is without parallel. At the time that the abbey was suppressed the Last Supper tympanum was installed above the entrance to the refectory. It may have belonged originally to one of the side doorways of the west façade; it would then have been removed to the abbey during the remodelling which took place in the thirteenth century. To sum up, the triple portal layout of Saint-Bénigne may have comprised a Majestas in the centre, flanked on either side by the martyrdom of Benignus and the Last Supper. Such a reconstruction has more to commend it than the view sometimes advanced that the two smaller tympana, when they were made in the twelfth century, were intended for doorways of the conventual buildings.

There is yet a fourth (smaller) tympanum to be mentioned: this depicts the Majestas and is also preserved in the Musée Archéologique (pl. 22 top, 23). It was excavated in 1833, on the north side of the church. In an eighteenth-century view the tympanum is shown in the cloister, above the tomb monument of Abbot Peter of Geneva who died in 1142. It is thought to have come from a doorway leading from the church into the cloister.

Style and dating. The portal of Saint-Bénigne was the first example of early gothic sculpture to appear on Burgundian soil. Among the surviving sculptures, the small tympanum with the Majestas (pl. 22 top, 23) is still in the tradition of Burgundian romanesque. When we turn to the jambs of the main portal (ill. 8), the only reminders of the architecture of Cluny, Vézelay and Autun are the fluted pillars. The style of the sculptures showed a close connection with the Royal Portal at Chartres, the Crosby relief (pl. 20) and also, it appears, with the cloister sculptures at Saint-Denis, which have not survived (ill. 4). That they were the work of northern French sculptors is shown by the firm, straight drapery folds and the symmetrical, calm facial features. This style stands in contrast with the animated, narrative

sculpture of Burgundian romanesque. All the same, regarded as early gothic works, the Dijon portal shows some peculiarities: the most unusual feature is seen in the tympana depicting the Martyrdom and Last Supper tympana, in which the absence of any architectonic division gives the appearance of painted lunettes illustrating a single scene.

As to date, the *terminus a quo* is provided by a report of a fire in 1137. There is no documentary record of the subsequent rebuilding, but we hear of a dedication of the church by Pope Eugenius III on 1 April 1147. The four doorways are unlikely to have been completed by that date. The architectural forms preserved on the jambs of the main portal argue for a date nearer 1160.

Inscriptions on the Last Supper tympanum (pl. 22 bottom) and on the small Majestas tympanum (pl. 22 top, 23) speak of renovations and embellishments, ascribed in both cases to 'Petrus'. It seems certain that this Peter was not the sculptor but the patron, i.e. an abbot of Saint-Bénigne. We can be fairly certain, too, that the renovations and embellishments refer not to the portal but to the church itself, rebuilt after the fire of 1137. In the course of the twelfth century Saint-Bénigne had three abbots named Peter. The Petrus named in the inscriptions must be either Peter of Geneva (1129–42) or his successor, Peter of Beaune (1142–45). The use of the past tense in the inscriptions need not imply that the portals were completed at latest by the end of the reign of Peter of Beaune. It is quite conceivable that they were not constructed until the time of Abbot Philip (1145–75), who then furnished them with inscriptions commemorating the rebuilding of the church under one of his two predecessors. There is thus no way of knowing from the inscriptions whether the portals came into being quite early, shortly after 1140, or only later, *c.* 1160, under the influence of the Ile-de-France. Stylistic arguments favour the later date.

U. Plancher 1729, vol. I, p. 499 ff.; W. Vöge 1894, p. 95 ff.; L. Chomton 1900, p. 163 ff.; G. Fleury 1904, p. 155 ff.; E. Mâle 1947[5], esp. p. 218 ff.; P. Deschamps 1922; A. K. Porter 1923, esp. p. 130 f.; M. Aubert 1929, p. 62 f.; L. Schürenberg 1937; C. Poinssot 1951; C. Poinssot 1954; P. Quarré 1957; M. Beaulieu 1957; A. Lapeyre 1960, p. 101 ff.; B. Kerber 1966, p. 41 ff.; *see also* Appendix to Bibliography.

Ill. 9

NESLE-LA-REPOSTE (MARNE), NOTRE DAME, ABBEY CHURCH
WEST PORTAL

When the abbey was moved in 1674 from Nesle-la-Reposte in southern Champagne to Villenauxe near Nogent-sur-Seine the monks took with them, remarkably enough, a figure-decorated portal dating from the twelfth century. Mabillon published an engraving of the portal and there is a reproduction of it in Montfaucon. The portal was demolished at the time of the Revolution and the sculptures were used as building material. To date all that has come to light are two fragments from the lintel, but we can hope for further discoveries.

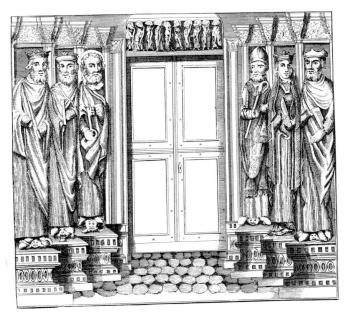

Ill. 9 Nesle-la-Reposte, Notre Dame, abbey church. West portal.
About 1160. (After Montfaucon I, pl. 15)

The engraving published by Mabillon, apparently from a very inaccurate drawing, shows only the jambs and the lintel. From this it appears that the arrangement, recessed walls, with low fluted socle and non-figurative capitals, must have been much the same as the portals of Saint-Germain-des-Prés (ill. 10) and Notre-Dame-en-Vaux at Châlons-sur-Marne (see p. 411). From the engraving we can identify three of the six jamb figures: Peter (inner left), the Queen of Sheba with her legendary goose-foot (centre right), and Solomon (outer right). The inner figure on the right, in pontifical vestments, is usually taken for Aaron, but must be

Ill. 10 Paris, Saint-Germain-des-Prés, abbey church. West portal.
About 1160. (After Montfaucon I, pl. 7)

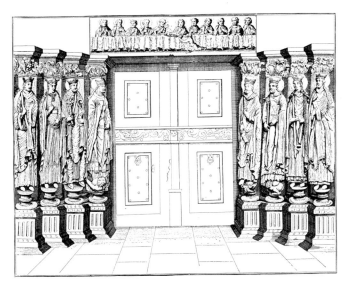

either a bishop or an abbot. The lintel shows standing apostles gazing upwards, so we must assume that the tympanum displayed an Ascension. From old descriptions it seems that the archivolt, as at Notre Dame in Etampes (pl. 31), contained Elders of the Apocalypse.

Style and dating. At present all that can be said is that Nesle-la-Reposte was among the royal portals in the circle of Chartres. The lintel fragments closely resemble the tympanum figures from Notre Dame, Corbeil (ill. 17). The date, subject to all due caution, must therefore be *c.* 1160.

J. Mabillon vol. I, p. 50f.; B. de Montfaucon 1729, vol. I, pl. XV; W. Vöge 1894, p. 340f.; J. Tillet 1902; G. Fleury 1904, p. 158f.; M. Jacob 1924; E. Mâle 1947[5], pp. 147, 359; M. Aubert 1929, p. 45f.; A. Lapeyre 1960, p. 118ff.; G. Chérest 1962; L. Pressouyre 1967 (II).

Ill. 10

PARIS SAINT-GERMAIN-DES-PRES, ABBEY CHURCH
WEST PORTAL

On 21 April 1163 Pope Alexander III dedicated the choir of the abbey church of Saint-Germain-des-Prés. It is generally assumed that the early gothic west portal was constructed at the same time as the choir.

The tympanum and archivolts were removed when an early baroque entrance hall was made in 1607–8. The eight jamb statues were destroyed at the time of the Revolution, but we have eighteenth-century pictures of them. Socles and capitals of the jamb survive, together with a carved lintel beam. It is not known whether there was a trumeau.

Style and dating. In construction the jambs resemble those of the portals at Nesle-la-Reposte (ill. 9) and Notre-Dame-en-Vaux at Châlons-sur-Marne (see p. 411). The fluted socles tally with Chartres, but the figured capital frieze, characteristic of Chartres, is lacking. Seven of the jamb figures represent kings and queens from the Old Testament. The bishop on the left jamb is often described as Aaron. There is much to suggest, however, that this figure represents Germanus, the patron saint of the abbey church.

From the old engravings it seems these portal statues showed no affinity with the other major work of Paris sculpture of *c.* 1160, the Porte Sainte-Anne at Notre Dame (see p. 404). On the other hand there is a surprisingly close resemblance to the jamb figures of the centre doorway of the west portal at Chartres (pl. 8, 10, 11). Several of the statues are in literal agreement.

The lintel, with its Last Supper, presents something of a problem. The use of the subject at the entrance of a church is by no means unparalleled, but this is the only example known from the Ile-de-France. Artistically, the relief is of mediocre quality and does not match the (destroyed) jamb figures. There is also a certain awkwardness in the installation. There is thus much to support Lebeuf's suspicion that the relief did not originally belong to the portal. Date: *c.* 1160.

J. Bouillart 1724, p. 296ff.; B. de Montfaucon 1729, vol. I; J. Lebeuf 1754, vol. II, p. 430f.; W. Vöge 1894, p. 200ff.; G. Fleury 1904, p. 147ff.; E.

Lefèvre-Pontalis 1919; E. Mâle 1947[5], p. 393; M. Aubert 1929, p. 50; M. Aubert 1946, p. 198f.; A. Lapeyre 1960, p. 162ff.; B. Kerber 1966, p. 64f.

Ill. 11–14

IVRY-LA-BATAILLE (EURE-ET-LOIR), NOTRE DAME, ABBEY CHURCH PORTAL

From the destroyed Benedictine abbey of Ivry-la-Bataille near Evreux we have remnants of a figure-decorated portal: a jamb figure and the archivolts. It is possible to reconstruct the destroyed portions from an account written in 1726. The archivolts, whose arrangement tallies with this description, display certain iconographic and technical irregularities: the scenes follow an erratic sequence and some of the stones have been trimmed. It may be that by the eighteenth century the portal was no longer as originally installed.

PROGRAMME

Five jamb figures are mentioned, four of them being of kings or queens. The cycle clearly corresponds to the statue cycles at Saint-Denis and Chartres (pl. 4). The tympanum, like the tympanum at Chartres (pl. 5), showed a Majestas, with apostles below. The inside arches of the archivolt show *inter alia* scenes from the Last Judgment (ill. 12). The programme thus combined the Majestas with Paradise and Hell: compare Saint-Ayoul, Provins (ill. 22). The outer arches of the archivolt include *inter alia* a Passion cycle of which the following scenes can be identified: Deposition (ill. 11), Women at the Tomb (ill. 13), Christ in Limbo.

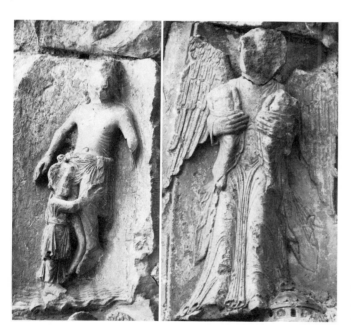

Ill. 11, 12 Ivry-la-Bataille, Notre Dame, abbey church. West portal. Archivolt figures: Deposition; angel with souls. About 1150–55

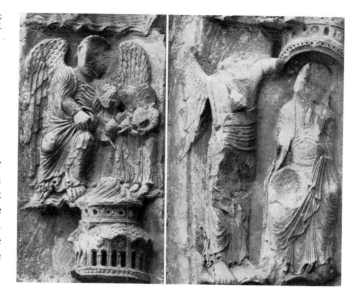

Ill. 13, 14 Ivry-la-Bataille, Notre Dame, abbey church. West portal. Archivolt figures: Women at the Tomb; Annunciation(?). About 1150–55

Style and dating. The execution shows exceptional care and delicacy. There is a surprising resemblance to the Royal Portal at Chartres. The one surviving statue recalls the figures on the left jamb of the Chartres centre doorway (pl. 10). The figures from the archivolt tally with the apostles beneath the Chartres Majestas (pl. 5). Date: *c.* 1150–55.

F. I. Mauduit 1899; G. Fleury 1904, p. 138ff.; M. Aubert 1929, p. 55ff.; A. Lapeyre 1960, pp. 193ff., 294ff.

Pl. 24, 25

SAINT-LOUP-DE-NAUD (SEINE-ET-MARNE), PRIORY CHURCH WEST PORTAL

The priory of Saint-Loup-de-Naud was subject to the abbey of Saint-Pierre-le-Vif at Sens. Lupus, its patron saint, had been archbishop of Sens. The church dates from the eleventh and twelfth centuries. The exceptionally well-preserved west portal is shielded by a small rib-vaulted porch.

PROGRAMME

Jambs, tympanum and parts of the archivolt display figures and scenes found on almost every early gothic royal portal. Jambs: six statues of Old Testament figures, Peter and Paul. Tympanum: Majestas with seated apostles on the lintel below, and surrounded in the inner archivolt by angels with candlesticks and censers. In the centre of the lintel a figure of the Virgin. Archivolt, bottom register: on the left, the Annunciation and Visitation; on the right, the Magi before Herod. The remaining sculptures all relate to the patron saint. On the trumeau Lupus is shown dispensing blessing, with two dragons at his feet. The trumeau capital portrays a

393

miracle from his legend: when the saint was saying Mass, a diamond dropped from heaven into his chalice. In the two outer arches of the archivolt, further scenes from the life of the saint, in some cases spread over two adjoining voussoirs. On the basis of the legend, it has so far been possible to identify only the groups on the left side. Reading from bottom to top: Lupus expelling the Devil from a drinking cup; Lupus healing a blind man; Lupus baptizing the Roman prefect Bosonus; Lupus opening by prayer the door of the church of Saint-Aignan, Orleans; the miracle already portrayed on the trumeau; Lupus, riding, hearing angels singing.

Style and dating. The style of the figures points to the circle of the Royal Portal of Chartres. There is a touching carefulness about the execution, but in the rendering of gestures and facial features it becomes timid. The portals in neighbouring Provins are not comparable. There are clear affinities with the capitals on the portal of Notre-Dame-en-Vaux at Châlons-sur-Marne (p. 411) or with Saint-Bénigne, Dijon (pl. 22 bottom, ill. 8). The Rheims fragment with an enthroned archbishop (pl. 27) is another related piece. The erection of the portal has been associated with a donation made in 1167 by Henri le Libéral, Count of Champagne, but there seems no compelling reason to connect the two events. Judging by the style of its sculptures, the Saint-Loup-de-Naud portal should be dated to the 1150s, at the latest 1160.

F. Bourquelot 1840–41; E. Grésy 1867; W. Vöge 1894, p. 206 ff.; G. Fleury 1904, p. 40; L. Roblot-Delandre 1913; E. Mâle 1947[5], p. 222 ff.; M. Aubert 1929, p. 42 ff.; F. Salet 1933; M. Aubert 1946, p. 197 f.; W. S. Stoddard 1952, p. 33 f.; A. Lapeyre 1960, p. 132 ff.; B. Kerber 1966, p. 63.

Pl. 26

SOUVIGNY (ALLIER), SAINT-PIERRE, PRIORY CHURCH
SCULPTURE FRAGMENTS

From 915 Souvigny was a priory of Cluny. St Majolus, abbot of Cluny until 994, and his successor St Odilo, who held office until 1049, died and were buried at Souvigny. Odilo's bones were removed in 1064, in the presence of Peter Damian. The translation of his relics, and those of Majolus, took place in 1095, in the presence of Pope Urban II.

Twelfth-century sculpture fragments displayed on the west wall of the north aisle are obviously the remnants of a larger ensemble, now destroyed. In addition to richly decorated blind arcading and slabs decorated with meanders and acanthus, there are the remains of figures. In the top row two standing apostles flank an enthroned Christ and a second enthroned figure. In the second row we see on the left an enthroned cleric in dalmatic and chasuble, on the right a standing angel. All heads and hands have been lost.

Stylistically these remnants belong with the lintel beams at La Charité (pl. 21). La Charité, especially on the lintel strip of the inner of the two doorways (pl. 21 bottom), prepared the way for the stiff, almost rigid, formal language which at Souvigny then becomes the characteristic style. The connection is also clear from the ornamental motifs and the

similar use made of the drill. These two Cluniac priories were neighbours, and the same workshop was presumably engaged on both. The La Charité lintel beams are the earlier.

The sources provide no definite clue to the original purpose of the Souvigny sculptures. At one time it was thought they were intended for a choir screen or an altar. More recent scholarly opinion favours the tomb of St Majolus, but parallel examples for the wall-tomb which is postulated by this theory have not survived from the twelfth century. Thus the suggestion is still only a hypothesis – and a very improbable one.

A document of 1173, which speaks of expenditure on the renovation of the church has been regarded as evidence for the date of the sculptures, but if we accept the dating proposed above for La Charité (1140–55), this is too late. The most likely date for the Souvigny fragments is *c.* 1150.

A. Allier 1833–38, vol. II, p. 153; F. Deshoulières 1913, p. 212; F. Deshoulières n.d., p. 62 f. (I); A. K. Porter 1923, p. 128 f.; M. Génemont, P. Pradel 1938, p. 260; P. Pradel 1944; M. Aubert 1946, p. 109; A. Lapeyre 1960, p. 223; B. Kerber 1966, p. 52 f.

Pl. 27

RHEIMS (MARNE), MUSEE SAINT-REMI
FRAGMENT WITH ENTHRONED ARCHBISHOP ('ODO TOMB')

The fragment was found in the debris of a house in Rheims in the course of clearance work after the First World War. On one face it shows an enthroned archbishop in pontificals and pallium, flanked at the edge by an engaged column; the opposite face has tendril ornament including animals. Seated in the bottom coil is a figure in secular attire, engaged in reading; carved beside him is the name 'Odo'. There are further incompletely preserved inscriptions on the socle and on a fragment of the archbishop's banderole.

The original provenance of the piece is uncertain. The name 'Odo' has led some to conclude that the fragment comes from the abbey church of Saint-Rémi; this abbey had from 1118 to 1151 an abbot named Odo, whose tomb monument was preserved there down to the Revolution. This monument is described as a niched tomb with a life-size figure recumbent on a tumba, the wall of which showed monks from Mont-Dieu, the Carthusian monastery founded by Odo. The description thus rules out the idea that our fragment was part of the tomb monument. Furthermore, the small figure named as Odo is not in clerical garb and hence cannot be identical with the abbot of Saint-Rémi. The provenance of the fragment remains a mystery, likewise its original purpose.

The archbishop figure has often been compared with the Lupus of the trumeau at Saint-Loup-de-Naud (pl. 24). There are certainly similarities in the physiognomies, and in the rendering of the borders on the liturgical vestments, but the formal language of the Rheims fragment is more extensive, more robust. The drapery folds have more volume, the limbs of the animals are more solid, more muscular than those of the graceful hybrids on the jamb capitals of Saint-Loup. A direct

link is therefore out of the question. A closely related piece, the fragment of a figure in pontificals discovered beneath Rheims cathedral, was published in the late nineteenth century but has since disappeared; compare also a capital in the Victoria and Albert Museum, London. Date: *c.* 1160.

P. Tarbé 1842, p. 70f.; M. Lascatte-Joltrois 1868, p. 177; L. Demaison 1902, vol. I, pl. 132; L. Demaison 1937; R. Hamann-MacLean 1956; P. Pradel 1957–58, no. 103; W. Sauerländer 1958 (I); A. Lapeyre 1960, p. 247; B. Kerber 1966, p. 72.

Pl. 28 top, ill. 15

RHEIMS (MARNE), SAINT-REMI, ABBEY CHURCH
HEAD OF KING LOTHAIRE

Two French kings, Louis IV (936–954, known as Louis d'Outremer) and Lothaire (954–986), were buried in the choir of the abbey church of Saint-Rémi at Rheims, to the left and right of the high altar. Seated statues of the two rules were set up close to the tombs; in 1756 they were removed to the north aisle and in 1793 destroyed – apparently on the day Louis XVI was executed. In 1729 Montfaucon had published engravings of the two figures, accompanied by a description. The Lothaire statue was shown with the inscription REX LOTARIUS (ill. 15); at his feet sat a small figure, as yet unexplained. The head of the Lothaire (pl. 28 top) was recovered in 1919. The torso of the Louis IV statue is in the Musée Lapidaire at Rheims.

The type of figure depicting an enthroned ruler has no parallel in twelfth-century France. The throne itself, raised up on steps and with a high back-rest, and the bearing

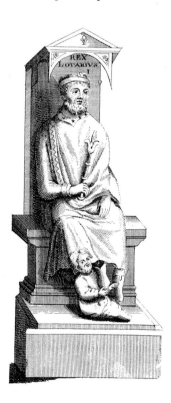

Ill. 15 Rheims, Saint-Rémi, abbey church. King Lothaire. 1140–50. (After Montfaucon I, pl. 30)

and dress of the kings recall earlier portraits of the medieval period. Compare the representation of emperors in ninth-century manuscripts: for example the Bible from S. Paolo fuori le Mura, Rome, the Evangeliary of Lothaire, and the first Bible of Charles the Bald. It appears that in making statues of rulers long since dead sculptors deliberately fell back on an earlier, presumably Carolingian, type. What specific models were available to the Saint-Rémi sculptors must remain an open question.

In the motifs, for example the hair style and crown, as also in the firm and precise delineation, the Lothaire head does not compare with kings from the circle of royal portals deriving from Chartres. A more likely connection is with the west portals of Saint-Denis, completed in 1140. If Montfaucon's illustrations are to be trusted, there is an especially close resemblance between the Rheims Lothaire and one or two heads among the royal statues of the left doorway of the west portal (ill. 2). Moreover the Louis IV torso suggests no resemblance to portals constructed in the Ile-de-France *c.* 1150, and points to an early date for the Rheims statues. The statues of Louis IV and Lothaire were probably made between 1140 and 1150 by a workshop which had come to Rheims from the Ile-de-France (from Saint-Denis?).

B. de Montfaucon 1729, vol. I, p. 348, pl. XXXI; H. Deneux 1921; R. Hamann-MacLean 1956; R. Hamann-MacLean 1957, p. 189; W. Sauerländer 1958 (I); P. Pradel 1957–58, no. 102.; *see also* Appendix to Bibliography.

Pl. 28 bottom

HEAD OF A KING
FRANKFURT-AM-MAIN, LIEBIEGHAUS

This head was acquired in 1955. According to the testimony of its previous owner it originated at Saint-Denis. There seems no comparison, however, with the three cloister statues illustrated by Montfaucon (ill. 4), and the figures on the west portals (ill. 1–3) are so very dissimilar that they do not need even to be considered.

There is a striking resemblance to the head of the two kings on the right jamb of the centre doorway of Chartres (pl. 11). These display the same broadly facial forms and the same benign, gentle expression. This facial type was widespread among the figures of early gothic royal portals and associated works. We find it at Le Mans (pl. 17) and Saint-Loup-de-Naud (pl. 25), on the capitals of the ambulatory chapels of Saint-Germain-des Prés, Paris, and on the transept roses of Notre Dame-en-Vaux at Châlons-sur-Marne. It is also characteristic of Saint-Bénigne, Dijon (pl. 22 bottom). It is thus not possible to determine the provenance of the Frankfurt head by style-critical methods. Many royal portals of the Chartrain group, regardless of regional boundaries, resemble one another so closely that there is no chance of determining the artistic province to which the head belonged. Date: *c.* 1160.

Gotische Bildwerke 1966, no. 1; B. Kerber 1966, p. 44f.; *see also* Appendix to Bibliography.

Pl. 29, ill. 16

HEAD OF OGIER THE DANE(?)
MEAUX (SEINE-ET-MARNE), MUSEE
MUNICIPAL

Until the first half of the eighteenth century the choir of the Benedictine church of Saint-Faron at Meaux housed an unusually elaborate niched tomb (ill. 16). On the tumba lay two tonsured figures of exceptional size; local histories give their length as 'seven feet'. Along the walls, which were arranged like the jambs of a portal, stood six statues. Destroyed before the Revolution, the monument was illustrated and described by Mabillon.

According to him it belonged to the small group of monuments connected with the *Chanson de Roland*. The story goes that Ogier the Dane, one of Charlemagne's most famous paladins, retired with his page Benedict to the monastery of Saint-Faron. Before doing so he visited a number of monasteries, to see whether his arrival in their church, with his pilgrim's staff jangling its little bells, would distract the monks from their devotions. Only the monks of Saint-Faron, with the exception of one novice, passed the test. Their successors clearly attached importance to this tradition,

since they added the conversion of Ogier as an appendix to the life of their patron saint.

The two enormous figures on the tumba are Ogier and Benedict. On the wall of the sarcophagus we see, left, the 'bell test' (=8 in Mabillon's numbering), next to it the flagellation of the novices (9); on the right, the petition to enter the community, with Ogier and Benedict (10) kneeling before the abbot (11); behind the abbot, monks equipped with scissors for the tonsure, cowls, and writing materials for recording the profession (12, 13, 14). In the inner arch of the archivolt, angels bearing the souls of the dead, in the outer arch, Christ as judge, angels with trumpets and the instruments of the Passion, and resurrected souls. It is difficult to form any clear picture of the programme on the jambs. Mabillon took the statues for figures from the *Chanson de Roland*. He claims that the words on the banderole of the inside figure on the right read: 'I give thee, Roland, my sister Alda to wife, and the bond of my lasting friendship.' From this he inferred that the figure in question (2) represents Oliver, the female figure beside him Alda (3) and the last on that side Roland (4). He identified the statues opposite as Archbishop Turpin (7), Charlemagne (5) and Hildegard (6). Although this interpretation has not previously been

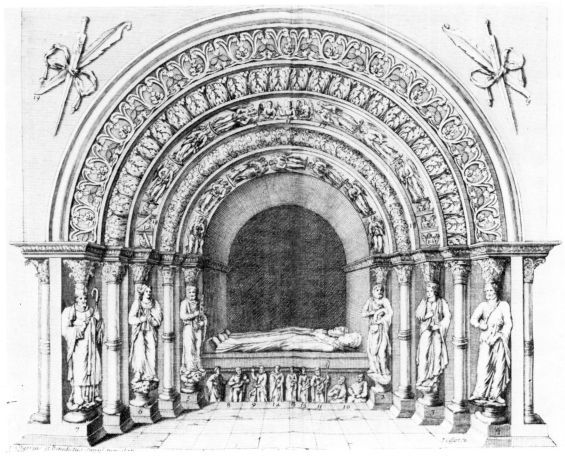

Ill. 16 Meaux, Saint-Faron. Tomb monument of Ogier the Dane and his page Benedict. About 1160.
(After Mabillon II, between pp. 376, 377)

doubted, some scepticism seems in order. For a medieval tomb monument such a cycle would be unique; also the dress of the figures is at variance with their alleged identities – Charlemagne has no crown, Roland and Oliver are not in martial attire. As is well known, the Maurists had a penchant for attaching secular names to biblical figures, and there is much to suggest that the statues were in fact of biblical or hagiographical origin.

An exceptionally large tonsured head was discovered at Meaux at the end of the last century; judging by the broken surfaces on its back it must have come from a tomb monument (pl. 29). Any doubts as to the identity are removed by another engraving published by Mabillon, which reproduces the tomb figures of Ogier and Benedict seen from above. The head is that of the nearer figure on the tumba. Mabillon's engraving shows us the open eyes and the characteristic ears. As pointers to the style we have the head's ungainly size combined with the extraordinary delicacy and finely drawn detail. To classify the head stylistically is difficult. It is comparable with the archbishop fragment in the Musée Lapidaire at Rheims (pl. 27). The ornament on the tomb monument, if we can trust the engraving, has an affinity with the gothic parts of Saint-Rémi at Rheims and with the Porte romane (pl. 56) of Rheims cathedral. Though it looks later than the head, the frequently expressed opinion that the various parts of the monument were made at different times is unlikely to be correct. The large size of the head can be explained on thematic grounds. The archaic impression is deceptive. All parts of the tomb date from or after c. 1160.

J. Mabillon 1703, vol. II, p. 376ff.; G. Gassies 1905; J. Bédier 1908, vol. II, p. 281ff.; M. Aubert 1929, p. 54f.; E. Mâle 1947[5], p. 306ff.; J. Hubert 1945-47; M. Aubert 1946, p. 199f.; R. Hamann-MacLean 1956; A. Lapeyre 1960, p. 231ff.; B. Kerber 1966, p. 72; R. Lejeune, J. Stiennon 1966, vol. I, p. 161ff.

Pl. 30, ill. 17

CORBEIL (SEINE-ET-OISE), NOTRE DAME, COLLEGIATE CHURCH
SCULPTURES FROM THE DESTROYED WEST PORTAL (NOW PARIS, LOUVRE, AND MONTGERMONT, CHATEAU)

The first reliable mention of the collegiate church of Notre Dame at Corbeil occurs in 1125. The nave, as the surviving fragments indicate, was built 1150–60. In 1180 houses in front of the west façade were pulled down to leave the entrance clear. The foundation was suppressed in 1601 and the west portal destroyed in 1793. Two of the jamb figures (pl. 30) were salvaged through purchase. From the Musée des Monuments Français they went to Saint-Denis, where they were restored in 1860, on the initiative of Viollet-le-Duc. They have been in the Louvre since 1916. When the church was demolished 1818–23, Comte de Contant-Biron acquired the remains of the tympanum and jambs for the park of his château at Montgermont, near Ponthierry (ill. 17).

PROGRAMME
The jamb, according to information given by Lebeuf, displayed six Old Testament figures. The capitals carried

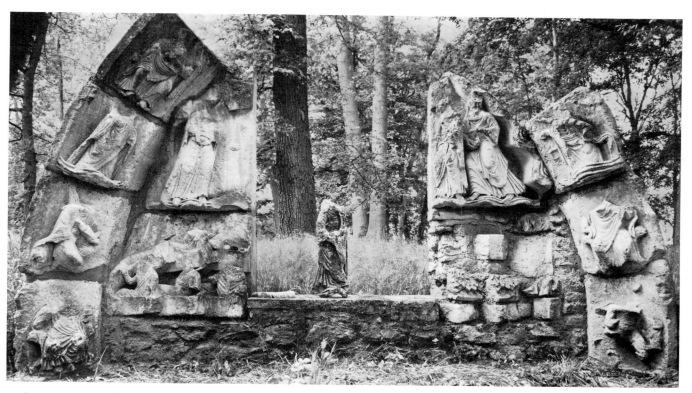

Ill. 17 Fragments from the tympanum and archivolt of the west portal of Notre Dame, Corbeil. 1150–60. (Château Montgermont)

397

scenic representations of the type found at Etampes (pl. 31) and Chartres (pl. 4). So far none of the scenes on the right jamb, now installed at Montgermont, have been identified. A capital which has become detached from its proper place shows the offerings of Cain and Abel. According to Raymond's description the tympanum and inner arch of the archivolt displayed the Last Judgment. Single items, arbitrarily assembled, are preserved at Montgermont. The outer archivolt is said by Raymond to have been decorated with Elders of the Apocalypse.

Style and dating. Stylistic judgment of the two figures in the Louvre is made difficult by the restoration undertaken in 1860. In the king figure, points of the crown, the nose, strands in the beard, parts of the book and the points of the feet have been added or restored. Similarly in the case of the queen hands and banderole have also been freely restored, and the clasp renewed. In both the facial forms have apparently been touched up, in a way that imparts an element of sentimentality to the physiognomy. On this point, the admiring judgment of Viollet-le-Duc and Vöge is due for revision. In type both figures agree with the jamb figures of the Chartres centre doorway. The king compares in particular with the outside figure on the right jamb (pl. 11), the queen with the female figure on the left (pl. 10), but as opposed to the tectonic severity of the Chartres figures, we have here a freer and more sensitive approach. There is greater delicacy and suppleness in the fall and delineation of the draperies, a greater wealth of nuances. The Corbeil queen, thanks to the less inhibited rendering of the draperies and the seductive richness of the finery, possesses a sensuous charm denied to the more austere Chartrain queens.

It was Lasteyrie who first claimed 1180, the year in which houses were demolished at the church's west end, as a *terminus ante quem* for the dating of the portal. Salet rightly doubted whether the event provided grounds for such conclusions and himself proposed for consideration 1180–90, suggested to him by the profiles of the bases as seen in the present installation of the jamb fragments at Montgermont. This dating, which would make Corbeil more than forty years later than the Royal Portal at Chartres, seems implausible. We can agree with Vöge that the Corbeil portal was 'a work of the Chartres school in its maturity', and with Kerber that the most likely date for it is 1150–60.

J. de la Barre 1647; J. Lebeuf 1754, vol. IX, p. 191; T. Pinard 1845–46; Viollet-le-Duc 1867, vol. VIII, p. 119 ff.; W. Vöge 1894, p. 235 ff.; R. de Lasteyrie 1902, p. 30 ff.; G. Fleury 1904, p. 153 ff.; M. Aubert 1929, p. 51 ff.; F. Salet 1941; M. Aubert 1946, p. 202 f.; M. Aubert, M. Beaulieu 1950, p. 70 ff.; A. Lapeyre 1960, p. 256 ff., p. 299 f.; B. Kerber 1966, p. 68 f.

Pl. 31

ETAMPES (SEINE-ET-OISE), NOTRE DAME, COLLEGIATE CHURCH
SOUTH PORTAL

Notre Dame at Etampes is said to have been founded in the eleventh century by King Robert II (996–1031), and its church rebuilt in the twelfth century, perhaps from 1140 on.

It has had a complicated architectural history of which no documentary record survives. The portal opens into the second bay on the south side of the nave.

PROGRAMME

Jambs. Of the six statues only Moses (left jamb), with the Tables of the Law, can be identified by name. Judging by the garments three other figures are male, and the two outer figures, with characteristic long plaits of hair, female. This is presumably an Old Testament cycle, as at Chartres and Saint-Denis. Tympanum and lintel show the Ascension. In the tympanum Christ, depicted frontally, is seen flanked by angels; in the lintel, Mary and the apostles. The archivolt shows the four-and-twenty Elders and prophets. The large angels with incense boats in the spandrels are presumably part of the Ascension group. The motif is unusual and is not found in other renderings of the theme. The Ascension is found in combination with figures from the Apocalypse in a large number of twelfth-century portals. Ascension and Second Coming are shown together on the basis of Acts 1:11: 'This same Jesus which is taken up from you into heaven shall so come in like manner as ye have seen him go into heaven.' The layout is very similar to that of the west portal at Anzy-le-Duc in Burgundy. The capitals on the left depict scenes from the Infancy, and, on the right, the Passion. The doorpost capitals have independent subjects: (left) the Temptation of Christ, (right) Expulsion from Paradise.

Style and dating. The building-out of the portal is an architectonic motif unusual in northern France. Derived from Roman civic gateways, it occurs on romanesque buildings of south-western France and northern Spain: Saint-Sernin, Toulouse, and San Isidoro, León. The large spandrel figures also point to similar precursors. A connection between Etampes and Languedoc is doubtful. A more likely theory is that both were engaged in the imitation and adaptation of Roman gateways in the provinces. The portal arrangement is not as in south-western France. The socle decoration, capital frieze and archivolt all resemble Chartres, though the execution is less elaborate.

The style of the sculptures resembles the outer figures on the left jamb of the left doorway of Chartres (pl. 14 left) – indeed, the agreement is close enough to postulate the same hand. This figure style is characterized by its fondness for graphic treatment of the drapery surfaces, for indicating joints or body protuberances by circles applied like 'tattoo marks' (Vöge). The origins of the style are to be found in Burgundy, above all at Vézelay. Whether Etampes precedes the Chartres Royal Portal in time, or is merely a provincial imitation of the famous exemplar, is almost impossible to decide. It is a striking fact that the figure style nowhere betrays the influence of the Chartres Head Master, evident in all other portals of the Chartres circle. This portal may executed *c.* 1140, shortly before Chartres.

W. Vöge 1894, p. 210 ff.; L. E. Lefèvre 1908; E. Lefèvre-Pontalis 1909; L. E. Lefèvre 1915; A. Priest 1923; M. Aubert 1929, p. 29 ff.; M. Aubert 1946, p. 191 f.; W. S. Stoddard 1952; L. Grodecki 1953; A. Lapeyre 1960; B. Kerber 1966.

Pl. 32, 33

ANGERS (MAINE-ET-LOIRE), CATHEDRAL OF SAINT-MAURICE
WEST PORTAL

The nave of Angers cathedral was vaulted during the episcopate of Normand de Doué (1149–53). The arrangement of the west façade, with flanking towers, large centre window and a portal, follows the model of domed churches, Angoulême for example, in Aquitaine, and the abbey church at Fontevrault. Until 1808 the lower storey of the façade featured a porch, presumably built on in the early thirteenth century; it appears in a view of 1699. There was some restoration of the portal after it had been struck by lightning in 1617; amongst other things, the existing symbols of the evangelists Matthew and Luke in the tympanum date from this period. In 1747 the trumeau with its figure of St Maurice (said not to be the original) and the lintel with its eight apostles were demolished. In 1830 Dantan did a thorough-going restoration. The head of the figure of Christ was renewed, and likewise the heads of many archivolt figures. Of the eight jamb figures, only three are said to have heads which date in part from the twelfth century.

PROGRAMME

On the jambs are Old Testament figures, including (right) Moses, recognizable from the Tables of the Law (pl. 33), and (left) David with his harp. The tympanum depicts the Majestas Domini, the lintel (lost) figures of Apostles, and the archivolt two rows of angels and Elders of the Apocalypse.

Style and dating. The composition is modelled on the centre doorway of Chartres (pl. 5, 8); in the upper portions – tympanum and pointed archivolt arches – the arrangement is almost literally repeated. However, the arrangement of the jamb figures and columns differs from Chartres. In place of columns supporting the figures there is a plain surface decorated only with engaged shafts surmounted by a ledge on which the squat jamb figures stand. The figures are separated simply by the undecorated recesses in the walls, and above them the squat capitals are decorated with acanthus, and, those nearest the door, with small Atlantes.

Compared with Chartres, the proportions and arrangement produce a heavy, clumsy effect. The composition of the Chartres centre doorway was modified in accordance with the forceful figure-conception of the Chartres Archivolt Master, with whom Angers shows a connection. This comes out particularly clearly in the figures on the right jamb (pl. 33). Characteristic indications are the layering of the draperies, the hems, the partiality for edgings, and the architectural forms given to the pedestals, for which there is a precedent in the Chartres Elders (pl. 15 top). The archivolt figures at Angers tally with the corresponding statuettes on the Chartres centre doorway. The enthroned Christ is a translation of the Christ of Chartres (pl. 5, colour pl. I) into the style of the Archivolt Master. Characteristic is the fall of the garments, diverging towards the folds at the feet.

Compare the Virgin of the right doorway at Chartres (pl. 6); that a workshop connection existed between Chartres and Angers can thus hardly be in doubt. It does not follow, as is usually asserted, that Angers is the more developed. Angers raises to the dominant one component of the Chartrain style, the forceful, weighty figure-conception of the Archivolt Master. Date: 1155–60.

L. de Farcy 1892, p. 41; W. Vöge 1894, esp. p. 257 ff.; G. Fleury 1904, p. 48 ff.; E. Mâle 1947⁵, p. 397; Ch. Urseau n.d., p. 45 ff.; M. Aubert 1929, p. 39 f.; M. Aubert 1946, p. 195 f.; A. Lapeyre 1960, p. 86 ff.; A. Mussat 1963, p. 185 f.; A. Mussat 1964, p. 29 ff.; B. Kerber 1966, p. 67 f.

Pl. 34–39

BOURGES (CHER), CATHEDRAL OF SAINT-ETIENNE
NORTH AND SOUTH PORTALS

Begun shortly before 1200, the five-aisled cathedral at Bourges is one of the most important gothic churches in France. On north and south two figure-decorated portals of the twelfth century open into the side aisles – immediately to the west of the original choir. From the evidence of their High Gothic bases, the portals were installed in their present position only c. 1225. On the south portal (pl. 37) the archivolt figures had to be trimmed to fit the new location. On both portals figures, socles and baldachins are too broad for the gradations of the jamb. On the north portal (pl. 34) we find later work patched into the twelfth-century tympanum (pl. 35 top). It looks, then, as though the twelfth-century sculptures were intended for some other position. It has been presumed that they were made for the west façade of the building which preceded the present cathedral. In the absence of archaeological evidence, further speculation as to the appearance of this older layout, which may never have been constructed, remains a matter of hypothesis. Reports of a building permit issued in 1172 and of collections for the cathedral's building fund under archbishop Guérin (1174–80), are not necessarily to be connected with the sculptures now seen on the north and south portals.

PROGRAMME

On the north portal the tympanum (pl. 35 top) depicts the Virgin enthroned flanked by angels, the Adoration of the Magi, Joseph(?), the Annunciation and Visitation. The Annunciation to the Shepherds is a thirteenth-century addition. On the jambs (pl. 34) there are two figures, one on either side; both are female, with heads held upright – in itself evidence enough to rule out the identification with Ecclesia and Synagogue sometimes proposed, since the latter would be expected to be shown with head bowed (cf. pl. 132, 133).

On the south portal (pl. 37) the tympanum portrays the Majestas Domini, and the lintel enthroned apostles. In the archivolt angels appear in the inner arch, prophets in the outer arch. The jamb figures (pl. 38, 39) are taken from the Old Testament, but only Moses, with the Tables of the Law, is

identifiable (right jamb, far right). The jambs also possess figure-decorated capitals: on the left (pl. 36 top) are depicted, on the outside, the Expulsion from Paradise, next to it the Fall, and on the inside David; on the right (pl. 36 bottom) are, on the inside, Noah with grapes, and the Sacrifice of Isaac, and on the third capital Samson and the lion. These capitals were probably not originally intended for the Majestas portal.

Style and dating. A connection with the Royal Portal at Chartres is most readily seen in the sculptures of the south portal. The Moses in particular betrays the influence of the works of the Archivolt Master (pl. 15 top). The tympanum is admittedly Chartrain in type, but in its lameness of execution falls short of the model. In the figures on the left jamb of the south portal (pl. 38), but above all in the tympanum and on the right jamb of the north portal (pl. 34), there is a rendering of drapery which divides the bodies into ornamental areas – a movement away from the coherent forms of Chartres. A striking feature of the Bourges portals is the wealth of ornamental forms on jambs and archivolts. While details of the jamb arrangement point to Burgundy – Saint-Bénigne, Dijon (ill. 8) – the wealth of ornament is found on a number of portals in regions not far from Bourges: Saint-Genest at Nevers, Donzy-le-Pré, Saint Pourçain-sur-Sioule and Saint-Benoît-sur-Loire (pl. 66).

In the light of more recent research, the idea occasionally entertained that the portals at Bourges are earlier than Chartres can no longer be taken seriously. Almost equally unlikely is a late, post-1165 date. We can assume that the sculptures and ornamentation installed on the external walls at Bourges in the thirteenth century originated *c.* 1160.

A. L. M. Buhot de Kersers vol. II 1883, p. 137ff.; W. Vöge 1894, esp. p. 241ff.; M. Aubert 1929, p. 36ff.; P. Gauchery 1931, p. 189ff.; R. Crozet 1932, p. 303ff.; F. Deshoulières 1932, p. 30ff.; M. Aubert 1946, p. 192f.; H. Giesau 1950; R. Branner 1957; P. Gauchery, C. Gauchery-Grodecki 1959, p. 99ff.; A. Boinet 1952 (3), p. 63ff.; A. Lapeyre 1960, p. 153ff.; R. Branner 1962, p. 132ff.; B. Kerber 1966, p. 54ff.

Ill. 18

DEOLS (INDRE), TYMPANUM FRAGMENT (NOW CHATEAUROUX, MUSEE DES BEAUX-ARTS)

The abbey of Notre Dame at Déols was one of the important Benedictine foundations of France. Its suppression in 1627 was followed by the almost total destruction of the church. The north portal survived until 1830 and is known to us from descriptions and travellers' impressions written in the early nineteenth century, which mention in particular the unusually tall jamb-figures. The tympanum – now only a fragment in the museum at Châteauroux – displays the Majestas Domini. Accounts speak of three archivolt arches: the inner one contained angels, the middle one a cycle of the Liberal Arts, with Philosophy at the apex, the outer one a Calendar. These few details about the programme are

sufficient to make clear that the portal at Déols in Berry was in the tradition of the early Gothic of the royal domain.

The portions preserved in the museum at Châteauroux confirm the supposition, but at the same time reveal a work of independent stamp. As regards content it is surprising to find a Christ enthroned over lion and dragon. The motif is taken from Psalm 91:13, 'the young lion and the dragon shalt thou trample under feet', but is normally used in connection with a standing Christ. Again, the folds in the border-decoration of the mandorla and the volute-shaped endpieces of the cushioned throne are without parallel among early gothic representations of the Majestas. Despite this, the theory of a connection with the Ile-de-France still holds. In any event, the highly forceful formal language, which treats the draperies in flat bands with no tracery of delicate lines, is far removed from the tympanum at Chartres (pl. 5). Nor is there any recognizable connection with nearby Bourges (pl. 35, 37). Thus the most that can be said is that while the stimulus came from the Ile-de-France, the interpretation is new; where to look for the stylistic and historical factors which influenced this change is still not clear. At one

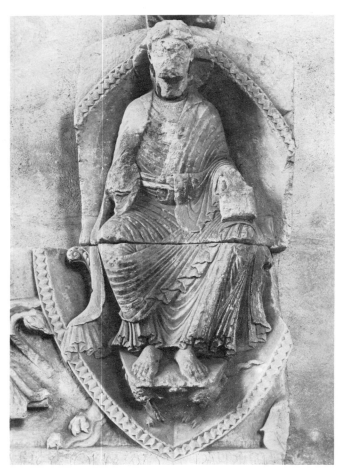

Ill. 18 Déols, Notre Dame, collegiate church. North portal, tympanum fragment: Majestas Domini. About 1160. (Châteauroux, Musée des Beaux-Arts)

time opinion favoured a date of *c*. 1150 – perhaps even earlier than the Chartres west doorways – but this theory has been abandoned. The date more recently suggested, *c.* 1180, is surely too late. The most likely date is *c*. 1160. It was in 1160 that Pope Alexander III dedicated the altar of the Holy Cross at Déols.

J. Hubert 1927; M. Aubert 1929, p. 48; R. Crozet 1932, p. 322 ff.; J. Hubert 1957; A. Lapeyre 1960, p. 81 ff.

Ill. 19, 20

VERMENTON (YONNE), NOTRE DAME WEST PORTAL

The west portal of the church of Notre Dame at Vermenton belongs to the small group of early gothic figure-decorated portals found in Burgundy. For its appraisal one must start from the engraving in Dom Plancher's *Histoire de Bourgogne* (1739), which shows the portal before its partial destruction at the time of the Revolution, when trumeau and tympanum were removed. Of the five jamb figures illustrated by Plancher only three survive, in a damaged condition. The archivolt is largely unscathed.

PROGRAMME

This is highly unusual and corresponds to no other early gothic portal known to us. The trumeau figure represents John the Baptist in knee-length garment, holding a baptismal bowl as his attribute. On the left jamb are the three Magi, and opposite them are (centre) a standing Virgin and Child (ill. 20) and a bishop, perhaps Nicholas of Bari. Representations of the Baptist on a trumeau are rare in the extreme; the only known parallel is found nearby at Vézelay, on the trumeau of the inner portal. Still more unusual, for the twelfth century, is an Adoration of the Magi in the form of large jamb figures. Vermenton anticipates a solution adopted again only decades later, on the right jamb of the west portal at Amiens (pl. 166). It should be noted, however, that Saint-Lazaire at Avallon (in the immediate neighbourhood of Vermenton) possessed an Annunciation on the jamb of its centre doorway. Thus it seems that early gothic portals of this region had a fondness for scenic jamb groups. Customary forms of Burgundian romanesque, as exemplified especially at Vézelay, perhaps still exerted some influence. The tympanum depicts the Majestas Domini, with angels in the inner arch of the archivolt. In the middle arch is a Calendar, and the groups of Elders in the outer arch relate to the Majestas; interpolated with them are a martyrdom of St Stephen and scenes from the legend of St Nicholas (rescue of the boy who fell into the sea with the cup; calming of the storm). The archivolt programme thus combines a variety of cycles (Calendar, Elders, legends) on a single portal, a procedure often met with on more modest installations. The basic theme is the Majestas, while the Calendar in the archivolt is in keeping with older Burgundian practice. St Stephen was the patron of the Auxerre diocese, and

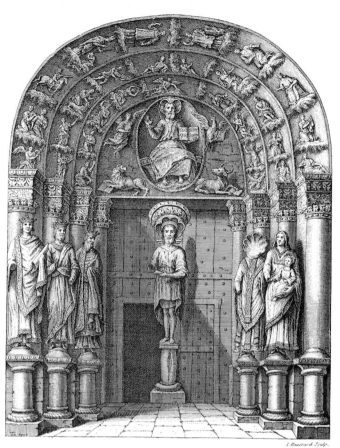

Ill. 19 Vermenton, Notre Dame. West portal. Towards 1170. (After Dom Plancher I, p. 514)

Nicholas appears to have been a saint especially venerated in the locality.

Style and dating. The construction of the portal bears a remote resemblance to the west portal of Saint-Bénigne, Dijon (ill. 8). As at Dijon, the jamb figures stand on short stumpy columns. Another point of resemblance is the archivolt, which is rounded and shows not single figures but figure-groups. The figure style is characterized by a ridge-like rendering of the drapery, and by a liking for folds tapering to an acute angle. There is not the slightest echo of the delicate but austere formal language of the Chartres Head Master. In the literature the Vermenton portal is compared with a host of others, in themselves a very varied assortment. None of the comparisons carry conviction. The fact remains that among surviving monuments, despite isolated points of resemblance to Dijon, the Vermenton portal is a fairly isolated case. The architectural evidence points to a date around 1175 for the western portions of the church; so far as the sculptures are concerned, however, this seems rather late.

U. Plancher 1739, vol. I, p. 514; G. Fleury 1904, p. 132 ff.; A. Philippe 1907; E. Mâle 1947[5], p. 390, 433; M. Aubert 1929, p. 63 f.; S. Abdul-Hak 1942, p. 66; A. Lapeyre 1952–53; M. Aubert 1958; A. Lapeyre 1960, p. 291 f.; B. Kerber 1966, p. 57 ff.

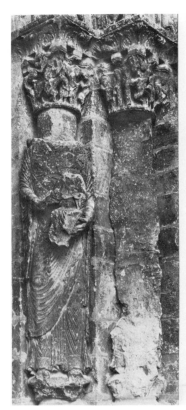
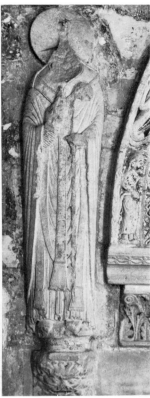

Ill. 20 Vermenton, Notre Dame. West portal. Virgin and Child on the right jamb. Towards 1170

Ill. 21 Loches, Notre Dame du Château (Saint-Ours), collegiate church. Bishop on the east wall of the porch. Before 1168

Ill. 21

LOCHES (INDRE-ET-LOIRE), NOTRE DAME DU CHATEAU (NOW SAINT-OURS), COLLEGIATE CHURCH
SCULPTURES IN THE PORCH

The porch of the collegiate church of Notre Dame du Château at Loches is presumed to date from the last years of Prior Thomas (known as Pactius), who died in 1168. The highly unusual sculptural decoration on the east wall was probably made and installed at the same period.

The portal has recessed jambs and above them an archivolt with a radial arrangement of the motifs, most of which are taken from the image cycle of Bestiaries. There is no tympanum. This type of portal is not early gothic but stems from the romanesque architecture of western France. The style of the archivolt figures, however, is not western French romanesque but derives from models in the Ile-de-France. Many of the hybrid beings show a surprising similarity to capitals in Saint-Germain-des-Prés in Paris or at Saint-Loup-de-Naud (pl. 24, 25). The case is thus remarkable, in that a workshop trained in northern France has supplied the decoration for a portal of the western French romanesque

type. Beside and above the doorway are zones of statues and reliefs, clearly originally intended for another setting. In the bottom zone on the right we recognize Peter, on the left a bishop (ill. 21). In the middle zone there are four column statues set into the wall: those on the left presumably represent an Annunciation, those on the right a Visitation(?). On a ledge above we have the Adoration, and adjoining it on the right the Dream of the Magi. Here is an ensemble with many features in common with early gothic portals, but deployed on the wall surface like a painted cycle. There can be no doubt that the original plan was quite different; it must have been abandoned while the sculptures were still in the making; a place was then found for them on the east wall of the porch.

Stylistically there is a close connection with the nave portals at Bourges (pl. 34–39). The work at Loches is later however, and cruder in execution. If a date of c. 1160 is assumed for the Bourges portals, there is nothing to contradict a date for the Loches sculptures before 1168, the year Prior Thomas died.

W. Vöge 1894, p. 254ff.; J. Vallery-Radot 1926; J. Vallery-Radot 1948; A. Lapeyre 1960, p. 253f.; L. Schreiner 1963, p. 31ff.

Ill. 22

PROVINS (SEINE-ET-MARNE), SAINT-AYOUL, PRIORY CHURCH
WEST PORTAL

The west portal of the priory church of Saint-Ayoul is in a poor state of preservation. In 1792 the trumeau, lintel and lower half of the tympanum were removed and the remaining figures damaged. The head of the jamb figure seen on the extreme right was unearthed in 1911 and assigned arbitrarily to its present place.

PROGRAMME
The eight jamb figures cannot be identified, though the figure on the extreme left is perhaps Peter; most of the remaining figures seem to stem from the Old Testament cycle of Saint-Denis and Chartres. About the trumeau figure nothing is known – that it represented St Aigulf remains sheer supposition. The tympanum displayed the Majestas, the lintel presumably the apostles. The three inner arches of the archivolt are an almost literal repetition of the Chartrain programme of angels and Elders. The outer arch introduces different themes including (bottom right) Ecclesia, and (bottom left) Synagogue. Above Ecclesia we have the gates of Paradise, an angel carrying souls, Abraham's bosom; above Synagogue, scenes of Hell. For the association of the Majestas with Ecclesia and Synagogue cf. Saint-Bénigne, Dijon (ill. 8), with Judgment motifs, Ivry-la-Bataille (ill. 11–14). Note the lateral reversal, with Hell on the right hand of Christ.

Style and dating. The connection with the Royal Portal at Chartres is clear from a few of the jamb figures. The execution is flabby. The forms are flattened, the lines of the folds

402

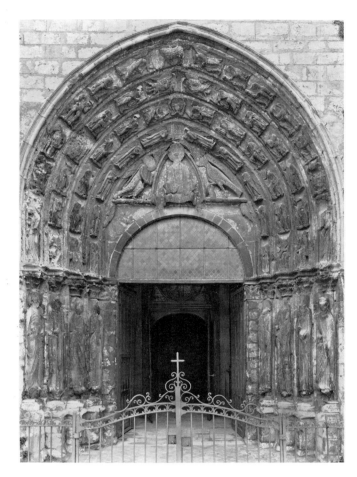

Ill. 22 Provins, Saint-Ayoul, priory church. West portal. After 1157

are limp. The strict relationship between bearing and drapery characteristic of the Chartres Head Master has here yielded to the taste for independently formed ornamental folds. There seems no connection with the Saint-Thibaut portal, also at Provins (ill. 23), or with Saint-Loup-de-Naud (pl. 24, 25). The Saint-Ayoul portal was presumably erected after a fire in 1157.

W. Vöge 1894, p. 204 f.; G. Fleury 1902; G. Fleury 1904, p. 40 ff.; E. Mâle 1947[5], p. 382; M. Aubert 1929, p. 40 ff.; Maillé, Marquise de 1939, vol. II, p. 71 ff.; M. Aubert 1946, p. 196; W. S. Stoddard 1952, p. 32 ff.; A. Lapeyre 1960, p. 187 ff.; B. Kerber 1966, p. 62.

Ill. 23

PROVINS (SEINE-ET-MARNE),
SAINT-QUIRIACE, COLLEGIATE CHURCH,
WEST PORTAL
ENTHRONED CHRIST, FROM SAINT-THIBAUT

The chapel of Saint-Thibaut belonged to the collegiate foundation of Saint-Quiriace. It was a small building, of which only vestiges remain. According to old descriptions and illustrations it possessed two figure-decorated portals.

One, opposite the patron's birthplace, featured a trumeau with a figure of the saint in lay attire. The other portal, opening into the south-facing façade, had a larger figure programme: St Theobald (as priest) on the trumeau, statues on the jambs, and presumably a Majestas in the tympanum. Extant are the St Theobald in the Grange aux Dîmes at Provins; a jamb figure, perhaps the Queen of Sheba, in the Pitcairn Collection at Bryn Athyn, Pennsylvania; and the enthroned Christ (ill. 23) from the tympanum, on the west portal of Saint-Quiriace.

Stylistically, the Christ of Saint-Thibaut is no longer within the tradition of the Chartres Royal Portal. The soft profiling of the mandorla border, the fullness of the features, the loose draping of the mantle with its rounded folds, the decoration of the borders with a fish-scale pattern, argue for a date later than the period of the royal portals. A remote comparison with the sculptures on the west façade of the collegiate church at Mantes (pl. 46–48 top) seems possible. The date of c. 1200 proposed in the existing literature is probably too late; c. 1170 seems nearer the mark.

W. Vöge 1894, p. 205 f.; Maillé, Marquise de 1939, vol. I, p. 191 ff.; M. Aubert 1946, p. 196 f.; A. Lapeyre 1960, p. 192; L. Pressouyre 1967, p. 108 (II).

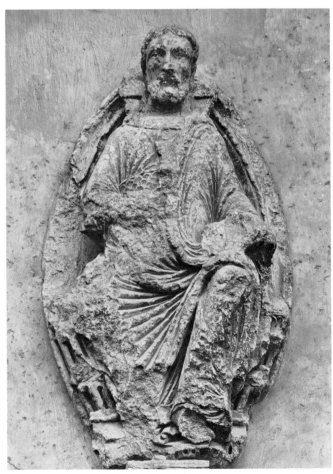

Ill. 23 Provins, Saint-Quiriace, collegiate church. Christ enthroned in the mandorla, from Saint-Thibaut. About 1170

403

CHATEAU-CHALON (JURA), NOTRE DAME, ABBEY CHURCH PORTAL

The church of the Benedictine convent at Château-Chalon possessed a figure-decorated portal which was destroyed at the Revolution; its appearance is known from an engraving and detailed description compiled in 1735. There were eight jamb figures among which (on the right) Peter, Paul and Moses are easy to identify; that the female figure is the Queen of Sheba is purely a conjecture. On the left jamb, the inside figure is an unmitred bishop dispensing blessing (not Aaron, as at one time suggested); next to him a deacon, possibly Stephen, with the martyr's palm. The identity of the remaining figures remains obscure. A recent conjecture that the male figure holding a tower represents Solomon is unconvincing, since the crown is lacking. The tympanum depicted the Majestas Domini with symbols of the evangelists and donors.

This portal must be regarded as the most easterly offshoot of the figure-decorated portal evolved in the French royal domain. The arrangement of the jamb and details of the programme may go back to Saint-Bénigne, Dijon (pl. 22, 23, ill. 8). The special type of the Majestas again points to Burgundian models. On the other hand, the presence of donors on the tympanum is virtually without parallel, whether in the royal domain or in Burgundy, though it is not uncommon in the Empire. The absence of a figure-decorated archivolt has parallels with extant portals found in Switzerland, Lorraine and south-west Germany, but not in Burgundy or the Ile-de-France. The portal must date from the third quarter of the twelfth century, or at most a little later. It seems to have had no successors. The suggestion that certain features of the sculptures dating from *c.* 1230 on the façade of the south transept at Strasbourg (pl. 130–135) were inspired by Château-Chalon has proved unfounded.

F. J. Dunod de Charnage 1735, p. 173 ff.; W. Vöge 1894, p. 337 ff.; R. Tournier 1954, p. 107 f.; A. Lapeyre 1960, p. 126 f.; B. Kerber 1966, p. 66.

Pl. 40, 41 middle and bottom, 50 bottom left, ill. 25, 26

PARIS, NOTRE DAME RIGHT DOORWAY OF THE WEST PORTAL (PORTAIL SAINTE-ANNE)

The cathedral of Notre Dame in Paris (ill. 72) is among the great early gothic churches of northern France. Robert of Auxerre reports that Bishop Maurice de Sully (1160–96) rebuilt the cathedral of Paris '*a fundamentis*'. Work must have started almost as soon as he became bishop. The statement that Pope Alexander III laid the foundation stone in 1163 comes from a late source and is not to be taken as certain. The construction of the building was from east to west. The cathedral's west doorways (pl. 144) are first mentioned in 1208 in a charter of Bishop Eudes de Sully, at which time they were still unfinished.

The name Porte Sainte-Anne is given to the right doorway because some of the sculptures in the lower lintel illustrate the story of Anne and Joachim. The doorway was erected in the first quarter of the thirteenth century. Most of the sculptures, however, are several decades earlier in date and presumably go back to the first years of Bishop Maurice's episcopate. Sculptural work for the west doorways was probably put in hand immediately after 1160, when a start was made on the new building. When the façade came to be erected in the early thirteenth century, the centre (pl. 145–151) and left (pl. 152–157 top) doorways were new creations. For the Porte Sainte-Anne, presumably the last to be installed, the older sculptures were used, complemented by newly worked additions.

INVENTORY AND PROGRAMME

The tympanum (pl. 40) dates from the twelfth century. The narrow lateral fields filled with tendril ornament, and the apical field with two censing angels are thirteenth-century additions. A few items are nineteenth-century replacements: the Virgin's sceptre, the Child's blessing hand, the top of the bishop's crozier. In the centre is the Virgin enthroned, flanked by angels with censers. The identity of the three remaining figures is uncertain. The kneeling king on the right is perhaps Louis VII (1137–80), during whose reign the portal was begun. If that is so, the bishop on the left is presumably Maurice de Sully. Both are holding scrolls, and it is possible that the portrayal commemorates a royal donation to Notre Dame, in which case the clerical scribe on

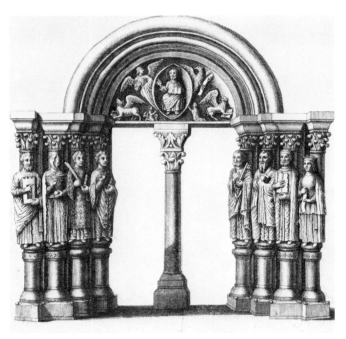

Ill. 24 Château-Chalon, Notre Dame, abbey church. Portal. 1170–1175. (After Dunod de Charnage I, part 2, p. 176)

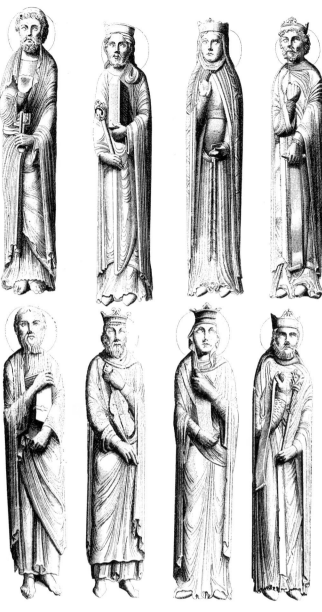

Ill. 25 Paris, Notre Dame. West portal, right doorway. Jamb figures. Shortly after 1160. (After Montfaucon I, pl. 8)

Ill. 26 Paris, Notre Dame. West portal, trumeau from the right portal: St Marcellus. Soon after 1160. (Notre Dame, north tower)

the left may be recording the gift in the cathedral's cartulary. Some have identified him as Barbedor, dean of the cathedral chapter.

Lintels (pl. 40). The top band is of twelfth-century date. Narrow sections at either end were added in the thirteenth century: the Presentation of the Virgin in the Temple, the horses of the Magi. Subjects, reading from left to right: Purification, Isaiah, Annunciation, Visitation, Nativity, Annunciation to the Shepherds, scribes and Pharisees, Herod, the three Magi. The bottom band with the marriage

of Mary and the story of Anne and Joachim dates from the thirteenth century.

Archivolt figures. The bottom figures, the keystones and a few of the topmost statuettes date from the thirteenth century. The subjects of the remaining figures (pl. 41 middle and bottom) include angels with censers, kings and prophets. The identification of the figures in the outer arch presents difficulties; some have vials or musical instruments as their attributes, and hence could be Elders, but crowns are lacking.

Jambs. The eight statues were destroyed at the Revolution and replaced in the nineteenth century. On the evidence of an engraving published by Montfaucon (ill. 25) the originals dated from the twelfth century. Among them we recognize Peter, Paul and David. A fragment of the Peter statue is in the Musée de Cluny. A head in the Metropolitan Museum, New York (pl. 50 bottom left), is associated with the figure of David.

Trumeau. This bore a representation of St Marcellus of Paris (ill. 26); it was broken and damaged at the Revolution and replaced in the nineteenth century. The original,

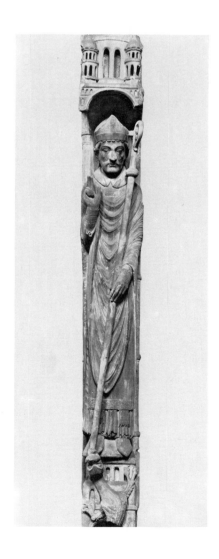

405

restored by Romagnesi in 1818, is now in the north tower of Notre Dame. This rarely portrayed saint – a fifth-century bishop of Paris – is shown striking a dragon, which nestles in the coffin of an adulteress, with the point of his crozier.

Style and dating. The sculptures of the Porte Sainte-Anne, which may not originally have been intended for installation on a single doorway, pose some difficult questions of style-criticism. The tympanum relief (pl. 40), which despite the doubts occasionally expressed may be regarded as a unit, is in the tradition of the Chartres Archivolt Master. The forms are smoother and more chased than at Chartres, the relief thus showing thereby a distinct feeling for the decorative effect of the contours. Further, there is not the same sturdily individual characterization of the heads we find in the Liberal Arts and authorities at Chartres (pl. 15 below). In the rendering of the faces there is less warmth and individuality. It is not from the iconography alone that this relief derives its air of strictly regulated ceremony. We thus cannot think of Paris and Chartres in terms of the same hands, but the differences we have noted would fit a date for the Paris tympanum shortly after 1160. In the other parts of the doorway the only echo of the tympanum style appears to be the trumeau figure, St Marcellus (ill. 26). The jamb figures and the reliefs of the upper part of the lintel form a second, and seemingly self-contained, group. Here the formal language shows no recognizable connection with the Royal Portal at Chartres. Whereas the Chartres Head Master was concerned to clarify the statuary and axial formation of his figures through a disciplining of the drapery, here we have surfaces segmented by a pattern of sharply defined folds. Precursors of this figure style have yet to be found. The hardest problem of all is posed by the archivolt figures (pl. 41): in many of the angels of the inside arch echoes of the group just described are few and far between. The prevailing figure type is one in which broad, compact bodily proportions are combined with a disproportionately large head. In one or two places the movement and the rendering of the drapery seem to show some lingering traces of the formal language of the west portal of Saint-Denis – doorposts of the centre doorway, and jamb figures of the right doorway (ill. 3).

The sculptures of the Porte Sainte-Anne were made very shortly after 1160. Precedents for them are to be sought at Chartres, but also at Saint-Denis. The lack of stylistic uniformity may be a result of the installation in the thirteenth century, which probably brought together on one doorway sculptures originally intended for a number of different locations. See also the following note.

B. de Montfaucon 1729, vol. I, p. 55f.; J. Lebeuf 1754, vol. I, p. 11f.; A. P. M. Gilbert 1821, p. 76ff.; F. de Guilhermy, E. Viollet-le-Duc 1856, p. 63; A. P. M. Gilbert 1840; R. Mortet 1888, p. 31; W. Vöge 1894, p. 135ff.; E. Mâle 1928, p. 188ff.; R. de Lasteyrie 1902, p. 36ff.; M. Aubert 1929, p. 57ff.; J. Rorimer 1940; M. Aubert 1946, p. 200f.; W. Sauerländer 1958, p. 125ff. (II); A. Lapeyre 1960, p. 147ff.; B. Kerber 1966, p. 69ff.; *see also* Appendix to Bibliography.

Pl. 41 top

PARIS, NOTRE DAME, ARCHIVOLT FRAGMENTS (NOW PARIS, LOUVRE)

The two fragments came to the Louvre in 1894, from the Dépôt Lapidaire of Notre Dame; both are keystones from the archivolt of a portal. They show: Christ between two angels, following the text: 'And out of his mouth proceedeth a sharp sword that with it he may smite the nations' (Revelation 19:15); an Agnus Dei between two angels. The pieces were clearly never installed. Two keystones depicting the same subjects were made afresh *c.* 1225–30 for the two outer arches of the archivolt of the Porte Sainte-Anne (pl. 40). The Louvre fragments were presumably rejected on the grounds that they did not fit the pointed arch construction of the thirteenth-century archivolt.

It is probable that these keystones with apocalyptical themes were not originally intended for the Virgin's portal of the Paris cathedral but for a centre doorway with a Majestas. In this connection it is important to note Viollet-le-Duc's reported discovery of a large tympanum with a Majestas beneath the side chapels of Notre Dame. The keystones in the Louvre, and the Elders from the archivolt of the Porte Sainte-Anne (cf. p. 404) may have been intended for the portal of which this was the tympanum. Date: after 1160.

P. Vitry 1910; M. Aubert, M. Beaulieu 1950, p. 67ff.; W. Sauerländer 1958 (II).

SENLIS, MANTES AND OTHER MONUMENTS
1160–1200

Pl. 42–45, 50 top right

SENLIS (OISE), CATHEDRAL OF NOTRE DAME WEST PORTAL

The cathedral of Notre Dame at Senlis belongs to the small group of early gothic churches in the direct line of descent from Saint-Denis. A building of modest size, it was started in 1153 and dedicated on 16 June 1191. The sculptures of the west portal were damaged in 1793. Apart from the traces of damage still visible in tympanum, lintel and archivolt, the heads, and in some cases the attributes of the jamb figures were destroyed. In 1845–56 the losses were made good by the sculptor Robinet, though not always in a manner appropriate to the content. For the condition of the portal

before 1845, comparisons can be made with illustrations from the early nineteenth century. Plaster casts of five of the figures, made before the restoration, are preserved in the Musée des Monuments français (pl. 43 bottom). Recently discovered heads of two of the figures are now in the Musée du Haubergier, Senlis (pl. 50 top right). The portal apparently possessed a trumeau, but nothing is known of the figure depicted.

PROGRAMME

The portal, the tympanum of which depicts the Coronation of the Virgin, is the oldest surviving monument of this type. In the following decades many other portals were modelled on its iconographic scheme. Senlis breaks away from the Old Testament cycle of the royal portals of Saint-Denis and Chartres, a cycle which, together with the Majestas, no longer features on early gothic church portals. The cycle, which forms the kernel of the new programme devoted to the Virgin, begins on the left of the lintel relief (pl. 42). The death and burial of Mary are combined in a single scene. Apostles place the body in a sarcophagus, while angels holding a crown bear her soul away to Heaven. The Assumption and Coronation of the soul of the Virgin are followed in the right lintel relief (pl. 43 top) by the raising of her body and, once again, a Coronation by angels who make ready to bear her heavenwards. There, following her bodily Assumption, she is depicted as Queen of Heaven, with crown and sceptre, at the right hand of the Lord; adoring them are angels with candlesticks and censers. The archivolt figures extend the programme (pl. 42, 44, 45): represented here is the genealogy of Jesus and of Mary, descended from the house of David. In the three inner arches we see their ancestors, enthroned amid tendrils sprouting from the Stem of Jesse (cf. Isaiah 11:1 – 'And there shall come forth a rod out of the stem of Jesse'). The sequence begins at the bottom in the third arch (counting from the inside), where we see David with his harp and above him Solomon, with crown and sword. Hovering above Christ and Mary in the apex of the inner arch is the Dove, i.e. the Holy Spirit (cf. Isaiah 11:1–2 – 'and a branch shall grow out of his roots: and the spirit of the Lord shall rest upon him'). Enthroned in the outer arch are patriarchs and prophets, whose purpose – as we know from similar portrayals in painting – is to expound the theme by prophecies of the coming of the Messiah.

This programme combines two themes of different provenance. One is the portrayal of Christ's human ancestry, which in the form of the Stem of Jesse first occurs relatively late in the West; from Saint-Denis onwards it is a familiar theme in early gothic stained glass. The other is the portrayal, based on apocryphal texts, of the death and bodily assumption of the Virgin Mary, for which there was a pictorial tradition going back over a long period. In the enthroned pair on the tympanum the two themes are combined. Mary and Jesus, as the last descendants of the line of Jesse, continue the series in the archivolt. The unusual curvature of the arch above the heads of the enthroned pair looks like a deliberate and final repetition of the curves made by the tendrils of the Stem of Jesse. However, Christ and the Virgin belong equally to the scenes in the lintel. It was Christ who raised and set at his right hand Mary who died surrounded by the apostles, and who was crowned and carried up to Heaven by angels.

In medieval exegesis the Virgin enthroned beside Christ is compared with the Bride in the Song of Solomon, and passages such as 'Come with me, from Lebanon my spouse' (4:8) were related to Christ and Mary. As Bride of Christ, Mary then became identified with the Church. The Christ of the Senlis tympanum is the Bridegroom of the Church, a bridegroom who sacrificed himself and whose sacrifice, through the sacrament, is a living presence in the church. It is to him that the eight statues on the walls of the portal refer, most of them by drawing attention to the sacrificial nature of his death (pl. 42, 43 bottom).

On the left jamb the figure on the left is John the Baptist with a kneeling candidate for baptism; with his right hand he points to the tympanum. Next to him Samuel is seen as a priest offering sacrifice: 'And Samuel took a sucking lamb, and offered it for a burnt offering wholly unto the Lord: and Samuel cried unto the Lord for Israel; and the Lord heard him' (1 Samuel 7:9). The reference to the eucharistic sacrifice is plain. The little relief figure beneath Samuel is the young David whom he anointed, and not Saul, as has often been supposed. David's anointing by Samuel was seen as referring to Christ: 'I will send thee to Jesse the Bethlehemite; for I have provided me a king among his sons' (1 Samuel 16:1). Samuel is followed by Moses, pointing with his right hand to the (destroyed) brazen serpent: 'And Moses made a serpent of brass and put it upon a pole, and it came to pass, that if a serpent had bitten any man, when he beheld the serpent of brass, he lived' (Num. 21:9). Once again, the christological significance is plain, and was enunciated by Christ himself: 'And as Moses lifted up the serpent in the wilderness, even so must the Son of man be lifted up' (John 3:14). On the socle below Moses is seen the golden calf. The last figure on this side is Abraham, about to sacrifice Isaac, who stands with his back to his father; Abraham holds a sword, grasped at the point by a (restored) angel, and below him is the ram sacrificed in Isaac's place: 'For now I know that thou fearest God, seeing thou hast not withheld thy son, thine only son from me' (Gen. 22:12). The parallel between the sacrifice of Isaac and the sacrifice on the Cross goes back to the Church Fathers.

On the right jamb David, on the extreme right, is depicted holding a banderole and, in his veiled left hand, two nails: 'For dogs have compassed me: the assembly of the wicked have inclosed me: they pierced my hands and my feet' (Psalm 22:16). The next figure is Isaiah. The long rod in his right hand, now broken off, probably ended in a blossom and referred to the rod of Jesse mentioned in Isaiah 11:1. After him comes Jeremiah, holding with both hands a cross (greatly restored): '... behold, and see if there be any sorrow

407

like unto my sorrow . . . wherewith the Lord hath afflicted me' (Lam. 1 : 12), a passage seen as related to the Passion. The last figure, next to the doorpost, is Simeon, carrying Christ; cf. his prophetic words to Mary, always taken as a reference to the Crucifixion: 'Yea, a sword shall pierce thy own soul also' (Luke 2 : 35).

The designation 'Coronation of the Virgin' does not do justice to the breadth of meaning encompassed by this programme. Its theme is the universality of the redemption of mankind in the Old and New Testaments, brought to fulfilment in Christ's marriage with the Church.

Construction, style, dating. The arrangement of the portal – with high recessed base and lintel set above slender columns – derives not from the Royal Portal of Chartres (pl. 4) but from the west doorways of Saint-Denis (pl. 1). At the same time we should note the differences. On the jamb, the figure zone is not recessed but forms a continuous wall, and in consequence there is more room to develop the volume and movement of the figures (on the evidence of early nineteenth-century pictures we must conclude that the capitals above their heads are arbitrary additions, made by Robinet). Further differences from Saint-Denis can be observed in the tympanum and archivolt. The tympanum is subdivided by three-dimensional arcades. The archivolt figures are encircled by the tendrils of the stem of Jesse in a manner suggesting deeply hollowed niches. With this goes an intensification of the curving, spiralling movement, expressed in violent gesticulations and abrupt twists and turns. This is plainly not a style in contact with Chartres. Equally plain, however, are the echoes of Saint-Denis: motifs from the statues of the side doorways, as illustrated by Montfaucon (ill. 2, 3), recur in the Senlis figures of the Baptist, Simeon and David. An intermediate stage can be discerned in Paris, where several archivolt figures of the Porte Sainte-Anne and the keystones now in the Louvre (pl. 40, 41; see p. 404 f.) are comparable with the style of Senlis. This still does not account for the intensification of three-dimensional movement found at Senlis. On the other hand there are surprising similarities between the archivolt figures of Senlis and works by Mosan goldsmiths, for example the Evangelists on the foot of the Cross from Saint-Bertin, now in the museum at Saint-Omer. It is possible that the unusual mobility of the Senlis style has been derived from this source.

The date of the portal has long been linked in the literature with the report of a dedication in 1191. Against this it must be said that both the style of the sculptures and the architectural forms of the portal favour an earlier date, probably towards 1170. Despite frequent repetitions of the Senlis programme on other portals, which continue into the thirteenth century, the style of Senlis had virtually no successors.

M. Aubert 1910; E. Mâle 1928, p. 209 ff.; M. Aubert 1929, p. 75 ff.; M. Aubert 1938; P. Wilhelm 1941; J. Vanuxem 1945; M. Aubert 1946, p. 205 ff.; E. Mâle 1947⁵, p. 436 ff.; W. S. Stoddard 1952; W. Sauerländer 1958 (II); W. Vöge 1958, p. 54 ff.; L. Grodecki 1959; A. Lapeyre 1960, p. 239 ff.; A. Katzenellenbogen 1963; B. Kerber 1966, p. 73 ff.

408

Pl. 46–48 top, 50 top left

MANTES (SEINE-ET-OISE), NOTRE DAME, COLLEGIATE CHURCH WEST PORTAL

In the twelfth century the collegiate foundation of Notre Dame at Mantes had close connections with the royal house, and for a while Louis VII (1137–80) and Philip Augustus (1180–1223) were its titular abbots. The church dates from the second half of the twelfth century, but there is no documentary evidence to determine the dates of the building operations. On the west façade there are three figure-decorated doorways, of which those in the centre (pl. 47) and on the left (pl. 48 top) survive in their original early gothic forms; the doorway on the right was remodelled in 1300. In 1794 the jamb figures were torn down and the tympana and archivolts damaged. The undecorated shafts on the jambs date from the early nineteenth century. The centre doorway has lost its trumeau. For the appearance of the doorways before 1794 we have to rely on an inaccurate engraving in Millin's *Antiquités Nationales*. The heads of four of the jamb figures were recovered in 1857, and are now on the gallery on the south front (pl. 50 top left).

PROGRAMME

In the centre is a Coronation portal (pl. 47) of the same type as Senlis (pl. 42), but with iconographic divergences which point to yet another scheme as the model. The Marian cycle has a richer complement of scenes. It starts on the left of the lintel (here undivided) with the legendary arrival of the apostles in Jerusalem. In the centre the death of the Virgin, with the apostles grouped around the corpse; at the head end of the couch we can make out Peter with the keys, on the left John with the celestial palm delivered to him by Mary before her death. In the third section of the lintel Mary is raised up to Heaven, in scenes which again show a deviation from Senlis. An angel (Michael?) standing beside the couch delivers her soul to Christ. To understand this scene it is necessary to refer to a text given in the *Legenda Aurea*: 'The Archangel Michael brought Mary's soul before the Lord, who said, "Arise, my best beloved." And at once Mary's soul passed into the body and passed up into Heaven, accompanied by a host of angels.' On the right, accordingly, we see angels raising her body.

In content the tympanum group agrees with Senlis. The heart-shaped double arch above Christ and Mary is replaced by a baldachin, architectural in form. The three inner arches of the archivolt contain a Stem of Jesse, starting as at Senlis in the third arch, bottom left: above Jesse, with the rod sprouting from his loins, we see David with harp, then Solomon with sword. The figures in the outer arch, though entwined by the tendrils of the Stem of Jesse, are presumably patriarchs and prophets as at Senlis, and a sibyl (?): that is to say, they do not belong to the genealogical sequence but nevertheless refer to the Stem of Jesse. The individual figures have not so far been identified. The way they are

assembled clearly diverges from Senlis. In the apex of the outer arch is the dove, in the inner arch two angels holding the Cross.

The jamb figures were probably the same characters as at Senlis. In the nineteenth century there were old inhabitants of Mantes who could still remember a figure of Abraham. The heads of Moses (pl. 50 top left) and Samuel(?) have survived. For the significance of the programme cf. Senlis, p. 407. It should be added that at Mantes the presence of the Cross above the enthroned pair makes explicit the reference to the Bridegroom's sacrificial death.

The theme of the left doorway (pl. 48 top) is the Second Coming, conceived in a manner not encountered on other early gothic portals. It is introduced on the lintel with the Easter scene of the three women at the tomb. On the left, beside the open sarcophagus, is the angel, addressing the women as they advance from the right: 'He is not here, for he is risen' (Matt. 28:6). The resurrected Christ is enthroned in the tympanum, flanked by censing angels and displaying attributes which allude to his Second Coming: in his right hand he holds the book with the seven seals (Rev. 5:1), in his left the earth's disc. Another attribute, also in the left hand, was badly damaged in 1794 and cannot now be identified for certain; it was perhaps the shaft of a cross with a dependent crown of thorns, i.e. instruments of the Passion, which were attributes of the Judge. In the apex of the archivolt, above the head of the enthroned figure, is the Agnus Dei flanked by standing prophets. The jamb figures were described by Millin as kings and saints, and this is all we know of them. Nothing is known about the trumeau.

Style and dating. Operations began with the left doorway. Characteristic features of the construction to be noted are: the doorpost decoration composed of acanthus tendrils growing from vases; the plain borders framing tympanum and lintel; and the long voussoirs, each with a standing figure. The arrangement shows great similarities with the north transept portal of Saint-Denis. The figure style, with its conspicuously schematic delineation of the draperies and fondness for clear-cut, rectilinear outlines, points in the same direction (pl. 48 bottom, 49 right). In the last analysis this formal vocabulary, more linear than sculptural, has its starting point in Mosan goldsmith's work and book illumination. It was transmitted by Saint-Denis, where the figure-style was already being employed in glass painting during Suger's lifetime (medallion of the *Tau*-writer in the ambulatory). The left doorway at Mantes dates from *c.* 1170.

The centre doorway (pl. 47) was the last to be built, presumably towards 1180. The jamb with its acanthus-decorated doorposts shows a similar construction. The individual forms are clearly more advanced: the calyx of the capitals has become more slender, the acanthus tendrils of the doorposts are more richly worked, with antique rosettes or little heads at the centre of the spiral motifs. The figure-style of tympanum and lintel agrees with that of the left doorway, but the flow of forms is freer and more animated. The archivolt figures (pl. 46) derive from the same

workshop tradition, but they have a vigour and buoyancy which must surely have been stimulated by Senlis (pl. 44, 45). The head of Moses (pl. 50 top left) shows that, in part at least, the jamb statues were in the same style as the archivolt figures, and probably by the same hand.

A. L. Millin 1790, vol. II, pl. XIX; E. Mâle 1928, p. 209ff.; M. Aubert 1929, p. 81ff.; A. Rhein 1932; M. Aubert 1938; M. Aubert 1946, p. 212ff.; J. Bony 1946; W. Sauerländer 1958 (II); W. Vöge 1958, p. 54ff.; L. Grodecki 1959; A. Lapeyre 1960, p. 237ff.; B. Kerber 1966, p. 73ff.

Ill. 27

NOYON (OISE), CATHEDRAL OF NOTRE DAME

VIRGIN AND CHILD

The portal sculptures of Noyon cathedral were almost totally destroyed in 1793. Before the First World War a Virgin enthroned, formerly crowned, occupied the trumeau of the centre doorway of the west portal (the figure was damaged in 1918 and its remains are now in the north wing of

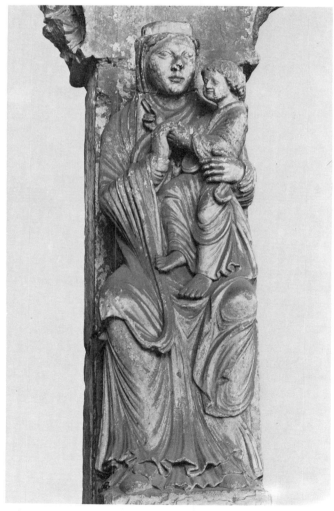

Ill. 27 Noyon cathedral, west portal. Virgin and Child from the trumeau of the centre doorway. About 1180 (cathedral cloister, north wing)

the cloister). Many features suggest that this animated group, in which the Child is shown turning sideways, originally formed part of a scene such as an Adoration of the Magi. The draperies, enlivened by curves encircling arms and knees, and gestures, recall the archivolt figures of the centre doorway at Mantes (pl. 46). These resemblances suggest a date of *c.* 1180, and that the work was installed only later on the thirteenth-century portal.

Ch. Seymour 1939, p. 168; W. Sauerländer 1956, p. 30 (II); W. Sauerländer 1958, p. 131 (II); W. Vöge 1958, p. 57.

Pl. 48 bottom, 49 right, ill. 28

SAINT-DENIS (SEINE), ABBEY CHURCH NORTH TRANSEPT PORTAL

When the façade of the north transept was erected in the thirteenth century it was furnished with the jambs, doorposts and archivolt of an early gothic portal, whose original intended location is not known. Tympanum and archivolts were damaged at the Revolution. The jamb figures went to the Musée des Monuments français, but were returned to Saint-Denis in 1816. The tympanum, lintel and archivolt were extensively restored by Debret. There are also many indications of patching and replacement on the jamb figures (pl. 49 right). A drawing made by Percier before 1800 (ill. 28), showing the portal after the removal of the jamb figures but before the start of renovation, confirms that the portal arrangement and the tympanum retain their original form. Some details of the lintel scenes remain unclear. The heads of four archivolt figures have been in the Louvre since 1881.

PROGRAMME
On the jambs are six statues of kings (pl. 49 right), and on the tympanum the martyrdom of St Dionysius and his companions, Eleutherius and Rusticus (pl. 48 bottom). Lintel scenes depict (left) the martyrs before the Roman prefect Fescennius Sisinnius, at whose feet is a female figure presumed to be the wife of Lubius, a convert (according to the legend she indicted the martyrs as sorcerers), and (right) their scourging and the last communion of Dionysius. It is not certain that all the iconographical detail is medieval. Under Debret's direction the thirty standing archivolt figures were restored as kings. The heads in the Louvre and Percier's drawing (ill. 28) show the restoration to have been at least partially consonant with the originals. The transept thus displayed thirty-six kings assembled round the martyrdom of St Dionysius: whether, as some have wondered, the programme represented kings of France as vassals of St Dionysius, is, in the absence of textual evidence, impossible to say. Saint-Denis, it may be noted, is unique in possessing two twelfth-century portals with programmes relating to the patron saint (cf. p. 379).

Style and dating. There is a close connection with the west doorways of Mantes (pl. 46–48 top). This is evident in the framing of the tympanum and its relief-like treatment, in the jamb capitals, and in the motifs of the doorposts, parts of

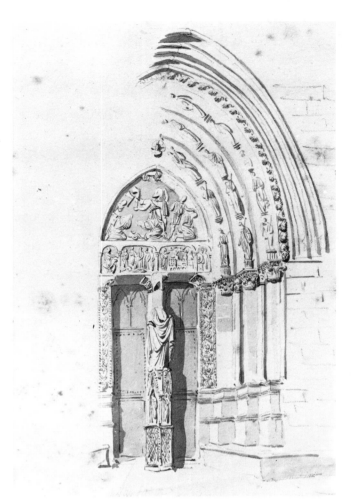

Ill. 28 Saint-Denis, abbey church. North transept portal. About 1175. Drawing by Percier showing its condition about 1790. (Compiègne, Bibl. mun., Album Percier, fol. 46)

which are in almost literal agreement. Among the large statues, the figure on the outside of the left jamb is in keeping with the figures in the two Mantes tympana (pl. 47, 48 top); for the heads there are again comparable pieces among the fragments preserved at Mantes. Striking features in the other statues are the bending of the body at the hips and the flowing rendering of the drapery, with its continuous slanting folds.

There are no external indications as to the date. Judging by appearance, the sculptures are later than the left doorway of Mantes (pl. 48 top), and are perhaps roughly contemporaneous with the Mantes centre doorway (pl. 47) – *c.* 1175. The north transept of Saint-Denis, together with the portal at Mantes, was the training ground for the workshop which from 1184 executed the west façade of Sens cathedral (see p. 416). The Saint-Denis sculptures thus hold a key position in the phase marking the transition from the austerely restrained figure-conception of the royal portals to the more relaxed sculptural style of the last years of the century.

A. Lenoir 1800, vol. II, p. 62, no. 525; W. Vöge 1894, p. 226 ff.; P. Vitry, G. Brière 1908, p. 60 ff.; M. Aubert 1929, p. 80 ff.; G. Huard 1936; M. Aubert

410

1946, p. 212; M. Aubert, M. Beaulieu 1950, p. 61f.; S. McK. Crosby 1953, p. 57f.; W. Sauerländer 1958 (II); W. Vöge 1958, p. 54ff.; L. Grodecki 1959; J. Formigé 1960, p. 102f.; A. Lapeyre 1960, p. 235ff.; W. M. Hinkle 1965, p. 30f.; B. Kerber 1966, p. 75f.

Pl. 49 left

TOMB MONUMENT OF CHILDEBERT I FROM SAINT-GERMAIN-DES-PRES (NOW SAINT-DENIS, ABBEY CHURCH)

Childebert I, king of the Franks 511–558, founded the abbey of Saint-Germain-des-Prés, Paris, and as its founder was buried in the abbey church. After the suppression of the abbey the tomb slab with the recumbent effigy found its way via the Musée des Monuments Français to Saint-Denis. It was broken into two pieces and must have been patched together for installation in its new home. The surface has been reworked. Montfaucon's illustration of it shows no divergence in the motifs from what we see now. It is sometimes said to have been restored in the seventeenth century, but there is no evidence for this.

The slab's trapezoidal shape is not unusual in tomb monuments of the twelfth and early thirteenth century. Childebert, lying as though inside a coffin, is shown wearing a crown; in his left hand he holds the sceptre, and in his right, as founder, a model of the church – a quite passable reproduction of the early gothic choir of Saint-Germain-des-Prés. Stylistically the tomb figure matches the Coronation portal of Senlis (pl. 42–45) and more especially the north transept portal of Saint-Denis (pl. 48 above, 49 right). There are no connections with the earlier west portal of Saint-Germain-des-Prés (ill. 10). Date: c. 1170–75, shortly after the dedication of the new choir.

J. Bouillart 1724, p. 5; B. de Montfaucon 1729, vol. I, p. 58; P. Vitry, G. Brière, 1908, p. 108; W. Vöge 1958, p. 59; B. Kerber 1966, p. 76.

Pl. 50 top left, *see p. 408.*

Pl. 50 top right, *see p. 406.*

Pl. 50 bottom left, *see p. 404.*

Pl. 50 bottom right

CHALONS-SUR-MARNE (MARNE), NOTRE-DAME-EN-VAUX, COLLEGIATE CHURCH HEAD OF A JAMB FIGURE FROM THE SOUTH PORTAL (NOW PARIS, LOUVRE)

For the collegiate church of Notre-Dame-en-Vaux see note to pl. 52–54 below. On the south side an early gothic figure-decorated portal, preceded by a more recent porch. The sculptures were almost completely destroyed at the Revolution. In construction and programme the portal declares its affinity with the circle of royal portals deriving from Chartres, coming closest to Saint-Bénigne, Dijon (pl. 22, 23, ill. 8) and Saint-Loup-de-Naud (pl. 24, 25). The tympanum

depicted a Majestas, and the lintel scenes from the Infancy of Christ. The jamb figures are said to have represented, on one side Christ's ancestors, and on the other 'Fathers of the Church'(?). A figure in priest's vestments can in fact be made out on the right. The head with a ribbed cap came to the Louvre from Châlons in 1896. It probably belonged to one of the jamb figures of the south portal. Stylistically close to Dijon, it also resembles heads on the west rose of the south transept of Notre-Dame-en-Vaux. Date: between 1160 and 1170.

W. Vöge 1894, p. 335ff.; M. Aubert 1929, p. 47; M. Aubert 1946, p. 199; A. Lapeyre 1960, p. 126ff.; W. Sauerländer 1962 (I); A. Prache 1966, p. 40; L. Pressouyre 1967 (I).

Pl. 51

SAINT-MAUR-DES-FOSSES (SEINE), COLUMN FIGURES (NOW MUSEE DE LA SOCIETE ARCHEOLOGIQUE)

By general consent these figures come from Saint-Maur, the Benedictine abbey suppressed in 1535. Their dimensions – they are 3 ft high – make it likely that the figures belonged to a cloister or conventual building, and not a portal. All that can be said of the male figure holding a book is that he is an ecclesiastic. The female figure with a child at the breast was long thought to represent the woman described in Revelation 12. In fact what we have here is a scene from the legend of St Nicholas, who even as an infant fasted on Wednesdays and Fridays by refusing to take suck more than once: hence the turning away of the child's head and the resisting movement of his right hand.

Most modern scholars date the Saint-Maur figures to the late twelfth century. The delineation of the draperies, with sparing, crescent-shaped folds over the legs and arms, and the cones of material between the feet favour an earlier date. There are no traces of the formal vocabulary which c. 1170 started to spread through the Ile-de-France from the workshops of Saint-Denis (north), Mantes and Senlis. We must therefore assume for the Saint-Maur figures a date between 1150 and 1160.

H. Rousseau 1924; F. Deshoulières 1925; C. Enlart 1927; M. Aubert 1929, p. 50f.; A. Lapeyre 1960, p. 226; M. Aubert 1946, p. 199; V. Egbert 1964; J. A. Schmoll (Eisenwerth) 1965; L. Pressouyre 1964 (I).

Pl. 52–54 centre

CHALONS-SUR-MARNE (MARNE), NOTRE-DAME-EN-VAUX, COLLEGIATE CHURCH CLOISTER

The first mention of Notre-Dame-en-Vaux as a collegiate foundation occurs in 1114. Church and cloister were remodelled in the twelfth century and building operations started before 1150. The collapse of parts of the church in 1157 acted as a spur to more intensive activity and in 1183 there was a partial dedication of the church of 'Sancta Maria in Vallibus' by Bishop Guido of Châlons. Though the church

was at that time unfinished, the richly furbished cloister on the north side was probably complete.

The cloister was pulled down in 1764. Excavations in 1963 succeeded in uncovering the foundations of the wings, 40 ft long. Most of the debris was used, between 1766 and 1770, for building on the spot. Demolition of parts of the eighteenth-century walls in 1935 and systematic investigation in 1963 brought to light the remains of numerous column figures and historiated capitals. These discoveries made it possible to identify figures and fragments preserved elsewhere as having come originally from the same cycle; examples are now in the church at Sarry, in the museum at Châlons, in the Louvre, in the Museum Mayer van den Bergh in Antwerp, in the museum in Cleveland, Ohio, and in the Stiftung Abegg, Berne. From this it appears that the cloister of Notre-Dame-en-Vaux possessed more than fifty column figures, from the freestanding supports of the cloister arcades and from the engaged columns of the *piliers cantonnés*. Beyond this we have to reckon with a large number of figure-decorated capitals. In view of the fragmentary state of the recovered material, a reconstruction and full elucidation of the programme scarcely seems possible, but for further details cf. the results of Léon Pressouyre's investigations.

As regards the programme, the figures identified so far seem to fall into at least four main groups: Old Testament, mostly with typological significance; Life of Christ; saints' legends; and an eschatological cycle accompanied by moralizing figures. Among the Old Testament or typological figures we can identify: Moses with the brazen serpent (pl. 52 bottom right), Abraham with Isaac, the widow of Zarephath with two sticks (1 Kings 17:10), John the Baptist with the Lamb, Simeon with the infant Christ. In addition there are prophets (pl. 52 top) and kings, though with no special attributes. While the Old Testament figures were throughout displayed as column figures, the Christological cycle appears to have been spread over the capitals. Extant are: the Presentation in the Temple, the Flight into Egypt (pl. 54 top), Baptism of Christ, the Raising of Lazarus (pl. 54 centre), the Marriage at Cana (pl. 53 top), Christ washing the feet of the disciples, the Angel at the Tomb, Noli me tangere, and the Supper at Emmaus. Whether a cycle depicting apostles, parts of which survive (pl. 52 left), belonged to these capitals must remain an open question. Saints' legends so far identified are: a martyrdom of St Margaret, shown in great detail; and a column figure with a fasting St Nicholas. At present the eschatological cycle is less easy to grasp: capitals show scenes of the Damned (pl. 53 bottom right) and the weighing of souls. The sequence of Foolish Virgins (pl. 53 bottom left) may belong to this ensemble, likewise the Virtues, shown as armed knights vanquishing the Vices.

Cloisters with extensive sculptural cycles survive more particularly in southern France, Spain and Sicily, and have hitherto been regarded as a peculiarity of the romanesque epoch. The finds at Châlons-sur-Marne show that we have also to reckon with large sculpted programmes in the cloisters of northern France, as late as the second half of the

412

twelfth century. The demolition of most of the large monastic complexes in the eighteenth century makes it difficult to say whether elsewhere the cycles were as extensive as the one at Notre-Dame-en-Vaux. The function of such an illustrated sequence in a cloister remains a matter of speculation.

Style and dating. A final verdict on the style of the cloister sculptures will only be possible when all the newly discovered fragments have been published. The cycle is not a self-contained unit, in that one can recognize not only various hands but probably also various styles. The rendering of the draperies by large looping folds, which circumscribe in particular the upper thigh, and the characteristic V-shaped double folds – features found in a large number of the fragments – recall the north transept portal of Saint-Denis (pl. 48 below, 49 right) and the tympana of the two portals of Notre Dame at Mantes (pl. 47, 48 above). Whether the similarities are the result of a direct connection, or were transmitted via a common Mosan or northern French source, must remain an open question. These comparisons suggest *c.* 1180 as a provisional date; it is likely that the cycle was completed shortly before the partial dedication of the church in 1183.

A. Paillard-Prache 1962; L. Pressouyre 1962; W. Sauerländer 1962 (I); W. Sauerländer 1963 (I) and (II); L. Pressouyre 1963; L. Pressouyre 1964 (II); L. Pressouyre 1967 (I); L. Pressouyre 1968 (I); L. Pressouyre 1968 (II); *see also* Appendix to Bibliography.

Ill. 29

COLUMN FIGURES FROM A CLOISTER OR CONVENTUAL BUILDING (SENS [YONNE], MUSEE MUNICIPAL)

Some of these allegorical figures – five in all, 3 ft in height – can be recognized from their attributes: Geometry with compasses (left), Dialectic with serpent (centre), Music with carillon (right). The second figure from the left, carrying a palm branch, is presumably a female martyr.

The provenance of these statues is unknown. From their dimensions they clearly come from a cloister or conventual building rather than a portal. They presumably formed part of a larger cycle which included a sequence of the Seven Liberal Arts. In view of the theme, the figures may have stood in a conventual or chapter building used for teaching.

Stylistically the figures belong with the sculptures of the left doorway of the Sens west portal (pl. 58). Date: presumably the late 1180s.

W. Sauerländer 1958 (III); F. Salet 1960.

Pl. 54 bottom

HONNECOURT (NORD), SCULPTURES FROM THE ABBEY CHURCH OF SAINT-PIERRE (NOW HONNECOURT, PARISH CHURCH)

Remains of sculptures from the Benedictine abbey of Saint-Pierre at Honnecourt survived until the First World War, built into one of the abbey's towers. Some of them were

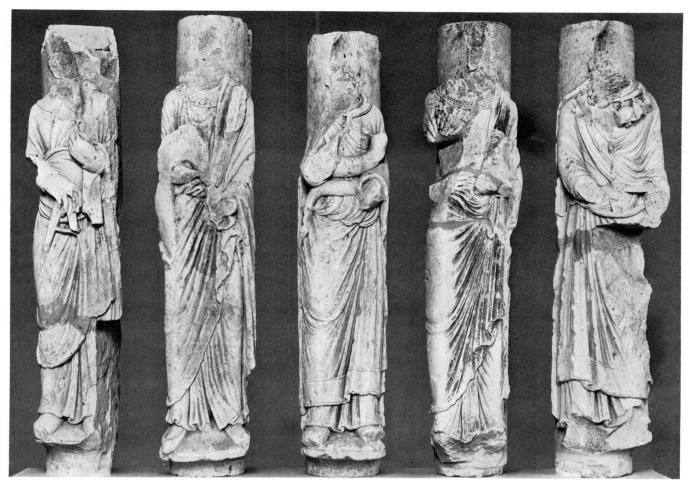

Ill. 29 Column figures from a cloister or conventual building. From the left: Geometry, female martyr (?), Dialectic, female figure, Music. 1185–90. (Sens, Musée municipal)

destroyed in 1918, others are now in the (modern) parish church, and there are further fragments in the museums at Lille and Cambrai. The main piece was a Christ enthroned in the mandorla, to which four fragments with Evangelist figures presumably belonged. Also extant are: two standing figures, one identifiable from the keys and banderole legend as Peter, the other holding a reliquary or model of a church; an angel; Elders of the Apocalypse; and a blessing Christ between seraphim (pl. 54 bottom). From these fragments Lapeyre has reconstructed a portal: tympanum with Majestas; inner archivolt, angels, outer archivolt, Elders and, at the apex, Christ between seraphim. If this is accepted, the ensemble would represent a northern French counterpart of Saint-Denis and the west portal at Chartres. In some of the fragments, for example the statue with the model of a church, there is also a stylistic pointer to the Chartres circle, in the finely delineated drapery with its straight running folds. By contrast, the archivolt figures (pl. 54 bottom) are of stocky proportions, and hands and attributes are disproportionately large. The round head of the blessing Christ is arresting, with its broad nose, low forehead and

prominent, ribbon-like eyelids. This formal language is blunter, and in a primitive sense more expressive, than that of Chartres. Again, the palmettes which form the border trimming are not comparable with ornament found in the Ile-de-France. Here we must reckon with a survival of local, independent traditions. Date: third quarter of the twelfth century.

M. J. Bulteau 1881; Deshaines 1886; A. Lapeyre 1954; J. Vanuxem 1955; A. Lapeyre 1960, p. 177 ff.

Ill. 30

ANGERS (MAINE-ET-LOIRE), FIGURES FROM THE CHOIR OF THE COLLEGIATE CHURCH OF SAINT-MARTIN (NOW YALE UNIVERSITY ART GALLERY, NEW HAVEN, CONN.)

In gothic churches of Anjou, which rarely have figure-decorated portals, sculpted figure cycles are sometimes found in the interior. These took the form of cycles on vault bosses, often quite extensive, and of rows of statues beneath

413

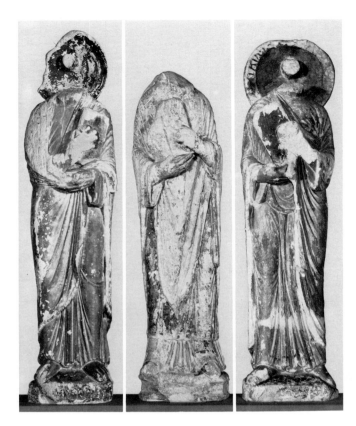

Ill. 30 Figures from the choir of Saint-Martin, Angers: two apostles, and (centre) a priest. 1180–95. (New Haven, Conn., Yale University Art Gallery)

with Chartres: note especially the regular pleating of the drapery. In the apostles (ill. 30, left and right) the rendering of the drapery is broader and more spirited and recalls the jamb figures of the north portal of Saint-Denis (pl. 49 right) or the column figures in the museum at Sens (ill. 29). We lack firm documentary evidence for the date of the early gothic choir of Saint-Martin. An opening of the Lupus shrine in 1195 is usually regarded as a *terminus ante quem* for its completion. Even granted that this is hypothesis, the stylistic findings point to a date between 1180 and 1195.

W. Vöge 1894, p. 263f.; P. Pinier 1910; W. Medding 1934; M. Aubert 1939; J. Levron 1950; G. H. Forsyth 1953, p. 175ff.; L. Schreiner 1963, esp. p. 9ff.; A. Mussat 1963, p. 203ff.

Ill. 31, 32

LEVROUX (INDRE), ABBEY CHURCH OF SAINT-SYLVAIN
FIGURES IN THE CHOIR

The sculptures in the abbey church of Saint-Sylvain are among the earliest and most impressive of the Angevin choir-figure cycles. On the boss of the vault is depicted an enthroned Christ over clouds with blessing gesture and holding the open book; below the ribs are four large statues. Local antiquarians took them for saints from this area, but the dress and attributes of the male figures – ribbed cap (ill. 31), banderole – suggest that they are Old Testament figures. One of the two female figures holds a crown in her hands, which gives some grounds for an identification with the Queen of Sheba. The overall programme remains uncertain.

Properly speaking, Levroux, which is not far from Bourges, lies outside the orbit of Angevin gothic. Angevin gothic has nevertheless influenced the positioning and arrangement of the cycle, although the style shows no connection with Angevin works – compare the figures from Saint-Martin, Angers (ill. 30). The connection sometimes suggested with Burgundian models is unconvincing. The style is formed from the Ile-de-France, and the combination of almost plain drapery surfaces with large looping folds suggests we should be thinking of the portal of the north transept of Saint-Denis (pl. 48 bottom, 49 right) and Mantes (pl. 46–48 top). Date: very probably c. 1190.

L. Schreiner 1963, esp. p. 55ff.; A. Mussat 1963, p. 326f.

Pl. 55 top

TYMPANUM (RHEIMS, MUSEE SAINT-REMI)

In the apex of the semicircular lunette we see two figures sitting facing one another amid tendril ornament: one figure holds up a book in his left hand, the other, hands outstretched, seems engaged in disputation. Beneath the smaller arches are, on the left, a figure struggling with a dragon and, on the right, a pair of lovers. The figures probably have an allegorical or moralizing significance.

the choir vaulting. The choir figures presumably continued the tradition of painted apsidal programmes; the change-over from painting to sculpture may well have been stimulated by the early gothic figure-decorated portals of the Ile-de-France.

The cycle in the apse and the bay preceding the choir of Saint-Martin originally comprised six figures. Until 1926 a Virgin enthroned and two apostles (ill. 30, left and right) stood beneath the ribs of the apse vaulting. Beneath the intermediate ribs of the bay preceding the choir there were two figures in pontificals (ill. 30 centre), apparently bishops or abbots: traces of mitres (pendants) and crozier shafts appear to have survived. The heads are lost, and there are many other signs of damage. Five figures are now at New Haven, Conn. In the vault of the pre-choir bay there is a boss in similar style, showing a beardless Christ with the earth's disc.

It has been suggested that the figures were originally made for a portal and only subsequently placed in the choir, but this seems unlikely; the matter cannot be decided without further investigation of both building and figures. The figures show no connection with the west portal of Angers cathedral. In the Virgin and the two ecclesiastics (ill. 30 centre) there are still remote echoes of works associated

The tympanum was found in 1857, in the foundations of a house being cleared in preparation for the construction of a prison; the house, known as the 'Maison de la Chrétienté' was in the Place du Parvis and had formerly belonged to the Rheims cathedral chapter. From the way it is divided we might assume the tympanum was originally placed above a two-part window. However in view of its dimensions – 5 ft 2 in. by 3 ft – it could equally well have belonged to the portal of a secular building.

Stylistically the tympanum shows no connections with other Rheims sculptures from the second half of the twelfth century, for example the archbishop fragment (pl. 27) and the Porte romane of the cathedral (pl. 56, 57). The figures are strikingly graceful and finely articulated, though they also have large hands and round heads. The rendering of tendrils, palmettes and drapery folds is fluent and shows a sharpness of line reminiscent of metalwork. The closest comparison seems to be with certain works of Mosan book illumination and goldsmith's work, for example the Floreffe Bible. Date: 1160–70.

C. P. Givelet, H. Jadart, L. Demaison 1895, no. 44; H. Jadart 1911; R. Hamann-MacLean 1937, p. 68f.; W. Sauerländer 1958 (I).

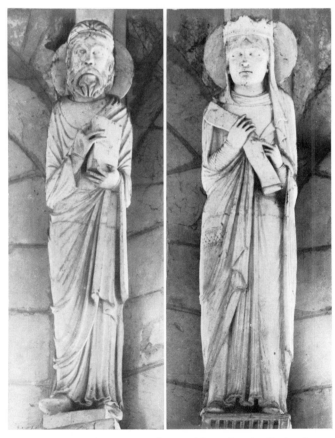

Ill. 31, 32 Levroux, Saint-Sylvain, abbey church. Choir: figures from the Old Testament. About 1190

Pl. 55 bottom

CAPITAL (RHEIMS, MUSEE SAINT-REMI)

The capital displays spiral tendrils with leaves turned back to form a hollow circle and occupied by naked figures in a sitting posture. The museum has a number of similar pieces. They appear to be more recent than the archbishop fragment (pl. 27), where the knotted tendril ornament on the side wall is of a simpler and more robust form. They are earlier than the vine tendrils with figures and pecking birds on the Porte romane (pl. 56), which shows fully formed, naturalistic foliage. Date: c. 1170. The alleged provenance of the capital, from the archbishop's palace near the Porte de Mars, is pure conjecture.

C. P. Givelet, H. Jadart, L. Demaison 1895, no. 78–9.

Pl. 56–57, ill. 33

RHEIMS, CATHEDRAL OF NOTRE DAME PORTE ROMANE

The cathedral's 'Porte romane' is on the west side of the north transept. The portal bay has straight-sided, undecorated walls and a pointed domical vault. Above the lintel beam, set against the unadorned back wall, which has been filled in with large ashlars, we see a Virgin enthroned beneath a curtained, architectural baldachin (pl. 57). The single arch is occupied by eight standing or pacing angels with banderoles or candlesticks; at the apex of the arch a soul is borne aloft by angels and crowned by a hand emerging from clouds. Other figures and groups complete the ensemble: large standing angels with processional crosses in the spandrels above the arch and, on either side of the Virgin, groups of clerics (not visible from the front) set into small vaulted niches. The groups consist of a bishop or abbot, vested in a cope, assisted by two subdeacons(?) in a reading or the sprinkling of Holy Water. The outward faces of these niches display vine tendrils with small figures and animals.

A certain roughness in the installation, together with the fact that this early figure style is out of place in thirteenth-century Rheims, suggests that the sculptures were taken over from the preceding building, which was burnt down in 1210. The arrangement and iconography are so unusual for a portal that it has been assumed, with justice, that we have here the remnants of an early gothic niched tomb, transformed in the thirteenth century into a tympanum. We can form a rough idea of the original layout from the late twelfth-century tomb of an archbishop (perhaps Rotrocus of Warwick, died 1183) in Rouen cathedral, and from the tomb of Abbot Arnoult from Saint-Père, Chartres (ill. 33), c. 1225. On the strength of these examples it seems we should imagine the sarcophagus with the recumbent effigy lying beneath the niche with the Virgin enthroned. Whether the upper part of the Rheims wall tomb originally terminated in a gable, as at Rouen and Chartres, is not clear. Also not clear is whether the reliefs with clerics reciting

415

Ill. 33 Chartres, Saint-Père, abbey church. Tomb monument of Abbot Arnoult. About 1225. (After Gaignières Ser. I, 466)

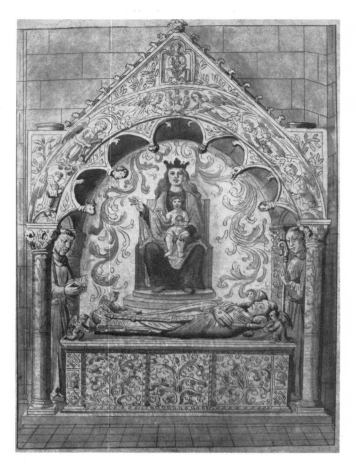

the Office for the Dead, now hidden from direct view, originally occupied the front wall of the sarcophagus.

So lavish a layout suggests that the fragments come from the tomb of an archbishop of Rheims. The style is not comparable with early gothic sculptures from the Ile-de-France. The rendering of the draperies is characterized by line upon line of wide and curving folds. The actions are lively but not vehement. The figures are rounded, large-headed, their attitude, gestures and expressions muted and gentle. The sources of the style can perhaps be found in Mosan goldsmith's work; there is a remote resemblance to figures on the Heribert shrine at Deutz, as also to the earliest portions, stylistically, of Nicholas of Verdun's altar for Klosterneuburg. In Rheims itself the same workshop must surely have been responsible for the statues on the west façade of the abbey church of Saint-Rémi. There is thus much to be said for the view that the sculptures of the Porte romane came from the former tomb of Archbishop Henri de France (died 1175), and that they were made towards or around 1180. Their installation on the transept was affected at the same time as the erection of the Calixtus and Judgment portals. Cf. p. 481.

L. Demaison 1902; L. Pillion 1904; H. Kunze 1912, p. 62ff.; P. Vitry 1919, vol. II, p. 42f.; E. Panofsky 1927, esp. p. 73f.; R. Hamann, W. Kästner 1929, vol. II, p. 128ff.; R. Hamann-MacLean 1956; W. Sauerländer 1956 (II); W. Sauerländer 1959 (I); A. Lapeyre 1960, p. 246ff.; H. Reinhardt 1963, p. 61ff.; E. Panofsky 1964, p. 61 (I); B. Kerber 1966, p. 78f.

THE TURN OF THE CENTURY: THE SCULPTURES OF SENS AND LAON, AND WORKS EMANATING FROM THEM

Pl. 58–62, 64, ill. 34–37

SENS (YONNE), CATHEDRAL OF SAINT-ETIENNE
WEST PORTAL

The cathedral of Saint-Etienne at Sens ranks with Saint-Denis as one of the oldest buildings in early Gothic. We know from documentary evidence that building work began under Henri Sanglier, archbishop from 1122 to 1142. The west façade was presumably not begun until after 1184, the date of a fire. In 1210 we hear of the dedication of an altar to St Michael in a chapel in the north tower, and in 1221 of an altar to St Vincent in the first storey of the south tower. In 1268 the south tower collapsed; the right doorway and the tympanum of the centre doorway were subsequently remodelled in the High Gothic style. In 1793 all the jamb figures were destroyed; the only surviving figure is that of St Stephen on the trumeau of the centre doorway. When

the west façade was restored between 1837 and 1848 the ornamental forms on the socle of the centre portal were also renewed. Remaining from the early gothic period are the left doorway and the centre doorway (with tympanum in High Gothic style).

PROGRAMME
The left doorway (pl. 58) is usually described as a Baptist's portal, because of the unusually elaborate cycle devoted to John the Baptist in the tympanum and archivolt. The cycle begins in the middle arch, starting bottom left with the angel appearing to Zacharias and ending bottom right with the bathing of the new-born child (ill. 35). It continues in the inner arch, where we see, reading again from the bottom left, the naming of John (in two scenes), his circumcision, John as baptist and preacher, and finally his disciples with Christ. The cycle ends with the scenes in the lintel and tympanum: the baptism of Christ, Herod's banquet, the

beheading of John; in the apex of the tympanum the half-figure of the Redeemer appears amid clouds, flanked by two angels bearing martyr's crowns. The cycle is extended in the outer archivolt by eight scenes referring to the relics of the Baptist. In some cases the scenes cannot be positively identified. The sequence begins bottom left with the opening of the tomb on the orders of Julian the Apostate and ends bottom right with the building of a church dedicated to the saint (ill. 35). The only other instance of such an elaborate cycle is the one on the west façade at Auxerre (pl. 283), which came within the archdiocese of Sens. It is said that the jamb figures represented (on the right) Elijah, Jeremiah, John the Baptist, and (on the left) a royal couple and a female figure, but the tradition may not be reliable. On the socles are (left) Avaritia, seated on a closed trunk, and (right) Largitas (pl. 61 top), a crowned female figure amid votive crowns, open caskets and vases. These socles are reproduced, almost literally, at Villeneuve-l'Archevêque (pl. 178).

Above the centre doorway (pl. 59) the tympanum, remodelled in High Gothic style, shows the sermon and

Ill. 35 Sens cathedral, west portal, left doorway. Detail of archivolt: story of John the Baptist. After 1184

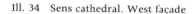

Ill. 34 Sens cathedral. West façade

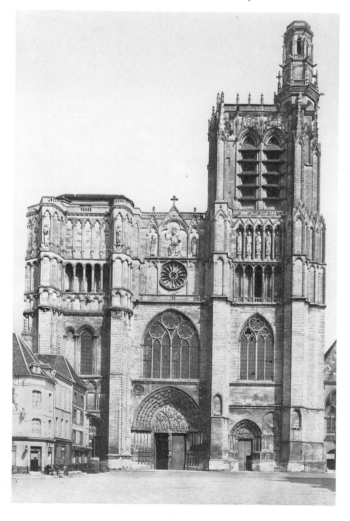

stoning of St Stephen, the theme presumably portrayed here before 1268; for comparison see the left doorway of the north transept at Meaux (ill. 40). The figures in the five arches of the archivolt presumably also relate to the martyrdom (pl. 60 left). Reading from the inside these are: twelve standing angels with candlesticks, books, chalices or censers; seated deacons with martyr's palms; standing martyrs with palms or crowns; figures not positively identified, with vases, banderoles or books; Virtues with round shields displaying stylized plants, phoenix and dove(?) as emblems. The trumeau figure represents St Stephen (pl. 59, 62), while the socle scenes survive only as fragments and are impossible to elucidate.

On the doorposts and jambs we have sequences annexed to the Stephen cycle. On the doorposts are the Wise (pl. 60 right) and Foolish Virgins. The theme, and this arrangement of it, goes back to Judgment portals like Saint-Denis (pl. 1). The sequence is expanded in medallions contained in the

417

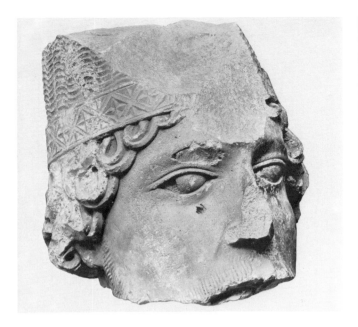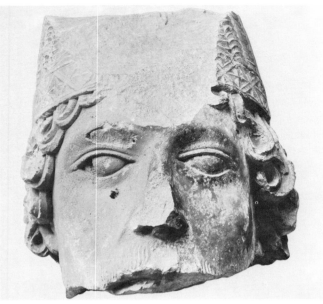

Ill. 36, 37 Head of a pope, from a statue on one of the west doorways of Sens cathedral (?). About 1200. (Sens, Palais Synodal)

spandrels above the archivolt. The medallion on the left, above the Wise Virgins, shows the open gate of a city, with the Bridegroom waiting within; in the medallion on the right, above the Foolish Virgins, the scene is the same, except that the gate is firmly shut. Jamb figures (missing) are said to have represented standing apostles; cf. the head (pl. 64 top) which presumably came from this sequence. Below are depicted, upper right, a Calendar (pl. 61 centre and bottom) and, left, Liberal Arts. The Calendar begins next to the doorpost with a two-headed Janus (January) and ends at the outer edge, next to the buttress, with pig-killing (December). The cycle of the Liberal Arts (pl. 59) begins on the outside (third field from the buttress) with Grammar, Dialectic and Rhetoric. These basic disciplines are followed by the quadrivium: Arithmetic, Geometry, Astronomy and Music. The sequence concludes with Philosophy, shown with sceptre, book and crown, exactly as described by Boethius. Incised at the neck and hem of her garment are the letters Θ (theory) and Π (practice). The four figures flanking the Liberal Arts are perhaps authorities from classical antiquity (cf. Chartres, pl. 15 bottom). The lower zone appears to be filled with a cosmographical cycle, many of the details being no longer recognizable. On the left we can still identify: swan, lion, bear, camel, crane and pygmy, griffin and basilisk, elephant and sciapods (according to Ctesias inhabitants of India who used their only foot as a sunshade). On the right, we have first Mare, riding oar in hand on a dolphin, then a Siren, and further on Terra, giving suck as mother earth. Cosmographical cycles, comprising elements and animals, monsters and fabulous beasts, found in treatises of antiquity on geography and natural history, a common feature of romanesque architectural sculpture but

not of gothic portals. The socle programme of the Sens centre doorway remains unique.

The triple portal on the Sens west façade thus displayed at the centre the martyrdom of the church's patron, on the left doorway the life of the Baptist and on the right doorway, now remodelled in High Gothic style, the Coronation of the Virgin. There is no allusion to the Last Days – Majestas or Last Judgment – such as we normally find on gothic triple portals. This set of themes presumably appeared on the upper storey (ill. 34). From what remains, it seems likely that at Sens, as later at Rheims, the figure programme extended across the entire façade and was perhaps grouped around a figure of Christ in Majesty.

Construction, figure-style and dating. The Baptist's doorway (pl. 58) provides the first example of the slanted rather than recessed socle which became the rule in portal layouts of the thirteenth century. Note too the decoration of the socle with reliefs in medallions or octofoils, which set the pattern for Paris and Amiens. Another apparent innovation is the merging of the baldachins over the jamb figures with the capitals of the engaged columns. In the thirteenth century this solution became canonical. As at Le Mans (pl. 18), Saint-Loup-de-Naud (pl. 24) and Vermenton (ill. 19), the archivolt contains not individual figures but scenic groups.

The construction of the later centre doorway (pl. 59) is a variant of the type created by Saint-Denis (pl. 1). The merging of baldachins and capitals is new. The jamb socle is still recessed, but the deployment of relief decoration in two zones points forward to Paris and Amiens.

The tympanum and archivolt of the Baptist's doorway (pl. 58), presumably executed shortly after 1184, display a figure style which points back to the centre doorway of

418

the west façade of Mantes (pl. 46, 47). As evidence of the connection, note the well-rounded proportions of the figures, the tautness of the draperies over the bodies, the large looping folds circumscribing individual limbs. Thus the first of the Sens workshops presumably came from Mantes. On the socle of the Baptist's doorway (pl. 61 top) and more especially on the archivolt and doorposts of the centre doorway (pl. 60), we find a change in the formal vocabulary. The proportions become more slender, there are wide draperies with flowing folds, the figure conception is becoming freer and more relaxed. The influences that produced this change of style within the Sens workshop have yet to be explained. Work on these portions of the centre portal cannot have continued much beyond 1210.

Th. Tarbé 1841; A. J. Crosnier 1847; M. Quantin 1850; E. Mâle 1902, esp. p. 105 ff.; Ch. Porée 1907; E. Chartraire 1914; E. Chartraire n.d.; M. Aubert 1929, p. 84 ff.; L. Bégule 1929; M. Aubert 1946, p. 278 ff.; W. Sauerländer 1958 (II); W. Sauerländer 1958 (III); A. Lapeyre 1960, p. 244 ff.; A. Katzenel-lenbogen 1964 (2), p. 77 ff.; A. Erlande-Brandenburg 1967; L. Pressouyre 1968 (III); L. Pressouyre 1969.

Pl. 63, ill. 38, 39

SENS (YONNE), CATHEDRAL OF SAINT-ETIENNE
CRUCIFIXION GROUP

This Crucifixion group in wood came originally from Cérisiers (between Troyes and Auxerre) and has been housed in Sens cathedral only since 1900. In the figure of Christ the lower parts of the limbs are replacements. The crown, or crown of thorns, is missing. The group is not a unit. The mourning figures (ill. 38, 39) are clearly earlier, and not from the same ensemble as the crucifix. Their gently rounded contours and freely hanging draperies, traversed by long folds, point to a date around 1200: cf. some of the archivolt figures on the Sens centre doorway (pl. 60 left). These figures were presumably made in Sens or within its immediate orbit. The crucifix is later by some decades. It already uses the triple nailing, a practice only gradually diffused after 1210. The heavy folds of the loin cloth, harshly broken up into angles, suggest a date close to 1260. Stricter classification is difficult, given the poor state of preservation and the absence of comparable pieces.

A. Goldschmidt 1915; P. Thoby 1959, p. 151; W. Sauerländer 1966, p. 49; L. Pressouyre 1968 (III).

Ill. 40

MEAUX (SEINE-ET-MARNE), CATHEDRAL OF SAINT-ETIENNE
NORTH TRANSEPT PORTAL

Installed on the north transept façade of Meaux cathedral are the remains of a Stephen's portal dating from the early

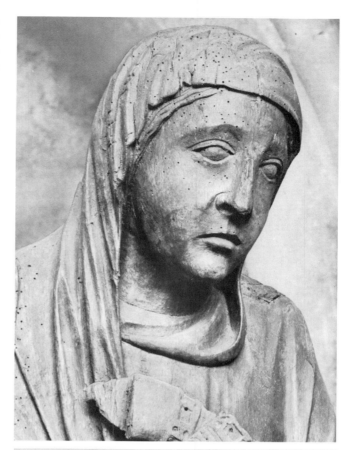

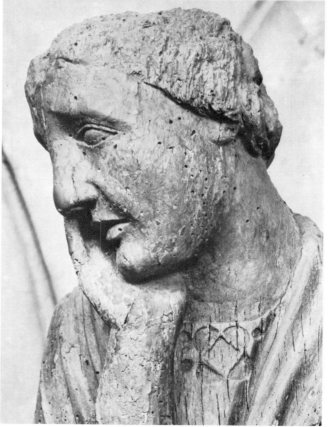

Ill. 38, 39 Sens cathedral. Mary and John, from the Crucifixion group from Cérisiers. About 1200

419

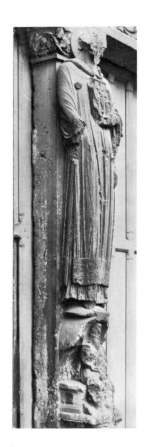

Ill. 40 Meaux cathedral. North transept portal. Trumeau figure: St Stephen. Early thirteenth century

Pl. 64, *see* note to pl. 58–62, 64 above.

Pl. 65, ill. 41

SAINT-DENIS (SEINE), ABBEY BASIN FROM THE FORMER MONASTERY FOUNTAIN

The well-house of Saint-Denis was in the south wing of the cloister laid out by Robert de Cotte. Only the upper basin of the fountain survives (limestone, 12 ft 6 in. in diameter; the pipes are later additions). The original appearance of the fountain is known from a sixteenth-century drawing, which shows this basin resting on columns standing inside the larger lower basin. This type of fountain was common in monastic establishments of the Middle Ages.

The figure decoration is unique. Running all around the shallow basin (the lip of which projects only slightly) are medallions in the form of shallow depressions, from which sculpted heads emerge; between the medallions we see quatrefoils decorated with foliage. Nearly all the heads are named in accompanying inscriptions. The programme presents an astonishing juxtaposition of cosmological and moralizing motifs, cheek by jowl with gods, heroes and mythical figures from classical antiquity. Thus we have not only the elements, animals (monkey, ram, wolf) and personifications of vices (drunkenness, avarice), but also Jupiter and Juno, Neptune and Venus, Paris and Helen (pl. 65). Taken as a whole, the content shows no recognizable coherence. The deities appear in a guise which is nonantique: the wings of Jupiter's eagle have taken root in the god's head, Neptune wears a fish on his head, Silvanus is a leaf mask and the head of Venus is adorned with a medieval chaplet of roses. This fountain basin is among the very few monumental witnesses to the survival of classical deities in the Middle Ages, which is otherwise reflected almost solely in illustrated encyclopaedias.

According to Félibien the fountain bore an inscription ascribing its erection to an Abbot Hugo. This could refer either to Abbot Hugh Foucauld (1186–97) or to his successor,

thirteenth century. The trumeau bears a figure of St Stephen. The figure tallies by and large with the Stephen on the centre doorway at Sens. Note however a divergence in the cover of the book held in the right hand, which here shows a crucifixion. The socle figure is unexplained: the identification with Saul is pure conjecture. On the lintel, Stephen's trial, death and burial. Stylistically the sculptures are in direct line of succession from the Sens centre doorway, but the forms are harsher. Date: early thirteenth century.

A. Boinet 1912; A. Boinet 1919; F. Deshoulières n.d., p. 62 ff. (II); M. Aubert 1929, p. 86; M. Aubert 1946, p. 279; *see also* Appendix to Bibliography.

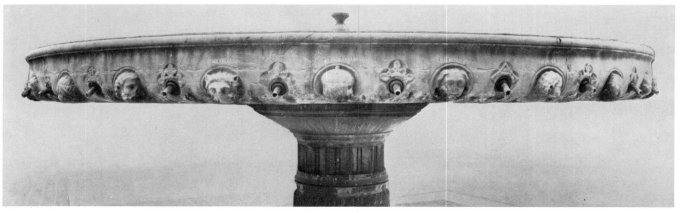

Ill. 41 Saint-Denis, abbey. Basin from the conventual fountain. About 1200

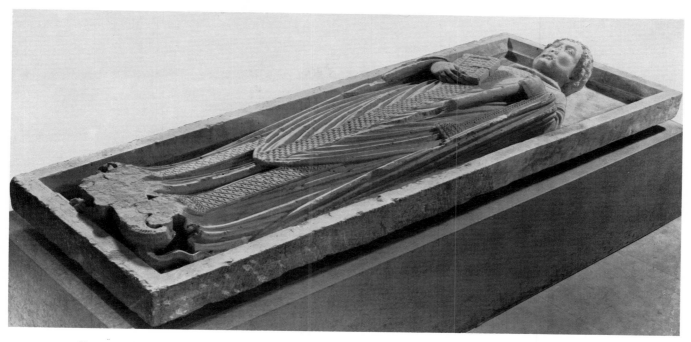

Ill. 42 Nesle-la-Reposte, parish church. Tomb monument of an abbot, from the former abbey. Towards 1200

Hugh of Milan, who died in 1204. The formal vocabulary, which with its sensitive modelling of surfaces, free rendering of tresses, and the placidity imparted to facial expressions has a distinct air of the antique, has an affinity with later works from the Sens cathedral workshop: the head from the centre doorway in the Palais Synodal (pl. 64 top), the mourners from the Crucifixion group in the cathedral (pl. 63, ill. 38, 39). Date: c. 1200.

M. Félibien 1706, p. 588; C. Enlart 1929, vol. I, p. 310 ff.; J. Adhémar 1936; J. Adhémar 1939, p. 265 ff.; W. Sauerländer 1959 (I); J. Formigé 1960, p. 20 ff.; W. Sauerländer 1961.

Ill. 42

NESLE-LA-REPOSTE (MARNE), FORMER
ABBEY OF NOTRE DAME
ABBOT'S TOMB

A little before 1929 the figure of an abbot was discovered beneath the high altar of the parish church of Nesle-la-Reposte. The effigy is dressed in alb, stole, maniple and chasuble; in the right hand there is a book, in the left a staff. The head is uncovered; the abbots of Nesle-la-Reposte were not granted the right to wear the mitre until the sixteenth century. There is a dragon coiled at the figure's feet. In 1966, thanks to the discovery of further fragments, it was possible to reconstruct the undecorated trapezoidal tomb slab to which the recumbent effigy belonged.

Trapezoidal tomb slabs, which frame the body as though in a coffin, are quite common in the late twelfth and early thirteenth century: cf. the tomb monument of Childebert I from Saint-Germain-des-Prés (pl. 49 left). The later tomb

slab of Philip of France, who died in 1235 and was buried at Royaumont, is also of this type (pl. 159 left).

According to a description written in 1532, the tomb monument was situated on the façade of the church's south transept. Excavations have uncovered the niches of three wall graves in this area. The tomb must undoubtedly have been that of an abbot of Nesle, but with the loss of the inscription no closer identification is possible. The style points to Sens. It can be compared with the figure of St Stephen on the trumeau of the Sens centre doorway (pl. 62). From the evidence of drawings in Gaignières there were tomb slabs of similar type in the abbey of Saint-Pierre-le-Vif at Sens: note especially the tomb monument of Abbot Helias, who died in 1209 or 1210. The tomb monument at Nesle appears to be older, probably c. 1200. For the abbey of Nesle-la-Reposte cf. p. 391.

L. Pressouyre 1967 (III).

Pl. 66

SAINT-BENOIT-SUR-LOIRE (LOIRET), ABBEY
CHURCH
NORTH PORTAL

The abbey of Fleury was one of the oldest Benedictine houses in France, and after the translation of the relics of St Benedict from Monte Cassino took the name Saint-Benoît-sur-Loire. The history of the abbey church, which still stands, is complicated and details of it are obscure. After a fire in 1184 the nave was not completed until the early thirteenth century. The final dedication took place on 26 October 1218. The early gothic figure-decorated portal at the fourth bay

421

from the west end, is now walled up. Its original function is not clear, since the north side was occupied by the abbey's domestic buildings. The six jamb figures are in a very bad state of preservation. The arch supporting the lintel is a later addition.

PROGRAMME
The tympanum depicts the Majestas Domini. The enthroned and blessing Christ, who holds the open book, is here surrounded by the four Evangelists who are inspired by the symbolic beasts. This type of Majestas is familiar from illuminated manuscripts but extremely rare on a tympanum. There are parallel examples at nearby Saint-Pierre-le-Moutier and in Spanish cathedral sculpture.

The lintel depicts the translation of the relics of St Benedict from Monte Cassino to Fleury. On the left the bones of Benedict and his sister Scholastica are being removed by monks from the grave and gathered into a basket; in the centre Benedict's relics are deposited in a shrine, at the touch of which a dead boy is brought back to life, and in the next scene the relics of Scholastica, placed in a smaller, tower-capped reliquary, work the same miracle for a dead girl; on the right Benedict's relics arrive at Fleury, where the procession bearing the shrine is received by monks with a censer. Translation of relics is a subject rarely depicted on portals; the lintel programme of Saint-Benoît is accounted for by the unique importance of Benedict's relics in securing the abbey's prestige.

The archivolt has, in the inner arch, figures of angels with candlesticks, censers and incense boats and, in the outer arch, apostles. Of the six jamb figures, only Abraham (inside right) can still be positively identified.

Style and dating. The jamb figures, both from their proportioning and from the graphic delineation of the folds, clearly have some connection with the north portal of Saint-Denis (pl. 48 bottom, 49 right), Mantes (pl. 46–48 top) and Sens (pl. 58). Tympanum, lintel and archivolt diverge in places from the formal language used on the jamb. The proportions are often fuller, the folds softer and more untidy, the faces rounder, and in some cases quite boorish in expression. This comically individual, and hence provincial, stylizing occurs again on the portal of Saint-Pierre-le-Moutier (pl. 67 top). Date: towards or *c.* 1200.

M. Aubert 1929, p. 88 f.; J. Banchereau 1930, p. 61 ff.; G. Chenesseau 1931, p. 194 ff.; M. Aubert 1946, p. 278; W. Vöge 1958, p. 54 ff.; W. Sauerländer 1958, p. 159 (II).

Pl. 67 top

SAINT-PIERRE-LE-MOUTIER (NIEVRE), PRIORY CHURCH CLOISTER DOORWAY

The priory of Saint-Pierre-le-Moutier in the Nivernais was subordinate to the abbey of Saint-Martin in Autun. Though it was an old foundation, the first mention of it occurs only

in 1164. The portal on the façade of the north transept opened on to the cloister, which has not survived.

PROGRAMME
The tympanum shows Christ surrounded by the Evangelists, very much as at Saint-Benoît-sur-Loire (pl. 66), apart from one or two changes in detail: Christ holds the orb instead of the open book and there is some simplification in the forms of the seats and desks. The archivolt depicts angels with candlesticks and censers, and on the consoles rivers of Paradise are shown. The jambs formerly displayed two statues surmounted by baldachins; their theme is unknown. A head now in private ownership is thought to be connected with the lost jamb figures, but shows some divergent stylistic traits.

Style and dating. The closest connection is with the tympanum and archivolt of Saint-Benoît-sur-Loire (pl. 66), though here the forms are softer and rounder. Date: after Saint-Benoît-sur-Loire, probably early thirteenth century.

E. Lefèvre-Pontalis 1913; M. Aubert 1929, p. 88 f.; M. Aubert 1946, p. 278; M. Anfray 1951, p. 161, 287 ff.

Pl. 67 bottom, ill. 43, 44

GERMIGNY L'EXEMPT (CHER), PARISH CHURCH WEST PORTAL

The small parish church of Germigny l'Exempt in Berry has a thirteenth-century figure-decorated portal in the bottom storey of a romanesque west tower.

PROGRAMME
The tympanum shows the Virgin enthroned beneath a baldachin, with (on the left) the Adoration of the Magi, and (on the right) the Annunciation, with Joseph beyond. The model was clearly a tympanum with the Adoration and Joseph, such as has survived, for example, from the left doorway of the Laon west portal (pl. 69 centre), with the Annunciation group as an interpolation. In the archivolt (a single arch, with a leafy garland border) are angels with banderoles. At the lower end of the archivolt, above the imposts of the outer jamb columns, lion and basilisk: presumably a reference to Psalm 91:31 – 'Thou shalt tread upon the lion and adder: the young lion and the dragon shalt thou trample under feet.' On each jamb there is a baldachin, intended for a statue; old views show (ill. 43) a queen on the left and a king on the right, presumably the Queen of Sheba and Solomon. The doorposts had tendril ornament, and on the consoles (ill. 44) a figure writing.

Style and dating. In the literature this portal is regarded as in succession to the south portal at Bourges (pl. 37–39). The figure style and architectural forms, however, appear to be later by several decades and point to other models. The baldachins are reminiscent of Saint-Pierre-le-Moutier (pl. 67 top) or the destroyed portal of Saint-Pierre, Nevers (ill. 45). There is also a look of Saint-Pierre-le-Moutier in the

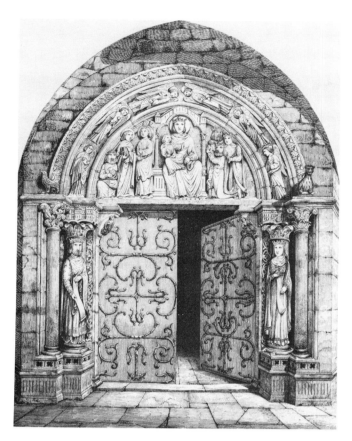

ponderous forms of the figure style. Nevertheless, the Germigny portal is later. The forceful figures in the close-clinging draperies are scarcely conceivable without some influence from the sculptures of the Solomon portal (pl. 88–93) on the Chartres transept. We can number the portal of Germigny l'Exempt among those unpretentious works which carry the art of the royal domain into the provinces, there to combine it, in this instance not without charm, with older local traditions. Date: despite much archaic detail, not earlier than 1215–20.

J. N. Morellet, Barat, E. Bussière 1838–40, vol. I, p. 194; A. L. M. Buhot de Kersers 1883, vol. IV, p. 248; W. Vöge 1894, p. 251 f.; G. Fleury 1904, p. 219; M. Aubert 1929, p. 91; F. Deshoulières 1932, p. 127 ff.; M. Aubert 1946, p. 289; A. Lapeyre 1960, p. 154.

Ill. 45

NEVERS (NIEVRE), SAINT-PIERRE PORTAL

The church was destroyed in 1771. The portal is known only from a drawing, which is the basis of the lithograph in

Ill. 43 Germigny l'Exempt, parish church, west portal. Tympanum: Adoration of the Magi, Annunciation. Archivolt: angels. Jamb: Queen of Sheba(?), Solomon. 1215–20. (After Morellet I, text, p. 194)

Ill. 44 Germigny l'Exempt, parish church, west portal. Lintel console: Evangelist(?). 1215–20

Ill. 45 Nevers, Saint-Pierre. Portal. Tympanum: Majestas Domini. Lintel: apostles. Archivolt: angels, Ecclesia and Synagogue, prophets. Jamb: (left) Peter, David(?); (right) Queen of Sheba, Solomon. About 1200. (After Morellet I, pl. 7)

423

Morellet's *Album pittoresque* (1838). It seems from this that the tympanum displayed a Majestas Domini with quatrefoil mandorla, and the lintel the apostles. The archivolt is formed from pointed arches: in the inner arch, angels, with Ecclesia and Synagogue bottom left and right; in the outer arch, Agnus Dei at the apex, elsewhere prophets(?). The jamb figures are (inner right) the Queen of Sheba with the goose's foot, as attributed to her in a number of medieval texts and illustrations, the king next to her being presumably Solomon, and (inner left) probably David, accompanied perhaps by Peter. The arch below the lintel is of late medieval date.

In the literature the portal of Saint-Pierre is associated with Saint-Bénigne, Dijon (ill. 8), and Bourges (pl. 37). Despite the old-fashioned motif of the queen with the goose-foot, it appears in fact to belong to the period around 1200. The jamb socles and the baldachins, like the tendril frieze bordering the pointed arch of the tympanum, have their closest parallels in the portal of Germigny l'Exempt (pl. 67 bottom, ill. 44), which was executed *c.* 1215–20. In style and type the tympanum composition can be compared with Til-Châtel, and still more, Maguelonne. The portal of Saint-Pierre thus has a place among those executed *c.* 1200 on the Loire, in eastern Berry and in the Bourbonnais; cf. Germigny l'Exempt (pl. 67 bottom, ill. 43, 44), Saint-Benoît-sur-Loire (pl. 66) and Saint-Pierre-le-Moutier (pl. 67 top).

J. N. Morellet, Barat, E. Bussière 1838–40, vol. I, p. 124f.; A. J. Crosnier 1851; W. Vöge 1894, p. 341f.; E. Mâle 1947[5], p. 390; M. Aubert 1929, p. 62; M. Aubert 1946, p. 205; A. Lapeyre 1960, p. 121ff.; M. Anfray 1964, p. 239f.

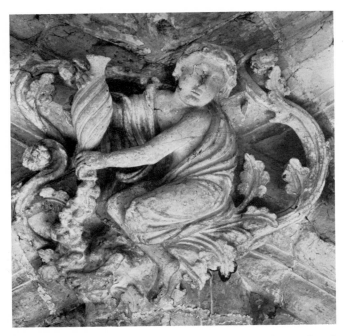

Ill. 46 Vézelay, Sainte-Madeleine, abbey church. Chevet chapel, vaulting boss: River of Paradise(?). Towards 1200

Ill. 46

VEZELAY (YONNE), SAINTE-MADELEINE, ABBEY CHURCH
CHEVET, VAULTING BOSS

The choir of the Madeleine was remodelled in early gothic style about 1185. The boss in the vault of the chevet chapel depicts a figure seated among tendrils, clad only in mantling and pouring water from an upturned, urn-shaped vessel. It has sometimes been taken for Aquarius, but is more likely to represent one of the four rivers of Paradise. The style is characterized by rounded, gently swinging forms, manifest not only in the contour and outer surface of the vessel and the delineation of the drapery but also in the movement of the entwining foliage. In Burgundy this figure is an isolated case; it has affinities with the consoles of the portals of Germigny l'Exempt (ill. 44) and Saint-Pierre-le-Moutier (pl. 67 top). Date: *c.* 1200.

E. Viollet-le-Duc 1867, vol. III, p. 262; F. Salet 1948, p. 75; W. Sauerländer 1966, p. 17f.

Ill. 47

CORBIE (SOMME), SAINT-ETIENNE, ABBEY CHURCH
WEST PORTAL

The abbey of Corbie, founded in the seventh century, possessed several churches: Saint-Pierre, Saint-Jean and Saint-Etienne. The west portal of Saint-Etienne belongs to the group of early gothic Coronation portals. The programme does not correspond to the scheme laid down at Senlis (pl. 42). In the tympanum Christ and the Virgin are enthroned between two angels and the symbols of the Evangelists. In the archivolt we see apostles in place of Christ's ancestors. Thus in this instance the espousal of Christ and Mary/Ecclesia is linked with motifs from the Majestas.

It is not clear whether the lintel was always in its present undecorated state. The jamb figure on the right can no longer be identified. The Assumption of the Virgin on the trumeau is singular, showing the Virgin in a standing position, borne aloft by angels. Despite the doubts sometimes expressed, the trumeau figure is contemporary with the other sculptures. In content it tallies with the lintel relief of Coronation portals of the Senlis type (pl. 43 top).

Style and dating. The tympanum and archivolt figures are broad and emphatically rounded. The draperies are stretched over the projecting shoulders, arms and knees. No other pieces of this kind are preserved in Picardy. Reference to the Saint-Denis fountain (pl. 65, ill. 41) is no less misleading than the supposition of an antique model for the trumeau Virgin. There are striking similarities with sculptures from the cloister of Notre-Dame-en-Vaux at Châlons-sur-Marne (p. 411). The capital depicting Christ washing the feet of the disciples compares closely with the Corbie archivolt figures, just as the Châlons Moses (pl. 52

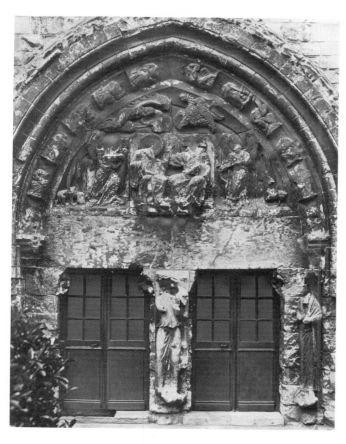

Ill. 47 Corbie, Saint-Etienne, abbey church. West portal.
Tympanum: Coronation of the Virgin. Towards 1200

bottom right) closely resembles the Corbie jamb figure.
Date: towards 1200.

L. Lefrançois-Pillion 1925; M. Aubert 1929, p. 57; J. Adhémar 1939, p. 266;
P. Héliot 1957, p. 59; A. Lapeyre 1960, p. 250ff.

Pl. 68–71, ill. 48–52

LAON (AISNE), CATHEDRAL OF NOTRE DAME WEST PORTAL

Laon was the seat of a bishopric as early as the fifth century.
At the beginning of the twelfth century its cathedral school
enjoyed high renown under Anselm of Laon. The cathedral
is one of the chief examples of early gothic architecture,
though precise dates for its construction are lacking. Work
presumably started during the episcopate of Gautier de
Mortagne (1155–74), whose annual expenditures on the
'opus Laudunense' are recorded. By the time of his death in
1174 the east portions, at most, had been completed. The
building of the nave and the west façade (pl. 68) continued
into the early thirteenth century. We have no firm indica-
tions by which to date the west façade. The gift of the quarry
at Chermizy to the cathedral chapter in 1205, though
important for the dating of the early thirteenth century
renovations to the eastern parts, provides no *terminus ante
quem* for the completion of the west façade.

The sculptures of the west façade suffered extensive
losses at the time of the Revolution; none of the jamb
statues have been recovered, and the tympanum relief,
the archivolt statuettes and the gable ornament of the
porches were damaged. The lintel of the centre doorway had
already been removed before the Revolution, to enlarge
the opening. At various times since 1853 efforts have been
made to replace or complete all the missing and damaged
sculptures; to allow a proper appraisal it was thus necessary
to include photographs showing the state of preservation
before restoration. Plaster casts taken before restoration of
the tympana and lintels of the two side doorways (pl. 69)
and from three archivolt statuettes on the left doorway
(ill. 50–52) are now in the Musée des Monuments français,
Paris. Despite the losses and damage, the sculptures of Laon
present the most important ensemble of north-western
French sculpture to survive from the late-twelfth and early-
thirteenth centuries. What made Laon so epoch-making was
the combination of a triple doorway and porch with sculp-
ture-decorated gables and aedicules. (The porch was
originally open between the centre and side doorways and
was bricked up only in the nineteenth century.) Probably
inspired by romanesque architecture in England (Bury St
Edmunds), this solution led on not only to the porches of the
Chartres transept (pl. 76, 106), but also to the greatest portal
layouts of the thirteenth century, Amiens (pl. 161) and
Rheims (pl. 190).

PROGRAMME

The centre doorway is a Coronation portal (ill. 48) and fol-
lows the scheme laid down at Senlis (pl. 42). The tympanum
and archivolt have been restored. The tympanum shows a
trifoliated arch resting on columns; in the centre, Christ
and the Virgin, and on either side standing and kneeling
angels holding candlesticks and censers. In the inner arch
of the archivolt are angels framed by clouds. The next three
arches are filled with a Stem of Jesse; the tendril shoots on
either side are no longer shaped, as at Senlis and Mantes,
as figures-of-eight, but circumscribe each figure with an
elongated, mandorla-like oval (ill. 49). The following figures
can be identified: Jesse (fourth arch counting from the
inside, bottom left), above him David with his harp, Bath-
sheba, and Solomon with the temple. The outer arch depicts
seated prophets; noteworthy are the high back-rests of the
seats, furbished at the upper corners with knobs or volutes.
On the heavily restored porch gable is a Virgin enthroned.

On the left doorway we find a programme new to portal
iconography and destined to become the model for the
north portal at Chartres and for Amiens. In the centre (pl.
69 middle and bottom) is a Virgin enthroned with adoring
Magi and Joseph, preceded in the lintel by the Annunciation,
the Nativity, and Annunciation to the Shepherds.

In the archivolt (pl. 70, 71) we see, above the Virgin at
the apex of the inner arch, the Dove, on a disc overlaid with
seven rays. In the next arch Virtues are shown overcoming
Vices: this is the first portal to array the Virtues around the

425

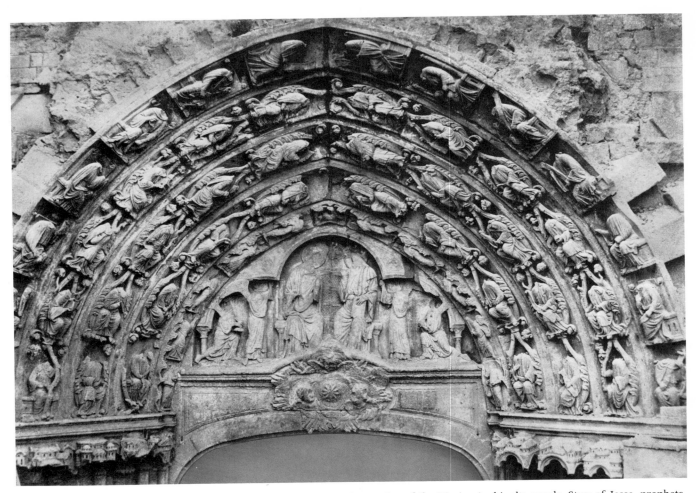

Ill. 48 Laon cathedral, west portal, centre doorway. Tympanum: Coronation of the Virgin. Archivolt: angels, Stem of Jesse, prophets. 1195–1205. (Photograph taken before the restoration)

Virgin, who is the perfect embodiment of all the virtues, and as usual they are shown as female figures. They are clad in full-length, mostly girdled, garments, and each is shown in a specific action. The presence of eight figures is unusual. In the choice there has been some departure from the canon hitherto observed, which goes back to Prudentius.

In the two outer arches of the archivolt we have prefigurations of Mary's virginity. This is the earliest example on a church portal of a widespread Marian typology. Mâle thought it likely that the types selected were based on a sermon of Honorius Augustodunensis for the feast of the Annunciation. A few examples are: on the left inner arch, second and third voussoirs from the bottom, Daniel in the lions' den with Habakkuk bringing him nourishment – just as Habakkuk penetrated the lions' den without breaking the sealed entrance, so Mary conceived Christ without losing her virginity; on the same arch, fourth from the bottom, Gideon's fleece – the fleece moistened with dew parallels the conception, the surrounding ground, which remained dry, parallels the preservation of Mary's virginity; on the

same arch, fourth from the bottom on the right, Moses and the bush which burned yet remained unconsumed – a common symbol for the Virgin; third from the bottom the Ark of the Covenant is shown – just as the manna from heaven was preserved in the Ark, so was Christ conceived in the body of Mary. The outer arch includes: bottom left, virgin and unicorn – this legendary beast could be captured only by a virgin and is a parallel for Christ, whom a virgin conceived; fourth from the bottom, Balaam, who prophesied: 'There shall come a Star out of Jacob'; fourth and fifth from the bottom, Nebuchadnezzar dreaming of the image made of gold, silver and brass, and with feet of iron and clay, destined to be crushed by a stone 'cut out without hands' – the stone loosed untouched from the rock parallels Christ, born of a virgin; second from the bottom (pl. 71), the Erythraean Sibyl, said by St Augustine to have pronounced the words 'E caelo rex adveniet per saecula futures' ('the eternal King will come from Heaven'), which he took to refer to Christ, thus justifying the Sibyl's place in the cycle; and, bottom right, Shadrach, Meshach and Abednego

426

in the fiery furnace – just as the young men were thrust into the flames but were not harmed, so did Mary conceive and yet remain a virgin.

All in all, the programme of this portal is an eloquent testimony to the cult of the Virgin which had been developing since the beginning of the twelfth century. The Virtues are invoked to demonstrate these qualities in the mother of Christ, and unusual typological themes are chosen to testify through parallels and omens to her virginity. A striking feature is that beside the Virtues and the typological figures there are incised inscriptions, barely decipherable with the naked eye when seen from below.

On the porch gable is a figure of St Proba, who suffered a martyr's death at Guise, in the diocese of Laon.

The right doorway is a judgment portal. To the Marian themes of the two other doorways is added the Last Judgment. The sculpted decorations of the Laon are not all of the same date; the figures in the tympanum and the two inner arches of the archivolt go back to a period shortly after work had started on the cathedral, *c.* 1160. The tympanum displays the Judge in the mandorla. Angels bearing instruments of the Passion emerge from clouds to hover near his head. On either side of him are four assessors, among them the Virgin, clearly identifiable from shoes and clothing, on his right. Below them is a scene of resurrection; this scene, together with the representation of the apostles, spills over into the two inner arches of the archivolt; in the upper ranges are angels sounding trumpets or bearing souls, and Abraham with souls of the Blessed in his bosom. These older portions, assembled somewhat arbitrarily when the portal was erected, were supplemented by the more recent sculptures in the lintel and in the three outer arches. The lintel (pl. 69 top) shows the separation of the Blessed from the Damned: the Blessed look up toward the Judge or turn in the direction of Paradise; the Damned are driven by an angel towards Hell. At the head of the Damned we can still make out Avarus with his money bag, who is received by a corpulent devil with horns and satyr's ears. In the outer arches, martyrs, followed by enthroned figures with nimbuses, but who are otherwise unidentifiable, and lastly, also seated, the Wise and Foolish Virgins; in the apex, Christ between two doors, one open, one shut. The programme extends to the porch gable, which depicts Michael subduing the dragon.

As at Sens and later on the west façade of Rheims, the sculpted cycle also spreads over the upper storey of the façade. In the rose-window storey the soffit of the window above the Judgment portal carries a Creation cycle; in the corresponding position above the Coronation doorway, we have a figure sequence representing Philosophy and the Liberal Arts. The sixteen large oxen standing in the corner aedicules of the towers remain a mystery. The nineteenth-century notion that they commemorate animals used to transport building materials to the cathedral is not tenable.

Style and dating. In the field of French cathedral sculpture the west façade of Laon is the earliest to show evidence of

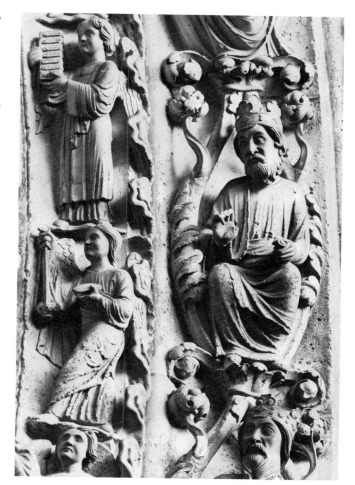

Ill. 49 Laon cathedral, west portal, centre doorway. Detail of archivolt: angels, figure from the Stem of Jesse. 1195–1200

the style first encountered in 1181 in the Klosterneuburg altar by Nicholas of Verdun, and soon afterwards in the book illumination of Winchester or the chapter house of Sigena in Catalonia: the style whose characteristics are a relaxed play of limbs and a fluent 'antique' rendering of draperies. The style of the three doorways is not completely uniform. In the archivolt of the centre doorway (ill. 48, 49) the figures show distinctly rounded forms, relaxed movements and flowing, billowy draperies. The proportions as a rule are thickset, the delineation of the folds, apart from a few ornamental motifs, follows the movement of the limbs. Here, one feels, may be a remote echo of the figures of prophets on the side walls of the shrine of the Magi in Cologne cathedral. The tympanum sculptures produce a less bold effect, and the rendering of the draperies is less fluent. At the hems the garments tend to fall in small, stepped folds. On the left doorway there is a similar discrepancy between the style of the tympanum sculptures (pl. 69 middle and bottom) and that of the archivolt (pl. 70, 71, ill. 50–52). Whereas in the tympanum we find a fondness

427

Ill. 50–52 Laon cathedral, west portal, left doorway. Casts (made before restoration) of archivolt figures, including (right) Erythraean Sibyl. 1195–1205. (Paris, Musée des Monuments français)

for motifs like the flying mantle end, the urgently puckered drapery tip or folds running in waves, the figures in the archivolt reveal a new conception of statuary: the draperies of the Virtues lie closely over the protuberances of the body, while in other figures the material stretches in fine-ridged, curving lines around the moving leg. Among all the sculptures of the Laon facade, it is these archivolt figures which point most plainly to the future. On the lintel of the Judgment portal (pl. 69 top) the forms are again softer, the play of draperies looser, the whole conception less statuesque. Where we should look for the origins of this figure style, which was the model as much for Chartres (pl. 76–125) as for Braine (pl. 73–75), and an indirect influence on Rheims, is a problem to which there is as yet no positive answer. References to the Rheims sculpture of the 1180s do not adequately account for the new features found at Laon. For the moment we must be content to refer in general terms to the changed direction of European style at the end of the twelfth century, seen at its most impressive in the œuvre of Nicholas of Verdun. A date for the Laon sculptures can only be arrived at by inference from Chartres and Braine. Assuming that the Coronation portal at Chartres (pl. 77–87), which must surely be the work of Laon sculptors, was begun directly after 1204, we have a date by which the Laon portals must have been more or less completed. If we stick to the date of dedication, 1216, as the *terminus ante quem* for the west portal at Braine (see below), we arrive at a similar conclusion, since sculptors from Laon were also active at Braine. The Laon portals must therefore date from the period 1195–1205.

J. Marion 1843; A. Bouxin 1902; E. Mâle 1902, esp. p. 106 ff., 179 ff.; L. Broche 1911; L. Broche 1926; M. Aubert 1929, p. 89 ff.; H. Adenauer 1934; E. Lambert 1937; M. Aubert 1946, p. 214 ff.; L. Grodecki 1957; A. Lapeyre 1960, p. 266 ff.; E. Verheyen 1962; F. Deuchler 1967, p. 161.

Pl. 72

FIGURES OF PROPHETS (LAON, MUSEE MUNICIPAL)

The provenance of these column figures – both 7 ft 8 in. high – is uncertain. Stylistically they belong within the circle of the cathedral's west doorways. Though the execution is cruder than in the sculptures of the cathedral tympana and archivolts, they perhaps give us an idea of the appearance of the destroyed jamb figures. The elongated heads, with almond-shaped eyes and slightly parted lips turning down at the corners, seem especially characteristic, and are again an indication of the close connection between Laon and the centre doorway of the Chartres north transept (pl. 77–87).

M. Aubert 1929, p. 91; E. Lambert 1937; M. Aubert 1946, p. 215; W. Sauerländer 1956 (II); A. Lapeyre 1960, p. 270, 275.

Pl. 73–75

BRAINE (AISNE), SAINT-YVED, ABBEY CHURCH SCULPTURE FRAGMENTS

Saint-Yved was a Premonstratensian foundation. The church, presumably begun shortly after 1180, was dedicated in 1216 and was among the most important early gothic structures in Champagne. After the suppression of the monastery at the Revolution the church was at first left to fall into decay. The restoration undertaken between 1829 and 1848 was confined to renovating the east portions of the church, and from 1832 the bays at the west end and the west façade were demolished. The following fragments survive, either in the church or in the Musée Municipal at Soissons.

1. Remains of the former centre doorway. This was a Coronation portal, on the lines of the scheme laid down at Senlis (pl. 42). The figures of Christ and the Virgin from the destroyed tympanum (pl. 74) are now in the church, in the bay preceding the choir. The Virgin is shown in profile and the hands were presumably in the gesture of prayer: at Senlis, Mantes, Laon and Chartres she faces forward and the hands are not laid together. We meet the same type in painting (Ingeborg Psalter). At the side of the Virgin we can make out the remains of an angel with a censer. A further fragment, from the right-hand corner of the tympanum, is at Soissons. It shows a column, with to the right of it a pacing angel (pl. 75 left). Judging by these fragments, the tympanum composition seems to have been roughly as follows: in the centre, Christ, the Virgin and two standing angels, all beneath a common baldachin, at the side two further angels, also standing. This arrangement does not correspond exactly with any of the extant Coronation tympana in the series from Senlis to Laon. In the north transept of the church a relief from the lintel has been installed as an antependium to a modern altar. Its theme was presumably the Death and Assumption of the Virgin. The group as we have it shows Mary and the apostles, but no Christ. Twenty-two figures from the archivolt are preserved on the existing west portal and in the church's interior. Apart from two seated prophets, they belong to the Stem of Jesse (pl. 75 right). The tendrils show the same octofoil form as at Senlis and Mantes, and the figures are in the composed attitude seen at Laon and Chartres. Tympanum and lintel were presumably framed, as at Senlis, Laon and Chartres, by three archivolt arches with the Stem of Jesse and a fourth with prophets. As at Laon, a porch gable above the portal was occupied by a Virgin enthroned; this figure, much restored, is now in the choir of the church. Whether the head of a jamb figure (now in the transept) and two lintel consoles with angels (on the present west façade) belonged to this ensemble is impossible to say.

2. Large fragment at Soissons (pl. 73). This consists of several blocks fixed together by broad cemented joins. We see two unrelated scenes. One depicts Christ in Limbo, with figures including the bearded Adam, and behind him Eve, her right hand across her breast; in the foreground, following the Byzantine model, lies the fettered Prince of Hell. The other shows a Procession of the Damned. A cauldron licked by flames stands in the gaping jaws of Hell. Inside it we see amongst others: Avarice, with Phrygian cap and money bag; Wantonness, with unbound hair and a toad gnawing her bosom; Falsehood, with his tongue being torn out. Above them a fearsome devil seizes two victims in his powerful arms and crushes them against his chest. To him is reported the arrival of the Damned approaching from the right. The procession is escorted by devils, and judging by the clothing and tonsures consists entirely of clerics. On adjoining blocks at the left and above are further fragmentary Hell scenes, most notably a gigantic devil's head, devouring a victim stuffed into his bulging cheeks. The burlesque monstrosity of the Hell scenes is unparalleled in the sculpture of the early and high gothic period in northwest France. In contrast with Burgundian romanesque sculptures and English twelfth-century miniatures, Gothic as a rule sought to moderate the impact of the Hell scenes, by reducing them to a smaller scale so that they do not stand out so prominently in the foreground. According to Prioux, down to 1832 this fragment was bricked into the organ loft. Nothing seems to be known about its original location. The present arrangement of the blocks, with the direct juxtaposition of Christ in limbo and fragments from a Last Judgment, can hardly represent the original scheme. Whether these fragments come from a tympanum or from some other ensemble, a jubé for example, is not clear.

Style and dating. These fragments, like Laon and the centre doorway of the Chartres north transept, are among those works of French sculpture which reflect the change of style in European art in 1180s and 1190s. The sculptures of the Braine atelier are distinguished by a liking for soft and swelling forms, just as evident in the pain-racked features of the Damned as in the exceptional loveliness of the Virgin's head (Coronation tympanum). Compared with Laon and Chartres, less importance attaches to the line, and the effect achieved is more immediate and unsophisticated: tenderness in the case of Mary, melodrama in the scenes of Hell. There are differences in formal language between the various fragments, but these are merely to be interpreted as nuances within a common style. The tympanum figures contain references to the fluent drapery style of the Stem of Jesse at Laon (ill. 48, 49). In the procession of the Damned the forms are less accented. The Christ in Limbo is again sharper and firmer. For each of these stylistic nuances, however, there is a counterpart on the Laon west façade. The current view, that only the Coronation portal (pl. 74, 75) was finished at the time the church was dedicated in 1216, and that the large Soissons fragment (pl. 73) followed several decades later, should therefore be rejected. It can justifiably be assumed that the surviving fragments all date from the period just before the church's dedication in 1216. The workshop presumably came from Laon.

E. Fleury 1877–82, vol. IV, p. 22f.; A. Boinet 1908; E. Lefèvre-Pontalis 1911; A. Boinet 1911; M. Aubert 1929, p. 93f.; P. Vitry 1929, p. 11f.; M. Aubert 1946, p. 218f.; J. D. Rey 1956; W. Sauerländer 1963 (III); F. Deuchler 1967, p. 161f.

Ill. 53

AMIENS (SOMME), SAINT-NICOLAS
CORONATION PORTAL

The jambs and lintel of the portal of the church of Saint-Nicolas, Amiens, which was destroyed at the Revolution, are known from an engraving in Millin's *Antiquités Nationales*. It shows a composition on the lines of Senlis (pl. 42). We see on the lintel the death of the Virgin (left) and the raising of her body (right). On the left jamb, reading from the outside, in second place Abraham and Isaac, then Moses(?), Samuel and David. (This sequence is identical with that on the left jamb of the north portal at Chartres, pl. 82.) On the right jamb, reading from the inside: Simeon (with tiara), Jeremiah, Isaiah(?), John the Baptist with the Agnus Dei. The outside figures left and right are presumably Solomon and the Queen of Sheba, regarded as Old Testament types for the Bridegroom and Bride; they appear on later Coronation portals, for example at Amiens (pl. 166) and

Rheims (pl. 204, 205). Judging by the capitals and figured baldachins reproduced by Millin, the portal must date from *c.* 1200.

A. L. Millin 1790–1802, vol. V, pl. LI, 2; J. Vanuxem 1945.

THE TRANSEPT PORTALS AND JUBE OF CHARTRES CATHEDRAL, THE SOUTH TRANSEPT PORTAL OF STRASBOURG CATHEDRAL, AND EARLY THIRTEENTH-CENTURY SCULPTURES

Pl. 76–125, ill. 54–58

CHARTRES (EURE-ET-LOIR), CATHEDRAL OF
NOTRE DAME
TRANSEPT PORTALS

When the eleventh-century cathedral was burned down on 10 June 1194, all that remained apart from the crypt were the twelfth-century west towers and the west portal. Plans were immediately made for a new building, though whether the retention of the twelfth-century façade and the Royal Portal was envisaged from the start is a moot point (cf. pp. 383 f., pl. 4–15). The decision to retain the earlier façade was probably one of the main reasons for the erection of elaborate new portals on the transepts (ill. 54). On the north (pl. 76), as on the south (pl. 106), three doorways open into the transept; richly sculpted porches are raised on podia approached by flights of steps. Recent investigation of the sources appears to have left us with only one firm date for the chronology of the transept portals: the gift of the head of St Anne to the cathedral by the Comte de Blois in 1204–5, which serves as a *terminus post quem* for the erection of the

trumeau of the centre doorway of the north transept (pl. 77–87). Observations based on the state of the building, hitherto the basis for conclusions regarding the chronology of the six doorways, need to be re-assessed.

The fact that we deal with the portals in the following order should not be taken as postulating a particular chronological sequence: north portal, centre doorway; south portal, centre doorway; south portal, side doorways; south porch; north portal, side doorways; north porch.

NORTH PORTAL, CENTRE DOORWAY (pl. 77–87)

The tympanum (pl. 78, 79) depicts the Coronation of the Virgin. Christ and Mary are shown beneath a baldachin with freestanding columns and a trifoliated arch – Christ blessing, and Mary at his right hand inclining towards him. In the apex of the baldachin angels with censers emerge from clouds, and to the left and right of the baldachin are large kneeling angels. The picture as a whole is framed by a border of cloud. This is the Coronation type emanating from Senlis. The baldachin comes closest to the one at Mantes (pl. 47). Compared with earlier such examples, here the

reduction of the number of attendant angels to two heightens the monumental impact.

The lintel (pl. 78) is separated from the tympanum by a battlemented arcade, and is divided into two fields by a central column. On the left is seen the death of the Virgin; around her couch are the apostles, with Christ receiving Mary's soul at the centre. Below the arcade we see angels with censers, processional cross and crown. On the right is the Assumption: angels lift the body from the sarcophagus, and beyond them others bear her soul away. The distribution of scenes has more affinity with Senlis (pl. 42) than with Mantes (pl. 47). Unlike Senlis, Chartres follows the traditional type which shows Christ present at Mary's death.

In the archivolt (pl. 80, 81) the inner arch shows angels with incense boats, books, candlesticks, ewers for holy water, and palm fronds; the variations in raiment presumably denote two different choirs of angels. In the third and fourth arches are shown the Stem of Jesse, flanked in the adjoining (second and fifth) arches by prophets and Old Testament figures. The scheme deviates from earlier examples in which only a single row of prophets appeared in the outermost arch. As at Laon (ill. 48, 49), the figures in the Stem of Jesse lack the signs of animation shown by their counterparts at Senlis (pl. 44, 45) and Mantes (pl. 46).

On the jambs (pl. 82, 83) the cycle begins on the left with Melchizedek or Aaron as priest of the Old Testament, and ends on the right with Peter in papal vestments. In his right hand Peter (pl. 86) holds the eucharistic chalice (only the foot has survived). As at Senlis, the jamb programme points forward to Christ's sacrificial death. Next to Melchizedek/ Aaron we have: Abraham, sacrificing Isaac; Moses pointing to the brazen serpent; Samuel offering sacrifice, at his feet the young David with girdle; David with lance and crown of thorns (the latter damaged). On the right wall, starting from the inside: Isaiah with the rod; Jeremiah with the cross (here displayed on a disc); Simeon with Christ; John with the Agnus Dei (for the interpretation see pp. 407 f.); Peter. A novel feature is that the figures follow the historical order as given in the Bible. Their number is increased to six on each jamb, presumably to tally with the apostles on the centre doorway of the south portal. The additions, apart from Melchizedek/Aaron and Peter, are Elijah and Elisha, placed against the buttress piers next to the bay opening (pl. 77). At the feet of Elijah another Elisha, receiving Elijah's mantle on his ascension to Heaven (cf. 2 Kings 2:13) – a typological reference to the Ascension. At the feet of Elisha is the Shunammite woman, whose son the prophet raised from the dead (2 Kings 4:36) – normally regarded as a typological reference to the Resurrection. The reference to Christ's sacrifice is thus here expanded to include prefigurations of the Resurrection and Ascension. On the trumeau is a figure of St Anne (pl. 87), a representation occasioned by the gift of her relics in 1204. The annunciation to Joachim formerly appeared on the socle.

Style. The style of the folds, beautifully fluent and delicately linear, the fondness for gently curving contours,

and the restraint in the facial expressions go back to Laon, in particular the archivolt of the left doorway of the west portal (pl. 70, 71, ill. 50–52). The arrangement of the doorway – slanting jambs with recessed socles occupied by twisted columns – points in the same direction. At Chartres, however, the arrangement is more concise: the lintel is sited above the jamb zone, the tympanum is larger and therefore more dominant. There is also greater discipline in the formal language, which for all its delicacy is tighter and more systematic. The sculptures are not a stylistic unity. Tympanum (pl. 78, 79), archivolt (pl. 80, 81), trumeau (pl. 87) and right jamb (pl. 85) display the figure style just described. On the left jamb (pl. 82), by contrast, we have more lanky figures clad in loosely hanging draperies, with narrower, more expressive faces (pl. 84). We should conclude from this not that the two groups were made at different periods, but that Laon sculptors schooled in slightly different traditions worked on the portal. The portal is presumably all of the same date, soon after 1204.

SOUTH PORTAL, CENTRE DOORWAY (pl. 107–113)

The tympanum (pl. 108) depicts the Judge, with hands raised to display the stigmata on the palms. At his head angels with cross, crown of thorns and nails. At the sides are figures of kneeling angels, with lance, column and scourge, and beside the Judge, the Virgin and John the Evangelist, as intercessors. The Judge displayed beneath the Cross is in keeping with the previous Western tradition. What is unusual is the depiction of enthroned intercessors. In the Deësis of Eastern art, the Virgin and the Baptist are shown *standing*; in the West (cf. Paris, pl. 147, Amiens, pl. 164, 165, Rheims, pl. 236) the intercessors are shown kneeling. The unusual arrangement at Chartres derives from the traditional pictorial type in which the assessors (apostles) were shown seated on either side of the Judge. The marked emphasis on the intercessors is new and corresponds to a change in the traditional portrayal of the Judgment at the beginning of the thirteenth century. The compositional distribution of the figures approximates to the arrangement on the Coronation tympanum of the north portal.

In the archivolt (pl. 112, 113) above this group, five ranks of angels, arranged according to their hierarchical position in the nine angelic choirs. In the inner arch, closest to the Judge's throne, are (on the right) six-winged seraphim with flames, on the left cherubim with orbs. In the second and third arches are the Thrones, Dominations, Virtues, Powers and Principalities, all enthroned figures, most of them with crown and sceptre. In the fourth and fifth arches presumably archangels and angels as the lowliest of the choirs and hence furthest from the Judge's throne; they are shown standing, vested liturgically according to their rank, some with alb and dalmatic, others with alb only. Exceptions are the five archangels in the fourth arch (right), standing with shield and lance over dragons. Apart from this, representations of the nine angelic choirs are not found on thirteenth-century Judgment portals. Immediately below the angelic choirs, in

431

the second voussoir from the bottom, we see the Resurrection; above in the outer archivolt pairs of angels sound trumpets. A unique feature is the ordering of the souls of the resurrected on either side of the Judge, arranged in groups of five or six, mostly with hands folded in prayer. At their head in the inner archivolt two single figures rise from sarcophagi, on the left presumably Eve, on the right Adam. This unique composition brings the plea for the Judge's mercy into the foreground of the section devoted to the resurrection of the dead.

On the lintel (pl. 108, 112, 113) are, at the centre, Michael with the balance for weighing souls, and, to the left, the Blessed, among them (in the front row) a king, a bishop, and a deacon; the sequence continues into the bottom zone of the archivolt, showing Paradise, with souls in Abraham's bosom and the crowning of the Elect. On the lintel, to Michael's right, a procession of the Damned, among them, a miser with his money bag, a king, a bishop, a lady in aristocratic dress, and a monk, advances towards the gaping jaws of Hell. In the bottom zone of the archivolt are paired figures of devils and damned, and in the fourth arch (reading from the inside) another miser with money bag, and (far right) Lasciviousness in the guise of a naked woman, slung head downwards across a devil's shoulder.

The representation of the weighing of souls and the arrangement of the Blessed and Damned according to rank follows pictorial tradition. Note the clarity of layout achieved on the lintel and bottom archivolt.

Down to the thirteenth century the apostles figured as assessors at the Last Judgment, as they do on the Judgment portals of Saint-Denis (pl. 1) and Laon (pp. 379, 427). At Chartres the Judge appears for the first time without assessors, the apostles being installed as statues on the jambs (pl. 110, 111); the figures are characterized by their attributes as martyrs with, at their feet, the tormentors on whose orders they met their deaths. On the left jamb, reading from the inside, are: Peter with keys and cross, beneath him not Nero, but Simon Magus with his money bag (cf. Acts 8:20); Andrew with cross, beneath him Egeas, the proconsul; Philip with sword, at his feet the king of Hierapolis; Thomas with sword, beneath him the king of India; in fifth and sixth places, Matthew and Simon. On the right jamb, reading from the inside, are: Paul with sword, beneath him Nero; John with book and (broken off) palm, and beneath him the priest of Diana at Ephesus, who made him take poison. James the Greater with sword and pilgrim's bag decked with shells, beneath him Herod Agrippa; James the Less with fuller's club, at his feet a Jew. In the fifth and sixth places Bartholomew and Judas Thaddaeus.

The portrayal of the apostles as martyrs, though common in the art of the later Middle Ages, at this date, c. 1200, was still a novelty. The instruments of their martyrdom may have been introduced to balance the Judge, portrayed with the instruments of the Passion.

On the trumeau (pl. 109) the figure of Christ, giving blessing and holding the book, stands over lion and dragon,

on the strength of the text' . . . the young lion and the dragon shalt thou trample under feet' (Psalm 91:13). Interpretation of the figure as a 'Teaching Christ' is unfounded. We have here the Saviour, shown at the threshold of the church triumphant over death and sin. The significance of the scenes at Christ's feet is uncertain: in the upper zone a kneeling figure, hands joined in prayer, with a chaplet of roses in the hair, and on either side figures more simply dressed, with loaves of bread; in the lower zone a seated woman and a standing male figure in front of whom is a table with bread, and on the left another standing figure more plainly dressed. The identification of the main figures as Pierre de Dreux and Alix de Bretagne, and of the bottom scene as their marriage banquet, is unfounded; the year of their marriage, 1212, thus becomes irrelevant as a clue to the date when work started on the doorway. The scenes possibly refer to founders we can no longer identify, shown distributing food to the poor. Acts of charity were often portrayed in conjunction with the Last Judgment.

Composition and figure style. Characteristic of the composition is the symmetrical layout with stress laid on the central axis – the trumeau Christ, Michael, the Judge, the Cross. The horizontal arrangement is built up in zones: on the jamb the apostolic college, in the bottom archivolt zone and the lintel, the weighing of souls, Paradise and Hell, the Judge, intercessors, and the resurrected. In each case the zone forms a band spanning the entire bay. The balance of the composition is matched in the figure style. The delineation of draperies, as of the faces, is more firm and definite than on the Coronation portal (pl. 77). The contours outlining the figures are straighter, and in place of the oval forms of the heads of the Coronation portal, here the features have angular outlines, low foreheads from which the hair grows in a straight line, heavily stressed jaw bones, wide mouths with straight lips. The figure style is also more uniform and shows only occasional variations in the quality of execution. The Judgement portal is probably later than the Coronation portal, not long before 1210. The workshop may well have followed on here from the Coronation portal.

SOUTH TRANSEPT, SIDE DOORWAYS
Despite recently expressed doubts, it still seems probable that the side doorways were planned at the same time as the centre doorway, and executed at most only a little later. Originally they had only six jamb figures (for the additions made when the porch was constructed see below). The programme of the side doorways is an extension of the central Judgment theme. On the left are Martyrs, on the right Confessors, all in their capacity as potential intercessors.

Left doorway (pl. 114). The tympanum and lintel show the martyrdom of St Stephen. The sequence starts in the bottom archivolt zone at the left, with Stephen's disputation with the scribes, and ends at the right with Saul watching over the clothes. On the lintel Stephen is seen being led away and stoned; he kneels in prayer, his head raised towards the crowned Christ standing with the martyr's palm in the

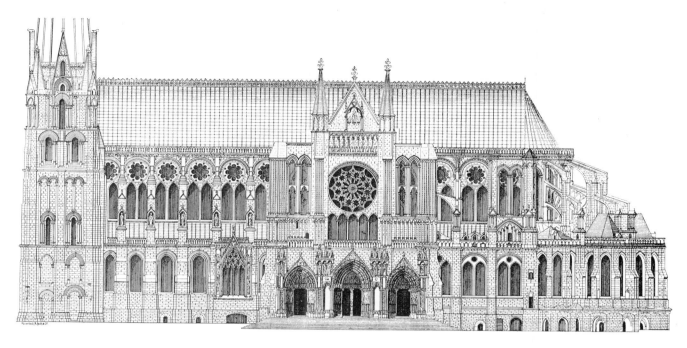

Ill. 54 Chartres cathedral. South elevation. (After Dehio/Bezold IV, pl. 416, 3)

tympanum (cf. Acts 7:56, 'Behold I see the heavens opened, and the Son of man standing on the right hand of God.') In connection with the Judgment theme the following passage (Acts 7:59) is important: 'And he kneeled down, and cried with a loud voice, Lord, lay not this sin to their charge.'

In the first arch (reading from the inside) of the archivolt are martyrs, presumably the Holy Innocents, with palms and orbs. The identification of the figures in the second arch is uncertain; at the apex is the head of a ram or a bull, the streams proceeding from its mouth being caught by the garments of the enthroned figures. For this reason the text of Rev. 7:14 has been invoked: 'These are they which came out of great tribulation, and have washed their robes, and made them white in the blood of the Lamb', but since the Lamb of God is not displayed at the apex the interpretation is not entirely convincing. In the fourth and fifth arches are unidentifiable clerics, probably martyrs.

On the left jamb (pl. 116) are figures of martyrs: (second left) Stephen, vested as a deacon, and at his feet a Jew with a banderole (thus the sequence of martyr statues on the jamb begins with the first martyr, whose death and role as intercessor are illustrated on the tympanum); next comes Clement of Rome, as pope (the socle shows a church engulfed by waves, an allusion to the story that Clement was drowned on Trajan's orders in the Black Sea and his body discovered in a temple amidst its waters); next Laurence, vested as a deacon, and below him the Emperor Valerian being strangled by a devil.

On the right jamb (pl. 117) are: on the inside, Vincent, the third deacon martyr, with on the socle, a wolf and a raven (two ravens protected the saint's body from wild beasts); Dionysius(?), first bishop of Paris, with a lion at his feet

(supposedly because the saint was thrown to hungry lions, who became so tame when he made the sign of the cross that they licked his feet); a priest martyr vested in a chasuble, supposedly St Piatus (a northern French saint whose relics belonged to Chartres), but the identification is not certain. The martyrs, like the precursors of Christ on the Coronation portal (pl. 82, 83), appear in chronological order, starting with Stephen and other early Roman martyrs and ending with saints who lost their lives in the evangelization of France.

In style the Martyrs' portal shows a direct connection with the Judgment portal (pl. 107). Its figure decoration was presumably the work of sculptors trained in the same workshop. Date: c. 1210–20.

Right doorway (pl. 118). The martyrs of the left doorway are followed by confessors. On the tympanum and lintel (pl. 119) we see: (bottom left) St Martin dividing his cloak and (above) Christ appearing to the sleeping saint, clad in the cloak he donated; (bottom right) St Nicholas delivering gold at the house of a poor man to save his daughters from prostitution and (above) healing oil dripping from the tomb of St Nicholas on to the sick. At the apex is a blessing Christ.

In the bottom zone of the archivolt are scenes from the life of St Giles. On the outer arch (left) the saint gives his coat to a sick beggar, and the sick man is cured. On three inner arches (pl. 124 top) we see: in the centre, St Giles as hermit, with the hind pursued by hounds and huntsmen; on the right, a huntsman who shoots an arrow at the saint (the bow is broken off) and wounds him; on the left the king offering the saint medical aid, which he refuses – it is more virtuous to suffer than be cured. On the right the saint celebrates Mass; behind him kneels Charlemagne, pardoned through the saint's intercession for an unconfessed mortal sin.

433

All the scenes thus relate to the Last Judgment: they show the good deeds done by the confessors and their celestial reward, and the forgiveness of sins through the saints' intercession. In the remaining arches we have more confessors, arranged in order of rank. The angels in the inside arch are followed by: a young man and clerics; an old man, a knight, deacons; aristocratic laymen, monks, abbots; kings, bishops, popes.

On the left jamb (pl. 120) are (second from the left): Leo the Great(?), cf. pl. 122 top right (the significance of the socle figures – three heads looking out of the ground – is unclear); Ambrose(?), below whom the crowned socle figure is alleged to be the usurper Maximus, but there is no proof of this; Nicholas(?).

On the right jamb (pl. 121, 122 left, 124 bottom) we see (from the inside): Martin and, at his feet, the hounds who at his command ceased their pursuit of a hare; Jerome, who points with his right hand to the Vulgate, and with his left winds up a scroll, thereby snatching it from the grasp of Synagogue, portrayed at his feet (the reference is to his translation of the Bible); Gregory the Great with, on his right shoulder, the Dove, according to Peter, the saint's amanuensis (shown on the socle), the source of Gregory's inspiration.

Style and dating. In the tympanum, lintel and bottom archivolt zone we find a narrative manner and figure conception radically different from the centre and left portals. The style is distinguished by its very precise rendering of objects accessory to the narrative: trees around the refuge of St Giles, the portcullis of the gateway into Amiens, the page's hat hung on the bedpost in St Martin's dream. The figures are highly animated. There is a notable fondness for folded arms and for flexed joints. One notes the striking capacity for enlivening the content of saints' legends beyond what was traditional in their representation. At Chartres itself there is affinity with the Solomon portal (pl. 88–90). The stylistic sources are to be found at Sens rather than Laon (see p. 418). The jamb figures are probably not all by the same hand. Those on the right wall have a particular appeal, because of the individual characterization, based on an acute perception of the varying personalities of the Fathers of the Church. The rendering of the liturgical vestments shows exceptional care and delicacy. As a *tour de force* one might mention the features of St Martin and the enhancing effect of the lofty mitre (pl. 122 bottom left). Here the closest affinity is with the bishop's head at Lèves (pl. 122 bottom right), and further back in time, a head of a king at Sens (pl. 64 bottom). Date: *c.* 1220. The workshop presumably came from Sens.

SOUTH TRANSEPT – PORCH (pl. 106)

The porch was not part of the original design and was a later addition. An ordinance issued by the chapter in 1224 concerning the removal of traders' stalls was aimed at securing the chapter's right of supervision and not, as has long been assumed, at clearing a space for the building of the south porch. External indications of date are lacking. The figures and reliefs continue the programme of the portals. The vaulted porch, open on all sides, rests on piers decorated with reliefs. The roof vaults and entrance arches carry figure sequences. Enthroned single figures on the gables and the figures in the intermediate aedicules round off a cycle whose scope is exceeded only by the west portals of Amiens and Rheims cathedrals. Here the details can be touched on only very briefly. Extension of the side doorways: the jamb of the left doorway (pl. 116, 117) included two more martyr-figures, both characterized by their armour and weapons as soldiers. The figure on the right must be St George (pl. 117), since the socle shows the wheel on which this saint was martyred. Whether the figure on the left (pl. 116, 115) is St Theodore, as Bulteau conjectured, or St Maurice, as Delaporte has more recently suggested, is hard to say; neither guess affords a convincing interpretation of the socle scene. Suffice it to say that the attempt to identify the figure as Roland is in any case invalidated by the nature of the overall programme.

Both statues display a freedom and an assurance unknown in the earlier jamb figures. The formal language is more pronounced, its preoccupation less with the curve than with the outline broken into angles. The pointing up of the facial features is especially marked in the St George; the eyebrows are drawn firmly together, the hair rendered in ringlets. Both statues are probably the work of a Paris sculptor, some time after 1230.

On the jamb of the right doorway (pl. 120, 121) two abbot saints belonging to the Chartres diocese have been added to the row of confessors. On the left jamb is St Laudomarus (pl. 123 left), and displayed on the socle is the miracle of the wine cask: while the saint as deacon reads the Gospel from the lectern, the wine in a cask he left unsealed in the cellar does not run out. On the right jamb is St Avitus (pl. 123 right); on the socle we see the saint as a novice, receiving cowl and tonsure.

In both figures the formal language makes for breadth, especially at elbow level. This is matched by a rendering of the folds in which the chasubles are traversed by long swinging arcs and spoon-shaped depressions hollowed out in the material. Hands and heads are small. The Avitus is remarkable for the large locks of hair, in which holes have been made with the drill. All these stylistic features point to the sphere of the Rheims Visitation group (pl. 199, 202, 203). The figures were made in the 1230s by a Rheims sculptor who has left no other trace of his activity at Chartres.

The porch piers each feature twenty-four scenic portrayals. Those on the west and east show martyrs (pl. 125 left) and confessors respectively, which supplement the jamb and archivolt sequences. The inner piers show, on the outer and lateral faces, Virtues and Vices (pl. 125 middle); the iconography of the cycle and its incorporation into the Judgment programme derive from the centre doorway of the west portal of Notre Dame, Paris (pl. 151). On the remaining faces (at the rear and facing the side entrances) the twenty-four Elders of the Apocalypse are depicted (pl. 125

434

right). This theme is often portrayed in conjunction with the Judgment.

The rows of figures in the roof vault fit into the same ensemble (pl. 106): preceding the Judgment portal are patriarchs and prophets; preceding the Martyrs' portal, the Wise and Foolish Virgins; preceding the Confessors' portal, the apostles, as the first to bear witness to the faith. On the outer arches of the side openings we have angels, and on the centre opening – as the sequence garlanding the Judgment scenes within – virgins with crowns and flowers.

The figures on the gables and in the aedicules (pl. 106) open up a new set of themes: on the gable of the Martyrs' portal we have St Anne, on the Confessors' portal the Virgin of the Annunciation, in the centre the Virgin enthroned. The aedicules, eighteen in number, are occupied by figures of kings with crowns and sceptres. Whether they represent kings of France or Christ's royal forebears is still undecided. Note, however, that the sequence begins with David, recognizable from his harp, and that the royal forebears of Christ, together with the gable figures of St Anne and the Virgin Mary, would make sense as the 'oldest' historical stratum in the overall programme.

Stylistically almost all the sculptures of the south porch go back to Notre Dame in Paris. The formal language is often quite metallic in its harshness. Variations between the figure sequences are practically non-existent. Date: *c.* 1230–40.

Together the three south doorways and the porch present a programme of exemplary compactness, in which a wide-ranging representation of the Communion of Saints is related to the overriding theme of the Last Judgment.

NORTH TRANSEPT – SIDE DOORWAYS (pl. 76)
It used to be assumed that following the erection of the Coronation portal (pl. 77) after 1204 the north façade had only the one entrance, the side doorways being later additions. This assumption was based, however, on data obtained from the structure, which have not proved completely valid. Thus, the present state of our knowledge makes it impossible to decide for certain whether or not the three north doorways are contemporaneous. The style of the sculptures on the side doorways argues in any case for a date not long after the completion of the centre doorway. The programme of the north portal is less compact and harder to grasp than is that of the south façade.

Left doorway (pl. 94, 95). The basic theme is the Infancy of Christ. On the left jamb is depicted the Annunciation. Gabriel, with sceptre, his right hand raised in salutation, advances to greet the Virgin with the words 'Ave Maria', and she seems gently to bow her head and almost imperceptibly to draw back. At Gabriel's feet is a devil; beneath Mary, the new Eve, we see the serpent of Paradise. The prophet on the left is Isaiah (cf. Isaiah 7:14, 'Behold a virgin shall conceive and bear a son'). The only earlier example of an Annunciation similarly displayed on a portal jamb is at Saint-Lazare, Avallon. This was not the source of inspiration for the Chartres group, which has to be understood in the

context of the enlargement of portal layouts and programmes at the beginning of the thirteenth century, when it became increasingly common for scenes to be portrayed on jambs.

The right jamb: depicts the Visitation (pl. 95). As in the Annunciation, Mary is placed next to the doorpost. Elizabeth, whose furrowed face bears the marks of age, addresses her with the prophetic words: 'Blessed art thou among women, and blessed is the fruit of thy womb.' (Luke 1:42). At Mary's feet the bush that burned and was not consumed – a symbol of the virgin birth. No explanation has been found for the figure beneath Elizabeth (the idea that it is Habakkuk, preparing nourishment for Daniel, has no support from any textual or pictorial source). On the right is a prophet with banderole (there is nothing to support the proposed identification with Daniel).

The continuation of the programme passes from the jamb to the tympanum, by way of the lintel (pl. 94). As on the Coronation portal (pl. 78), the lintel is divided. In the left field we see the Nativity, and on the right, the Annunciation to the Shepherds. The tympanum also contains two scenes: on the left, the Adoration of the Magi, and on the right an angel appearing to one of the kings and forbids their return to Herod. At the apex is the star of Bethlehem. This historical programme is framed in the archivolt by moralizing parables and personifications related to the Virgin. In the inner arch we see angels with torches; the sequence of the Wise and Foolish Virgins in the second arch points to Mary as 'Virgo prudentissima'. In the same way the cycle of Virtues victorious over Vices in the third arch relates to Mary as the exemplary embodiment of all the Virtues. Presumably the sequence of twelve crowned female figures with sceptres and banderoles in the outer arch also relates to the Virgin and her qualities.

The programme and structure of the portal clearly derive from the left doorway of the west portal at Laon (pl. 70, 71). The workshop presumably also worked on the (south) Judgment portal (pl. 107–113). In the Annunciation and Visitation, movements, gestures, draping and folds are combined with vigour and terseness to bring out the full significance of the content. The countenances are almost without play of facial features. The angular heads, with vertical foreheads, close-lying and only lightly undulating hair, and sharply cut lips, are not without harshness. There is an air of dignified stiffness about the female figures, which is as close to the Judgment portal as it is remote from the freer, more animated figure conception of the Confessors' portal (pl. 118–121). Date: *c.* 1220.

Right doorway (pl. 88–93). The subjects of the sculptures are here taken from the Old Testament. That there is an underlying typological reference in the figures and scenes can be taken for granted, but there are difficulties when it comes to grasping some of the details.

On the left jamb (pl. 92) we see, on the outside, Balaam, whose only other appearance on a portal is at Laon (see p. 426). This soothsayer is shown with a flowing beard, and holding in his left hand a banderole, and in his right the

435

stick he used to beat his obstinate ass (Numbers 22:22–23). We are shown the point in the story at which the ass, here the socle figure, says to the irate Balaam: 'What have I done unto thee, that thou hast smitten me these three times?' (Num. 22:28). Balaam is included here because of his prophecy, '. . . there shall come a Star out of Jacob' (Num. 24:17), which was taken to refer to Christ and Mary/Ecclesia. The Queen of Sheba and Solomon, who follow as a pair, are to be understood in similar fashion – as a type for the espousal of Christ and the Church. At the feet of the queen is a Negro, bearing a goblet filled with coins (cf. 2 Chronicles 9:1, where it is stated that '. . . she came with a very great company, and camels that bare spices, and gold in abundance, and precious stones . . .'). Solomon is in costly apparel: pointed shoes, mantle with tippets of ermine, jewelled collar, and with hair and beard most delicately curled. As antitype to the wise king we have the fool Marculf, crouching beneath the socle slab in the lowly posture of the *spinario*.

The statues of the right jamb (pl. 93) cannot be named with complete certainty. The figure next to the doorpost is known as Jesus Sirach, on account of an inscription allegedly still legible in the nineteenth century. However, since there is nothing to prove that the author of the Book 'Jesus Sirach' (Ecclesiasticus) was an architect, the socle scene showing the building of the Temple makes the identification doubtful. As an alternative Zerubbabel has been suggested, since he is mentioned as builder of the Temple (Ecclesiasticus 49:13; Zechariah 4:9). The identification of the next figure as Judith is improbable, since she is dressed not as a widow, but wears a diadem – and there is no passage in the Book of Judith which would account for the dog beneath her feet. The figure is more likely to represent Aseneth, the wife of Joseph (Gen. 41:45). Joseph is shown next to her, also with a diadem, and with sceptre and ring. The pair could then refer to Christ/Ecclesia. The figure at Joseph's feet is presumably Potiphar's wife, listening to insinuations whispered by a serpent.

The lintel (pl. 90) shows the Judgment of Solomon. The king is on the left, and standing behind the throne a Negro with sword. A servant, whose backward glance shows him to be still half-listening to the king, delivers the child to the anxious rightful mother; on the right is the amazed audience. As regards typology, the reference is either to the wisdom of Solomon as a prefiguration of the wisdom of Christ, or to Solomon's recognition of the rightful mother as a prefiguration of Christ and the Church.

The tympanum (pl. 90) shows (left) the long-suffering Job being addressed by his friends and (right) his wife, in an agitated attitude; at the back the Devil, with large talons and horns. Here the reference is either to the mocking of Christ, or, more likely in this instance, to the Church beset by heretics but ultimately triumphant. The cosmic attributes – sun, moon, stars – of the four angels at the bottom of the inner archivolt (pl. 88, 89) could perhaps refer to the text of Job 38:31–33.

In the archivolt (pl. 88, 89, 91), as on the Baptist's portal at Sens, the figures do not stand in isolation but are grouped in scenes. The inner arch has four scenes on either side, relating to (left) Samson, and (right) Gideon. Both scenes start below with promises and lead upward to triumphs over Israel's enemies. At the bottom left Manoah and his wife are shown making the thank-offering for the annunciation of the birth of Samson. At the top, Samson is seen bearing the gates of Gaza. At the bottom right Gideon, threshing grain beneath the oak tree, is called by the angel of the Lord. At the top Gideon leading the captive Midianite princes, Oreb and Zeeb. The typological reference is to Christ's triumph over death, and victory over heretics. The middle arch has five scenes on each side, relating to (left) Esther, and (right) Judith. Esther's coronation by Ahasuerus is a type for the coronation of the Virgin or for the espousal of Christ and Ecclesia. Judith, slayer of Holofernes is a type for Mary, vanquisher of the Devil. In the outer arch are twelve scenes from the Apocryphal story of Tobias. The sequence begins with the burials by night which led to the blindness of the exhausted Tobias (left, third scene from the bottom), and ends with Tobias being cured by his returning son (bottom right). The typological reference is to Christ restoring light to the blinded Jews (Synagogue).

All the Old Testament happenings depicted on this portal thus prefigure the espousal of Christ and the Church, or the triumph of Christ and the Church over their adversaries.

Style and dating. The formal language is full of commotion, but in a way wholly subservient to a narrative manner at once dramatically animated and true to the texts. In the composition of the groups the forceful, stocky figures are packed close together, and the flexing of limbs and joints, the fall of the draperies, the characterization of the facial features all conspire to make them lively and energetic. Motifs and rendering of movement derived from the sculpture of the late twelfth century have been made to serve the purposes of a new manner of realistic representation. Elsewhere on the Chartres transept the only possible comparison is with a few sculptures on the Confessors' portal, and these are not of the same rank. The sculptures of this doorway, the Solomon portal, were made about 1220 by a workshop originally from Sens.

NORTH TRANSEPT – PORCH (pl. 76)

The planning coincides with the erection of the side doorways, and the execution is earlier than that of the south porch. Alterations since 1316 include the renewal of one pier socle, and presumably the removal of aedicules between the gables (for what may have been the original state cf. the south porch, pl. 106, where the aedicules have survived). In 1793 seven out of the twenty porch statues were destroyed, three of them together with their socle relief. The arrangement of the figure decoration differs from that on the south porch; pairs of statues flank the entrances.

The programme can be understood only in part, since with two exceptions it is no longer possible to identify the statues.

436

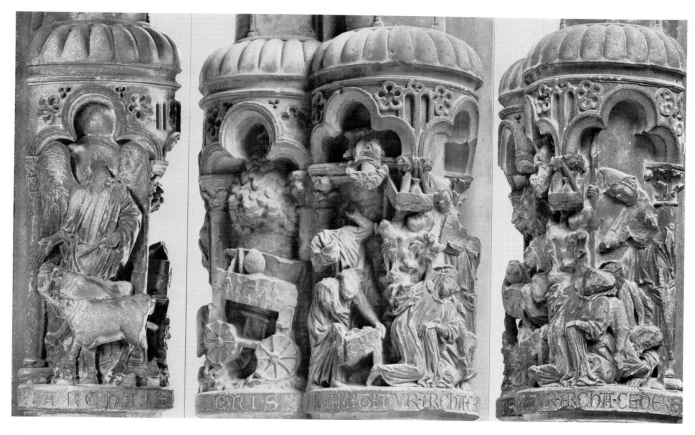

Ill. 55–57 Chartres cathedral, north transept. Socle reliefs of the middle entrance. *Right.* Victory of the Philistines over Israel; death of Hophni and Phinehas. *Centre* (reading from the right). The Ark of the Covenant in the temple of Dagon; Dagon's image falls from its pedestal; the cart which conveyed the Ark back to the Israelites. *Left.* The pair of kine which drew the cart to Beth-shemesh; behind them an angel. 1220–30

Presumably the basic idea, as on the south side, was to extend the iconography of the portals. When we look at the outer arch of the left porch (pl. 105) the connection is easy to follow: in the inner row are ten seated women; on the left half of the arch they are busily preparing wool, on the opposite side they are shown reading or meditating. The intention is to convey the contrast between the active and the contemplative life, whose biblical prototypes are Leah and Rachel (cf. Gen. 29) or Martha and Mary (cf. Luke 10:39–40). Statues of Leah and Rachel, the one sewing and the other reading, were formerly included beneath the row of voussoir figures. The cycle relates to the Virgin, who fulfilled the demands of both the contemplative and the active life. In the outer row are crowned female figures with shield and standard, personifications of the blessings of Heaven, first described by Anselm of Canterbury. On the left, for example, we have beauty, swiftness and strength, as blessings of the body, on the right wisdom, friendship and concord as heavenly joys of the soul. This row, too, is presumably intended to extol the merits of the Virgin. The archivolt of the portal and the outer arch of the porch, thus carry the same theme. There may be a similar connection between the figures on the right-hand arch of the porch and

the tympanum of the right doorway (pl. 90). In the outer row of the arch we have at the bottom summer and winter, with the signs of the Zodiac above, and on the inner row a Calendar. Occasion for the theme would be provided by the passage: 'Knowest thou the ordinances of heaven? canst thou set the dominion thereof in the earth?' (Job 38:33).

On the arch leading to the centre doorway is the Creation (pl. 100–104). Starting from the bottom, the course of the action ascends on the left side and descends on the right. The left side (pl. 100) shows: 1, the separation of the waters (Gen. 1:2); 2, creation of sun and moon (the composed attitude of the reading figure is singular); 3, God the Father and adoring angels; 4, creation of the plants; 5, God the Father and angels with stars; 6, creation of the fishes and birds (the presence of Adam is unusual); 7, creation of four-footed beasts; 8, God the Father and the trees of the Garden of Eden; 9, Creation of Adam, and four-footed beasts. On the right (pl. 101) we see (reading from the top): 9, creation of Eve, fishes and birds; 8, Rivers of Paradise; 7, God the Father and Adam; 6, Adam standing among plants, Adam asleep; 5, the Fall; 4, God calls Adam; 3, interrogation of Adam and Eve; 2, expulsion from the Garden of Eden; 1, Adam and Eve toiling. The sequence of the cycle and the

437

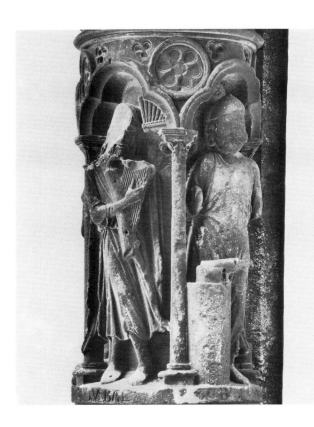

Ill. 58 Chartres cathedral. North transept. Socle relief from the right entrance: Jubal and Tubalcain. 1220–30

coherence between the scenes seem to have been upset by mistakes in the installation (cf. further pl. 102–104). Whether the cycle can justifiably be related to the antithetical Adam-Christ and Eve-Mary figures on the Coronation portal is hard to say.

The statues on the east flank and outer face of the porch cannot now be named individually though it is clear that they represent kings, priests, patriarchs and women from the Old Testament (pl. 96, 97, 98 left). Below the figures on the left of the middle entrance we see the boyhood of David from his anointing to the victory over Goliath (the latter renewed after 1316), and on the right: Samuel in the temple at Shiloh, and the capture and return home of the Ark of the Covenant. These scenes (ill. 55–57) presumably do not relate to the figures above them (pl. 96, 97). On the right-hand porch entrance we have a cycle devoted in large part, it seems, to the Artes mechanicae. It starts on the left with Adam as an old man, followed by Abel as herdsman, Cain as tiller, Jubal as music-maker, and Tubalcain as smith (ill. 58). After three more figures which cannot be certainly identified, the series ends with 'Philosophus' and 'Magus'. In thirteenth-century France there is nothing comparable; one is reminded of later Italian cycles, for example the reliefs on the campanile at Florence.

On the west flank are figures of (on the left) St Potentianus as archbishop of Sens, and (on the right) St Modesta (pl. 98 right, 99); Potentianus was regarded as the first

438

Chartrain missionary, and Modesta was the daughter of the Roman governor who visited him in prison. These two local saints stand outside the Old Testament programme which is the general theme of the north side. No names can be given to the four enthroned kings on the front of the porch or to the figures in the roof vault. The figures on the gables are of Christ and, on either side, bishops.

Style and dating. We have here a number of different workshops, working side by side. The statues on the centre doorway and the king on the east flank adopt the formal language of the Coronation portal (pl. 77–87), but with smoother draperies and greater composure in facial features and gestures. The self-absorption of these hushed, un-dramatic figures influenced the art of the sculpture at Rheims of *c.* 1230. By contrast, St Potentianus, and still more St Modesta (pl. 98 right, 99), reveal the development, through the free play of folds and tresses, of another formal language. A few of the small figures on the porch arches point in the same direction: Pulchritudo (pl. 105 left) from the Blessings cycle, and Summer and Winter on the right-hand arch. It was from this tendency that the workshop of the Strasbourg Ecclesia was to develop its style.

The reliefs beneath the large figures were worked up from separate parts. They pursue the formal language of the Solomon portal (pl. 90–93) and transform it into a harshly broken-up, wrinkled style. This links up with the Creation cycle on the centre arch of the porch (pl. 100–104), probably the last to be made, whereas the Calendar on the right shows signs of Parisian influences.

The north porch, made presumably between 1220 and 1230, shows the Chartres workshops in a state of stylistic uncertainty, with no clear connections with the latest artistic currents. Thereafter, with the erection of the south porch (pl. 106 ff.) and the completion of the jubé (pl. 126, 127), the local traditions founded on Laon and Sens were finally broken.

M. J. Bulteau 1887–92, vol. II, p. 131 ff.; E. Mâle 1902; K. Franck-Oberaspach 1903, p. 77 ff.; E. Houvet 1919; M. Aubert 1929, p. 95 ff.; K. Bauch 1929–30; P. Vitry 1929, p. 14 ff., p. 33 ff.; S. Abdul-Hak 1942; G. Schlag 1943; M. Aubert 1946, p. 219 ff.; L. Grodecki 1951; W. Sauerländer 1956 (II); Y. Delaporte 1957; W. Vöge 1958, p. 63 ff.; P. Kidson 1958; A. Katzenellenbogen 1959; J. van der Meulen 1965; J. G. v. Hohenzollern 1965, p. 25 ff.; W. Sauerländer 1966, p. 51 ff.; R. Lejeune, J. Stiennon 1966, vol. I; J. van der Meulen 1967; *see also* Appendix to Bibliography.

Pl. 126, 127, ill. 59–62

CHARTRES (EURE-ET-LOIRE), CATHEDRAL OF NOTRE DAME
SCULPTURES FROM THE JUBE

The jubé of Chartres cathedral was dismantled in 1763 owing to its dilapidated state and the debris was used as infilling for the pavement of the choir. The first fragments were found in the course of repair work following the great fire of 1836, which destroyed the cathedral's famous medieval roof timbers. Digging in 1848 brought to light many more fragments, which were deposited in one of the

Ill. 59 Chartres cathedral. Interior aspect in 1697, before the destruction of the jubé. After an engraving by Nicolas de Larmessin

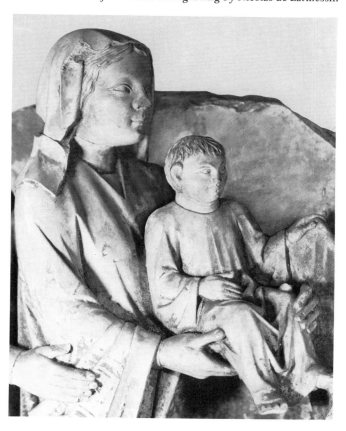

crypt chapels. The long-standing plan for a partial reconstruction of the jubé has still not been realized, nor do we have an inventory of the fragments so far discovered. Thus all we can do is to summarize the present state of research.

A ground plan of 1678 shows that the jubé stood in front of the east piers of the crossing. The steps leading up to the loft lay between the piers. According to seventeenth- and eighteenth-century engravings (ill. 59) the jubé opened into the nave through an arcade with seven arches crowned by gables and further divided by intermediate supports. The exact dimensions, and the detailed reconstruction, are matters of debate. Above the arcade zone, the front and presumably also the flanks displayed narrative reliefs. Judging from old illustrations, the space between each of the gables was occupied by three superposed slabs. The rib-vaulting beneath the loft had figure-decorated bosses. The jubé cross was placed centrally above the arcade; a report of 1506 stated that the cross was of silver gilt. The sources tell us nothing about the programme of the reliefs. The most important of the known fragments fall into several groups.

The first group consists of slabs depicting the Infancy of Christ: the Annunciation, Nativity (pl. 126), Annunciation to the Shepherds (pl. 127 bottom), the Adoration and Dream of the Magi (pl. 127 top), and the Presentation in the Temple (ill. 60). The remains of another slab showing the Massacre of the Innocents has recently been identified. These slabs, about 3 ft. in height, were disposed immediately below the parapet. Whereas elsewhere the main theme adopted for the jubé seems to have been the Passion, at Chartres pride of place was given to the Infancy of Christ.

The second group comprises fragments of smaller reliefs which were placed below the large slabs or in the spandrels between the gables: recognizable are the Blessed from a Last Judgment, and the figure of Christ from the Entry into Jerusalem. The Passion was thus represented, but in a subordinate position. A fragment in the Louvre which comes from Chartres but was not brought to light by the excavations is thought to be connected with these smaller reliefs: it shows a young man writing under the inspiration of an angel, and may represent the Evangelist Matthew (ill. 61). The considerable divergence in the measurements – the fragment is just over 2 ft high – makes it difficult to place on the jubé; the provenance of the piece cannot be taken as certain.

The third group includes the bosses from the vaulting of the arcade, depicting the Virgin, the Annunciation, Majestas, and Agnus Dei.

Finally, there are two large slabs with quatrefoils, which perhaps decorated the back of the parapet (ill. 62). Among the subjects we can recognize are the Agnus Dei with symbols of the Evangelists, and on another slab fleeing animals and hunting scenes. The proposal that the slabs represent parts of a Zodiac and Calendar does not entirely

Ill. 60 Chartres cathedral. Relief from the jubé: Presentation in the Temple. Towards or about 1240

439

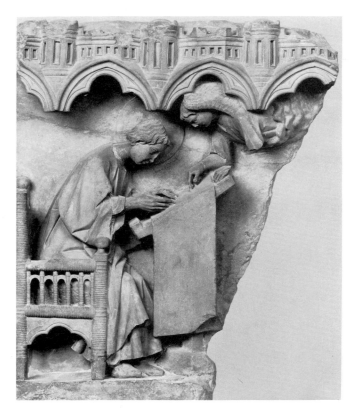

Ill. 61 Relief with figure writing (Matthew?) and angel, supposedly from the jubé of Chartres cathedral. Towards or about 1240. (Paris, Louvre)

meet the case, and the same applies to a moralizing interpretation, according to which they represent fortitude and strength. An allegory of cowardice can be made out in the top right-hand corner.

Various style-groupings emerge. In a first group we can place the slabs depicting the Nativity (pl. 126), the Magi before Herod and the Annunciation. Characteristic is the fondness for complicated movements, narrow limbs crossing over and having angular joints. The delineation of the drapery works in with the 'antique' motifs of the so-called 'trough' style, but pushes them towards a sharply brittle rendering of the forms. The singular projection of the figure of the Virgin in the Nativity relief – both from the side and from the top – is explained by the position of the slab, high up beneath the parapet of the jubé. A close connection exists with the sculptures of the Solomon portal on the north transept (pl. 88–93), though the hardening of the forms argues for a somewhat later date, c. 1230. The Adoration of the Magi perhaps belongs to the same stylistic phase.

A second group is characterized by a completely different, much later style; within it we can include the Dream of the Magi (pl. 127 top), the Presentation in the Temple (ill. 60), the vault bosses, and perhaps the figure of Matthew in the Louvre (ill. 61). The draperies no longer show the pleating favoured by the workshops responsible for the transept portals; instead we have the planed, firm surfaces which

first appear on the Paris west façade, later to become characteristic of High Gothic sculpture in the 1230s and 1240s. Most of the heads are small and notable for their charming expression, with narrow eyes beneath lofty brows, pursed lips and rounded chin. These slabs show no trace of the mechanical stiffness of block-like forms such as is found on many contemporary pieces at Amiens. They show great variety in the treatment of surfaces, and a vivid, almost theatrical, style of grouping and narration. There is no vestige of the style of workshops active on the transept. These reliefs were executed by a 'foreign', perhaps Parisian atelier, towards or about 1240. Contemporary with them are the small reliefs, in which the drapery is rendered in broad folds. Other slabs stand independently. The Annunciation to the Shepherds (pl. 127 bottom) perhaps compares with the Calendar on the arch at the west entrance of the north porch. The parapet slabs (ill. 62) show agreement with decorative forms on the socles of the north porch (middle entrance, right). Whether the Chartres jubé was planned and executed as a single operation must for the moment remain an open question. It is possible that work halted for a time after the earliest slabs, executed by a workshop active on the transept portals, had been completed, to be resumed and brought to a finish by a Paris atelier c. 1240. Not least among the pointers to Paris, and to the Sainte-Chapelle in particular, is the magnificent capital ornament. In any case, no definitive judgment is possible until all the known fragments have been catalogued and made accessible.

M. J. Bulteau 1887–92, vol. III, p. 53ff.; P. Vitry 1908; E. Houvet 1919; P. Vitry 1929, p. 42ff.; Y. Delaporte 1940; H. Bunjes 1943; M. Aubert 1946, p. 238f.; M. Aubert, M. Beaulieu 1950, p. 89ff.; J. Maillon 1964; J. Villette 1965; L. Pressouyre 1967 (IV).

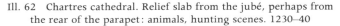

Ill. 62 Chartres cathedral. Relief slab from the jubé, perhaps from the rear of the parapet: animals, hunting scenes. 1230–40

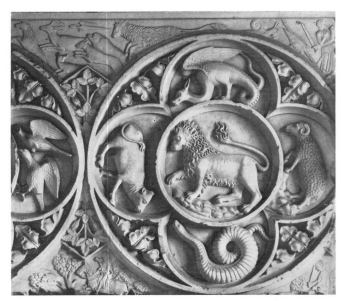

440

Pl. 122 bottom right, ill. 63

LEVES, NOTRE-DAME-DE-JOSAPHAT, ABBEY CHURCH
TOMB SCULPTURES

The abbey of Notre-Dame-de-Josaphat, founded in 1117, stood outside the gates of Chartres. In the second half of the twelfth and the early part of the thirteenth century its church was the burial place for the bishops of Chartres, six of whom were buried there between 1148 and 1217. In addition, members of the founders' family, the lords of Lèves, had themselves buried in their own foundation. After damage done during the Hundred Years' War, the ravages of the Huguenots, and the total demolition of the abbey church at the Revolution, the tomb sculptures survive only in small fragments or in copies.

In 1905 the sarcophagus of Bishop John of Salisbury (died 1180) was excavated from what had been the south transept. Its wall displays blind arcading, containing tendril ornament of exceptionally fine workmanship. It was presumably made *c.* 1200. In 1909 the remains of a tomb monument and the mitred head of an effigy (pl. 122 bottom right) were discovered in what had been the north transept. From the place where it was found, it could be the head of Bishop Renaud de Mouçon, died 1217. The narrow face beneath the tall mitre and the gaunt, ascetic features have a close affinity with the wall statues of the Confessors' portal, on the south transept of Chartres cathedral (pl. 122), so much so that we must reckon with the same workshop. The identification of the head is probably, though not certainly correct: if it is indeed Renaud, we have before us the bishop whose episcopate coincided with the building of the High Gothic cathedral. The same workshop was clearly responsible for a clerical effigy, preserved only in a copy, which Gaignières mistakenly took for Bishop Pierre de Celles (died 1183), and for a head fragment linked by its discoverer with the tomb of an archdeacon, Philippe de Lèves, who died in 1216. The stylistic sources for these fragments are to be found at Sens. The tomb sculptures presumably precede by a few years the figures on the side doorways of the Chartres south transept.

Equally to be associated with particular sculptures on the Chartres transept are a number of tomb slabs relating to laymen. A slab showing a female figure in simple dress, with the head laid on a small cushion supported by angels, shows a stylistic connection with the lintel relief on the Solomon portal (pl. 90).

The slab depicting a young man (ill. 63) in a close-fitting, belted surcoat parted at the front, with swelling body forms and an unusually animated pose, recalls archivolt figures from the Confessors' portal (pl. 118, 119, 124 top). Lastly, a slab showing a man with a rose chaplet in his hair can be attributed to sculptors engaged on the socles of the north porch.

The Lèves tombstones are unique in thirteenth-century France in that they provide evidence that workshops

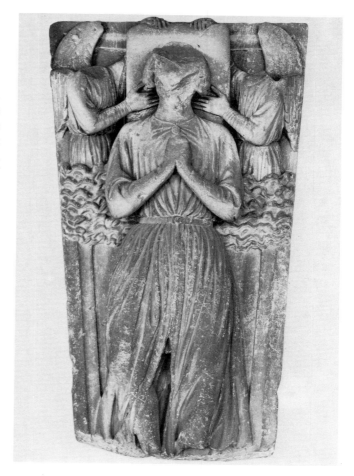

Ill. 63 Tomb slab of a man in secular dress from Notre-Dame-de-Josaphat, Lèves. Towards or about 1220. (Lèves, Asile d'Aligre)

engaged on the portals of a great cathedral were simultaneously occupied with sculptures for episcopal and aristocratic tombs in a nearby burial place.

C. Metais 1905; C. Metais 1908; C. Metais 1911; R. Hamann-MacLean 1956; W. Sauerländer 1964; W. Sauerländer 1966, p. 68 ff.; L. Pressouyre 1968 (III).

Pl. 128, 130–140, colour pl. II, ill. 64

STRASBOURG (BAS-RHIN), CATHEDRAL OF NOTRE DAME
SCULPTURES ON THE SOUTH TRANSEPT

The east portions of the early romanesque cathedral at Strasbourg were remodelled piecemeal, starting in the second half of the twelfth century. Because of the many changes of plan, the architectural history is not easy to elucidate. Firm documentary evidence is almost entirely lacking. The south transept was in progress, with a double portal already installed when a new gothic workshop took over and not only altered the architectural forms but also

441

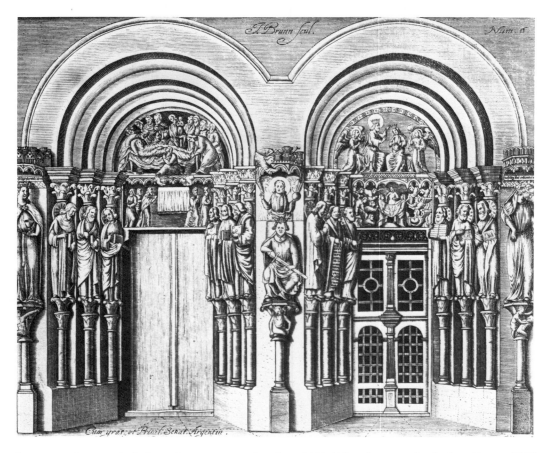

Ill. 64 Strasbourg cathedral, south transept portals. About 1230. (After the engraving by Isaac Bruun, 1617)

embarked on an extensive sculptural cycle. There are two ensembles which merit particular attention.

The first group consists of figures now introduced on the double portal previously installed on the south façade (ill. 64). Tympana and lintels display a Marian cycle, the sequence of which is unusual: it begins in the left tympanum with the death of the Virgin (pl. 131 top), continues on the lintel with the bearing of the body to the grave, and leads up by way of the bodily Assumption in the right lintel to the Coronation in the right tympanum (pl. 131 bottom). Details are reminiscent of Notre Dame, Dijon (ill. 65), e.g. the bearing to the grave and the placing of Mary on the left side of Christ in the Coronation. The figure crouching in front of the death bed, which is an unusual feature, is presumably one of Mary's female companions, as found in Eastern representations. There are Eastern precedents too for Mary's bestowal of her girdle on Thomas in the Assumption (because he had not been an eye witness of her elevation); so far as we know, there are no contemporary Western parallels. The portal jambs were occupied by figures of apostles. They were presented in the old manner, with books instead of the instruments of their martyrdom, and had nimbuses of the shell type. Between the entrances was Solomon enthroned with the sword of judgment. Depicted beneath the console was the child restored by Solomon's wisdom to his mother;

beneath the baldachin, Christ giving blessing and holding the orb. On the extreme left is Ecclesia, with chalice and pennanted cross, on the right Synagogue, with her eyes bandaged, the lance broken, and the Tables of the Law slipping from her hands (pl. 132–135).

So much was destroyed at the Revolution that the programme can only be made out with the help of the engraving Isaac Bruun made for the pattern book of Oseas Schadaeus (ill. 64). Solomon, jamb figures and lintels were totally demolished; Solomon and the lintels were replaced in the nineteenth century.

Heads of two of the jamb figures are in the Musée de l'Œuvre Notre-Dame at Strasbourg (pl. 128 bottom); another is said to have been sold to the U.S.A. Extant are: both tympana (pl. 130, 131, colour pl. II); Ecclesia (pl. 132, 134); and Synagogue (pl. 133, 135). There are very few restorations on the tympana. The chalice and cross of Ecclesia are modern. The figures of Ecclesia and Synagogue now seen on the portal are nineteenth-century copies; the originals are in the Musée de l'Œuvre Notre-Dame. The consoles beneath Ecclesia and Synagogue are new.

The Last Judgment pillar, in the cathedral's interior (pl. 136 left), provides the second group of sculptures. The pillar stands in the middle of the south arm of the transept. It consists of an octagonal core with attached major and

442

minor columns. The form is derived from the *piliers cantonnés* used, for example, as internal supports in Chartres cathedral. It is highly unusual to find it, as here, transformed into a freestanding pillar in the middle of a hall-like space, and furnished with an extensive cycle of statues. There are three superposed zones, each with four figures mounted on the diagonal axes. At the bottom are the four Evangelists (pl. 136 right, 137) with banderoles; they stand on socles shaped like capitals, on which are displayed their symbols. In the middle zone, angels with trumpets stand on tall, drum-shaped socles. At the top, on still taller socles, we have angels with the instruments of the Passion (pl. 138, 139), and on the west side the enthroned Judge (pl. 140) with the resurrection. All the angels are vested as deacons.

This representation of the Last Judgment on a pillar within the church is without parallel. A convincing explanation, which would have to be supported by the special liturgical orders in use at Strasbourg cathedral, has not so far been given. Many features in the iconography correspond to the gothic Last Judgments of the royal domain. The presence of the Evangelists is perhaps to be understood as a way of linking the Last Judgment with a Majestas, a not unusual combination. The Judge-type, with one hand raised, the other pointed downward in rejection, is unusual in the thirteenth century; note also that the sides associated with election and rejection are here reversed (pl. 140).

As well as these large ensembles, the Strasbourg transept and the St John chapel contain a series of console figures and a large boss with a figure of St John, all from the same workshop.

Style and dating. The figure style is characterized by the slender, not to say haggard, proportions and the mobility of the finely articulated joints. The draperies enveloping the statues are light, veiling rather than covering the bodies. With this style goes the expression of emotion seen in the faces, with deep-set eyes, sunken cheeks, and in the lively rendering of the hair. The wealth of invention and subtlety of execution place this ensemble among the most outstanding works of the century.

The search for the origins of this unusually impassioned figure style takes us back via the north porch of Chartres – Solomon (pl. 92), Blessings (pl. 105), and St Modesta (pl. 98 right, 99) – to the archivolt of the Sens centre doorway (pl. 60). The Strasbourg cycle displays the style in many variations. Ecclesia (pl. 132, 134), Synagogue (pl. 133, 135) and the Death of the Virgin (pl. 131, colour pl. II) display the formal language at its most versatile. In the pillar there is some unevenness in quality: alongside impressive figures like Luke, Matthew and Mark (pl. 136 right, 137), we find figures as weak and timid as the angel with the Crown of Thorns. Much of the Coronation tympanum (pl. 131 bottom) is the work of a craftsman from an older, local workshop.

Precise identification of hands is neither possible nor meaningful. It is in any case improbable that the stylistic differences point to a chronological sequence. The sculptures were all produced at much the same time, in a workshop which contained several executants. This workshop presumably arrived from Chartres towards 1230. The question as to whether the kindred works at Besançon (pl. 129), Dijon (pl. 128 top) and Beaune preceded, followed, or were exactly contemporary with the work at Strasbourg is unanswerable.

K. Franck-Oberaspach 1903; O. Schmitt 1924; E. Panofsky 1924; H. Jantzen 1925; L. Hell 1926; P. Vitry 1929, p. 56 ff.; K. Bauch 1929/30; E. Panofsky 1930; K. Bauch 1934; L. Schürenberg 1937; A. Weis 1947; A. Weis 1951; H. Haug 1957, p. 73 ff.; W. Sauerländer 1966; *see also* Appendix to Bibliography.

Pl. 128 top, ill. 65

DIJON (COTE-D'OR), NOTRE DAME, PARISH CHURCH
WEST PORTAL

The church of Notre Dame, Dijon, which had existed since the twelfth century, belonged to a parish subject to the monastic foundation of Saint-Etienne. Very little remains of the twelfth-century building. The remodelling in the first half of the thirteenth century was on an unusually lavish scale for a parish church. Pointers to the exact date are few: in 1230 there is mention of a bequest 'ad opus ecclesie beate Marie'. An anecdote from the period around 1240 perhaps relates to the gargoyles on the façade. In 1251 the final dedication still seems to be in prospect; in fact the church was dedicated only in 1334. In 1791 the portal sculptures were totally destroyed. They were presumably the first thirteenth-century sculptural cycle to appear on Burgundian soil, and significant evidence of the transmission of forms of the royal domain to regions further east. The sculptures on Sainte-Madeleine at Besançon (pl. 129, ill. 66) and on the transept at Strasbourg (pl. 130–140) belong to the same stylistic circle. The question as to which came first is impossible to decide.

Notre Dame in Dijon had a triple portal layout (ill. 65) preceded by a porch without sculptural decoration. The wide central doorway with round-arched archivolt, despite some High Gothic details, follows the local twelfth-century tradition (cf. ill. 8). The side doorways, by contrast, are conspicuously narrow, with stilted arches. Twenty-four figures stretched in an unbroken succession across the jambs and buttresses. With the help of descriptions, Le Jolivet's drawing, and traces still remaining, it is possible to reconstruct the main features of the programme.

The central doorway belongs among the Coronation portals of the Senlis type (pl. 42), but shows certain divergences: in the tympanum the Virgin is enthroned on the left of Christ, and it is he who crowns her. In the lintel, next to the Death of the Virgin we have not her bodily Assumption but the bearing of her body to the grave. This is in striking agreement with Strasbourg. On the trumeau is a figure of the Virgin. The jamb cycle does not appear to be completely identical with Chartres or Senlis: it is thought possible to make out Jacob with his ladder. One of the jamb columns preserves the representation of an altar. It has been suggested that his belonged to a portrayal of Noah making the

443

burnt offering, as found at Trier and Mont-devant-Sassey (ill. 103). The altar with trees in the background is more likely to have been part of a sacrifice of Isaac. The left doorway is a Virgin's portal, with the Adoration of the Magi in the tympanum. The part played by the Chartres (pl. 94) or rather the Laon (pl. 69) programme is clear. The tympanum of the right doorway displays the Passion, for which we know no counterpart in the royal domain *c.* 1220–30. Representations of the Passion on the tympanum are met with, however, in romanesque churches of the Rhône valley.

Style and dating. The only sculptures preserved *in situ* are two console figures beneath the lintel of the left doorway. Their squat proportions and vehement movement make them comparable with the Strasbourg console figures and with the triforium at Nevers. The broad faces with deep-set eyes beneath oblique, strongly projecting eyelids, point clearly to the Solomon (pl. 92) on the Chartres north transept. There are similar heads acting as consoles in the east portions of the church. Two heads in the Musée archéologique – a Peter (pl. 128 top) and a second bearded head – are closely comparable in style and presumably came from the jambs of the west portals. They are as close to the Chartres Solomon as they are to the Strasbourg Death of the Virgin (pl. 131 top, colour pl. II). The doorways of Notre Dame, Dijon, were presumably made towards 1230, by a workshop from Chartres.

E. Fyot 1910; E. Fyot 1928, p. 135ff.; Ch. Oursel, Paris n.d.; E. Panofsky 1930; K. Bauch 1934; L. Schürenberg 1937; P. Quarré 1963–65; P. Quarré 1964–66; W. Sauerländer 1966, p. 116ff.; *see also* Appendix to Bibliography.

Pl. 129, ill. 66

BESANÇON (DOUBS), SAINTE-MADELEINE, COLLEGIATE CHURCH
SOUTH PORTAL

The church was rebuilt after a fire in 1221; the high altar and the St Michael altar in the south choir were dedicated in 1284. On the south side a figure-decorated portal with a porch opened into the nave. According to a drawing made in the eighteenth century (ill. 66) and Dunod's description, the trumeau displayed Michael with his sword standing over the dragon. There were seven figures on each jamb. The middle figure on the right was Synagogue, and on the left Ecclesia. The other figures were as follows: on the right, reading from the inside, David with the Crown of Thorns, Jeremiah with the Cross, Moses with the Tables of the Law, Samuel with the sacrificial lamb, Elijah with wheels, Melchizedek with bread and chalice; on the left, apostles with the instruments of their martyrdom. Without the example of the cycles of the royal domain the programme

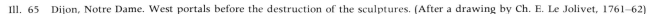

Ill. 65 Dijon, Notre Dame. West portals before the destruction of the sculptures. (After a drawing by Ch. E. Le Jolivet, 1761–62)

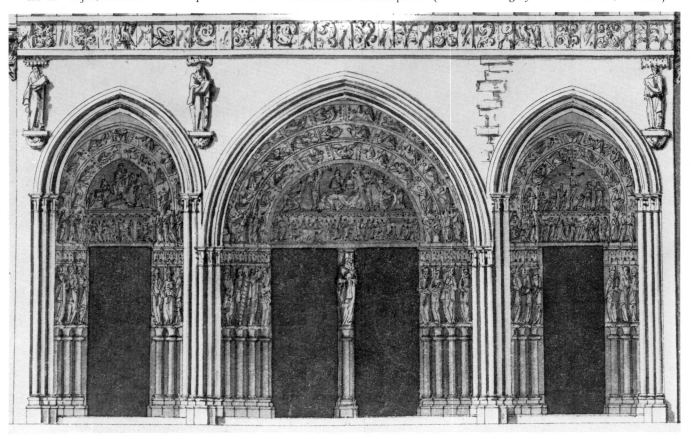

444

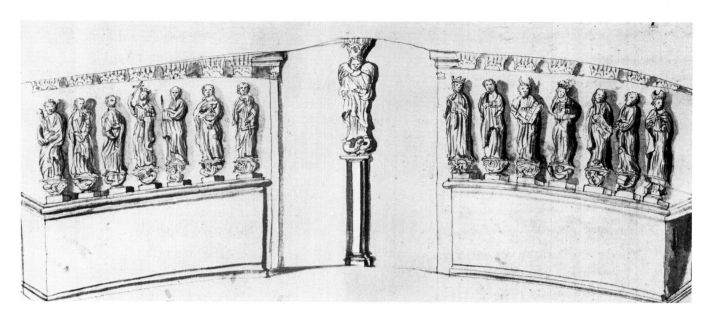

and the iconography of the individual figures would be inconceivable. There is no comparable example for the Michael on the trumeau. (The only parallel is on the Porta Picta of the cathedral at Lausanne, which belonged to the archdiocese of Besançon.) The trumeau statue may have been a reference to the St Michael altar in the south choir. The theme of tympanum and lintel can no longer be clearly determined.

Extant are: the busts of the statues of Moses (pl. 129 bottom left) and Samuel (pl. 129 bottom right), both in the museum at Besançon, and the bust of the Melchizedek (pl. 129 top), with crown and mitre, in the south transept of the church. These torsos reveal an unusual tension, expressed in the case of Samuel and Moses in the stooping thrust of the powerful heads, in the more graceful Melchizedek in the animated turn of the head, placed above narrow shoulders. There is a surprising affinity with sculptures in the south transept of Strasbourg cathedral: the head of Samuel resembles the Luke (pl. 136) of the Judgment pillar, and Melchizedek the Ecclesia of the south transept portal. In both places we have to reckon with the activity of the same workshop, trained at Chartres. Nevertheless it is generally assumed that Besançon preceded Strasbourg; in that case the Besançon portal must have dated from soon after 1221.

F. J. Dunod de Charnage 1750, vol. I, p. 106 ff.; J. Gauthier 1895; E. M. Blaser 1918; R. Kautzsch 1928; K. Bauch 1929–30; K. Bauch 1934; A. Weis 1947; R. Tornier 1954, p. 265 ff.

Ill. 67

HEAD OF AN ANGEL(?)
SEMUR-EN-AUXOIS (COTE-D'OR), MUSEE MUNICIPAL

A head in the museum at Semur-en-Auxois belongs in the Nevers (ill. 70), Dijon, and Strasbourg circle. The youthful, beardless countenance, with almond-shaped eyes above gently rounded cheeks, the tresses arranged like a garland

Ill. 66 Besançon, Sainte-Madeleine, collegiate church. South portal before its destruction. (After a drawing in Besançon, Bibliothèque de la Ville, Ms. 732, fol. 24)

around the face (or sleeked back under a band), resembles heads from the Strasbourg Judgment Pillar, but without engendering the same emotion, and is presumably the head of an angel. Provenance unknown. Date: *c.* 1230.

W. Sauerländer 1966, p. 214.

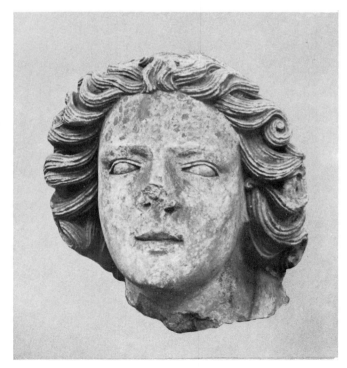

Ill. 67 Head of an angel(?). About 1230. (Semur-en-Auxois, Musée municipal)

Ill. 68

MAILLY-LE-CHATEAU (YONNE), SAINT-ADRIEN, PARISH CHURCH
SCULPTURES ON THE WEST FAÇADE

On the west façade of the parish church of Saint-Adrien there is a four-part open arcade. The columns, short and sturdy with crocketed capitals and diagonally placed abacuses, rest on unusually tall socles with supporting figures. Beneath the four outer columns the figures are of men in simple dress – short, belted surcoat with capuchon – bowed beneath the plinths of the columns, with their arms and legs in the position, traditional since antiquity, of Atlantes. All four seem drawn towards the figure in the centre: a standing female figure wearing a long girdled dress and a mantle with clasps, with a crown on her unbound hair. Her head is not bowed beneath the plinth but rises above and in front of the column base. The right hand rests on the hip, the (broken off) left hand grasps the cords of the mantle.

The suggestion put forward in 1847 that the scene represents Mathilde de Courtenay, Countess of Nevers and Auxerre, granting serfs their freedom accords better with Jacobinism than with medieval ideas. The interpretation is more likely to be allegorical, but since no attributes are to be seen the question must remain open. The installation is the same as at Nevers (ill. 70). The style of the figures, the freedom of movement, is reminiscent of Sens (pl. 60) and the north porch at Chartres (Blessings, pl. 105), as also of Strasbourg (pl. 132). Date: *c.* 1230.

V. Petit 1847; M. Quantin 1868, p. 36; M. Anfray 1964, p. 46; W. Sauerländer 1966, p. 113ff.; M. Beaulieu, F. Baron 1966, p. 376.

Ill. 69

BEAUVAIS (OISE), SAINTE-ETIENNE, PARISH AND COLLEGIATE CHURCH
WEST PORTAL

The nave of Saint-Etienne, Beauvais – a parish church which was also used by the collegiate foundation of Saint-Vaast – was vaulted after a fire in 1180 and extended westward by two bays. The west doorway then erected shows the Coronation of the Virgin in the tympanum, with Christ

Ill. 68 Mailly-le-Château, Saint-Adrien. Sculptures on the west façade. About 1230

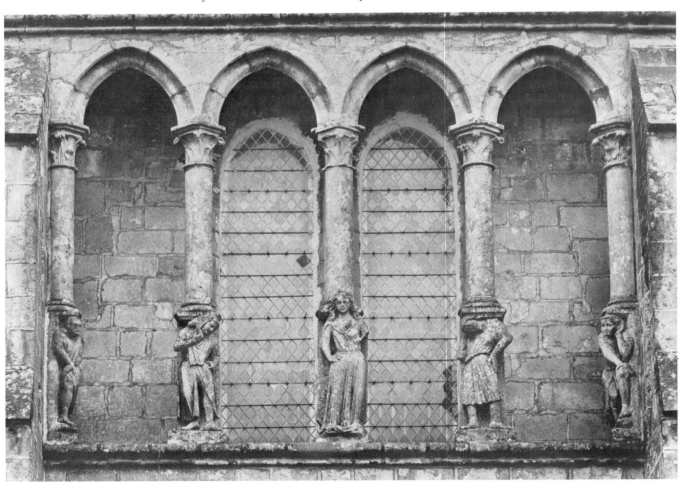

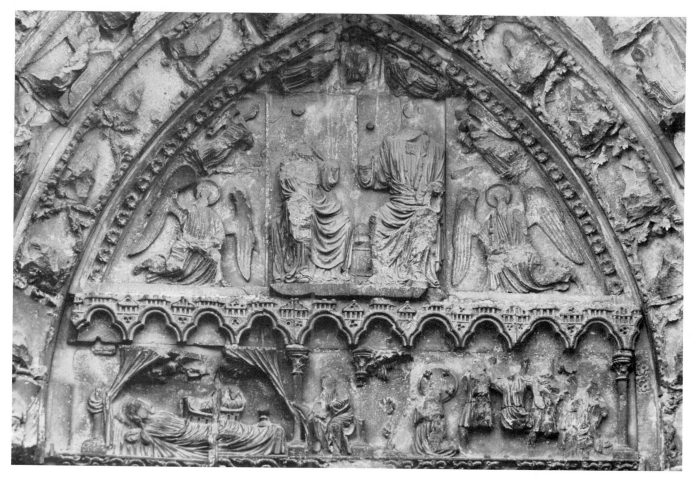

Ill. 69 Beauvais, Saint-Etienne. West portal. Tympanum: Coronation of the Virgin. Lintel: Nativity, stoning of St Stephen. About 1230

and Mary flanked by angels. On the lintel are, on the left, the Nativity, and, on the right, the stoning of St Stephen. Still recognizable in the archivolt are, on the inside arch, the Stem of Jesse, followed by angels, and, on the outside arch, two rows of enthroned figures with nimbuses. The six jamb figures have been destroyed, several of the heads are in the Musée départemental de l'Oise, Beauvais. Of the trumeau figure only the socle remains.

The figures in the tympanum and lintel feature draperies activated in soft arcs with groove- or loop-shaped folds. The formal language has no great force, and its rendering of limb joints is conspicuously weak. This is late work in the 'trough' style, as used in the goldsmith's work of Hugo of Oignies and in pen-and-ink drawing by Villard de Honnecourt. The late phase is characterized by mechanical repetition of 'antique' fold motifs. For comparison see parts of the admittedly far superior sculptures on the Calixtus portal of Rheims cathedral (pl. 243 right). Date: c. 1230.

V. Leblond 1929, p. 40f.; J. Vanuxem 1945; W. Vöge 1958, p. 59, 129.

Ill. 70

NEVERS (NIEVRE), CATHEDRAL OF SAINT-CYR
WINDOW-POST FIGURES

The nave of Nevers cathedral was remodelled in the first half of the thirteenth century. The triforium has small support figures, mostly sitting or crouching, beneath the supports, and angels in the spandrels. At clerestory level there are larger, standing, support figures beneath the columns of the windows (ill. 70).

The thirteenth-century cathedrals of the royal domain do not have figure sculpture in their triforia. There is a remote comparison with the triforium decoration of the east parts of Notre Dame at Semur-en-Auxois and the nave of Bourges cathedral. Angels are found in the triforia of gothic churches in England (Worcester Cathedral, Westminster Abbey).

The triforium decoration of Saint-Cyr, which combines support figures with angels in the spandrels, is unique. Nor

447

is there anything elsewhere to compare with the figures on the nave windows (ill. 70). Similar support figures are found, it is true, on the west façade of Sens (ill. 34), but there is no comparable instance for their installation on window-posts. The figures, only partially preserved, follow no apparent programme: next to a female statue in gown and mantle (ill. 70) we have male figures clad only in a mantle or not at all. Stylistically the sculptures derive from Sens and form a surprising parallel to the Ecclesia (pl. 132) and the support figures on the Strasbourg transept.

Contrary to recently expressed doubts, the work was only put in hand after a fire in 1228. The most stylistically advanced of the figures are in the east bays.

A. J. Crosnier 1854; H. Jantzen 1949, p. 32; R. Branner 1960, p. 68 ff. and p. 157 f.; M. Anfray 1964, p. 19 ff.; M. Beaulieu, F. Baron, 1966; W. Sauerländer 1966, p. 102 ff.

Pl. 141 top

LEMONCOURT (MOSELLE), CHURCH
WEST PORTAL

The small, single-aisled church of Lemoncourt, whose architectural forms point to an origin in the first decades of the thirteenth century, has a simple west doorway with no figures on jamb or archivolt, but a sculptured tympanum. It shows the Coronation of the Virgin, with Christ and Mary here unaccompanied by angels, whose place is taken by two kneeling figures in secular costume. On the right the figure, a man in surcoat and mantle, holds a palm branch in his upraised hands; on the left is a woman in similar attire with touret and, above her head, angels bearing a crown towards her. Presumably these are founders, receiving the heavenly reward for their good deeds.

The Lemoncourt tympanum is probably the oldest surviving work of gothic sculpture in the archdiocese of Trier, even earlier than the sculptures of the Liebfrauenkirche at Trier or the Virgin's portal of Metz cathedral (pl. 281 top). Characteristic of the style is the loosely parallel delineation of the looping or arc-shaped folds. Faces and hands are virtually unmodelled. Altogether this is craftsman's work and the attempt to link it with the sculptures of the Strasbourg transept (pl. 130, 131) is misguided. The comparison is rather with Lothringian goldsmith's work of the thirteenth century, for example the reliquaries of the Holy Cross of Mettlach and St Matthias, Trier, or the work of Hugo of Oignies. Date: c. 1230.

F. X. Kraus 1876 ff., vol. III, p. 257 ff.; G. Dehio 1926, p. 419 f.; W. Hotz 1965, p. 95.

Pl. 141 bottom

DONNEMARIE-EN-MONTOIS (SEINE-ET-MARNE), NOTRE DAME
SOUTH PORTAL

The church, in the diocese of Sens, is a small building dating from the first decades of the thirteenth century. In addition

to a badly damaged west doorway, whose sculptures show an obvious connection with the sculptures of Sens cathedral, there is a second figure-decorated doorway of more recent date on the south side of the nave. The round-arched tympanum shows in the centre the Virgin enthroned (the Child destroyed), flanked by angels with censers and incense boats, conspicuously archaic in form. At Mary's feet are two kneeling founders, clearly ecclesiastics. The moulding of the frame consists of a continuous band of foliage.

This little-known portal is a characteristic production of the late trough style. The draperies show a multiplicity of narrow, curving folds following an even course. The spherical heads are expressionless. There is no longer any recognizable connection with Sens. The comparison is rather with works like the St Ulphia (pl. 169) on the west façade of Amiens or the jamb figures of the Calixtus portal at Rheims (pl. 246, 247). Date: c. 1220–30.

Maillé, Marquise de 1928.

Pl. 142, ill. 71

FONTEVRAULT (MAINE-ET-LOIRE), NOTRE DAME, ABBEY CHURCH
TOMB MONUMENTS OF THE PLANTAGENETS

The abbey of Fontevrault was founded by Robert of Arbrissel in the late eleventh-early twelfth century and soon became the head of a separate congregation. Around 1200 the abbey church became for a short time the burial place of the Plantagenets, who from 1154 occupied the throne of England. Henry II, the first of the dynasty, who died in nearby Chinon in 1189, was also the first to be buried here (pl. 142 top). He was followed in 1199 by his son Richard I the Lionheart (pl. 142 bottom), who died before Chaluz, and Richard's sister Joan, who had become a nun at Fontevrault. In 1204 Henry's window, Eleanor of Aquitaine, died at Fontevrault and was buried beside her husband (pl. 142 middle).

With the conquest of Anjou by Philip Augustus of France, Fontevrault lost its role as the favourite burial place of the Plantagenets. After 1204 there were no more burials for several decades. In 1243 Isabella of Angoulême, widow of King John, entered the convent; when she died (1246) she was buried first in the abbey's cemetery and her remains were later transferred to the church. Her son Raymond VII of Toulouse (died 1250) had himself buried at Fontevrault. Henry III of England bequeathed his heart to the abbey, and its eventual transfer there in 1292 brought the history of Plantagenet burials in the Angevin monastery to an end.

After drastic alterations in 1504 and 1638 and the sack of the burial place during the Revolution there remain: the tomb monuments of Henry II, Richard I, and Eleanor of Aquitaine – the correctness of the designations is known from inscriptions discovered on the north-west pier of the crossing in 1910. In addition to these tomb monuments in tufa there is a fourth, smaller one of wood, which shows the effigy of a woman (ill. 71). It is generally held to be the

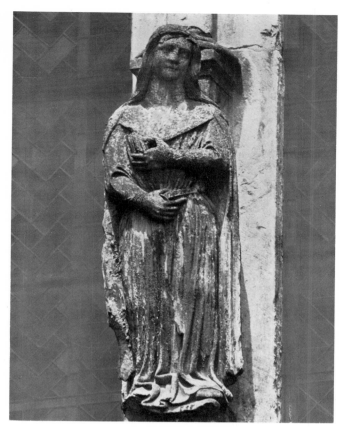

Ill. 70 Nevers cathedral, nave. Female figure from a window in the clerestory. 1230–35

restorations, the type seems authenticated by parallel examples in nearby Asnières and Niort. This form of grave, which is suggestive of the lying in state, is found nowhere outside western France. It is impossible to say whether the now solitary 'death beds' were originally flanked by auxiliary figures.

Style and dating. The oldest figures are Henry II (pl. 142 top) and Richard the Lionheart (pl. 142 bottom). They show no connection with other monuments in the vicinity – the west portal of Angers cathedral (pl. 32, 33), and figures in the choir of Saint-Martin, Angers (ill. 30). The folds spreading over the bodies, without following the contours of the individual limbs, put one in mind of the north transept of Saint-Denis (pl. 48 bottom, 49 right) or the Childebert tomb monument from Saint-Germain-des-Prés (pl. 49 left), but their corporeality and statuesque conception place the figures in the early thirteenth century.

The tomb monument of Eleanor of Aquitaine is a substantial advance (pl. 142 middle): her girdled drapery, fitting closely at the waist, stretching in finely delineated folds around the hips and billowing in waves at the feet, follows models on the side doorways of the Chartres north transept (pl. 92) and even on the north porch (pl. 98 left). Its date can hardly be earlier than 1220.

The smaller figure in wood is puzzling (ill. 71). The stylistic data argue for a date in the 1230s, which does not fit the generally accepted view that the monument relates to Isabella, who was buried in the church only in 1254.

C. A. Stothard 1817–32; L. Courajod 1867; A. Rhein 1910 (I); L. Magne 1910; M. Aubert 1946, p. 295 f.; L. Schreiner 1963, p. 67 ff.; E. Panofsky 1964, p. 57 (I); A. Erlande-Brandenburg 1964.

monument of Isabella of Angoulême, who died in 1246 but whose remains were transferred to the church only in 1254. The inscription, however, in this case reduced by damage to a single letter, offers no firm grounds for the identification. In the last century all the monuments were drastically restored and completed; with their modern overpainting, it is impossible, without consulting older illustrations, to distinguish the original parts from the new.

The type of tomb monument is unusual: the figures repose on cloth-decked biers. Despite the thoroughgoing

Pl. 143

THE ANNUNCIATION
TOULOUSE (HAUTE-GARONNE), MUSÉE DES AUGUSTINS

This marble Annunciation group comes from the Franciscan church in Toulouse, which was begun only in 1310; its original provenance is unknown. Since monumental sculptures are very rare in Franciscan buildings, we must presume

Ill. 71 Fontevrault, Notre Dame, abbey church. Tomb monument of an unknown woman (known as Isabella of Angoulême). 1220–30

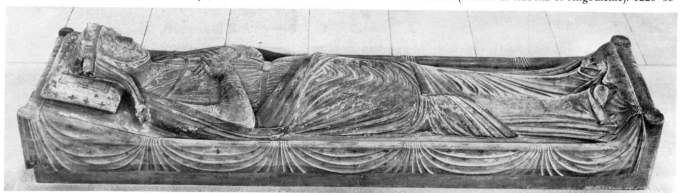

449

the group was made for some other church or community in Toulouse. The high-relief figures, almost fully rounded and somewhat over life-size, are flat at the back. Column figures were never a native form in the south, but marble slabs with relief figures had a long local tradition dating back to the late eleventh century. The figure of Gabriel is fully preserved, but the socle and the feet are missing from the figure of the Virgin and there is a fracture line on the neck.

The question of the date at which the old sculptural school of Toulouse first made contact with the gothic sculpture of northern France is a matter in dispute. In the individual works outside influences and borrowed motifs often merge indistinguishably with customary forms surviving in the locality. There is agreement that the sculptures from the chapter house of La Daurade, which belong to the late twelfth century, are inconceivable in the absence of contact with the north. The next phase of early Gothic in Toulouse, clearly connected with the sculptures just mentioned, is the phase characterized by the Annunciation group.

Gabriel's curled hair is adorned with ornamented crossover bands. The points of the wings curve in behind the powerful head. The sleeves of the long undergarment have decorative borders, with a clavus on the upper arm. The fall of the mantle is spirited, with numerous indentations at the hem. The right hand of the archangel is raised to emphasize his words, and with the finger tips of his left hand he holds the base of a flowering sceptre. The front foot, standing somewhat higher, is placed on the neck of the dragon-like serpent of Paradise.

Mary, her robe close-fitting and her mantle pulled about her body, holds her right hand stiffly against her shoulder. The Virgin is depicted frontally, Gabriel in profile; this circumstance, as also the drapery rendering and attitude of the Virgin, links the group more closely with Eastern models than with comparable pieces from northern France, in which Angel and Virgin face one another.

There is certainly a very close stylistic connection with the statues from the chapter house of La Daurade (for example, the Virgin, and the king with the ampulla). What is hard to decide is whether the Annunciation group also implies the use of more modern, northern, models – for example the Chartres transept.

Date: the first quarter of the thirteenth century. The idea, occasionally put forward, of a connection with an Annunciation group at Lerida in Catalonia is unconvincing.

A. K. Porter 1923, p. 244f.; M. Aubert 1929, p. 72f.; R. Rey 1934, p. 249; J. Bergos 1935, p. 146f.; P. Mesplé 1961, no. 248–9.

THE WEST PORTAL OF NOTRE DAME, PARIS, AND RELATED MONUMENTS

Pl. 144–156, ill. 72–78

PARIS, NOTRE DAME
WEST PORTAL

For the dates of Notre Dame see note to the Portail Sainte-Anne, p. 404.

The five-aisled cathedral has a twin-towered west façade (ill. 72) with three doorways (pl. 144). The middle entrance, wider and higher, opens into the centre aisle, the side entrances into the bottom storeys of the towers. The buttress piers are almost flush with the façade. The portal bays lie behind these buttresses and are not crowned by projecting gables. This solution points back to Saint-Denis (pl. 1) and Mantes (pl. 47). The novel feature is the fact that the three doorways are more firmly drawn together as a composition, thanks to the aedicules on the buttress piers and the gallery beneath the rose window storey. The scheme, perfect in its precision and polish, found no imitators. Later façade compositions of the thirteenth century followed Laon (pl. 68).

In 1771 Soufflot removed the trumeau and doorposts of the centre doorway and broke away the central parts of the two bottom strips of the tympanum to make an opening, in the form of a pointed arch, to allow the passage of the processional canopy. In 1793 the statues were removed from the jamb walls, from the buttress piers and from the gallery above the entrances. A daguerrotype made about 1840 (ill. 73) shows the resulting state. The reconstruction undertaken by Lassus and Viollet-le-Duc from 1843 aimed at a complete reconstruction of the medieval appearance and the replacement of all the removed sculpture by neo-gothic figures. This is the first great example of a truly historical restoration.

PROGRAMME

As at Saint-Denis, and later at Amiens, a Last Judgment stands at the centre of the triple portal layout (pl. 145). The centre doorway of Notre Dame follows Chartres (pl. 107) as the second great Judgment portal of the thirteenth century. As at Chartres, the Judge appears without assessors in the apex of the tympanum (pl. 147), but in other respects the composition of the tympanum is different. Christ sits on a raised throne (the Heavenly Jerusalem seen at his feet is an invention of the restorers), and beside him, as guardians of the throne, stand two angels with instruments of the Passion – on the right the cross, on the left the nails and (restored) spear. The intercessors – John the Evangelist and the crowned Virgin – are not enthroned but kneeling: this is the posture which from now on becomes canonical in northern French representations of the theme.

450

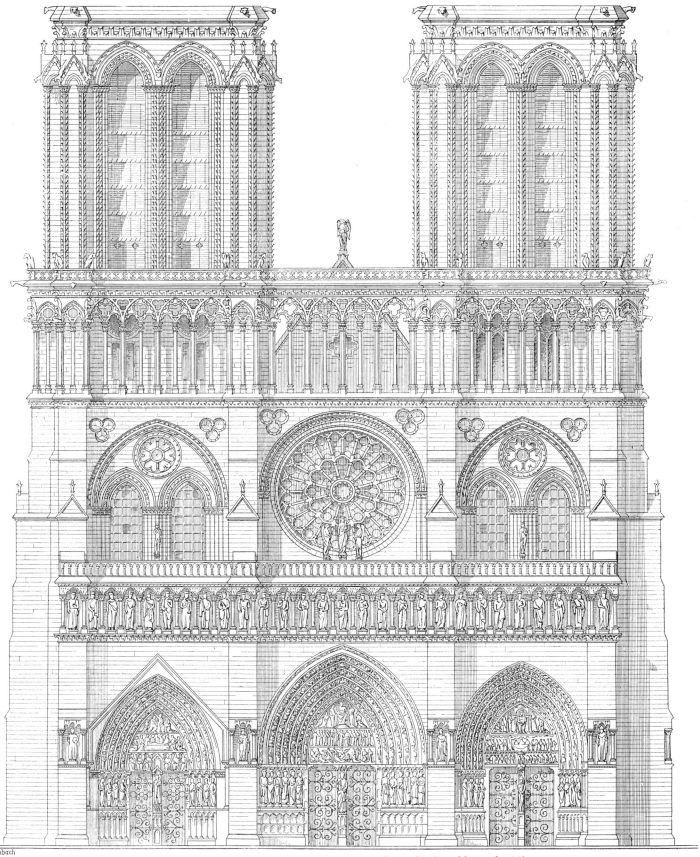

Ill. 72 Paris, Notre Dame. West elevation. (After Dehio/Bezold IV, pl. 410)

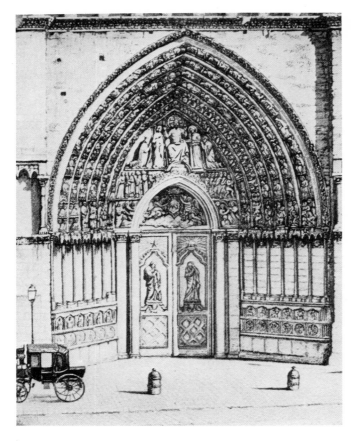

Ill. 73 Paris, Notre Dame. West portal. Centre doorway before restoration. (After a daguerrotype, about 1840)

The Judge's retinue, which at Chartres is dispersed over the side doorways and the porch, is here assembled in the upper ranges of the six archivolt arches (pl. 148, 149). The two inside arches show half-figures of angels, in a radial arrangement, turning towards the Judge in postures of awe or wonder. Unlike Chartres, no distinction appears to be made between the angelic hierarchies. The third arch from the inside contains patriarchs and prophets, with (at their head) Moses with the Tables of the Law and (on the right) Aaron with tiara and breastplate. These are followed, reading outward, by ecclesiastics with books, martyrs with palms and, in the last arch, Virgins with crowns and presumably candles – a few of the latter have been mistakenly restored as palms. All in all no less than 120 figures, arranged in strict order, accompany the judge.

The execution of the Judgment is portrayed in the two bands of the tympanum beneath Christ's feet, and continues in the lower ranges of the archivolt. The lower tympanum band is completely restored, the upper only at the centre. The original corner pieces of the lower band are in the Musée de Cluny (pl. 146). The content and distribution of the restored scenes correspond to the original state, as emerges from a drawing of 1771 (itself not preserved in the original). In the lower band (pl. 145) we see the resurrection

of the dead, with an angel bearing a trumpet at either end. Above, in the middle of the band (pl. 147), is the separation of the Blessed from the Damned. On the right a devil drags his chained victims into the jaws of Hell, and on the left the Blessed, with crowns on their heads, proceed toward Paradise. They are awaited by an angel, standing slightly lower in the inner archivolt: he extends his left hand in invitation and points with his right to Paradise, shown in the bottom zone of the archivolt. Here we meet first – as three-quarter figures – two of the (crowned) Blessed, one clearly male, the other female – quite possibly Adam and Eve. Next to them is Abraham, with souls held in his bosom, and the patriarchs Isaac and Jacob. Behind them, as in Eastern paintings of the Last Judgment, stand the trees of Paradise. The two outer arches show crowned busts of the Blessed.

On the right are the complementary Hell scenes (pl. 149, 150), here in unusual association with themes from the Apocalypse. The sequence begins in the inner arch, where as counterpart to the angel guarding the gates of Paradise we see the gaping jaws of Hell. They open upwards, to receive

Ill. 74 Head. Northern French, after 1200. Supposedly from the centre doorway of the west portal of Notre Dame, Paris. (Art Institute of Chicago)

452

a female figure, with long flowing hair (Luxuria?) who falls, as though through a trap-door, into the cauldron below. A second figure tumbles head first into the flame-licked pot, his hands gnawed by toads and his neck encircled by a snake, while hairy devils prod him down into the depths. For the next scene (reading from the inside) cf. the passage: 'And behold a pale horse: and his name that sat on him was Death.' (Rev. 6:8.) On the back of a scrawny horse we see an emaciated female figure (la Mort) with a bandage over her eyes and a knife in either hand and, plunging behind her, a dead man with open entrails. The text of Revelation continues: 'And power was given unto them over the fourth part of the earth, to kill with sword . . .'. In the next arch are devils tormenting the Damned, and annexed to this group are a second apocalyptical rider and further Hell scenes. A fat devil with female breasts plumps down on a bishop and a king (fifth arch from the inside). Damned and demons intertwine in a tumultuously active skein impossible to disentangle. The topmost devil holds a bow and arrow between his teeth. The pictorial pedigree of these surprising Hell scenes – surprising because of the blending with apocalyptical motifs – has yet to be investigated. They were imitated at Amiens (pl. 165), and in an altered form reappear on the right doorway of the Rheims west façade.

The trumeau figure, as at Chartres (pl. 109), was Christ over 'lion and dragon'. The jamb figures were apostles, with the instruments of their martyrdom: extant are a large torso (Andrew) in the Musée Carnavalet (ill. 76), and a smaller fragment in the Musée de Cluny (ill. 75). In a recent conjecture, a head (ill. 74) in the Art Institute of Chicago has been associated with the figure in the Musée Carnavalet. The doorposts, as at Saint-Denis (pl. 1), Sens (pl. 59) and later at Amiens (pl. 160), displayed the Wise and Foolish Virgins.

In the socle zone, the relief decoration survives in its original form, despite a thoroughgoing, though surprisingly sympathetic, restoration in the eighteenth century (pl. 151). This is the first centre doorway in which the socle zone runs at a continuous slant. There is a direct precursor in the socle of the small Baptist's portal at Sens (pl. 58). The Virtues and Vices are portrayed in two zones, one above the other, the Virtues enthroned beneath trefoil arcades, the Vices in medallions. Here, for the first time, the Virtues and Vices are incorporated into the programme of a Judgment portal. They symbolize the qualities and actions which lead to salvation or to damnation. Iconographically speaking the cycle is a new creation. The Virtues are no longer warrior maidens in victorious combat with the Vices, but enthroned figures. They display shields with their emblems. The Vices are exemplified by scenes from daily life, which may have had their source in illustrations to law books. The whole sequence is an eloquent testimony to a thirteenth-century trend towards greater characterization of individual figures in traditional image cycles in an attempt to make them more comprehensible, because closer to everyday life. The first steps in this direction had been taken with the Virtues in the archivolts of the Coronation portals at Laon (pl. 70, 71)

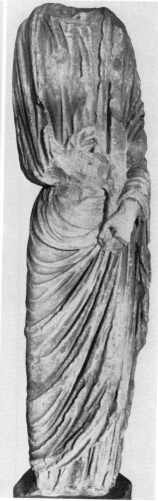

Ill. 75, 76 Paris, Notre Dame. Jamb figures from the centre doorway of the west portal. *Left*. Unidentified fragment. *Right*. Andrew(?). 1200–10. (Paris, Musée de Cluny and Musée Carnavalet respectively)

and Chartres (pl. 94). For repetitions of the sequence, cf. Amiens (pl. 162), the south porch of Chartres (pl. 125 middle) and Magdeburg.

The figures on the left jamb are as follows (reading from the inside, i.e. from right to left in pl. 151 top): 1, Faith with a cross (below her Idolatry, as a result of erroneous eighteenth-century restoration, is now seen adoring a cameo-like portrait instead of the standing figure of a devil at Chartres, Amiens and Magdeburg); 2, Hope with her banner, and below her Despair (a man plunging a sword into himself); 3, Charity with a lamb (the poor man she was in the act of clothing was removed during the eighteenth-century restoration work); the remaining figures on the left jamb were all renewed, more or less correctly, in the eighteenth century. On the right jamb we see (reading from the inside, i.e. from left to right in pl. 151 bottom): 1, Courage, dressed in armour and with lion and sword (below him is Cowardice, a man letting his sword drop and running away from a hare); 2, Patience with an ox (below presumably Impatience, a woman dressed in flowing draperies and threatening a man dressed in a hooded cloak; 3, Meekness with a sheep (her counterpart is a hardhearted lady dealing her servant a

453

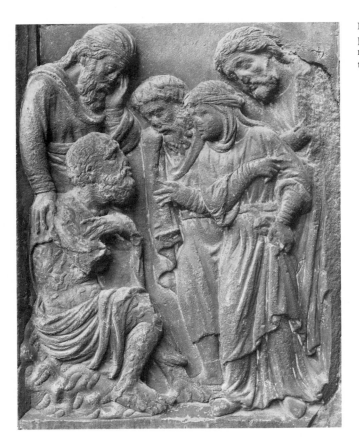

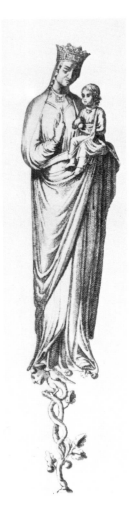

Ill. 77 Paris, Notre Dame, west portal. Centre doorway, buttress relief: Job with his wife and the three friends. 1200–10

kick); 4, Concord with olive branch (the corresponding figure of the vice is restored); 5, Obedience with camel, restored (Disobedience is a layman who revolts against his bishop); 6, Constancy with crown (Inconstancy is a monk who throws away his cowl and abandons the cloister).

On the buttress piers on either side of the jamb are two further reliefs, ranged one above the other: (top left) Job in colloquy with his wife and friends (ill. 77); (top right) the sacrifice of Isaac. Some have thought these may be intended as biblical examples of Patience and Obedience, thus continuing the Virtues cycle. The lower scenes, framed in arches, are difficult to interpret. The figure on the right is said to be Nimrod making war on Heaven, for which there seems no precise textual foundation. On the left we see a huntsman with a spear beside a stream, and on the ground a bow and three arrows. No explanation is so far forthcoming. These reliefs are not installed in the place originally intended for them, which points to a change of plan during the assembly of the centre portal.

Left doorway (pl. 152). The decoration shows the Coronation of the Virgin in an assemblage of scenes which deviates from the form that Senlis (pl. 42) had made canonical. The tympanum, like that of the centre doorway, is divided into three bands (pl. 153). The cycle begins at the bottom. Instead of scenes illustrating legends of the Virgin's death, we start with a symbolic representation. In the centre is the Tabernacle in the form of a gothic altar-ciborium, with the Ark of the Covenant inside. The deposition of the Ark in the Taber-

Ill. 78 Paris, Notre Dame, west portal. Trumeau of left doorway: Virgin and Child. (After Lenoir II, pl. XIV)

nacle was regarded as a prefiguration of Mary's bodily Assumption into Heaven, and at the same time as a prefiguration of Christ in the Virgin's womb. Enthroned on the left are three patriarchs or prophets and, on the right, three kings of the Old Testament. Each group is holding a wide banderole, whose inscription, now lost, presumably contained references to the typological significance of the Ark in the Tabernacle. The Marian cycle begins only in the middle band, with a scene which breaks with pictorial tradition. Hitherto this had followed the Koimesis based on Eastern models, in which Christ is present at his mother's death, receives her soul and delivers it to Michael. To this the West added in the twelfth century the bodily Assumption of Mary to Heaven: angels lift the resuscitated Mary from her tomb, and after her soul has been reunited with her body, bear her aloft (cf. pl. 43 top). In Paris the two events are merged. Mary is lifted from the tomb by angels. It is this scene, and not the scene of the bodily death of Mary and the raising of her soul, which takes place in the presence of Christ and the apostles. The latter do not appear as mourners but are shown standing quietly in the background or seated solemnly beside the sarcophagus: Peter and Paul at the head end, John, on the outside, at the foot. The trees, olive and fig, are

454

probably there to indicate the place of burial. The Coronation follows in the tympanum: Christ blesses Mary, an angel descending from a cloud places the crown on her head, and an angel bearing a candlestick kneels on either side. Here, more firmly than in the narrative registers below, the bodily Assumption of Mary into Heaven is placed at the centre of the programme. This may be connected with the cathedral's specific dedication to the Assumptio Mariae.

In the inner arch of the archivolt (pl. 155), as a border to the middle register and apex of the tympanum, we see half-figures of angels with candlesticks or censers. The remaining figures – full length in the bottom ranges, busts in the upper – are taken from the Old Testament: in the second and fourth arch, patriarchs or prophets with banderoles, between them kings, presumably Christ's ancestors.

The programme on the trumeau and jamb is novel. On the trumeau was a standing figure of the Virgin (ill. 78). Western art of the twelfth century had already adopted the Eastern standing Madonna and used it as a trumeau figure (Moutiers-Saint-Jean). Paris introduces some new features: a crowned Mary, the New Eve, standing above the serpent coiled about the Tree of Knowledge. In place of the Old Testament figures of the older portals of the royal domain, the jamb-displayed figures of saints. The arrangement of the ungraduated jamb, with arcaded socle and a chain of gables above the statues' heads, continued to be imitated until the late thirteenth century. The traditional console figure was apparently deemed inadequate for a characterization of the saints; hence the reliefs with scenes from saints' lives (pl. 156) introduced on to the socle arcade, at a height level with the capitals. While the console figures have been restored, these reliefs remain untouched. Among the figures and reliefs the following can be identified with certainty: on the left jamb, Dionysius, in keeping with the legend holding his severed head in his hands and being escorted by angels to his grave. The socle relief shows the saint's decapitation (pl. 156 top right). Beneath his escorts, on the left, the fall of the angels is depicted (pl. 156 top left): against a star-strewn background, an angel lunges with his sword at the fallen Lucifer. Beneath the right escort, Michael (pl. 156 middle), in fluttering cloak and identifiable from the *loros* assigned to him in Eastern iconography, victorious over the dragon. The destroyed Paris statue group was the first example of its type, viz. the representation of a walking decapitated martyr escorted by angels in the form of large jamb figures. It was repeated at Amiens and Rheims, as also at Bamberg. On the opposite wall, the inside figure was John the Baptist; on the socle relief, his beheading (pl. 156 bottom left), with on the left Salome, her hair in a long plait. Next came Stephen, with his stoning shown on the socle relief (pl. 156 bottom right). Beside him stood St Geneviève. In selecting the subjects for jamb figures prominence was given to local saints: Dionysius was the first bishop of Paris, Geneviève was revered as 'Parisiorum patrona'; Stephen was the original patron saint of the cathedral. The programme may have been influenced by relics allegedly given

to the cathedral by Philip Augustus, among them, it is said, those of Stephen, the Baptist, and Dionysius. At Amiens, Bourges and Rheims still greater efforts were made to give locally important saints a place of honour at the entrance to the cathedral; once again, Paris had led the way. The two outer figures represented on the left a crowned ruler, on the right a pope. From the socle scene, the pope must have been Leo III, which makes it probable that the crowned figure was Charlemagne.

The doorposts (pl. 154 right) and side faces of the trumeau (pl. 154 middle) carry an extended cosmological cycle. It was a long-established tradition in medieval art to place Christ, as ruler of the world, at the centre of sequences of this kind. What is new is to find such an example on a Virgin's portal. The cycle begins in the socle zone with personifications of Terra and Mare: Terra is shown as the nursing mother, holding trees in her hands; Mare rides a dolphin, and holds a ship with spreading sail. The front and inner sides of the doorposts display signs of the Zodiac and a Calendar. The cycle begins (bottom left) with Aquarius, continues up as far as Leo, starts at the top on the other side with Cancer, ends at the bottom with Capricorn. A similar arrangement, reflecting the rise and fall of the year, had already been used on the doorposts of the side doorways of Saint-Denis (pl. 2). Paris shows an alteration in form, as also in the pictorial distribution: the scenes are framed by unadorned rectangles, and Zodiac and Calendar are combined on a single doorway. Note that as we go from bottom to top the fields enlarge – to match the lengthening days. Leo and Cancer are not in their correct order, having been transposed. Before 1793 a stonemason stood where one would expect Virgo (the existing Virgo is new), but whether this was so in the thirteenth century is impossible to say. Speculation to the effect that the trumeau figure of the Virgin was regarded as the Virgo missing from the Zodiac must be dismissed as mere fantasy.

The narrow sides of the trumeau carry complementary sequences (pl. 154 middle). The figures on the right are easily recognized: the six ages of man, according to Isidore of Seville. At the bottom a standing child, in a long, girdled robe: *Infantia*. Above him is a boy with a bow, standing among trees from which a bird emerges in flight: *Pueritia*. In third place is a young man walking, with hound and falcon: *Adolescentia*. The next figure is the first to be shown bearded, and likewise the first shown seated: man's estate. Then a second seated figure, now with a full beard and inclined head, presumably the age Isidore dubbed *Gravitas*. At the top is an old man, infirm, with wrinkled face and a cap against the cold, supporting himself with a stick: *Senectus*. It was not customary to portray the ages of man on a church portal; the only other example, and it does not tally completely, is on the west doorway of the baptistery at Parma.

An explanation for the six figures on the other side is more difficult. At the bottom we see a thickly clad figure warming his feet by the fire, and at the top a naked young

455

man, standing beside a fruit tree. In between are four figures manifestly depicting the transition from colder to warmer temperatures. Note especially the fourth figure from the bottom: it is Janus-faced, with one side of the body clad, turning its bearded face in misery towards the freezing figures below, while the other side, youthful and naked, turns to face the figures standing in the warmth above. The familiar divisions of the year – months and seasons – do not fit, and unless some apposite text comes to light, the sequence must remain a puzzle. A recent attempt to explain it on the strength of a passage in the *De Universo* of Rabanus Maurus is unconvincing. The posts next to the outer jamb figures show representations of trees and plants (pl. 154 left). Amongst others we recognize rose, ivy, olive, oak, pear and vine, all of which figure in literature as strands in the vast web of metaphor spun around the Virgin Mary in the high and late Middle Ages. Iconographically, the programme of the Paris Coronation portal is among the most inventive and ingenious of the early thirteenth century, along with the Virgin's portal at Laon (see p. 425, pl. 70, 71) and the Solomon portal (see p. 435 f., pl. 88–93) and north porch (see p. 436, pl. 76) at Chartres.

The occupants of the buttress aedicules were: on the left, on the corner facing the former cloister, Stephen; on the right, on the corner next to the former bishop's palace, Dionysius. The centre doorway was flanked by Ecclesia and Synagogue. In the gallery were twenty-eight kings: as on the south porch at Chartres (pl. 117), they probably represented Christ's forbears rather than kings of France, but there is nothing to prove either theory.

Style and dating. There is no stylistic uniformity in the sculpture of the west façade. Advanced works foreshadowing the style of the 1240s stand alongside archaic pieces in which the forms are still those of the early years of the century. More clearly than the transept portals of Chartres, the Paris sculptures reflect the changes of the first third of the thirteenth century which led to the trough style and linear rendering of drapery being superseded by a formal language evolved from the techniques and locational requirements of architectural sculpture: a language simpler as to details, more concise and energetic in its general effect.

The earliest of the thirteenth-century sculptures are in the socle zone of the centre portal. The Virtues and Vices (pl. 151), like the reliefs on the buttresses (ill. 77), show signs of a free expression of feeling; the draperies are light and flowing, the folds softly curving. There are models for this style on the centre doorway at Sens (pl. 59, 61). From the surviving fragments (ill. 75, 76), it appears that the formal language of the jamb figures was likewise early, though different. The rendering of the folds is more linear. Characteristic motifs of the trough style, for example, the loop-shaped depressions on the drapery surface, appear on the torso in the Musée de Cluny (ill. 75), but not on the socle reliefs. The archivolt and tympanum of the Judgment portal (pl. 146–150) display more advanced forms yet seem to have been created some time after the jamb figures. The sculptures of the Coronation portal (pl. 152–156) occupy an intermediate position. Here, for the first time, we see evidence of the stylistic revolution which made Paris the leading centre of French sculpture. The construction of the portal, with the emphasis on the horizontals and verticals, the preference for unadorned rectangular shapes as frames, the avoidance, by and large, of pictorial motifs and of animated figure groupings, must be regarded as a turning away from the traditions, based ultimately on painting, which had still prevailed at Laon, Sens, and on the Chartres transept. Characteristic of the handling of relief is the way cleanly outlined figures stand out from neutral backgrounds. The draperies solidify. The folds form straight lines or sharp angles instead of curves. The contours of the heads are most angular, the foreheads vertical, the countenances flawless, with no play of facial features. The beauty of these sculptures resides not least in the clarity, the metallic precision of their forms. At the same time, the individual form is often delicate, indeed quite finely articulated, and in a figure like the Salome (pl. 156 bottom left) a deliberately worldly allure emerges as a new aim of figure stylization. Whereas in the late twelfth century plants and shrubs were still being copied from models whose motifs in many cases went back to antiquity, the flora of the Coronation portal (pl. 154 left) is a reflection of nature. In place of acanthus and tendrils in ornamental combinations, we have sprigs of rose or oak. In the archivolt of the Judgment portal (pl. 148–150), the formal language carries on from the Coronation portal. The draperies become more material, more voluminous. The Hell scenes (with the exception of arches four and five) are the work of a sculptor of the first rank; the emphasis on the macabre is unusual in French work of the thirteenth century. The tympanum shows two clearly distinguishable styles (pl. 146, 147). Mary, John and the angel with the cross adhere to the formal language of the Coronation portal (pl. 153). The draperies of the Christ and the angel with the lance are heavy and concealing, the material bellies out in angular, broken folds. In place of the multiplicity of fine lines characteristic of drapery rendering in the early thirteenth century, we have a few large motifs obtained from the opening up of the block. The faces show a pointed characterization, with small eyes, vigorously modelled noses, curled locks. The expression combines elegance with a piercing clarity. The fragments from the bottom register of the tympanum (now in the Musée de Cluny) show the two styles side by side: the right fragment (pl. 146 bottom) tallies with the intercessors and the cross-bearing angel, the left (pl. 146 top) with the more advanced figures in the apex of the tympanum.

Firm indications for the dating of the Paris west portal are few and far between. In 1208 the cathedral chapter paid compensation to the Hôtel-Dieu for houses which had to be pulled down because of building operations in the area of the west façade. Building work started on Amiens cathedral in 1220, and sculptors from Paris were busy there not long after that date. We can assume that the jamb sculpture of the

Paris centre doorway was started about 1200. The Coronation portal was being worked at latest by 1210. The Judgment portal was not completed until some time in the 1220s.

For the general literature on the west portals of Notre Dame see p. 406. For the Coronation portal and the Judgment portal add: E. Mâle 1902, esp. p. 88 ff., 136 ff., 417 ff.; M. Aubert 1929, p. 110 ff.; P. Vitry 1929, p. 7 ff.; W. Medding 1930, p. 69 ff.; J. Vanuxem 1947; W. Sauerländer 1959 (II); A. Heimann 1962; A. Katzenellenbogen 1964, p. 75 ff.; L. Behling 1964, p. 55 ff.; R. Hamann-MacLean 1964; J. G. v. Hohenzollern 1965, p. 17 ff.; W. M. Hinkle 1966; E. B. Greenhill 1966; W. M. Hinkle 1967; C. Gnudi 1969; *see also* Appendix to Bibliography.

Pl. 157

PARIS, SAINT-GERMAIN-L'AUXERROIS, COLLEGIATE/PARISH CHURCH
WEST PORTAL

The canons of Saint-Germain-l'Auxerrois were subordinate to the bishop of Paris, but their church was also used for public worship. The west doorway (with the exception of the trumeau and tympanum, removed in 1710) survives in its thirteenth-century state. The colouring applied to the sculptures in 1838 has recently been removed; the surfaces have presumably been touched up. The trumeau was discovered beneath the Lady chapel in 1950.

PROGRAMME

Judging from the archivolt programme, the tympanum displayed the Last Judgment. Abraham's bosom and the cauldron of Hell have survived in the inner archivolt. The iconographic connection with Notre Dame is plain. In this case the Wise and Foolish Virgins appear not on the doorposts but in the second arch of the archivolt. Similarly, the apostles have been transferred from the jambs to the archivolt. The jambs (pl. 157) display instead Old Testament figures and saints with special local significance. On the left jamb are a pair of rulers, presumably Solomon and the Queen of Sheba, and next to them a deacon, probably Vincent, the church's auxiliary patron. On the jamb are a bishop (among the canonized bishops of Paris, Marcellus and Landericus come to mind as possible candidates), and next to him Geneviève, going to church by night with a burning candle, which the devil is blowing out – but the angel on the right has a flame ready to relight it. The trumeau figure was Germanus, the patron saint.

The jamb figures are among the few large statues from the first decades of the thirteenth century to survive in Paris. The formal language matches the sculptures of Notre Dame. The Solomon resembles the kings in the archivolt of the Coronation portal (pl. 155), the rounded faces of Geneviève and the smiling angel have their counterparts among the Blessed of the Judgment portal (pl. 148). The execution lacks bite. There is nothing original about the positioning of the limbs or the rendering of the draperies. This is work of secondary importance, from the atelier engaged on the cathedral. Date: *c.* 1220–30.

W. Medding 1930, p. 102 ff.; A. Boinet 1958, p. 264 ff.; W. Sauerländer 1959, p. 44 ff. (II).

Ill. 79

LONGPONT (SEINE-ET-OISE), NOTRE DAME, PRIORY CHURCH
WEST PORTAL

The priory was founded in the eleventh century. The west façade of the church features a thirteenth-century figure-decorated doorway. The tympanum depicts the Coronation of the Virgin. The composition follows the model of Notre Dame in Paris (pl. 153): while Mary prays, an angel sets the crown on her head. The lintel, by contrast, returns to the earlier scheme: the entombment and the bodily Assumption into Heaven are shown as separate scenes. At the Assumption Christ is not, as in Paris, accompanied by the apostles. In the inner arch of the archivolt we see angels bearing chalices and censers, in the second the Wise and Foolish Virgins; at their feet, on the left a tree bearing fruit, on the right a tree bare of leaves, with an axe laid across its trunk. See Matt. 7:17 ff.: 'Even so every good tree bringeth forth good fruit . . . Every tree that bringeth not forth good fruit, is hewn down' (cf. also Matt. 3:10). On the trumeau Mary (head restored) is shown above two dragons. The jambs show, on the left, a deacon (Stephen?), and probably Paul, in which case Peter is on the right, together with an ecclesiastic in chasuble and dalmatic.

The portal is among the works in line with the Paris west façade (pl. 144 ff.). The forms have a brassy hardness, a frosty rigidity. A few of the small archivolt figures already show signs of the so-called gothic 'sway'. Both legs – weight-bearing and free-moving – are placed in a parallel position, the direction taken by the body shows itself in a sharp bend at the hips. Longpont shows the sculpture of Paris at a more advanced stage than the portal of Saint-Germain-l'Auxerrois (pl. 157) or the St Geneviève (pl. 158) in the Louvre, and must have been made towards 1230. One is struck by resemblances to the sculptures of the south porch (pl. 106) at Chartres.

E. Mâle 1902, p. 294; J. Vallery-Radot 1920; M. Aubert 1929, p. 114; W. Medding 1930, p. 84 ff.; M. Aubert 1946, p. 290 f.; W. Sauerländer 1959, p. 46 f. (II).

Ill. 80, 81

SOISSONS (AISNE), SAINT-MEDARD, ABBEY CHURCH
HEAD OF CHLOTAR I (NOW SOISSONS, MUSEE MUNICIPAL)

The abbey of Saint-Médard, Soissons, was founded by King Chlotar I, who died in 561. The middle chapel of the crypt contained the double tomb monument of the founder and his son, Sigebert I. It showed the two kings beneath gable-crowned trifoliated arches, with sceptres and similar model churches. In addition we have illustrations of statues of the two founders (ill. 81). These were erected in the same chapel and showed the rulers with only the sceptre. If we can trust pictures from the period before the destruction, the statues

457

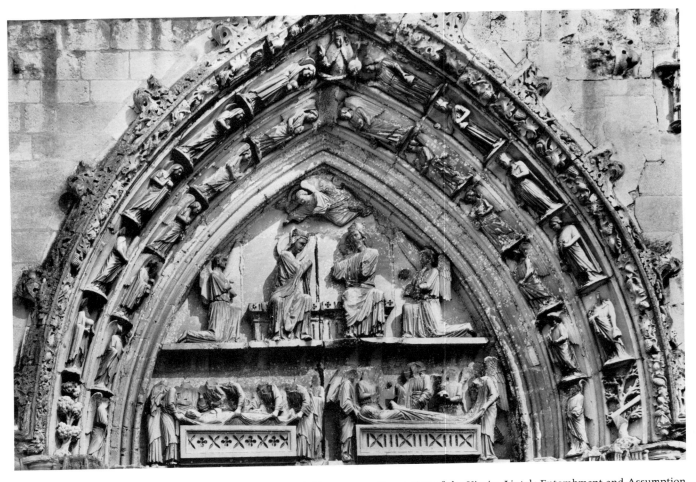

Ill. 79 Longpont, Notre Dame, priory church. West portal. Tympanum: Coronation of the Virgin. Lintel: Entombment and Assumption of the Virgin. Archivolt: Angels, Wise and Foolish Virgins. Towards 1230

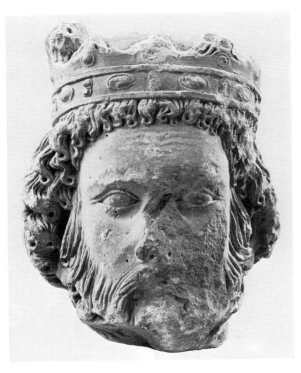

Ill. 80 Head of Chlothar I, from Saint-Médard, Soissons. About 1225. (Soissons, Musée municipal)

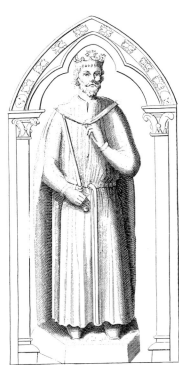

Ill. 81 Niche statue in the crypt of the abbey church of Saint-Médard, Soissons. Chlothar I. About 1225. (After Montfaucon I, pl. 11)

458

were older than the strongly animated tomb figures, distinguished by their High Gothic 'sway'.

A bearded head (ill. 80) in the Musée municipal, Soissons, is presumably from the statue of Chlotar I. The hair-style, with its fringe falling onto the forehead beneath the circlet of the crown, fits the pictures of the statue but is difficult to reconcile with the sideways turning head of the tomb monument, on which only a tuft of hair appears in the centre of the forehead. The tomb effigies and cenotaph statues in Saint-Médard were among the many retrospective founders' figures produced in the twelfth and thirteenth centuries, as monumental testimony to the eminence of an abbey's original benefactors and to the rights the abbey claimed in consequence. This head of Chlotar I, with its finely delineated hair and almond-shaped eyes must have been made c. 1225. It cannot for the present be assigned a place among the other works surviving from this period.

C. Dormay 1663, vol. I, p. 262f.; U. Durand, E. Martène 1724–27, vol. II, p. 13; J. B. de Laborde 1792, no. 18–19; A. E. Poquet 1849, p. 26ff.; E. Fleury 1878 and 1884, vol. II, p. 204 and vol. IV, p. 147f.; J. D. Rey 1956.

Pl. 158

PARIS, SAINTE-GENEVIEVE, ABBEY CHURCH WEST PORTAL, TRUMEAU FIGURE OF ST GENEVIEVE (NOW PARIS, LOUVRE)

The foundation of the famous abbey on the Montagne Sainte-Geneviève in Paris goes back to the reign of Clovis I; (481–511). St Geneviève, afterwards the titular saint of the abbey, was buried there in 511 (see note to pl. 159 right). The church, demolished in 1807, had a gabled gothic façade of an unpretentious kind, with three simple portals. Until the beginning of the seventeenth century the centre doorway possessed a trumeau with a statue of the church's patron. This was rediscovered in 1849 and later found its way to the Louvre.

As usual, the saint is shown, with book and candle, going to church by night. The devil crouches on her left shoulder, about to blow out the flame. Appearing over the right shoulder is the angel whose candle will relight the flame extinguished by the devil (the devil's head and the candles held by Geneviève and the angel are missing). Stylistically the statue belongs to the circle of sculptures deriving from Notre Dame, and together with those on the west portal of Saint-Germain-l'Auxerrois (pl. 157) is among the few large thirteenth-century statues of Paris workmanship to survive the Revolution. Date: c. 1220–30.

A. Michel, 1903; P. Vitry 1929, p. 13; M. Aubert 1946, p. 244; M. Aubert, M. Beaulieu 1950, no. 107; W. Sauerländer 1959, p. 44 (II); C. Giteau 1961.

Ill. 82 Tomb monument of Philip of France, formerly in the abbey church of Royaumont. Soon after 1235. (After Bodleian Library, Oxford, Ms. Gough, Drawings: Gaignières 2, fol. 28ʳ)

Pl. 159 left, ill. 82, 83

ROYAUMONT (SEINE-ET-OISE), TOMB MONUMENT OF PHILIP OF FRANCE (NOW SAINT-DENIS, ABBEY CHURCH)

Royaumont, a Cistercian house, was founded in 1228 by St Louis (King Louis IX). The king and his mother, Blanche of Castile, were present at the dedication of the church in October 1235, and Louis later stayed several times in the monastery. Three of his children who died young, Blanche, Jean and Louis of France (pl. 272) were buried there, likewise his brother Philip (pl. 159 left). After the suppression of the abbey and the demolition of the church, the tomb monuments came via the Musée des Monuments français to Saint-Denis. The monument of Philip of France (ill. 82) was displayed beneath a baldachin resting on slender attached columns. The walls of the tumba were lined with arcades containing standing figures of angels and clerics. (These have been completely renewed; a few remains are in the Louvre and the Musée de Cluny.) The trapezoidal slab shows Philip, aged about thirteen when he died, standing on a lion; he is dressed in the long, sleeveless surcoat slit down the front with ornamental sleeves and the long 'cotte'. Angels with censers support the cushion beneath his head, his hands are laid together in the attitude of prayer (pl. 159 left; hands and nose restored).

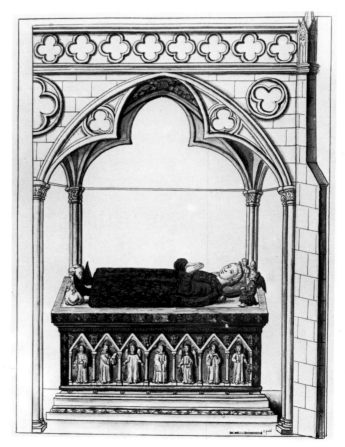

459

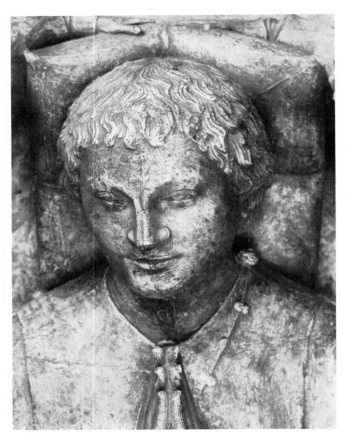

Ill. 83 Head from the tomb monument of Philip of France (from a cast). Shortly after 1235. (Saint-Denis, abbey church)

Philip died *c.* 1235. Contrary to the current opinion, the tomb monument appears to have been made not around the middle of the century but shortly after Philip's death. The vigorous body forms, the rounded, boyish head with short, close-lying locks, point to a date before the apostle statues of the Sainte-Chapelle (pl. 184, 185). The head shows closest agreement with the angels from the archivolt of the Amiens Judgment portal (pl. 164, 165); it can also be compared with several of the fragments from the Chartres jubé, for example the head of Christ from the Presentation in the Temple (ill. 61). This beautiful effigy is thus a witness to Paris sculpture as it was after the completion of the west doorways of Notre Dame and before the start of work on the Sainte-Chapelle. Date: shortly after 1235.

F. de Guilhermy, Ch. Fichot 1867, p. 58–60; G. de Heylli 1872, p. 42, 156; L. Courajod 1876–88, vol. I, p. 181; P. Vitry, G. Brière, 1908, p. 116; P. Vitry 1929, p. 90; M. Aubert 1946, p. 296; H. Gouin 1964.

Pl. 159 right

PARIS, SAINTE-GENEVIEVE, ABBEY CHURCH TOMB MONUMENT OF CLOVIS I (NOW SAINT-DENIS, ABBEY CHURCH)

Clovis I (481–511) founded the abbey of Saint-Pierre et Saint-Paul (later Sainte-Geneviève) in the year 505, and was buried there in 511. The tomb monument was renewed in the thirteenth century; when the church was destroyed, the piece found its way, via the Musée des Monuments français, to Saint-Denis. It is much repaired: amongst other things, sceptre and crown have been completely renewed, the point of the nose and some of the fingers have been patched on, and the surfaces have been touched up. All the same, there is no reason to regard the figure as a baroque copy, made when the tomb monument was reinstated in 1627. The rendering of cotte and clasped mantle, the faithful reproduction of the tab

for the alms bag, itself typical in form, together with the delineation of the features places the figure among the Paris sculptures of the 1220s. It compares not only with one or two figures from Notre Dame but also with the statues on the left jamb of the portal of Saint-Germain-l'Auxerrois (pl. 157) and still more with those on the Firmin portal of Amiens cathedral (pl. 168 right, 169), which even show the same ungainly proportions.

F. de Guilhermy, Ch. Fichot 1867, p. 36–8; G. de Heylli 1872, p. 150; L. Courajod 1876–88; P. Vitry, G. Brière 1908, p. 107f.; C. Giteau 1961.

FROM THE WEST PORTAL OF AMIENS CATHEDRAL TO THE NORTH TRANSEPT PORTAL OF NOTRE DAME, PARIS

Pl. 160–173, ill. 84–87

AMIENS (SOMME), CATHEDRAL OF NOTRE DAME WEST PORTAL

Amiens takes its place beside Chartres and Rheims as the third of the great French cathedrals of the thirteenth century.

The preceding building is presumed to have been burnt down in 1218. The existing complex was begun in 1220, under the direction of Robert de Luzarches. The nave was perhaps complete as early as 1233. The extension of the building eastward under Thomas de Cormont – bottom storey of the choir, radiating chapels – presumably continued until *c.* 1240. The final stages were directed by Regnault de

460

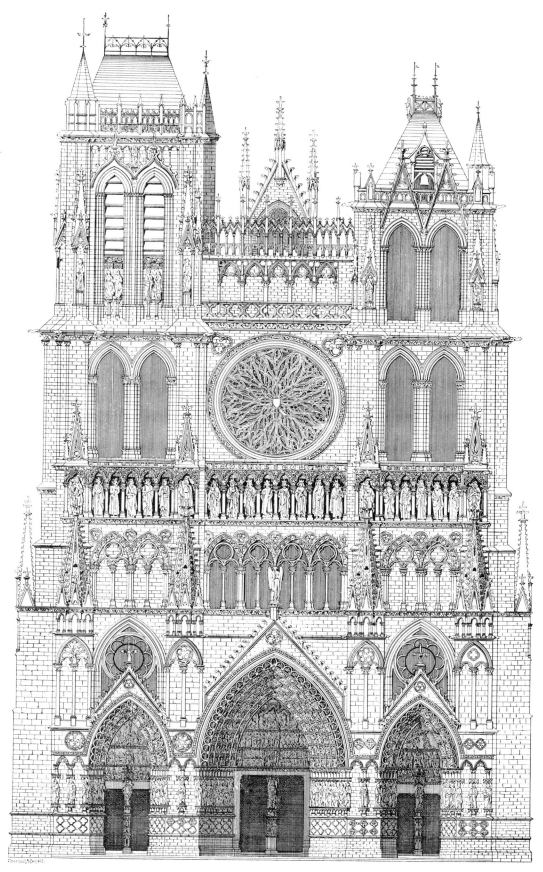

Ill. 84 Amiens cathedral. West elevation. (After Dehio/Bezold IV, pl. 411)

461

Cormont, and because of a fire in 1258 were not completed until the 1260s. The sculptures of the west portals were spared destruction at the Revolution. Between 1844 and 1847 they were subjected to an arbitrary restoration; Didron's trenchant criticism of this undertaking was an epoch-making event in the history of the preservation of monuments in France.

The arrangement of the three west doorways (pl. 161) follows the scheme first evolved at Laon (pl. 68). The entrances lie back from projecting buttress piers crowned by aedicules. The spaces between the buttresses are vaulted, and the entrance arches are adorned with gables. The dimensions are much greater than at Laon. The mounting and distribution of the sculptures is completely different: since the sides of the centre buttress piers were no longer pierced, the large statues and the quatrefoil reliefs in the socle zone could extend across the jambs and buttresses in an unbroken succession, thus making the triple portal layout a unity. The programme is constructed according to a system which fits the architectural layout.

PROGRAMME

In the centre, as on the west façade in Paris (pl. 144, 145), is a Judgment portal (pl. 161). The exceptionally tall tympanum of the centre doorway is divided horizontally into four bands and encompassed by six arches in the archivolt. The basis is unmistakably the Paris programme. Here, too, the separation of the Blessed from the Damned takes place at the feet of the Judge, to be followed in the lower band by the resurrection of the dead. Again, as in Paris, the two inner arches are occupied by angels (pl. 164, 165), and the Hell scenes, in part with identical motifs, invade the lower zone of the archivolt. All the same, there are important differences.

The apex of the tympanum once again displays Christ on the lines of Revelation 1:16, with the sword proceeding from his mouth and flanked by angels with the sun and moon. The group around the Judge is differently distributed: the intercessors kneel at Christ's side, the angels with the instruments of the Passion are set further back. There are certain divergent motifs in the procession of the Blessed and the Damned. The Blessed advance straight to the gate of Heaven, where they are received by Peter; the Damned are shown naked, with the jaws of Hell open at the end of the tympanum band instead of in the archivolt. The resurrected, in two rows in the bottom strip, are assembled in small rectangular groups. Michael with the scales is not between the Blessed and the Damned but stands in the band below, among the resurrected. The overall dimensions are greater than either Chartres (pl. 107, 108) or Paris (pl. 145, 147), but the individual motifs are smaller. This multiplication of many-figured groups is characteristic of most of the great portal layouts of the thirteenth century. Monumental compositions of the old hieratical style are no longer found.

In the archivolt (pl. 164, 165) the programme is clearly affiliated to Paris (pl. 145–150), but does not show the same ingenuity in combining the course of the action with the placing of the actors. As in Paris, there are angels in the two inner arches, but they are not half-figures directed radially towards the Judge. At Amiens the arrangement is less imaginative: the small figures are all standing in the first arch in an attitude of prayer; in the second they bear the souls of the Blessed, who themselves turn in prayer towards the Judge. The next three arches contain martyrs, clerics, and female figures with books or vases. In the sixth arch we have the Elders of the Apocalypse, frequently shown in conjunction with the Last Judgment, but here perhaps also related to the Christ of the Apocalypse in the apex of the tympanum. As in Paris, the bottom zones of the archivolt carry scenes of Paradise and Hell. On the left, at the point where in Paris the angel draws the attention of the Blessed to Paradise lying below, we see a standing figure of Abraham. He reaches up towards the procession to gather the souls of the Elect into his arms: the traditional repose of the souls in Abraham's bosom is thus here changed to become part of the action. The following arches are occupied by groups of the Blessed being led by angels towards Paradise. An angel bearing a crown awaits them at the gate, further angels point to the abodes of bliss or make music. The Elect carry flowers or leafy branches. On the right (pl. 165) the Hell scenes begin on the inside arch with the torments of Luxuria and Avaritia. The cauldron, portrayed with all manner of technical detail, appears only on the third arch. It rests on a pedestal, and is stacked beneath with wood; a devil fans the blaze with bellows while another, brandishing a red-hot iron, burns off the lying tongue of the slanderer as he simmers in the pot. Next come two riders from the Apocalypse: the first is a female figure with bandaged eyes, stabbing a male figure seated behind her – cf. Rev. 6:8 and the corresponding group in Paris (pl. 150); the second rider is male and holds a balance in his right hand – cf. Rev. 6:5: 'And I beheld, and lo a black horse; and he that sat on him had a pair of balances in his hand.' In the outer arch is a solitary devil with bow and arrow, aiming at David: cf. Psalms passim, and especially 37:14.

In the vault of the porch is a Stem of Jesse and the patriarchs. Note the unusual duplication of the Jesse figure, who appears at the bottom of either side, so that the Stem ascends on both sides to the apex. At the top, on the left, is Mary, on the right, Christ.

The programme on the jamb and trumeau appears to follow Paris almost exactly. On the trumeau the Christ in benediction (pl. 163; both hands renewed) standing over lion and dragon, as known from Chartres (pl. 109) and Paris. The trumeau at Amiens is unusually tall (pl. 160), and the extra height has been used to enlarge on the theme of the Saviour in triumph. In an upper zone on the front face there is a vine – cf. John 15:1, 'I am the true vine'. On the narrow faces we see asp and basilisk, which means that all four beasts mentioned in Psalm 90:13 of the Vulgate (Psalm 91:13) are represented on the trumeau. Standing on the front face and beneath the figure is a king with sceptre and banderole; he has been taken for Solomon, but is more probably David,

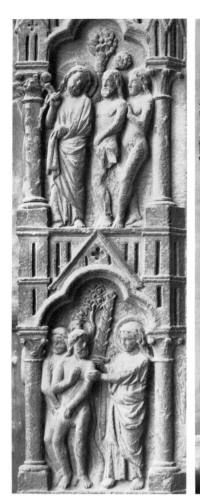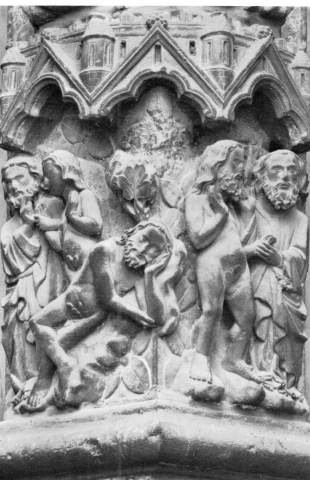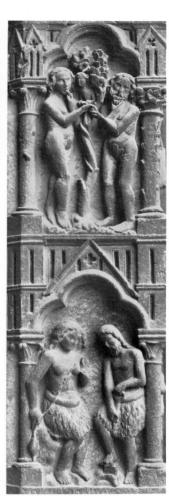

Ill. 85–87 Amiens cathedral, west portal, right doorway. Trumeau, socle scenes. *Middle*. Creation of Eve and God speaking to Adam.
Left. God shows Adam and Eve the trees of Paradise. *Right*. The Fall; Adam and Eve at work. 1220–30

as author of the Psalm. The side faces show vases with blossoming plants, on the left the lily, on the right the rose. A passage in the Song of Solomon – 'I am the rose of Sharon, and the lily of the valleys' (2:1) – has been invoked in explanation, but must be rejected, on various grounds. The jamb figures, as was customary since Chartres (pl. 110, 111), are the apostles with the instruments of their martyrdom (pl. 162). As a result of partially mistaken restoration, only Peter, Paul, the two James, John and Andrew are still recognizable. On the socle are Virtues and Vices (pl. 162 bottom). The cycle corresponds to its counterpart in Paris (pl. 151; for details cf. p. 453). Here, however, the use of quatrefoil frames for both groups removes the nice distinction betwen vice and virtue achieved by the Paris arrangement. At Amiens not a single motif escapes the uniformity aimed at for the entrance façade. Figures and scenes were intentionally strung together with the regularity of architectural members in the nave of a High Gothic cathedral. As at Saint-Denis (pl. 1), Sens (pl. 59, 60) and Paris, the doorposts depict the Wise and Foolish Virgins. In the

fields at the bottom are the fruitful and the barren tree, the latter with the axe at its root (cf. Longpont, p. 457, ill. 79).

The Judgment portal of Amiens is a less original invention than that of Chartres or Paris, but it represents the grand total of all the various motifs which had been mustered from Saint-Denis onward for the portrayal of the Last Judgment.

The right doorway (pl. 161) bears a Marian programme, compiled from the motifs of earlier Virgin's portals. The vast dimensions of the Amiens west front demanded an extension of the cycles. In the tympanum the compositional scheme of Senlis (pl. 42) is combined, in a manner not wholly satisfactory, with material appropriated from the Coronation portal in Paris (pl. 153). As in Paris, the Ark of the Covenant with the Tabernacle appears above the trumeau figure. It is flanked by Moses with the Tables of the Law and Aaron with the sprouting rod, accompanied by four Jewish priests, two on either side. The Paris composition introduced only one scene above the Ark. Amiens, in the middle band of the tympanum, gives us the traditional juxtaposition of the death and burial of the Virgin and the Assumption, and has

463

the Coronation following these scenes at the apex. There was also a return to the earlier formula for the archivolt figures: in addition to angels we have the Stem of Jesse, which Paris had replaced by half-figures of kings and prophets (pl. 155).

The trumeau figure (pl. 168 left) is determined wholly by the Paris model: Mary, as the 'New Eve', treads down the serpent, which here has the head of a woman wearing a touret (the right hand of Mary and the head of the Child are new). On the socle of the unusually tall Amiens trumeau it was possible to display a cycle expanding the allusion to Eve (ill. 85–87). In the upper zone, corresponding to the consoles of the jamb figures, we see God speaking to Adam, and the creation of Eve (ill. 86). For the outward facing scenes below (ill. 85, 87) an arrangement similar to that of the jamb socle has been adopted: projecting cornices, followed by reliefs ranged one above the other, but framed in this instance not by quatrefoils but by blind arcades. At the top left (ill. 85) God warns Adam and Eve not to eat from the Tree of Knowledge – the tree is seen on the left, entwined around the shaft of a column. At the top right (ill. 87) is depicted the Fall: the female head of the serpent looks out at Eve between the leaves of the fruit tree. At the bottom left the angel with the flaming sword expels Adam and Eve; in the background can be seen the Tree of Life. At the bottom right Adam and Eve, dressed in aprons made of animal skins, are seen at work with spade and spindle.

For the jambs a plan was needed which would embrace no less than twelve figures. By 1220 the old typological cycle, as it appeared on the walls of Coronation portals from Senlis to Chartres, had fallen out of fashion. The new combination of Coronation and Saints' portal, recently used at Paris, was ruled out, since at Amiens the saints had a large portal of their own to fill. It was therefore decided to mount a jamb cycle which presented scenes from earlier Virgin's portals – Chartres (west; pl. 6), the left doorway of Laon (pl. 70, 71), the side doorways of the Chartres north portal (pl. 92, 94) – in the form of large statues. The cycle begins on the right jamb with the Annunciation, followed (reading outward) by the Visitation and the Presentation in the Temple (pl. 167). This grouping in pairs is adhered to on the left jamb (pl. 166). Here the two outer figures are Solomon and the Queen of Sheba, who had already made their appearance as types for Sponsus and Sponsa, Christ and Mary, on the Chartres north transept (pl. 92). The next pair shows Herod in conversation with one of the three Magi, after the text: 'Then Herod, when he had privily called the wise men, inquired of them diligently what time the star appeared' (Matt. 2:7). This is followed by two kings in adoration, turning towards the trumeau figure.

Lastly, it was necessary to select themes for the twenty-four socle reliefs. The reliefs beneath the Annunciation display Old Testament types for the virgin birth, which had already been used in the archivolt of the Virgin's portal at Laon (pl. 70, 71; cf. p. 425 f.): Nebuchadnezzar's dream of the stone which broke loose and shattered the image, here shown with Daniel, who interpreted the dream; Gideon's fleece, impregnated with dew while the threshing floor around it

stayed dry; the bush which burned before Moses, and yet was not consumed; Aaron's rod, which sprouted. The other reliefs expand the scenes portrayed on the jamb. Thus beneath the Visitation we have the story of Zacharias and Elizabeth: 1, the angel appears to Zacharias in the Temple and announces the birth of a son to him (top, beneath Mary); 2, Zacharias, struck dumb, departs from the Temple and gestures to the waiting people (top, beneath Elizabeth; pl. 172 bottom left); 3, the lying-in of Elizabeth (bottom, beneath Mary); 4, the naming of John (bottom, beneath Elizabeth; pl. 172 bottom left). Beneath the Presentation in the Temple are (top row): the flight into Egypt (pl. 172 bottom), overthrow of the Egyptian idols (pl. 172 bottom); (bottom row) the twelve-year old Jesus in the Temple (pl. 172 bottom), and the return of the Holy Family either from Egypt or to Nazareth (pl. 172 bottom).

On the opposite side the story of the Three Magi and Herod is similarly expanded, beneath the relevant figures. Beneath Solomon and the Queen of Sheba we see: Solomon on the six-stepped lions' throne; Solomon at table; Solomon praying in front of the Temple; and Solomon displaying his wealth and piety to the Queen of Sheba. No later thirteenth-century layout matched this Marian programme in scope. The centre doorway of the Rheims west façade (pl. 189, 191–203, colour pl. IV), the most beautiful of all thirteenth-century Virgin's portals, took the Amiens cycle as its starting point.

The left doorway has a saints' programme, with strong local colouring. The composition repeats formal motifs of the Coronation portal, while altering the content. The uniformity of the total layout demanded that the side doorways should be precisely balanced.

On the trumeau is a figure of St Firmin, the first bishop of Amiens and the cathedral's auxiliary patron (pl. 168 right). Just as Mary sets her foot on the serpent, so Firmin stands triumphantly over the pagan priest Auxilius(?), who had demanded the death penalty for him. In form and ornament the trumeau matches that of the Virgin's portal. The scenes are now scarcely identifiable; in the top zone at the left is perhaps the martyrdom of St Firmin. The baldachin surmounting the trumeau figure complements the Tabernacle above the Virgin, and just as Moses, Aaron, and priests of the Old Testament appear beside the Ark, so here bishops are ranged beside the baldachin.

The tympanum shows in unparalleled detail the translation of St Firmin's body. In the lower band we see St Salvius, bishop of Amiens, at Firmin's burial place, whose whereabouts had been disclosed by a sign from Heaven: the grave exhaled a sweet fragrance over the entire region and brought the inhabitants of the neighbouring cities of Thérouanne, Beauvais, Noyon and Cambrai flocking through their town gates to hasten to the spot. In the upper band, the shrine containing Firmin's body is borne by bishops and clerics in solemn procession to Amiens. It is winter, but the trees are sprouting and, as at Christ's entry into Jerusalem, children climb into the branches and bystanders spread their garments before the approaching train. This tympanum is the

first to be devoted entirely to a local saint; since his *Life* plainly offered little scope for illustration, it was necessary to fall back on the material offered by the translation. The angels in the archivolt, with their crowns, candlesticks, and censers, were no doubt intended to add weight to the proceedings in the tympanum.

Precise identification of the twelve figures displayed on the jamb is a virtual impossibility. Georges Durand attributed to them the names of little-known saints whose bodies were venerated in the cathedral but whose lives the extant sources leave veiled in obscurity. It is clear there were difficulties in filling all twelve places, even in the thirteenth century. The names proposed by Durand are (reading from the inside): on the right, Firmin the Confessor, Domicius, Salvius, Fuscianus, Warlus, Luxor; on the left (pl. 169), Honoratus, an angel (the censer and incense boat are the work of a restorer), Acius, Aceolus, angel with stole (banderole added by the restorer) and Ulphia. Even if the accuracy of these appellations cannot be guaranteed, it is still characteristic that where the Chartres south transept portals gave pride of place to universally venerated saints – Stephen, Laurence, Nicholas, Martin etc. – at Amiens it is local saints who take the stage. Signs of this coming development are already seen on the Paris Coronation portal and on the two porches at Chartres, thus the statues of Piatus, Modesta (pl. 98, 99), Laudomarus and Avitus (pl. 123). The socle zone shows the Zodiac and Calendar.

A further sixteen statues are mounted on the buttress piers, three to each outer face – a centre figure facing forward, flanked by two corner figures placed diagonally (pl. 161) – with the remaining four on the side faces of the buttresses at the opening of the centre bay. The scheme chosen was a prophets' cycle, the selection and sequence being based on the prophetic books of the Old Testament. The four figures of the so-called major prophets are mounted on the centre portal. The sequence begins with Isaiah, the inside figure on the right wall; he is accompanied by Jeremiah as second in rank. It continues on the left wall with Ezekiel as the inside figure, and concludes with Daniel (pl. 160). The twelve minor prophets were placed on the fronts of the buttress piers (pl. 170, 171). The sequence begins with Hosea, outside right, on the south corner of the façade, and ends with Malachi, on the north corner, outside left. With a few exceptions the figures are without specific attributes and hold only a banderole. Isaiah's attribute is destroyed (the palm is an invention of the restorer), Jeremiah holds the cross, Amos is distinguished by crook and bag as a shepherd.

The plan of the façade assigned to the sixteen statues forty-six socle reliefs, for which themes had to be found in the writings of the prophets. The figures on the flat faces of the walls – the Major Prophets and the Minor Prophets in the centre of the buttresses – have only two scenes apiece, likewise Hosea and Malachi on the flanks of the façade. The corner figures have four each, two on the front of the buttress and two on its flank. This distribution was dictated by considerations of a numerical order, arising from the uniform arrangement of the façade. Thus in working out the programme, while two pictures had to suffice for, say, Jeremiah or Ezekiel, no less than four appropriate scenes had to be found for less important prophets like Obadiah and Haggai. With the help of the prophetic writings it is possible to identify nearly all the subjects portrayed. As Durand has demonstrated, in the commentaries of the Church Fathers the visions and prophecies chosen are almost without exception related to the Last Days, which links them with the central theme of the Amiens programme. A more ambitious interpretation, which seeks to divide all the scenes into a positive (right) and negative (left) half, is unconvincing. We can describe here only the handful of reliefs illustrated in the plates. In plate 173 bottom, the two quatrefoils on the right of the picture relate to Nahum. Above, the four figures, closely pressed together, walking in a leftward direction, probably represent the fleeing inhabitants of Nineveh – 'Stand, stand, shall they cry; but none shall look back.' (2:8). Below, a bearded man shaking a fig tree, with three figures pointing up at its branches, relates to the prediction of the fall of Nineveh – 'All thy strong holds shall be like fig trees with their firstripe figs: if they be shaken, they shall even fall into the mouth of the eater.' (3:12). In Jerome's commentary the corruption of Nineveh is to be compared with the corruption of the world before the Last Judgment. The two quatrefoils in the centre of plate 173 bottom relate to Habakkuk. Above, God is shown sitting with open book on his knees, and before him is a standing figure with a nimbus (the object held in his hands is no longer recognizable); cf. (probably) the text, 'God came from Teman and the Holy One from mount Paran.' (3:3). Below, Habakkuk, with food in his hands, is transported through the air by an angel to Daniel in the lions' den (cf. Apocrypha, Daniel 6:16–23). The two quatrefoils on the left of plate 173 bottom relate to Zephaniah. Above, the Lord, holding a cross-headed staff in his left hand and an upraised sword in his right, stands among figures cowering before him – 'Ye Ethiopians also, ye shall be slain by my sword.' (2:12). According to Jerome, the Ethiopians smitten by the sword of the Lord are to be compared with sinners who will not do penance. Below, we see a city with breached walls and ruined houses inhabited by animals – monkey, fox, cat, dragon etc. A number of passages in Zephaniah foretell the ruin of inhabited places, especially: 'And he will . . . destroy Assyria; and will make Nineveh a desolation, and dry like a wilderness. And all the flocks shall lie down in the midst of her, all the beasts of the nations . . .' (2:13, 14). Jerome's comment reads: 'The corrupt building will be destroyed, so that thereafter the good building – the Heavenly Jerusalem – can be set up.' Plate 172 top shows two further reliefs relating to Zephaniah (to the right of the Calendar). Above, the Lord, with lanterns, searching Jerusalem (1:12); below Nineveh destroyed (2:14). Plate 173 top right shows scenes for Haggai; the subjects of the two quatrefoils are linked. Below, the Lord addresses the prophet, seated in meditation at his feet; God points with his right hand to the devastated building in the quatrefoil

465

above – 'Thus speaketh the Lord of hosts, saying, This people say, the time is not come, the time that the Lord's house should be built. Then came the word of the Lord by Haggai the prophet, saying, Is it time for you . . . to dwell in your cieled houses, and this house lie waste?' (1 : 2–4). This is the Lord's complaint against the Jews for their tardiness in rebuilding Solomon's temple. Cf. St Augustine: 'In prophetic language, the restoration of that building signifies the second Covenant and the Church, which Christ would come to build.' In the centre of plate 173 top appear scenes relating to Zechariah and, again, the two reliefs go together. Below, an angel directs the prophet's attention to the scene above, where two female winged figures in secular attire are shown bearing an urn-shaped vessel, with a woman seated within it – 'Then the angel said unto me, Lift up now thine eyes . . . This is an ephah that goeth forth . . . and this is a woman that sitteth in the midst of the ephah. And he said: This is wickedness . . . and, behold, there came out two women, and the wind was in their wings . . . and they lifted up the ephah between the earth and the heaven.' (5 : 5–9). On the left in the plate are scenes for Malachi, also linked. Below, a dialogue between the Lord, pointing with his right hand to the picture above, and three men; in the upper scene we see two men transfixing the Lord with a spear; one of them also holds a sheaf, and the whole is a literal illustration of Malachi 3 : 7–8. God is in angry colloquy with the priests and people of Israel and complains of deception over the offering of first-fruits. The Vulgate uses the expression 'affiget homo Deum', hence the spear-thrust on the Amiens relief. Jerome relates the passage to the Passion.

The prophets' sequence on the Amiens west façade is unique. No other portal layout repeats this elaborate cycle. Whereas the iconography of the Virgin's and Judgment portals consists merely of a mass of familiar motifs, this represents an original conception. It uses the preordained architectonic layout to evolve a programme whose sequential precision is the equal of the architectural design of Robert de Luzarches. The outer figures on the buttresses are of the prophets, followed on the jambs by the apostles, and rising above the threshold of the nave is the Last Judgment. We are aware from the west portal of Saint-Denis onwards of a striving to achieve a meaningful harmony between the structure and the sculptural decoration of portals; the west façade of Amiens represents the highest achievement – therein lies its greatness, and its limitations.

Style and dating. The sculptures of the Amiens façade present a more uniform stylistic appearance than do the transept portals of Chartres or the west façade of Paris and the later west façade of Rheims. There is no question of older sculptures being pressed into service, or of any noticeable change of plan or workshop in the course of execution. The statues and reliefs seem to have been executed on the basis of a unified design, and in fairly rapid succession, while the nave was being built. Even so, there are stylistic differences to be noted, and the juxtaposition of archaic and advanced works.

A start was presumably made with the sculptures of the Virgin's portal (pl. 166–168 left). The style is formed from the Paris west façade (pl. 144–156). The jamb figures, with their rigid stance, their draperies gathered into hard flanges and acute-angled folds, their flawless, impassive countenances, indicate that this was the starting point. There is a dignified quality to their bearing and appearance, a restraint which is virtually expressionless. The architectural components are accomplished with great skill. The baldachins above the figures are complemented by the architectural formation of the polygonal consoles below. The sculptural and the architectural are merged. At the same time, the portal shows older forces at work. There are echoes in the archivolt of fold motifs belonging to the trough style. In the tympanum there is a tendency to consolidate the figure groups in blocks, combined with a liking for voluminous folds. The figures are changing in type: they are becoming more thickset, with large, spherical heads. A certain coarsening is unmistakable. The style of the centre doorway continues from here. The apostle figures of the left wall (pl. 162) are blocks of massive volume, which yet give no hint of corporeality; the limbs lie concealed beneath the bulky draperies. One is left with a lifeless, fusty impression. In the tympanum and archivolts (pl. 164, 165), the figures are formed like squared off trunks and covered with a crumple of folds. This tendency towards simplification is still plainer in the Stem of Jesse, and most of all in the patriarchs beneath the vault, undoubtedly the last to be made. Confronted with these sharply prismatic forms, one can no longer speak of a linear rendering of the folds. Here we have workshops cutting loose from the graphical methods which twelfth-century sculptors had appropriated from painting and goldsmith's work. The production process leading from unhewn block to worked up figure is perceptibly curtailed. The effect is weightier than with figures in the trough style, for example, and particularly appropriate for figures intended for positions well above the ground, which was precisely what the cathedrals in the High Gothic style of the thirteenth century demanded. A similar trend towards a more rationalized, more schematic working can be seen in the architecture and glass painting of the period. In this stylistic upheaval, which determined the later course of gothic sculpture, the Amiens workshops of the decade 1225–35 played a decisive role. Yet within the Amiens façade itself sculptures showing older linear tendencies can still be found alongside more advanced work. The Virtues and Vices to the right of the centre doorway display slender figures and a fluent rendering of the draperies; in those on the left (pl. 162 bottom), the forms are broader and crinkled. In the St Ulphia (pl. 169, 170) we see a statue almost classical in its drapery rendering; in the adjacent figure, Haggai (pl. 170), the forms of surcoat and mantle are heavy and bulky, the fold motifs few and large.

E. Jourdain, Th. Duval 1845–46; A. Didron 1847; P. Clemen 1892; G. Durand 1901, esp. vol. I, p. 299 ff.; E. Mâle 1902 (2); P. Vitry 1929, p. 22 ff.; W. Medding 1930; L. Lefrançois-Pillion 1931, p. 136 ff.; M. Aubert 1946, p. 252 ff.; A. Katzenellenbogen 1952; H. Jantzen 1957, p. 119 ff.; W. Vöge 1958; R. Branner 1965, p. 138 ff.

Pl. 174, ill. 88

AMIENS (SOMME), CATHEDRAL OF NOTRE DAME TOMB MONUMENT OF BISHOP EVRARD DE FOUILLOY

Bishop Evrard de Fouilloy, who laid the foundation stone of the present cathedral, died in December 1222. Until 1762 his tomb monument stood in the first bay of the nave, immediately behind the main doorway. The slab was then removed, to permit the passage of processional canopies. It was installed in its present position in 1867, by Viollet-le-Duc.

The slab, cast in bronze, today rests on the backs of six small lions, which from their style and technique do not belong to the original (ill. 88). Originally the slab probably rested on a tumba. The bishop, whose head reposes on a cushion patterned with animal masks, has his right hand raised in benediction. His lowered left hand formerly held the crozier, whose base entered the muzzle of one of the two dragons at his feet. The vestments are richly ornamented. The quatrefoil decoration on the amice and the addorsed birds in quatrefoil frames on the border of the dalmatic have been cast and chiselled; the simpler ornamental forms on the forked cross of the chasuble and on the maniple are engraved. Standing on the curled tails of the dragons are two upward gazing clerics vested in alb and amice and bearing candles. Level with Evrard's shoulders are two angels, swinging censers on long chains up towards his head. Whereas the slabs at Nesle-la-Reposte (ill. 42), Lèves (ill. 63), and even that of Philip of France (pl. 159 left) showed no subdivisions, the bishop appears in a complex architectonic frame. Slender columns with shaft rings and exaggerated pedestals protruding beneath the socles support a trefoil arch. Beside the arch rise polygonal towers, which are joined by flying buttresses to a moulded pinnacle-crowned structures which project above the apex of the open arches. The whole looks like a rough cross-section of a High Gothic basilica. The sloping border has a decoration of finely worked palmettes.

The slab is a unique example of High Gothic bronze casting, for which little evidence has otherwise survived. It shows no recognizable stylistic connection with the sculptures of the Amiens west façade. Date: presumably soon after 1222.

The inscription engraved on the arch and borders reads:
+QUI POPULUM PAVIT: QUI FUNDAMĒTA LOCAVIT+
HUI' STRUCTURE: CUIUS FUIT URBS DATA CURE+
HIC REDOLENS NARDUS: FAMA REQUIESCIT
EVVARDUS+
VIR PIUS AFFLICTIS VIDUIS: TUTELA RELICTIS+
CUSTOS: QUOS POTERAT: RECREABAT MUNERE ŪBIS+
MITIB' AGNUS: ERAT: TUMIDIS LEO LIMA SUPBIS+
(He who protected the people, who laid the foundations of this edifice, to whose care the city was entrusted: here lies Evvardus, a spikenard redolent of fame; the pious one, who was the protector of oppressed widows, the defender of

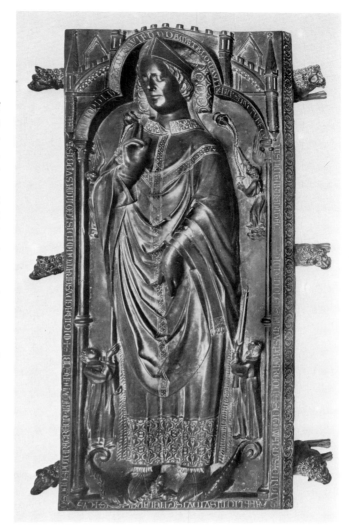

Ill. 88 Amiens cathedral. Tomb monument of Bishop Evrard de Fouilloy (died 1222). Shortly after 1222

orphans, who brought encouragement everywhere, through word and deed, as only he was able; to the meek he was a lamb, to the self-important a lion, to the proud a sword).

G. Durand 1903, vol. II, p. 510f.; P. Vitry 1929, p. 91; M. Aubert 1946, p. 300.

Pl. 175

'KING CHILDEBERT' (PARIS, LOUVRE)

This statue of a king in cotte and clasped mantle is probably from the trumeau of the refectory doorway of the abbey of Saint-Germain-des-Prés. Dom Bouillart, writing in 1724, described a figure in this position whose dimensions and apparel tally exactly with the statue now in the Louvre, to which it came in 1856, via the Musée des Monuments français; the abbey was suppressed in 1790 and the conventual buildings sold. The disfiguring paint applied in the nineteenth century has recently been removed.

The figure provides a characteristic example of the so-called gothic 'sway'. The left foot pivots sideways, the right hip bows out, the upper torso makes a corresponding bend to pivot in the opposite direction. The figure treads like a dancer. The bend of the arms emphasize the angular outlines. Note the hair style: Apart from a few small curls emerging below the lower edge of the crown the forehead is bare; the rest of this waved hair is smoothed back over the ears and fashioned into an upturned roll at the nape of the neck. The strands of moustache and sideburns are similarly waved, as though with curling irons. This coiffure refines the head and confers on the features a distinct air of man-of-the-world qualities.

The refectory of Saint-Germain-des-Prés was built between 1239 and 1244. The view that the figure was added only around the middle of the thirteenth century is unfounded. We have here an example of Parisian work of the early 1240s. There is a close affinity with the Judge of Notre Dame (pl. 147), and the king figures on the right jamb of Villeneuve-l'Archevêque (pl. 179 right), as also the Baptist's portal at Rouen (pl. 182 top), may well be contemporaneous and related works. Dom Bouillart takes the figure for that of the abbey's founder, King Childebert I. The learned Benedictines of Saint-Germain-des-Prés had a well-known propensity for attaching the names of French rulers to biblical figures, so some scepticism is in order.

M. Pierre Pradel was kind enough to grant permission for photographs to be taken, although he had not yet completed his restoration of the statue's feet.

J. Bouillart 1724, p. 123 f.; L. Courajod 1876–88, vol. I, p. 8; P. Vitry 1929, p. 88 f.; M. Aubert 1946, p. 296; M. Aubert, M. Beaulieu 1950, no. 109; W. Vöge 1958, p. 169; W. Sauerländer 1969; see also Appendix to Bibliography.

Pl. 176, 177

THEROUANNE, CATHEDRAL CHURCH (DESTROYED), FIGURES OF THE JUDGE, MARY AND JOHN THE EVANGELIST (NOW IN SAINT-OMER CATHEDRAL)

The city of Thérouanne, in the extreme north of present-day France, was razed to the ground by the Emperor Charles V in 1553, after his unsuccessful siege of Metz. The bishopric was suppressed and its territories fell in part to the newly established see of Saint-Omer. Thérouanne possessed a choir with an ambulatory and niches for chapels. A dedication is said to have taken place in 1134. The transept was of thirteenth-century date and, as we know from a panorama of 1537, displayed the Judge with intercessors on the gable above the south portal (which had no tympanum). The group survived, to pass into the possession of the neighbouring cathedral of Saint-Omer.

The grouping is the usual one: the Judge between Mary and John the Evangelist, the latter kneeling and with hands in prayer. The peculiar proportioning is explained by the group's lofty installation on the gable; it was designed to be seen from below. The town with pinnacled ring wall at the Judge's feet is unusual: since some of the buildings are collapsing, it is probably meant to represent the 'Babylon' of the Apocalypse (cf. Rev. 18:10). The Judge wears the crown of thorns, which is normally, like the cross and spear, carried by accompanying angels.

The group is usually dated to the time of Bishop Henricus de Moris (1276–86), whose epitaph refers to the execution 'du grant portail'. A date as late as this must be rejected on style-critical grounds. The figures from Thérouanne are plainly derived from the west portals of Amiens, but do not take as their model the most advanced works, for example the Stem of Jesse beneath the centre barrel vault; they must then have originated in the 1230s.

L. Deschamps de Pas 1852–56; van Drival 1875; J. M. Richard 1879; R. Crozet 1952; W. Sauerländer 1962 (II); see also Appendix to Bibliography.

Pl. 178, 179

VILLENEUVE-L'ARCHEVEQUE (YONNE), NOTRE DAME, PRIORY CHURCH NORTH PORTAL

From 1172 the priory church of Notre Dame in Villeneuve-l'Archevêque was subordinate to the abbey of Saint-Jean-les-Sens. It was here, in August 1239, in the presence of King Louis IX and the queen-mother Blanche of Castile, that the archbishop of Sens received the Crown of Thorns, to be preserved in the cathedral of Sens pending its later transfer to the newly erected Sainte-Chapelle in Paris (see p. 471).

The sculptured decoration of the portal, which opens into the first bay of the north aisle, is unusually elaborate for a church of this modest size. The tympanum depicts the Coronation of the Virgin. The crowned Virgin is enthroned on the right of the uncrowned Christ for whom the crown borne on a veil by two angels in the apex is obviously destined. Sponsus and Sponsa are flanked by angels with censers and candles. In the archivolt are more angels, then enthroned apostles with the instruments of their martyrdom, and lastly the Stem of Jesse. Note two unusual features: Jesse wears a crown, and above him is a figure in a tiara.

With a few minor deviations, the Coronation programme follows the scheme established at Senlis (pl. 42). Instead of the death and Assumption of Mary, the lintel displays the Infancy of Christ. This combination of themes was already present at Laon (pl. 68 ff.) and Chartres (pl. 76 ff.), in so far as the Coronation and Virgin's portals stood side by side; at Amiens the two were combined for the first time on a single portal (pl. 161 right), and Villeneuve continues the development.

The lintel scenes depict in succession the Visitation, Nativity, Annunciation to the Shepherds, Presentation, and Adoration. In the Nativity and Annunciation to the Shepherds there are striking similarities to the iconography of the jubé at Chartres (pl. 126, 127). The trumeau features a standing figure of the Virgin; note the exact reproduction of a twin-towered façade on the baldachin.

468

On the left jamb (pl. 179) is the Annunciation (the start of the cycle portrayed on the lintel), and the third statue, a female figure with nimbus and banderole, though not positively identifiable, may be Elizabeth. On the socle Avaritia and Largitas are shown in a free rendering of the socle reliefs on the Baptist's portal at Sens (pl. 58, 61 top). On the right jamb are Old Testament figures: on the outside, David with his harp, in the middle presumably Solomon. The third figure is sometimes named as Moses, but since the head is covered and the figure appears to have held a branch, may perhaps be Aaron. The programme combines snippets from a number of thematic fields, as is quite frequently the case with smaller layouts.

The classification of the portal found in the literature shows a surprisingly uncertain touch. Despite the older stylistic features generally observed, there is unanimous support for a date in the third quarter of the thirteenth century. The models are assumed to be the later statues on the west façade at Rheims. In fact the date seems to be considerably earlier. The Solomon, like the David, resembles the 'Childebert' from Saint-Germain-des-Prés (pl. 175), executed between 1239 and 1244. The Solomon even has the same pose, and both figures agree with the Paris statue in clothing, physiognomy and hair style. The execution is less refined. The Virgin is of the frontal type found both at Amiens (pl. 168 left) and in a statue said to come from the Lady Chapel of Saint-Germain-des-Prés – this is now in the Musée de Cluny; it is thus without the swaying stance which later became general and which is found, for example, in Paris (pl. 188) and in the 'Vierge dorée' of Amiens (pl. 277, 279). The heads – in the Stem of Jesse for example and those of the Magi on the lintel – have some similarity to the more recent of the slabs and bosses from the Chartres jubé (pl. 127 top, ill. 61): we see the same tall brows above small slitted eyes, the hair is fine-stranded and wavy, but not coiled in large ringlets as for example in the Rheims Joseph (pl. 194). True, the angels smile – as they did on the Firmin portal at Amiens (pl. 169) – but there is nowhere that brilliant intensification of expression lighting up sensitive features seen in the more recent of the Rheims statues.

Thus everything points to a date shortly after 1240. The portal is not of the first rank, but it reflects Parisian sculpture in the stylistic phase which was the starting point for the later ateliers at Rheims. There is attraction in the idea that the portal is connected with the ceremony of 1239. The unusual prominence given to Christ's crown in the apex of the tympanum might then be an allusion to the relic received on that occasion, namely the Crown of Thorns.

P. Vitry 1929, p. 93f.; J. Vallery-Radot 1955; R. Branner 1960, p. 194f.

Pl. 180, 181

RAMPILLON (SEINE-ET-MARNE), SAINT-ELIPHE

The church was built in the thirteenth century, but exact dates seem to be lacking. In the late thirteenth century it belonged to a commandery of the Templars. There is evidence of benefactions in the 1280s and 1290s, but they cannot be associated with the building of the church, which from its forms seems earlier by four to five decades.

The south doorway is a small portal leading into the fourth bay counting from the west. The tympanum depicts the Coronation of the Virgin: Christ blesses the praying Mary, who is crowned by two angels, and flanking them are two kneeling angels. The attributes are broken off. It compares with Villeneuve-l'Archevêque (pl. 178), but the execution is finer: note for example the rendering of the hair and the pronounced fondness for decorated borders on draperies and book covers. The crown with its pentagonal plates and pearl trimmings is in literal agreement with the Dream of the Magi on the Chartres jubé (pl. 127 top). We are thus in the circle of Paris sculpture shortly before, or contemporary with, the Sainte-Chapelle.

The west doorway has a tympanum depicting the Judge between standing angels bearing instruments of the Passion, with intercessors kneeling on either side; the scheme is already familiar from Notre Dame in Paris (pl. 147). The archivolt contains only one sculpted arch, filled with standing angels. At either end of the lintel is an angel with trumpet, and between them the resurrection. The left field shows in addition the weighing of souls and Abraham's bosom, the latter in a highly original version. The souls walking past either grasp the patriarch by the knees or turn with imploring gestures to the figure above.

The jamb figures are apostles, mounted not as usual in the form of column statues, but within pointed niches. The trumeau figure holds the book as his only attribute. The facial type, as also the clothing – which includes shoes – rules out Christ as a possibility. The church's patron, St Eliphius, is usually shown holding his severed head, so he too can be excluded. In any case we have to be cautious in our speculations about the programme, since in the nineteenth century all the large figures were housed inside the church and only later reinstated on the portal. The angels bearing crowns, seen in the spandrels between the jamb arches, belong to the Last Judgment.

The socle zone shows blind arcading with figures: outside left, the Presentation in the Temple, and in the corresponding position opposite, the Adoration of the Magi; between them is a Calendar and (on the left) three further (unidentified) figures. Especially charming are the little heads in the spandrels. So far as one can judge, the programme is characteristic of the smaller church which sought to unite several themes – Judgment, Infancy of Christ, Calendar – on a single portal.

Portal type, style and dating. The niched jamb, the socle arcading, and the absence of a carved archivolt make this an unusual type of portal. In many respects it is comparable with the portal on the south transept of the abbey church of Saint-Denis (pl. 183); there, however, the niches are all blind, and not filled with figures. There is a figure-decorated portal without sculpted archivolt on the west façade of the

469

neighbouring church of Donnemarie (pl. 141 bottom).

The state of preservation makes a stylistic judgment difficult: many of the jamb figures, the figures in the tympanum and probably those in the right half of the lintel have had their surfaces touched up. If we look only at the parts apparently unaffected – the left half of the lintel and the socle – it is impossible to agree with a late thirteenth-century dating as met with in the literature. Among the resurrected and angels of the lintel there are heads which tally exactly with the Chartres jubé (pl. 126, 127). The head of Abraham bears comparison with figures from the Stem of Jesse at Villeneuve-l'Archevêque (pl. 178). Nevertheless, the execution is freer and bolder. On the socle there are heads which point not to the Rheims west façade but probably to the Rheims transept. The most likely date, therefore, seems to lie between 1240 and 1250. The obvious affinity with the centre doorway of the west portal of Bourges cathedral (pl. 292) presents no obstacle, especially since the question of priority is still wide open.

A. Carlier 1930; M. Aubert 1946, p. 284f.

Pl. 182

ROUEN (SEINE-MARITIME), CATHEDRAL OF NOTRE DAME WEST PORTAL

The cathedral at Rouen is the largest gothic church in Normandy. Choir and nave post-date a fire in 1200, while the west façade goes back to the second half of the twelfth century. As a consequence of late medieval remodelling, the only portions to survive from this building phase are the north tower – Tour Saint-Romain – and the jambs and archivolts of the side doorways.

The left doorway is a Baptist's portal. The richly ornamented socle, the jambs – with mouldings of foliage – and the tendril-decorated doorposts are early gothic; compare the jamb of the centre doorway of the west portal at Mantes (pl. 47), dating from c. 1180. The forms at Rouen are later, probably from the turn of the century. The archivolt is of the same period; apart from four small busts, the forms are purely ornamental. Note the unusual decorations featuring quatrefoils, crescents, etc. à jour. The socle reliefs include the beheading of John the Baptist and Herod's banquet, so the portal possessed scenes relating to the Baptist even in its original state. In the tympanum added later (pl. 182 top), the lower band shows: (left) Herod's banquet, with the dance of Salome; (right) the beheading of John; and (centre) the delivery of his head to Herodias. The table stands on a podium decked with roses. Seated beside Herod and Herodias are two guests. In front are two servants and a begging dog; on the left, the court jester, bald-pated, pointing at the crowned pair above. Salome dances on her hands, balancing between her knees a staff with a capital-shaped head supporting a vessel on top. The interior space was originally divided into two halves by a column. Above the upturned head of John in the charger appears the blessing hand of God, emerging from a cloud. The executioner, shown as a Negro with thick lips and close-curled hair, swings a curved sword in his right hand. Affixed to the prison in which John awaits the death blow is a foliated mask with deep-set eyes. The scene in the apex of the tympanum has been interpreted as the burial of John the Evangelist. Probably it is in fact the burial of the Baptist, following the text: 'And his disciples came, and took up the body, and buried it.' (Matt. 14:12).

The right doorway is a Stephen's portal. Jamb and archivolt date from c. 1200. On the socle, small reliefs, including the stoning of Stephen. The tympanum added in the thirteenth century (pl. 182 bottom) has been cut away at the bottom by the baroque lintel; it again shows the stoning of Stephen. The saint kneels in the centre, beneath the 'opened heavens' (cf. Acts 7:55–60). On the left Saul keeps watch over the cast off garments; note the tall Jew's hats. Above, Christ on the rainbow is enthroned in the mandorla, flanked by angels, an old type no longer met with elsewhere in the French sculpture of the thirteenth century.

Style and dating. The tympana of Rouen are major works of Paris sculpture from the period around 1240. Exceptionally close are the connections between the lower band of the Baptist's tympanum and the more recent parts of the Paris Judgment portal; compare for example the head of the Baptist with the Paris Judge (pl. 147), and the heads of the two guests with the angels with trumpets (pl. 146 top) from the Paris tympanum, now in the Musée de Cluny. The relief at the apex of each of the two Rouen tympana diverge somewhat from this style, but only to draw close to the two upper bands of the Paris north transept portal (pl. 186).

The banquet and the beheading of John – by reason of their delicacy, artistic quality and mordant accuracy – are among the most important works by French sculptors of the thirteenth century.

L. Pillion 1904; C. Enlart 1912; A. Loisel n.d.; L. Lefrançois-Pillion 1926; P. Vitry 1929, p. 63f.; M. Aubert 1946, p. 292f.; *see also* Appendix to Bibliography.

Pl. 183

SAINT-DENIS (SEINE), ABBEY CHURCH SOUTH TRANSEPT PORTAL

In the eighteenth century the south transept portal was walled in by a newly erected structure, and was only opened up again in 1893–97. Extant is the jamb arrangement, showing a low arcaded socle, columns, with foliage or lilies in the grooves. Contrary to a recent conjecture, there were never any jamb figures. Tympanum and trumeau have been broken off, but parts of the sculpted archivolt survived the immurement. In the upper ranges of the inner arch are standing angels and, in the second and third arch, apostles with the instruments of their martyrdom. In both the lower

ranges, groups and pairs extend over the whole section. Only the left side survives. Above is a close-packed series of figures, among them a cleric with processional cross and a bishop with crozier; presumably a procession of the Blessed. Below, reading from the outside, are: the Annunciation, Visitation, and the remains of the Annunciation to the Shepherds. An archivolt fragment with the Damned, preserved in the Louvre since 1881, has been conjecturally associated with the portal and recently assigned to the right-hand section. By inference, the programme was as follows: Last Judgment in the tympanum and archivolt, Infancy of Christ in the lintel zone and the lower ranges of the arches.

Portal type, style and dating. Jambs without figures but with foliage decoration in the mouldings are a feature of Paris portals from the first half of the thirteenth century: the Sainte-Chapelle, the Lady chapel of Saint-Germain-des-Prés, the refectory of Saint-Martin-des-Champs, Saint-Pierre-aux-Bœufs. The south transept portal of Saint-Denis belongs to this group. As precursors from the period *c.* 1200 we can cite the side doorways of Rouen cathedral (pl. 182).

Stylistically there are remotely comparable pieces among the fragments of the Chartres jubé: one thinks especially of the small-figure groups, for example the procession of the Blessed. They have in common heavy draperies, a voluminous rendering of folds, presentation in breadth. At Saint-Denis, however, there are more of the continuous diagonal folds, and in general greater efficiency in the figure construction; the outlines are more precise. There is a remote affinity with the somewhat later doorpost angels of the centre doorway of the Rheims west portal (pl. 189), though the latter are without the same heavy rendering of the drapery. Recent research into the history of the construction of the transept proposes 1241 as the date of its completion. The sculptures of the south portal, however, must have been made between 1240 and 1250, at the same time as the apostles of the Sainte-Chapelle (pl. 184, 185) and the north transept portal of Notre Dame in Paris (pl. 186–188). They show no connections with the workshop which was engaged during the 1260s on the royal tombs in the interior of the abbey church (pl. 272, 273). The fragment with the Damned, recently inserted into the archivolt series, is difficult to evaluate because of its very damaged condition. It shows signs, however, of being stylistically more advanced; hence, although the measurements fit, whether or not it belongs to the portal remains an open question.

P. Vitry 1929, p. 73; M. Bunjes 1937, p. 67; M. Aubert 1946, p. 263; M. Aubert 1949; S. McK. Crosby 1953, p. 64; J. Formigé 1960, p. 114ff.; R. Branner 1965, p. 47; C. Gnudi 1969, p. 26ff.

Pl. 184, 185, ill. 89

PARIS, SAINTE-CHAPELLE
APOSTLE FIGURES

St Louis acquired the relics of the Crown of Thorns from the East Roman Emperor in Constantinople in 1239; in August of that year he was present at the solemn reception of the priceless relics, which took place at Villeneuve-l'Archevêque (cf. p. 468). The Crown of Thorns was taken to Sens and thence to Paris, where it was deposited in the St Nicholas chapel close to the royal palace. On 14 September 1241 further relics of the Passion reached Paris from Constantinople; this was presumably the moment when it was decided to build a new two-storey chapel to house them. Clerics were appointed to serve the chapel in January 1246, and the dedication, by a papal legate and the archbishop of Bourges, followed on 26 April 1248. The name of the architect is unknown; on stylistic grounds, Thomas de Cormont, who built the ambulatory of the cathedral of Amiens, has been thought a likely possibility.

The upper chapel, dedicated to the Crown of Thorns and the Holy Cross, contained large statues mounted on columns between the arcaded socle and the windows; the figures of apostles held discs with consecration crosses, and in some cases displayed their attributes as well. When the upper chapel became an archive in 1797 the figures were removed; at the same time, two statues were destroyed. The remaining figures went to the Musée des Monuments français and, when that was dissolved in 1816, were distributed among various churches and depositories. Work on restoring the Sainte-Chapelle started in 1840; the figures were recovered, painted and repaired; where necessary, copies were made. Only three of the statues now in the Sainte-Chapelle can be regarded as originals: north side 4, James the Less (pl. 185 right), north side 5 (pl. 185 left), south side 5 (pl. 185 middle). The obtrusive modern colouring makes it difficult to judge the condition of the surfaces. Four fragmentary statues, uncoloured, are in the Musée de Cluny: John (pl. 184 middle), Bartholomew (ill. 89; identification not certain, but suggested by an old drawing), and two others, to which no name can be attached (pl. 185 left and middle). The foregoing are all represented in the Sainte-Chapelle by replicas. The five remaining figures, as we see them today, are either more or less free inventions on the part of the restorers or extensively renewed.

Even as it is now, the cycle is still recognizable as a major work of Paris sculpture from the 1240s. At the same time it shows no touch of the charm cultivated by one trend of the Paris style, as seen for example in the later portions of the Chartres jubé (pl. 127 top, ill. 60) or the tomb monument of Philip of France (pl. 159 left, ill. 83). There is no comparison either with the pleasantly narrative manner of the perhaps contemporary, or near-contemporary, north transept portal of Notre Dame (pl. 186–188). The forms of the Sainte-Chapelle apostles have a different kind of intensity. The rendering of the folds and their crinkled, broken up appearance, which at Amiens led to a solidification and standardization of the figures, here invests them wholly with a taut, nervous energy. Judging by the torsos in the Musée de Cluny (pl. 184, ill. 89), the combination of refined elegance and weighty stature is characteristic of the cycle. The statues have a special significance: they surround, as a

grave, dignified congregation of apostles, the relics of the Passion preserved in the choir.

The cycle is not a stylistic unity. The statues in the Musée de Cluny (pl. 184, ill. 89) and the figure from the south side of the chapel (pl. 185 middle) show a strictly block-like construction and avoid protruding forms. The folds form narrow ridges or run down the upper torso like spear-heads. The beginnings of this style are to be found on the west façade of Notre Dame in Paris: the Coronation portal (pl. 153), and above all the later parts of the Last Judgment portal (pl. 146 top, 147). An intermediate stage is characterized by the figure of Christ on the trumeau of the centre doorway of the Amiens west portal (pl. 163).

The fourth and fifth figures on the north side (pl. 185 left and right) are different. They show a broad rendering of the draperies, either bellying out or in piled up masses. The facial characteristics of the fourth figure (pl. 185 right) – the hair parted in the centre, the curled beard accentuating still further the oval outline of the face – resemble those of the Judge of Notre Dame. The fifth figure (pl. 185 left) displays an abundance of short locks which frame the cheeks and forehead like a wig. The emphasis on lavish display, which was characteristic of the architecture and furnishing of the Sainte-Chapelle, is reflected especially clearly in the style of these two figures, the most unusual of the cycle. All the same, in view of the colouring, it is difficult to judge the state of preservation.

F. de Guilhermy 1867; H. Stein 1912; P. Vitry 1929, p. 74f.; H. Bunjes 1937, p. 30ff.; F. Salet 1951; F. Salet 1954; L. Grodecki 1962; R. Branner 1965, p. 56ff.; C. Gnudi 1969.

Pl. 186–188

PARIS, NOTRE DAME
NORTH TRANSEPT PORTAL

The rebuilding of the cathedral, which began in 1160, was completed in the early decades of the thirteenth century with the erection of the west façade. Simultaneously, a start was made on alterations and additions. In the second quarter of the thirteenth century walls to contain chapels were built between the buttresses of the nave. Subsequently the arms of the transept were extended north and south. An inscription on the south transept gives 1257 as the year when the building was begun and names Jean de Chelles as the architect. It is generally assumed that the slightly earlier facade of the north transept was designed by the same architect c. 1250 and executed by him during the ensuing decade. The north transept portal led to the private area reserved for the canons of Notre Dame, hence the name 'Porte du cloître'. Of the large figures only the trumeau figure of the Virgin (pl. 188) survives. According to Lebeuf the Three Magi were displayed on the left jamb. Jamb figures and trumeau statue were thus incorporated into a scenic group, as on the Coronation portal at Amiens (pl. 168 left, 166, 167). On the left jamb, according to Lebeuf, were the theological Virtues: Faith, Hope and Charity. The

combination of Marian iconography with the Virtues is already found on the left doorway at Laon (pl. 70, 71) and the north portal at Chartres (pl. 94); a novel feature is the representation of the Virtues as large jamb figures.

The tympanum is divided into three bands (pl. 186). The bottom bands shows the Infancy of Christ: (from left to right) the Nativity, Presentation, Massacre of the Innocents, Flight into Egypt. In the Nativity and Presentation there are striking iconographic similarities with the jubé at Chartres (pl. 126, ill. 60). An unusual feature is the presence of the Dove (Holy Spirit) at the Nativity. Herod orders the massacre on the whispered instructions of a small devil. The two upper bands illustrate one of the Virgin's best known miracles: the legend of Theophilus. Theophilus acted as governor for the bishop of Adana in Cilicia. Removed from office by the bishop's successor, Theophilus turns eventually to a Jewish sorcerer for advice on how to recover his prestige; through this intermediary a pact is arranged between Theophilus and the Devil. In the middle band (on the left) Theophilus kneels down and pledges himself as the Devil's vassal; behind Theophilus stands the sorcerer, with his left hand on the 'vassal's' shoulder and in his right the contract, with its dependent seal. Theophilus becomes prosperous and distributes money, which he receives from the Devil. Eventually he is smitten with remorse and prays to the Virgin to release him from his pact with the Devil. The prayers he offers, kneeling beneath an arcade and facing an altar dedicated to the Virgin, are heard. The Virgin threatens the Devil with a raised sword held by the blade and tears the parchment from him. Mary's stance bears a striking resemblance to that of a Christ in Limbo or to representations of Michael. In the upper band we see the bishop of Adana, displaying and expounding the sealed compact to a gaping populace. It bears the inscription 'Carta Theophili'. The figure to the left of the throne is presumably Theophilus. The Marian programme of the Porte du Cloître thus resembles that of Chartres or Laon in associating the Virgin with the Virtues, but by adding the Theophilus story stresses her role in the salvation of repentant sinners. Cf. liturgical texts referring to the Office of the Virgin in which the restoration to grace of Theophilus is specifically mentioned.

In the archivolt arches (pl. 187) are angels, standing female figures and seated male figures with banderoles (prophets?). Many of the attributes are replacements.

Portal type. This is the first example of a gothic portal with niches for jamb figures. The socle is unusually high. Its compartments are arranged like the aedicules on the finials of High Gothic buttress piers. The narrow niches are polygonal – extending over three sides of the octagon – and topped by pentagonal baldachins. This jamb arrangement was widely imitated in portals of the later thirteenth and early fourteenth century. The trumeau has a socle of the same 'aedicule' type (pl. 188 right). Its diagonal placing is inspired by the side doorways of the west façade of Amiens. In this case the diagonal arrangement prepares the way for the turning movement of the trumeau figure above. Another

Ill. 89 Bartholomew(?), from the Sainte-Chapelle, Paris. Between 1241 and 1248. (Paris, Musée de Cluny)

Ill. 90 The group of the Three Magi, from a buttress aedicule of Notre Dame, Paris. Towards or about 1260. (Paris, Musée de Cluny)

new feature is the tall gable crowning the portal. It is independent of the wall of the façade and is thus purely ornamental. This device, which gives the portal its steep and pointed silhouette, was imitated throughout Europe until well into the fourteenth century.

Style and dating. The trumeau figure is characterized by the curvature of the body: it starts from the right foot, runs freely up to the left hip and is underlined by a few, sharply indicated, drapery motifs. The lower part of the body is greatly elongated, the torso conspicuously short. There is an explicit pointedness to the whole figure, both in face and outline. The pronounced turn towards the right jamb today looks incomprehensible, and must be seen in the context of the adoring Magi who formerly occupied that position. All the same it is significant that Amiens used the same group twenty-five years earlier, without introducing any torsion into the trumeau figure (pl. 168 left). The stylistic antecedents are difficult to detect. It is only in the most general sense that we can admit the Salome of the Paris Coronation portal (pl. 156 bottom left) as a remote prototype. As parallels we can perhaps adduce the sculptures of the Baptist's portal at Rouen, in particular Herodias and Salome (pl. 182 top). The effect of this Paris Virgin was far-reaching, witness amongst others the Virgins and Virtues of the west façade of Strasbourg.

The bottom band of the tympanum is quite different, with its broad, unstrained forms, and with the scenes ranged one beside another in picture book style. The upper bands with the Theophilus legend, which are the work of another hand, reveal more of the flexibility of the trumeau figure. Here the

emphasis is on an effect achieved through the contours. Pointed gestures and supple movements are used to support an eloquent narrative. Here too there are remote parallels with Rouen – the apex of the tympanum in both side door-ways (pl. 182). For later manifestations of the style see the south transept portal of Notre Dame (pl. 267–270) and the Porte Rouge (cf. p. 490, pl. 271). Elsewhere this figure style, at once highly conventional, vivid and dry, seems to have found few imitators. Even on the Paris south transept, it was already being overtaken by modern influences emanating from Rheims. Date: *c.* 1250.

J. Lebeuf 1754, vol. I, p. 13; F. de Guilhermy, E. Viollet-le-Duc 1856, p. 80ff.; M. Aubert 1920, p. 137ff.; P. Vitry 1929, p. 66f., p. 71f.; M. Weinberger 1930–31; H. Bunjes 1937, p. 37ff.; M. Aubert 1946, p. 260ff.; R. Branner 1965, p. 76ff.; D. Kimpel 1969; *see also* Appendix to Bibliography.

Ill. 90

PARIS, NOTRE DAME
THE THREE MAGI (NOW MUSEE DE CLUNY)

In the third quarter of the thirteenth century walls to contain chapels were built between the buttress piers of the nave of Notre Dame. A start was also made on renewing the buttress work; all that survives from this building phase is the first pier to the east of the north transept. It is surmounted by an open aedicule with slender columns, small pinnacles at the corners and pointed finials (completely restored under Viollet-le-Duc, preserving the old forms). The delicately proportioned forms of this Paris aedicule provided a model amongst others for the west façade of Strasbourg. The

interior was occupied by the Three Magi as a group carved from the same block; the sculpture seen here today is a replica. The originals are in the Musée de Cluny (ill. 90). The pronounced bend to the body, together with the sharp delineation of the drapery, marks the group as a work from the circle of the Virgin on the trumeau of the north transept portal (pl. 188). There are records from the 1250s and 1260s of the endowments of altars for the two chapels east of the north transept. The group was presumably made not long after the trumeau figure, towards or *c.* 1260.

J. Lebeuf 1754, p. 12 f., vol. I, p. 12–13; M. Aubert 1920; Musée de Cluny 1922, no. 188; M. Weinberger 1930–31; H. Bunjes 1937, p. 40.

THE SCULPTURES OF RHEIMS CATHEDRAL

Pl. 189–265, ill. 91–99

RHEIMS (MARNE), CATHEDRAL OF NOTRE DAME

The archdiocese of Rheims with its ten suffragan sees was one of the largest ecclesiastical provinces in Gaul. In 496 an archbishop of Rheims, St Remigius, baptized Clovis I, the first king of the Franks to be converted to Christianity. In the ninth century Rheims evolved the legend that at the time of his baptism Clovis was anointed with oil brought down from heaven by a dove. It was from this legend that the archbishops of Rheims derived their claim to anoint and crown the kings of France. The holy oil was supposedly preserved in the 'Sainte Ampoulle' in the abbey church of Saint-Rémi, and was delivered to the archbishop for the anointing on the day of coronation. The cathedral of Rheims was the coronation church of French kings from the thirteenth century until the Revolution.

The existing cathedral is an edifice rebuilt in the thirteenth century. Its chronology and architectural history are still matters of debate. We have only a few firm dates to go on. The old cathedral was probably destroyed by fire on 6 May 1210. The new building was begun on 6 May 1211. During the first twenty years we hear of building activity carried on 'cum industria maxima'. Between 1233 and 1236 the archbishop and cathedral chapter had to yield to rebellious townsmen. Stones from the building site were used for the erection of barricades, and at that period work on the new building presumably came to a complete standstill. On 7 September 1241 the chapter occupied the new choir. On progress in the following decades the sources offer only indirect information: in 1246 and 1251 Innocent IV issued indulgences in respect of contributions to the building costs. In 1299, when the archbishop gave permission for a strip of land on the south side of the nave to be used by the masons' yard, the cathedral – apart from the royal gallery and the freestanding storeys of the west towers – must have been long since completed. Set into the pavement of the nave was a labyrinth, destroyed in 1778, the inscriptions on which have come down to us in an incomplete and apparently not wholly reliable version. It named as the architects Jean d'Orbais, Jean Loup, Gauche de Reims and Bernard de Soissons. From the brief information given in this inscription it is impossible to deduce the order in which they succeeded one another or the nature of their contribution.

In scope the sculpted cycles of Rheims cathedral exceed all comparable thirteenth-century undertakings, not only in France but throughout Europe. From the portals the statuary decoration spread to all parts of the building and was eventually continued even on the inner wall of the west façade. The buttress piers of the ambulatory chapels, the aedicules surmounting the buttresses from the choir to the west façade, are all adorned with large figures; statues and reliefs appear in the soffits of the rose window. The triforium of the transept displays busts and head-shaped corbels – the 'masks' which are then repeated in the archivolts of the clerestory windows and beneath the eaves of the transept towers. On choir and nave, above the buttress arches, Atlantes crouch beneath the cornice. A few neighbouring structures (Châlons-sur-Marne, Notre-Dame-en-Vaux; Braine, Saint-Yved; Laon cathedral; Soissons, Notre Dame) had prepared the way by spreading figure decoration to the eastern portions or the upper storeys. Compared with Rheims, however, these efforts were modest in scope and also – so far as we can now tell – in execution. On the choir and transept of Rheims cathedral even sculptures destined for the most out of the way position are works of the highest artistic merit.

The French Revolution caused only minor damage to the centre of the west portal. Renovations had already taken place in the archivolts and gables of the west façade, starting in 1611, and on the upper storeys of the west façade, starting in 1734. The nineteenth century brought further, not very extensive restorations, for example to the archivolt of the left doorway of the west portal and to the Judgment doorway on the north transept. Enormous damage was done by artillery bombardment during the First World War. The works which suffered most, and which could be reinstated only in part, were: the sculptures on the ambulatory chapels, on the upper storeys of the transept, on the left doorway of the west portal, on the rose window storey of the west façade, and the side portions of the sculpture on the interior west wall. In recent years the sculptures on the west façade have been cleaned.

Of the dates mentioned above, the only ones of any consequence for the chronology of the sculptures are 1211, the year in which building began, and 1241, when the chapter took possession of the choir. We need look for no sculptural activity earlier than 1211; by 1241 the sculpture on the upper storeys of the choir and transept was presumably

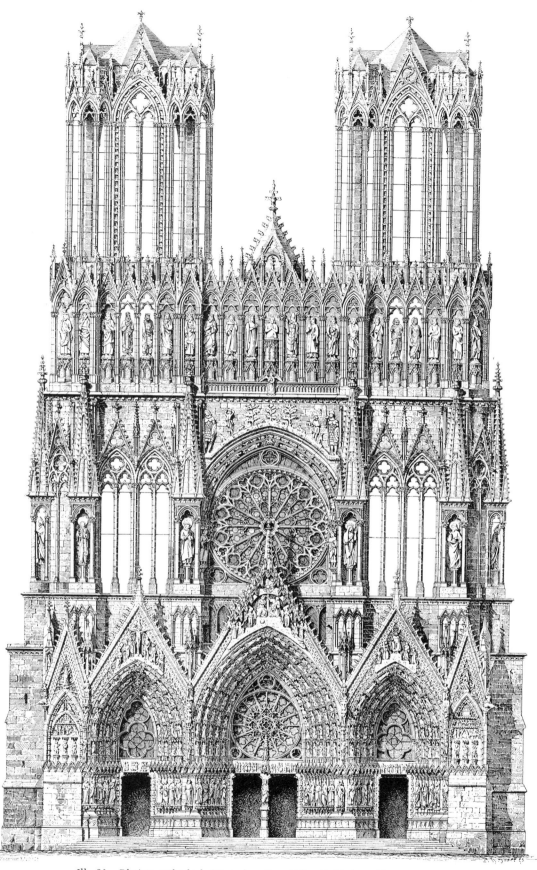

Ill. 91 Rheims cathedral. West elevation. (After Dehio/Bezold IV, pl. 412)

complete. We have no firm dates for the west doorways. Comparison with dated monuments deriving from Rheims gives us a few further points of reference. The cathedral at Bamberg was dedicated in 1237; the Bamberg sculptures presuppose the existence of those of the eastern parts of Rheims, including the corbel heads and the statues on the buttresses of the main choir, together with several figures on the west façade. If the Bamberg sculptures were in fact completed by 1237, the works in question at Rheims must have been made before the disturbances of 1233. The jubé of Strasbourg cathedral is mentioned for the first time in a document of 1261; the sculptures on it presuppose the existence of the archivolt sculptures of the left doorway of the Rheims west portal. In 1263–64 St Louis commissioned a new burial place for the Carolingian and Capetian kings at Saint-Denis. Employed on this project were sculptors who had worked on the archivolt on the right doorway of the Rheims west portal. It follows that the later portions of the Rheims west doorways were probably completed during the 1250s. Our only means of establishing a chronological order for the remaining vast but highly diverse body of Rheims sculpture is by comparative style-criticism coupled with close attention to the history of the cathedral's construction. As an additional complication, in the period before 1241 work was proceeding simultaneously on the eastern portions and on the sculptures for the prospective west façade. Taken on its own, therefore, the place of installation is an insufficient basis for a style-critical verdict, and hence, with the exception of the 'Porte romane' (for which see above p. 415), the Rheims sculptures are here illustrated and discussed all in one group. We begin with a summary of the content and then proceed to a brief survey of stylistic developments.

WEST FAÇADE

On the centre portal (pl. 190, 191) the principal theme is the Coronation of the Virgin. In the great triple portal layouts which precede Rheims – Paris (pl. 144) and Amiens (pl. 161) – the Last Judgment is the central feature of the programme. In part the programme for the Rheims west portals may possibly have been decided shortly after 1221, and adhered to when the time came later for its execution. The tympanum, like the tympana of the side doorways, is pierced by a window. The Coronation is therefore displayed on the gable. The existing group is a modern replica; the original is in the Palais archiépiscopal. There had already been some tampering with the group during the restoration of 1611. A crowned Christ sets the crown on the head of a praying Mary; flanking the pair are seraphim and angels.

The archivolt figures, with a few exceptions, were renewed in 1611–12. Extant are the inside arch with standing and kneeling angels bearing candlesticks, sun and moon, and crowns, also four enthroned kings with musical instruments. In the second arch, bottom left, is the slumbering Jesse, here with a rose bush growing from his loins (ill. 92), together with kings, mostly with musical instruments, perhaps Elders of the Apocalypse – not entirely preserved in

their original state. In the three outer arches very few of the figures are old: on the right, amongst other subjects, are God in the burning thorn bush, the three young men in the fiery furnace, the angel marking the houses of the Israelites. The archivolt thus portrayed Christ's royal forebears, but not in the traditional form of the Stem of Jesse accompanied by Old Testament types for Mary's virginity (cf. the left doorway of Laon, pl. 70, 71 and the Coronation portal at Amiens, pl. 166, 167). Bottom left we see Mary going with Anne and Joachim to the Temple. This group was presumably associated with the Marian scenes on the lintel, chiselled off in 1793.

The standing trumeau figure is Mary, shown – as at Paris and Amiens – as the New Eve (pl. 189). (The Child and Mary's crown are new and Mary's head has been touched up.) The polygonal socle shows on the left God speaking to Adam and Eve, on the right the expulsion from Paradise. The front face, now bare, showed the Fall. As at Paris, the side faces of the trumeau are adorned with figures: the Virgin is accompanied by fourteen angels bearing censers (pl. 189 left). The angels, in relief, are unframed, the same arrangement being found on the doorposts (pl. 192, 193), where on the inner side a further sixteen angels turn in attitudes of prayer towards the Virgin. On the outer side are the Calendar and Seasons(?). The model was obviously the programme in Paris (pl. 154 middle and left).

On the jambs (pl. 192, 193), as at Amiens (pl. 167), are single figures illustrating the main events from the life of the Virgin and the Infancy of Christ. The cycle begins (inside right) with the Annunciation (pl. 198, 200, 201), followed on the outside by the Visitation (pl. 199, 202, 203). While on this jamb, as previously at Amiens (pl. 167), the figures are grouped in pairs, in the Presentation on the left jamb (pl. 192) the statues appear in a group of four: Mary with the Child (pl. 195) and Simeon, with covered head and hands (pl. 196), are flanked on the left by Joseph (pl. 194) with the sacrificial doves, and on the right by Mary's maidservant (pl. 197), who perhaps held a second basket containing doves. Joseph wears the characteristic Jew's hat of the thirteenth century.

On the front face of the buttresses are, on the left, the Queen of Sheba (pl. 204) and, on the right, King Solomon (pl. 205). As Old Testament types for Sponsa and Sponsus they had already figured at Amiens in the programme of the Coronation portal (pl. 166). The figures on the corners of the buttresses cannot be named with certainty. On the left there is a prophet, again wearing the Jew's hat (Isaiah?; pl. 204). On the right, a bearded king (David?; pl. 205). This programme had Paris and Amiens as its starting point.

Seven of the statues have been found to carry installation marks: the figures on the right jamb bear a T, and those on the left a crescent. The sequence on the jamb was indicated by strokes: thus the Virgin of the Annunciation is marked with a T and two strokes, the corresponding figure of the Visitation with three strokes, Elizabeth with four and the king on the corner of the buttress with five. Two figures

476

carry marks which do not tally with their present position. The angel of the Annunciation (pl. 198, 200) is marked with an arrow and three strokes. According to this marking he was originally intended as the left-hand escort of the martyr saint on the left doorway of the west portal (pl. 206, 210) and only became Gabriel when the statuary was finally assembled; this accounts for the smile, unusual in an angel of the Annunciation. The right wing must have been removed to allow for placing next to the doorpost. According to the marks – crescent and three strokes – Mary's maid-servant was originally intended to stand next to Joseph, which means that the present grouping as a foursome was devised only when the figures were assembled. The original intention was to show the figures in pairs, as on the right jamb. The Queen of Sheba (pl. 204) and Solomon (pl. 205) were also surely meant to stand beside one another as a pair. The queen, coming to seek out the wise ruler, is shown with a walking movement (cf. Chartres, pl. 92). The present placing destroys the logic of the content. The columns originally at the back of the statues have been pared away or bricked in. Traces of the same process can be seen in the four figures on the front of the flanking buttress piers of the side doorways. It has long been recognized that the planning of the Rheims jamb cycle went through many different stages. Even when the last statues were completed, changes were made in the course of installation. Formal considerations, the desire to achieve a symmetrical grouping, led to sacrifices of coherence in the content.

Side doorways. On the left the central theme is the Crucifixion, on the right Christ as Judge. The juxtaposition of a Coronation portal at the centre and a Judgment on the right is already met with on the west façade at Laon. It seems to have been a local tradition. On the other hand, there is no precedent for the Passion cycle of the left doorway. The jamb programme of the side doorways is not entirely clear, partly because the sequence of the existing installation may possibly diverge from the original design, and partly because of uncertainties regarding the identification of individual statues.

In the gable of the left doorway is the Crucifixion (extensively restored in 1734). In the archivolt, a christological cycle appears (pl. 214, 215). It begins on the left, on the buttress pier next to the portal, level with the bottom rank of the archivolt. Far left, the Devil challenges Christ to turn stones into bread. This is followed by the second temptation, in which the Devil is still on the buttress; the Lord, in the first arch of the archivolt (bottom; pl. 214) is shown enthroned on a gothic building symbolizing the pinnacle of the Temple. The third temptation is made the subject of a group. Christ is seated on a hill; below him kneels the Devil, showing him all the treasures of the world; in the next three arches we see Christ, making a gesture rejecting the Devil, flanked by angels with censers: 'And, behold, angels came and ministered to him' (Matt. 4:11). The cycle is arranged like a frieze running across the arches of the archivolt. Narrative coherence and content are more important

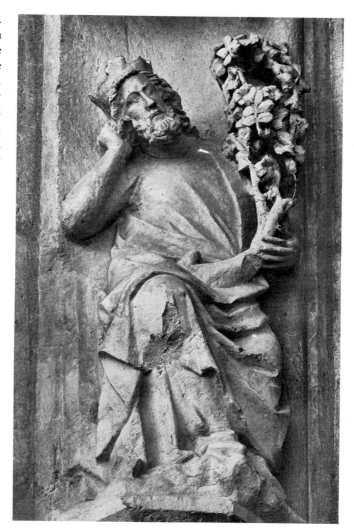

Ill. 92 Rheims cathedral, west portal, centre doorway. Detail of left archivolt: Jesse. About 1245–55

than conformity with the architectonic framework of the portal. Thus in the second register the Entry into Jerusalem spreads across all five arches: on the outside, Peter and another apostle (destroyed in 1914), then Christ on the donkey, with the foal trotting beside; the escorting figure is John; next the populace, spreading their garments before him and breaking branches from the trees, followed in the inner arches by further groups of waiting spectators (in the inside arch, destroyed). In the next row above, the first two arches show Christ washing the feet of the disciples (the group with Peter at their head is largely destroyed). In the three inner arches we see the watching disciples and Christ climbing the Mount of Olives (Christ's drapery seemingly remodelled in the baroque style). The sequence continued above with the arrest, Peter and Malchus, the kiss of Judas, disciples and soldiery with lanterns, the scourging, Christ bearing the cross and its preparation, and the suicide of Judas. These scenes were very badly damaged in 1914.

477

The cycle is important historically as the oldest surviving example of a Passion sequence in thirteenth-century portal sculpture. The figures on the right (pl. 215) were in a bad state of preservation even before 1914. The apostles in the two outer arches were renewed in 1837, prophets from the interior west wall being used as models. In the bottom row, reading from the outside, are: Christ in Limbo; a hell scene derived from illustrations of the Last Judgment; the Resurrection (the figure of Christ retouched) and an angel with a censer, turning towards Christ. Above, Emmaus: Christ is depicted in a pilgrim's fur robe facing the two disciples, who are dressed in travelling clothes and carrying long staffs (partially damaged in 1914). In the row above, Christ is flanked by three disciples (the two outer figures destroyed in 1914), a scene representing one of Christ's appearances after the Resurrection. Higher up are further scenes following the Resurrection, including the Ascension.

Despite the many reworked and damaged figures it is thus clear that this unusual cycle began on the outside with the temptations of Christ, culminated in the gable with the Crucifixion, and continued on the right with scenes from the Passion to the Ascension. Broadly speaking, the blind tympanum on the north buttress also belongs to the Passion cycle; it depicts the Discovery of the Cross by the Empress Helena.

The lintel, with the conversion of Saul (pl. 222 top), extends the cycle still further. On the right we see the walls, gate and houses of Damascus; the preceding scene on the left shows the blinded Saul, in cloak and armour, plunging from his horse. The 'light from heaven' (Acts 9:3) streams from a band of cloud on to the head of Saul and his horse. A companion in helmet and armour draws his sword, while the retinue, armed with axes and halberds, gaze with astonishment at the fallen figure. The sequence continues on the lintel of the right doorway (pl. 222 bottom). The blinded Saul is led to Damascus; he regains his sight and is instructed by a priest; he is baptized as Paul. For the baptism he stands naked in a basin while a cleric pours water on her head; on the left are five figures who, in accordance with liturgical custom, bear the baptismal shift and a processional cross.

On the inner side of the doorposts we see angels (pl. 206, 207); their attributes were unrecognizable even before 1914. On the outer sides are enthroned male figures with banderoles, book, and cross, who are no longer identifiable. At the top is an angel.

On the left jamb (pl. 206), reading from the inside (i.e. from the right in the picture) we see: a martyr flanked by angels (pl. 209–211), who is vested as a priest but without pallium or rationale (insignia of a metropolitan archbishop), and who presumably held the sawn-off top of his cranium in his hands; a woman with a crown (pl. 206, 208); two figures – a bishop without the pallium, and a deacon with a book – were destroyed in 1914. On the right jamb (pl. 207), reading from the inside (i.e. from the left in the picture) we see: a deacon with palm; a male figure in a long robe, cloak

and shoes, and carrying a book; a woman with a book (pl. 207, 212); a beardless apostle (pl. 207, 213); and a bishop without the pallium. Many identifications have been proposed, but none can be regarded as certain. The martyr on the left jamb (pl. 210) is thought to be either Nicasius or Dionysius; as archbishop of Rheims Nicasius would wear the pallium and rationale, so of the two Dionysius is the more likely. The crowned woman (pl. 208) has been described as Helena, but the appropriate attribute, the cross, is lacking. The apostle (pl. 213) is presumably John the Evangelist. The other figures provide no clues as to their identity.

The installation mark for the left jamb (pl. 206) is an arrow. It is present on the angel (pl. 211), the martyr (pl. 210) and the deacon, who are thus in their intended places. There is also an arrow sign with four or five strokes on the papal figure (pl. 217 right) on the right doorway of the west portal. From the evidence this figure, too, was intended for the left jamb of the left doorway. The angel (pl. 209) on the right of the martyr bears a T and a stroke. From the marking, therefore, it was originally intended as Gabriel, and was exchanged at the time for installation with the angel of the Annunciation (pl. 200) marked with an arrow. Even so, he was probably originally intended as a martyr's angel, since he is shown with a censer. In studying the jambs of Rheims, we have to reckon with many changes of plan. There is nothing to be gleaned from the installation marks on the right jamb, since the facts are not clear. Equally, there seems no prospect of offering well-founded comments on the programme as a whole.

Above the right doorway the Judge and attendant figures in the gable have been extensively renewed. In the archivolt (pl. 223–225) we find not the Last Judgment but the Apocalypse, a cycle as singular in thirteenth-century portal sculpture as is the Passion cycle on the left doorway. So far no detailed examination of it has been made. For elucidation of minutiae in the content one would have to make comparisons with other renderings. Mâle drew attention to resemblances between individual scenes and the so-called Anglo-Norman Apocalypse illustrations of the thirteenth century. The cycle begins in the outer arch, bottom left (pl. 224), with John turning at the sound of the great voice behind him (Rev. 1:10). Beside him, and in the row above, are depicted the seven churches of Asia (Rev. 1:11); each of these buildings contains an altar with a chalice, and a pendant light, and is surmounted by an angel bearing a scroll. The figures in the three outer arches in the rows above were largely renewed in 1611. In the third row of the inner arches we see the Elders, standing figures with crowns and vials but without musical instruments (Rev. 4 and 5). At the top of the inside arch is an angel holding the wind (Rev. 7:1); the angel is standing, the wind is personified as a head (pl. 224, 223). In the second and third arch angels armed with sharp sickles reap the harvest (Rev. 14:14). The scenes in the two outer arches probably portray the sealing of the righteous (Rev. 7:4–8), and the souls of the slain, clothed by an angel (Rev. 6:9–11). On the right, at

478

the bottom of the inner arch (pl. 225), we see perhaps the seven-headed beast (Rev. 13:1), and beside it the angel with the key (Rev. 20:1). Next come the angels bound in the Euphrates, who will be released at the sixth blast of the trumpet (Rev. 9:14); on the neighbouring buttress they are shown slaying a third of mankind (Rev. 9:15). In the second row we see (inside) John and the angel (renewed 1611) whose countenance was like the sun (Rev. 10:1), followed in the outer arches by the war of the angels in heaven (Rev. 12:7), with Michael vanquishing the dragon. In the row above the marriage of the Lamb (Rev. 19:7) is depicted: Christ, as the lamb, appears with the chalice on the inside arch; facing him is the Bride; in the outer arches are angels and elders. The upper ranges portray punishments and torments. In the inner arch, an angel pours one of the vials of wrath over a shrieking man (Rev. 16:2). Next to him the Rider of the Apocalypse from whose mouth went a 'sharp sword' (Rev. 19:15). Above him is the angel in the sun(?) referred to in Rev. 19:17. In the third arch the birds feed on the flesh of 'men . . . both small and great' (Rev. 19:18), and, above, the angel casts the millstone into the sea (Rev. 18:21). The cycle ends (top right) with the sealing of the bottomless pit into which the Devil is cast (Rev. 20:3). Below, two figures bewail the fall of Babylon (Rev. 18:11 and 21). As on the left doorway, therefore, the first scene of the cycle is placed at the bottom left and the last scene at the top right; in between, however, the presentation does not adhere to the sequence of the text, and this makes individual scenes difficult to interpret. Further apocalyptical scenes appear on the blind tympanum of the buttress: John before the Lamb as he opens the book with seven seals, the Riders of the Apocalypse, the souls of the slain crying for vengeance before the altar.

An exhaustive elucidation of the twenty-eight reliefs on the doorposts (pl. 221) has yet to be achieved. It may be correct to see the figures on the inner sides as Virtues (left) and Vices (right), confronting one another. Thus there is a woman with an alms bag (pl. 221 middle) – Largitas(?) – and higher up perhaps Hope, a woman looking up. On the outer faces the interpretation is more difficult still. The top four reliefs on the right seem to follow the iconography used for representations of the months (pl. 221 right): below a half-clad man we see a young man seated in front of a vine, and below him a man in a hooded cloak warming himself before a fire in a grate, but this is followed by another figure in a vineyard. Various interpretations have been offered of the three figures at the top left (pl. 221 left): of these the Ages of Man is the most plausible. Level with the lintel brackets are seraphim.

The left jamb (pl. 218), reading from the inside (i.e. from the right in the plate), includes a male figure in a long robe, cloak and shoes and holding a book; a male figure with Jew's hat and banderole; and a pope. In addition to the conical tiara, the latter wears the rationale. Next comes a male figure attired like the first, again holding a book (pl. 217 middle); then a bishop without the pallium (pl. 217 left, pl. 205 right).

The second figure from the inside is certainly a prophet. The pope is presumably Calixtus I, whose body has been in the cathedral's possession from the early Middle Ages; he is also shown on the trumeau of the centre doorway of the north portal (pl. 244, 249). No names can be attached to the remaining statues. As already mentioned, according to the installation marks the figure of Calixtus (pl. 217 right) was originally intended for the left doorway of the west portal. We pass over the other installation marks so far discovered, since they allow no positive conclusions. On the right jamb (pl. 219, 220) we see, reading from the inside (i.e. from the right in the plate): Simeon; John the Baptist; Isaiah, with the slumbering Jesse on the console; Moses and the brazen serpent, with the golden calf on the console. Then come Abraham with Isaac, with the ram on the console, and Samuel, with David(?) at his feet. These six figures were part of an earlier programme, subsequently abandoned, and were installed on the existing façade as stop-gaps. In content they bear no relation to the other sculptures of the portal.

The following sculptures help to extend the programme of the west portals (pl. 190). On the outer flanks of the buttresses are scenes referring on the north side to John the Baptist, on the south side to John the Evangelist. Between the archivolts of the portals we see rivers of Paradise. The four support figures beneath the gargoyles above the rivers have no specific content: their proposed identification as the four quarters of the earth has no foundation. Equally, no definite explanation can be given of the eight figures with musical instruments, enthroned between the gables. They have to a large extent been renewed. The suggestion that the heavily restored female figures on the outer blind gables are Mary (left) and the crowned Ecclesia (right) is also hypothetical. There is no doubt as to the identity of the figures in the aedicules between the gables: on the left, Ecclesia and Synagogue on either side of the Crucifixion; on the right, angels with trumpets flanking the Judge. To sum up: whereas the jamb figures, many of them completed decades before the portals were erected, were in several cases installed without noticeable regard for a coherent content, the programme on the gables, archivolts and lintels forms a meaningful whole. At the centre stands the traditional Coronation of the Virgin, flanked on one side by the Passion, on the other by the Last Judgment. The cycles of the side doorways were previously unknown in portal sculpture.

Interior west wall. The programme of the upper portions of the west portal is expanded internally. The walls next to the doorway openings are lined with figure-niches. In the centre aisle (pl. 229) these reach up as far as the triforium. In the side aisles they cover the entire wall between the doorway opening and the formerets (pl. 234, 235). Each figure and niche is made from a block 4 ft 6 in. high, the figures being in high relief, rather than freestanding statues. Each niche was worked and installed separately, so that the walls are built up from individual figure blocks. Here again the units carry marks indicating their pre-ordained position. In the centre aisle they are same as for the jamb outside.

The programme in the centre aisle the northern (right) half of the wall is concerned with John the Baptist, the southern half with Mary. Individual scenes on the right are as follows (cf. plate 229): (bottom row) a priest in dalmatic and chasuble standing before an altar, in his left hand the chalice, in his right the Host; facing him, an armoured figure in chain mail and tunic, his hands laid together in prayer; a second figure in armour. No convincing explanation for this Communion scene has yet been found: the identification with Abraham and Melchizedek is dubious; Archbishop Turpin and Roland are definitely wide of the mark. In the second row from the bottom we see (in the centre) the Baptist preaching ('And now also the axe is laid unto the root of the trees', Matt. 3:10), with prophets, presumably, on either side (pl. 231 left). In the third row: the Baptist before Herod and Herodias (pl. 230 right, 233); cf. the Baptist's words: 'It is not lawful for thee to have her' (Matt. 14:4). In the fourth row the Baptist is shown with the Lamb of God (pl. 229), perhaps with disciples on either side. The fifth row shows the annunciation to Zacharias, and the sixth row the Baptism of Christ. In the top row John's disciples are seen asking Jesus: 'Art thou he that should come?' (Matt. 11:3). On the left (pl. 229, 230 left) we see (in the bottom row): on the right, a king (David?); a prophet (pl. 231 right); and, on the left, a figure in long robe and cloak, but without shoes (apostle?). In the second row the Annunciation to Anne and Joachim is depicted. (According to the apocryphal gospels Joachim received the news in the fields, Anne at Nazareth; here Anne, Joachim and the angel are shown side by side.) Anne's wrinkled face very clearly characterizes her as an old woman. In the third row we see the meeting at the Golden Gate (pl. 230 left, 232). The scene deviates from the customary presentation in that Joachim and Anne do not fall into one another's arms beneath the gateway but walk behind each other towards it. Standing beneath the arch is a servant with a staff, smiling at the approaching pair. Anne shows the same signs of age as in the annunciation. Joachim is shown here as a toothless old man with sunken cheeks, toiling along with the aid of a stick. In the fourth row are three prophets, the middle one holding as his attribute the crib with the Christ Child, ox and ass (Habakkuk). The fifth and sixth rows depict the Massacre of the Innocents at Bethlehem. In the seventh row we see the Flight into Egypt, with Mary shown on foot instead of mounted. In the niches beside the apex of the arch are two types for the virgin birth of Christ: Moses and the burning bush, Gideon and the fleece. The scenes on the left relating to the Virgin are a very clear continuation of the portal programme. The connection was presumably even plainer when the lintel scenes were still *in situ*. The iconography shows some peculiarities, often due to the need to represent scenes by means of single figures displayed in the niches.

The inner side of the lintel (pl. 229) depicts the execution of John the Baptist and the burning of his bones, in each case in the presence of Herodias and Salome(?). On the inner side of the trumeau the standing figure of St Nicasius: he turns

inward and is vested in pontificals, including the rationale to which he was entitled as archbishop of Rheims. He is shown headless. According to his Legend, he was martyred at the hands of marauding Vandals on the threshold of the first cathedral; the event is commemorated in the 'Rouelle', a marble slab in the pavement of the centre aisle.

The north aisle has sixteen standing figures (prophets?), in pairs, on either side of the doorway opening. The reliefs round the doorway arch show, on the left, types for the Crucifixion (e.g. sacrifice of Isaac; brazen serpent; widow of Zarephath), and, on the right, scenes from the life of Christ (pl. 235), e.g. the calling of Matthew; the raising of Jairus' daughter (not, as usually assumed, the healing of Simon Peter's wife's mother); the Samaritan woman at the well. The reference to the exterior Passion cycle is unmistakable.

The south aisle likewise has sixteen single figures, said to be prophets. Around the arch (pl. 234) are scenes from the Apocalypse corresponding to those in the archivolt outside. At the bottom left we see angels 'holding the four winds' (Rev. 7:1); the winds are open-mouthed heads. The remaining reliefs on the left show John several times over, facing angels by whom he is called or inspired. The scene at the bottom right is usually associated with the wrath of God (Rev. 14:10). Above this is the 'woman clothed with the sun, and the moon under her feet' with her child, and, on the right, the menacing seven-headed dragon (Rev. 12:1–6). Next come two figures kneeling or in awestruck posture, facing a winged rider on a dragon-headed horse; John witnesses the avenging angels loosed from the Euphrates and their army (cf. Rev. 9:14). Further up John appears with angels. This cycle, unlike the scenes from the Apocalypse on the exterior, appears to follow the text of Revelation in its correct sequence. It begins bottom left with the stilling of the winds (chapter 7) and ends bottom right with the vials of God's wrath (chapter 14).

The inner sides of the lintels of the side doorways show the martyrdom of Stephen. The martyr's prayer for his tormentors, 'Lord, lay not this sin to their charge', is portrayed in the middle of the lintel on the Apocalypse/Judgment portal. Once again we are made aware that exterior and interior programme are one. (The lower portions of the interior walls of the side aisles were badly damaged in 1914.)

Upper storeys of the west façade (pl. 190). Like all the buttresses of the cathedral's exterior, those on the west façade are crowned by figure-filled aedicules. A cycle of ten statues represents the Lord's appearances after the Resurrection. In the aedicule just to the right of the rose, Mary Magdalen is depicted turning to Peter to tell him (John 20:2) of the empty tomb. It is striking how the dialogue connection is established between the two statues across the expanse of the south tower. With this group goes the figure of John standing in the northern aedicule: according to the Gospel he hastened with Peter to the tomb. The aedicule just to the left of the rose was occupied by Christ (pl. 228) in the dress of a pilgrim, meeting the disciples on the road to Emmaus. The two smaller statues in the soffit of the rose

window belong to this scene: the disciple standing nearest to Christ turns round to look at him, the other looks across at him. Note again the great distances involved in this group composition. On the flank of the north tower, the Resurrected Christ (pl. 227) appears to doubting Thomas (pl. 226). In the corresponding position on the south side are Paul, to whom the Lord appeared at Damascus, and an apostle with a knobbed stick, James the Less. The cycle is further expanded on the east corners of the towers. (The figures on the north tower were destroyed or damaged in 1914.)

The portals, interior wall and buttress aedicules of the Rheims west façade present a programme whose intent is exclusively sacred. In the zone above the rose window (pl. 190) the figures start to refer to the cathedral's role as the coronation church. Among the prayers which accompanied the coronation ceremony God is invoked as follows: 'May He who raised up David and delivered him from Goliath and who filled Solomon with wisdom, protect the king of France, raise him up like David and make him wise like Solomon.' The anointings of David and Solomon, the judgment of Solomon and his building of the temple, appear in the archivolt around the west rose. On the wall above, David vanquishes Goliath. During the king's anointing with holy oil, words were sung recalling the miracle which occurred when Clovis I was baptized by the archbishop of Rheims. In the topmost zone of the west façade Clovis is seen at his baptism, between Remigius and Queen Clothilde. Ranged at the sides are the kings of France. The figures of this topmost zone were made in the middle of the fourteenth century. The sculptures of the rose storey, however, in part renewed, belong to the portions executed in the thirteenth century.

NORTH TRANSEPT

Three figure-decorated portals open into the north transept: in the centre, a Saints' portal (the Calixtus portal; pl. 244), on the left a Judgment portal (pl. 236), and on the right a Virgin's portal, known as the Porte Romane (cf. p. 415).

The Saints' portal and the Judgment portal were installed as afterthoughts, as we can tell from the bricking up of the previously existing windows. It has been assumed that part of the sculpture was intended for a project on the west façade which was subsequently abandoned, but whether this is correct is impossible to decide. It can be taken as virtually certain that the Judgment portal (pl. 236–243), at least, was created specifically for its present location. The jamb of the Saints' portal (pl. 243 right–249) shows some irregularities in arrangement which might be due to a change in plan. No credence can be given to the unhistorical supposition that inroads were made on the architecture of the north transept façade in order to provide a home for rejected sculptures. The portals were undoubtedly assembled on their present site – before the erection of the west façade – to create an imposing entrance to the east portions of the cathedral. How the portals and the chapter cloister, which lay in front of the north transept, stood in relation to one another in the thirteenth century remains an open question.

The Saints' portal (pl. 244–249 and 243 right) has a trumeau figure of Pope Calixtus I (pl. 244, 249), in pontificals with rationale and tall conical tiara. On the walls (pl. 246, 247) are depicted the two most important archbishops of Rheims. On the left jamb (pl. 246) St Nicasius, holding his severed head in his hands, and also wearing the rationale; above the neck is a strip of cloud, from which angels emerge bearing the martyr's crown. On the right is his sister Eutropia, also a martyr, and on his left, the escorting angel, with censer and incense boat. On the right jamb we see St Remigius (pl. 248), vested as an archbishop with pallium and rationale, and by his head the dove which brought the Sainte-Ampoulle down from heaven; on his right is an angel, formerly with an incense boat. The figure in aristocratic lay attire on the left is still unidentified: the proposals so far made – Clovis, Samuel, Job – are either wide of the mark or conjectural.

The tympanum (pl. 245), divided into five bands, is further evidence of the way narrative cycles were replacing the older, hieratically monumental compositions on thirteenth-century portals. In the bottom band the scenes link up with the jamb programme. On the left, starting next to the trumeau, we see the martyrdom of St Nicasius. The martyr bishop, with folded hands and lowered head, kneels before the Vandals on the threshold of Rheims cathedral which is indicated by an aedicule. Behind him stands his sister Eutropia, who according to the Legend scratched out the eyes of one of the Vandals. After his death the saint walked to the altar and deposited his head upon it. Like all such martyr saints, he was escorted thither by angels, and we see them standing beside him, with censer and incense boat. On the right is the baptism of Clovis. Before the First World War, Remigius held in his right hand the Sainte-Ampoulle, and the legendary Dove hovered above it.

The second and fourth bands portray miraculous events associated with Remigius. In the second band: 1, an angel announces the saint's birth to Montanus the hermit; 2, the martyr's aged parents; 3, Remigius heals the blind Montanus with his mother's milk; 4, the saint expels the Devil from a young noblewoman of Toulouse. The last scene, lost as a result of war damage, showed the archbishop banishing fire demons from Rheims. In the fourth band: 1, Remigius brings back to life the young woman from Toulouse who had died after the expulsion of the Devil; 2, Remigius makes the sign of the cross over an empty cask in a wine cellar, whereupon wine flows from it and swamps the floor. Note that even the miracle scenes are rendered in ceremonious fashion, as though they were liturgical actions to be completed in accordance with a fixed ritual. In the apex, Christ is depicted between angels bearing martyr's crowns.

The third band portrays the story of Job. In the centre, Job scraping his body with the potsherd (2:8). The identification of the other groups presents some difficulty. The figure just to the left of Job is his wife. The group near his feet are perhaps the brethren and sister mentioned in Job 42:11. Job's three friends, Eliphaz, Bildad and Zophar (Job 2:11) appear twice over, far left. Emile Mâle interpreted the scene

481

(far right) as the arrival of the tidings of Job's first misfortune (Job 1 : 13–14).

In the archivolt (pl. 244, 243 right) the figures are of popes and (inside) bishops wearing the pallium – perhaps archbishops of Rheims. The figures in the middle are thought to be high priests; they wear the old cap-like mitre of the twelfth century and carry books.

The programme of the portal gives especial prominence to saints who were important to the church at Rheims: Pope Calixtus, whose body was preserved in the cathedral, Nicasius, who was a local martyr bishop, and above all Remigius, as founder of the archbishops' claims to crown the kings of France. Hence the idea that in content, if not in function, the Calixtus portal should be linked with the royal coronations.

The form of the Judgment portal (pl. 236–243 left) is unusual. The jambs are neither recessed nor slanting, but meet the entrance wall at a right angle. Thus in place of the usual archivolt we have a vault with pointed arches. This solution, which made it difficult to contrive a sensible distribution of the figure-programme, arose from the need to fit the portal between two existing buttress piers.

In the apex of the tympanum appears the strikingly large figure of the Judge, with arms outspread; on either side are the kneeling figures of Mary and John the Baptist. Beyond them two angels kneel (one on either side) with the cross, spear, and crown of thorns. Two zones immediately below the Judge are filled with the resurrected (pl. 238, 239). The two bottom bands show scenes of Paradise and Hell. At the bottom left, Abraham is shown with souls in his bosom, brought to him by angels on either side; this scene is flanked by angels escorting the Blessed. In the zone above are seated figures of the Blessed: an archbishop with pallium and rationale, an abbot with staff, a royal couple, a virgin with chaplet. On the right is an angel with censer and incense boat, and next to him a tree of Paradise. At the bottom right the angel with the flaming sword drives the Damned towards the cauldron of Hell, towards which the devil at their head is pulling them on a chain. The procession includes a king, a bishop, a monk and at the rear a miser with his money bag. Above were groups of the Damned (chiselled off in the eighteenth century).

In the vault (pl. 243 left) we see: on the inside, the Wise and Foolish Virgins; in the middle, ecclesiastics with books; on the outside, angels with trumpets or crowns (modern: on the right, the three upper lines, on the left, the top figure in the outside range). The iconography is in some respects reminiscent of Laon: for example, the placing of the Wise and Foolish Virgins in the archivolt, the angel with the sword separating the Blessed from the Damned, and the absence of the coronation of souls. This seems to reflect local tradition.

The trumeau features a standing Christ (pl. 237), as at Chartres and Amiens. In his hand he holds the orb in place of the book, and at his feet we see merely a small winged dragon. The socle reliefs (pl. 242) are difficult to interpret. According to local, post-medieval tradition, the scenes depict the following: 1, a cloth merchant's shop, with male and female figures standing in front of a table on which cloth is being cut; 2, a larger group of figures, among them two women recognizable from the first scene. (A bale of cloth is being cut. A scribe is seated in the foreground, and on the right a hooded man is reading from a tablet. The merchant stands just to the left of the table – possibly he is being arrested. The suggested interpretation is that the merchant is guilty of false measure.) 3, an altar with an image of the Virgin, and before it a man kneeling with arms crossed on his breast, while four figures, none of them ecclesiastics, witness the act. (The interpretation becomes still more contrived: the guilty man donated the trumeau statue in expiation for his sins.) These explanations are pure conjecture. The idea that an important portal statue was the donation of a swindler has a ring of improbability. The most likely explanation is that the scenes illustrate some not yet determined legend of the Virgin. On the jambs are six apostles: on the left, reading from the inside (i.e. from the right in pl. 240), Peter, Andrew, Bartholomew; on the right (reading from the left in pl. 241), Paul, James the Greater, John. According to Cerf the socles of the figures on the right jamb were renewed in 1827. (The heads of the trumeau statue and of Bartholomew were destroyed in 1914.)

AMBULATORY CHAPELS; UPPER STOREYS OF CHOIR, TRANSEPT AND NAVE

The statues on the ambulatory chapels (pl. 250–253) consist of twelve figures – Christ and angels – placed on the buttress piers and at the corners of the polygonal chapels. Their baldachins are integrated into the cornice. Supports are provided on the buttress piers by corbels, on the corners by attached columns. The sculptures are in high relief, each figure having been worked up from a single tall rectangular block, inserted into the square-stone wall. The outspread wings were carved from separate blocks placed horizontally. It follows that the angels were installed when the ambulatory walls were in course of erection.

In his right hand Christ holds a book; his left hand was presumably raised in blessing. The angels hold a variety of attributes: in addition to censers and incense boats, there are books, sceptre, processional cross, crown, reliquary, holy water ewer. A convincing explanation of the cycle has not so far been found. Bréhier thought it might represent the Celestial Liturgy, on late Byzantine lines. (Many of the figures were renewed or completed post-1918.)

A further twenty-two angel statues appear in the aedicules of the flying buttresses (pl. 254, 255), eight on the choir, fourteen on the nave. The figures are executed almost completely in the round, with a flat surface at the back. They stand on tall pedestals, and are offset from the back wall of the aedicule. In this way they are made to appear almost like freestanding statues, an impression reinforced by the raised wings, whose points jut freely between the aedicule supports. The choir angels have nimbuses, which in their later counterparts on the nave are lacking. Some of the attributes are

482

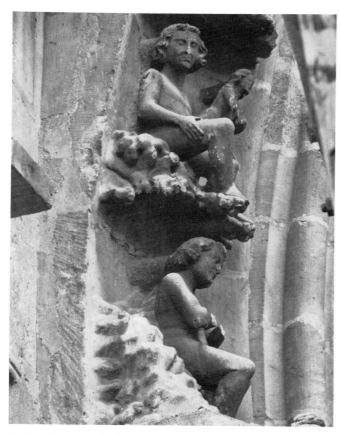

Ill. 93 Rheims cathedral. North transept. Figures from the soffit around the rose: Adam; creation of Eve. Before 1241

missing. Those present include, as on the ambulatory, censer and book, but there are also examples of chalice, ciborium, ampulla, sun and moon. At the end of the nave the sequence merges with the cycle on the rose window storey of the west façade described above. Fourteen statues of kings (pl. 260–262, 264, 265) occupy corresponding aedicules on the transept. Whether they represent French or biblical rulers is a matter on which opinions diverge: the programme around the transept roses seems to favour biblical figures. (The figures on the south-west tower suffered especially heavy damage in 1914–18. One figure was removed from the north-east tower after 1918.)

In the soffit of the north rose we see Adam and Eve (pl. 258), both fully dressed. Eve (pl. 259) holds as her attribute the dragon-like serpent with open jaws, Adam the apple from the Tree of Knowledge. Both are column figures standing on rounded socles decorated with foliage; the baldachins above are more than usually magnificent. In the soffit arch, on the left, are depicted *inter alia*: the creation of Eve (ill. 93), the Fall, the expulsion from Paradise, the toil of Adam and Eve, Abel the herdsman, Cain the tiller, Tubalcain the smith; on the right, above Eve, sacrifice of Cain and Abel, Cain's killing of Abel. The figures higher up presumably portray Cain's descendants working at various occupations.

The cycle has not so far been fully investigated, but there seems little likelihood that the figures can be named, as proposed, on the strength of Genesis 4. On the south rose (pl. 262) stand Ecclesia and Synagogue (replaced by copies; Ecclesia was destroyed in 1917, Synagogue is in the Palais archiépiscopal). The plan is similar to that followed with Adam and Eve on the north side. Above Ecclesia are eleven apostles (ill. 94–97), among whom the following are recognizable: Peter with keys (ill. 94), Paul, bald-headed and with sword, Andrew with a cross (ill. 97), John(?), beardless. The others have no specific attributes. Above Synagogue are Old Testament figures (pl. 263): the first figure is Moses: the ugly naked figure with bulldog features seated on a heap of earth and holding a bell in his hand (fifth from the bottom; ill. 98) could be Job; the bald-headed figure, ninth from the bottom, is probably Jonah. The names of the remaining figures, for all their undeniable expressiveness, elude us.

One is struck by the fact that on both the south and the north side the figures depart freely from iconographical tradition. The overall programme places Adam and Eve, the Fall, and Cain's fratricide – thus the epoch *ante legem* – on the north side opposite Synagogue and Moses – *sub lege* – and Ecclesia and the apostles – *sub gratia* – on the south. Also of thirteenth-century date are the figure galleries above the rose window, comprising fourteen statues, presumably of Old Testament figures. The transept gables, with on the north an Annunciation and on the south the Assumption, date from after a fire in 1481.

Style and dating. A definitive judgment on the style-critical questions will be possible only when we have a complete published record of the extant sculptures and of the photographs taken before 1914. Until that is accomplished, the most that can be offered is an expression of opinion.

It is generally agreed that the oldest sculptures surviving on the cathedral from the thirteenth century are the six typological figures on the right jamb of the right doorway of the west façade (pl. 219, 220). They probably belonged to the programme first devised for the west portals and subsequently abandoned, which envisaged at the centre a Coronation of the Virgin of the Senlis type. The stylistic connections with the figures on the Chartres north transept (pl. 82, 83) have frequently been stressed. The Rheims statues are broader and more powerful, and they show greater freedom of movement. There is no trace of the schematic arrangement noticeable on the right jamb of the Chartres portal. The *terminus post quem* is 1211, the year in which building work began at Rheims. The Rheims John the Baptist (pl. 219, 220) already resembles figures in the north porch at Chartres (the priest on the right of the porch, next to the centre opening, pl. 98 left). We are thus entitled to think of a date c. 1220.

The differences vis-à-vis Chartres provide a starting point in the next phase of Rheims sculpture, represented by the north portals and the twelve figures on the ambulatory. The Eutropia (pl. 246 right) resembles the Elizabeth of the Chartres Visitation, and the Calixtus (pl. 249) resembles

483

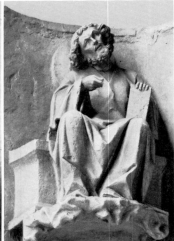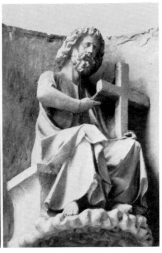

Ill. 94–97 Rheims cathedral, south transept. Figures from the soffit around the rose: four apostles, including (left) Peter and (right) Andrew. Before 1241

the Peter (pl. 86) of the Chartres Coronation portal. In the Rheims statues, however, the models are transformed. They are more thickset and more voluminous, and are more boldly detached from the column shaft. The figures on the left jamb (pl. 246) are especially remarkable for their freedom of movement. The angel to the right of St Nicasius (pl. 246 left) gives the appearance of walking. The draperies show a fondness for heaping up furrow- or loop-shaped folds and for hanging the material in loose swags. The rendering of the hair shows fine strands rolled into coils and ringlets. The whole tendency of the style is towards the splendid and ornate, but expressive force is lacking. It is possible that here we must already reckon with Roman, as well as Chartrain stimuli, and that we have here an early sign of an influence which would shortly preoccupy Rheims sculpture to a much greater extent. The upper bands of the tympanum give a more balanced effect (pl. 245). Here a conspicuously tranquil formal language prevails, an undramatic narrative manner. In parts at least there are very close connections with the porch statues of the Chartres north transept. There are also figures in the archivolt (pl. 243 right) whose models are to be found in the figures symbolizing the *Vita Activa* and *Vita Contemplativa* at Chartres (pl. 105). These connections indicate a date for the Calixtus portal well before 1225. As we have already seen, it must remain an open question whether the portal was originally destined for the west façade or for the north transept, whose bottom storey was probably by that time complete.

With the Judgment portal (pl. 236) the formal language starts to change. Out of the six apostle statues (pl. 240, 241), only three – Bartholomew, John and James the Greater – can compare with the left jamb of the Calixtus portal (pl. 246). The formal language of the figure of Andrew (pl. 240) is restless, but at the same time acute. Peter (pl. 240) and Paul (pl. 241) surprise us by their tense, vigorous bearing; the crinkled drapery is stretched tautly around the bodies, and the

powerful heads give an air of character studies. Not least, the renewed encounter with the antique has vanquished the empty formality of the jamb figures of the Calixtus portal. The sculptors who made the six apostles had no hand in the tympanum (pl. 236, 238, 239), archivolt and trumeau (pl. 237). Here the prevailing style follows the lead of the Chartres north porch, but imparts greater mildness and roundness to the unfolding of the forms. The Last Judgment has rarely, if ever, been represented with such absence of emotion and force. The faces of the Blessed in the second band (pl. 238) are completely devoid of tension, the expressive features – mouth, eyes – are small and without specific accent. The trumeau Christ (pl. 237) can be placed within the same stylistic context. Compared with its counterparts at Chartres (pl. 109) or Amiens (pl. 163), this figure is more tranquil. The head has about it a touch of classical beauty. There is again a varying of Chartrain prototypes in the socle reliefs (pl. 242): the women around the merchant's counter are an adaptation of the female figures to the left of the centre opening on the Chartres north transept (pl. 98 left). The Judgment portal is more recent than the Calixtus portal. The sculptors engaged on it are later found working on the triforium and on the upper storey of the transept. The portal may not have been finished until 1230.

The figures on the ambulatory reflect a stylistic situation similar to that on the north portals. The Christ, the first three angels on the north side, and the last two angels on the south, come close to the Calixtus portal or the older-style figures of the Judgment portal. They show the same rendering of the drapery and the same poverty of expression. Around the chevet chapel the formal language changes (pl. 251–253). The drapery, traversed by only a few folds, lies plainly over the energetically rounded body, activated in *contrapposto*. The face becomes fuller, almost podgy, with its firmly padded chin and distinctly sensuous lips. The head is framed by an abundance of small drilled curls, as though by a

484

wig. There is a flaunting of classical detail. There are similar heads in the archivolt of the Judgment portal (pl. 243 left). Architectural historians favour a date close to 1220 for the completion of the ambulatory. It is hard to imagine the angels of the chevet could have been made so early, and a date nearer 1230 seems preferable.

Hard on the heels of the completion of the north portals and the ambulatory cycle came the great undertakings of the 1230s: the sculptural adornment of the upper storeys of choir and transept and a second but arrested attempt on the west portals. Although sculptors who had worked on the north portals and the ambulatory remain active, new features come to the fore, which point to a rapprochement with Amiens. This is seen most clearly on the west façade. It seems that the first programme, with the typological figures, was discarded as outmoded c. 1230. It was now decided to create for the Coronation portal a cycle on the model of the one at Amiens, consisting of statues portraying the Infancy of Christ. In addition, plans for a Saints' portal were set in train. The new statues no longer stand on support figures – like the Christophoroi or the apostles – but on polygonal socles shaped like baldachins, as on the west façade at Amiens. C. 1230–33 nine statues were made for the Coronation portal. The Mary of the Annunciation (pl. 198, 201), and the Mary and Simeon of the Presentation (pl. 195, 196) are the work of an Amiens master. The angular formal language – drapery bunched together in flanges or folded at a sharp angle – contrasts violently with the older work at Rheims. Nevertheless, when compared with the Amiens counterparts (pl. 167), the rigidity is seen to be alleviated. At the same time a Rheims sculptor was creating the Visitation (pl. 199, colour pl. IV, pl. 202, 203), which is the most important testimony we possess to the association of the thirteenth century with antique sculpture in the round. The style had been anticipated on the jambs of the north portal, and the sculptor had previously worked on the figures for the ambulatory: he was responsible for a very fine angel with a crown, partially destroyed in the First World War. His work is characterized by the ease with which the rounded body movements of his figures extend into space, in a way otherwise unknown in gothic architectural sculpture. The 'man with the Odysseus head' (Vöge) on the corner of the buttress (pl. 204) has the same fullness of body and shows the concern for weight distribution noticeable in the figure of Elizabeth. But where the drapery of the Visitation group is abundantly pleated, on this figure the drapery falls in large, harshly delineated folds. The head with its small spiral ringlets adapts motifs from the Calixtus portal. The want of expression and the blind mimicry of those earlier heads has here yielded to a graceful virility. The figure reveals the way in which Rheims sculpture was diverting the new High Gothic impulses from Amiens to its own uses. The opposite statue on the right – David? (pl. 205 left, 216) – shows more stiffness in the drapery and bearing. The influence of the Amiens figure conception is thus greater. The vigorous head with its arching brows adopts features from the Peter of the Judgment portal (pl. 240 right). To the

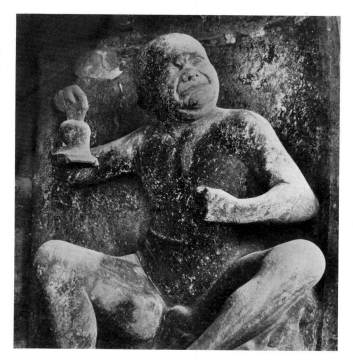

Ill. 98 Rheims cathedral, south transept. Figure from the soffit around the rose: Job(?). Before 1241

same phase, finally, belong Solomon (pl. 205 middle) and the Queen of Sheba (pl. 204 middle). The advancing queen in swirling robe and broad mantle is among the proudest achievements of Rheims sculpture. The artist responsible is another whose work can also be seen on the north portals; the socle beneath the trumeau figure of the Judgment portal (pl. 242) is by his hand. The seven figures executed at this time for the Saints' portal can be dealt with only in summary fashion. These are: the statues of a deacon and a bishop, destroyed in 1914, which stood on the left jamb of the north portal, Dionysius (pl. 206, 210) and the angel (pl. 206, 209) on his right, the two bishops on the inner buttress corners of the side doorways (pl. 204, 205, 217), and Calixtus (pl. 217 right, 218 left) on the right-hand doorway. The angel accompanying Dionysius is important, since this figure develops fully the pacing motif already adumbrated in the figures on the chevet chapel and combines it with a sideways turn of the head. The Calixtus statue (pl. 217 right, 218 left) is one of the noblest figures on the Rheims façade. The countenance with its signs of old age resembles the Elizabeth of the Visitation (pl. 199, 203). The sixteen statues just enumerated were probably finished by the time the dispute between chapter and townsmen interrupted work in 1233, but the foundations of the new west façade were not yet laid. The new statues, along with the six typological figures already on hand (pl. 219, 220), had to await the resumption of work on the west façade, which was postponed for more than a decade.

Work on the upper storeys of the eastern portions had been proceeding simultaneously with the west façade. From

485

the point of view of the installation the earliest sculptures should be the busts and heads in the triforium of the transept. It has been claimed that the hand of the Visitation master and of the sculptor of the Queen of Sheba can in fact be detected on the north side. The corresponding works on the south transept look more advanced. The fourteen royal statues on the rose storey demonstrate in dramatic fashion the changeover from the style of the early thirteenth century, in which all the stress was on line, to a formal language with sharp contrasts. The most divergent tendencies in Rheims sculpture are thus visible side by side. The figure of a king in the east aedicule on the south front (pl. 264 far right), in which the motifs are still very much those of Chartres, is stylistically the earliest of the figures. Its closeness to the tympanum of the Judgment portal (pl. 108) is unmistakeable. The lofty location does not reveal fully the troughs and lines of the drapery folds. The inner figure on the west side of the north transept (the so-called St Louis; pl. 261) comes closer still to the Blessed of the Judgment portal. The quiet and gentle formal language, with its meek avoidance of all intensity, is so similar that we must think of it as by the same hand. Another statue was the work of the master who made the figures on the right jamb of the Calixtus portal (pl. 247): the king on the east side of the south transept, with the outsize head and hair in ringlets. The statue to the west of the north rose (pl. 258) resembles David (pl. 205, 216) from the jamb of the centre doorway. Most interesting of all are the figures whose style had not been anticipated in the lower parts, first and foremost the so-called Philip Augustus (pl. 260), east of the north rose, and the king in the west aedicule of the south façade (pl. 264 far left). Their bearing is tense but not rigid; there is a gaunt keenness to limbs and features. The drapery is rendered by just a few large yet restless outlines: the ridges of the folds run erratically, in places darting like lightning flashes. The sunken-eyed emaciated countenances, from which the hair stands off like a wreath, have an eloquence verging on the demonic. The next statues to convey such strong emotion are Donatello's on the campanile at Florence. None of the remaining figures reach the same artistic level. The king to the west of the south rose (pl. 264 half left) presupposes the existence of the statues just described. His neighbour (pl. 264 half right) oddly combines drapery motifs of the 'man with the Odysseus head' (pl. 204 right) from the west portal with the head type of the angels (pl. 251–253) on the chevet.

The sculptor of the most exciting of the king figures (pl. 260 and 264 far left) seems to have played a vital role in the upper storeys of the transept. Admittedly, the large statues in the soffits of the rose window are unaffected by his style. The figures of Adam and Eve have always been regarded as in line of succession from the Calixtus portal. The head of Eve resembles that of Eutropia (pl. 246), Adam's facial type, somewhat sour, has its fellow in various parts of the tympanum (pl. 245). The plentiful drapery folds of the Calixtus portal have given way to plain surfaces. Here again, the

style of the earlier years of the thirteenth century has been overcome. Ecclesia and Synagogue (pl. 262) develop the style of the more advanced angels on the ambulatory, in respect of the close fitting drapery and swaying stance. They come closest to the angel (pl. 251) to the left of Christ – on the second chapel starting from the north. In the rose archivolts, most of the figures (pl. 263, ill. 94–98) appear to bear the imprint of the master of the two royal statues (pl. 260 and 264 far left). The types are altogether unusual in their strident pointedness; physiognomies with sunken eyes and furrowed features seem to have been an obsession with this master. They are to be found among the prophets of the south rose, but equally among the head-shaped corbels he made for the main choir and the south-west tower (pl. 257 left, bottom and top). Motifs old and new – the hand grasping the mantle cords, the propped head, the cross-legged sitting position – are wrenched away from convention and imbued with nervous haste and fuming impatience. His style is keenly pointed – yet it avoids the dash of worldliness imparted to the High Gothic forms of the Paris Judge (pl. 147) or the Baptist's tympanum at Rouen (pl. 182 top). So far as it is still possible to judge, most of the Atlantes beneath the drip cornice (pl. 250, 256) of the main choir originated in his circle.

His was by no means the only hand at work on the corbel heads (pl. 257), those astonishing thirteenth-century testimonies to an art which was creating from life and no longer merely from tradition. On the inner side of the south tower we find the work of the sculptor of the Peter of the Judgment portal (pl. 240) and perhaps of the master of the Visitation. Where the vitality of the heads is at its most commanding, we are in the presence of works by the master of the two royal statues (pl. 257 top and bottom left, centre bottom). Ascribable also to him are that strangely gloomy foliated mask of the choir and the menacing lion's head on the west side of the south transept (pl. 257 middle), shown devouring a calf's foot. The angels in the aedicules of the flying buttresses of the choir must belong to the same stylistic phase (pl. 254, 255); the history of the building's construction and the stylistic evidence, as demonstrated in the pieces illustrated here, are proof of this. The angel in the aedicule to the south of the chevet chapel (pl. 255 left) clearly stands in the direct line of succession to the figures on the corners of the chapel below (pl. 251–253). The next angel going north (pl. 255 right) shows the drapery motifs of the 'man with the Odysseus head' (pl. 204) from the centre doorway of the west portal, while the curly head, its face lit by a smile, has its exact counterpart on the inner side of the south-east tower. It seems questionable whether all these extensive undertakings could really have been completed in the years before 1233. The formation of the style of the master of the two statues of kings (pl. 260, 264 far left), which are characterized by harshly broken forms, presumably originated in the works of the Amiens west façade. There is thus some plausibility in the theory that work continued until 1241. At all events, the Judgment portal, the sixteen statues of the west façade, and the sculptures on the eastern parts of the cathedral must have

486

been produced as one series. The start was made in the late 1220s at the earliest, and the latest date for completion is presumably 1241, the year when the new choir was occupied.

Resumption of work on the west façade presumably followed only a few years later, between 1245 and 1250. It is quite possible that the rather mediocre angels in the aedicules on the east bays of the nave were made immediately after 1241. They represent an unoriginal and arid continuation of the formal language of the angels on the west buttresses of the main choir. It is not until we reach the three western aedicules of the nave, especially those on the north side, that an impression of the later façade statues makes itself felt. This third attempt on the west façade produced the trumeau figure of the Virgin (pl. 189) and another twelve jamb figures; in addition, all the figures for the doorposts, arches, buttresses and gables were made at this time. Simultaneously, or immediately afterwards, the same work force produced the sculptures for the interior west wall (pl. 229–235); all this must have been complete by c. 1260. The statues and reliefs of the rose storey of the west façade and for the western aedicules on the nave followed immediately afterwards, their execution perhaps continuing well into the 1260s. Even at this last stage, there were still alterations and changes of plan, as we can tell from the installation marks.

In this late phase the earlier sculptures were available as models. Transformed, we meet the 'man with the Odysseus head', for example, in two large statues on the side doorways: on the right the prophet next to the doorpost (pl. 218), and on the left the figure next to the martyr deacon (pl. 207). There are also echoes of this figure's imposing drapery motif, on the interior of the east wall (pl. 231 left). The Queen of Sheba (pl. 204) – the *grande dame* in girdled robe and wide-flung mantle – reappears in doorpost figures on the left doorway (pl. 221 centre) and in the Herodias of the interior west wall (pl. 233). Motifs from the Christ of the north transept portal (pl. 237) are used again in the superbly tranquil statue to the right of Calixtus (pl. 217 middle).

The manner of presentation, however, is new. For its origins we must look not to the earlier Rheims sculptures but to impulses from outside, to be precise from Paris. The pointing up of the physiognomy as we see it in Joseph (pl. 192, 194) – the pointed Jew's hat, beneath which delicately vivacious features emerge from smoothed-back hair whose locks, with the lightest, most inimitable of touches, play round the expressive countenance – is far removed from the emotionally charged forms of Rheims sculpture of the 1230s. For the prototypes we must look to the Judge of Notre Dame in Paris (pl. 147), the 'Childebert' of Saint-Germain-des-Prés (pl. 175), the Apostles from the Sainte-Chapelle (pl. 184, 185). Thus in the more recent Rheims sculptures local traditions and influences from Paris appear to coalesce.

During this last phase three statues were made for the centre portal: the Joseph already mentioned (pl. 192 left, 194), the maidservant from the same group (pl. 192 right, 197)

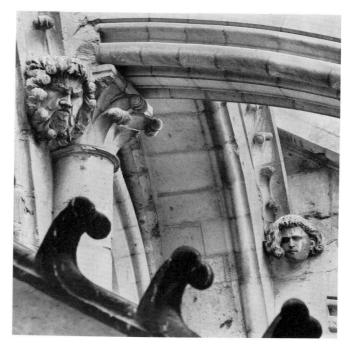

Ill. 99 Rheims cathedral, choir. Detail of buttresses and profile of the window soffits with head-shaped corbels

and the angel now installed, having been diverted from its intended position, as the Gabriel in the Annunciation (pl. 198, 200). Common to all these figures is a pronounced gathering together of the draperies, and a dancer-like pivoting stance, complemented by an equally pronounced turn of the head. The smiling escort of a saint to Paradise, the bearing of sacrificial doves to the Temple, are made occasions for intensity combined with grace. These figures apart, there is only one other we can assign to the 'Joseph master' (as he is known on Vöge's suggestion): the angel on the left hand of St Dionysius (pl. 206 right, 211). We see the same dancing movement, the same blissful smile. To this final phase also belong five statues on the left portal: the female saint (pl. 206 left, 208) on the left jamb, and all four figures on the right jamb (pl. 207, 212, 213). None show the pointedness which is the distinguishing mark of the Joseph master. The outlines are broader and above all more concise. The facial surfaces are larger, the expressions more composed. The only exception is the second figure from the inside on the right jamb (pl. 207; second left in the plate). Here the delineation is sharper, and the narrow features, framed by activated locks, more animated, but the result still lacks the charm of heads from the Joseph master.

The style formation on the archivolts and blind tympana has to be looked at in relation to the jamb. Thus the sculptor of the female figure on the left jamb (pl. 206 left, 208) appears to have worked the Discovery of the Cross on the north buttress, which in turn points forward to the statues on the interior west wall (north aisle). At this point everything hangs together – the sculptures above and below, inside and out. On the right doorway all the statues on the left jamb

487

(pl. 217–218), with the exception of Calixtus, were made during this last phase. Figures such as the two prophets next to the doorpost (pl. 218 middle and right) are from sculptors whose work we meet again on the interior west wall. The right-hand figure, with its curly head of hair, reproduces motifs from the 'man with the Odysseus head' (pl. 204 right), but in the style of the Joseph master. The prophet next to him shows a more arid execution. It is nevertheless a hand that we can also recognize on the interior wall. More important is the statue to the right of Calixtus (pl. 217 middle). The quietly spreading drapery goes with the air of meditation imparted to the tranquil countenance. Here is the work of yet another master who must rank among the most important in the Rheims school of sculptors. From his hand are the angels beneath the blind tympanum of the south buttress; he created the exquisite River of Paradise between the centre and right doorways of the west portal, and most notably the huge Emmaus Christ (pl. 228) next to the rose window (this was cracked by fire in 1914). Despite all the shifts of style, we again see, running through this master's œuvre, the inner continuity of the sculptor's art at Rheims. In his figures, the gentle quietude of the trumeau and tympanum figures of the Judgment portal (pl. 236–239) still lives on.

The literature on the Rheims sculptures is so vast that the bibliography has had to be drastically pruned. The older literature is given in full in Demaison, 1902.
Cerf 1861; L. Demaison 1902; L. Pillion 1911; H. Kunze 1912, p. 44ff.; L. Bréhier 1916; P. Vitry 1919; H. Deneux 1925; E. Panofsky 1927; E. Mâle 1928, p. 226ff.; L. Lefrançois-Pillion 1928; E. M. Paillard 1936; R. Hamann-MacLean 1956; W. Vöge 1958; A. Paillard 1958; D. Schmidt 1960; Th. Frisch 1960; R. Branner 1961; H. Reinhardt 1963; R. Hamann-MacLean 1964; H. Keller 1965; W. M. Hinkle 1965; J. G. v. Hohenzollern 1965, p. 39ff.; R. Hamann-MacLean 1966; R. Lejeune, J. Stiennon 1966, vol. I, p. 203ff.; F. Salet 1967 (I); see also Appendix to Bibliography.

SCULPTURES EMANATING FROM RHEIMS, AND WORKS OF THE THIRD QUARTER OF THE THIRTEENTH CENTURY

Pl. 266–269

PARIS, NOTRE DAME
SOUTH TRANSEPT PORTAL

The south transept portal (pl. 267) was erected in the thirteenth century, when chapels were added to the cathedral and new façades built for the transepts (cf. p. 472). An inscription on the transept socle commemorates the laying of the foundation stone in February 1257. The portal opened into a courtyard of the bishop's palace. The large figures on the trumeau and jambs were destroyed at the Revolution and renewed under the direction of Viollet-le-Duc.

The tympanum (pl. 269) is devoted to St Stephen; in the eighth and ninth century the saint is named as the church's auxiliary patron. In the bottom band, left, Stephen is shown disputing with adherents of the synagogue 'of the Libertines, and Cyrenians, and Alexandrians' (Acts 6:9). Stephen, seated, points with his left hand to an open book; his right hand is raised in discourse. The other parties to the argument are shown in a state of great agitation: they cross their limbs, motion with their hands, pluck their beards, wrinkle their foreheads. Next, Stephen preaching. The deacon stands before a spellbound audience of five, among them a woman wearing touret and cloak, who suckles her child during the sermon. The standing figure with writing tablet is probably one of Stephen's denouncers. On the right Stephen is led before a judge and accused on the testimony of false witnesses. An armed figure in showy plate armour, with cornettes in his close-curled locks, seizes Stephen, as he stands with crossed hands before the elder of the council, by the hair. To the left and right we see the false witnesses who charged him with blasphemy. Moses and Aaron, named by Stephen in his speech in his own defence (cf. Acts 7:20), are portrayed in niches set into buttresses above the portal (pl. 267). In the upper band of the tympanum we see, on the left, the stoning, in which Stephen is shown not kneeling, as at Chartres (pl. 114) or at Rouen (pl. 182 bottom), but falling to the ground and raising his right hand in self-protection. The physiognomies make clear that the false witnesses and stone-throwers are the same (cf. Acts 7:58). On the right Nicodemus and Gamaliel place the saint's body in a sarcophagus (cf. the Golden Legend); standing behind it we see a grieving woman, a cleric and an acolyte with processional cross and holy water. Above, in the apex of the tympanum Christ appears standing on a cloud between two angels. This is the most detailed Stephen cycle extant in French sculpture of the thirteenth century. The tympanum has a border of vine tendrils. The moulding below the lintel beam is adorned with rosettes.

The archivolt (pl. 268) includes, on the inside, angels with martyr's crowns; in the middle, twelve additional martyrs, no longer with palms but holding individual attributes. Recognizable among these are (on the right) Laurence with the grid-iron, Dionysius(?) holding his severed head in his hands, George in chain mail and holding a wheel, and (on the left) at the bottom, Vincent(?) vested as a deacon and holding a book, Eligius with a hammer, and Eustace, with in front of him, caught in a tree, the stag with the head of Christ between its antlers. These details are important as evidence of iconographical changes taking place in the

488

thirteenth century, which aimed at providing, even in the archivolt of a portal, a tag to identify every saint. The outer arch contains clerics and monks, presumably confessors.

The jambs, according to Lebeuf, included (among others) figures of Dionysius and his companions, Eleutherius and Rusticus. Torsos of twelve statues discovered in 1839 in the Rue de la Santé are now in the north tower of Notre Dame (pl. 266). A bishop's head in the depository of the Musée de Cluny has recently been associated with the jamb figures.

On the gables adjoining the portal we see on the right St Martin dividing his cloak; on the left Christ between two angels with the cloak.

A few minor alterations apart, the portal type corresponds to that on the north transept. The work was directed not by Jean de Chelles but by his successor, Pierre de Montereau, who supervised the masons' yards at Notre Dame until his death in 1266. The sculptures were executed not long after 1258, as emerges from the evident activity on them of the workshop from the north transept portal: this was responsible for the statues of Moses and Aaron in the buttress niches, for the Martin reliefs, and for certain of the figures in the outer arch of the archivolt.

The remaining sculptures are from an atelier not previously seen in Paris. It is characterized by restless movement in the drapery, manifest in the crinkled folds and the hems winding in and out of one another. The movements, especially the gestures, are complicated and protracted, in some cases by means of highly artificial motifs. Equally striking is the insistent dramatizing of facial features: uneasily contorted locks, deep-sunken eyes and prominent brows, expressions pensive or wrathful. This is a theatrical method of projection, which mimics and simulates emotion but lacks real force, in contrast with the Paris sculpture of the first half of the thirteenth century. The workshop may have had some contact with Rheims. The group composition in the Discovery of the Cross on the blind tympanum of the north buttress of the Rheims west façade, is remotely comparable; note the figures standing one behind the other. In this scene, as in the Martyrdom of John the Baptist on the inner face of the lintel of the Rheims centre doorway (pl. 229), we also note figures, wearing Roman-style plate armour, with broad heads and typically vulgar features. The torsos of the Paris jamb figures can be compared with the Nicasius on the inner side of the Rheims trumeau. Date: between 1260 and 1265.

M. de Guilhermy, E. Viollet-le-Duc 1856, p. 88 ff.; M. Aubert 1920, p. 137 ff.; P. Vitry 1929, p. 68 f.; M. Weinberger 1930–31; H. Bunjes 1937, p. 37 ff.; M. Aubert 1946, p. 262 f.; R. Branner 1965, p. 101 ff.; D. Kimpel 1969.

Pl. 270

PARIS, NOTRE DAME
SOUTH TRANSEPT, BUTTRESS RELIEFS

The two buttress piers on the south transept display, in the region immediately above the socle zone, eight rectangular reliefs featuring quatrefoils (pl. 267). The scenes portrayed show no recognizable connection with the Stephen's portal. There is no self-evident sequence in which to read them. Nor has anyone yet found an explanation for the individual groups, since efforts to link the scenes depicted with written texts have so far met with no success. Here we can do no more than refer to isolated scenes and to the proposed interpretation at present most current. In pl. 270 the middle relief on the right shows a seated figure, dressed in hooded cloak and cap and lecturing on a text at which the right hand is pointing, raised above the audience who are for the most part similarly dressed in long hooded robes. At the bottom there are two dog-headed dragons, and a dog reposes on the arc which forms the apex of the quatrefoil. In the adjacent relief on the left the apex of the quatrefoil is occupied by a scroll; the figures beneath – some in front of, some behind a railing – are gathered about a rotulus, and seem to be involved in disputation. In the left half of another quatrefoil (top right), four figures huddle around a lectern and lay their hands on an open book; in the right half is a second group, including a woman in cloak and touret. In the lower left corner a man beats a lion, and on the right we see a dog. In the adjacent relief a woman is shown tied by the hands to the sides of a ladder; fixed to her breast is a label, on which a nineteenth-century author claimed to read the letters P. FAUSS, which he interpreted as standing for 'pour faus serment'. The figure might thus represent a woman pilloried as a perjurer. Standing in front of the ladder are two men, with sword and cudgel, and on either side two smaller figures, looking up at the woman. The top corners contain miniature houses, whose windows are filled, on the left, with spectators, on the right with a quarrelling couple. Felix de Verneilh, in an amusing and, as he admitted, inventive reconstruction, related the scenes to student life in Paris: as he pointed out, we know that in the thirteenth century the university frequently had to resort to harsh measures to restore law and order. The chancellor of the university was subject to the bishop of Paris, which would explain why the scenes were displayed on the cathedral. In fact the content of the reliefs remains an enigma. The most likely explanation is that the scenes belong to a cycle with a legal connotation.

Style and dating. The figures are slender and fine-limbed, their movements pointed and angular. The outlines are adapted with finicky skill to the arcs and angles of the surrounding frames. Witty contrivance is one of the characteristics of the style: the dragons affecting dogs' heads, the quadrupeds ducking beneath the geometrical shapes of the frame, the arched wrists and extended index fingers of the disputants. The reliefs clearly follow on from the Theophilus legend on the north transept portal (pl. 186), but modify the formal language to a pointed angularity. Date: between 1260 and 1265.

M. de Guilhermy, E. Viollet-le-Duc, 1856, p. 86 f.; F. de Verneilh 1869; E. Mâle 1902, p. 399; P. Vitry 1929, p. 69 ff.; A. Fischel 1930; H. Bunjes 1937, p. 68 ff.; M. Aubert 1946, p. 263.

Pl. 271

PARIS, NOTRE DAME
PORTE ROUGE

The four chapels to the east of the north transept were presumably erected before 1271. Opening into the third chapel is a figure-decorated portal which owes its name, 'Porte rouge', to the original colouring of its door panels.

The tympanum depicts the Coronation of the Virgin. Mary is blessed by the crowned Christ and receives her crown from an angel. At the side we see benefactors kneeling in prayer: on the left a king in surcoat and clasped mantle, on the right a queen. It used to be fancied that they represent St Louis and his wife, Margaret of Provence.

In the archivolt the Legend of St Marcellus of Paris is illustrated by multi-figure groups (for Marcellus see p. 405): 1 (bottom left), the dragon found nestling in the grave of an adulteress (fully restored); 2, Bishop Marcellus administering baptism (note the chalice-shaped font, in which the candidate stands in an attitude of prayer); 3, Marcellus celebrating Mass; 4, Marcellus seated on the cathedra, surrounded by clerics; 5, Marcellus leading the tamed dragon, using his stole as leash (the female martyr at his side cannot at present be identified); 6, (partially restored) Marcellus is blessing a male figure – with, apparently, a dragon seated on his head – standing before his throne (perhaps representing the healing of a man possessed by the devil). The arches are edged with tendril ornament of roses and oak leaves with acorns.

Nothing is known of the figures which stood in the two jamb niches. The jamb socle displays rhomboid fields edged with pearl ropes – with rosettes at the intersections – containing dragons, centaurs, sirens, stags, etc.

Portal type, style and dating. The portal type, with jamb niches and crowning gable, is a modification of forms found on the transept portals; in part the individual forms are closer to the older north portal than they are to the Stephen's portal. Stylistically, too, the sculptures of the Porte rouge belong with the Theophilus legend (pl. 186) and the archivolt figures (pl. 187) of the north transept portal. This emerges most clearly in the plain surfaces of the drapery, interrupted by a few stiff folds, and in the compact contours and fullness of the features, which are expressionless. The archivolt scenes are somewhat more inventive. Even so, the history of the cathedral's construction postulates a relatively late date for the sculptures, probably c. 1260.

M. de Guilhermy, E. Viollet-le-Duc 1856, p. 93ff.; M. Aubert 1920, p. 137ff.; P. Vitry 1929, p. 70, 88; M. Weinberger 1930–31; M. Aubert 1946, p. 263; J. Bayet 1954; R. Branner 1965, p. 101ff.

Pl. 272

TOMB MONUMENT OF LOUIS OF FRANCE
FROM ROYAUMONT
(NOW SAINT-DENIS, ABBEY CHURCH)

Louis of France, the eldest son of Louis IX, died at the age of seventeen in 1260 and was buried at Royaumont (for the

abbey see p. 459). When the abbey was suppressed in 1791 the tomb monument was brought in the first instance to Saint-Denis, and only later transferred to the Musée des Monuments français. It was later returned to Saint-Denis, where it is today.

The tumba, like that of Philip of France (cf. ill. 82), stood beneath a freestanding baldachin. At the foot end the wall of the tumba showed the bier with the corpse being carried by four figures, two of them kings, and on the long sides the cortège of clerics and laymen. On the head end there was probably a standing Virgin between angels. This is an important example of a tumba with a representation of the funeral procession. The figures have been either replaced or restored. The dead youth is shown on the slab, beneath an arcade (partially renewed). He is dressed in a plain surcoat with capuchon, and his feet rest on the back of a dog (the hands, the tip of the nose, parts of the shoes, and the head and hind quarters of the dog have been replaced). The forms are conspicuous for their simplicity. The folds are few, linear and tranquil. The elongated head with close-cropped hair has boyish features, at once aristocratic and full of charm.

This fine figure has been wrongly associated with that of Philip of France (pl. 159 left), which is some ten years older. Nor is there any recognizable stylistic connection with the tomb monuments which Louis IX commissioned at Saint-Denis in 1263–64. The present figure compares most readily with the later portions of the Chartres jubé – admittedly considerably earlier in date – for example the dream of the Three Magi (pl. 127 top). Some figures from the inner archivolt (pl. 187) of the north transept portal of Notre Dame, Paris, also come to mind. The monument is presumably Parisian work, post 1260.

F. de Guilhermy 1891, p. 56–8; P. Vitry, G. Brière 1908, p. 116f.; P. Vitry 1929, p. 90; R. Hamann, W. Kästner 1929, vol. II, p. 133ff.; H. Bunjes 1937, p. 63; M. Aubert 1946, p. 296f.; E. Panofsky 1964, p. 62 (I).

Pl. 273

SAINT-DENIS (SEINE), ABBEY CHURCH
TOMB MONUMENT OF ROBERT THE PIOUS
AND CONSTANCE OF ARLES

In 1263–64 Louis IX commissioned sixteen tomb monuments for the Carolingian and Capetian rulers buried at Saint-Denis. The thirteenth century saw much remodelling of founder's tomb monuments and dynastic burial places as figure-decorated tombs, the most ambitious of which was undoubtedly this undertaking by the French king. It was presumably connected with his efforts to enhance the prestige of the king of France over and above the other monarchs of Europe. At the Revolution the burial place suffered the same fate as the dynasty: the graves of the rulers were destroyed. It was possible to salvage fourteen of the sixteen dating from the time of St Louis. They were deposited in the Musée des Monuments français, and were returned in 1816. The present installation is the work of Viollet-le-Duc,

who between 1860 and 1864 tried so far as possible to restore the burial place to its previous condition. In many cases the effigies had to be given new crowns, sceptres, hands and feet.

Artistically, the pair known as Robert the Pious and Constance of Arles stand above the general run of the figures, many of which seem like stencilled copies. The king wears an undergarment and a long surcoat and clasped mantle, while the queen is clad in a full-length, girdled robe, a mantle and a veil; the king holds the sceptre, the queen a book. The fabric of the draperies bellies out to form pointed pocket folds, the contours are sharply broken up. The king's face, framed by a short beard and heavily undercut locks, has a distinct air of the flatterer. The dependency from Rheims is plain. It might even be conjectured that two of the Elders of the Apocalypse in the archivolt of the right doorway of the west portal – second arch, third from the bottom (pl. 224) – are by the same hand. In that case the sculptor would have moved on to Saint-Denis when work finished at Rheims c. 1263.

E. Berger 1879, p. 18ff.; F. de Guilhermy 1891 (3), p. 49; P. Vitry, G. Brière 1908, p. 83ff.; P. Vitry 1929, p. 89f.; H. Bunjes 1937, p. 49ff.; M. Aubert 1946, p. 296; S. McK. Crosby 1953, p. 64; see also Appendix to Bibliography.

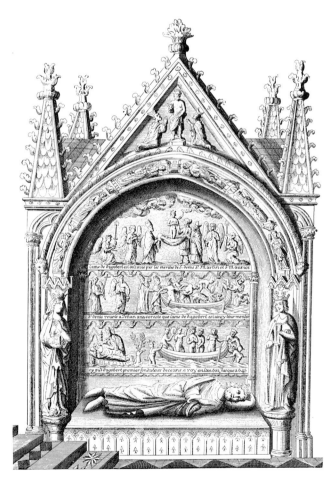

Ill. 100 Saint-Denis, abbey church. Cenotaph of Dagobert I. 1263–64(?). (After Montfaucon I, pl. 14)

SAINT-DENIS (SEINE), ABBEY CHURCH
CENOTAPH OF DAGOBERT I

The works commissioned at Saint-Denis by Louis IX in 1263–64 probably included the cenotaph for the abbey's founder, Dagobert I. It has the place of honour in the choir, just to the right of the high altar. Its present state is largely the result of restoration under Viollet-le-Duc, based on earlier illustrations of the monument – an engraving in Montfaucon, drawings by Percier. The recumbent effigy and the figure in the wall on the right are new. A replica (laterally reversed) of the Dagobert, deposited in Saint-Denis, was also made in the nineteenth century, under the restorer Debret. As a type the cenotaph (as shown in Montfaucon's engraving) is of the highest interest.

The starting point is the form of niche-grave used in the twelfth century for the tomb monument of Ogier the Dane at Saint-Faron, Meaux (ill. 16). The detailed arrangement uses forms of the thirteenth century; motifs from figure-decorated church portals may well have played a part. The corners of the monument are crowned with finials, archivolt figures adorn the arch framing the niche. Above the arch is a gable. The inner wall of the niche is divided into bands and shows narrative reliefs. Figures were even displayed on the back of the monument. Comparable pieces are lacking. To commemorate the abbey's founder, it was obviously desired to create something out of the ordinary. This is not a tomb monument but a cenotaph: Dagobert was buried beneath the high altar.

The king is shown lying on his side, his hands laid together in prayer. He thus faces the high altar, dedicated to Dionysius. The tumba is flanked at the foot by Dagobert's wife, Nanthilde, at the head by his son Clovis. The inner wall tells how the dead man's soul was saved: the Gesta Dagoberti relates that Bishop Ansoald of Poitiers questioned a hermit named John, who told him that Dagobert was being tormented by devils on the seashore. Contrary to the French inscription reproduced by Montfaucon, which was presumably added later, Ansoald and the hermit must have been depicted bottom left, with Dagobert in a boat, being tormented by devils, on the right. Dagobert calls on three saints – Dionysius, Maurice and Martin – who deliver him from the power of the devils and bear his soul up to Heaven; the angels with censers in the archivolt are part of this scene. Dionysius and Martin reappear in the gable, making intercession to a standing Christ. On the strength of the Dagobert legend, the programme calls attention to the role of St Dionysius as protector of the kings of France, which was an important factor in securing the abbey's privileged status. This circumstance may partly explain the unusually lavish memorial, but even without it, there was reason enough for according a place of honour in the newly created royal burial place to the abbey's royal founder.

So far as it is still possible to judge, the style of the sculptures shows an unmistakeable resemblance to the tomb

491

monuments erected in 1263–64. The figure of Nanthilde, preserved in the original apart from the head, resembles the figures of Robert the Pious and Constance of Arles (pl. 273).

B. de Montfaucon 1729, vol. I, p. 164 f.; E. Viollet-le-Duc 1867 ff., vol. IX, p. 31 ff.; P. Vitry, G. Brière 1908, p. 109 ff.; R. Hamann, W. Kästner 1929, vol. II, p. 130 ff.; H. Bunjes 1937, p. 64 ff.; M. Aubert 1946, p. 297; W. Sauerländer 1968.

Ill. 101

SAINT-DENIS (SEINE), ABBEY
FIGURE OF DAGOBERT, FORMERLY IN THE CLOISTER

In the eighteenth century a group of three figures still stood in the north wing of the cloister of Saint-Denis, to the right of the transept portal. Enthroned in the centre was a ruler, with crown, sceptre or staff, and orb. His feet rested on the backs of two lions. Flanking him were two standing figures, bearded and uncrowned. An inscription on the socle beneath the royal figure read: 'Here is portrayed King Dagobert, founder of this church.' The Benedictine scholars of the seventeenth and eighteenth centuries took the auxiliary figures for sons of Dagobert – Sigebert and Clovis. Whether the inscription was always part of the group is not clear; in any case, since the abbey attached so much importance to its royal foundation, it is quite feasible that the centre figure was made in the thirteenth century as a portrait of the founder. The designation of the flanking figures as Sigebert and Clovis seems on the other hand to be an invention of modern antiquaries; it is more likely that we have here the conventional representation of a retinue or counsellors. The lions beneath Dagobert's feet were no doubt a reference to his dispensation of justice, by analogy with Solomon; the inscription dubbed the ruler: 'Justitiae cultor'.

The three statues are known only from an engraving in Montfaucon. In style they were presumably very close to the tomb monuments set up at Saint-Denis 1263–64. The head of Dagobert, with the distinctive treatment of hair and beard, is very like that of Robert the Pious. The remodelling of the royal burial places as figure-decorated tombs, the erection of the elaborate Dagobert cenotaph, and the installation of the group in the cloister would thus be parts of one overall project. Similarly, the monuments would testify to the link, reinforced shortly before by Louis IX, between the royal house and the abbey of Saint-Denis: in 1260 the king decreed that the royal insignia should henceforth be kept permanently at Saint-Denis, and brought by the abbot to Rheims at the time of the coronation. It is not clear whether the thirteenth-century group in the cloister displaced the earlier figure of a ruler from the time of Abbot Suger, which in post-medieval times was likewise taken for Dagobert, and in the eighteenth century stood in the west end of the church (cf. p. 382).

J. Doublet 1625, Book I, chapter XLIV; M. Félibien 1706, p. 551; B. de Montfaucon 1729, vol. I, p. 163 f.; W. Medding 1930, p. 126 f.; J. Formigé 1960, p. 114.

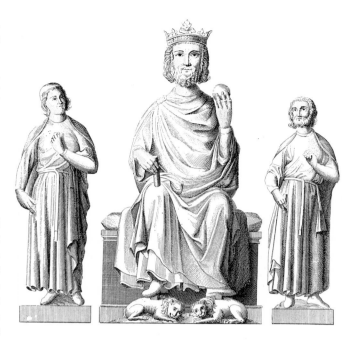

Ill. 101 Enthroned figure of Dagobert, formerly in the cloister of Saint-Denis. 1263–64(?). (After Montfaucon I, pl. 13)

Pl. 274, ill. 102

MONUMENT FOR THE HEART OF COUNT THIBAUT V OF CHAMPAGNE
PROVINS (SEINE-ET-MARNE), HOPITAL GENERAL

Thibaut V, Count of Champagne and King of Navarre, died at Trapani in 1270, on his way home from the seventh crusade. He was buried with the Franciscans at Provins, but had provided that his heart should repose in the Dominican church at Provins. The practice among the higher aristocracy of arranging for their hearts and bodies – sometimes even their entrails – to be deposited in different churches is attested from early in the Middle Ages. In the sixteenth century the kings of France had their hearts consigned to urns.

The heart of Count Thibaut reposes in a hexagonal miniature edifice, 2 ft 9 in. high, with a tent-roof made of copper, the tip of which is crystal. Engraved on it are armorial bearings, hybrid creatures and an inscription in Middle French: 'Here reposes the noble heart of King Thibaut, King of Navarre, Count Palatine of Champagne and Brie'. Beneath the crystal knob is a small heart made of stone. The singular form must have been inspired by the so-called tower reliquaries. Seated in the blind arcades of the main structure are Dominican friars with breviaries, offering prayers for the dead and in attitudes of grief. The forms of the little figures are peaceful and somewhat dry; they look like contemporaries, or slightly later successors, of the most advanced figures on the west towers of Rheims. Date: shortly after 1270. In 1791 the monument was removed to the

Franciscan convent at Provins. In 1843 it was painted and restored (ill. 102), the restorations being removed in 1932.

Maillé, Marquise de, 1939, vol. II, p. 205 ff.

Pl. 275 left

COMPIEGNE (OISE), SAINT-CORNEILLE, ABBEY CHURCH (DESTROYED) VIRGIN AND CHILD (NOW COMPIEGNE, SAINT-JACQUES)

The somewhat less than life-size limestone figure which today stands in the transept of Saint-Jacques is thought to have come from the destroyed abbey church of Saint-Corneille. The lower part of the Virgin's right arm is missing, and the drapery at the neck and round the brooch may have been touched up. Both heads have been reinstated after being broken off.

The Virgin is clad in a girdled robe and mantle, and her head beneath the crown is veiled. The left hip, above which the Child is carried, projects, while the right leg is set far back; the mantle falls in front of the weight-bearing leg in broad folds. The contours of the Virgin's cheeks and the carving of the mouth and eyes show vigorous rounding, and the delineation of mouth, eyes, and brows is sharp. The draping of the mantle – gathered upward in front of the right leg – resembles that of the Virgin of the Paris north transept (pl. 188) and the 'Vierge dorée' of the south transept at Amiens (pl. 277, 279). The statue as a whole comes closer to certain ivory figures of the Virgin – that in the museum at Orleans (Koechlin no. 73) may be somewhat earlier, and the so-called Virgin of the Sainte-Chapelle (Koechlin no. 95) is perhaps contemporary. The latter should be dated to the period 1265/67–1279, when the inventory was made, which is not the dating proposed hitherto. The statue in Saint-Jacques at Compiègne, previously unpublished, was presumably executed c. 1270.

R. Koechlin 1924, nos 73, 95.

Pl. 275 right

VIRGIN AND CHILD FROM ABBEVILLE (NOW PARIS, LOUVRE)

The figure stands 3 ft 10 in. high and is carved in wood. It has been in the Louvre since 1907, and is said to have come from the Ursuline convent in Abbeville; its original provenance is apparently unknown. Mary's crown (in metal) and the head and hands of the Child are missing, and the Virgin's right hand is new. No traces of the colouring have survived.

Set on an octagonal socle, the figure is slender, with the lower part of the body relatively elongated; the head is small and delicate. Mary is attired in a full-length robe, a mantle laid across both shoulders and gathered up in front beneath the right elbow, and a short veil. The figure has a dancer-like mobility: in front of the left leg, drawn back, the mantle bellies into deep pockets, and there is also movement on the right side of the body, with the inclination of the

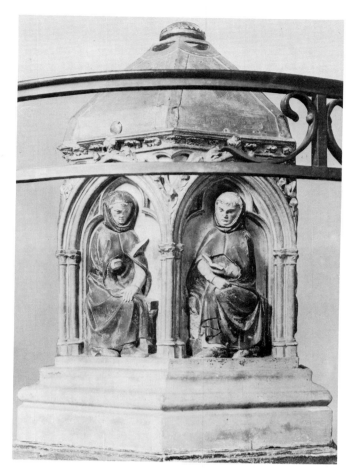

Ill. 102 Provins, Hôpital Général. Tomb monument for the heart of Count Thibaut V of Champagne. Shortly after 1270

upper torso and head. It is difficult to understand how this capricious figure could have been classified with the progeny of the comparatively statuesque 'Vierge dorée', and even dated to the early fourteenth century. The three-dimensional quality, together with the lively rendering of the drapery and surfaces, point to a date around or shortly after 1270. As remotely comparable, one can cite work from the last phase of the Rheims west portals: the blind tympanum with the Discovery of the Cross on the north buttress. For an almost exact repetition of the figure in ivory, see the statuette formerly in the Fitzhenry Collection, in Koechlin's catalogue no. 98.

R. Koechlin 1924, no. 98; L. Lefrançois-Pillion 1933; M. Aubert, M. Beaulieu 1950, no. 199.

Pl. 276

TWO ANGELS HUMBERT (PAS-DE-CALAIS), CHURCH

Preserved in the small village church of Humbert near Montreuil-sur-Mer (Pas-de-Calais) are two statuettes of angels, 3 ft high, carved in oak. In the first half of this century the figures were lye-washed. The wings are modern.

The slender figures in long robe and mantle, their elegant faces, framed by animated curls, touched by a fleeting smile, have often been compared with angels by the Joseph master of Rheims (see p. 488). In type they come just as close to several angels in the archivolts of the Rheims west portals, or to the angels in the two buttress aedicules at the west end of the nave on the north side. There were also similar figures at Royaumont – the tomb monument of Louis of France (pl. 272) – and inside the transept of Notre Dame, Paris. The theory that the figures are imitations in wood, executed by carvers from Champagne, of the statues on the Rheims west portals, is an unacceptable simplification based on stylistic connections which clearly exist.

In 1959 two further angels, clearly part of the same series, were discovered in a chapel at Saudemont between Arras and Cambrai. It is also possible that the angel presented to the Louvre by Arthur Sachs in 1930 comes from the same ensemble. It has been conjectured that all five figures originated in the cathedral at Arras, destroyed at the Revolution. A sixteenth-century panel painting shows one of the altars of Arras cathedral: it is flanked by six slender columns, as supports for the altar curtains, each surmounted by a standing angel. The inventory of 1791 mentions six silver columns, and the gilded wooden angels which stood on them. Similar groups are of course known in other cathedrals and monastic churches, but nearby Arras seems the most likely provenance for the angels at Humbert and Saudemont. Date: late in the third quarter of the thirteenth century.

J. Lephay 1929; C. Enlart 1929, vol. II, p. 847ff.; M. Aubert, M. Beaulieu 1950, no. 142; J. Lestocquoy 1959.

Pl. 277–279

AMIENS (SOMME),
CATHEDRAL OF NOTRE DAME
SOUTH TRANSEPT PORTAL

The three-aisled transept of Amiens cathedral has a portal on both north and south sides. The north portal, opposite the bishop's palace and the church dedicated to St Firmin, has a glazed tympanum, and features a single large figure, the bishop, presumably Firmin, on the trumeau. By contrast, the south portal carries a programme rich in figures. A thoroughgoing restoration was undertaken in 1843.

The eight jamb figures (pl. 279) include two angels – the inside figures on each side – but the remaining statues, which include two priests and an abbot(?), have not been identified.

The trumeau (pl. 277, 279) features the Virgin and Child. The Virgin's nimbus is supported by three angels. (The right hand of Mary, and the Child's hands, with the attribute, have been renewed, and the angels partially restored). Ten figures in ecclesiastical and secular attire, standing in blind arcades, appear on the socle beneath; these have no iconographic connection with the Virgin and no interpretation is possible.

On the lintel twelve figures are arranged in pairs. Despite the presence of shoes on their feet, and the absence of

physiognomies characteristic of Peter and Paul, these are apostles. The figure with pilgrim's hat and staff immediately to the right of the baldachin is presumably James the Greater. The scene has been interpreted as the leavetaking of the apostles before their missionary journey.

The tympanum depicts miracles from the Legend of St Honoratus, bishop of Amiens reputedly in the late sixth century. The story occupies all four bands. The bottom band shows (left) presumably St Honoratus receiving his call to episcopal office. The saint is seen seated far left; he is reluctant to accept the dignity; a ray from Heaven touches his head and certifies his election. The remaining figures, six in all, no doubt belong to this scene. Also in the bottom band (right) Honoratus, in episcopal vestments, is seated beneath a turreted arcade, which denotes the city of Amiens. In the forest nearby the priest Lupicinus is led by divine providence to discover the bodies of the martyrs Fuscianus, Victoricus and Gentianus. This miraculous discovery of relics is said to have occurred while Honoratus was bishop. In the second band (left) the hand of God appears to Honoratus while he is celebrating Mass. The bishop stands before an altar with a low retable. At his back, one behind another, stand a cleric, a deacon, a subdeacon and a choirboy. As is often the case in the thirteenth century, the liturgical action is reproduced with formal and pedantic exactness, down to the detail of the bowl to receive the paten (held by the choirboy), as prescribed by the order in use at Amiens. In the second band (right) the saint heals the sick. The altar in the middle is adorned with a meticulously reproduced antependium; on the mensa is a seated figure of the bishop. According to the Legend he appeared to a blind woman (the head of this figure has been restored) and commanded her to touch her eyes with the altar cloth, whereupon she regained her sight. (This scene is much restored.) In content the third band of the tympanum and the apex go together: once when the relics of Honoratus were being carried in procession, an image of Christ Crucified is said to have bowed down towards the reliquary (much of this has been renewed, including the Crucifixion at the apex which is modern). The tympanum with the Honoratus scenes is one of the many in the thirteenth century to display miracles from the Legend of a local saint. At Amiens the Firmin tympanum had already led the way (see p. 464).

The archivolt programme (pl. 279, 278) is unusual. The first arch, reading from the inside, includes angels with censers and crowns. The second arch features Old Testament figures. The sequence, which begins bottom left, shows: 1, Adam digging; 2, Noah building the ark; 3, Melchizedek with wine and bread; 4, Abraham and Isaac; 5, Isaac blessing Jacob; 6, Jacob blessing Ephraim and Manasseh; 7, Job. On the right, starting from the top, there follow in sequence: Moses; Aaron; David's anointing by Samuel; the judgment of Solomon; Judith; Judas Maccabaeus (completely renewed); John the Baptist. As a comprehensive and chronologically correct Old Testament cycle the sequence is unique on gothic church portals. The third arch features the major

and minor prophets, already portrayed on the west façade (pl. 170, 171; cf. p. 465). The major prophets are in the apex of the arch. The minor prophets, arranged in the order given in the Vulgate, begin bottom left: 1, Hosea with the whore Gomer (Hosea 1:3); 2, Joel sounding the trumpet, 'for the day of the Lord . . . is nigh at hand' (Joel 2:1); 3, Amos the herdsman standing before the gates of a city ravaged by fire (cf. Amos 1:7, 'I will send a fire on the wall of Gaza'); 4, instead of the prophet Obadiah, the Obadiah who was chamberlain to King Ahab and provided the persecuted prophets, hiding in caves, with bread and water (cf. 1 Kings 18:13; the confusion between the two Obadiahs also occurs in the quatrefoil reliefs on the Amiens west façade, and is quite common in written works); 5, Jonah spewed up by the whale; 6, Micah with an anvil on which swords are beaten into ploughshares and spears into sickles (cf. Micah 4:3). The sequence begins again on the right with Nahum and ends bottom right with Malachi. Returning to the left side, at the apex of the arch we have for Daniel the story of Susannah (completely renewed) and the stoning of Jeremiah, known only from Apocryphal sources, and the two remaining major prophets in the corresponding positions on the right. Full cycles of major and minor prophets occur in thirteenth-century sculpture only on the cathedral at Amiens. We must assume that the west portals and the south transept portal had the same theological basis, though the scenes rarely coincide. In the fourth arch we see New Testament figures, including the apostles and evangelists. In addition there are four female figures, one of them crowned. The crowned figure is perhaps the Virgin, with Mary Magdalen, Mary Cleophas and Mary Salome. Cf. for example, 'These all continued with one accord in prayer and supplication, with the women, and Mary the mother of Jesus.' (Acts 1:14). This interpretation is more convincing than the alternative proposal of Ecclesia with three sibyls. Reading from the inside, the programme of the three outer arches of the archivolt thus shows the era of the Old Testament *ante legem* and *sub lege*, the prophets, and the era of the New Testament. The typological significance of the Old Testament scenes also had a part to play in the assembling of the programme: one notes, for example, among the figures in the third arch a series of types for the Crucifixion. A connection is thus established with the scene in the apex of the tympanum.

Style and dating. The portal was not made as a unit. Two phases are to be distinguished. Up to the height of the triforium the transept façade belongs to the parts of the cathedral finished in 1236 or shortly before. To this period belong: the jambs, with eight figures; the trumeau with its baldachin, but without the surmounting polygonal tower; the blind gable framing the tympanum (pl. 279). The architectural forms and the figure style correspond to those of the Amiens west portals. The socle reliefs suggest that the trumeau was originally intended to display the figure of a bishop – but not, as suggested, the bishop on the trumeau of the north transept, which is patently later in date. All the remaining sculptures – the trumeau statue, the figures on

the lintel and in the tympanum and archivolt – were made after a fire in 1258, at the time the clerestory of the main choir was built. The window of the chevet is dated 1269, and the boss of the choir vault is by the same workshop as the later sculptures on the transept, which gives us a *terminus ante quem* for their completion: the sculptures of the Honoratus portal were made between 1259 and 1269. At that time the Rheims west portals were just completed and work on the transept of Notre Dame in Paris still in progress. There seem to be connections with both these centres. The figure of the Virgin – known as the 'Vierge dorée' from its original gold colouring – has been compared with the maidservant from the Rheims Presentation group (pl. 192, 197). At Amiens the forms are heavier, the surfaces duller. There can be no question of the same hand as at Rheims. Our view, on the whole, is that the style owes more to Paris than to Rheims, and in particular the north transept portal of Notre Dame (pl. 186) and those figures on the south transept façade (pl. 268, 269) which have stylistic connections with the north side. There too a model is to be found for the dry and precise figure conception, with the harsh buckling of the drapery folds, as also for the uninspired narrative manner, which contents itself with a superficial juxtaposition of gesticulating figures. In isolated cases Amiens and Paris are even in literal agreement. In our view the later parts of the Amiens south transept portal should be regarded as unitary. They are probably the work of an atelier which came to Amiens from Paris. Date: Between 1260 and 1269.

E. Jourdain, T. Duval 1844; G. Durand 1901, vol. I, p. 429ff.; P. Vitry 1929, p. 64f.; W. Medding 1929; M. Aubert 1946, p. 255; A. Katzenellenbogen 1961; *see also* Appendix to Bibliography.

Pl. 280

OLD TESTAMENT FIGURES
TROYES (AUBE), MUSEE DES BEAUX-ARTS

The two statues, 6 ft 10 in. high, were acquired by the museum in 1887 from a local dealer; a gardener is said to have found them in a stream on the outskirts of Troyes, but this cannot be verified. A statement that the figures came from the Benedictine abbey of Montiers-la-Celle has proved to be false. The provenance is thus unknown. The figures cannot have come from a portal with column figures since the backs are flat.

From their dress these statues represent Old Testament figures. The youthful figure (pl. 280 right) with raised arm wears a cap running to a point. The attribute he once held is missing. His feet are planted on the neck of a prostrate woman, who wears a narrow diadem beneath her touret. With so little to go on, it is now impossible to give the figure a name; its current designation as a prophet narrows the field unduly. The second statue (pl. 280 left), poring over the text of the long banderole, wears a conical cap with upturned brim. It has been thought this headgear represents the tiara worn by Jewish priests. The figure cannot be Aaron, however, who is normally shown with the breastplate. At the feet of the statue lies a king, and associated with him are

495

three shields displaying ape-like idols standing on their heads. This suggests a ruler whose idolatrous practices incurred the censure of the priest or prophet portrayed in the statue. A convincing identification has yet to be proposed.

Style and dating. If the formal language is harsh and rigid, it is also strongly expressive. The prominent gestures and angular drapery motifs invest the huge figures with an icy emotion. The appearance, which is more commonly met with in German than in French sculpture of the thirteenth century, is governed by a powerful intensification of stylistic devices and by a forceful assertion of the content. Stylistically, the immediately preceding phase is perhaps represented by the interior west wall of Rheims (pl. 229) – north and south sides in particular (pl. 235, 234) – or the south transept portal of Notre Dame, Paris (pl. 268, 269). No directly comparable pieces can be adduced in sculpture. There seems to be a close affinity with standing Old Testament figures in the window glass of Saint-Urbain, Troyes, so we should be thinking in terms of local connections. The alleged influence on the sculptures of the west façades of Basle and Strasbourg or on the cathedral at Regensburg is difficult to detect. Date: c. 1270.

L. Lefrançois-Pillion 1933; H. Reinhardt 1962; J. Roserot de Melin 1964–66; F. Salet 1967; P. Quarré 1969.

Pl. 281 top

METZ (MOSELLE), CATHEDRAL OF SAINT-ETIENNE
RELIEF WITH FIGURES OF APOSTLES

Just beyond the romanesque west façade of Metz cathedral stood the collegiate church of Notre-Dame-la-Ronde. The rebuilding of the cathedral nave in the first half of the thirteenth century incorporated the church. The foundation continued, however, as a separate entity: to it belonged the three west bays of the cathedral nave, with a choir and elaborate figure-decorated portal. In the third quarter of the eighteenth century, when the exterior of the cathedral was incorporated by J. F. Blondel into the layout of the 'Place d'Armes', the portal of Notre-Dame-la-Ronde was bricked up; it was exposed again in 1860, only to be subjected, in the years following 1871, to a garbled restoration. Stylistic judgment of the sculptures must inevitably be qualified. All we have to go on are a few old photographs, casts, and above all the right half of the lintel illustrated here; this had not been reinstated at the time of the restoration and thus escaped the attentions of the restorers. The fragment is preserved in the cathedral crypt.

PROGRAMME
The portal was associated with the dedication of the church to the Virgin. The tympanum displayed at the apex the coronation, in the middle band her death, with Christ behind the death bed holding her soul; only two apostles are present. The remaining ten apostles are portrayed on the lintel; at their head is an angel with a censer. The side walls of

a porch displayed scenes relating to Christ: on the right, the flagellation, bearing of the cross and Crucifixion; on the left, the Resurrection, Ascension and Last Judgment. When the portal was opened up in 1860, the jamb figures and sculptures on doorposts and archivolts were no longer extant.

Style and dating. The drapery of the group at the apex of the tympanum is still in the linear style of the first decades of the thirteenth century. It has sometimes been suggested that there is a connection with the south transept of Strasbourg cathedral. The Metz figures, however, are fuller and more thick-set. The remaining parts of the tympanum look more recent. A discriminating style-critical judgment is no longer possible. The lintel reveals a heavy, block-like formal language, but the two halves differ between themselves, the left half, not illustrated, being in lower relief. The figures, ranged one behind the other, are seen in profile; they wear concealing draperies with practically no movement in them. It has been suggested that the same sculptor worked on the Neuweiler portal (pl. 282 right). The right half shows a dramatized rendering of the same theme: high relief, figures in various places and positions, bellying and gathering of draperies. Connections have been observed with the west jubé of Mainz cathedral and the sculptures of the Stifterchor at Naumburg. It must be said, however, that the theory that this is an early work of the Naumburg Master is an over-individualized interpretation of stylistic relationships. There are no grounds for concluding a direct connection with Mainz (the Martin relief at Bassenheim). More important, so far as the Metz relief is concerned, is the question of its stylistic antecedents. The expressively dramatic treatment of block-like forms is found on the upper storeys of the Rheims transept: in the two most important of the king statues (pl. 260, 264 far left) and in the figures around the south rose (pl. 263). It was from here that the style of the Metz relief was formed. Date: the 1240s.

E. Panofsky 1924, p. 157f.; O. Schmitt 1929; M. Aubert 1931, p. 161ff., 199ff.; R. Hamann-MacLean n.d.; J. A. Schmoll (Eisenwerth) 1966; W. Goetz 1968, p. 56f.

Ill. 103

MONT-DEVANT-SASSEY (MEUSE), NOTRE DAME
SOUTH PORTAL

The church of Notre Dame in Mont-devant-Sassey belonged to the convent of Andenne on the Meuse. In the thirteenth century a gothic figure-decorated portal was erected on the south side of the romanesque nave. Artistically it is not very important, but deserves attention as the one surviving example of a type once widespread in Lorraine.

PROGRAMME
The right jamb shows (reading from the left in ill. 103): Eve, Adam, uncouth figures clad only in loincloths made from large coarse leaves. Adam has a massive chest, Eve enormous breasts – unique in thirteenth-century sculpture; over their

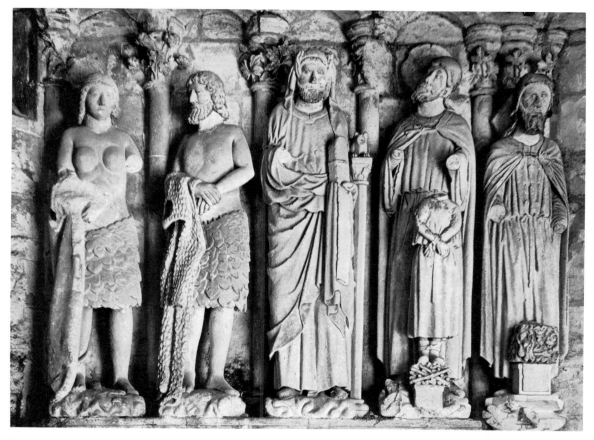

Ill. 103 Mont-devant-Sassey, Notre Dame. South portal, right jamb: Eve, Adam, Moses, Abraham, Noah. 1240–50

arms they hold the garments God gave them after the expulsion. There follow in succession: Moses with the Tables of the Law and the brazen serpent; Abraham with Isaac, standing on the kindling for the sacrificial altar; Noah sacrificing after the Flood (the Ark appears on the socle). Not illustrated are a king with an open book, and David(?) – with the building of the porch after 1754 this last figure was removed from the jamb and installed in a side niche. On the opposite wall the subjects include, on the inside, the Annunciation. The tympanum depicts the Infancy of Christ; the archivolt includes the apostles and Old Testament figures.

In the jamb programme Adam/Eve and Gabriel/Mary stand out as clearly recognizable companion pieces. The portals of the royal domain established a similar relationship between a statue and its socle figure. Moses with the brazen serpent and Abraham with Isaac no longer appeared in the royal domain after 1220, while Noah offering sacrifice never formed part of typological jamb programmes. Mont-devant-Sassey thus presents us with an independent cycle, which was not unknown in the archdiocese of Trier. Down to the Revolution the cathedral at Verdun possessed a portal which displayed Adam and Eve. The 'Portail des Bourgeois' on the church of Saint-Maurice, Epinal, appears to have had this same programme. In many respects Epinal resembles the portal of Notre-Dame-la-Ronde in Metz (see p. 496), so it may

be that the Metz jamb carried the same programme. Lastly, there is a figure of Noah among the statues on the façade of the Liebfrauenkirche at Trier. Thus we can infer for the thirteenth century a group of portals in Lorraine which, at least so far as their programmes were concerned, had certain features in common. The sculptures of Mont-devant-Sassey, which are exceptionally crude in execution, go back indirectly to the sculptures on the eastern parts of Rheims cathedral. Date: between 1240 and 1250.

H. Reiners, W. Ewald 1921, p. 38 ff.; C. Aimond 1933, p. 91; E. Fels 1933.

Pl. 281 middle and bottom

SAINT-GERMER-DE-FLY (OISE), ABBEY CHURCH
ALTAR RETABLE (NOW PARIS, MUSÉE DE CLUNY)

The abbey of Saint-Germer-de-Fly near Beauvais was founded in the seventh century. The existing church is an early gothic building, begun in the second quarter of the twelfth century. The chevet chapel in the ambulatory was replaced under Abbot Pierre de Wesoncourt (1259–72) by a large Lady Chapel on the lines of the Sainte-Chapelle in Paris. The chapel was dedicated by Guillaume de Grez, a bishop of

497

Beauvais who died on 21 February 1267; it is probable, therefore, that the chapel was finished by 1266.

Its principal altar had a stone retable, which came to the Musée de Cluny in Paris in 1863. It takes the form of a long low rectangle, not divided into compartments. A plainly profiled frame runs all round, broken only by a triangular gable which marks the centre of the top edge. Thirteenth-century altarpieces just as simple in form survive in the ambulatory chapels of the abbey church of Saint-Denis. The retable depicts single figures in relief, equally spaced; in the centre is a Crucifixion group, which is flanked by Ecclesia and Synagogue, Peter and Paul. The *Vita Geremari* gives the church's patrons as Mary, John and Peter. To the left and right we see respectively the Annunciation and Visitation. The remaining figures presumably depict incidents from the Legend of St Geremar, but the interpretation is uncertain.

The peaceful standing figures with their compact contours, the draperies with their prominent folds, call to mind the last phase of the Rheims west portals. Synagogue, for example, can be compared with the doorpost figures of the right-hand doorway (pl. 221 middle) or with the Herodias of the interior west wall (pl. 223). Drapery motifs of the Ecclesia are found on the Rheims tympanum with the Discovery of the Cross, and at Auxerre. In point of detail the treatment is admittedly quieter and more restrained than at Rheims or Auxerre. Date: between 1259 and 1267.

L. Régnier 1905; A. Besnard 1913, p. 115 f.; H. Bunjes 1937, p. 112f.

Pl. 282 left, ill. 104

STRASBOURG (BAS-RHIN), CATHEDRAL OF NOTRE DAME
JUBE

The nave of Strasbourg cathedral, begun before the middle of the thirteenth century, was completed in 1275. The jubé stood in front of the crossing, in the east bay of the nave. Protestant since the Reformation, the cathedral reverted in 1682 to the Catholic church, and at this time it was decided to refurbish the choir, and remove the jubé. Its arrangement and programme are known from drawings and engravings antedating its destruction (ill. 104). Statues and fragments which since the nineteenth century have been recovered from the cathedral or from private ownership are now in the Musée de l'Œuvre Notre-Dame in Strasbourg. Two arcades have been erected there to give an idea of the original arrangement. A standing figure of the Virgin, now in the Cloisters of the Metropolitan Museum, New York, has been associated with the Strasbourg jubé.

The jubé opened into the nave through a seven-arched gabled arcade. There were two doorways, one on either side of the centre arch, beneath which stood the 'Frügealtar' (at which morning Mass was said). Four more altars, one of them dedicated to the Virgin and another to St Nicholas, stood beneath the outer arches.

The programme was unlike that of other known jubés; the narrative cycle, as found at Chartres, Bourges, Paris, Naumburg and Gelnhausen, is absent. In the spandrels of the arcade stood figures of Virgin and apostles. The figure of the Virgin, with the rose bush, was the earliest example of this rarely found type. The parapet had no figure decoration, only open tracery. On the outer gables works of mercy were shown, and in the centre the Last Judgment. The rostrum presumably carried a deacon figure as support for the lectern.

Style and dating. The extant statues – nine apostles (pl. 282), the deacon and possibly the New York Virgin – show no recognizable connection with the earlier sculptures of the Strasbourg south transept. The architecture of the jubé has been justly compared with the west façade of the destroyed abbey church of Saint-Niçaise, Rheims. The style of the sculptures shows great similarity with the Passion cycle in the archivolt of the left doorway of the west portal of Rheims cathedral (pl. 214, 215). The agreements are so close that we may reasonably assume that the Strasbourg sculptors were trained in this particular Rheims atelier.

The date of the jubé sculptures is disputed and is not without importance for the chronology of Rheims. Two documents are significant. In 1252 we hear for the first time of an 'altare civitatis in ecclesia beatae Mariae Argentinensis'. The altar in question is presumably the 'Frügealtar'. The text has no bearing on the jubé, and the proposal to date the latter to before 1251 is off the mark. In 1261 a document issued by the bishop of Strasbourg speaks of the 'lettenere' (German *Lettner* = jubé); this gives as a firm date for the installation of the sculptures. The jubé was made *c.* 1260.

J. Knauth 1903; O. Schmitt 1924, vol. II, p. viii ff.; E. Panofsky 1924, p. 166 f.; O. Schmitt 1926–27; H. Haug 1931; J. Rorimer 1949; H. Haug 1950; H. Reinhardt 1951.

Pl. 282 right

NEUWEILER (BAS-RHIN), SS. PETER AND PAUL, COLLEGIATE CHURCH
NORTH PORTAL

In 1496 the Benedictine abbey of SS. Peter and Paul at Neuweiler was turned into a collegiate church. The existing church was a new building of the late twelfth century and the first half of the thirteenth. The choir, transept and double bay in the east of the nave are in the late romanesque tradition of Alsace. The western bays of the nave show a transition to High Gothic forms. The figure-decorated portal on the north side belongs to these more recent structures.

The portal type, without jamb figures or archivolt, is fairly common in Alsace and Lorraine. The tympanum shows the Judge between angels bearing the instruments of the Passion. The Judge has one arm raised and the other lowered, a posture rarely found on gothic portals. Standing on short columns beside the jamb are statues of the two patrons, Peter and Paul; their attributes are missing. For this arrangement compare Ecclesia and Synagogue on the Strasbourg south transept (pl. 130). On both statues the surface has been

498

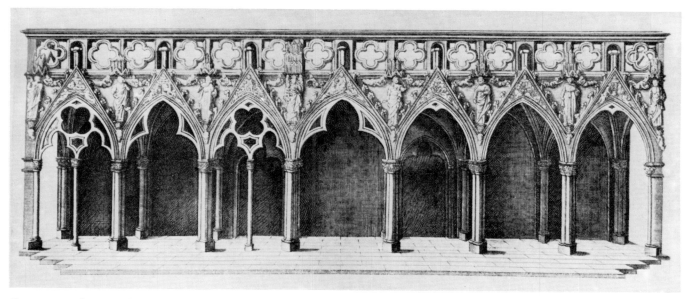

Ill. 104 Strasbourg cathedral. Destroyed jubé. Shortly before 1261. (After an engraving perhaps by Arhardt in the Musée de l'Œuvre Notre-Dame, Strasbourg)

touched up. Their places were probably exchanged when they were installed in their present positions.

Style and dating. The tympanum relief with its broad figures in heavy, partly smooth, partly uneasily crumpled draperies, points unmistakeably to the south rose of the Rheims transept (pl. 263). The motifs of the figure of Christ are repeated almost exactly in the Rheims apostles (ill. 95–98), though at Neuweiler the execution has not the same tension. The relationship with Metz (pl. 281) is questionable. The Neuweiler apostle statues point equally to a connection with Rheims. The drapery motifs are found in kings on the Rheims transept (pl. 264 far left) and in the 'man with the Odysseus head' (pl. 204) on the Rheims west façade. Also important in this connection are the prophets in the loggia above the Rheims south rose. Date: the 1240s.

F. X. Kraus 1876, vol. I, p. 178; O. Schmitt 1929; R. Hamann-MacLean n.d.; W. Kleiminger 1939, p. 17; J. A. Schmoll (Eisenwerth) 1966.

Pl. 283–287, ill. 105

AUXERRE, CATHEDRAL OF SAINT-ETIENNE WEST PORTAL

The choir of the cathedral was begun about 1215 and we know of an interment there as early as 1239; the cathedral was completed only in the sixteenth century. Between 1230 and 1240 work began on the south-west tower; the portal, however, was begun only after 1250 and clearly made halting progress, the centre doorway not being completed until the fifteenth century.

PROGRAMME
In the centre is the Last Judgment, on the left the Coronation of the Virgin, and on the right John the Baptist. We shall here confine ourselves to the right doorway and the jambs

and doorposts of the centre doorway. The remaining portions post-date 1270.

In the tympanum of the right doorway (pl. 283) the cycle must be read upwards from the lintel. The lintel shows: 1, Visitation; 2, birth of the Baptist; 3, circumcision of the Baptist. The middle band of the tympanum shows the Baptist preaching, with Christ among his audience, and the Baptism of Christ, with (right) angels drying Christ after his baptism. Above are John's disciples, coming to Christ to ask: 'Art thou he that should come?', and Herod's banquet.

In the archivolt (pl. 284) we have not single figures but scenes, obviously intended to be read horizontally, though no strict sequence seems to be observed. The story of John the Baptist appears on the right: (bottom, reading from the outside) 1, John in the wilderness; 2, a figure writing, with an angel standing by (unexplained); 3, John's disciples. In the next register we see: (reading from the outside) 1, Herod talking to John in prison; 2, Herodias conferring with Salome; 3, John's disciples. These scenes are followed (above) by the beheading, the burning of John's bones and the reception of his soul into Abraham's bosom. The Infancy of Christ is depicted on the left side. The details of the lower scenes are not clear. In the second register we see (reading from the outside) the Birth of Christ, shown in an unusual arrangement: on the outside we see Joseph and Mary, without the Child, in the customary pensive attitudes; next, the crib, with ox and ass, but having in front the scene, current in Byzantine art, in which the new-born Christ is bathed. This is followed by the Circumcision. Above, further scenes from the infancy story are shown.

The scenes represented on the jamb socle are unusual (pl. 285). In niches crowned by gables the story of David and Bathsheba is told. The cycle begins on the inside of the right jamb (pl. 285 top). It shows David gazing from his

499

palace on the bathing Bathsheba whose maidservant is pouring water over her and rubbing her bosom; Uriah riding to Rabbah. The cycle continues on the left jamb, starting on the outside (pl. 285 bottom): Uriah is killed before Rabbah; David leads Bathsheba into his palace and she is seen enthroned beside him. In patristic exegesis Bathsheba bathing is a type for the Church, cleansed by baptism, and David a type for Christ, choosing her for his bride – hence the incorporation of the story of Bathsheba into this Baptist's portal. In the spandrels between the gables stand Philosophy (with crown, pl. 285 top left) and the seven Liberal Arts. Still recognizable are, on the right jamb (reading from the inside) Grammar with two pupils, Dialectic with a snake for her belt, and Rhetoric(?), making a gesture of emphasis. On the left jamb we see the Quadrivium (pl. 285 bottom): in the last place but one (second from the inside), Music, traces of whose carillon and of a stringed instrument are still visible, and to the right of her is Astronomy gazing up at the stars(?). The two preceding figures would then be Arithmetic and Geometry. While the Liberal Arts are a favourite theme for illustration in the protohumanist climate prevailing around 1200, they are rarely found in the thirteenth century. Auxerre was the seat of an important cathedral school, but by the time the portals were made its heyday was already past. The sculpted decoration continues to the right, across the façade. In the socle zone are scenes relating to David. Below the blind gable the Judgment of Solomon (ill. 105) is depicted.

The jamb, tympanum and archivolt of the centre doorway are late medieval works. Plans for a Judgment portal had already been made, however, in the thirteenth century, as we can tell in particular from the presence of the Wise and Foolish Virgins on the doorposts (pl. 286 top).

Once again, the socle programme (pl. 286–287) is unusual, consisting of six niches with seated pairs of figures engaged in dialogue. Interpretation is difficult, but the apostles can be excluded as a possibility since, as was customary, they were planned as jamb figures. It may be that these are prophets and a sibyl, with reference to the Judgment. Below the niches are, on the left – the side of the Blessed – the story of Joseph who was sold into Egypt (pl. 286), and, on the right – the side of the Damned – the story of the Prodigal Son (pl. 287 bottom). Joseph, under various aspects, was regarded by the exegetes as a type for Christ. The Prodigal Son was an example of the repentant sinner receiving forgiveness from the Lord. It has here a patent connection with the Judgment theme, which the Joseph cycle does not.

The cycle on the right is much eroded. The arrangement of four medallions round a central field was presumably inspired by the field divisions used in stained-glass windows. The course of the action proceeds in the top and bottom lines from inside outwards. We illustrate and discuss here only the scenes in a good state of preservation (pl. 287 bottom). Above, top left, the prodigal dining with prostitutes, who bathe him, top right; bottom right and left, the banquet prepared by the father for the homecoming of his

500

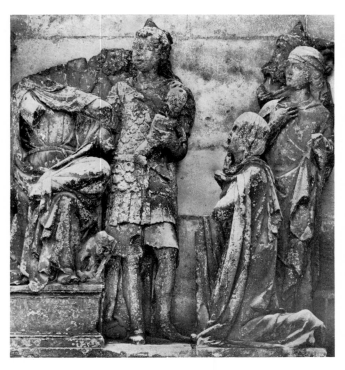

Ill. 105 Auxerre cathedral. The Judgment of Solomon, beside the right doorway of the west portal. Towards or about 1260

son. In the centre medallion is Luxuria, a female figure making a dancer's cross step and suckling dragons. This portrayal of Luxuria, which in form supposedly stems from the classical Terra, was widespread in the architectural sculpture of the first half of the twelfth century; in Gothic, apart from this instance, it is found only among the sinners in the cauldron of Hell. The figure here relates to the scenes with the prostitutes.

The basic scheme of the Joseph cycle on the left (pl. 286) is similar. In both lines the action proceeds from inside outwards. The fields are arranged side by side and not in a star formation around a central medallion; quatrefoils alternate with narrow blind arcades. The sequence of events depicted in the top line is: 1, Joseph dreams of the sheaves and stars; 2, Joseph tells his dream to Jacob; 3, the brothers depart; 4, Joseph is stripped and lowered into the well; 5, Jacob is shown the bloodstained coat; 6, Joseph is sold to the Ishmaelites; 7, the journey into Egypt; 8, Joseph kneels before Potiphar; 9, Potiphar's wife tries to seduce Joseph; 10, Joseph escapes. The sequence in the bottom line is: 1, Joseph is accused; 2, Joseph is imprisoned; 3, 4, the cupbearer is brought from the prison and kneels before Pharaoh's table; 5, 6, Pharaoh's dream of the fat and lean cattle. The interpretation of the following scenes is uncertain: 7, the cupbearer tells Pharaoh of Joseph(?); 8, 9, Joseph is fetched from the prison; 10, Joseph before Pharaoh(?); 11, Joseph as governor of Egypt. In the top line, just before the journey to Egypt, we see Hercules with the Nemean lion; in the field below, a satyr with goatskin. Insertion of figures from pagan mythology into a biblical

cycle is otherwise unknown in the thirteenth century. Local discovery of classical remains cannot by itself account for the presence of these surprising figures, which undoubtedly relate in some way to the content of the Joseph story. The most convincing explanation to date (E. Panofsky) adverts to the fact that both Hercules and the satyr had connections with Egypt or the Egyptian desert. Whether or not this can be accepted as the definitive interpretation remains an open question. The presence of a slumbering Cupid on the socle beneath the Wise Virgins is puzzling.

The programme of the west portals of Auxerre is both unconventional and imaginative. There are none of the figures of local saints which around the middle of the thirteenth century were practically de rigueur. Auxerre was a suffragan see of the archdiocese of Sens, and Sens seems to have inspired the themes of the side doorways (cf. p. 416). They are worked out, however, in an independent fashion, which dispenses with the formulas current c. 1250.

Style and dating. In the Baptist's portal (pl. 283), the arrangement, and the disposition of the figures, reverts to that of the left doorway of the Sens west façade, several decades earlier in date. The execution of the sculpture is naturally different. The full-bodied figures, the drapery motifs, the broad heads, combined with a sensuously descriptive but not histrionically exaggerated manner of narration, point to a direct connection with the last phase of the Rheims west portals. A Rheims workshop executed this portal (pl. 283–285, ill. 105), towards or c. 1260. The history of the jambs and doorposts of the centre doorway (pl. 286, 287) is more complicated. The right jamb (pl. 287) dates from the same period and is also the work of Rheims sculptors. The left jamb (pl. 286) is by another workshop and was probably made later. The delineation of the blind traceries in the niches and of the profiles of the gables inserted between them is sharper and more sparing; the same goes for the sculptures. Nevertheless, this jamb dates from not later than 1270. The right and left doorposts (pl. 286 top, far right) display the same differences as those observed between the right and left jambs.

E. Daudin 1871/2/3; C. Enlart 1907; Ch. Porée 1926; L. Lefrançois-Pillion 1931 (2), p. 187 ff.; J. Adhémar 1939, p. 283 ff.; C. Schaefer 1944; E. Panofsky 1960, p. 93 f.

Pl. 288

SAINT-THIBAULT-EN-AUXOIS (COTE-D'OR), PRIORY CHURCH
NORTH TRANSEPT PORTAL

Saint-Thibault was a priory of Saint-Rigaud-en-Maconnais, a Benedictine abbey. The extant portions of the church date from the thirteenth and early fourteenth century. The portal on the north transept belongs to the oldest phase.

PROGRAMME
The tympanum depicts the Coronation of the Virgin, with her death and Assumption in the lintel. The archivolt shows,

in the inner arch, the Wise and Foolish Virgins; in the outer arch, confronting one another in pairs, are Moses and Aaron; David and Solomon(?); Jeremiah with the cross, and a prophet holding a crenellated tower (Nehemiah?); a figure with a banderole, and Melchizedek with bread and wine; Simeon and John the Baptist. This sequence assembles fragmentary items from the jamb and archivolt programme of earlier Coronation portals of the Senlis (pl. 42) and Paris (pl. 152) type. On the trumeau we see St Theobald in liturgical vestments. The jamb figures are, on the left: an archbishop; an aristocratic lady in long robe and mantle (pl. 288 right), with a veil as well as a touret. On the right, two male figures in contemporary dress with banderoles; the outer, youthful figure, wears a chaplet. The faithful reproduction of the costumes and the distinctive physiognomies have led some to think that the figures represent Duke Robert II of Burgundy (died 1305) and his son Hugo V (on the right), and his widow Agnes, with Hugues d'Arcy, bishop of Autun, appointed as her counsellor in the duke's will. This theory is not only untenable on iconographical grounds but is also upset by the dating. The statues were executed more than fifty years before the death of Robert II. They represent biblical figures or saints, precisely which it is no longer possible to say.

Style and dating. The sculptures of the portal show a stylistic trend deriving from Rheims which is found in other places in Burgundy – Semur-en-Auxois (pl. 291), Vézelay (ill. 106), Rougemont, Chablis – and also at Le Mans and Bordeaux (pl. 304, 305). The statues on the right wall are a striking illustration of its particular features: broad, hulking figures, with coarse but fully characterized heads, which by dint of emphasizing the contemporary dress creates the illusion of closeness to life. Yet the workshops use formulas which were widely current. The archbishop on the jamb follows precisely the pope on the lintel of the Le Mans portal, and the figures on the right jamb at Saint-Thibault also have their counterparts in the train of the Blessed on the same portal. As at Semur (pl. 291), and again making due allowance for the inferior quality, one is faintly reminded of the sculptures of Naumburg cathedral. The resemblances can be accounted for by the existence of a common starting point, Rheims. Date: c. 1240–50.

L. Lefrançois-Pillion 1922; M. Aubert 1928; M. Aubert 1946, p. 314; A. Colombet, n.d.; P. Quarré 1965.

Pl. 289

STATUE OF ST PETER
CHABLIS (YONNE), SAINT-MARTIN,
COLLEGIATE CHURCH

The statue in the south aisle of Saint-Martin, Chablis, was discovered in 1836 in the churchyard of Saint-Pierre.

The broad, heavy forms and the facial type – with prominent cheek bones, rounded eyeballs, low forehead – are in keeping with mid-century works found in Burgundy: Vézelay (ill. 106), Saint-Thibault-en-Auxois (pl. 288), Semur-

501

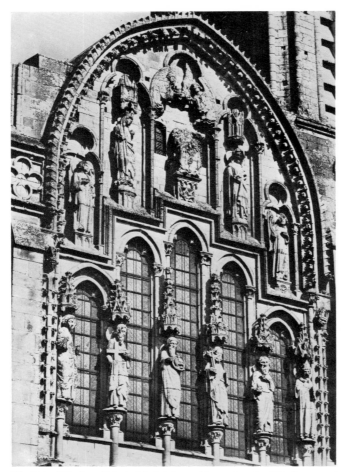

Ill. 106 Vézelay, Sainte-Madeleine, abbey church. Windows and gables of the west façade. Four apostles, John the Baptist, Lazarus(?); (above) Christ between Mary and Mary Magdalen, angels. Towards or about 1250

en-Auxois (pl. 291). For the stylistic origins see Le Mans, portal of Notre-Dame-de-la-Couture (p. 503). Date: c. 1250.

J. Duband 1852, p. 125; F. Salet 1958

Ill. 106, 107

VEZELAY (YONNE), SAINTE-MADELEINE, ABBEY CHURCH

The west façade of the abbey church (the Madeleine) at Vézelay, with its triple portal layout, dates from the 1140s. Towards 1250 the romanesque wall above the centre doorway was demolished and replaced by five lancet windows, graduated upwards to the highest point at the centre; as the crowning touch a steeply pointed gable was added. These new portions were provided with a full programme of figures. Large statues were mounted between the windows:

Ill. 107 Vézelay, Sainte-Madeleine (Dépôt lapidaire). Female figure with martyr's palm. Towards or about 1250

from left to right, John the Evangelist, Andrew, John the Baptist, Paul, Peter, and a figure with cope and mitre (Lazarus?). In blind arcades on the gable: an enthroned Christ flanked by the crowned Virgin, Mary Magdalen, the church's patron (ill. 107), and two angels with censers. The implication of the gable programme is clear: Mary Magdalen, patron of the pilgrim church at Vézelay, ranks as intercessor with the Virgin. Damage done at the time of the Revolution and the restoration under Viollet-le-Duc make a stylistic judgment difficult. Many fragments of the originals not reinstated by the restorers are preserved in the gallery of the narthex.

The façade composition is unique. What must be a later imitation of it can be seen on the church at Saint-Père-sous-Vézelay, which belonged to the abbey. The sculptures show the trend started by the eastern portions of Rheims and widely followed in Burgundy. By way of comparison see Semur-en-Auxois (pl. 291), Saint-Thibault-en-Auxois (pl. 288), Chablis (pl. 289), Rougemont, and (outside Burgundy) Le Mans (pl. 290) and Saint-Seurin in Bordeaux (pl. 304, 305). The sculptures are all from the same workshop and were made c. 1250.

F. Salet 1948, p. 97f.

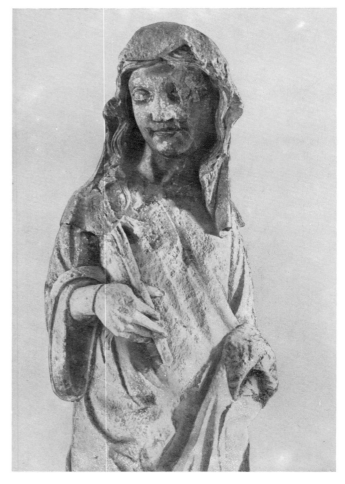

Pl. 290, ill. 108

LE MANS (SARTHE), NOTRE-DAME-DE-LA-COUTURE, ABBEY CHURCH
WEST PORTAL

The Benedictine abbey of Notre-Dame-de-la-Couture was founded in the early seventh century. The existing church is an eleventh- to thirteenth-century building. The west façade features a porch set between square towers. A view dated 1695 shows that on the entry side there was a tripartite arcade. The trumeau, which displayed a statue of Christ, and the arcade have been demolished.

PROGRAMME

The theme is the Last Judgment: in the tympanum, Christ is shown as judge between kneeling intercessors and angels with instruments of the Passion; on the lintel, the resurrection of the dead, and the separation of the Blessed from the Damned. The jambs have figures of six apostles: on the left, supposedly Peter, James the Greater and John; on the right (pl. 290), Paul and (unidentified) two outer statues.

Style and dating. The portal was not made as a unity. The jambs and lintel belong to a first phase and the sculptures of this first phase show conspicuously broad and heavy forms; the execution is crude, and the rendering of the drapery perfunctory. The realism imparted to the heads, with their large, prominent eyeballs, pronounced cheekbones and the lines at the root and sides of the noses, is derived from discoveries noted in important prototypes, and here transmuted into a formalized uncouthness (pl. 290). Direct connections exist both with Saint-Seurin, Bordeaux (pl. 304, 305), and with works in Burgundy. The common starting point is Rheims sculpture from the period before 1241: the Judgment portal (pl. 236 ff.), upper storeys of transept and choir (pl. 254–255, 258–264), the 'man with the Odysseus head' (pl. 204). Date: *c.* 1245 or shortly after.

The formal language of the tympanum and archivolt figures is more pointed, the proportions more elongated, the delineation of the folds sharper and more angular. Even the facial type is different – realism and truth to life are absent; a nobler and more conventional stylization is achieved. The origins are perhaps Parisian: thus a work like Villeneuve-l'Archevêque (pl. 179) is older, the south transept of Notre Dame (pl. 267 ff.) surely more recent. Date: *c.* or after 1250.

A. Launay 1852; P. Vitry 1929, p. 75 f.; J. Polti 1936; H. Branthomme 1948; F. Lesueur 1961; A. Mussat 1963, p. 129 f.

Pl. 291

SEMUR-EN-AUXOIS (COTE-D'OR), NOTRE DAME, PRIORY CHURCH
NORTH TRANSEPT PORTAL

Notre Dame, Semur, was a priory subordinate to the abbey of Flavigny. The existing church is a new building begun about 1225. The eastern portions were completed *c.* 1250.

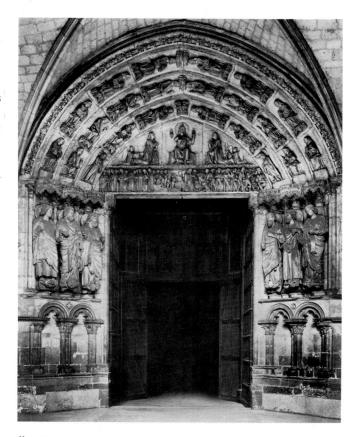

Ill. 108 Le Mans, Notre-Dame-de-la-Couture, abbey church. West portal. Tympanum and archivolt: Last Judgment. Jamb: apostles. From 1245 to shortly after 1250

The north transept portal has a sculptural programme filled with figures. In the single arch of the archivolt is a Calendar. The tympanum illustrates in three bands the legend of the apostle Thomas. The sequence begins in the middle band, left: 1, the resurrected Christ appears to doubting Thomas; 2, Christ recommends Thomas as an architect to Abbanes, steward of King Gundoforus of India; 3, Thomas and Abbanes travel by ship to India. The story continues in the lower band, starting on the right with the wedding feast of King Gundoforus's daughter. Thomas is seated extreme right, and refuses the food proffered him by the cup-bearer. According to the Legend the cup-bearer struck Thomas, whereupon he declared: 'I shall not rise from this spot until the dogs bring hither the hand that smote me.' The cup-bearer was then torn to pieces by a lion while he was drawing water, and a black dog carried his right hand to the banqueting table; the dog can be seen at the apostle's feet. The female tumbler – in form reminiscent of portrayals of Salome – in the foreground is perhaps the flautist mentioned in the Legend who sang (in Hebrew): 'There is one God in Heaven, the Hebrew God, who has created all things and the sea.' Note the faithful reproduction of the table-ware and of the folding stool with animal heads on which the king is seated. In the next scene the king,

in the presence of Abbanes, commissions Thomas to build the palace. Next, Thomas distributes the building money to the poor; at the apostle's feet is a basket containing coins. Before him are two cripples: one squats on the ground, supporting himself with a hand crutch, the other, with the head of a Negro and half naked, stands upright with his crutch held under his armpit. Thomas is imprisoned for his offence, and finally the king, converted by the miraculous return of his dead brother, kneels at the apostle's feet. Thomas points to the celestial palace in the band above. Cf. a passage in the Legend: 'There are untold palaces prepared in Heaven from the very beginning of the world, to be bought by faith and alms.' In the apex of the tympanum we see Christ with the orb, flanked by angels with censers. The four jamb figures have not survived.

Style and dating. The jambs, including the baldachins, belong to the first building phase, *c.* 1225–35; they are connected with the west doorways of Notre Dame in Dijon (ill. 65). The tympanum was not made until 1240–50. It shows the broad, heavy forms, the full faces, encountered at Vézelay (ill. 106, 107), Saint-Thibault-en-Auxois (pl. 288), Rougemont, on the altar from the Sainte-Chapelle in Dijon and (outside Burgundy) at Le Mans (pl. 290) and Bordeaux (pl. 304, 305). The origins are to be found in the eastern portions and the second phase of the west portal at Rheims. Though far inferior in quality, Semur shows certain parallels with the sculpture of the cathedral at Naumburg, explicable in terms of common sources at Rheims.

P. de Truchis 1907; P. Vitry 1929, p. 95; C. Contant 1932; M. Aubert 1946, p. 294; P. Quarré 1964–66.

SCULPTURES FROM THE REGION SOUTH OF THE LOIRE

Pl. 292–293

BOURGES (CHER), CATHEDRAL OF SAINT-ETIENNE WEST PORTAL

For Bourges in general, see p. 399. The west façade of the five-aisled cathedral survives only in part in its original state. Of the five thirteenth-century doorways, the two to the north were almost completely destroyed when the north tower collapsed in 1506, and were reinstated in sixteenth-century forms. In 1562 the jamb figures were smashed by the Huguenots. Restoration between 1829 and 1846 led to further disfigurement of such sculpture as remained. A few archivolt figures removed at this time are preserved in the Louvre and in the Musée de Berry in Bourges.

PROGRAMME

This is the only quintuple portal layout in thirteenth-century France. The distribution of the themes over the five entrances, so far as it can still be ascertained, presumably corresponds to the thirteenth-century design. The centre is occupied by the Last Judgment. On the two narrow inner entrances flanking the main portal, to the south Stephen as patron of the cathedral, to the north Mary; the two outer doorways are assigned to two canonized archbishops of Bourges – on the south, Ursinus, founder of the see, on the north William, who held office from 1205 to 1209 and was canonized in 1218. The programme thus shows a distinctly local colouring.

The trumeau figure of the centre doorway is modern, and the standing figures on the right jamb are from elsewhere and of varying periods. The tympanum depicts a Last Judgment, whose iconography in the main follows the Paris type: at the apex is the Judge, flanked by angels with

instruments of the Passion, with the intercessors in the corners. The middle band shows not the resurrection of the dead but the separation of the Blessed from the Damned, with the weighing of souls at the centre. The resurrection appears only in the lower zone, in a very free arrangement (here in particular many repairs have been effected, and only one head is old). In details there are divergences from Paris: the scenes do not spill over into the archivolt; the angels with instruments of the Passion have increased from two to four; above the Judge's head are two smaller angels holding the sun and moon. Paradise takes the form of an aedicule, in which Abraham is enthroned with souls. Peter, with a sweeping gesture, invites the souls to enter; at their head, directly behind the apostle, stands a Franciscan. As at Braine (pl. 73), the cauldron of Hell is implanted in the jaws of Leviathan. Among the Damned we recognize Luxuria, with a toad gnawing at her breast, and Slander, whose tongue is bitten through. In the archivolt, reading from the inside, are: 1, Seraphim; 2, standing angels; 3, enthroned male figures, their hands laid together in prayer; 4, confessors in ecclesiastical vestments and with books. The martyrs and prophets in the two outer arches are modern. In the spandrels below the tympanum are: (on the inside) angels with censers, related to the (modern) Christ on the trumeau; (on the outside) on the left a woman with vase, and on the right a little naked female figure with loose hair; presumably to be related to the states of blessedness and damnation. On the gable we see Christ and the intercessors again, and in the spandrels of the rose, the Wise and Foolish Virgins.

The trumeau figure of the Stephen's portal is modern. The lintel shows: (on the left) the ordination of Stephen as deacon, with the six other deacons referred to in Acts 6:5 behind him; (on the right) Stephen being led out to be stoned

– his martyrdom being in the middle band. At the apex, Christ is shown as a standing figure, which is usually the case in the context of the stoning of Stephen.

The trumeau figure of the Ursinus portal (pl. 293) is modern. The lintel shows: (on the right) Peter despatching Ursinus and Justus on their mission; (centre) Ursinus burying Justus, who died en route for Bourges; (left) Ursinus continuing on his way and finally preaching in Bourges. In the middle band: Leocadius, the Roman senator, does homage to Ursinus; Ursinus dedicates the first cathedral. At the apex Ursinus baptizes Leocadius and his son, who are shown standing in the font, while a dove appears above them. The cycle is somewhat unimaginative, but provides a telling example of the growing prominence given to local saints in the programme of church portals.

The socle zone of the jambs is filled, as at Paris, with blind arcading, which until 1506 continued across the entire façade and even covered the buttresses. The spandrels between the arches are not, however, used for console figures relating to the jamb figures, but carry instead a narrative cycle, stretching from the left jamb of the centre doorway to the south buttress (i.e. on the right) of the façade. The socle region thus has its own programme, whose frieze-like arrangement binds the portals together. The sequence begins with the creation of the angels and ends with Noah's drunkenness. Nothing is known of the content of the socle reliefs of the two left doorways, destroyed in 1506.

Style and dating. External clues to the dating of the portal are lacking. Among the extant portions, the Ursinus portal (pl. 293) seems to be the oldest; like the Coronation portal in Paris (pl. 152), it has gables above the jamb. On all other walls the baldachins are polygonal. The figures with their angular contours and square-built heads should be connected with Amiens and dated to c. 1240. The Amiens prototypes have been adopted in a summary, somewhat half-hearted manner: the relief is flat, and a striking feature is the large amount of empty space between the figures. The Stephen tympanum shows the same style. The socle reliefs, some of which have great charm, also belong in this context. Only occasionally, for example in the creation of the angels, do we find more recent forms – harshly broken folds. All these portions were presumably executed c. 1240. The history of the centre portal is more complicated. While socle and jamb also belong to the period around 1240, the tympanum, the spandrels beneath the lintel and the arches are of later date and the work of a new atelier. The slender, graceful figures with small heads on long necks, with expressive faces and hair, belong to a stylistic phase different from that of the stiff figures, lacking in expression, found in the side tympana. Their stylistic origins lie in the last phase of the Rheims west portals, so we should date these Bourges sculptures to 1255–1260. The centre doorway was thus left unfinished for some fifteen years before its completion by a new workshop from Rheims. The statues, perhaps from the west portal, now seen on the north tower and on the porticos on the north and south side of the nave, have yet to be investigated in

detail. Stylistically most of them seem older than the tympanum of the centre portal.

A. de Girardot 1877; A. Didron 1889; A. Boinet 1912; P. Vitry 1929, p. 95 ff.; M. Aubert 1946, p. 281 ff.; M. Aubert, M. Beaulieu 1950, nos 163–5; C. Gauchery-Grodecki 1959; R. Branner 1962; C. Gnudi 1969.

Pl. 294

BOURGES (CHER),
CATHEDRAL OF SAINT-ETIENNE
JUBE

The choir of Bourges cathedral was begun at the end of the twelfth century and completed in 1214. The erection of the nave followed after a long interval; it is reckoned that work was finished by c. 1255. The jubé stood at the dividing line between nave and choir in front of the ninth bay from the west. Damaged by the Huguenots in 1562, and subjected to restoration from 1653, the jubé was finally demolished after 1750. A large number of fragments came to light in the course of the nineteenth century. The best pieces went in 1891 to the Louvre and others to the Musée de Berry in Bourges; smaller fragments were deposited in the cathedral crypt. In 1962 the Louvre essayed a free reconstruction, intended to give a general impression of the original arrangement. The currently accepted view of the appearance and programme rests on the reconstruction by P. Gauchery.

The jubé opened into the nave through an arcade of eleven arches. The wide central opening led into the choir; altars stood beneath the outer arches to north and south. The flanks of the jubé loft were two arches deep. The parapet carried reliefs on the flanks as well as on the front. The cycle began on the north side, i.e. on the left looking from the nave. The scenes depicted on the flank were: 1, Judas being paid his pieces of silver (pl. 294 top left) – he holds an open money bag, and standing on the right is the High Priest (the figure on the left is difficult to interpret, and is perhaps an attendant of the High Priest); 2, the Kiss of Judas (pl. 294 top middle) – Judas embraces Christ, who is seized from the left, and on the right we see two more figures, one grasping Christ's garment, the other holding a lantern. The next scene (on the front) shows a standing figure before Pilate (pl. 294 top right) – Pilate's wife sends her maid-servant to the governor: 'Have thou nothing to do with that just man: for I have suffered many things this day in a dream because of him' (Matt. 27:19); this interpretation is not certain. This was followed by the scourging (touched up in the seventeenth century), Christ before Pilate (said to be lost, but perhaps identical with pl. 294 top right), and Christ bearing the Cross (pl. 294 bottom). The Crucifixion itself (pl. 294 bottom) was depicted on a taller slab placed at the centre of the jubé. There was no cross above the jubé loft at Bourges; its place was taken by the Crucifixion group emphasized by a trefoil arch. To the right of the Crucifixion were the Deposition (pl. 294 bottom), the Entombment, watchers at the tomb, and the women at the tomb (these slabs are in Bourges cathedral). On the south flank – on the right

looking from the nave – were: 1, Christ in Limbo (pl. 294 middle left) – Satan lies chained on the ground, and in front of Christ stand Adam and Eve; 2, the jaws of Hell (pl. 294 middle); 3, the cauldron of Hell (pl. 294 middle right). The central scenes from the Passion, introduced on the narrow side by the betrayal and arrest, are concluded similarly on the right with Christ's descent into Hell. The programme was complemented by side figures of the twelve apostles, displayed on the front side in the spandrels between the arches. Compared with the Chartres jubé, the structure of the programme is simpler and more forceful.

Style and dating. Against a background pattern (which was originally inlaid with glass) the figures are emphatic and vigorously rounded. The heavy draperies fall in broad sweeps or swell out as deep rounded folds. All the figures are conspicuous for their volume, which is never obfuscated by affectedness in the action or by complicated drapery motifs. Moreover the joints and hands, elsewhere in thirteenth-century sculpture rendered with a pronounced delicacy of articulation, are here brawny and firm. The surfaces, though nowhere rigid, yet lack the wealth of nuances which invest the most brilliant gothic sculptures with the charm of heightened vivacity.

External clues to the date are lacking. The history of the cathedral's construction permits us to go as early as the second quarter of the thirteenth century, but no precise date. There is no recognizable connection with the sculptures of the cathedral's west portals. C. Gnudi has recently associated the sculptures with the apostles from the Sainte-Chapelle in the Musée de Cluny (pl. 184, ill. 89) and the transept portal of Saint-Denis (pl. 183). This appears to demolish both the traditional dating of the jubé to the late thirteenth century and the assertion that the jubé and the Judgment on the west façade are works from the same atelier. In any case, to us the stylistic phase seems to have more in common with the later works on the Rheims west façade – doorpost figures of the right portal (pl. 221 middle) – or the Saint-Germer retable (pl. 281 bottom) than with the 1240s. Date: towards 1260.

O. Roger 1891; A. Gandilhon 1911; A. Boinet 1912; P. Gauchery 1919; M. Aubert 1946, p. 323f.; M. Aubert, M. Beaulieu 1950, nos 163–6; C. Gnudi 1969.

Pl. 295

TOMB MONUMENT OF ADELAIS OF CHAMPAGNE
JOIGNY (YONNE), SAINT-JEAN

Adelais of Champagne, wife of Count Renaud II of Joigny, died in 1187 and was buried in the house of the Premonstratensians at Dilo. Her tomb monument was in the north wall of the choir, and is supposedly preserved for us in a tumba, transferred to Joigny before the abbey was destroyed (1843) and erected in the parish church of Saint-Jean in 1892.

The effigy of the dead woman lies on the slab in conspicuously low relief. She wears a long girdled robe and a broad mantle, also the touret. The hands are laid together in prayer. At her feet, beneath the socle covered with a rose tendril, reposes the dog frequently found on female tomb monuments in the thirteenth century. The long wall of the tumba features an arcade composed of four trefoil arches, each with a single standing figure: two young men, one of them with a falcon on his hand, and two women. Depicted on the foot end is a parable from the Story of Barlaam and Josaphat which is very rarely seen illustrated outside book illumination. Barlaam was a hermit who told the king's son Josaphat the following parable, to bring home to him the hollowness of earthly happiness. A man fleeing from a unicorn fell over a precipice, but tried to save himself by clinging to the branches of a tree. When he looked down at its roots, however, he saw them gnawed at incessantly by a black and white mouse. Raising his eyes again, he saw honey dripping from the branches, forgot the danger and succumbed entirely to imbibing the tree's sweetness. The *Legenda Aurea*, which retells the story, gives it the following explanation: the unicorn signifies death, man's constant pursuer; the precipice is the world, full of evil; the branch is our life, 'consumed without ceasing by every hour of the day and night, as though by black and white mice, and drawing ever closer to its fall; the sweet honey is the illusory pleasure of the world, which deceives man and makes him forget his peril.' The legend exists in many versions and includes other motifs which have not found their way into the tumba relief. Here we have dragons in place of the mice; presumably therefore the portrayal is based on the Old French version which describes the gnawing animals only as 'besteletes'. The significance of such a parable on a tomb monument needs no further comment. It is interesting to note, however, that this is the only known example in medieval sepulchral sculpture of a very widespread legend.

The stylistic phase corresponds to the last phase of the Rheims west portals. The man in the tree can be compared with the Herod (pl. 230 right top) of the interior west wall, some of the figures on the long side compare with doorpost figures of the right doorway on the west façade (pl. 221 middle). At Joigny, however, the forms are harsher and more angular. The usual dating, *c.* 1250, is very likely too early. The tomb monument of this countess who died in 1187 must have been made *c.* 1260.

L. Pillion 1910; J. Vallery-Radot 1958; E. Panofsky 1964 (II).

Pl. 296–299, ill. 109

POITIERS (VIENNE), CATHEDRAL OF SAINT-PIERRE
WEST PORTAL

Poitiers cathedral, begun *c.* 1170, is famous in architectural history as the first gothic hall church on French soil. The building of the nave dragged on beyond the first decades of the thirteenth century. Architectural historians place the lower storey of the west façade before the middle of the

506

century. Massive towers flank the façade which is pierced by a large triple doorway layout (pl. 296). Seventeenth-century views show the jambs as already devoid of figures, and though statues must certainly have existed, no trace of them remains. Although the sources are silent on the matter, they were probably destroyed by the Protestants in 1562.

PROGRAMME

As in the great cathedrals of the north, the portal features the Last Judgment in the centre, with side doorways devoted to the Virgin (left) and to Saints. We give here only a general description of the programme. There is in any case no detailed interpretation available of the extensive cycles in the archivolts. The scheme of the Last Judgment composition (pl. 297 top) is in keeping with Paris (pl. 147): a tympanum divided into three bands. At the apex we see the Judge, and standing beside him the angels with the instruments of the Passion, with kneeling intercessors beyond. In the spandrels we have in addition angels with trumpets – the mouths of the trumpets emerge through a strip of cloud into the middle band below. This band is occupied with the separation of the Blessed from the Damned; the resurrection of the dead appears in the band below (pl. 297 bottom). These scenes do not, as in Paris, spill over into the archivolt. The weighing of souls is absent from the separation scene; an angel with a sword drives the sinners towards the jaws of Hell on the right. In the archivolt are seated and standing figures, including the confessors, martyrs etc., always found accompanying the Judgment. In the tympanum of the left doorway are the Death and Coronation of the Virgin. The portrayal of Mary's death combines motifs from the current Koimesis iconography – Mary surrounded on her death bed by Christ and the apostles – with the bodily Assumption. Mary's body is raised up by angels standing at the head and foot of the death bed. The influence of Paris is plain (pl. 153). The same influence probably accounts for the otherwise inexplicable departure from the customary two scenes on the lintel. Among the archivolt figures, the usual Old Testament personages are conspicuous by their absence. The saints' portal displays in the tympanum (pl. 299) scenes from the life and legend of the apostle Thomas. In the lower band, Doubting Thomas, in the presence of the other apostles, touches the wound in Christ's side. At the apex, the apostle with companions distributes alms to the poor, while in Heaven a building appears, its doors and windows filled with angels. Cf. the apocryphal text attributed to the apostle: 'Untold palaces have been prepared in Heaven from the very beginning of the world, to be bought by men with faith and alms.' On the archivolt (pl. 298, ill. 109) we see, reading from the inside: the Wise and Foolish Virgins; martyrs; enthroned ecclesiastics; angels. The Thomas portal at Poitiers cannot be compared with the many portals which depict saints of local importance. There is no evidence that Thomas was especially

Ill. 109 Poitiers cathedral, west portal, right doorway. Detail of archivolt: Foolish Virgins, saints. About or shortly after 1250

venerated in the cathedral at Poitiers. This side doorway with its celestial palace built by faith and alms must thus be regarded as complementary to the Judgment of the centre doorway. The same applies to the Wise and Foolish Virgins

Style and dating. The Poitiers west portal is among the works which infiltrated the Gothic of the royal domain into the south, the region which had seen the development of romanesque building and architectural sculpture. The construction is wholly northern French in its forms. The socle arcading on the jambs recalls the Paris Coronation portal (pl. 152). As at Amiens (pl. 279) and on the Paris transept (pl. 267), the portals are crowned by gables (pl. 296). The unity imparted to the triple portal layout by the incorporation of the broad fronts of the buttresses into the jamb may have been inspired by Bourges (pl. 292). There is monotony in the figure compositions: for example in the way the statuettes are distributed in the archivolts as a repetition of the same motifs. The execution of the different parts is uneven in quality: thus the single figures on the centre portal (pl. 297) are somewhat listless, while the tympanum and archivolt of the Thomas portal (pl. 299, 298, ill. 109) give a more animated impression. The archivolt statuettes are characterized by small heads and wide draperies, which break fulsomely on the pedestal; a few of the figures are not without a bizarre charm. The delineation of the heavy draperies, which completely conceal the play of limbs, is effected by a few vigorous flange folds. The sources for the style lie in the royal domain and not in any local tradition. One thinks in particular of the archivolt of the centre doorway of the Amiens west portal (pl. 164, 165); it is there, surely, that the roots of this figure style, at once block-like and expressive, are to be found. In any case it is plain that the work at Poitiers is more recent.

The recently revived suggestion of a date *c.* 1270 for the sculpture at Poitiers hinges on a text erroneously applied to the sculptures on the west doorways of the neighbouring abbey church of Charroux (see below). The Poitiers sculptures are certainly much earlier and were probably executed at the same time as the bottom storey of the west façade, say about or shortly after 1250. It has been conjectured that the activity of northern trained sculptors on the west portals of the cathedral was due to the intervention of Alphonse of Poitiers, a brother of St Louis and count of Poitiers from 1241, but the sources offer no evidence to support the supposition.

E. Maillard 1921; P. Vitry 1929, p. 94f.; M. Aubert 1946, p. 287; R. Crozet 1952; A. Mussat 1963, p. 255ff.

Pl. 300–303, ill. 110

CHARROUX (VIENNE), SAINT-SAUVEUR, FORMER ABBEY CHURCH
FIGURES FROM THE WEST PORTAL

Saint-Sauveur, Charroux, was an abbey founded in the eighth century. In consequence of the suppression of the abbey in 1760–62 and the sale of its buildings at the Revolution,

virtually nothing remains of the romanesque abbey church. A lithograph published by Thiollet (ill. 110) in 1823 shows a triple gothic portal on the west façade. It is possible to make out the Last Judgment on the tympanum of the centre doorway. Old descriptions assert that the five arches of the archivolt displayed in succession kings, abbots with mitre and crozier, male and female figures with vessels and chalices(?), reading saints(?), and lastly the apostles. Most, if not all, the figures now preserved in the chapter house of the former abbey (pl. 300–303) presumably come from this centre portal. It is apparently not clear whether the side entrances carried any figures in the archivolt. Moreover, the contract of sale dated 1840 by which the state acquired the sculptures from a baker, refers to 'remains of the centre portal of the old abbey church, which is part of my house'.

Extant are the Judge (pl. 301 left), a small fragment from the resurrection of the dead, and over forty archivolt figures. These include kings (pl. 302 left), abbots, prophets (pl. 302 right, 303), apostles, and the Wise and Foolish Virgins (pl. 301 right). Stylistically these remnants are associated with the sculptures on the cathedral at Poitiers (cf. p. 506). There is the same shaping of the figures in conformity with the block; the weight given to the volume and an emphatic rendering of the drapery makes for a somewhat unrefined but powerful expression. The care given to the execution varies, and is at its best in the Judge (pl. 301 left). Here the mantle is in restless movement, the body forms are conspicuously bony, the face gaunt.

A conveyance of land dated 28 February 1270 has been thought to have a bearing on the date of the sculptures. It

Ill. 110 Charroux, Saint-Sauveur, abbey church. About 1250. View from the west. (After a lithograph in Thiollet, pl. 1)

508

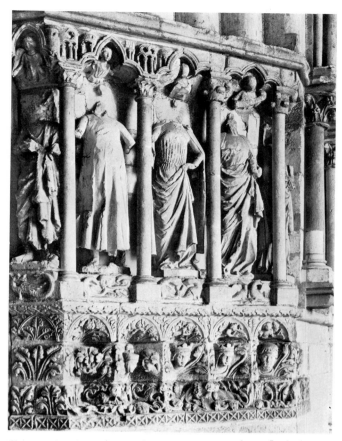

Ill. 111 Candes, Saint-Martin, collegiate church. North portal: jamb figures and socle. 1225–30 and 1250

merely mentions, however, the necessity to complete 'pilaria incepta ante portas dicti monasterii', that is to say, 'the pillars on which work has started *in front of* the portal of the aforesaid abbey'. This document provides no serviceable clue to the dating of the west portal of the abbey church. The Charroux sculptures, like the sculptures of Poitiers cathedral, are in the line of succession from the archivolt figures of the Amiens centre doorway (pl. 164, 165), and were probably made at much the same date, *c.* 1250. Which came first, Charroux or Poitiers, is for the moment impossible to decide. The Charroux figures are altogether fresher and more animated.

M. Aubert 1928; M. Aubert 1946, p. 286f.; M. Aubert, M. Beaulieu 1951, no. 171/172; Y. M. Froidevaux 1951; R. Crozet 1952.

Ill. 111

CANDES (INDRE-ET-LOIRE), SAINT-MARTIN, COLLEGIATE CHURCH NORTH PORTAL

The collegiate church of Saint-Martin, Candes, has a two-storied structure on the north side of the nave; the upper storey houses a chapel dedicated to St Michael, below which a figure-decorated portal would open into the nave. The

portal type diverges from prototypes in the royal domain: the tympanum is conspicuously small, and with the exception of the inner arch the archivolt is undecorated. The figure-decorated jamb extends beyond the portal bay to the back wall of the porch. The statues stand in niches (ill. 111) formed from columns and trefoil arches. Although there is a remote resemblance to the south portal of Saint-Seurin, Bordeaux (pl. 304, 305), there can be no question of a direct connection between the two. What is more likely is that a shared regional tradition of façades laid out in the romanesque manner has led to analagous modification of portal types imported from the royal domain. At the same time, the link with local tradition is less obvious at Candes than it is in Bordeaux. This particular solution seems to have found no imitators.

The programme is recognizable only in part, and many of the jamb figures cannot now be named. The present assembly may not fully accord with the original. The small tympanum displays Christ standing between Mary and John, and there are further Judgment scenes in the sculpted inner arch of the archivolt. On the jamb, in addition to the apostles, we recognize female statues and also Abraham with Isaac before the sacrificial altar. The styles of socle and statues are in striking contrast. The socle is rich in lively ornament: foliage, birds, dragons, sirens, interspersed with large heads wearing a crown or a touret. The motifs are archaic and only rarely met with in the royal domain Gothic of the thirteenth century. But the individual forms – the relative naturalism of the foliage, the shape of the crowns, the headgear of the women – exclude a date earlier than 1225–30. The niche statues come closer to models in the royal domain. The full volume, the drapery lying in deep folds, and a certain affectedness in the poses point to Rheims prototypes such as the Queen of Sheba (pl. 204), i.e. to works which must have been made before 1241, possibly earlier. The execution is crude: the elegance of borrowed motifs has been coarsened and flattened by a provincial hand. The niche statues were made *c.* 1250.

A. Rhein 1910 (II); B. Thomas 1934; L. Schreiner 1963, p. 106 ff.; A. Mussat 1963, p. 380 ff.

Pl. 304, 305

BORDEAUX (GIRONDE), SAINT-SEURIN, COLLEGIATE CHURCH SOUTH PORTAL

The first mention of a new building occurs in 1243, when Henry III of England donated a sum of money 'ad fabricam ecclesiae'. The nave is thought to have been completed about the middle of the century. The portal opens into the nave at the second bay of the south aisle. Extensive restoration in 1844 makes for difficulties in appraising the layout, which has not so far been closely investigated.

PROGRAMME
The tympanum shows the Last Judgment. The Judge is enthroned on the rainbow (cf. Rev. 4:3), and at his side we

see standing angels with the instruments of the Passion and kneeling intercessors. The narrow lintel displays angels with trumpets, the resurrected and the weighing of souls. The archivolt shows the nine choirs of angels. The twelve apostles and the statues of Ecclesia and Synagogue on the jamb belong to the Judgment scene; Synagogue is shown 'blindfolded' with a dragon. In the small tympana we see on the left the women at the Tomb, and on the right the meeting between St Severinus and St Amandus(?). The side tympana have two arches to their archivolts: on the inside, angels; on the outside, prophets and respectively bishops or abbots.

Style and dating. The arrangement – a middle entrance and small blind niches at the sides – is independent of northern models and belongs to a regional tradition. Numerous romanesque façades in the region between Poitiers and Saintes follow the same scheme. It crops up later, in advanced gothic forms, on the north side of the collegiate church at Saint-Emilion. There are striking discrepancies in the successive levels of the portal. The socle zone with its capitals and continuous foliage frieze presumably belongs to an initial design which did not include jamb figures, and in which the tympana and archivolts were intended to start immediately above the capitals. (Compare, for example, the west façade of the church at Guîtres, north-west of Bordeaux.) This first design was still unaffected by Gothic. Inspired by northern models, a second design phase then introduced the figure-decorated jamb above the socle zone and the trefoil arch above the entrance. At the same time the sculptures for the centre tympanum and the archivolts were executed. The atelier responsible for them followed the trend emanating from Rheims, which was noticeable around the middle of the century in Burgundy – at Semur-en-Auxois (pl. 291), Saint-Thibault-en-Auxois (pl. 288), Vézelay (ill. 106) – and at Le Mans (pl. 290, ill. 108). Here we find the same broad figures with crudely expressive heads, the same soft draperies limply drawn round the bodies, as at Le Mans.

A *terminus ante quem* for the completion of the layout is provided by the inscription on the trefoil arch above the entrance, which mentions the death of Canonicus Ramundus de Fonte in July 1267. Completion in the 1250s seems quite possible. The reliefs of the side tympana and the appurtenant angels in the inner archivolt arches are in a completely divergent style. The graphic rendering of the draperies, the restless movements, the architectural forms, all point to the early thirteenth century. These stylistic differences further support the theory that an earlier design, still firmly rooted in the regional tradition, was abandoned with the arrival of a new workshop, presumably *c.* 1250. The gothic-sculptured portal they created presents a singular appearance: jamb figures inspired by Rheims appear in an architectural setting dictated by Romanesque, on a façade which bears the stamp of south-west France. This portal needs to be subjected to specific investigation if the complicated story of its origins is to be finally unravelled.

J.-A. Brutails 1912, p. 18ff.; G. Loirette 1939; M. Aubert 1946, p. 288; R. Hamann 1955, p. 381ff.; J. Gardelles 1963, p. 167f.

Pl. 306

BORDEAUX (GIRONDE), CATHEDRAL OF SAINT-ANDRE 'PORTAIL ROYAL'

The 'Portail Royal' of Bordeaux cathedral opens into the sixth bay of the single-aisled nave. The cathedral's west façade lay within the precincts of the bishop's palace; this portal on the north side was the main entrance to the cathedral for the laity. The name 'Portail Royal' first occurs in 1619, and relates to the use of this entrance on the occasion of the marriage of Louis XIII to Anne of Austria. The jamb and trumeau figures were removed in 1826–27 and dispersed to different places. In 1883 ten of the jamb figures were returned to the cathedral, to be installed in 1890 on the existing modern socles. Despite assertions to the contrary in the local literature, there are also signs that the upper parts of the portal, the archivolt figures in particular, were retouched in the nineteenth century.

PROGRAMME

The tympanum depicts the Last Judgment. The group around the Judge – standing angels, kneeling intercessors – is of the Paris type (Notre Dame; pl. 147). It is here augmented at the sides, however, by further angels vested as deacons with, beyond them, as at Poitiers, angels sounding trumpets (Poitiers; pl. 297 top). Above the Judge's head is a further group comprising eight angels, bearing the sun and moon in their midst – presumably a reference to the text of Rev. 21:23. By contrast the execution of the Judgment is represented solely by the resurrection of the dead in the narrow strip below. The archivolt has four arches containing angels, female figures with books and (renewed?) palms, and Old Testament figures, among them Moses and Aaron. The trumeau is said to have displayed a bishop. The jambs have ten figures of apostles, in an arrangement which goes back to the restoration in 1890. The attributes are missing, which makes identification in most cases impossible.

Style and dating. Gardelles, who has investigated the history of the building's construction, is of the opinion that the Portail Royal was erected simultaneously with the vaulting of the sixth and seventh bay of the nave, *c.* 1250. Style-critical judgment of the portal is made difficult by the poor state of preservation. A striking feature is the rich patterning not only of the socle zone but also of the figure zone of the jambs: inside the blind arcading beneath the statues it takes the form of quatrefoils in square frames, at the backs of the figures, oculi alternate with hollowed-out quatrefoils, with small circles here and there. This attempt at simulating a textile or tiling effect is carried over to the fronts of the flanking buttresses, and can be compared most readily with the patterning of the jubé slabs from Bourges (pl. 294), with the socle zone in the upper chapel of the Sainte-Chapelle in Paris, and with the facing of the bottom storey of the west façade of Saint-Niçaise, Rheims, all works from the middle of the century. The jamb, tympanum and –

so far as we can still judge properly – the archivolt figures are of elongated proportions, spare and without tension. The elbows bend back sharply, the lower arms are long and spindly. The heads of the apostles, especially, are characterized by their elliptical contours; the forehead is low and the expression vacant. The origins of the style's formation are most readily to be found in Paris. As contributing influences we can cite not only the apostles from the Sainte-Chapelle (pl. 184, 185), but also the statues from the south transept of Notre Dame (pl. 267–269). Their similar proportioning makes the figures of Moses and Aaron on the buttresses of the Paris south transept (pl. 267) particularly apt comparisons; therefore, with all due caution in allocating a date, we propose c. 1260 for the Bordeaux figures. This portal is a telling example of the way animation and mobility was lost to gothic sculpture when it was imitated in parts of France outside the region in which it originally developed.

P. Vitry 1929, p. 94; P. Courteault 1939; M. Aubert 1946, p. 287 f.; J. Gardelles 1963, p. 141 ff.

Pl. 307

BAZAS (GIRONDE), CATHEDRAL OF
SAINT-JEAN-BAPTISTE
WEST PORTAL

The see of Bazas, which belonged to the archdiocese of Eauze, and afterwards to Auch, is mentioned by Gregory of Tours. The existing cathedral goes back to the thirteenth century; the foundation stone was laid in 1233. The jamb figures were destroyed by the Protestants in 1651. During a previous occupation by the Protestants in 1577–78 the inhabitants were required to raise 10,000 écus as protection money for the portal.

PROGRAMME
In the centre we see the Last Judgment and John the Baptist; the right doorway is devoted to the Virgin, and that on the left to Peter. The Judgment portal (pl. 307 top) is in three zones: at the top the Judge with, at his feet, the Blessed and Damned, and in the bottom zone the resurrected. This is the Paris grouping (pl. 147), as also appropriated by Poitiers (pl. 297). In a fourth, lower strip we see the story of John the Baptist. The archivolt has five arches: 1, angels victorious over devils, angels with trumpets; 2, angels with crowns and musical instruments. In the next three arches are standing figures with books or martyr's palms, mostly in ecclesiastical vestments; in the outer arch there are additionally angels, and bottom right a crowned rider (from the Apocalypse).

The archivolt of the right doorway – the Coronation portal, with Mary's death on the lintel – depicts a Stem of Jesse, rarely found in this location after 1220, scenes from the life of the Virgin (second arch, right), the Zodiac and Calendar. On the left doorway the sequence begins at the apex of the tympanum. We see an empty boat and Peter amid the waves (cf. Matt. 14:29–31): 'And when Peter was come down out

of the ship, he walked on the water to go to Jesus. But when he saw the wind boisterous, he was afraid; and beginning to sink, he cried, saying, Lord, save me.' In the middle band we see the miraculous draught of fishes, and (bottom) the delivery of the keys to Peter, who stands beside the image of the Church, and finally the crucifixion of Peter and beheading of Paul. There is no other instance among French church portals from the thirteenth century of a Petrine cycle which stresses the Roman primacy. In all other respects the programme of the Bazas west portals is derived from prototypes in the royal domain. The themes are assembled in compilatory fashion, without any noticeable additional attempt at interpretation. The sterile imitation of the great exemplars in the north emerges not only in the treatment of form but also in the shaping of the programme. Works of this kind have no independent tradition behind them. They have been borrowed and adopted literally from the north, and mark the end of the south's artistic independence.

Style and dating. The arrangement, notably the socle arcading, which until the sixteenth century probably continued across the fronts of the buttresses, follows the type of Paris Coronation portal (pl. 152). It may here be derived from Poitiers (pl. 296). In its proportioning, especially in the relative narrowness of the side doorways, the scheme is recognizably that of the romanesque church façade current in the Bordelais. The sculptures are somewhat crude. As at Poitiers and Charroux, they are heavy, and bulky in volume. The working up of the figure does not disguise the shape of the block. Bazas takes its place in a stylistic chain – Amiens, Charroux, Poitiers – in which the quality of the execution grows progressively weaker. The variously alleged connections with the Portail Royal in Bordeaux (pl. 306) are not discernible. Date: after 1250.

J.-A. Brutails 1912, p. 32 ff.; P. Vitry 1929, p. 94; J. Vallery-Radot 1939; M. Aubert 1946, p. 288; J. Gardelles 1963, p. 168.

Pl. 308, 309

DAX (LANDES), CATHEDRAL OF
NOTRE DAME
FORMER WEST PORTAL

The diocese of Dax, which was a suffragan see first of Eauze and later of Auch, was established as early as the fourth century. In the seventeenth and eighteenth century the gothic cathedral was replaced by a new structure. The medieval west façade was demolished in 1894. The main doorway, with its representation of the Last Judgment, has been reassembled in the north transept.

PROGRAMME
In the tympanum, only part of which survives are intercessors, angels with instruments of the Passion, further angels with the sun and moon, and Michael with the balance. The figure of the Judge is destroyed. In part, at least, the present installation cannot represent the original design, for example, it must be wrong that the intercessors and Michael

511

with the balance are placed in the same zone. The lintel shows the resurrection. The Judgment continues in the lower lines of the archivolt: on the left are groups of the Blessed in Paradise, and on the right Hell scenes, shown in extensive detail (pl. 309). In the arches of the archivolt we see female figures with books, the Wise and Foolish Virgins, deacons, bishops, and enthroned male figures. The angels with trumpets appear in the outside arch, immediately above the Blessed and the Damned. On the trumeau Christ stands over a crouching lion, and on the jambs are figures of the twelve apostles.

Style and dating. The Dax portal is among those works in the south of France which appropriate ready-made prototypes from the royal domain. The composition of the Judgment corresponds most closely to Paris and Amiens, though it is later by several decades. In the south the portals of the royal domain are imitated as types with canonical validity, with the result that the execution lacks the rich nuances imparted to it in the north by continuing artistic development. Imitations of this kind retain only the motifs of gothic sculpture, and lack life. This makes a stylistic judgment difficult. Dax is a work from the third quarter of the thirteenth century. Paris, among the northern centres, is the most likely source, but one is hard put to it to identify specific models which formed the style. Rheims, which has sometimes been mentioned in this connection, shows nothing comparable.

J. E. Dufourcet, P. Camiade 1890–99; P. Vitry 1929, p. 94; F. Salet 1939; M. Aubert 1946, p. 288; J. Gardelles 1963, p. 169 f.

Pl. 310

CARCASSONNE (AUDE), CATHEDRAL OF SAINT-NAZAIRE CHOIR STATUES

In 1269 Louis IX authorized a grant of land for the building of a gothic choir for Carcassonne cathedral. The complex was completed only in the third decade of the fourteenth century. To the east of the square crossing lie a bay with sexpartite vaulting and an apse extending over seven sides of a dodecagon. The building is of distinctly slender proportions.

Supports and attached columns ascend without interruption from the socle to the impost.

Starting on the east piers of the crossing, the supports of the pre-choir bay and the choir polygon carry a cycle of twenty-two statues: eight around the crossing piers, six on three sides of the piers at the entrance to the choir, and a further eight on the attached columns of the choir. They are mounted high up – well above the precipitous socle arcading – roughly speaking in the bottom third of the windows. On French soil, the Saint-Nazaire statues are the first example since the Sainte-Chapelle in Paris of a figure cycle in the interior of a choir. The famous Paris model has usually been regarded as the direct inspiration. This could apply, however, only to the motifs, not to their execution. The mounting of the figures is different, and so is the style. There is also a divergence in the programme: the apostles stand in the polygon, and the pillars at the entrance to the choir carry amongst other subjects the Annunciation (pl. 310 left) and Helena, the pillars of the crossing display Christ, Mary (pl. 310 middle) and locally venerated saints (pl. 310 right).

Stylistically, the cycle is not a unit. The execution of the apostles is for the most part lacking in force. Here and there one perceives glimmers of motifs familiar from the interior wall of Rheims (pl. 229 ff.). The Virgin is more sharply delineated (but here we must be on our guard, since the Virgin's right hand, the rose sprig, and the crown have been restored, and likewise the Child's lower right arm; the face of Mary, and perhaps other portions, has been touched up). The concept of the draped figure in which a clear distinction is made between the weight-bearing and free-moving leg and the draperies form deep, widely projecting folds, is derived from the royal domain sculpture of the third quarter of the thirteenth century. There is no connection with the cycles in Poitou or in the neighbourhood of Bordeaux. The figures have been worked from the same block as the columns; they were thus not mounted separately but installed at the same time as the pillars. The usual dating, 1315–20, must therefore be rejected on both archaeological and style-critical grounds. Probable date: *c.* 1280.

J. Lahondès 1901; J. Lahondès 1906; L. Schürenberg 1934, p. 82 ff.; L. Lefrançois-Pillion 1935; M. Aubert 1946, p. 331; B. Mundt 1965.

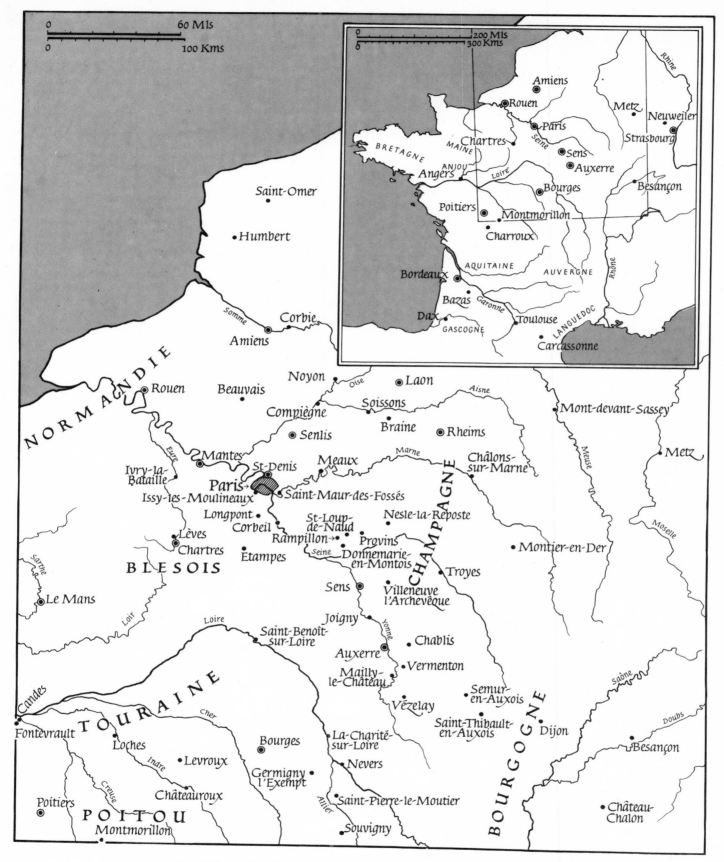

Map of France showing sites of the monuments and sculptures illustrated

513

SOURCES OF ILLUSTRATIONS

514

BIBLIOGRAPHY

The following abbreviations are used in the case of frequently cited journals:
A.B. – Art Bulletin
Bull. Mon. – Bulletin Monumental
C.A. – Cahiers d'Art
G.B.A. – Gazette des Beaux-Arts

Abdul-Hak, S., *La sculpture des porches du transept de la cathédrale de Chartres*, Paris 1942

Adenauer, H., *Die Kathedrale von Laon*, Düsseldorf 1934

Adhémar, J., 'La fontaine de Saint-Denis', *Rev. archéol.* 6e sér., 7 (1936), p. 224 ff. *Influences antiques dans l'art du moyen-âge français*, London 1939

Aimond, C., *La cathédrale de Verdun. Etude historique et archéologique*, Nancy 1909

Aimond, Ch., *L'Eglise Notre-Dame de Mont-devant-Sassey*, Bar-le-Duc 1933

Allier, A., *L'ancien Bourbonnais*, 1833–38

Anfray, M., *L'architecture religieuse du Nivernais au moyen-âge. Les églises romanes*, Paris 1951; *La cathédrale de Nevers*, Paris 1964

Aubert, M., 'Le portail occidental de la cathédrale de Senlis', *Rev. de l'Art chrétien* 60 (1910), p. 157 ff.; *Notre-Dame de Paris*, Paris 1920; 'Statues du portail de Charroux', *Bull. Mon.* 87 (1928), p. 361 ff.; 'Saint-Thibault en Auxois', *C.A.* 91 (1928), p. 252 ff.; *Die gotische Plastik Frankreichs 1140 bis 1225*, Florence/Munich 1929; *La cathédrale de Metz*, Paris 1931; 'Têtes gothiques de Senlis et de Mantes', *Bull. Mon.* 97 (1938), p. 1 ff.; 'Statues du chœur de Saint-Martin d'Angers', *Medieval Studies in Memory of A. Kingsley Porter*, Cambridge 1939, vol. II, p. 405 ff.; 'Le portail Royal et la façade occidentale de la cathédrale de Chartres. Essai sur la date de leur exécution', *Bull. Mon.* 100 (1941), p. 177 ff.; 'Têtes de statues-colonnes du portail occidental de Saint-Denis', *Bull. Mon.* 103 (1945), p. 243 ff.; *La sculpture française au moyen-âge*, 1946;

'Le portail du croisillon sud de l'église abbatiale de Saint-Denis', *Mélanges Ch. Picard*, Paris 1949, vol. I, p. 12 ff.; and M. Beaulieu, *Musée Nat. du Louvre. Description raisonnée des sculptures*, I, *Moyen Age*, Paris 1950; 'Vermenton', *C.A.* 116 (1958), p. 275 ff.

Banchereau, J., *L'église de Saint-Benoît-sur-Loire*, Paris 1930

Barre, J. de la, *Les Antiquités de la ville, comté et châtellaine de Corbeil*, Paris 1647

Barret, P., 'Le tympan de l'ancienne église romane d'Issy', *Bull. Mon.* 66 (1902), p. 296 ff.

Bauch, K., 'Chartres und Strassburg', *Oberrheinische Kunst* 4 (1929/30), p. 33 ff.; 'Zur Chronologie der Strassburger Münsterplastik im 13. Jahrhundert', *Oberrheinische Kunst* 6 (1934), p. 3 ff.

Bayet, J., 'Le symbolisme du cerf et du centaure à la porte rouge de Notre-Dame de Paris', *Rev. archéol.* 44 (1954), p. 21 ff.

Beaulieu, M., 'Les anciens portails de Saint-Bénigne de Dijon', *Bull. Mon.* 115 (1957), p. 293 ff.; and F. Baron, 'Les cariatides de la cathédrale de Nevers', *Bull. Mon.* 124 (1966), p. 363 ff.

Bédier, J., *Les Légendes épiques*, Paris 1908

Beenken, H., 'Die Tympana von La Charité-sur-Loire', *Art Studies* 6 (1928), p. 145 ff.

Bégule, L., *La cathédrale de Sens*, Lyons 1929.

Behling, L., *Die Pflanzenwelt der mittelalterlichen Kathedralen*, Cologne/Graz 1964

Berger, E., 'Annales de St. Denis', *Bibliothèque de l'Ecole de Chartres* 40 (1879)

Bergós, J., *L'escultura a la seu de Lleida*, Barcelona 1935

Besnard, A., *L'eglise de Saint-Germer-de-Fly et sa Sainte-Chapelle*, Paris 1913

Blaser, E. M., *Gotische Bildwerke der Kathedrale von Lausanne*, Basle 1918

Boinet, A., 'Le tympan de Saint-Yved de Braine au Musée de Soissons', *Bull. Mon.* 72 (1908), p. 455 ff.;

'L'ancien portail de l'église Saint-Yved de Braine', *C.A.* 78 (1911), vol. II, p. 259 ff.; 'Les sculptures du portail de la cathédrale de Meaux', *Rev. le l'Art chrétien* 4 (1912), p. 89 ff.; *Les sculptures de la cathédrale de Bourges (Façade occidentale)*, Paris/Lille 1912; 'Les sculptures des portails de la cathédrale de Meaux', *C.A.* 82 (1919), p. 171 ff.; *La cathédrale de Bourges*, Paris 1952³; *Les églises parisiennes. Moyen Age et Renaissance*, Paris 1958

Bony, J., 'La collégiale de Mantes', *C.A.* 104 (1946), p. 163 ff.

Borries, J. E. von, 'Die Westportale der Abteikirche von Saint-Denis', (thesis, unpublished) Hamburg 1955

Bouillart, J., *Histoire de l'abbaye de Saint-Germain-des-Prés*, Paris 1724

Bourquelot, F., 'Notice historique et archéologique sur le prieuré de Saint-Loup-de-Naud', *Bibliothèque de l'Ecole de Chartres 1840/41*, 2, p. 244 ff.

Bouxin, A., *La cathédrale Notre-Dame de Laon*, 1902².

Branner, R., 'Les portails latéraux de la cathédrale de Bourges', *Bull. Mon.* 115 (1957), p. 263 ff.; *Burgundian gothic architecture*, London 1960; 'The north transept and the first west façades of Reims cathedral', *Zeitschrift für Kunstgeschichte* 24 (1961), p. 197 ff.; *La cathédrale de Bourges et sa place dans l'architecture gothique*, Paris/Bourges 1962; *St. Louis and the Court Style in gothic architecture*, London 1965

Branthomme, M., *Notre-Dame de la Couture*, Paris 1948

Bréhier, L., *La cathédrale de Reims*, Paris 1916

Broche, L., 'La cathédrale de Laon', *C.A.* 78 (1911), vol. I, p. 162 ff.; *La cathédrale de Laon*, Paris 1926

Brutails, J.-A., *Les vieilles églises de la Gironde*, Bordeaux 1912

Buhot de Kersers, A. L. M., *Histoire et statistique monumentale du département du Cher*, vol. II, Bourges 1883

Bulteau, M. J., *Notice archéologique sur les anciennes abbayes d'Honnécourt et de Vaucelles*, Lille 1881; *Monographie de la cathédrale de Chartres*, 1887–1892

Bunjes, H., *Die steinernen Altaraufsätze der hohen Gotik und der Stand der gotischen Plastik in der Ile-de-France um 1300*, Würzburg 1937; 'Der gotische Lettner der Kathedrale von Chartres', *Wallraf-Richartz-Jahrbuch* 12/13 (1943), p. 70ff.

Carlier, A., *L'église de Rampillon*, Paris 1930

Cerf, Ch., *Notre-Dame de Reims*, Rheims 1861

Chartraire, E., 'La sculpture du grand portail de la cathédrale de Sens', *Bull. archéologique* 1914, p. 499ff; *La cathédrale de Sens*, Paris n.d.

Chenesseau, G., *L'abbaye de Fleury*, Paris 1931

Chérest, G., 'Une abbaye de la Brie champenoise', *Mém. de la Soc. d'agriculture, commerce, sciences et arts du département de la Marne* 87 (1962), p. 32ff.

Chomton, L., *Histoire de l'église Saint-Bénigne de Dijon*, Dijon 1900

Clemen, P., 'Studien zur Geschichte der französischen Plastik. I: Der Skulpturenschmuck der Kathedrale von Amiens und die Bildhauerschule der Ile-de-France', *Zeitschrift für christliche Kunst* 5 (1892), p. 225ff.

Colombet, A., *Saint-Thibault en Auxois*, Dijon n.d.

Contant, C., 'Le tympan de la porte des Bleds', *Bull. mensuel de la soc. des sciences historiques et naturelles de Semur-en-Auxois* 1932, p. 48ff.

Courajod, L., 'Les sépultures des Plantagenets à Fontevrault', *G.B.A.* 23 (1867), p. 537ff.; *Alexandre Lenoir, son journal et le Musée des Monuments français*, Paris 1876–88

Courteault, P., 'Cathédrale Saint-André de Bordeaux', *C.A.* 102 (1939), p. 30ff.

Crosby, S. McK., 'Fouilles exécutées récemment dans la basilique de Saint-Denis', *Bull. Mon.* 105 (1947), p. 167ff; *L'abbaye royale de Saint-Denis*, Paris 1953

Crosnier, A. J., 'Iconographie des portails de Sens', *C.A.* 14 (1847), p. 99ff.; *Monographie de la cathédrale de Nevers*, Nevers 1854; 'L'ancien portail de l'église de St.-Père de Nevers', *C.A.* 18 (1851), p. 227ff.

Crozet, R., *L'art roman en Berry*, Paris 1932; *L'art roman en Poitou*, Paris 1948; 'L'ancien portail gothique de l'abbaye de Charroux', *G.B.A.* 6ᵉ pér., 40 (1952), p. 149ff.;

'La frise de la Maison-Dieu de Montmorillon et ses rapports avec la sculpture chartraine, bourguignonne et bourbonnaise', *Bull. de la Soc. des Antiquaires de l'Ouest*, 4ᵉ sér., 8 (1965), p. 83ff.

Daudin, E., 'La cathédrale d'Auxerre. Sculptures des portails', *Annuaire d'Auxerre 1971/72*, 1873

Dehio, G., *Handbuch der Deutschen Kunstdenkmäler, IV: Südwestdeutschland*, Berlin 1926

Delaporte, Y., 'Quelques bas-reliefs inexpliqués de la cathédrale de Chartres', *Mém. de la Soc. archéol. d'Eure-et-Loir* 17 (1940), p. 203ff.; 'Saint Maurice et sa statue à la cathédrale de Chartres', *Mém. de la Soc. archéol. d'Eure-et-Loir* 20 (1957), p. 75–81

Demaison, L., *Album de la cathédrale de Reims*, Rheims 1902; 'La restauration de la basilique Saint-Rémi de Reims', *Bull. Mon.* 96 (1937), p. 91ff.

Deneux, H., 'Tête d'une statue du XIIᵉ siècle trouvée dans l'église Saint-Rémi de Reims', *Bull. Mon.* 80 (1921), p. 118ff.; 'Signes lapidaires et épures du XIIIᵉ siècle à la cathédrale de Reims', *Bull. Mon.* 84 (1925), p. 99ff.

Deschamps, P., 'Les deux tympans de Saint-Bénigne de Dijon et de Til-Châtel', *Bull. Mon.* 81 (1922), p. 380f.

Deschamps de Pas, L., 'Translation à Saint-Omer du portail de la cathédrale de Thérouanne', *Bull. de la Soc. des Antiquaires de la Morinie* 1852–56, vol. I, p. 116ff.

Deshaines, *Historie de l'art dans la Flandre, L'Artois et le Hainaut avant le XVᵉ siècle*, Lille 1886

Deshoulières, F., 'Souvigny', *C.A.* 80 (1913), p. 182ff.; *Souvigny et Bourbon l'Archambault*, Paris n.d. (I); *La cathédrale de Meaux*, Paris n.d. (II); 'Les sculptures de l'abbaye de Saint-Maur', *Bull. Mon.* 84 (1925), p. 171ff.; 'Germigny-L'Exempt', *C.A.* 94 (1931), p. 428ff.; *Les Eglises de France. Cher*, Paris 1932

Deuchler, F., *Der Ingeborgpsalter*, Berlin 1967

Didron, A., 'Vente de trois bas-reliefs romans, peints et dorés', *Annales archéol.* 3 (1845), p. 296ff.; 'Dégradation de la Cathédrale d'Amiens', *Annales archéol.* 7 (1847), p. 321ff.; 'Rapport sur les travaux exécutés de 1829 à 1848 à la cathédrale de Bourges', published by O. Roger in *Mém. de la Soc. des Antiquaires du Centre* 16 (1889)

Dormay, C., *Histoire de la ville de Soissons*, 1663

Drival, van, 'Sur une statue de la cathédrale de Saint-Omer provenant de Thérouanne', *Bull. de la comm. départementale des antiquités du Pas de Calais*, 1875, p. 306ff.

Duband, J., *Histoire de Chablis*, Sens 1852

Dutourcet, J. E., and P. Camiade, 'Le portail gothique de Notre-Dame de Dax', *Aquitaine historique et monumentale* 3 (1890/99), p. 73.

Dumolin, M., and G. Outardel, *Les églises de France. Paris et Seine*, Paris 1936

Dunod de Charnage, F. J., *Histoire des Séquanois*, Dijon 1735; *Histoire de l'église, ville et diocèse de Besançon*, Besançon 1750

Durand, G., *Monographie de l'église Notre-Dame cathédrale d'Amiens*, Amiens/Paris 1901; and E. Martène, *Voyage littéraire de deux religieux bénédictins*, Paris 1724/27

Egbert, V., 'St. Nicholas: The fasting child', *A.B.* 46 (1964), p. 69ff.

Enlart, C., 'La sculpture des portails de la cathédrale d'Auxerre', *C.A.* 74 (1907), p. 599ff.; 'Il portale della cattedrale San Lorenzo di Genova', *Atti del X congresso internazionale di storia dell'arte in Roma* 1912, p. 135ff.; 'L'église de Wast en Boulonnais et son portail arabe', *G.B.A.* 69 (1927/2), p. 1ff.; *Manuel d'archéologie française*, Paris 1929

Erlande-Brandenburg, A., 'Le "Cimetière des Rois" à Fontevrault', *C. A.* 122 (1964), p. 482ff.; 'Une tête de style Sénonais', *Bull. Mon.* 125 (1967), p. 415ff.

Farcy, L. de, 'Galons gravés sur les vêtements des statues du grand portail, à la cathédrale d'Angers', *Rev. de l'art chrétien* 35 (1892), p. 41

Félibien, M., *Histoire de l'Abbaye Royale de Saint-Denis en France*, Paris 1706

Fels, E., 'Mont-devant-Sassey', *C.A.* 96 (1933), p. 471ff.; 'Die Grabung an der Fassade der Kathedrale von Chartres', *Kunstchronik* 8 (1955), p. 149ff.

Fischel, A., 'Die Seitenreliefs am Südportal der Notre-Dame in Paris', *Jahrbuch für Kunstwissenschaft* 1939, p. 189ff.

Fleury, E., *Antiquités et monuments du département de l'Aisne*, Paris 1877–82

Fleury, G., 'Le portail de Saint-Ayoul de Provins et l'iconographie des portails du XIIᵉ siècle', *C.A.* 69 (1902), p. 458ff.; *Etudes sur les portails imagés du XIIIᵉ siècle*, Mamers 1904

Formigé, J., *L'abbaye royale de Saint-Denis*, Paris 1960

Forsyth, G. H., *The church of Saint-Martin at Angers*, Princeton, N.J. 1953

Franck-Oberaspach, K., *Der Meister der Ecclesia und Synagoge*, Düsseldorf 1903

Francovich, G. de, *Benedetto Antelami*, Milan/Florence 1952.

Frisch, T. G., 'The twelve choir statues of the cathedral at Reims', *A.B.* 42 (1960), p. 1 ff.

Froidevaux, Y. M., 'Eglise abbatiale de Charroux', *C.A.* 109 (1951), p. 356 ff.

Fyot, E., *Notre-Dame de Dijon*, Dijon 1910;
Dijon. Son passé évoqué par ses rues, Dijon 1928

Gandilhon, A., 'Le premier jubé de la cathédrale de Bourges', *Mém. de la Soc. des Antiquaires du Centre* 36 (1911), p. 249 ff.

Gardelles, J., *La cathédrale Saint-André de Bordeaux*, Bordeaux 1963

Gassies, G., 'Note sur une tête de statue trouvée à Meaux', *Bull. archéol.* 1905, p. 40 ff.

Gauchery, P., 'Restes de l'ancien jubé de la cathédrale de Bourges', *Mém. de la Soc. des Antiquaires du Centre* 36 (1919);
'Notes sur la cathédrale de Bourges', *Mém. de la Soc. des Antiquaires du Centre* 44 (1931), p. 189 ff.

Gauchery-Grodecki, C., *Saint-Etienne de Bourges. Notices historiques et archéologiques* (1959)

Gauthier, J., 'L'ancienne collégiale de Sainte-Madeleine de Besançon', *Bull. archéol.* 1895, p. 158 ff.

Génemont, A., and P. Pradel, *Les églises de France, Allier*, Paris 1938

Giesau, H., 'Stand der Forschung über das Figurenportal des Mittelalters', *Vorträge auf dem ersten deutschen Kunsthistorikertag 1948*, Berlin 1950, p. 119 ff.

Gilbert, A. P. M., *Description historique de la basilique métropolitaine de Paris*, Paris 1821;
'Rapport sur les statues du moyen-âge découvertes à Paris, rue de la Santé en décembre 1839', *Mém. des Antiquaires de France* 15 (1840), p. 364 ff.

Girardot, A. de, 'Description des sculptures du portail de la cathédrale de Bourges', *Mém. de la Soc. des Antiquaires du Centre* 7 (1877)

Giteau, C., 'Les sculptures de Sainte-Geneviève de Paris', *Mém. de la Fédération des Sociétés historiques et archéologiques de l'Ile-de-France*, 1961, p. 7 ff.

Givelet, Ch. P., Jadart, H., Demaison, L., *Catalogue du musée lapidaire rémois*, Rheims 1895

Gnudi, C., 'Le jubé de Bourges et l'apogée du "classicisme" dans la sculpture de l'Ile-de-France au milieu du 13e siècle', *Rev. de l'Art* 3 (1969), p. 18 ff.

Goetz, W., *Zentralbau und Zentralbautendenz in der gotischen Architektur*, Berlin 1968

Goldscheider, C., 'Les origines du portail à statues-colonnes', *Bull. des Musées de France* 11 (1946), p. 22 ff.

Goldschmidt, A., 'Das Naumburger Lettnerkreuz im Kaiser-Friedrich-Museum in Berlin', *Jahrbuch der Königlichen Preussischen Kunstsammlungen* 36 (1915), p. 137 ff.

Gotische Bildwerke aus dem Liebieghaus, Frankfurt am Main 1966

Gouin, H., *L'abbaye de Royaumont*, Paris 1964

Greenhill, E. B., 'The provenance of a gothic head', *A. B.* 49 (1966), p. 101 ff.

Grésy, E., *Iconographie de Saint-Loup, empruntée principalement aux monuments de l'art local*, Meaux 1867

Grodecki, L., 'The transept portals of Chartres cathedral: the date of their construction according to archaeological data', *A.B.* 23 (1951), p. 155 ff.;
review of W. S. Stoddard, *The West Portals of Saint-Denis and Chartres*, in *Bull. Mon.* 111 (1953), p. 312 ff.;
'La sculpture française autour de 1200', *Bull. Mon.* 115 (1957), p. 119 ff.;
'La "première sculpture gothique". Wilhelm Vöge et l'état actuel des problèmes', *Bull. Mon.* 117 (1959), p. 265 ff.;
La Sainte-Chapelle, Paris 1962

Grosset, Ch., 'Etude sur la frise de la Maison-Dieu à Montmorillon', *Bull. de la Soc. des Antiquaires de l'Ouest*, 3e sér., 14 (1948), p. 553 ff.;
'La Maison-Dieu de Montmorillon', *C.A.* 109 (1951), p. 192 ff.

Guibert, J., *Les dessins d'archéologie de Roger de Gaignières*, Paris n.d.

Guilhermy, F. de, and E. Viollet-le-Duc, *Description de Notre-Dame cathédrale de Paris*, Paris 1856;
Description de la Sainte-Chapelle, Paris 1867;
and Ch. Fichot, *L'église impériale de Saint-Denis et ses tombeaux*, Paris 1867;
L'abbaye de Saint-Denis. Tombeaux et figures historiques des rois de France, Paris 1891³

Hamann, R., *Die Abteikirche von St. Gilles und ihre künstlerische Nachfolge*, Berlin 1955;
and W. Kästner, *Die Elisabethkirche zu Marburg*, Marburg 1929.

Hamann-MacLean, R., 'Das ikonographische Problem der "Friedberger Jungfrau"', *Marburger Jahrbuch für Kunstwissenschaft* 10 (1937), p. 37 ff.;
'Das Apostelrelief vom Liebfrauenportal am Metzer Dom', in: L. Roselius, *Deutsche Kunst*, vol. X, nos 63/64;
'Reims als Kunstzentrum im 12. und 13. Jahrhundert', *Kunstchronik* 9 (1956), p. 287 ff.;
'Merowingisch oder Frühromanisch?', *Jahrbuch des Römisch-Germanischen Zentralmuseums in Mainz* 4 (1957), p. 161 ff.;
'Stilwandel und Persönlichkeit. Der Reimser "Priester"-Meister', *Recueil des Musées national* 4, Belgrade 1964, p. 243 ff.;
'Die Versatzmarken der Westportalstatuen der Kathedrale von Reims', *Kunstchronik* 10 (1966), p. 287 ff.

Haug, H., 'Les œuvres de miséricorde du jubé de la cathédrale de Strasbourg', *Archives Alsaciennes d'histoire de l'art* 10 (1931), p. 99 ff.;
Der Strassburger Lettner im Frauenhaus-Museum, Form und Inhalt. Otto Schmitt zum 60. Geburtstag, Stuttgart 1950, p. 139 ff.;
La cathédrale de Strasbourg, Strasbourg 1957

Heimann, A., 'The master-sculptor of the west facade in Chartres', *Actes du XVe Congrès international d'Histoire de l'Art*, London 1939, p. 20;
'Jeremiah and his girdle', *Journal of the Warburg and Courtauld Institutes* 25 (1962), p. 1 ff.;
'The capital frieze and pilasters of the portail royal, Chartres', *Journal of the Warburg and Courtauld Institutes* 31 (1968), p. 73 ff.

Heinrich, J., *Die Entwicklung der Madonnenstatue in der Skulptur Nordfrankreichs von 1250 bis 1350*, Leipzig 1933

Héliot, P., *L'abbaye de Corbie*, Louvain 1957

Hell, L., *Der Engelspfeiler im Strassburger Münster*, Freiburg 1926

Heylli, G. de, *Les tombes royales de Saint-Denis, histoire et nomenclature des tombeaux*, Paris 1872

Hinkle, W. M., *The portal of the saints of Reims cathedral*, New York 1965;
'The king and the pope on the virgin portal of Notre-Dame', *A. B.* 46 (1966), p. 1 ff.;
'The cosmic and terrestrial cycles on the virgin portal of Notre-Dame', *A. B.* 49 (1967), p. 287 ff.

Hohenzollern, J. G., Prinz von, *Die Königsgalerie der französischen Kathedrale*, Munich 1965

Hotz, W., *Handbuch der Kunstdenkmäler im Elsass und in Lothringen*, Munich 1965

Houvet, E., *Cathédrale de Chartres*, Chelles 1919

Huard, G., 'Percier et l'abbaye de Saint-Denis', *Les monuments historiques de la France* 1936, p. 134 ff.

Hubert, J., 'L'abbatiale Notre-Dame de Déols', *Bull. Mon.* 86 (1927), p. 5 ff.;

'Le mausolée d'Ogier le Danois', *Bull. de la Soc. Nat. des Antiquaires de France* 1945/47, p. 253;
'L'abbaye de Déols et les constructions monastiques de la fin de l'époque carolingienne', *Cahiers archéol.* 9 (1957), p. 155 ff.

Hucher, E., 'Note sur le portail bizantin de la cathédrale du Mans', *Bull. Mon.* 8 (1842), p. 38 ff.

Jacob, M., *Un chapitre d'histoire artistique de Villenauxe – Autour d'un portail*, Troyes 1924

Jadart, H., 'Musées de Reims', *C.A.* 78 (1911), I, p. 150 ff.

Jantzen, H., *Deutsche Bildhauer des 13. Jh.*, Leipzig 1925;
Burgundische Gotik, Munich 1949;
Kunst der Gotik. Klassische Kathedralen Frankreichs, Hamburg 1957

Jourdain, E., and Th. Duval, *Le portail Saint-Honoré, dit de la Vierge Dorée de la cathédrale d'Amiens*, Amiens 1844;
'Le grand portail de la cathédrale d'Amiens', *Bull. Mon.* 11 (1845), p. 145 ff., p. 279 ff., p. 430 ff.; 12 (1846), p. 96 ff.

Katzenellenbogen, A., 'The prophets on the west façade of the cathedral at Amiens', *G.B.A.*, 6e pér., 40 (1952), p. 241 ff.;
The sculptural programs of Chartres Cathedral, Baltimore, Md. 1959;
'Tympanum and archivolts on the portal of St. Honoré at Amiens', in: *De Artibus Opuscula XL. Essays in Honor of Erwin Panofsky*, New York 1961, p. 280 ff.;
'Iconographic novelties and transformations in the sculpture of French church façades, ca. 1160–1190', *Studies in Western Art*, Princeton, N.J. 1963, vol. I, p. 108 ff.;
Allegories of the virtues and vices in medieval art, New York 1964[2]

Kautzsch, R., 'Ein frühes Werk des Meisters der Strassburger Ekklesia', *Oberrheinische Kunst* 3 (1928), p. 133 ff.

Keller, H., *Zur inneren Eingangswand der Kathedrale von Reims. Gedenkschrift Ernst Gall* 1965, p. 235 ff.

Kerber, B., *Burgund und die Entwicklung der französischen Kathedralskulptur im 12. Jh.*, Recklinghausen 1966

Kidson, P., *Sculpture at Chartres*, London 1958

Kimpel, D., 'Le sort des statues de Notre-Dame de Paris. Documents sur la période révolutionnaire', *Rev. de l'Art* 1969/4, p. 44 ff.

Kleiminger, W., *Die Plastik im Elsass 1260 bis 1360*, Freiburg 1939

Knauth, J., 'Der Lettner des Münsters. Ein verschwundenes Kunstwerk', *Strassburger Münsterblätter* 1 (1903), p. 33 ff.

Koechlin, R., *Les ivoires gothiques*, Paris 1924

Kraus, F. X., *Kunst und Alterthum in Elsass-Lothringen. Beschreibende Statistik*, Strasbourg 1876

Kunze, H., *Das Fassadenproblem der französischen Früh- und Hochgotik*, Leipzig 1912

Laborde, J. B. de, *Voyage pittoresque de la France*, vol. X (1792) Soissonais

Lacatte-Joltrois, M., *Histoire et description de l'église Saint-Rémi de Reims*, Rheims 1868[2]

Lahondès, J., 'Les statues de Saint-Nazaire', *Bull. de la Soc. archéol. du Midi* 1901, p. 258 ff.;
'Carcassonne. Eglise Saint-Nazaire', *C.A.* 73 (1906), p. 32 ff.

Lambert, E., 'Les portails sculptés de la cathédrale de Laon', *G.B.A.* 17 (1937), p. 83 ff.

Lapeyre, A., 'Le portail de l'église de Vermenton', *Bull. de la Soc. Nat. des Antiquaires de France* 1952/53, p. 162;
'Les sculptures de l'église d'Honnecourt (Nord)', *Mém. de la Soc. Nat. des Antiquaires de France. Recueil du Cent Cinquantenaire* 1954, p. 203 ff.;
Des façades occidentales de Saint-Denis et de Chartres aux portails de Laon, 1960

Lasteyrie, R. de, 'Vierge en bois sculptée', *Gaz. archéol.* 9 (1884), p. 317 ff.;
'Etudes sur la sculpture française au moyen-âge', *Mon. Piot* 8 (1902)

Launay, A., *Recherches archéologiques sur les œuvres des statuaires du moyen-âge dans la ville du Mans*, Le Mans 1852

Lebeuf, *Histoire de la ville et de tout le diocèse de Paris*, Paris 1754

Leblond, V., *L'église Saint-Etienne de Beauvais*, Paris 1929

Lefèvre, L. E., *Le portail royal d'Etampes*, Paris 1908[2];
Le portail royal d'Etampes et la doctrine de Saint Irénée sur la rédemption, Paris 1915

Lefèvre-Pontalis, E., *Etude historique et archéologique sur la nef de la cathédrale du Mans*, Mamers 1889;
'Les façades successives de la cathédrale de Chartres au XIe et au XIIe siècle', *C.A.* 57 (1900), p. 256 ff.;
'Nouvelles études sur les façades et les clochers de la cathédrale de Chartres', *Mém. de la Soc. archéol. d'Eure-et-Loir* 13 (1901–4), p. 1 ff.;
'Les campagnes de construction de Notre-Dame d'Etampes', *Bull. Mon.* 73 (1909), p. 5 ff.;
'Braine', *C.A.* 78 (1911), vol. I, p. 428 ff.;
'Saint-Pierre-le-Moutier', *C.A.* 80 (1913), p. 292 ff.;
'Etude historique et archéologique sur l'église de Saint-Germain-des-Prés', *C.A.* 82 (1919), p. 301 ff.

Lefrançois-Pillion, L., 'L'église de Saint-Thibault-en-Auxois et ses œuvres de sculpture', *G.B.A.*, 5e pér., 5 (1922), p. 136 ff.;
'Le portail de l'église Notre-Dame de Corbeil', *Bull. Mon.* 84 (1925), p. 131 ff.;
'La sculpture monumentale de la cathédrale de Rouen', *C.A.* 89 (1926), p. 72 ff.;
Les sculpteurs de Reims, Paris 1928;
Les sculpteurs français du XIIIe siècle, Paris 1931[2];
'Une œuvre énigmatique. Les statues des prophètes du musée de Troyes', *G.B.A.*, 6e pér., 11 (1933), p. 343 ff.;
'Les statues de la vierge à l'enfant dans la sculpture française au XIVe siècle', *G.B.A.*, 6e pér., 14 (1935/2), p. 129 ff. and 204 ff.

Lejeune, R., and J. Stiennon, *La légende de Roland dans l'art du moyen-âge*, Brussels 1966

Lenoir, A., *Musée des Monumens français*, Paris 1821;
Statistique monumentale de Paris, Paris 1867

Lephay, J., 'Sur deux statues d'anges', *G.B.A.* 71 (1929/2), p. 121 ff.

Lestocquoy, J., 'Quelques anges artésiens du XIIIe siècle', *Les monuments historiques de la France* 5 (1959), p. 31 ff.

Lesueur, F., 'L'église de la Couture au Mans', *C.A.* 119 (1961), p. 119 ff.

Levron, J., *L'église collégiale de Saint-Martin d'Angers*, Angers 1950

Loirette, G., 'Eglise Saint-Seurin de Bordeaux', *C.A.* 102 (1939), p. 59 ff.

Loisel, A., *La cathédrale de Rouen*, Paris n.d.

Mabillon, J., *Annales Ordinis S. Benedicti*, Paris, 1703–39

Magne, L., 'Rapport sur les tombeaux trouvés dans le transept de Fontevrault', *C.A.* 77 (1910), p. 155 ff.

Maillard, E., *Les sculptures de la cathédrale Saint-Pierre de Poitiers*, Poitiers 1921

Maillé, Marquise de, 'L'église de Donnemarie-en-Montois', *Bull. Mon.* 87 (1928), p. 1 ff.;
Provins. Les Monuments Religieux, Paris 1939

Maillon, J., *Chartres. Le jubé de la cathédrale*, 1964

Mâle, E., *L'art religieux du XIIIe siècle en France*, Paris 1902[2];
Art et artistes du moyen-âge, Paris 1928;
L'art religieux du XIIe siècle en France, Paris 1947[5]

Marion, J., *Essai historique et archéologique sur l'église cathédrale Notre-Dame de Laon*, Laon 1864

Mauduit, F. J., *Histoire d'Ivry-la-Bataille et l'abbaye de Notre-Dame d'Ivry*, Evreux 1899

Medding, W., 'Der Josephsmeister von Reims', *Jahrbuch der königlichen preussischen Kunstsammlungen* 50 (1929), p. 299ff.;
Die Westportale der Kathedrale von Amiens und ihre Meister, Augsburg 1930;
'Sculptures de Saint-Martin d'Angers,' *G.B.A.*, 6ᵉ pér., 12 (1934), p. 170ff.

Mesplé, P., *Toulouse. Musée des Augustins. Les sculptures romanes*, Toulouse 1961

Métais, C., 'Découverte du tombeau de Jean de Salisbury, évêque de Chartres', *Bull. Mon.* 69 (1905), p. 501ff.;
Eglise Notre-Dame de Josaphat, Chartres 1908;
'La crosse et le tombeau de Renaud de Mouçon', *Rev. de l'Art chrétien* 61 (1911), p. 211ff.

Meulen, J. van der, 'Histoire de la construction de la cathédrale Notre-Dame de Chartres après 1194', *Mém. de la Soc. Archéol. d'Eure-et-Loir* 23 (1965), p. 81ff.;
'Recent literature on the chronology of Chartres cathedral', *A.B.* 49 (1967), p. 152ff.

Michel, A., 'Les acquisitions du département de la sculpture au Musée du Louvre', *G.B.A.*, 3ᵉ pér., 29 (1903/1), p. 299ff.

Millin, A. L., *Antiquités Nationales,* Paris 1790–1802

Montfaucon, B. de, *Les monumens de la monarchie françoise*, Paris 1729

Morellet, J. N., Barat, Bussière, E., *Le Nivernois. Album historique et pittoresque*, Nevers 1838–40

Mortet, R., *Etude historique et archéologique sur la cathédrale et le palais épiscopal de Paris du VIᵉ au XIIᵉ siècle*, Paris 1888

Mundt, B., 'Der Statuenzyklus von Carcassonne', *Wallraf-Richartz-Jahrbuch* 27 (1965), p. 31ff.

Mussat, A., *Le style gothique de l'Ouest de la France*, Paris 1963;
'La cathédrale Saint-Maurice d'Angers. Recherches récentes', *C.A.* 122 (1964), p. 22ff.

Ostoia, V. K., 'A statue from St. Denis', *The Metropolitan Museum of Art Bull.* 13 (1955), p. 298ff.

Oursel, Ch., *L'église Notre-Dame de Dijon*, Paris n.d.

Paillard, A., 'Têtes sculptées provenant de la cathédrale de Reims', *Bull. Mon.* 116 (1958), p. 29ff.

Paillard, E. M., *Portail de Reims*, Vitry-le-François 1936.

Paillard-Prache, A., 'Le cloître de Notre-Dame-en-Vaux de Châlons-sur-Marne', *Mém. de la Soc. d'Agriculture, Commerce, Sciences et Arts du département de la Marne* 77 (1962), p. 61ff.

Panofsky, E., *Deutsche Plastik des 11. bis 13. Jahrhundert*, Munich 1924;
'Uber die Reihenfolge der vier Meister von Reims', *Jahrbuch für Kunstwissenschaft* 1927, p. 55f.;
'Zur künstlerischen Abkunft des Strassburger "Ekklesiameisters"', *Oberrheinische Kunst* 4 (1930), p. 124ff.;
Renaissance and Renascences in Western Art, Uppsala 1960;
Tomb sculpture, New York 1964 (I);
'The mouse that Michelangelo failed to carve', *Essays in Honor of Karl Lehmann*, New York 1964, p. 242ff. (II)

Petit, V., 'Notes pour servir à la description de quelques églises du département de l'Yonne', *Bull. Mon.* 13 (1847), p. 253ff.

Philippe, A., 'Eglise de Vermenton', *C.A.* 74 (1907), p. 148ff.

Pillion, L., 'Le portail roman de la cathédrale de Reims', *G.B.A.*, 3ᵉ pér., 32 (1904), p. 177ff.;
'Un tympan de porte à la cathédrale de Rouen. La mort de Saint Jean l'Evangeliste', *Rev. de l'Art* 15 (1904), p. 181ff.;
'Un tombeau français du treizième et l'apologue de Barlaam sur la vie humaine', *Rev. de l'art ancien et moderne* 1910/2, p. 321;
'Le jugement dernier de la cathédrale de Reims et ses prétendues figures de vertus', *C.A.* 78 (1911), vol. 2, p. 247ff.

Pinard, T., 'Monographie de l'église Notre-Dame de Corbeil', *Rev. archéol.* 2 (1845/46), p. 165ff. and p. 643ff.

Pinier, P., 'Ancienne église Saint-Martin d'Angers', *C.A.* 77 (1910), 1, p. 191ff.

Plancher, Dom U., *Histoire générale et particulière de Bourgogne*, Dijon 1739

Poinssot, C., 'Note sur le réfectoire de l'abbaye bénédictine de Saint-Bénigne de Dijon', *Bull. des relations artistiques France-Allemagne* 1951;
'Le bâtiment du dortoir de l'abbaye Saint-Bénigne de Dijon', *Bull. Mon.* 112 (1954), p. 303ff.

Polti, J., *Le grand portail de l'église Notre-Dame de la Couture. Province du Maine*, 1936

Poquet, A. E., *Pèlerinage à l'ancienne abbaye Saint-Médard de Soissons*, 1849

Porée, Ch., 'Sens. La cathédrale', *C.A.* 74 (1907), p. 205ff.;
La cathédrale d'Auxerre, Paris 1926

Porter, A. K., *Romanesque sculpture of the pilgrimage roads*, Boston, Mass. 1923

Prache, A., 'Notre-Dame-en-Vaux de Châlons-sur-Marne', *Mém. de la Soc. d'agriculture, commerce, sciences et arts de la Marne* 1966, p. 1ff.

Pradel, P., 'Sculptures (XIIᵉ siècle) de l'église de Souvigny', *Mon. Piot* 40 (1944), p. 147ff.;
Chefs-d'Œuvre romans des Musées de Province, Paris 1957/58

Pressouyre, L., 'Sculptures du premier art gothique à Notre-Dame-en-Vaux de Châlons-sur-Marne', *Bull. Mon.* 121 (1962), p. 359ff.;
'La colonne dite "aux trois chevaliers" de Châlons-sur-Marne', *Bull. de la Soc. Nat. des Antiquaires de France* 1963, p. 76ff.;
'Nouvelle identification d'une statue de Saint-Maur-des-Fossés', *Bull. Mon.* 122 (1964), p. 393ff. (I);
'Fouilles du cloître de Notre-Dame-en-Vaux de Châlons-sur-Marne', *Bull. de la Soc. Nationale des Antiquaires de France* 1964, p. 23ff. (II);
'Une tête du Louvre prétendue dyonisienne', *Bull. de la Soc. Nationale des Antiquaires de France* 1967, p. 242ff. (I);
'Quelques vestiges sculptés de l'abbaye de Nesle-la-Reposte', *Bull. de la Soc. Nationale des Antiquaires de France* 1967, p. 104ff. (II);
'Un tombeau d'abbé provenant du cloître de Nesle-la-Reposte', *Bull. Mon.* 125 (1967), p. 8ff. (III);
'Pour une reconstruction du jubé de Chartres', *Bull. Mon.* 125 (1967), p. 419ff. (IV);
'Fragments du cloître de Notre-Dame-en-Vaux de Châlons-sur-Marne', in: *L'Europe gothique XIIᵉ–XIVᵉ siècles*, Paris 1968, p. 6ff. (I);
'Le cloître de Notre-Dame-en-Vaux à Châlons-sur-Marne', *Archaeologia* 1968, p. 68ff. (II);
'Rezension zu W. Sauerländer, "Von Sens bis Strassburg"', *Bull Mon.* 126 p. 215ff. (III);
'Sculptures retrouvées de la cathédrale de Sens', *Bull. Mon.* 127 (1969), p. 107ff.;

Priest, A., 'The masters of the west façade of Chartres', *Art Studies* 1 (1923), p. 28ff.

Quantin, M., 'Le grand portail de la cathédrale de Sens', *Annuaire de l'Yonne* 1850, p. 313ff.;
Répertoire archéologique du département de l'Yonne, Paris 1868

Quarré, P., 'La sculpture des anciens portails de Saint-Bénigne de Dijon', *G.B.A.*, 6ᵉ pér., 50 (1957), p. 177ff.;
'Les sculptures du portail de Notre-Dame de Dijon et celles du transept de la cathédrale de Strasbourg', *Mém. de la Comm. des Antiquités de la Côte-d'Or* 26 (1963–65);
'La sculpture en Bourgogne au XIIIᵉ siècle', *Bull. de la Soc. des Amis du Musée de Dijon* 1964/66, p. 19ff.;
'Le portail de Saint-Thibault et la sculpture bourguignonne du XIIIᵉ siècle', *Bull. Mon.* 123 (1965), p. 181ff.;
'Le Saint Jean-Baptiste de Rouvres et l'atelier de Mussy-L'Evêque', *Rev. de l'Art* 1969/3, p. 67ff.

Raeber, R., *La Charité-sur-Loire*, Berne 1964

Régnier, L., 'Saint-Germer', *C.A.* 72 (1905), p. 81 ff.

Reiners, H., and W. Ewald, *Kunstdenkmäler zwischen Maas und Mosel*, Munich 1921

Reinhardt, H., 'Le jubé de la cathédrale de Strasbourg et ses origines rémoises', *Bull. de la Soc. des Amis de la cathédrale de Strasbourg*, 2ᵉ sér., no. 6 (1951), p. 19 ff.; 'Sculpture française et sculpture allemande au XIIIᵉ siècle', *L'Information d'Histoire de l'Art* 5 (1962), p. 174 ff.; *La cathédrale de Reims*, Paris 1963

Rey, J. D., 'Sculptures du Musée de Soissons', *Jardin des Arts* 1956, p. 737 ff.

Rey, R., *L'art gothique du midi de la France*, Paris 1934

Rhein, A., 'Fontevrault', *C.A.* 77 (1910), vol. I, p. 48 ff. (I); 'Candes', *C.A.* 77 (1910), vol. I, p. 39 ff. (II); *Notre-Dame de Mantes*, Paris 1932

Richard, J. M., 'Deux plans de Thérouanne', *Bull. de la comm. départementale du Pas de Calais* 5 (1879), p. 103 ff.

Roblot-Delandre, L., 'Saint-Loup-de-Naud', *Mon. Piot* 21 (1914), p. 111 ff.

Roger, O., 'L'ancien jubé de la cathédrale de Bourges', *Bull. de la Soc. des Antiquaires du Centre* 18 (1891), p. 77 ff.

Rohault de Fleury, Ch., *La messe. Etudes archéologiques sur ses monuments*, Paris 1883

Rorimer, J., 'A twelfth century head of king David from Notre-Dame', *The Metropolitan Museum of Art Bull.* 1940, p. 17 ff.; 'The virgin from Strasbourg cathedral', *The Metropolitan Museum of Art Bull.* 1949, p. 220 ff.

Roserot de Melin, J., 'Les deux "prophètes" du musée de Troyes', *Mém. de la Soc. académique de l'Aube* 104 (1964/66), p. 73 ff.

Rousseau, H., 'Le musée du vieux Saint-Maur', *Bull. de la Soc. historique et archéologique de Saint-Maur-des-Fossés* 2 (1924), p. 51 ff.

Salet, F., 'Saint-Loup-de-Naud', *Bull. Mon.* 92 (1933), p. 156 ff.; 'Dax. Cathédrale', *C.A.* 102 (1939), p. 380 ff.; 'Notre-Dame de Corbeil', *Bull. Mon.* 100 (1941), p. 81 ff.; *La Madeleine de Vézelay*, Melun 1948; 'Les statues d'apôtres de la Sainte-Chapelle conservées au Musée de Cluny', *Bull. Mon.* 109 (1951), p. 135 ff.; 'Nouvelle note sur les statues d'apôtres de la Sainte-Chapelle', *Bull. Mon.* 112 (1954), p. 359 ff.; 'Chablis', *C.A.* 116 (1958), p. 197 ff.;

'Les sculptures de Sainte-Marie d'York', *Bull. Mon.* 118 (1960), p. 324 ff.; 'Rezension zu R. Raeber, "La Charité-sur-Loire"', *Bull. Mon.* 123 (1965), p. 345 ff.; 'Chronologie de la cathédrale [de Reims]', *Bull. Mon.* 125 (1967), p. 347 ff.; 'Les statues de prophètes de "Montier-La-Celle" au Musée de Troyes', *Bull. Mon.* 125 (1967), p. 307 ff.

Sauerländer, W., 'Zu den Westportalen von Chartres', *Kunstchronik* 9 (1956), p. 155 ff. (I); 'Beiträge zur Geschichte der frühgotischen Skulptur', *Zeitschrift für Kunstgeschichte* 19 (1956), p. 1 ff. (II); 'Chefs-d'Œuvre romans des Musées de Province', *Kunstchronik* 11 (1958), p. 33 ff. (I); 'Die Marienkrönungsportale von Senlis und Mantes', *Wallraf-Richartz-Jahrbuch* 20 (1958), p. 117 ff. (II); 'Sens and York. An inquiry into the sculptures from St Mary's Abbey in the Yorkshire Museum', *Journal of the Archaeological Association*, Third Series 22 (1958), p. 53 ff. (III); 'Zu einem unbekannten Fragment im Museum in Chartres', *Kunstchronik* 12 (1959), p. 298 ff. (I); 'Die kunstgeschichtliche Stellung der Westportale von Notre-Dame in Paris', *Marburger Jahrbuch für Kunstwissenschaft* 17 (1959), p. 1 ff. (II); 'Art antique et sculpture autour de 1200', *Art de France* 1 (1961), p. 47 ff.; 'Skulpturen des 12. Jahrhunderts in Châlons-sur-Marne', *Zeitscrift für Kunstgeschichte* 25 (1962), p. 97 ff. (I); 'Cathédrales. Zu einer Ausstellung im Louvre', *Kunstchronik* 15 (1962), p. 225 ff. (II); 'Twelfth-Century Sculpture at Châlons-sur-Marne', *Studies in Western Art*, Princeton, N.J. 1963, vol. I., p. 119 ff. (I); 'Eine Säulenfigur aus Châlons-sur-Marne im Museum in Cleveland (Ohio)', *Pantheon* 21 (1963), p. 143 ff. (II); 'Cathédrales', *Art de France* 3 (1963), p. 210 ff. (III); 'Tombeaux chartrains du premier quart du XIIIᵉ siècle', *L'Information d'Histoire de l'Art* 9 (1964), p. 47 ff.; *Von Sens bis Strassburg*, Berlin 1966; 'Das Stiftergrabmal des Grafen Eberhard in der Klosterkirche zu Murbach', *Festschrift Werner Gross* 1968; 'L'Europe gothique XIIᵉ–XIVᵉ siècles. Points de vue critiques à propos d'une exposition', *Revue de l'Art* 1969/3, p. 83 ff.

Schaefer, C., 'Le relief du jugement de Salomon à la façade de la cathédrale d'Auxerre', *G.B.A.*, 6ᵉ sér., 26 (1944), p. 183 ff.

Schlag, G., 'Die Skulpturen des

Querhauses der Kathedrale von Chartres', *Wallraf-Richartz-Jahrbuch* 12/13 (1943), p. 115 ff.

Schmidt, D., 'Portalstudien zur Reimser Kathedrale', *Münchner Jahrbuch der bildenden Kunst* 11 (1960), p. 14 ff.

Schmitt, O., *Gotische Skulpturen des Strassburger Münsters*, Frankfurt 1924; 'Notizen zum Strassburger Lettner', *Oberrheinische Kunst* 2 (1926/27), p. 62 ff.; 'Das Liebfrauenportal der Kathedrale von Metz', *Elsass-Lothringisches Jahrbuch* 8 (1929), p. 92 ff.

Schmoll (Eisenwerth), J. A., 'Sion-Apokalyptisches Weib – Ecclesia Lactans. Zur ikonographischen Deutung von zwei romanischen Mater-Darstellungen in Metz und Pompierre', in: *Miscellanea pro arte (Festschrift Hermann Schnitzler)*, Düsseldorf 1965, p. 91 ff.; 'Mainz und der Westen. Stilistische Notizen zum "Naumburger Meister", zum Liebfrauenportal und zum Gerhardkopf', in: *Mainz und der Mittelrhein in der europäischen Kunstgeschichte. Studien für W. F. Volbach zu seinem 70. Geburtstag*, Mainz 1966, p. 289 ff.

Schoene, W., *Das Königsportal der Kathedrale von Chartres*, Stuttgart 1961

Schreiner, L., *Die frühgotische Plastik Südwestfrankreichs*, Cologne/Graz 1963

Schürenberg, L., *Die kirchliche Baukunst in Frankreich zwischen 1270 und 1380*, Berlin 1934; 'Spätromanische und frühgotische Plastik in Dijon', *Jahrbuch der preussischen Kunstsammlungen* 58 (1937), p. 13 ff.

Seymour, Ch., *Notre-Dame of Noyon in the Twelfth Century*, New Haven, Conn. 1939

Stein, H., *Le Palais de justice et la Sainte-Chapelle de Paris*, Paris 1912

Stoddard, W. S., *The West Portals of Saint-Denis and Chartres*, Cambridge 1952

Stothard, C. A., *The monumental Effigies of Great Britain*, London 1817–32

Tarbé, P., *Les sépultures de l'église Saint-Rémi de Reims*, Rheims 1842

Tarbé, Th., *Description de l'église métropolitaine de Saint-Etienne de Sens*, Sens 1841

Thiollet, M., *Antiquités, Monuments et Vues Pittoresques du Haut-Poitou*, Paris 1823

Thoby, P., *Le crucifix des origines au Concile de Trente*, Nantes 1959

Thomas, B., 'Die westfälischen Figurenportale in Münster, Paderborn und Minden', *Westfalen* 19 (1934), p. 1 ff.

Tillet, J., 'Les ruines de l'abbaye de Nesle-la-Reposte', *C.A.* 69 (1902), p. 514 ff.

Tournier, R., *Les églises comtoises. Leur architecture des origines au XVIII^e siècle*, Paris 1954

Truchis, P. de, 'Semur-en-Auxois', *C.A.* 74 (1907), p. 64 ff.

Urseau, Ch., *La cathédrale d'Angers*, Paris n.d.

Vallery-Radot, J., 'L'église de Notre-Dame de Longpont', *Bull. Mon.* 79 (1920), p. 65 ff.;
Loches, Paris 1926;
'Bazas', *C.A.* 102 (1939), p. 274 ff.;
'Saint-Ours de Loches', *C.A.* 106 (1948), p. 120 ff.;
'L'église Notre-Dame de Villeneuve-l'Archevêque', *C.A.* 113 (1955), p. 445 ff.;
'Tombeau d'Adélaïs, comtesse de Joigny', *C.A.* 116 (1958), p. 130 ff.
'La Charité-sur-Loire. A propos d'une thèse récente', *Cahiers de civilisation médiévale* 9 (1966), p. 51 ff.

Vanuxem, J., 'Les portails détruits de la cathédrale de Cambrai et de Saint-Nicolas d'Amiens', *Bull. Mon.* 103 (1945), p. 89 ff.;

'La sculpture de Notre-Dame sous la Révolution et l'Empire', *Chroniques de Notre-Dame* 1947;
'La sculpture du XII^e siècle à Cambrai et à Arras', *Bulletin Monumental* 113 (1955), p. 7 ff.

Verheyen, E., 'Das Fürstenportal des Bamberger Doms', *Zeitschrift für Kunstwissenschaft* 16 (1962), p. 1 ff.

Verneilh, F. de, 'Les Bas-reliefs de L'Université à Notre-Dame de Paris', *Annales archéologiques* 26 (1869), p. 96 ff.

Villette, J., 'Précisions nouvelles sur le jubé de la cathédrale de Chartres', *Mém. de la Soc. archéol. d'Eure-et-Loir* 22 (1965), p. 127 ff.

Viollet-le-Duc, E., *Dictionnaire raisonné de l'architecture*. Paris 1867 ff., vols I–X

Vitry, P., 'Les acroissements de département de la sculpture du moyen-âge, de la renaissance et des temps modernes', *Rev. de l'art ancien et moderne* 13 (1908/1), p. 106 ff.;
'Nouvelles observations sur le portail Sainte-Anne de Notre-Dame de Paris. A propos de deux fragments de voussures conservées au Musée du Louvre', *Rev. de l'art chrétien* 60 (1910), p. 70 ff.;

La cathédrale de Reims. Architecture et sculpture, Paris 1919;
Die gotische Plastik Frankreichs 1226–1270, Florence/Munich 1929;
and G. Brière, *L'église abbatiale de Saint-Denis et ses tombeaux*, Paris 1908

Vöge, W., *Die Anfänge des monumentalen Stils im Mittelalter*, Strasbourg 1894;
Bildhauer des Mittelalters, Berlin 1958

Weinberger, M., 'Die Madonna am Nordportal von Notre-Dame', *Zeitschrift für bildende Kunst* 64 (1930/31), p. 1 ff.

Weis, A., 'Die "Synagoge" am Münster zu Strassburg', *Das Münster* 1 (1947), p. 65 ff.;
'Die Himmelfahrt Mariens am Strassburger Münster und die Bildsymbolik der Kathedralskulptur', *Das Münster* 4 (1951), p. 12 ff.

Wilhelm, P., *Die Marienkrönung am Westportal der Kathedrale von Senlis*, Hamburg 1941

Zarnecki, G., *Gislebertus, sculpteur d'Autun*, Paris 1960 ,

APPENDIX TO BIBLIOGRAPHY

The following publications, listed under the name of the building or sculpture to which they refer, appeared since the German edition of this book was prepared:

Saint Denis, abbey church, west portal
Crosby, S. McK., 'A relief from Saint-Denis in a Paris apartment', *Gesta* VIII (1969), p. 45 ff. [the author shows that the tympanum of the left doorway bore, even in the late eighteenth century, a relief with a scene from the martyrdom of Dionysius, Eleutherius and Rusticus; from this evidence it is probable that the mosaic destroyed in 1771 also depicted the same subject];
'The west portals of Saint-Denis and the Saint-Denis style', *Gesta* IX (1970), p. 1 ff. [this article contains an extensive report of a detailed examination of the state of preservation in 1968]

Chartres cathedral, west portal
Chadefaux, M. C., 'Le portail royal de Chartres', *G.B.A.*, 6e pér., LXXVI (1960), p. 273 ff. [report on the state of preservation since the 17th century, occasioned by the removal of several statues in 1967]

Crozet, R., 'A propos des chapiteaux de la façade occidentale de Chartres', *Cahiers de la civilisation médiévale* XIV (1971), p. 159 ff.
[a critical appraisal of the work of A. Heimann in 1968]

La Charité-sur-Loire, lintels
Thérel, M. L., 'Les portails de la Charité-sur-Loire. Etude iconographique', *C.A.* 125 (1967), p. 86 ff. [an attempt at an iconographical interpretation of the two lintels, with the aid of texts of Petrus Venerabilis]

Dijon, Saint-Bénigne, portal
Schlink, W., *Zwischen Cluny und Clairvaux*, Berlin 1970, p. 120 ff. [in a section on 'Die Portalplastik von Saint-Bénigne in Dijon', the author reviews the facts known in the light of research to date]

Rheims, Saint-Rémi, head of King Lothaire
Prache, A., 'Les monuments funéraires des Carolingiens élevés à à Saint-Rémi de Reims au XII^e siècle', *Rev. de l'Art* 6 (1969), p. 68 ff. [an investigation into the origins of the seated figures of Louis VI and Lothaire, which are dated to shortly after 1130]

Frankfurt, Liebieghaus, head of a king
Pressouyre, L., 'Réflexions sur la sculpture du XII^e siècle en Champagne', *Gesta* IX (1970), p. 16 ff. [shows that the head probably came from the portal of Nesle-la-Reposte]

Paris, Notre Dame, Portail Sainte-Anne
Kahn, W., 'The tympanum of the portal of Saint-Anne at Notre Dame de Paris and the iconography of the division of powers in the early middle ages', *Journal of the Warburg and Courtauld Institutes* XXXII (1969), p. 55 ff. [attempts to determine the iconographical meaning of the figures of a king and bishop which appear on the tympanum]

Thirion, J., 'Les plus anciennes sculptures de Notre-Dame de Paris', *Comptes-Rendus de l'Académie des Inscriptions et Belles-Lettres* (1970), p. 85 ff. [proposes the identification of the king as Childebert and the bishop as St Germanus; it is presumed that the different parts of the portal were developed in a sequence between 1150 and 1165]

Châlons-sur-Marne, Notre-Dame-en-Vaux, former cloister
Pressouyre, L., *Un apôtre de Châlons-sur-Marne*, Berne 1970 [publication of a column figure from Châlons-sur-Marne, now preserved in the Abegg-Stiftung, Berne]

Meaux cathedral, north transept portal
Kurmann, P., *La Cathédrale Saint-Etienne de Meaux*, Geneva 1971, p. 87 [the author presumes that the sculptures of the present north transept portal are the remnants of an earlier portal originally on the south transept]

Chartres cathedral, south transept portal
Gosebruch, M., 'Zur Bedeutung des Gerichtsmeisters am südlichen Querhaus der Kathedrale von Chartres', in *Argo. Festschrift für Kurt Badt*, 1970, p. 142 ff. [an unconvincing attempt at a revised chronology for the transept sculptures]

Strasbourg cathedral, transept sculptures
Grodecki, L., and R. Recht, 'Le bras sud du transept de la cathédrale: Architecture et Sculpture' (Quatrième colloque international de la Société Française d'Archéologie, Strasbourg, 1968), *Bull. Mon.* 129 (1971), p. 7 ff. [an excellent critical survey of the present state of research]

Dijon, Notre Dame, west portal
Quarré, P., 'Les sculptures des portails et de la façade de l'église Notre-Dame de Dijon', *Mém. de la Commission des Antiquités du département de la Côte d'Or* XXVI (1963–69), p. 305 ff. [a detailed analysis of the majority of the extant sculptures]

Paris, Notre Dame, west portal
Vieillard-Trojekouroff, M., 'Les zodiaques Parisiens sculptés d'après Le Gentil de la Galaiserie', *Mém. de la Société des Antiquaires de France*, 9ᵉ série, IV (1968), p. 161 ff. [reviews eighteenth-century publications dealing with the Zodiac and Calendar of Notre Dame]

Hoffmann, D., *The Year 1200* (exhibition at the Metropolitan Museum, New York), 1970, no. 15 [shows that the head in Chicago is of a different type of stone from the torso in the Musée Carnavalet, Paris, and therefore does not originate from Notre Dame]

Reiff, D. D., 'Viollet-le-Duc and Historic Restoration. The west portals of Notre-Dame', *Journal of the Society of Architectural Historians* XXX (1971), p. 17 ff. [a detailed analysis of the restorations carried out in the nineteenth century]

Vitry, B., 'Le lavage de Notre-Dame de Paris', *Les Monuments historiques de la France*, nouvelle série XVII (1971), p. 41 ff. [a brief report on the controversial cleaning of the sculptures in 1969/70]

Paris, Louvre. King Childebert
Beaulieu, M., 'Restauration de la statue de Childebert', *Revue du Louvre* 19 (1969), p. 161 ff. [report on the removal of the modern painted decoration]

Saint-Omer cathedral. Christ, the Virgin and John, from Thérouanne
Coolen, G., 'Le Jugement dernier de Thérouanne', *Bull. trimestrielle de la Société académique des Antiquaires de la Morinie*, 1969, p. 103 ff. [publication of four further heads which are ascribed to this same group of sculptures]

Rouen cathedral, west portal
Krohm, H., 'Die Skulptur der Querhausfassaden an der Kathedrale von Rouen', *Aachener Kunstblätter* 40 (1971), p. 40 ff. [this also deals with the sculptures of the west portal, p. 83 ff.]

Paris, Notre Dame, north transept portal
Kimpel, D., *Die Querhausportale von Notre-Dame zu Paris und ihre Skulpturen*, Bonn 1971 [a monograph which examines in detail the entire sculptural content of both transept portals]

Rheims cathedral
Schüssler, I., 'Die Reimser Visitatio-Maria als erste Trumeau-Madonna', *Marburger Jahrbuch für Kunstwissenschaft* XVII (1969), p. 119 ff. [the proposal that the Virgin of the Annunciation group is a modified trumeau figure is not convincing]

Saint-Denis, abbey church. Tomb of Robert the Pious and Constance of Arles
Sommers, G. R., 'Royal tombs at Saint-Denis in the reign of Saint Louis' (Ph.D. thesis), Columbia University, 1966 [a basic monograph-type treatment of the tombs; not always convincing in terms of style criticism]

Amiens cathedral, south transept portal
Suckale, R., *Studien zu Stilbildung und Stilwandel der Madonnenstatuen in der Ile-de-France zwischen 1230 and 1300*, Munich 1971 [postulates a date even before 1240 also for the later parts of the portal; similar opinions are expressed in D. Kimpel, op. cit.]

INDEX